1961 BERLINART 1987

Edited by

Kynaston McShine

With essays by

René Block, Laurence Kardish,
Kynaston McShine, Karl Ruhrberg, Wieland Schmied,
Michael Schwarz, and John Willett

The Museum of Modern Art, New York
Prestel, Munich

Published on the occasion of the exhibition *BERLINART 1961–1987*
organized by Kynaston McShine, Senior Curator, Department of Painting and Sculpture
The Museum of Modern Art, New York
June 4–September 8, 1987

Also shown at
San Francisco Museum of Modern Art
October 22, 1987–January 3, 1988

Certain illustrations are covered by claims to copyright cited in the Photograph Credits.
Texts by Wieland Schmied, Karl Ruhrberg, René Block, and Michael Schwarz were
translated from the German by John William Gabriel.
Translations of Pandemonium manifestoes are reprinted from *Georg Baselitz: Paintings 1960–1983*
with the kind permission of Whitechapel Art Gallery, London.

Library of Congress Catalogue Card Number 87-61022
ISBN 0-87070-255-6 Hardcover
ISBN 0-87070-256-4 Paperback

The Museum of Modern Art
11 West 53 Street
New York, New York 10019

Prestel-Verlag
Mandlstrasse 26
8000 Munich 40

Composition by Fertigsatz GmbH, Munich
Color separations by Repro Dörfel, Munich
Printed by Karl Wenschow – Franzis Druck GmbH, Munich
Bound by R. Oldenburg, Heimstetten

Printed in the Federal Republic of Germany

Front cover:
Georg Baselitz. *The Great Friends.* 1965. Oil on canvas. 8' 2 3/8" x 9' 10 1/8" (250 x 300 cm).
Museum Moderner Kunst, Vienna, on loan from Ludwig Collection, Aachen

Back cover:
Rainer Fetting. *Van Gogh and Wall V.* 1978. Oil on canvas. 6' 8" x 8' 4" (201 x 251 cm).
Collection Marx

Frontispiece:
Helmut Middendorf. *Airplane Dream.* 1982. Synthetic polymer paint and oil on canvas.
13' 1/2" x 9' 10" (400 x 300 cm). Collection Federal Republic of Germany

Prestel-Verlag ISBN 3-7913-0815-7 Hardcover Trade Edition

Contents

This publication has been made possible by
a generous grant to The Museum of Modern Art from

The Bohen Foundation

The exhibition *BERLINART 1961–1987* has received generous support from

The Ministry of Foreign Affairs of the Federal Republic of Germany
The Senator for Cultural Affairs, Berlin
National Endowment for the Arts, Washington, D.C.

Deutsche Bank
Philip Morris Companies Inc.
The International Council of The Museum of Modern Art

Additional support for transportation has been provided by

Lufthansa German Airlines

Foreword

This book is published on the occasion of the exhibition *BERLINART 1961–1987*, which happily coincides with the City of Berlin's commemoration of its 750th anniversary. Berlin has also had a long history as an artistic center, and the postwar City has again become a vital and influential focal point for the arts. Since the 1960s, Berlin (West) has come to represent a deep and abiding commitment to the spirit of internationalism and artistic freedom, not only through the work of its own artists but also through its hospitality to artists from all over the world. It is, therefore, an appropriate moment to present for the first time in the United States an exhibition devoted to the coherent contribution that this unique city has made to recent art history.

On behalf of the trustees and staff of The Museum of Modern Art, I wish to express our deep appreciation to the Ministry of Foreign Affairs of the Federal Republic of Germany and to the Senator for Cultural Affairs, Berlin. Their generous support for an exhibition of very recent work is an impressive example of enlightened sponsorship. We also owe particularly warm thanks to Deutsche Bank for its early and enthusiastic commitment to this project. We are grateful to Deutsche Bank not only for direct financial assistance but also for active and productive help in enlisting other sponsors.

We are very appreciative to Lufthansa German Airlines for graciously contributing the transportation of many of the works included in the exhibition. Lufthansa's patience and cooperation in coping with the special requirements this entailed have been admirable.

The participation of Philip Morris Companies Inc. in the sponsorship of this exhibition exemplifies their prominence among corporate sponsors who value and encourage innovation in the arts. Similarly, the generous support received from the National Endowment for the Arts, Washington, D.C., and from The International Council of The Museum of Modern Art continues their long and distinguished records of furthering contemporary art. We are also most grateful for the additional contributions made by Axel Springer Verlag, Hamburg; The Ritz-Carlton Hotel; and Daimler-Benz.

The scope and quality of this book, published in conjunction with the exhibition, owe much to the major grant provided by The Bohen Foundation. We are very warmly grateful to Frederick B. Henry and Cecilia Metheny, whose personal interest and imagination were responsible for The Bohen Foundation's deeply appreciated assistance to this publication.

There are many other individuals to whom we owe warm thanks for their personal involvement and help with this entire project. Among them, I should like especially to cite Ambassador Berthold Witte, of the Federal Foreign Office, Bonn; Mayor Eberhard Diepgen, Berlin; Senator for Cultural Affairs Volker Hassemer, Berlin; Jörg-Ingo Weber, of the Office of the Senator for Cultural Affairs, Berlin; Richard S. Zeisler, of this Museum's Board of Trustees; Christian Strenger and Herbert Scheidt of

Deutsche Bank; Hans Dieter Altmann and Felix Becker of Lufthansa German Airlines; Stephanie French of Philip Morris; and Timotheus Pohl of Daimler-Benz.

The Friedrich Naumann Foundation office in New York has been of great help to us, especially its Director Fräulein Manina Lassen-Grzech. We have also been most fortunate to have the friendly counsel and cooperation of Dr. Peter Sympher, Consul-General of the Federal Republic of Germany in New York, and his staff. We have benefited, too, from the interest and assistance of Dr. Jürgen Ohlau, Director of Goethe House. We wish to thank our colleagues at the San Francisco Museum of Modern Art, Director John R. Lane and Chief Curator Graham Beal, for their enthusiastic cooperation in having this exhibition seen on our West Coast.

The individual most responsible for this ambitious undertaking is Kynaston McShine, Senior Curator in the Department of Painting and Sculpture, who conceived and organized the exhibition and who edited this publication. He deserves our admiration as well as our gratitude. In his research, in the planning and installation of the exhibition, and in the preparation of this book he has had the benefit of close collaboration with Thomas Schulte, special research assistant from Berlin, and Marjorie Frankel Nathanson of the Department of Painting and Sculpture, to whom we also express our thanks. They have all had the dedicated support of the staff of the Museum, which complemented its customary professionalism with special enthusiasm for this project.

Finally, we are deeply grateful to the lenders without whose generosity and cooperation no undertaking like this exhibition would be possible. Above all, we thank and honor the artists whose imagination and creativity are celebrated in this exhibition and this book.

Richard E. Oldenburg
Director
The Museum of Modern Art

Acknowledgments

The contributions to contemporary art made by many artists from Berlin in the last several years are well known in Europe, but much less so in the United States. It is the intention of this exhibition and publication to attempt to redress the imbalance, and to present to an American public the significant art created in Berlin over the past quarter-century both by Berliners and by the many visiting artists whose work has shown a specific response to the unique condition of the city. It is hoped that the free creative spirit and the internationalism in which their art has been nurtured will allow a larger public to comprehend its extraordinary impact on the art of the last twenty-five years. It has been a vanguard art that is serious, intellectual, and humanistic.

The enthusiasm, cooperation, support, and generosity of a great many people have been crucial to the realization of this presentation. On behalf of the trustees of The Museum of Modern Art I wish to express my deepest gratitude to all who have participated in the preparation of the exhibition *BERLINART 1961–1976* and its accompanying publication. I extend my personal thanks to the Mayor of Berlin, Eberhard Diepgen, and to the Senator for Cultural Affairs of Berlin, Volker Hassemer, whose wholehearted support of this project has been exemplary. And I owe a special debt of gratitude to Jörg-Ingo Weber, of the office of the Senator for Cultural Affairs, who has offered advice with patience and good humor, and who has guided me through the intricacies of Berlin with memorable friendliness and professionalism. They have had the vision to recognize the purpose and significance of this undertaking. The support and good will of the Ministry of Foreign Affairs in Bonn has been much appreciated and my personal thanks go to the Foreign Minister and Ambassador Berthold Witte. I also most gratefully acknowledge the contribution of the National Endowment for the Arts which has generously assisted exhibitions of contemporary art over the years.

For its generous support of this publication I am indebted to The Bohen Foundation, whose assistance has made possible a comprehensive contribution to the literature on contemporary art.

I would also like to thank the Friedrich Naumann Foundation, the Consul-General of the Federal Republic of Germany in New York, and Goethe House in New York. Their advice and cooperation were given unhesitatingly, and they, too, have offered vital encouragement for this project.

The International Council of The Museum of Modern Art, a unique group of dedicated individuals, has from the outset offered generous encouragement, and I extend my special thanks to the Council, and particularly to its Chairman, H. R. H. Prinz Franz von Bayern, and two of its members for their crucial assistance, Mr. Richard S. Zeisler of New York and Dr. Peter Ludwig of Aachen.

In addition to their texts, the authors of this book have provided valuable information, guidance, and assistance. I have depended on them greatly and appreciated their suggestions. I especially thank René Block, Karl Ruhrberg, and Wieland Schmied, who have done much to shape the artistic environment of the last twenty-five years in Berlin. I also thank John Willett and Michael Schwarz.

The research and preparation of both publication and exhibition owe much to two people who have been my collaborators on every aspect of this project: Thomas

Schulte and Marjorie Frankel Nathanson. I am personally deeply indebted to both of them. Thomas Schulte has provided invaluable knowledge and extensive research. His attentiveness to detail has been matchless, his resourcefulness and persistence extraordinary, and he has given unstintingly of his time and energy. He deserves my heartfelt thanks. Marjorie Nathanson has done much to assure the success of this exhibition. She has been an equally valuable researcher, and has been involved in all the detailed intricacies of organizing an exhibition and book of this amplitude. Her good judgment and keen sensibility are admirable. She is a valued colleague. I also wish to thank them both for their contributions to this volume.

Many colleagues at the Museum and elsewhere have lent encouragement and support throughout the months that this project has been in preparation. William Rubin, Director of the Department of Painting and Sculpture, has not only been a supporter of the project, but his considered judgment has enriched its focus. Richard Oldenburg, Director of the Museum, has made every effort toward the realization of this project. I owe them a special debt of gratitude.

In the Department of Painting and Sculpture, particular thanks are due Todd Alden, who has handled the voluminous correspondence and many related tasks for the exhibition and book, skillfully and with exemplary patience and good will. His assistance has been invaluable. Carolyn Lanchner has given her kind personal advice at all times when it was needed. I also thank Linda Shearer who generously assisted with other curatorial responsibilities to allow me crucial time for this project. Indeed, its success has depended on the cooperation of the entire Department of Painting and Sculpture, for which I thank each of its members.

A particular debt is owed the Museum's Department of Publications for producing this volume, and especially to Harriet Bee, Managing Editor, who has edited the book with thoroughness and clarity, expertly and swiftly. I wholeheartedly thank her for her splendid efforts. I also acknowledge the contributions of Louise Chinn and Nancy Kranz. In guiding this book through all the phases of its production we have benefited greatly from our collaboration with Prestel-Verlag of Munich. I most warmly thank Jürgen Tesch for his guidance in this successful endeavor. Under great pressure, beyond transatlantic demands, Franz Mees has, with patience and skill, given this complicated book a design which deserves our admiration. We have also benefited from the expert work of the editors in Munich, Michael Foster and Peter Stepan.

Richard Palmer, the Museum's Coordinator of Exhibitions, has generously given his experience in the planning of the exhibition. His knowledge of the complexities of, and his deep commitment to, international exhibitions is always to be acknowledged. Jerome Neuner has given his customary thoroughness and attention to detail to a challenging installation. Special thanks are owed the Department of the Registrar, and particularly Lynne Addison who has efficaciously coped with the various difficulties of assembly and disassembly of the works. The special cooperation of the Department on this project is gratefully acknowledged. The Conservation Department is also to be thanked for the advice and assistance of its staff.

The Department of Education has been of great assistance. Its Director, Philip Yenawine, and Emily Kies of that department have cooperated in the preparation of the brochure and the organization of the lecture series. It would be appropriate here to thank the lecturers who will provide further insights into the history of art in Berlin. They are Professor Thomas Gaehtgens, Professor Donald Kuspit, Richard Calvocoressi, Wolfgang Max Faust, and Professor Michael Stürmer.

The Department of Film is to be thanked for organizing the film program presented in conjunction with the exhibition. I am indebted to Laurence Kardish, Curator of Film, who has not only selected the films but also provided the essay on recent film in Berlin which is included in this book. I also thank the Director of the Department, Mary Lea Bandy, for her cooperation.

An indispensable department for the preparation of any exhibition at the Museum is the Library, and I thank the staff for its willingness and cooperation as well as its

invaluable contribution in providing informative documentation. I specially thank Daniel Starr for the bibliography he has contributed to this volume.

Many other members of the Museum's staff have contributed in various ways. I especially acknowledge Riva Castleman, Deputy Director for Curatorial Affairs and Director of Prints and Illustrated Books; Jeanne Collins, Director of Public Information; Waldo Rasmussen, Director of the International Program; and James Snyder, Deputy Director for Planning and Program Support. I would like to thank Mikki Carpenter, Lacy Doyle, Alistair Duguid, Louis Estrada, Diane Farynyk, Susan Jackson, Kate Keller, Susan Kismaric, Philip Lee, Marlene McCarty, Timothy McDonough, Kristin Teegarden, Richard Tooke, and Monica Weigel.

Many museum colleagues and friends of The Museum of Modern Art have been generous in offering information, insights, and valued assistance. It would be impossible to name them all, but I must specially thank the following. In Berlin: Heiner and Céline Bastian; Rolf von Bergmann; Alf Bold; Monika Brehmer; Jürgen Bruning; Clara Burckner; Clemens Fahnemann; Johann Feindt; Dagmar Forelle; Freunde der deutschen Kinemathek; Erika Gregor; Ulrich Gregor; Dr. Michael Haerter, Künstlerhaus Bethanien; Prof. Dr. Dieter Honisch, National-galerie; Mr. and Mrs. Max Jacoby; Anne Jud; Godehard Lietzow, Galerie Liet-zow; Mrs. M. Lindemann, DAAD Artists Program, Berlin; Dr. Erich Marx; Mr. E. Nohall, Paris Bar; Jes Petersen; Claus Dieter Platte; Rainer Pretzell; Prof. Dr. Karl Roeloffs, Secretary General DAAD, Bonn; Dr. Uwe Rosenbaum; Prof. Dr. Eberhard Roters, Berlinische Galerie; Joachim Sartorius, Director DAAD Artists Program, Berlin; Wolf Jobst Siedler; Galerie Volker Skulima; Ruthild Spangen-berg, Bücherbogen am Savignyplatz; Galerie Springer; Dr. Hans Hermann Stober; Dr. Sabine Vogel; Galerie Wewerka; Karsten Witte; Galerie Zellermayer; and Werner Zellien. In Cologne: Lothar von und zu Dohna; Galerie der Spiegel; Galerie Max Hetzler; James Hofmaier, Galerie Michael Werner; Armin Hundert-mark; Benjamin Katz; Buchhandlung Walther König; and Aurel Scheibler. In Munich: Walter Bareiss, Galerie Fred Jahn, Galerie Klewan, Ulrike Lang, Galerie Van de Loo, Sabine Lutzeier, and Max Oppel. I also wish to thank Gianfranco Benedetti, Galleria Christian Stein, Milan and Turin; Galerie Heike Curtze, Vienna and Düsseldorf; Julia Ernst, Saatchi Collection, London; Nigel Greenwood Books, London; Detlev Gretenkort, Derneburg; Peter Goulds, L.A. Louver Gallery, Venice, California; George Hemphill, Middendorf Gallery, Washington, D.C.; Eva Lips, Turske & Turske, Zurich; Gilbert Lloyd, Marlborough Fine Art Ltd., London; Galerie Vera Munro, Hamburg; Mr. and Mrs. Ura Raussmuller, Crex Collection, Schaffhausen; Galerie Alfred Schmela, Düsseldorf; Nicholas Serota, Whitechapel Art Gallery, London; Christian Siebeck, Bonn; Galerie Ulysses, Vienna; and Jörg Zutter, Kunstmuseum, Basel.

I also appreciate the cooperation, support and encouragement this project received in New York from Douglas Baxter, Paula Cooper Gallery; Michael Boodro; Mary Boone–Michael Werner Gallery; Jeanne-Claude Christo; Drentel Doyle Partners; Xavier Fourcade; William Garbe; Sylvia Guirey; Bob Goldberg, Byrd Hoffman Foundation, Inc.; Nathan Kolodner, André Emmerich Gallery; Robert Kovich; John Limpert, Jr.; Irmgard Lochner; Brunhilde Mayor; Jason McCoy; David Nolan; Annina Nosei Gallery; David Robinson, Marlborough Gallery; Barbara Ross; Ingrid Scheib-Rothbart, Goethe House; Steven Schoen-felder; Alarik Skarstrom; Charles Tebo; and Ragland Watkins.

The exhibition will travel to the San Francisco Museum of Modern Art, and I thank my colleague, Graham Beal its Chief Curator, for enabling it to be seen there.

The greatest contribution to BERLINART 1961–1987 is that of the artists, without whom there would be neither exhibition nor book. They have not only provided us with their work, but have also very kindly cooperated with us on all our questions and demands. Particular thanks are also due the lenders to the exhibition, who graciously consented to share their works on this occasion. They have all been overwhelmingly generous, and I am most grateful. K. McS.

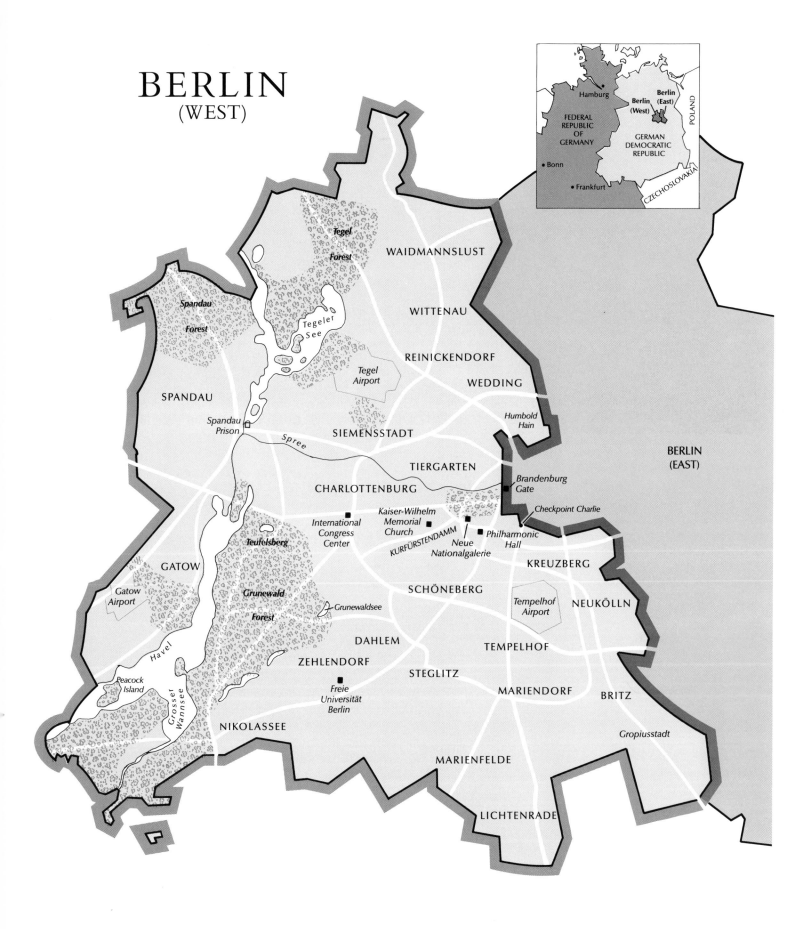

BERLIN
(WEST)

FEDERAL REPUBLIC OF GERMANY

Hamburg

Berlin (West)

Berlin (East)

POLAND

GERMAN DEMOCRATIC REPUBLIC

Bonn

Frankfurt

CZECHOSLOVAKIA

Tegel Forest

Spandau Forest

WAIDMANNSLUST

WITTENAU

Tegeler See

REINICKENDORF

WEDDING

Tegel Airport

SPANDAU

Spandau Prison

Spree

SIEMENSSTADT

Humbold Hain

BERLIN (EAST)

TIERGARTEN

CHARLOTTENBURG

Brandenburg Gate

International Congress Center

Kaiser-Wilhelm Memorial Church

Checkpoint Charlie

Philharmonic Hall

KURFÜRSTENDAMM

Neue Nationalgalerie

Teufelsberg

KREUZBERG

GATOW

Grunewald Forest

SCHÖNEBERG

NEUKÖLLN

Gatow Airport

Grunewaldsee

Tempelhof Airport

DAHLEM

TEMPELHOF

Havel

ZEHLENDORF

STEGLITZ

MARIENDORF

BRITZ

Peacock Island

Crosser Wannsee

Freie Universität Berlin

NIKOLASSEE

Gropiusstadt

MARIENFELDE

LICHTENRADE

BERLINART: An Introduction

Kynaston McShine

> In Berlin everything is very complicated.
> *Shusaka Arakawa*
>
> In Berlin everything is much easier.
> *Constantin Xenakis*

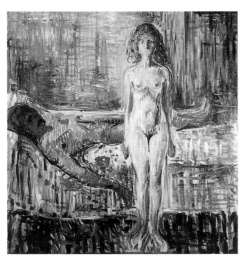

Figure 1: Edvard Munch. *The Death of Marat.* 1907. Oil on canvas. Munch Museum, Oslo

During the past quarter-century Berlin has become a major center of contemporary artistic activity. The first extensive American look at this extraordinary city's contribution to recent art, the present exhibition necessarily focuses on the unique phenomenon of Berlin itself and on its role as an environment for the making of art.

In the first third of the twentieth century, Berlin was a crossroads of the arts. Artists such as the Norwegian Edvard Munch (figure 1), the Russians Kasimir Malevich and Wassily Kandinsky, the Frenchman Robert Delaunay, and many others worked there. Berlin's contributions to the history of modernism in Expressionist painting and sculpture, in architecture, theater, film, and music are well-documented. It had its own branch of Dada and, at another extreme, was the final home of the Bauhaus in Germany. Max Beckmann, George Grosz, Ernst Ludwig Kirchner, Fritz Lang, Wilhelm Lehmbruck, and Ludwig Mies van der Rohe were among the many who created Berlin's distinctive atmosphere of creativity and rebellion.

But the city's spirit was unnaturally stopped with the advent of Nazism and the Second World War. Political events caused the name Berlin to mean the headquarters of a great evil—a machine that led to war, murder, catastrophe, unforgettable tragedy. The War nearly destroyed the city; but in rebuilding itself, Berlin endeavored to learn from its recent past, insisting on a cultural and artistic freedom that had not existed since 1933. This ideal was severely tempered by the political realities of occupation.

After the War, with the beginning of free artistic activity, Berlin's younger generation of artists felt a need to "catch up" with what had been happening in the United States and Europe. A sense of isolation was felt intensely by Berliners, but was perhaps even more vivid for its artists, whose heritage in German Romanticism already fostered identification with solitude, loneliness, alienation, and exile. While such an attitude had been a source of creative energy for earlier generations, its effects were sometimes debilitating to artists living in the harsh circumstances of postwar Berlin. Berlin's situation became even more acute in August 1961 when construction of the Wall by the Soviet-backed East German government effectively isolated the city, creating an island of free thought surrounded by a sea of control. Inevitably, the Wall became a bleak symbol of man's folly.

It may not be a coincidence that 1961 was also the year in which the beginnings of a strong resurgence of expressionism and figuration became more publicly apparent. Protest against the provincialism of Berlin's postwar society and culture began to be strongly asserted in the work of a young generation of painters—predominantly students of the Hochschule für bildende Künste (College of Visual Arts)—who were reacting against the prevailing formalist postwar European styles of painting, *l'art informel* and *tachisme*.

Unlike the contemporary, more optimistic, and often humorous inventions of Pop and *Nouveau Réalisme*, Berlin's art bore witness to melancholy, claus-

trophobia, and social tensions. Out of the pressures of this period came the beginnings of the figurative, socially-involved art that has since become a major current in the contemporary art world. Perhaps the most significant event of the period came in November 1961, when two young students at the College, Georg Baselitz and Eugen Schönebeck, published their first manifesto, *Pandemonium*, and organized an exhibition of their work. *Pandemonium* is a strong and poetic statement, an incantation on life as seen from the bottom up, a cry of anguish expressing the pessimism and isolation that also appears in the contemporary imagery of its authors' drawings and paintings.

Both Baselitz and Schönebeck had come to West Berlin in the mid-1950s from eastern Germany. As students at Berlin's College of Visual Arts, they admired the work of artists such as Jackson Pollock and Philip Guston, which they saw first-hand in two important exhibitions of Abstract Expressionism in Berlin in 1958: *The New American Painting* and *Jackson Pollock: 1912–1956*, both organized by The Museum of Modern Art.

In Baselitz's early work, his keenly felt sense of being caught between the abstract and figurative traditions is apparent, as in *Amorphous Landscape*, 1961, and *Saxon Landscape*, 1962–63 (plates 2 and 3), with their elusive, quasiabstract evocations of landscape, and human and biomorphic forms. This conflict is apparent in Baselitz's drawings and paintings of this period, even as they echo the texts of the *Pandemonium* manifestoes whose literary imagery was influenced by figures such as Lautréamont (Isidore Ducasse), Charles Baudelaire, and the mad and saintly French Surrealist poet and actor, Antonin Artaud.

A vivid example of Baselitz's often violent and shocking pictorial language of this time is to be found in the series *P. D. Feet* (plates 4–13), depicting feet that are sometimes crudely dismembered from the body. Metaphors of rootlessness, these tortured feet recall Crucifixion imagery, and also can evoke the suffering of displaced people who have walked to escape from pandemoniac (the *P.D.* of the title is an abbreviation for pandemonium) oppression. The tendency to use highly charged imagery became even more pronounced in Baselitz's paintings *The Great Piss-Up*, 1962–63 (see page 47), and *Naked Man*, 1962 (figure 2), which so offended the authorities that they were confiscated as obscene.

A more direct treatment of the figure can be seen in his work of 1964–66. His series of drawings, prints, and paintings called the New Type, is representative of this change. In these works the image usually consists of a single male, or "hero," who holds symbolic objects (plates 19, 22, and 24). These heroes represent Baselitz's reflections on his position as an artist and continue his pictorial meditations on the defeated spirit and on hopelessness. In the important painting of 1965, *The Great Friends* (plate 20), two pointedly nonheroic, almost androgynous, figures appear to be reaching out to each other, unable to touch with their stigmata-scarred hands. In this dark picture with its hints of a wall, a fallen flag is ambiguous, revealing no sense of victory or defeat. The implications of negation and of the possibility of fulfillment make this work a strong metaphor for Berlin and Gemany's recent history. *The Great Friends* was exhibited in early 1966, shortly before Baselitz left Berlin to live in southwest Germany, where he began to develop the unique personal style for which he has since become well known. From his poignant images of suffering evolved his fractured figures and, eventually in the late 1960s, drawings and paintings of upside-down figures and objects (figures 3 and 4).

While Schönebeck was close to Baselitz at the beginning of his career, their aesthetic aims diverged when their friendship ended in 1962. Schönebeck's style became what he has called his own personal "socialist realism." In 1965 he painted a series of portraits of Vladimir Mayakovsky (figure 5), Nikolai Lenin, Mao Tse-Tung, and David Alfaro Siqueiros—major figures in terms of the

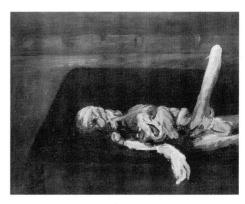

Figure 2: Georg Baselitz. *Naked Man*. 1962. Oil on canvas. Whereabouts unknown

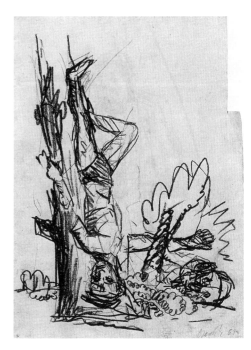

Figure 3: Georg Baselitz. *Man at a Tree Downward*. 1969. Grease pencil on paper. Kunstmuseum Basel, Kupferstichkabinett

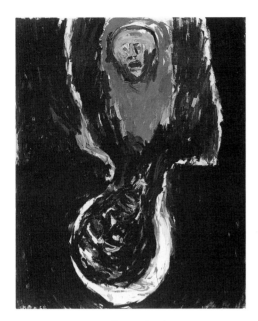

Figure 4: Georg Baselitz. *Edvard's Spirit, 21. VIII. 1983*. Oil on canvas. Private collection

relationship of art to politics who represent a strong social idealism. This counterpoint to Baselitz's heroes came to an abrupt end in 1966 when Schönebeck ceased painting. In the same year, Baselitz left Berlin. Antonius Höckelmann, now well known for his biomorphic abstract sculptures, initially shared the existential aesthetics of his fellow students Baselitz and Schönebeck. However, Höckelmann's use of amorphic and grotesque swirling forms in his large drawings since the mid-1960s expressed a uniquely introverted vision related to the tradition of the grotesque.

Despite the generally strong reaction against *l'art informel* in Berlin in the early 1960s, several artists did not renounce abstraction and attempted to champion its cause as the soul of modernism. The most significant of these artists is Fred Thieler who was strongly attached to Abstract Expressionism. His unswerving devotion to abstract art has been an encouragement to a younger generation of Berlin artists. Another adherent of abstraction is Walter Stöhrer, whose work seems closest to that of the CoBrA group, especially its Danish member Asger Jorn. Stöhrer's strongly colored and formally energetic canvases are often titled in dedication to writers, among them Samuel Beckett, Frank O'Hara, and Paul Valéry.

Although Baselitz left Berlin and Schönebeck stopped painting, three painters of their generation, K. H. Hödicke, Markus Lüpertz, and Bernd Koberling, remained in Berlin, and their gestural, expressionist work has been a major influence there. In 1964 they were connected to the influential cooperative gallery, Grossgörschen 35, of which Hödicke and Lüpertz were among the founders. After working in an early figurative style, often strongly reminiscent of that of Max Beckmann and other German Expressionists, Hödicke gave up painting in favor of a more conceptual approach and worked in other mediums. In 1972–73 he began to teach at the College of Visual Arts and returned to painting. The resulting canvases focused on his immediate Berlin environment: Hödicke lives close to the Wall, near an area, still war-flattened, that was once the heart of Berlin, between Potsdam Square and Anhalter Station. The view from his studio in a tall, old commercial building includes East Berlin with its dominating radio tower and some of the former official buildings of the German empire and the Third Reich. These vistas of his surroundings appear in pictures that have made Hödicke the foremost painter of the cityscape—a prominent theme in the recent art of Berlin. In one 1983 painting Hödicke's city has become a voracious animal (plate 38), while another, less depressive, more escapist aspect of his work can be found in works such as the lush *Against the Light* (plate 36), an image of bathers in the water of the Havel, in a bucolic sunset of late summer light, away from the denser side of Berlin and the expected landscape of bombed-out buildings and hasty architecture.

Escapism is more extreme and more strongly emphasized in Koberling's paintings, which tend toward a more romantic involvement with nature and the rugged outdoor life. His floral series (plate 46) is almost unique in Berlin work for its gentle pastoral quality. The artist's love of fishing has become a predominant theme in many of his paintings: his exotic terrains are the streams of Scotland and the waters of Iceland, Lapland, and Norway. In *No Sun*, 1969 (plate 44), the shared darkness of the winter months in Germany and the frozen north becomes his motif. Koberling's paintings are a romantic note in the very diverse symphony of Berlin art.

While Hödicke paints the city and Koberling the northern outdoors, Lüpertz approaches figuration with less concern for the representation of outward reality. Since 1963, he has been creating a painted world which he calls "dithyrambic" in reference to Dionysian artforms, orgiastic catharsis, and the Nietzschean use of the term *dithyramb* as the turning point between shapelessness

Figure 5: Eugen Schönebeck. *Mayakovsky*. 1965. Oil on canvas. Collection Dr. Hanspeter Rabe, Berlin

and form. Since the mid-1960s, Lüpertz's paintings have confronted the viewer with often huge, abstract, seemingly three-dimensional forms. Through their force and scale, these invented objects attain an almost mythical quality and so mislead the viewer who looks for meaning they do not have. About 1970, the meaningless worlds of Lüpertz's canvases began to display recognizable symbols of German history, which, juxtaposed with his imaginary objects, ironically throw into question meaning itself. Similar issues of value are addressed in *Interior III* (plate 40). Here, the proximity, in a painter's studio, of a painting of a military cap and a painting of a palette abolishes notions of hierarchy and openly declares painting to be its own fit subject. Lüpertz's subsequent work strongly demonstrates his preoccupation with art as a motif for art, as in *The Big Spoon* (plate 43), whose imagery and facture recapitulate the major movements of modernism.

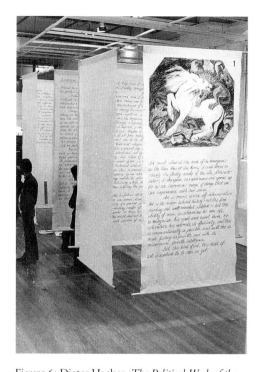

Figure 6: Dieter Hacker. *The Political Work of the Artist Begins with His Work.* 1974. Crayon, chalk, and photographs on canvas. Installed at Institute of Contemporary Arts, London, 1974. Collection the artist

While painting was the predominant activity in the 1960s, Conceptual and Performance art also emerged as important presences in Berlin. The center for these activities was the Galerie René Block, through which Joseph Beuys was introduced to Berlin in 1964 with the important performance *The Chief.* While Beuys never really lived in Berlin, his performances and "actions" became an important element of and influence on the Berlin scene. *Eurasia: 32nd Movement of the Siberian Symphony* (plate 49), performed in 1966, was part of the beginning of the international reputation of the mythic Beuys: mere documentation of this event still retains a powerful aura. On May 1, 1972, Beuys swept the streets and accumulated all of the refuse of the traditional May Day parade, which he later enclosed in a vitrine (plate 50). The Fluxus group, a loose association of international artists to which Beuys was closely connected, found a spiritual home in Berlin for its sometimes slightly absurd but always memorable activities, performances, poetry, and concerts. It promoted art based on chance, and was little concerned with traditional painting and sculpture. Nonetheless, certain of its members such as Ludwig Gosewitz, Robert Filliou, Arthur Koepcke, Tomas Schmit, and Emmett Williams, produced enduring objects. One of the more whimsical and ironic responses to the Wall was that of the American Fluxus artist, Allan Kaprow, who in 1970 built his own brick wall near the Berlin Wall using bread and jam for mortar (plate 51).

During the mid-1960s and 1970s Berlin was one of the most active centers of the international youth movement in Europe, a focus of politically committed protest against bourgeois society and against war. The atmosphere of this period was expressed in the works of artists like Wolf Vostell, K. P. Brehmer, and Dieter Hacker, all of whom strove to arouse social and political consciousness. The artistic activities of Vostell in the 1960s largely had to do with Happenings and environments. His assemblages and graphic works are often related to these activities; sometimes they are even parts of them. This is typically represented by the *Mania Cycle* and *Berlin-Fever* series in which mass-media imagery and symbolic every-day objects are boxed as collages to express the political and sexual obsessions of our time (plates 71–76). Vostell's covering of whole environments—even a railroad car—with concrete and lead are also undisguised metaphors for the atrophying of our culture and our personal social behavior and the pollution of our world and our minds. Brehmer's conceptual objects and graphic works also evidence a sociopolitical agenda in a directly confrontational style. In *Correction of the National Colors According to the Distribution of Wealth* (plate 70), Brehmer has redesigned the German flag: the equal areas of red, gold, and black of the official flag of the Federal Republic of Germany are reapportioned and scaled to reflect the inequalities in German society.

In 1971, Hacker established his own gallery: 7. Produzentengalerie, which he opened with a show called *Everybody Could Be His own Artist*, referring to a

statement by Beuys, and with overtones of Marcel Duchamp and Andy Warhol. One of its aims was to provide a forum for the discussion of the problems of art, especially in terms of critical theory, its relationship to society, and its function as a commercial product. Hacker's concept was amplified in 1974 in the work he created for the exhibition *Art into Society, Society into Art*, at the Institute of Contemporary Arts in London. In an environment titled *The Political Work of the Artist Begins with His Work* (figure 6), he used a reproduction of a painting by George Stubbs, accompanied by a text which began with the words, "Art must claw to the neck of the bourgeois as the lion does at the horse," to assert that the artist should have a more important role in society. It was a comment on the tensions between bourgeois society's expectations of art and art's expectations of society. In 1976 Hacker turned to traditional painting, although his art did not cease to reflect the concerns of his earlier Conceptual period. While Hacker meditates on his formal beginnings as a constructivist in *The House Painters Begin to Paint Their own Future* (plate 85), first shown in his 1977 exhibition *Paintings on Paintings*, he also refers to issues relating art to revolution, society, and politics.

By the early 1970s the Berlin scene had reached its apogee: its art was celebrated in several exhibitions within Germany and in other countries. The galleries and museums of Berlin became extremely active, and artists from other countries, many under DAAD grants, also added to the energy. But most importantly, at this time Berlin became a center and focus for young people in Germany; the fact that there was no military draft for residents of Berlin not only provided a practical reason for going there, but accorded well with the antimilitarist spirit of the time. For the young German generation, Berlin represented a free and cosmopolitan spirit. It is at this point that a second generation of artists began to emerge. Rainer Fetting, Helmut Middendorf, and Salomé moved to Berlin in 1972–73 to become students at the College of Visual Arts. They were among those who founded the Galerie am Moritzplatz in the Kreuzberg district, an area adjacent to the Wall where several of the artists lived. In its first year, Galerie am Moritzplatz developed into an important center of activity. Along with the Swiss artist Luciano Castelli and with Bernd Zimmer, Fetting, Salomé, and Middendorf became widely known as the "violent" painters, the *Neue Wilde* (New Wild Ones)—the exemplification of exuberance, extroversion, and excess.

This young generation, born after the war, showed an eagerness for the international urban life, courting both its glamor and its perils. Salomé's 1976 *Self-Portrait* (plate 88) has become an icon of that time. Derived from a performance he had done with television sets, the image dramatizes the young generation's involvement with performance, theater, and the "hype" of urban nightlife, and flaunts the influences of popular culture. An image of the artist surrounded by barbed wire, the painting also serves as a poignant metaphor for the plight of the artist as an awkward, isolated actor, a late twentieth-century descendant of Antoine Watteau's *Pierrot (called Gilles)* (figure 7). In his narcissistic painting, *For Luciano* (plate 89), Salomé portrays himself and others as defiant performers in a cabaret act. Here the intense personal relationship between the artists, their *modus vivendi*, their close collaboration as performers, musicians, and artists is displayed. During a trip to the Canary Islands, Castelli and Fetting dressed up as Indians, made movies on the beach, and later painted portraits of each other and of themselves. *Indians I* (plate 93), Castelli's bold, colorful, and exotic painting of himself and Fetting is an idealized portrait of friendship. And Fetting's *Large Shower (Panorama)* (plate 92) with its open sexuality relates also to Salomé's and Castelli's work. This erotic painting portrays a showering room as a stage for the display of bodies, evoking Ernst Ludwig Kirchner's prophetic

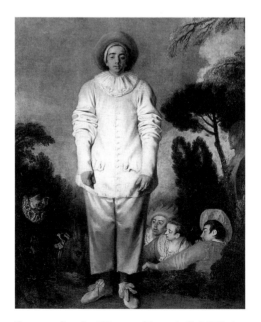

Figure 7: Antoine Watteau. *Pierrot (called Gilles)*. 1715–21. Oil on canvas. Musée du Louvre, Paris

image of a group of lonely artillerymen of the First World War in a shower (figure 8).

Middendorf's sensibility is of a different order than that of Fetting, Salomé, or Castelli, but, like them, he pushes the traditional concept of the artist as performer to an extreme degree. His *Painter* (plate 94), with its protagonist arched and poised as if playing an electric guitar, dramatically conveying personal and painterly tensions, is a modern version of the traditional harlequin of earlier painting. Middendorf's powerful *Airplane Dream* (plate 95), however, expresses an urban angst particular to our own time, and especially meaningful to Berlin. Zimmer's bold gestures and rugged brushstrokes linked him to the "violent" painters of Moritzplatz, but his thematic interests remain different. Like that of the other Moritzplatz painters, his work reflects Hödicke's teaching, but his aesthetics are more associated with Koberling's interest in nature.

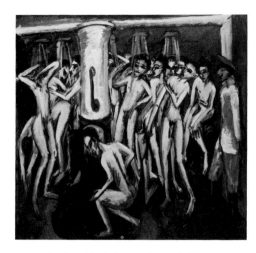

Figure 8: Ernst Ludwig Kirchner. *Artillerymen*. 1915. Oil on canvas. The Museum of Modern Art, New York

The late 1970s and early 1980s in Berlin were dominated and widely influenced by the painters from Moritzplatz and their predecessors, Hödicke, Koberling, and Lüpertz. But other tendencies simultaneously existed, and new artists emerged who represented different styles. For example, the collaborations and vigorous individual paintings of Thomas Wachweger and Ina Barfuss are, in comparison to the realism of the Berlin *Neue Wilde*, almost abstract symbolic abbreviations. Martin Kippenberger's paintings are highly ironic remarks on German culture; and there are also "metaphysical" approaches to the object by Peter Chevalier and others. At the same time, the abstract vocabulary of Thieler and Stöhrer is alive, and their tradition has been carried forward in the large, spontaneous paintings of the younger painter, ter Hell. The current Berlin scene is vivid and immensely varied. The styles of its artists are often very individual, and, other than the Moritzplatz group, do not represent what could be called a particular school. Exemplifying this plurality of approach are the works of artists as different as Eva-Maria Schön, Olaf Metzel, Martin Rosz, and Hermann Pitz. Schön's often large environmental works and gouaches are lyrical and joyous meditations on abstract forms, which might allude to nature but are structured through strictly controlled calligraphic gestures.

Metzel's works are radical comments on the physical, social, and intellectual environment he lives in. His *Oak Leaf Studies* (plate 133) constitutes a forceful reaction against intellectual and social stagnation in German society. In two acrylic showcases he placed prefabricated plaster casts of the heroes of the intellectual and artistic past of Germany—such as Kant, Schiller, Bach, Lessing, Nietzsche, and von Humboldt—along with casts of oak leaves, the traditional symbol of Germany and of its imperial past. Both the vitrines and the casts show cracks, traces of violent intervention by the artist, symbols of protest against intellectual stagnation and cries for clarity from Germany's cultural present. Metzel is currently working on a large outdoor sculpture for the Kurfürstendamm that contains controversial references to tensions between the police and the young people of Berlin (figure 9), which he considers a parallel, conceptually, to his *Oak Leaf Studies*.

Figure 9: Olaf Metzel. *13. 4. 1981.* 1987

By contrast, Rosz's work is an almost immediate expression of his life. *Arachne*, a large environmental piece (plate 84)—consisting of a series of watercolors mounted on large panels—alludes to the famous weaver of Greek mythology, who depicted intimate scenes from the lives of men and gods on a large cloth in a contest with the goddess Athena. In this display of motifs from Rosz's daily life—objects from his apartment in Berlin and portraits of his parents and his friend—*Arachne* speaks of the symbiotic relationship of art and life, a tapestry of the artist's inner thoughts, experiences, and observations.

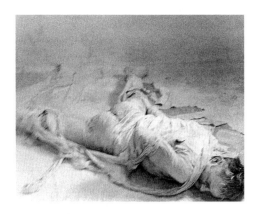

Figure 10: Günter Brus. *Ana.* "Action" at Atelier Mühl, Vienna 1964

A view of Berlin's artistic scene of the last twenty-five years would be misleadingly incomplete if the enormous number of foreign artists working in Berlin during this period were to be overlooked. Many of them were invited by the Berlin Artists Program of the DAAD (German Academic Exchange Service), and many others came to stay without any official support, expecting Berlin to provide the necessary climate for their work. Many of those artists have produced an art of very direct impressions, which helps us to understand the city and what it means to live there. Many realized projects that could only have been executed in Berlin, using the unique phenomenon of that city as the material for their work.

One of the first foreign artists to go to Berlin was the Italian Emilio Vedova. In 1963, he was one of the earliest recipients of a grant from the Ford Foundation's artists-in-residence program, later incorporated under German administration as the DAAD program. With great passion and energy, Vedova threw himself into Berlin life and constructed, painted, and assembled semisculptural, semipainterly, and three-dimensional works, which he named *Plurimi*, some freestanding, some hung from the ceiling or walls. This energetic output, *Absurd Berlin Diary* (plate 30), echoes Kurt Schwitters, recalls many elements of Berlin Dada, and celebrates the gestural qualities of Abstract Expressionism.

Among a group of Austrian writers and artists who came to Berlin, Vienna "actionist" Günter Brus arrived in 1969 to avoid arrest after offending the Viennese police with his self-destructive and provocatively sexual performances (figure 10). During his almost ten years of exile in Berlin, Brus's art changed; he gave up performances and produced a large graphic oeuvre. The imagery in his drawings and books is that of an introverted Symbolism and Romanticism, often evoking the sinister, fantastic worlds of Johann Heinrich Füssli, Hieronymus Bosch, William Blake, and Alfred Kubin—all artists whom Brus admires. Brus's art differs from that of the majority of Berlin's foreign visitors in that it does not reflect a reaction to the artificial environment of the city.

When the international exhibition *Zeitgeist* took place in Berlin at the Martin-Gropius-Bau in 1982, several artists invited to take part had never before confronted Berlin. The American Jonathan Borofsky, whose work is relentlessly autobiographical, drew the image of a frightened, running man, one of his recurring and archetypal symbols, on the Wall as part of his contribution to the exhibition (plate 107). He also made a figure of a man flying out of a window (figure 11) toward reconciliation with the East—which proved to be a minor provocation for the watchful East German guards. When Borofsky returned to the United States, he did several works explicitly expressing his feelings about Berlin, such as *Berlin Dream* (plate 106), in which the central image is a dog with a bird in its mouth; other birds are lined up, flightless and imprisoned.

From Malcolm Morley's experience in Berlin in 1977 came his painting *The Day of the Locust* (plate 98). The title is derived from the American writer Nathanael West's novel of the same name. The predominant image is one of chaos, of a metropolis in destruction. West's novel stresses the bleakness and artificiality of Hollywood, which Morley sees here as an antecedent and complement to the glittering chaos of Berlin. The bottom of the painting depicts the Berlin Wall, inscribed with the griffiti: "For a unified, independent, soc. . . ." It is a tale of two cities, Los Angeles and Berlin, and the negative forces that unify them. Another visitor of the late 1970s was Victor Burgin, a British Conceptual artist, who made a series of eight photographic diptychs about enclosure and isolation in Berlin called *Zoo 78*. *Zoo IV* (plate 99) juxtaposes the personal voyeurism of Berlin peepshows in one panel with the surveillance psychosis concomitant with political division in another, represented by an inconsequential reproduction of the Brandenburg Gate before the War. The text on one of

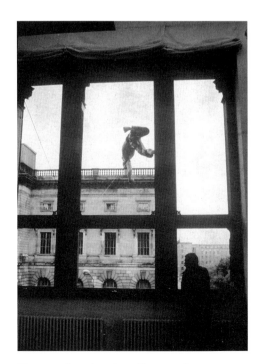

Figure 11: Jonathan Borofsky. Installation at exhibition *Zeitgeist*, Berlin 1982

the panels describes the structure of the "Panopticon" prison, where all the inmates can be observed from a single tower; it is a reminder of the potential perversities of voyeurism and power.

Christo, well known for his ambitious projects, is still working on the possibility of wrapping the Reichstag, the German parliament building that was set on fire in February 1933 shortly after Hitler became chancellor (plate 110). The Reichstag symbolizes both a unified Germany and the destruction of democracy by the Nazis. Christo has made elaborate drawings of this important urban landmark to stir enough interest to involve a large public in his plans. A controversial, enormously complicated project, Christo's proposal has generated a great deal of feeling. Christo expects to realize it in 1988. Its proximity to East Germany emphasizes the free interaction of art and society and makes this a more telling project than those he has executed at more neutral sites.

Among the visitors to Berlin who have had a substantial impact on its cultural life is the well-known American artist Edward Kienholz. Invited to Berlin by DAAD in 1973, Kienholz's initial reaction was shock; however, he has since found Berlin a rich source for his art and now elects to live there for at least half the year. In the Berlin flea markets, he gathered objects that he has used in pieces such as the *Volksempfänger* series (figure 12). This group of works, incorporating objects and materials from his flea-market forays, creates a powerful series of sculptures, evoking the sinister nature of Berlin's Nazi past.

Other foreign visitors have gravitated toward the Berlin of an earlier day and its intellectual history. Giulio Paolini, the Italian, reached back to the Berlin of the nineteenth-century architect Karl Friedrich Schinkel, and to the writings of the eighteenth-century archeologist and critic Johann Winckelmann, and especially to the latter's observations on ancient art and ideal beauty. In *Study with a Figure from "Embarquement pour Cythère" by A. Watteau* (plate 104), Paolini subtly integrates a figure from the beautiful painting by Watteau in Schloss Charlottenburg with a conceptualized landscape of the Schinkel buildings of the museum island, now in East Berlin. Bruce McLean, better known as a Performance artist than as a painter, was given a large studio in the Künstlerhaus Bethanien when he went to Berlin, where he began to paint for the first time. McLean's exuberant large-scale *Going for Gucci* (plate 103) is based on a fifteenth-century *Christ as Man of Sorrows beneath the Cross* by an unknown Austrian master that McLean saw in the Gemäldegalerie in Dahlem (figure 13).

Figure 12: Edward Kienholz and Nancy Reddin Kienholz. *The Bench*. 1976. Mixed mediums. Staatliche Museen Preussischer Kulturbesitz, Nationalgalerie, Berlin

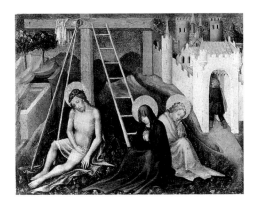

Figure 13: Master of the Presentation in the Temple. *Christ as Man of Sorrows beneath the Cross.* c. 1420–40. Staatliche Museen Preussischer Kulturbesitz, Gemäldegalerie, Berlin

The earlier painting is direct and religious; McLean's 1984 paraphrase utilizes its dramatic composition to criticize contemporary consumerism and social climbing.

This narrative of the art produced in Berlin in the last twenty-five years cannot, of course, be complete. There have been major bookmaking activities of publishers such as Edition Hundertmark and Rainer Verlag; elsewhere in this volume the story of film in Berlin is told, and in other articles the special achievements of various aspects of Berlin creativity during this period are discussed.

Berliners of the early 1960s recount that they then had no art fairs, that they had no critics and no collectors and few galleries. Nevertheless, it was a time of great activity. In a sense, isolation forced artists back on their own visions, and a strong communality developed among the artists, who had few commercial outlets. While the situation has greatly changed in the 1980s, Berlin and its Wall still stimulate interior freedom and foster the development of creative energy. In some sense, Berlin stands for every place in the modern world, every vulnerable city and town. It is a symbol of freedom and freedom in the arts, and of the possibility of the arts developing in a free way, in spite of a threatening future.

The art of Berlin, with its strong Expressionist flavor and its self-aware political reality has made a significant contribution to the art of our time. These works of art encompass all of the expected and surprising emotions of life, and should be thought of as a continuum where the creative imagination has been allowed to grow and to instruct us in the strange norms of our situation. The absurd *can* nourish art.

Pandemonium has its benefits.

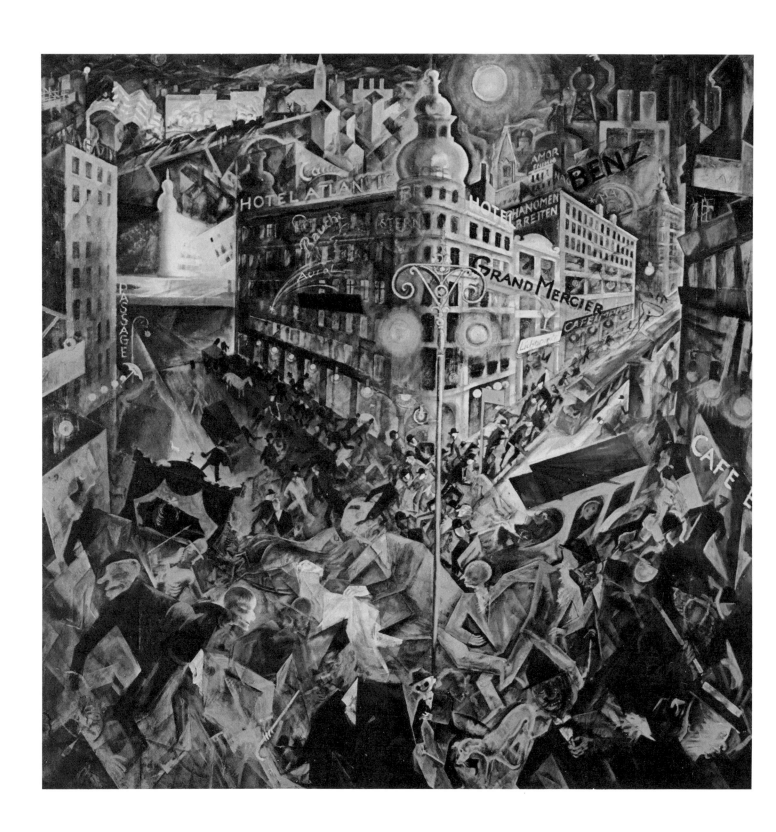

Art in Berlin 1900-1937

John Willett

Berlin differs from other great European cultural capitals in the fact that its rise to a leading position coincided with the development of the modern movement in the arts. Until our own century there were still a number of German-speaking cities that were more important than Berlin—attracted more artists; had better theaters, orchestras, and opera houses; and boasted finer art collections. And something of the effects of this cultural decentralization of the German-speaking world persists even today. Most of those places had a long tradition, reaching back through the age of Goethe and Beethoven to the Renaissance, so that their most glorious periods tend to lie in the past. When Berlin became the capital of the German empire (while continuing to be that of Prussia) it started not only to grow larger and richer but simultaneously to develop a new, energetic industrial and commercial middle class with an open-minded interest in painting, music, and the theater. French Impressionism, naturalist theater, and the Paris cabarets were just coming to the public notice. Heartily disliked by the emperor and his military courtiers, they suited the wide-ranging critical curiosity of the new patrons, so that from then on virtually every successive stage of the modern movement found an echo there. The fresh climate of artistic enterprise that brought this about drew significant artists—creative and interpretive alike—to the city and turned it from a glorified garrison town into a major center of modern ideas and vision.

Up to the 1880s the chief outside artistic influences in Germany were still those of Gustave Courbet and his followers, which had entered via Munich and Frankfurt, and of the Barbizon and Hague schools. Gradually these stagnated (though they were to revive for a while half a century later, particularly in southern Germany, under Adolf Hitler's art policies).

In the course of the next decade, however, the young Berlin artist Max Liebermann, who had hitherto been painting somewhat gloomy peasant subjects in the Netherlands and at Barbizon, became so infected with the new vision of Édouard Manet and the Impressionists that he helped introduce it into German collections, and himself led a movement known as German, or more specifically Berlin, Impressionism. This gave rise to such delightful, spontaneous open-air paintings as Liebermann's own sea- and landscapes (figure 1), or Lovis Corinth's later Walchensee pictures (figure 2), with their rich blues, although its best-known products often seem unexciting when set against their French counterparts (Max Slevogt's Manet-style portraits and figures, for instance, and the landscapes of Curt Herrmann). Such artists formed the nucleus of the Berlin Secession which Liebermann had founded in 1892 with the help of the capital's chief Impressionist dealer Paul Cassirer, and the success of their new group induced some of the most promising members to move to Berlin, starting with Corinth and Slevogt in 1900.

Berlin was the last major German-speaking city to support an artistic breakaway of this kind, marking the end of the monopoly enjoyed by the old official academies. Starting with the splintering of the Paris salon after the Franco-

George Grosz. *The City*. 1916–17. Oil on canvas. Collection Thyssen-Bornemisza, Lugano

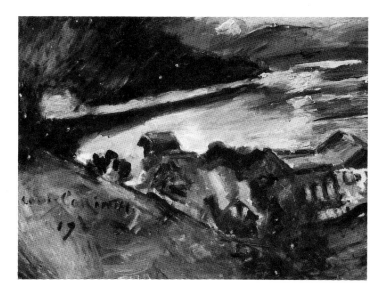

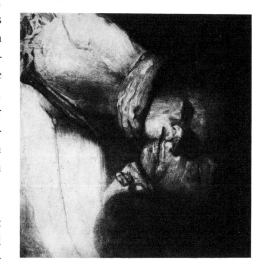

Prussian War, a whole succession of new exhibiting societies had been formed in Russia and Western Europe, leading in the 1890s to the secessions of Munich, Düsseldorf, Dresden, Vienna, and finally Berlin. These shared something like a common core of a new art, largely arising out of Impressionism proper: the Neo-Impressionism of Georges-Pierre Seurat and Theo van Rysselberghe; the Fauvism that originated with Paul Gauguin; the Symbolism of Ferdinand Hodler and Jan Toorop; the work of individualists like James McNeill Whistler, Charles Rennie Mackintosh, Henry van de Velde, and Edvard Munch. Thanks largely to Liebermann and Cassirer, and in defiance of imperial taste, such leading European modernists could now be seen in Berlin. Meanwhile Germany's own contribution broadened, as fresh artists continued to move to the capital. Among them were the great graphic artist Käthe Kollwitz (figure 3), whose style and choice of socialist themes recall the cartoonist and lithographer Théophile-Alexandre Steinlen in Paris, and the early neoromantic Max Beckmann, followed later by a number of still younger artists from the Dresden group *Die Brücke* (The Bridge), originators of what would soon become known as Expressionism.

The Berlin Secession was not only an artistic and commercial phenomenon but also a social one, proclaiming an alternative "good taste" for the enlightened bourgeoisie and connecting with other events of the time to effect a major change in the city's nature and climate. For it was during that same decade that the naturalist drama was established there, with the arrival of the playwright Gerhart Hauptmann, and a unique socialist theater organization set up in the form of the *Volksbühne* (People's Stage), which still exists today in both halves of the city. Close on the heels of these events came the young actor Max Reinhardt from Vienna to revolutionize stage technology and become perhaps the twentieth century's most brilliant theater director and impresario, turning Berlin into the unquestioned theater capital of Europe, with the works of August Strindberg, Hugo von Hofmannsthal, George Bernard Shaw, William Shakespeare, and Frank Wedekind as part of its living heritage. Modern architecture also got a footing, notably with Peter Behrens's buildings for AEG (figure 4), the great new electric company headed by Liebermann's cousin Walter Rathenau; Le Corbusier was an assistant in Behrens's Berlin office, as were Ludwig Mies van der Rohe and Walter Gropius. And all this increased the incentive for artists, writers, publishers, and actors to settle in Berlin, giving the new patrons a sense of belonging to an important movement whose progress could be set against the immobility of the ruling caste. It was worth buying.

Figure 1: Max Liebermann. *The Artist's Garden in Wannsee.* 1918. Oil on canvas. Kunsthalle, Hamburg

Figure 2: Lovis Corinth. *Walchensee in Moonlight.* 1920. Oil on canvas. Städtische Galerie im Lenbachhaus, Munich

Figure 3: Käthe Kollwitz. *Death, Woman and Child.* 1910. Etching. The Museum of Modern Art, New York

Figure 4: Peter Behrens. AEG Turbine Factory, Berlin. 1909

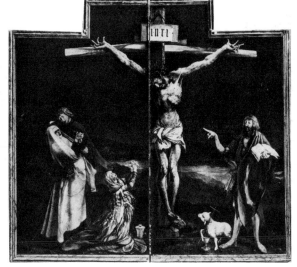

Figure 5: Matthias Grünewald. Isenheim Altarpiece. 1512–16. Oil on wood. Musée d'Unterlinden, Colmar

from Cassirer's gallery, they felt; it was worth underwriting Reinhardt's always privately financed theaters. However dubious the prospect for the Prussian monarchy, culturally, at least, the place had a future.

Expressionism, which was soon to overtake and swamp the Secession, was a very different and more distinctly German affair, whose view of the world and of the whole human race could veer from utopian visions to the blackest desperation. Nowadays we trace its beginnings back to about 1906, when the *Brücke* artists in Dresden started showing pictures influenced by Henri Matisse, André Derain, and other so-called French Fauves, followed a year or two later by *Der Blaue Reiter* (The Blue Rider), the more Symbolist-inclined group of Munich painters around the Russian Wassily Kandinsky. It was only when it reached Berlin, however, that the new trend acquired its name, along with the passionate broken angularity which seems to distinguish twentieth-century Expressionism from all the other European "isms" by relating it to the great German tradition of Gothic sculpture and woodcuts, of grotesque caricature and that "typhoon of unrestrained art," Matthias Grünewald's Isenheim Altarpiece of the sixteenth century (figure 5). The change can be dated from some four years before the First World War, from that turning point in 1910 when, as the poet Gottfried Benn put it, "All the timbers started creaking."[1] This was when a new band of Berlin writers and editors began aligning themselves with the young artists, and the student Jakob Van Hoddis first declaimed his poem "World End," which became for them "the Marseillaise of the Expressionist rebellion:"[2]

> The Bourgeois's hat flies off his pointed head,
> in every air the echoes ring like shouts.
> Tilers hurtle from roofs and break apart.
> Along the coast (we read) the tide's in flood.
>
> The storm has come, the dancing seas grow frenzied
> and flatten thick embankments in their rages.
> Most people find they're slightly influenza'ed.
> The railways plunge down off the railway bridges.[3]

Such unexpectedly jagged images of violence and sudden collapse had been lacking from the work of the Munich and Dresden artists when they first started exhibiting with the Berlin Secession between 1903 (Emil Nolde and Kandinsky) and 1908 (Ernst Ludwig Kirchner and Max Pechstein), and it was not till the spring of 1910 that the established modernists woke up to the threat of a radically new movement. This was when twenty-seven submissions to the Seces-

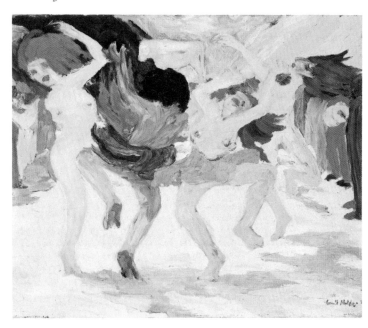

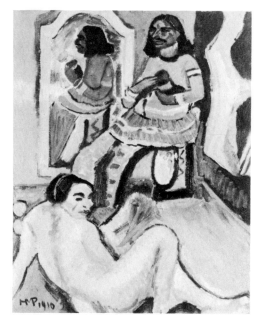

sion, including those of all the *Brücke* painters, were rejected by the jury, and Pechstein and Nolde (figures 6 and 7) responded by founding a short-lived New Secession. It was probably on that occasion that Cassirer first used the term Expressionism to describe one of Pechstein's canvases, and within a few months it was being applied to poets too. For the essence of this movement was that it came to embrace almost every aspect of the avant-garde culture of the time: not only the Munich and Dresden groups where it had originated, but also the music of Béla Bartók and the Arnold Schönberg circle, the dancing of Mary Wigman, and the plays of Oskar Kokoschka, Walter Hasenclever, and Georg Kaiser. Architecture, cinema, and the mainstream theater and opera, being more complex activities, took longer to conquer, but already it was clear that Expressionism would bring about a major upheaval in all the arts.

This wide-ranging affinity, particularly between writing, theater, and the visual arts, remains one of the movement's distinctive features: the same mixture of passion, distortion, and self-dramatization can be found in them all. The element of rebellion here was plain: a rebellion not only of the artists against the Prussian court and its ambitions but also of the younger generation against its fathers and their tedious bourgeois lives. The common preoccupation with

Figure 6: Emil Nolde. *Dance around the Golden Calf*. 1910. Oil on canvas. Nolde Foundation, Seebüll

Figure 7: Max Pechstein. *Indian and Woman*. 1910. Oil on canvas. The Saint Louis Art Museum

Figure 8: Ernst Ludwig Kirchner. *Street, Berlin*. 1913. Oil on canvas. The Museum of Modern Art, New York

Figure 9: Ludwig Meidner. *Apocalyptic Landscape*. 1913. Oil on canvas. The Los Angeles County Museum

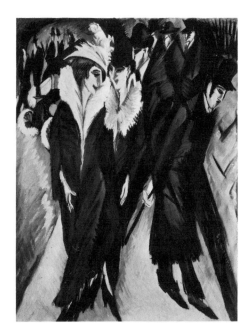

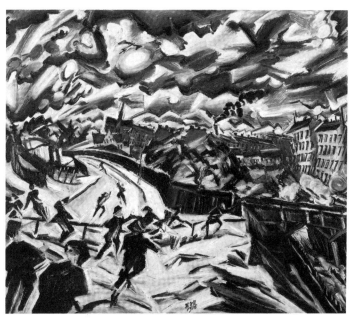

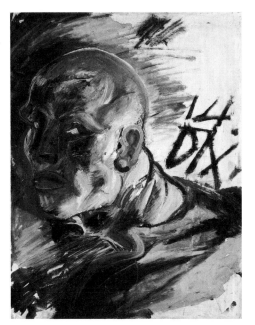

Figure 10: Otto Dix. *Self-Portrait as a Soldier.* 1914–15. Oil on paper. Galerie der Stadt, Stuttgart

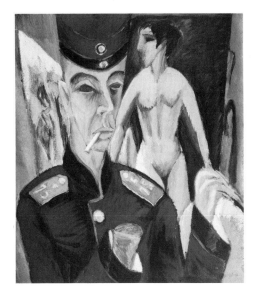

Figure 11: Ernst Ludwig Kirchner. *Self-Portrait as a Soldier.* 1915. Oil on canvas. Allen Memorial Art Museum, Oberlin College

disease, crime, and prostitution became more intense; the once brilliant Fauve colors yielded to the subdued browns, pinks, and blues of Kirchner's Berlin street scenes (figure 8). From 1911 on, the apocalyptic paintings of Ludwig Meidner, recalling the imagery of Van Hoddis's poem "World End" (figure 9), Kandinsky's explosive abstractions, and the last poems of Georg Heym all pointed half-consciously to a war which the young conscript Alfred Lichtenstein visualized in similarly violent terms:

> You'll freeze in tents. You'll be too hot. You'll hunger.
> Drown. Burst. Bleed. Fields will lie gasping.
> Church towers will totter. Flames lick the horizon.
> The winds will twitch. Crash of great cities.
> Round the skyline will loom the cannon's thunder.
> Out of the ring of hills white smoke will puff
> And overhead you'll hear exploding shrapnel.[4]

Three weeks after Lichtenstein wrote this (in a poem with the hopeful title "On Finishing His Military Service") the First World War broke out. Eight weeks later he was killed on the French front.

The severe wartime losses among the most promising poets and artists, along with the traumatic experiences suffered by many of the survivors (figures 10 and 11), all helped to reinforce Expressionism's position as the movement of protest. Soon Berlin was no longer so predominantly its center, and by 1916, when the war-shocked Max Beckmann finally abandoned his old academic style to start his great unfinished painting *Resurrection II* (figure 12), Expressionism had begun spreading out into three main areas. First, there were the artists and intellectuals actually involved in the fighting, many of whom contributed to the antiwar Expressionist magazine *Die Aktion*. Second, there was a broadly like-minded group which had managed to get out of Germany into neutral Switzerland and out of reach of imperial censorship: this included the founders of Zurich Dada. Finally, there were those poets and theater people, scattered across provincial Germany, who saw hope in an eventual military collapse and were already adapting the formal conventions of Expressionism to point the way to a new socialist utopia: Pechstein and Karl Schmidt-Rottluff were among the returning artists who joined them. By the end of the war (which was also the end of the Prussian-imposed empire) there had been no very radical change in the outward style of Expressionist paintings and graphics. But within the broader movement serious differences in purpose and content had developed.

Thus there was Dada, which spread from Zurich to Berlin in the winter of 1917–18, to infect such previously Expressionist artists as Otto Dix, Kurt Schwitters, and Raoul Hausmann (figure 13) with its nihilism. There was a minority of revolutionary antimilitarists, like George Grosz and John Heartfield (figure 14), who supported the Russian Bolshevik revolution and its local advocates (notably Rosa Luxemburg). And, finally, against these was the main Expressionist revival after the war, which was not only emotionally on the side of the embryo republican government but positively anxious to fulfill the role of a new arts establishment. In organizational terms this last aim was very fruitfully realized, since the main national and provincial galleries were now opened up to the modern movement, art teaching was liberalized, the *Novembergruppe* (November Group) of moderate republican artists was formed, and the Weimar Bauhaus was set up in 1919 by Gropius largely under the influence of utopian Expressionist thinking. So far as the actual work of those artists was concerned, however, there was a certain stagnation. That is to say that the most exciting new visual ideas came in fields which the Expressionists had not been able to explore earlier: notably architecture, with Bruno and Max Taut, Erich Mendelsohn, and Hans Poelzig (figures 15 and 16) and unrealized projects of Mies van

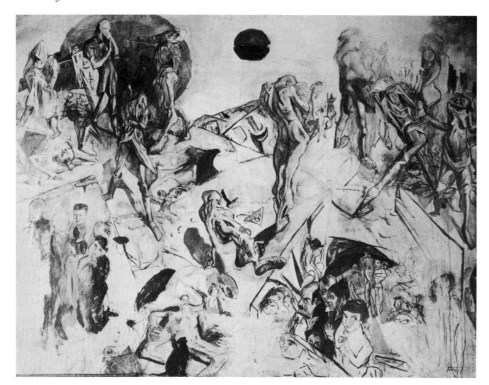

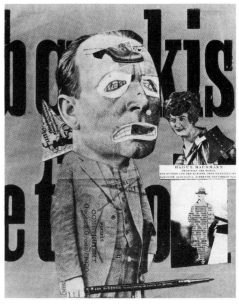

Figure 12: Max Beckmann. *Resurrection II.* 1916–18. Oil on canvas. Staatsgalerie, Stuttgart

Figure 13: Raoul Hausmann. *The Art Critic.* 1919. Photomontage and collage. The Tate Gallery, London

der Rohe and Hermann Finsterlin (figures 17 and 18); and theater and film design, culminating in Robert Wiene's *The Cabinet of Dr. Caligari* (figure 19). In painting and graphic art, as also in poetry, the survivors of the movement had little more to contribute. The avant-garde had become otherwise engaged.

Dada began in Zurich as a small international group whose members were linked primarily by their disgust with the war and secondarily by their wish to shock the public; they set out with no common visual or literary conventions other than a distrust of convention as such. Something of their Expressionist background could be inferred from the works they discussed or included in their shows—works by Kandinsky, Schönberg, Kokoschka, and Mary Wigman, for instance—and from their evident respect for Herwarth Walden's magazine and gallery, *Der Sturm* (figure 20). The original contributions of Zurich Dadaists—even of German members—were characterized more by informality, nonsense, and the exploitation of chance than by any formal hallmarks. Once the first of those members returned to Berlin, however, the Dada idea developed very differently, as rabidly antimilitarist ex-soldiers like Grosz and Dix (figures 21 and 22) took it up and applied Zurich shock tactics to more radical ends. Expressionist distortion, Futurist simultaneity, and childish graphics were now switched into deliberate venomous caricature; the dummies of the new Italian "metaphysical" artists became allusions to the anonymity of the machine age and to the artificial limbs of the wounded; the artist started seeing himself as a mechanic or engineer, with a penchant for machine processes and use of the rubber stamp. Recognizably new forms resulted: the dissected photomontages of Heartfield and Hausmann, the collages and drawings of Hannah Höch (figure 23), the rubber-stamp art and "Merz" rubbish pictures of Schwitters.

As a coherent movement Berlin Dada was short-lived, petering out not long after its big group exhibition, the *Erste Internationale Dada-Messe* (First International Dada Fair), in the summer of 1920 (figure 24), when it began allying itself with the new Constructivist aesthetic of Soviet Russia. Thereafter the various brands of Constructivism—whether functional or gratuitous in their handling of three-dimensional space—found supporters among the recent

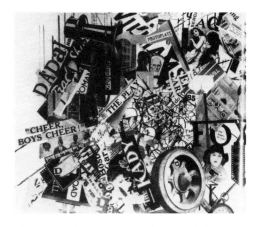

Figure 14: George Grosz/John Heartfield. *Comings and Goings in Universal City around Twelve-O-Five Midday*. c. 1919. Photomontage and collage. Whereabouts unknown

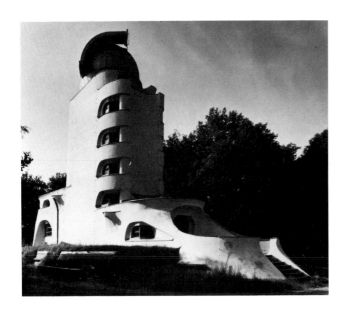

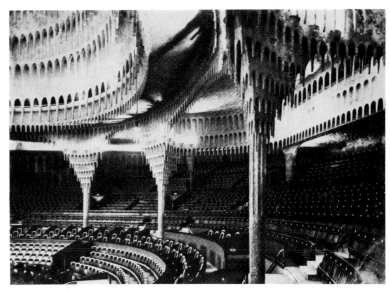

Figure 15: Erich Mendelsohn. Einstein Observatory, Potsdam. 1919

Figure 16: Hans Poelzig. Grosses Schauspielhaus, Berlin. 1919

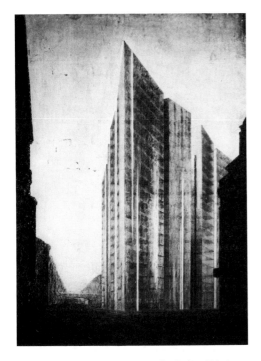

Figure 17: Ludwig Mies van der Rohe. Friedrichstrasse Skyscraper. Project 1921. Charcoal and pencil on brown paper. The Museum of Modern Art, New York

Dadaists, including not only Grosz, Schwitters, and Hans Richter but also some members of the Bauhaus and those gifted Hungarian artists, like László Moholy-Nagy, who had entered as refugees via Vienna. The same shift of interest among an important section of "Left" artists was further stimulated as a result of the Treaty of Rapallo between Germany and Russia, and the closer cultural relations which followed, starting with the big Berlin exhibition of Soviet art in the fall of 1922. This was the first sample of the new Russian movements to be seen in the West, and its impact was reinforced by the arrival of a number of leading Soviet avant-gardists of whom Vladimir Mayakovsky, Ilya Ehrenburg, and El Lissitzky became important mediators in both directions. The effect for some years was to strengthen the rational element in German art and design.

Great movements like Expressionism do not come to a sudden stop, but certainly there was a general stabilization of the wilder elements in the arts throughout Europe about 1921–22. Individual self-assertiveness and the artist's personal handwriting no longer seemed so important; anonymity and collectivity took over; the search for formal innovation lost much of its appeal. With the growth of a militant utilitarianism (as formulated in the Bauhaus slogan "Art and Technics, A New Unity" during the following year) the more expressively tortuous Dada painters like Dix preferred to practice a socially critical Verism, directed not so much at Truth as at the less palatable home truths of poverty, illness, prostitution, and war. Beckmann, in Frankfurt, was for a time identified with this trend, thanks particularly to his graphic work, which at first had something of the same hardness and bite as that of Grosz, although he never shared that artist's more extreme political views. Generally, the Verists were centered in the eastern German city of Dresden, where Dix, Conrad Felixmüller, Otto Griebel (and for that matter Grosz) had all studied and where there was a continuous tradition of committed painting.

The cooler, more impersonal, yet still sharply critical spirit of the early 1920s first became identified as a major movement in 1925, when an exhibition was held at Mannheim under the title *Die neue Sachlichkeit*, meaning new objectivity, sobriety, or matter-of-factness which had begun to permeate the visual arts. At first the concept embraced two contrasting aspects, thanks to the ambiguous way in which that exhibition was organized, with a group of neo-academic, generally Italianate paintings by Munich artists forming a separate category of Magic Realism, as against the "new realism bearing a socialistic flavor" prac-

ticed by Beckmann, Grosz, and the Verists—which it had primarily been planned to show. A number of members of both groupings had passed through an Expressionist phase. But since the Magic Realist works bore little or no sign of this, the only evident links were a restrained sense of color, a dispassionate eye for the telling detail, and a new smoothness of finish (figure 25). Behind it all one could sense, in the Verist/ex-Dada group, something of the old Expressionist despair about the surrounding world. The pictures might have humor, but they lacked joy.

It was not long before the notion of *Neue Sachlichkeit* was adopted for the wider artistic movement, very much as Expressionism had been before the war. Once again this was because it coincided with a change in the climate of the times, affecting all kinds of artists. Economically, the country's revival dated from the making of the first American loans (under the so-called Dawes plan which came into effect in September 1924); then in 1925 the political reaction followed when Field Marshal Paul von Hindenburg, the former imperial commander-in-chief, was elected president. These changes set the scene for the boom years of the "golden twenties." Pragmatism was in, idealism out; yet socialist administrations continued to govern some of the great cities, with spectacular results in town planning and provision for the arts. Under the growing prosperity the situation was full of unresolved conflicts, so that as the bourgeois order of things gained ground not only did the forms of art harden but its sensibilities did so too. Anger underlay the more or less cynical matter-of-factness which we find entering the work of Grosz and Rudolf Schlichter (figure 26), the cabaret lyrics of Kurt Tucholsky and Walter Mehring, and the plays of the young Bertolt Brecht (figure 27). Meanwhile new theaters and opera houses were opened and a new building designed by Gropius for the Bauhaus at Dessau. Among other landmarks of the times were the first stage productions of Igor Stravinsky's *Oedipus Rex* and Alban Berg's *Wozzeck*, Brecht and Kurt Weill's *The Threepenny Opera*, Erwin Piscator's first two seasons, and the Western European premiere of Sergei Eisenstein's film *Battleship Potemkin*.

A flood of major creative talent now descended on Berlin, thanks partly to the inducements offered by the Prussian arts administration, the Reinhardt theaters,

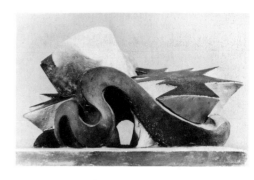

Figure 18: Hermann Finsterlin. Community House. c. 1919. Plaster model. The Museum of Modern Art, New York

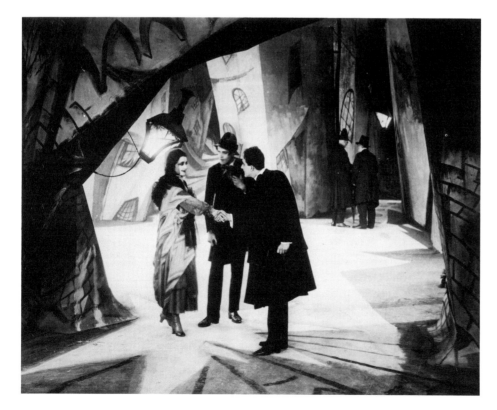

Figure 19: Robert Wiene. *The Cabinet of Dr. Caligari.* 1919–20

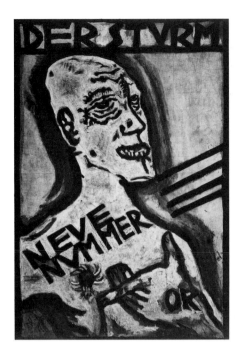

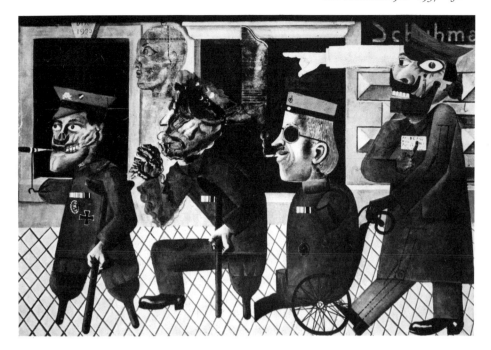

Figure 20: Oskar Kokoschka. *Design for "Der Sturm" Poster.* 1910. Oil on canvas. Szépmüvészeti Museum, Budapest

Figure 21: Otto Dix. *War Cripples.* 1920. Oil on canvas. Whereabouts unknown

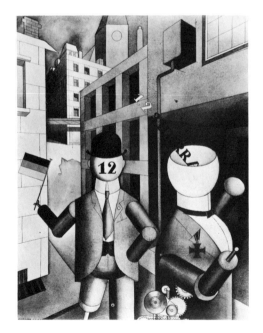

Figure 22: George Grosz. *Republican Automatons.* 1920. Watercolor. The Museum of Modern Art, New York

and other patrons, and partly to the electric atmosphere to which so many memoirs of the times bear witness. Thus Schönberg and Paul Hindemith took teaching posts there; Stravinsky started using the city as the primary showcase for his work. Brecht, his designer Caspar Neher, playwright Carl Zuckmayer, and the director Erich Engel were all brought in by Reinhardt; Otto Klemperer became conductor at the new Kroll Opera, with radical implications for repertory and presentation alike. The emphasis of the arts magazines shifted, as clearly expressed, socially critical reviews like *Die Weltbühne, Das Kunstblatt,* and *Die Neue Bücherschau* replaced the aging Expressionist press. At the same time there was a growing interest on the part of the artists in new media, leading Brecht and Weill to the radio, Lissitzky and Moholy-Nagy to photography, and Richter to the professional cinema. Many of the crucial experiments in relating music to society and the other arts took place in Hindemith's festivals in Donaueschingen and Baden-Baden, whose backwash reached Berlin through the *Novembergruppe*'s concerts and Hindemith's move to the city.

Even more than the prewar Expressionists, with their interest in the growing metropolis, or the Dadaists, with their cult of the automaton, the leading figures of *Neue Sachlichkeit* were up-to-the-minute in their modernity. Plays and operas had to be "of the times;" music geared itself to new technologies and changing economic conditions; serious composers experimented with jazz; writers studied the detective novel and wrote light verse or reportage; artists turned to advertising design. None of this was dictated by any prophets or organizers of the new movement, which, unlike French Surrealism, was a largely unconscious tendency with no formal membership, leaders, or structure. Yet the distinguishing features of its art seem clear enough: the hard-edged cold-eyed realism; the often drab street scenes; the new unflattering portraiture with its well-chosen paraphernalia (references, allusions, views from the window, tools of the sitter's trade); the concern with sexual eccentricities and deviations; the implied social criticism and sometimes barely concealed distaste for the subject of the work. Between Expressionism and the militantly political art of the republic's closing phase it was like a moment of suspended emotion.

In Expressionism's relationship to the war and the establishment of the Weimar republic there had certainly been a political component—though not normally a party-political one—while in Kollwitz the movement could boast a

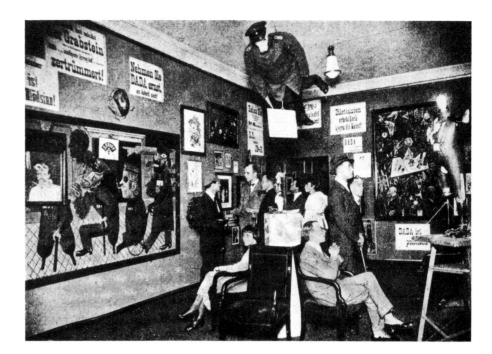

great socialist precursor who maintained her integrity right through the Second World War. In the early 1920s, too, the art of Grosz and his friends was consciously and specifically communist, though their *Rote Gruppe* (Red Group) of 1924 did not open its doors to the untalented or regard artistic criteria as secondary to political, since for these artists the two categories seemed one and the same. As the 1920s drew to a close, however, the German Communist Party took a new and more authoritative attitude to such matters, setting up an artistically broad-based *Association revolutionärer bildender Künstler* (Association of Revolutionary Visual Artists) the so-called ASSO, to propagate its ideas by a variety of means, down to the humblest posters and banners. At first this sizable body was directed primarily against the socialists, aligning itself theoretically with the militant "proletarian" cultural groupings in Russia, and much of its work was aesthetically retrograde. But with the arrival of the world economic crisis in 1929 the political conflict became fiercer and more polarized, the Nazis suddenly emerged as a major threat, and in the heat of the propaganda battle a number of new forms were hammered out.

The most striking of these were to be found in the performing arts: Brecht's didactic *Lehrstück*, the agitprop theater, Hanns Eisler's militant songs, and the extraordinary "collective" film *Kuhle Wampe*. If there was a visual equivalent it lay in Heartfield's use of photomontage for political posters and cartooning, notably in the pages of the workers' illustrated journal AIZ. Grosz, Heartfield's former comrade and partner, had by then exhausted both his political faith and his satirical powers; Dix was turning into a latter-day Lucas Cranach with uncomfortable overtones; the *Rote Gruppe* had broken up. There was, however, a new political force in the work of some of the lesser Verists and former Expressionists, particularly the Berlin proletarian painter Otto Nagel and such Dresden Secessionists as Griebel, Kurt Querner, and Kurt Günther. These people maintained a German tradition of social concern which stretched back through Kollwitz and the early Wilhelm Lehmbruck to the Düsseldorf realists of the mid-nineteenth century and, unlike Soviet Socialist Realism, had largely come to terms with the modern movement. There were even a few committed nonfigurative painters, of whom Oskar Nerlinger was the best known.

Even before Hitler's ascension to power in 1933 there had been a reaction against several aspects of modernism. This was due partly to the stringent

Figure 23: Hannah Höch. *Mechanical Garden.* 1920. Watercolor. Collection H. Marc Moyens

Figure 24: First International Dada Fair at Galerie Burchard, Berlin, 1920. Left to right, Raoul Hausmann, Hannah Höch, Otto Burchard, Johannes Baader, Wieland Herzfelde, Mrs. Herzfelde, Otto Schmalhausen, George Grosz, John Heartfield.

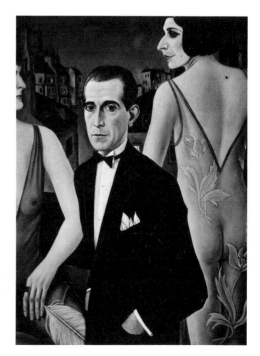

Figure 25: Christian Schad. *Count St. Genois d'Anneaucourt.* 1927. Oil on panel. Private collection

economy measures which forced the closing, for instance, of Klemperer's Kroll Opera; partly to Nazi lobbying against "art Bolshevism," "Negro culture," and other bogeys; partly to the enforced abdication of the socialist-led Prussian government with its enlightened arts apparatus. Then came the burning of the German parliament at the end of February 1933 (figure 28), followed by the abolition of the republic, the proclamation of the Third Reich, and the final installation of the Nazi dictatorship. Slowly but surely the arts were whipped into line, as Liebermann and all the leading modernists were made to resign from the Prussian academy or purged from art schools and public galleries throughout the country. For a while there were a few major figures who seemed to be tolerated despite their artistic originality—Nolde, Benn, and Hindemith, for instance. Moreover, both Gropius and Mies van der Rohe submitted official competition projects (notably for the reconstruction of the Reichsbank) and carried out lesser commissions for the Nazi Labor Front. Some even hoped that Expressionism, as an undeniably German movement with mystical and irrational aspects, would sooner or later be assimilated within the new Nordic ideology of blood and soil; indeed, Nolde was an old Nazi. But Hitler's blinding hatred of modern art was too strong for that.

By 1935 the German leader had determined to move the center of the visual arts from Berlin to Munich, "the capital of the Movement," where his favorite architect Paul Ludwig Troost was building a House of German Art in heavy neoclassical style. Twenty-six works by Beckmann, Nolde, and others were banned that year from a Munich exhibition, *Contemporary Art from Berlin*, after which a dim local academic painter named Adolf Ziegler was put in charge of the propaganda ministry's powerful Art Chamber. Ziegler's mission was to scour the country's museums and galleries for "works of decadent art in the sphere of painting and sculpture since 1910"[5] and collect them in a great *Degenerate "Art"* exhibition (figures 29 and 30). Here, in the summer of 1937, the Bavarian public could see works by all the leading modern artists, with large and crudely written mocking labels, the whole prefaced by a tortuous Expressionist crucifixion by the sculptor Ludwig Gies. At the same time the House of German Art was opened by Hitler himself with examples of art in the style approved by the Third Reich. This was based primarily on a nineteenth-century naturalism derived from Courbet's German disciples. It had to be compatible with such Nazi tenets as race, blood, and soil; masculine superiority; militarism; and the leadership principle. The result was a generally tame mixture of peasant scenes, south German landscapes and woodlands, battle pictures, athletic neoclassical nudes, pastiches of German and Flemish old masters, and portraits of party or army leaders and their smart, preferably blonde, wives.

Those modernists who had not already left the country now had to do so if they wanted to be able to show their work or even, as in some cases, to paint at all. So Beckmann, Lyonel Feininger, and Schwitters finally emigrated (as did Mies van der Rohe), while the remainder had to conform or else be driven underground. There were two main threads in this "inner emigration." On the one hand there were those hitherto nonpolitical artists like the Cubist-influenced Willi Baumeister and some of the Bauhaus painters, who managed to find jobs where they were able to paint; these tended to move into abstraction. On the other hand there were the active opponents of Nazism whose underground art expressed their political resistance, often in much the same terms as did the paintings of the left-wing émigrés and of the independent humanist Kokoschka. For such activities some of the Dresden ASSO members served terms in jails or concentration camps, notably Griebel and Hans and Lea Grundig; the latter's cycles of anti-Nazi etchings, in particular, comprise more than one hundred plates in the Verist/Expressionist tradition. In Berlin during the same years

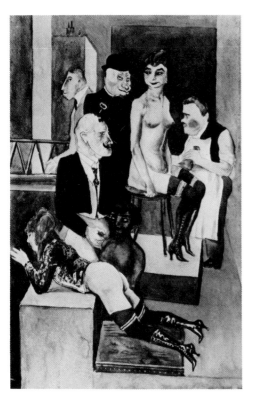

Figure 26: Rudolf Schlichter. *Meeting of Fetishists and Flagellators.* c. 1921. Watercolor. Private collection

students of the Hochschule für bildende Künste (College of Visual Arts), including pupils of the "degenerate" Gies, produced antiwar works in more conventional form and collaborated with the Red Orchestra resistance group; three of them were executed. Since 1981, when Peter Weiss completed his great trilogy, *The Aesthetics of Resistance*, they have been seen as embodying its central concept and title.

It is not easy to understand the links between the pre-1933 modern movement and the Berlin artists of a half century later without taking the political aspect into account. Obviously the art policies of the Third Reich and the physical destruction of the war years combined to disrupt any normal continuity. At the same time the circumstances of Nazi Germany's defeat made it difficult after 1945 for young artists to pick up the threads of the old modern culture. Admittedly there were a number of uncompromised senior survivors from the earlier movement ready to take over the Berlin art schools: notably Nerlinger, Pechstein, Schmidt-Rottluff, Karl Hofer, and Georg Tappert. At first, however, the allied occupation of the country worked against any rehabilitation of Expressionism or its sequels, thanks partly to Western ignorance of modern German art and partly to Soviet dismissal of it all as having been a product of "ideological decline," one aspect of the prelude to Hitler. Only when the occupiers had moderated their effort to sell or to impose their own brands of art—from *tachisme* and Abstract Expressionism to Stalinist naturalism— was the way clear in the 1950s for the Germans to come to terms with their own radical past. In West Germany and West Berlin a whole succession of art books and major retrospectives began to make it available; new museums were built, and many of the "degenerate" works of art were brought back from abroad. In the Communist-ruled East, despite the relative poverty of its collections, enterprising publishers and a less cramping view of political art allowed the same indigenous influences to reach the younger generation.

Berlin has been the meeting point for this dual process of rediscovery. Even the Wall that now divides the city can be penetrated by images and ideas, and sometimes by the new artists themselves. Expressionism is now studied on both sides; Berlin Dada, Constructivism, and the Bauhaus are once again of interest

Figure 27: Rudolf Schlichter. *Portrait of Bert Brecht.* c. 1926–27. Oil on canvas. Städtische Galerie im Lenbachhaus, Munich

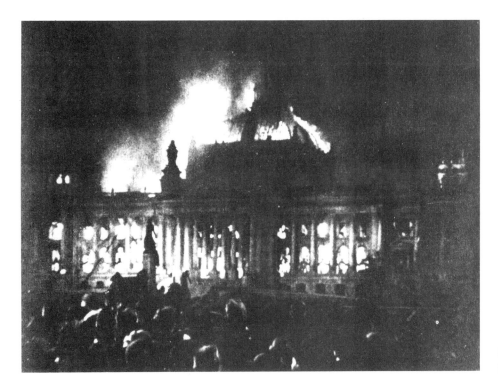

Figure 28: Burning Reichstag building, Berlin, February 27, 1933

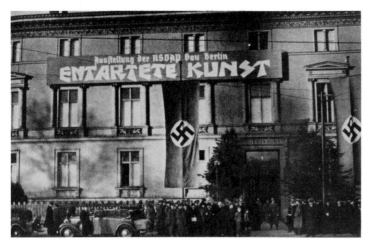 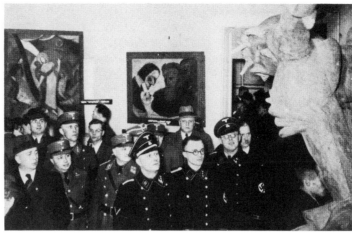

Figure 29: Exhibition *Degenerate "Art"* at former Japanese embassy, Berlin, 1938

Figure 30: Visitors at the exhibition *Degenerate "Art,"* Berlin, on opening day, February 26, 1938

to the East; West Berlin scholars and gallery directors have introduced the West to the forms and purposes of the old militant communist art; small exhibitions recall the student resistance of the 1930s. What we see as a result is a refunctioning of the visible passion, explosiveness, and commitment of German modernism, often as filtered through specific artists (Beckmann, Corinth, Dix, Grosz, Heartfield, Kokoschka). In a more disillusioned age, however, its context is very different. It must compete with today's dominant Western schools and convey the peculiar unease of that powerful, wealthy, but still severely wounded country which lies at the unsettled center of our world.

Notes

1. Gottfried Benn, "Introduktion," in *Lyrik des expressionistischen Jahrzehnts* (Munich, 1962).

2. Johannes Becher, Cited in cabaret program for "Lulu and After" (London: Royal Academy, December 1985).

3. Jakob Van Hoddis [Hans Davidsohn], "World End," *Die Aktion* (1911). Trans. J. Willett.

4. Alfred Lichtenstein, "On Finishing His Military Service," *Gedichte und Geschichten,* vol. 1 (1919). Trans. J. Willett.

5. Joseph Goebbels to Ziegler, June 13, 1937, in H. Grosshans, *Hitler and the Artist* (New York, 1983), p. 99.

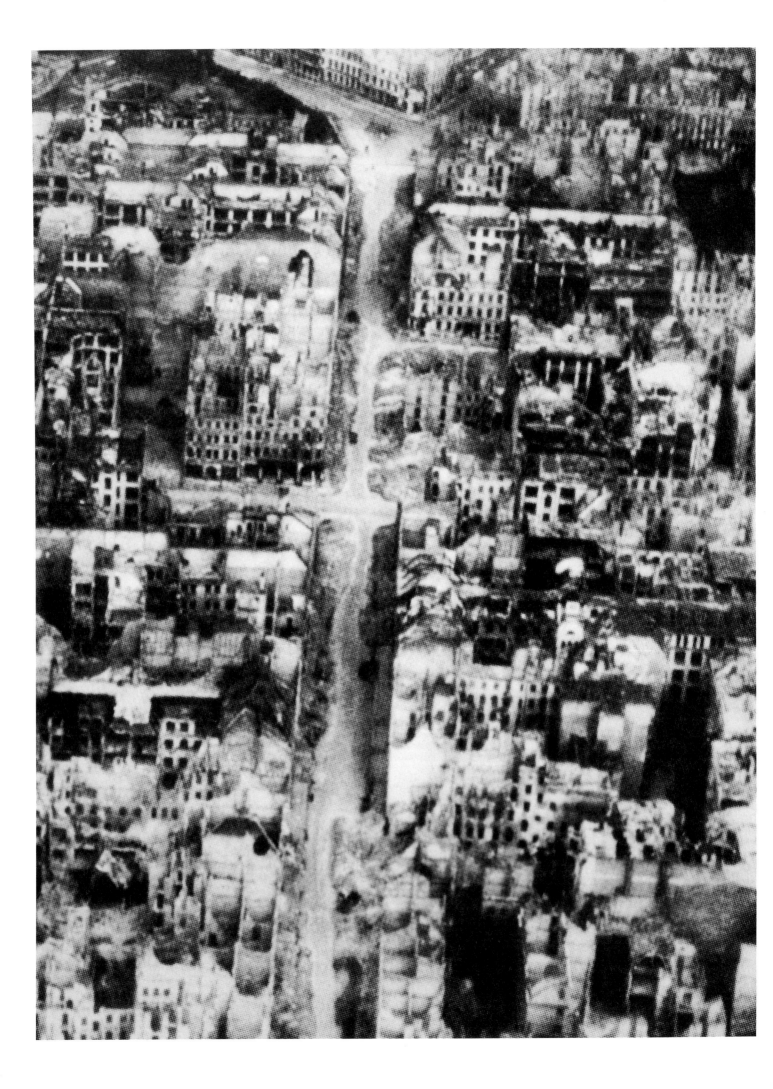

Typical and Unique: Art in Berlin 1945-1970

Wieland Schmied

The situation in Berlin immediately after the Second World War was typical in many respects of conditions throughout Germany. Air raids and the Battle of Berlin had devastated it quite as thoroughly as any other German city; its division in July 1945 among the four Allied powers symbolized the fate of the country as a whole. In Berlin, the dividing lines bisected streets and buildings, institutions and families; Eastern and Western ideals, ideologies and propaganda clashed at close quarters. The blockade of 1948–49, during which the tenuous thread of the airlift was the only connection with the Western world, left West Berliners with the eerie sense of living in an outpost. Nor did the famous "economic miracle" reach them until a very late date. Yet there developed in this city, long unrecognized in official places, a subculture of fascinating diversity, matched by no other German center.

There also emerged in Berlin a special sensibility for historical change, a high pitch of political awareness, a compulsion to live in and with the realities of the day. It was here that Germany's division was irrevocably cemented—irrevocably, but for how long?—by a wall built through the center of the city in 1961. It was here that an unusually high number of foreigners, especially of Turkish origin, came to live and work. It was here that runaway property and building speculation set in, officially encouraged by federal tax write-offs, to which an aware minority, mostly of young people, reacted by occupying condemned buildings and staging demonstrations. Because of ugly press campaigns at the time, these events often enough turned into street fights and violence. The campus revolt of 1968, too, had been more passionately radical in West Berlin than anywhere else in Germany.

From 1945 to the currency reform and the blockade of 1948–49, and possibly until the building of the Wall in 1961, these developments could be called typical of those throughout Germany. But during the 1960s West Berlin became more and more of a special case. Nor was this markedly changed by the Berlin agreements of the early 1970s, or by the gradual normalization of everyday life that ensued. Quite the contrary: the Berlin agreements, like the four-power agreements of 1948 and the occupation statutes of 1945 and 1949, are complicated and unprecedented legal constructions. And normalization would have been impossible without continuing substantial aid from the federal government in Bonn. Without this aid West Berlin would not be viable, just as without the protection of the three Allies it could hardly survive as an "island" in Warsaw Pact territory.

A considerable portion of the federal funds Berlin receives is earmarked for cultural affairs, in particular for the Berlin Festival, important exhibitions, theater and music projects, and the Berlin Artists Program. In 1965, this program, established by the Ford Foundation shortly after the Wall was built to counter the threat of West Berlin's isolation, was turned over to German hands—those of the DAAD, the German Academic Exchange Service. As regards the city's cultural affairs in general, Bonn provides special subsidies for projects and

Aerial photograph, Berlin, 1945

programs that promise to attract national, if not international, attention, while "normal" policy remains largely the responsibility of the Berlin senate and its budget (which, in turn, relies on federal aid to a considerable extent).

There are good practical reasons for this emphasis on cultural matters. Shortly after the war it had already become clear that Berlin, the former imperial capital, would no longer play a decisive political or economic role (unless as a seismographic station where tensions between the two great power blocs would first be registered). The only field in which the city could hope to recoup its international significance was that of culture and the arts. No doubt this hope, fed by nostalgic recollections of Berlin's great decades between 1910 and 1930, of the fall of the empire and rise of the young Weimar republic (which all too soon died a violent death), and particularly of the hectic brilliance of the "golden twenties," was not without an element of self-deception. Self-deception, however, can be productive, and in the case of Berlin it definitely has been, even if certain high-flown expectations came to nothing and had to be abandoned.

What has been said about the political and intellectual life in Berlin during the postwar decades is true for the visual arts. Here too, particularly in the immediate wake of the war, we find many phenomena typical of the period and exemplary of the West German situation; and here too, subsequent years brought shifts away from the typical toward the exceptional. From the 1960s on, Berlin art gradually came to be a special case, if a highly interesting one, in which many buried or suppressed traditions in German art again found a voice; and much was articulated that found scant resonance in Hamburg, Düsseldorf, Frankfurt, and Munich.

As in many other German cities, artists who had survived the war and Nazi defamation resumed work in Berlin; but nowhere did the surviving Expressionist generation around Karl Schmidt-Rottluff, Max Pechstein, and Max Kaus establish such a bastion as the Berlin Hochschule für bildende Künste (College of Visual Arts), founded by Heinrich Ehmsen and Karl Hofer (figure 1) in 1945. As in many other German cities, a young generation in Berlin began to adopt the international language of abstraction; but nowhere else did an enclave devoted to the aims of Parisian Surrealism emerge like that formed by Hans Thiemann, Heinz Trökes, and Mac Zimmermann (figure 2) in Berlin. As in many other German cities, American information centers, British Council centers, and Maisons de France offered sustenance to a culturally starved generation that had long been cut off from developments abroad; but nowhere was this information as concentrated as in West Berlin, and nowhere was such intensive use made of it.

In Berlin, as elsewhere in Germany, artists once again began to form groups, but only in Berlin did one of them choose a name that directly reflected contemporary political realities. In an allusion to the four zones of occupation, the group was called Zone 5, as if to demarcate a preserve for the free spirit beyond the harsh political divisions. Zone 5 comprised the "surrealist" painters Thiemann, Trökes, and Zimmermann; the graphic artist Jeanne Mammen, who worked in a critically realist style; and the semiabstract sculptors Karl Hartung and Hans Uhlmann. The first new galleries in Berlin appeared almost concurrently with those established in West German towns and cities. Galerie Buchholz, which resumed operations after a short interruption, was soon joined by the galleries of Gerd Rosen, Walter Schüler, Anja Bremer, and Rudolf Springer, several of which—Galerie Springer foremost—are still active today. Every German gallery devoted to contemporary art had great obstacles to overcome, and went through many lean years. But nowhere were the years leaner than in Berlin, where the expulsion and extermination of the great collec-

Figure 1: Karl Hofer. *Night in the Ruins.* 1947. Oil on canvas. Baukunst-Galerie, Cologne

Figure 2: Mac Zimmermann. *P.I.C.A.S.S.O.* 1949. Distemper on paper. Collection the artist

tor families had deprived a long-established art trade—symbolized by such names as Herwarth Walden, Fritz Gurlitt, Paul Cassirer, Neumann-Nierendorf, and Alfred Flechtheim—of its livelihood; where the isolation of the city had stifled every new influx from its hinterland; and where the boons of economic recovery were long delayed. It was not until the 1970s that connoisseurs were again able to acquire works of art on a regular, and sometimes even systematic, basis.

In Berlin, as throughout Germany, abstract art had soon found many impassioned supporters among critics, who championed not only such major figures as Willi Baumeister and Fritz Winter, who had worked in nonobjective styles long before the war, but also a number of young and unknown abstract painters. This is not to say, however, that abstract art found immediate general acceptance. Thanks in great measure to a Nazi art policy that for twelve years had touted illusionistic salon painting to the exclusion of all else, wide sectors of the public were simply baffled by abstraction, indeed, were unable even to approach it with an open mind. If to many younger artists (and of course younger museum people and art historians) abstraction seemed an international language by which German art could re-establish links with art in Paris, London, and New York and thus regain international stature after a period of hopeless isolation, the same abstract art struck a great many Germans as a style imposed upon them by the victors, a bitter and unasked-for medicine which they found hard to swallow.

Those years witnessed the publication of a number of ugly pamphlets (for example, by Alois Melichar), incredibly malicious in tone and vulgar in argumentation. These diatribes condemned the entire modern movement—which they associated with all abstraction and Surrealism—and confirmed the bias of a public whose power of judgment had already been shaken enough. This naturally led the advocates of modernism to pitch their arguments a shade higher, and they grew increasingly impatient and strident. The result, in turn, was that many artists of an older generation who had remained true to a realistic or expressionistic style through years of Nazi persecution, felt themselves misunderstood, overlooked, relegated to obscurity. They no longer understood the world. They had naturally hoped that after years of being branded "degenerate," after the demise of the Third Reich, their day would come. Now the hated regime had at last gone under, yet still they were compelled to look on from the sidelines as a new generation that had nothing to say to them, whose pictures remained foreign to them and seemed merely

streamlined products designed to make an international splash, found critical recognition and occupied center stage.

The debate over modern art, and particularly over the issue of abstraction, was carried on with great vehemence throughout postwar Germany. At the Darmstadt Talks of 1950, Baumeister, the grand old man of German abstraction, assisted by the collector Dr. Ottomar Domnick, defended abstraction against critics who decried the "loss of the human image" and the "loss of the center." In Berlin, this discussion—again, both typically and exceptionally—culminated somewhat belatedly, in the early months of 1955, with the now-notorious controversy between Hofer and Will Grohmann. Once again, every known argument for and against abstract art was passionately, even rancorously, advanced, without either of the antagonists—the dean of realists art-college director Hofer or the high priest of criticism Professor Grohmann—having relinquished even an inch of his territory to the other. Just the opposite: nowhere in Germany did the battle over an alleged "dominance of abstraction" and the potential role of realism leave such lasting scars as in Berlin, and nowhere did it reverberate for so long. Though Hofer died shortly after the end of his public debate with Grohmann, the arguments advanced on both sides continued to feed a smoldering controversy. The intellectual climate in Berlin, at the meteorological divide between East and West, was uniquely favorable to the old quarrel between proponents of figurative and abstract art, and it flared up again and again, particularly during the 1960s.

If the Hofer–Grohmann controversy was a special instance which, at the same time, typified the period, the same can be said of two artists who came to prominence in Berlin shortly after the war: the painter Werner Heldt and the sculptor Hans Uhlmann. The work of both artists was unique in postwar West Germany, and both the painter of semiabstract cityscapes and the "contructivist" sculptor, though they stood quite alone, expressed the prevalent mood of the hour with acute sensitivity.

Heldt, a deeply unhappy and depressive man, is the painter of "zero hour," the hour following the apocalypse, when it seemed that nothing new could ever arise from the destruction. And, to the mind of anyone who knows German art of the twentieth century, he is the painter of Berlin par excellence. These two aspects of his work cohere inseparably.

Heldt is the painter of Berlin in a special sense—he strips the city entirely of local color. Beneath it yawns the abyss of centuries, as though it will never again

Figure 3: Werner Heldt. *View from a Window with Dead Bird*. 1945. Distemper on fiberboard. Sprengel Museum, Hannover

Figure 4: Werner Heldt: *Berlin by the Sea*. 1949. India ink on paper. Whereabouts unknown

Figure 5: Hans Uhlmann. *Head.* 1937. Wire. Collection Hildegard Uhlmann (on loan to Wilhelm Lehmbruck Museum, Duisburg)

Figure 6: Hans Uhlmann. *Steel Sculpture.* 1951. Steel and aluminum. Wilhelm Lehmbruck Museum, Duisburg

stand on solid ground. In Heldt's Berlin, polar winds have blown the streets empty, scoured them clean. "Of these cities will remain that which passed through them, the wind," wrote Bertolt Brecht before the catastrophe; Heldt recorded its results.

At the end of 1945, when he had just returned from a prisoner of war camp, Heldt painted his famous canvas *View from a Window with Dead Bird* (figure 3). We look out over an abandoned city—fire-walls, ruins, the empty sockets of windows—our gaze finally coming to rest on the dead crow with tattered wings next to the jug on the window sill. From this picture on, Heldt presented ciphers of an age into which we returned as strangers, without coming home— the empty cities, the abandoned squares, the rubble, bare trees, dead birds, crumbling facades, vacant windows. The tall apartment buildings hammer out a harsh, merciless rhythm; behind their walls no one dwells, no lives are lived. These windows open on nothingness.

Heldt experienced war-torn Berlin as an existential site where the fate of the German people was made manifest. Perhaps only here could ruins and debris, destruction and what had survived the destruction be delineated with such detachment, so unsentimentally as in the series of views from a window that Heldt painted between 1945 and 1950. In his later pictures (Heldt died, just fifty years old, in 1954) the city rose from the ashes, pristine, unscathed, and seemingly invulnerable; but this resurrection, as Heldt's surviving sketches show, was also engineered in a truly Berlin spirit—austerely planned, ordered, geometric.

Heldt often called his city "Berlin by the Sea." This name seems justified, first of all, by the sea of dust and debris that flows through the streets and breaks in waves against the walls—waves that could snap buildings off at their foundations and carry them off like jetsam, as in many of the artist's ink drawings. The title *Berlin by the Sea* (figure 4), however, would also seem to carry historical and even prehistorical connotations, alluding to Berlin's insular existence after 1945, and to the soil on which it was built, which millions of years ago was once the floor of the sea.

In 1945 Uhlmann (figures 5 and 6) was just as solitary and unknown as Heldt. After attending the Berlin Technische Hochschule (Technical College), he worked as an engineer until 1945, first in industry, then at the Technical College. In 1933 he had been fired from his job for political reasons and convicted of "inciting to high treason" for distributing anti-Nazi leaflets. After two years' incarceration at Berlin-Tegel prison, he was released in 1935 and allowed to return to work, which involved the design of adding machines. In 1950 he was appointed professor at the Berlin College of Visual Arts.

A constructivist tendency characterizes Uhlmann's entire oeuvre. He never denied the engineer in him—the mathematical, exact, lucid, and uncompromising bent of his nature. All his works were carefully planned and painstakingly executed. If they were infused, particularly in later years, by a certain poetry, an ineffable magic, this seems to have arisen gratuitously, unconsciously, solely as a product of the logic of their construction.

Uhlmann's career as an artist began with a number of drawings: designs for sculptures of which only an extremely small proportion was ever executed. These sketches were done during his imprisonment at Tegel, in 1933–35; it was, of course, not possible at the time to translate them into sculpture. Yet idea after idea occurred to him, and every scrap of paper that fell into his hands was used to record them. For his material Uhlmann envisioned iron wire; his theme was the human head—or rather, heads, busts, beards, braids and locks of hair, all woven, twisted, intertwined. Fortunately, these drawings, which read like blueprints, have survived. Owing to a pedantic emphasis on the qualities of

the material—iron wire—they all evoke prison: the head as cage, its structure cross-barred like an iron grille. Uhlmann was able to realize a few variations on these head constructions in the late 1930s.

Even though he ceased using iron wire during the early postwar years and turned first to rods of iron, brass, copper, or aluminum, and then to steel rod and tubing, steel bands, and cut sheet steel, Uhlmann retained the basic design principles of his earlier pieces. These aimed from the start at replacing solid volumes by a transparent network whose tensed, linear elements visualized the energies and forces at work in organic bodies. For masses he substituted a structural scaffolding with contours descriptive of mass. Instead of reproducing a solid as such, he evoked it by suggestive interweaving of wire, rods, and tubing. While his early heads were still based on a static scaffolding, the postwar works increasingly accentuated dynamic forms and rhythmic structures. This change was reflected in the titles that Uhlmann now occasionally gave his works: *Bird, Flight, Feeler Insect, Winged Insect, Aggression.* By the mid-1950s, the linear rods and narrow bands had begun to give way to more expansive, planar elements, which again lent his sculptures more of a static, stable quality. His titles changed accordingly: *Symmetry, Tower, Column, Labyrinth, Pyramidal Sculpture, Fetish.* The contrasts between differently sized and contoured planar shapes of various thickness were frequently heightened by red and black paint, which increased the latent tension of the configuration, brought certain forms into threatening proximity, and made others recede. The modern engineering approach and a poetic sensibility combine in Uhlmann's Fetishes into a unity that is at once austere and breathtakingly sensual.

Figure 7: Wolfgang Petrick. *Beauty.* 1974–75. Synthetic polymer paint. Berlinische Galerie, Berlin

If we review the art created in Berlin during the twentieth century, there emerge, roughly speaking, five lines of development. First, there is a line that begins with the painters of *Die Brücke* (The Bridge)—Ernst Ludwig Kirchner, Max Pechstein, Erich Heckel, Otto Mueller, and Schmidt-Rottluff, all of whom came to Berlin about 1910. It then leads via Georg Baselitz, Eugen Schönebeck, Markus Lüpertz, K. H. Hödicke, and Bernd Koberling, who worked in Berlin from the late 1950s on, to those young painters who made a mark on art history in the late 1970s as *Neue Wilde* (New Wild Ones): Rainer Fetting, Helmut Middendorf, Salomé, and Bernd Zimmer. This first line extends, in a word, from the painters of the Moritzburg Lakes to those of the Galerie am Moritzplatz.

Then there is the realist tradition. Represented at the start of the century by Max Liebermann and Lesser Ury above all (who have sometimes been classified as German Impressionists), this tradition was continued by Lovis Corinth, the East Prussian who moved from Munich to Berlin in 1901 and later developed toward Expressionism. During the 1920s, the painters of *Neue Sachlichkeit* (New Objectivity)—Otto Dix, George Grosz, Christian Schad, Rudolf Schlichter, to name only the most significant—dominated the scene. In the 1960s an attempt was made to revive this tradition by the Critical Realists Wolfgang Petrick, Ulrich Baehr, H. J. Diehl, and Peter Sorge (figures 7, 8, and 9), joined later by Klaus Vogelgesang, Jürgen Waller, and soon many more. They, too, can be characterized in the terms we have applied to various postwar artistic phenomena, being both typical of the period and exceptional—typical equally of the time and the city in which they emerged, yet highly exceptional in the international context. Their idea was to take the socialist realism prevalent in the eastern half of the city, East Germany, and other socialist countries, enliven it with formal elements derived from Pop art and other contemporary Western movements, bring the stylistic means of *Neue Sachlichkeit* to bear on the result, and come up with an instrument of critical and committed commentary on the

Figure 8: H. J. Diehl. *The Redirected Student.* 1968. Oil on canvas. Staatliche Museen Preussischer Kulturbesitz, Nationalgalerie, Berlin

Figure 9: Peter Sorge. *Mr. America.* 1973. Pencil and colored pencil on paper. Collection Bonaventura Kiefer, Oelde

social realities of our day. Though much of their work may have bogged down in clichés, their approach—a synthesis of stylistic means transcending political systems—was important, perhaps even historically necessary, and in the hands of some of the Critical Realists it led to interesting results.

A third line of development can be traced from Dada. In Berlin, Dada developed a committed, even belligerent political character, but also brought forth such crucial formal innovations as photocollage in the work of Raoul Hausmann, Hannah Höch, Richard Huelsenbeck, and John Heartfield. This line runs straight to the Neo-Dadaist manifestations of the 1960s: Fluxus, Happenings, and Conceptual art. Just as Dada initially emerged in Zurich, then New York, Cologne, and Hannover, but developed a characteristic and inimitable aspect in Berlin, so the Fluxus idea leapt the gap from West Germany to Berlin, at the early date of 1964, when Joseph Beuys and Wolf Vostell first appeared there, followed in 1965 by Ludwig Gosewitz and Tomas Schmit. And just as Heartfield's political commitment soon took him beyond Dada, Vostell, who shifted his center of operations from Cologne to Berlin in 1971 and who, aside from Beuys, is probably the most complex personality within the entire Fluxus movement, not only belongs in the Dada-Neo-Dada line but can with equal justification—by intention if not by style—be classed with the Critical Realists.

A fourth line extends from the Constructivists of the 1920s, from Naum Gabo, who lived in Berlin in 1922–33 (figure 10), and Johannes Itten, who ran an art school there in 1923–33, through the sculptor Uhlmann to the painters Frank Badur, Johannes Geccelli, Raimund Girke (figure 11), Andreas Brandt, and Paul Uwe Dreyer, of whom the first three have long held professorships at the Hochschule der Künste (College of Arts), renamed in 1975.

Fifth, and finally, we come to *tachisme* or Abstract Expressionist art, which since the 1950s has been represented in Berlin particularly by two "poetic abstractionists," Fred Thieler and Hann Trier (figure 12), from whose classes at the College of Arts some of the most gifted Neo-Expressionists and realists have emerged. In the second generation, this approach was taken up above all by two respected and original artists who single-mindedly pursued it for many years and who today likewise teach at the College: the painter Walter Stöhrer and the sculptor Rolf Szymanski (figure 13). In the meantime, a third generation of highly talented and promising younger artists has emerged whose interests extend beyond free gestural painting to sculpture.

Figure 10: Naum Gabo. *Model for a Fountain.* 1923–24 (reassembled 1985). Glass and enameled metal. Art Gallery of Ontario, Toronto

This schematic outline of a rich artistic development, which was shaped by outstanding individuals producing numerous interrelated approaches, must remain cursory. Many significant sculptors, painters, and draftsmen are not even mentioned. How inadequate these coordinates are to describe the decades from 1900 to 1970 becomes obvious from the mere fact that a unique artist like Heldt finds no place in the scheme. He is neither an Expressionist nor a Realist nor a Constructivist—and a Cubist tradition is something Berlin has never had. Heldt fits into no pigeonhole; he drops through the meshes of this art-historical net and yet remains as typical of Berlin art as any of the other artists.

Of these five lines of development, the most significant in terms of art history is certainly the first, expressive or Expressionist line, while the second, realistic one has always found more adherents and elicited a greater response than any of the others. Berlin is by nature and inclination a realistic town, a frank, plain-spoken, laconically humorous place, as both Berliners and outside observers have never tired of remarking. Realistic painting has been at home here ever since the days of Liebermann, since Dix and Grosz; and in our own day, such artists as Petrick, Baehr, Diehl, and Sorge are still actively exploiting the realist heritage. And although perhaps overestimated on their home ground, these artists have yet to gain the recognition they deserve on the international scene.

The third, and, to an even greater extent, the fourth of the lines I have sketched, by contrast, have always been as underrated in Berlin as they have been celebrated elsewhere. The Constructivist artists, and even more the prac-titioners of a reserved, meditative, low-key abstraction, have suffered from almost complete disregard. Gabo, an early victim, complained in his diary of 1931: "Lacking any opportunity to show my work in a vital atmosphere, it will die with me, it will never bear fruit."[1]

Figure 11: Raimund Girke. *White Motion*. 1960. Synthetic resin on canvas. Private collection

As the 1950s gave way to the 1960s, signs of a crisis, a deep caesura, a radical change in mood began to mount. The postwar era was over; the developments it had brought became a source of widespread unease. Much, apparently, had gone wrong. What had become of the daring utopias of the first postwar years? Where were the hopes of a new beginning? Gradually the negative aspects of economic recovery and of the affluent society began to make themselves felt, particularly the spiritual dessication of the pursuit of prosperity at all costs.

This mood precipitated first in literature; it was noted in the arts pages of the newspapers and formed the subject of meetings and conferences. Soon it had inundated visual art. Significantly, it was a handful of artists who had emigrated from East to West Germany—Baselitz, Schönebeck, and Lüpertz in Berlin; Gerhard Richter and Sigmar Polke in Düsseldorf—who most cogently ex-pressed this feeling of malaise, this dual disillusionment over lost postwar utopias and over the free life in the West, into which they had projected such high expectations. While Düsseldorf artists like Richter and Polke tended to react cynically, by proclaiming a new style called Capitalist Realism, the reac-tion in Berlin went deeper and led, on the one hand, to angry outbreaks and obstinate self-assertions (Baselitz and Schönebeck) and, on the other, to a savage hymn in praise of life at the brink of the abyss (Lüpertz).

Many ideals of the immediate postwar years began to tarnish about 1960. Among them was the dream of a gradual but inexorable advancement of art toward an ideal, pure, harmonious abstraction; another was the belief, born of naive yearning, in an all-encompassing internationality of the arts. Art can be many things—a passionate attack on injustice, sublime utopia, painful self-revelation, or frightening vision. But one thing it is not is a means to human fraternity, a tool in the service of international understanding. The cruelties that Germany had inflicted on Europe in a terrible war could not simply be conjured

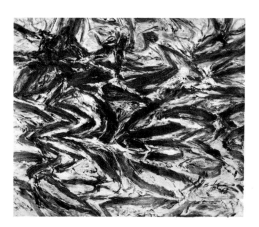

Figure 12: Hann Trier. *Aquaba*. 1963. Oil on canvas. Private collection

away by a few German artists who, for all their undisputed talent and goodwill, began to paint abstract pictures in the same style and with the same élan as the pioneers of *l'art informel/tachisme* or Action Painting/Abstract Expressionism in Paris and New York.

Relinquishing these dreams, in which much hope and more enthusiasm had been invested, was no easy task. But by the early 1960s, it had become apparent that German artists had no other choice. Step by step, they emancipated themselves from the ideals of the postwar era, and began gradually to reassess their own traditions. The emerging generation, as unfair to their fathers as any new generation, condemned the art of the late 1940s and early 1950s almost as radically as that of the Nazi period. Overleaping both, they attempted to connect with the intellectual and artistic legacy of pre-1933 German art: Expressionism and the Bauhaus on the one hand, and Dada and *Neue Sachlichkeit* on the other. As a philosophical point of reference, Friedrich Nietzsche, who had been central to the Expressionists Kirchner, Heckel, and Schmidt-Rottluff, again loomed large, and the furor and magnificence of his language again proved irresistible to artists like Baselitz, Schönebeck, and Lüpertz, influencing even the wording of their manifestoes. Nietzsche's radicalization of existence in a tragic world and his heroic will to life inspired this later generation and pointed the way for them, as it had inspired an earlier generation at the turn of the century.

Yet although they announced a new start, invoked a clean slate on which every mark they made would differ radically from those of their progenitors, these artists did not reject every achievement of the post-Expressionist generation. It is Heldt's facades that Hödicke quotes in painting after painting; it is the free forms of Ernst Wilhelm Nay and Werner Gilles that Lüpertz treats, transforms, and projects onto a large format in his Style sequence.

More important than outstanding artists of this German "interim generation," however, were impulses from abroad, especially from the great American painters of the 1950s, Jackson Pollock, Willem de Kooning, Franz Kline, Mark Tobey, Mark Rothko, Clyfford Still. Young German artists were confronted with their work for the first time in the fall of 1958, when two American exhibitions were shown together in Berlin at the College of Visual Arts (where Baselitz, Schönebeck, Hödicke, and Koberling had just enrolled). *The New American Painting* and *Jackson Pollock: 1912–1956* (figures 14 and 15), organized by The Museum of Modern Art in New York, toured extensively in Europe owing in part to the enthusiasm of Arnold Rüdlinger of the Kunsthalle, Basel. The young generation of wild, expressive, so-called Neo-Expressionist painters, in other words, became acquainted with seminal German Expressionism through the filter of American Abstract Expressionism. This fact cannot be stressed enough. The path they took would be equally unthinkable without the experiences of the New York School as without the achievements of Edvard

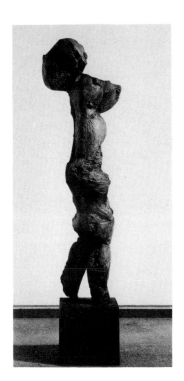

Figure 13: Rolf Szymanski. *Young Lady in Algiers*. 1961. Bronze. Galerie Brusberg, Berlin

Figure 14: Exhibition *The New American Painting* at Hochschule für bildende Künste, Berlin, September 1958

Figure 15: Exhibition *Jackson Pollock: 1912–1956* at Hochschule für bildende Künste, Berlin, September 1958

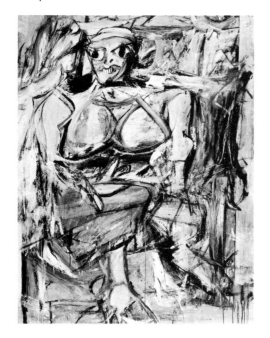

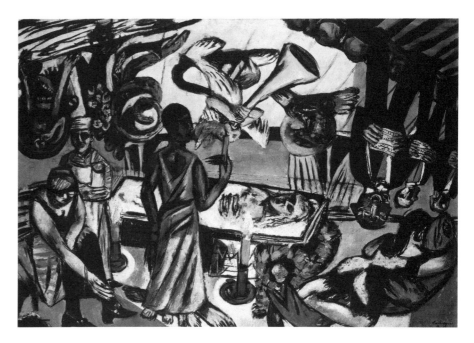

Munch, Max Beckmann, and Kirchner. The Neo-Expressionists' image of Munch was galvanized by de Kooning (figure 16), their image of Beckmann (figure 17) refracted through Arshile Gorky and Kline, their image of Kirchner filtered through Pollock. Or, one can reverse this and say that without the visions of the Expressionist generation these artists may not have seen the chance of developing the free, gestural approach of the Americans in a new direction, toward a new image steeped in contemporary experience of man and his environment, the big city and open country.

Back then, in the early 1960s, when abstraction had found general acceptance if not official sanction, this aim was bound to appear illusory if not positively reactionary. The efforts of these young artists accordingly went on in open or covert resistance to established art, its institutions, galleries, and advocates, who either ignored or condemned them. And this, in turn, made them feel like conspirators, in league with a handful of friendly dealers and critics. The disapproval of a public that had just begun to make its peace with the language of abstraction further increased the cohesion of this group, which went underground among the lofts and backstairs apartments of low-rent Berlin.

But let us now direct the clear light of chronology and topography on this scene, and pinpoint just when and where the artistic manifestations of the early 1960s took place. In 1961, Baselitz and Schönebeck exhibited their canvases in the attic of an old condemned building near the Fasanenplatz. They also published their first manifesto *Pandemonium*, the language of which oscillates between ecstasy and apocalypse, between Nietzsche and Lautréamont: The "poets lay in the kitchen sink / body in morass. / The whole nation's spittle / floated on their soup / . . . / Their wings did not carry them heavenward—/ . . . not a drop wasted writing—/ but the wind bore their songs, / and those have shaken faith . . ."[2] Insofar as a message can be inferred here, it implies a rejection of *tachisme* in favor of a pathos-filled realism. That same year, following a similar impulse, Hödicke and Koberling, together with a few friends, founded the Vision group and launched a short-lived magazine of the same name (figure 18).

In 1962 Baselitz and Schönebeck published the second *Pandemonium*, which is suffused with the same pathos as their first manifesto:

Negation is a gesture of genius, not a wellspring of responsibility . . . With solemn obsessiveness, autocratic elegance, with warm hands, pointed fingers,

Figure 16: Willem de Kooning. *Woman, 1.* 1950–52. Oil and charcoal on canvas. The Museum of Modern Art, New York

Figure 17: Max Beckmann. *Death.* 1938. Oil on canvas. Staatliche Museen Preussischer Kulturbesitz, Nationalgalerie, Berlin

Figure 18: *Vision: Pamphlet on Art*, 1961. Drawings by K. H. Hödicke and J. K. S. Hohburg

rhythmic love, radical gestures—we want to excavate ourselves, abandon ourselves irrevocably—as we have no questions, as we look at each other, as we are wordless, as we, most noble profanity—our lips kiss the canvas in constant embrace—as we . . . carry our color ordeal over into life, . . . what our sacrifice is, we are. In happy desperation, with inflamed senses, undiligent love, gilded flesh: vulgar Nature, violence, reality, fruitless. . . . I am on the moon as others are on the balcony. Life will go on. All writing is crap.[3]

Figure 19: Markus Lüpertz. *Kitchen—Dithyramb.* 1964. Pastel on paper. Private collection

Schönebeck then began a series of paintings in which he attempted to combine experiences of *l'art informel* (Jean Fautrier) and the new figuration with a socialist realism reduced to its basics (the late Kasimir Malevich and Alexander Deineka).

In 1963 Lüpertz arrived in Berlin. In his biography he notes for that year: "Invention of the dithyramb in the 20th century." From then on he was to call his paintings, with changing adjectives, Dithyrambs (figure 19). The title alludes to a recurring, convoluted, plastic *form* that is conceived as an *object*. This became the point of departure for an approach that maintains a delicate balance between figuration and pure painting.

That same year, Michael Werner and Benjamin Katz opened a gallery and devoted their first exhibition to the work of Baselitz. Two paintings, *The Great Piss-Up* (figure 20) and *The Naked Man* were removed from the show by the authorities, on a charge of pornography. Two years of investigation ensued; then charges were finally dropped and the canvases returned. Werner and Katz went their separate ways after this show, though both retained contact with Rudolf Springer, the Berlin dealer who became something of their mentor. About this time, Christian Chruxin founded his gallery, Situations 60, which concentrated principally on constructivist painting and concrete poetry.

In 1964 René Block opened his gallery on Frobenstrasse in Kreuzberg (also the location of Chruxin's Situations 60) with a significant eye-opening exhibition titled *Neo-Dada/Pop/Décollage/Capitalist Realism*. Beuys was represented, then still in the context of Neo-Dada and Fluxus; *décollage* referred to the work of Vostell; and the term Capitalist Realism indicated Block's close ties with the Düsseldorf scene and K. P. Brehmer. His first one-man show was devoted to Beuys. Werner, in his First Orthodox Salon, on Pfalzburger Strasse, exhibited Baselitz's 1964 painting *Oberon*. Yet even these activities could not satisfy the younger generation's appetite for public appearances. On the initiative of Lüpertz, fifteen artists convened to form Grossgörschen 35 (figure 21), the address of their exhibition space. Their project represented an innovation for Berlin—the cooperative gallery. It soon became a focus of important events, organized by two subgroups within Grossgörschen 35, the first comprising Lüpertz, Koberling, Lambert Maria Wintersberger, and Hödicke (who in 1964 had his first show of big-city and neon-sign paintings there). The second group, formed by the "hard core" Critical Realists, included Baehr, Diehl, Petrick, and Sorge.

In 1965 Koberling showed at Grossgörschen 35 a series of northern European landscapes from Lapland and Scotland begun in 1963, titling his exhibition *Special Romanticism.* Vostell, with the support of René Block, presented two of his major early Happenings, *Phenomena* and *100 Events,* in which such other key Berlin artists as Brehmer, Gosewitz, Hödicke, and Lüpertz participated.

In 1966 Lüpertz exhibited at Grossgörschen 35 and published his *Dithyrambic Manifesto* on that occasion. It breathes the spirit of Nietzsche's Dionysian affirmation, intoxication with the world, and self-confidence: "The grace of the 20th century is made visible by the dithyramb I invented. . . . The artist's relationship to the object should be like that of the caricaturist to his human subject." Shortly after Lüpertz's show, the Grossgörschen group finally dissolved, with Lüpertz, Hödicke, and Koberling going their separate ways and the Criti-

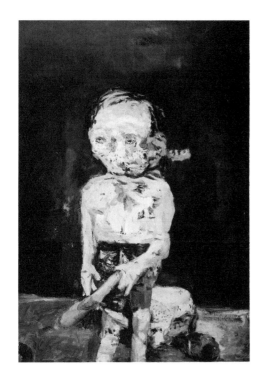

Figure 20: Georg Baselitz. *The Great Piss-Up* (*Die Grosse Nacht im Eimer*). 1962–63. Oil on canvas. Museum Ludwig, Cologne

cal Realists forming their own Grossgörschen Secession. Baselitz, on Werner's initiative, showed his canvas *The Great Friends* at Galerie Springer, and in an unusual handout in poster form ironically explained "Why *The Great Friends* is a good painting," listing seven "formal" and two "substantial" criteria (figure 22). The irony cannot hide the fact that *The Great Friends* is a deeply tragic image in which Baselitz attempts a contemporary realism (see his *Bonjour, Monsieur Courbet*, 1965) expressive of the German postwar situation and the artist's position within it: the necessity of maintaining inner calm and detachment in the face of widespread demoralization and destruction. That same year, Baselitz left Berlin and, after a year in Florence, settled near Worms, a town on the Rhine in southern Germany. Schönebeck, just thirty years old, renounced all artistic activity, and has lived in complete seclusion in Berlin ever since.

Behind these dry dates is concealed one of the most far-reaching transformations in German art of the past forty years. Within a space of only five years, the Berlin art world was totally altered. Not, it is true, completely on the quiet—its attendant circumstances were too spectacular for that—but largely unnoticed by the general public. Only very gradually did a realization of the scope of this change set in. If anyone had maintained at the time that not only the postwar era but the entire modern movement with its utopias and projections had run up against its limits, that something in the nature of a postmodern sensibility had begun to emerge, he would have been ridiculed. Pop and Op art, Color-Field abstraction, Photorealism, then Minimal art and monochrome painting, *Spurensicherung* and Conceptual art, continued to dominate the scene. And it was precisely the hegemony of Minimalist and Conceptual approaches that caused that "picture hunger" which rang in a "change of image" and presaged *A New Spirit in Painting* (*Bildwechsel* and *Zeitgeist*), at the start of the 1980s.

What a decade and a half later became well known and the focus of heated controversy was a development for which the ground was prepared in Berlin from the mid-1960s to the mid-1970s. Outwardly, however, Berlin art merely continued to drift ever further from view, seemed condemned forever to play a marginal role, to be nothing more than a special, if interesting, case. The 1960s clearly belonged to the Rhineland. Beuys's stature was becoming increasingly obvious; creative potential concentrated in and around Düsseldorf, with the Group Zero around Heinz Mack, Otto Piene, and Günther Uecker; the Capitalist Realists Richter and Polke; the "superrealist" Konrad Klapheck; Gotthard Graubner and his obsession with color; Blinky Palermo blazing the

Figure 21: Markus Lüpertz exhibition at Galerie Grossgörschen 35, Berlin, March 1965

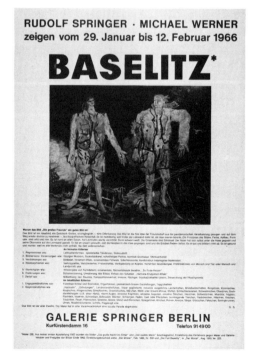

Figure 22: Poster for Georg Baselitz exhibition at Galerie Springer, Berlin, January–February 1966

Figure 23: K. H. Hödicke/René Block. *Cold Stream*. Ten pails with tar. Installed at Kunstverein, Stuttgart, May–June 1972

trail of a new abstraction; and many, many more. The Cologne art fair was inaugurated in 1967, and it soon became an institution with an irresistible attraction for the galleries. They not only came to show at the fair but settled in Cologne for good, making it the capital of the German art trade, just as Düsseldorf became the artists' capital—a "republic of loners."

Berlin, meanwhile, was burdened with other concerns. The radicalization of the political climate, and the campus revolt triggered by horror at the continually escalating Vietnam War affected art more profoundly in Berlin than elsewhere in Germany. It was the great hour of the Critical Realists, despite the difficulties they had in gaining a hearing beyond a limited circle, for example in Hannover or Braunschweig. It was also an hour in which artists, particularly the more sensitive among them, began to doubt the efficacy of their traditional means: Hödicke and Koberling, for example, experimented for a while with other techniques (figure 23). But the seeds that had been sown in the early 1960s continued to green, and a younger generation of artists looked on in fascination. The first of the "1961 generation" to take up painting again was Hödicke, who returned to his cityscape theme and who in 1974 received a professorship at the Berlin College of Arts (while others taught elsewhere). From Hödicke's class, in particular, emerged many of the painters who were to make names for themselves in the "second wave" of the new Berlin painting.

Notes

1. Naum Gabo, "Diary," May 26, 1931, in Steven A. Nash and Jörn Merkert (eds.), *Naum Gabo: Sechzig Jahre Konstruktivismus* (Munich: Prestel, 1986), p. 61.
2. Georg Baselitz and Eugen Schönebeck: "First Pandemonium," in *Georg Baselitz* (London: Whitechapel Art Gallery, 1983). pp. 23–24.
3. Baselitz and Schönebeck, "Second Pandemonium," *ibid.*, pp. 24–25, 29.

Visitors to a City in Exile

Karl Ruhrberg

> Berlin (West): A surrealist cage;
> those inside it are free.
> *György Ligeti*

"A city in exile" is how Georges Tabori, the Hungarian playwright and director who works primarily in West Germany and Great Britain, describes bisected Berlin, symbol of a divided Germany, but also of a divided world and either/or thinking in East and West. Old Berlin, capital of a German empire founded in 1871 and destined to last barely seventy-five years, was Europe's youngest metropolis. Perhaps its ambition to catch up with the venerable cultural centers of London and Paris had something to do with its scintillating unrest, that devil-may-care style of life which so impressed Lovis Corinth, the Expressionist among German Impressionists, at the close of the nineteenth century. Corinth noted in his memoirs that people in Berlin were highly interested not only in art generally but in every new phenomenon that appeared on the scene. An incredible tempo in artistic matters and audiences whose reactions are quick, critical, and sometimes aggressive have characterized Berlin to this day. Nor is the half of the city beyond the Wall an exception. Though it goes by the official title of capital of the German Democratic Republic, East Berlin is not the capital of its visual arts; yet both there and in the art centers Dresden and Leipzig, developments in West Berlin and the Federal Republic of Germany are followed with consummate interest. Personal contacts among artists, critics, and museum people were never completely severed, and over the years, Western artists have made frequent appearances for the benefit of selected audiences on the other side. These culminated in late October 1986 with the opening, at the historical Altes Museum in East Berlin, of the first state-approved exhibition of West German painting since 1945. Titled *Positions,* it included some of the finest works by artists from Ernst Wilhelm Nay and Willi Baumeister to Anselm Kiefer and Sigmar Polke.

No authority has ever completely succeeded in obfuscating Berliners' acute judgment, not the Kaiser nor even for that matter the Nazis. Although William II denounced the work of the progressive painters and sculptors of the day as "gutter art" and prevented an award being made to Käthe Kollwitz, he could stop neither an influx of Expressionists and Futurists into his imperial capital nor the founding of the Berlin Secession by Max Liebermann. The official court artist, Anton von Werner, even lost proceedings in the German Reichstag against his great, and hated, Norwegian rival, Edvard Munch. And before the First World War was over, Richard Huelsenbeck, Hannah Höch, and Johannes Baader formed Berlin Dada, politically the most active of all the Dada groups in Europe and the United States.

Even during the Third Reich, that regime for a long time hesitated to prosecute its campaign against "degenerate art" as radically in Berlin as elsewhere. Joseph Goebbels, the mephistophelian intellectual head and chief propagandist of the Nazi movement, would initially hear nothing of closing those galleries which opposed, openly or secretly, official arts policy. A covert admirer of Expressionists like Ernst Barlach and Emil Nolde, he tolerated these subversive activities as a "necessary evil" for a relatively long period before casting his lot

Daniel Buren. *Sail/Canvas—Canvas/Sail.*
Photograph of event on Wannsee, Berlin, 1974

with the hard-liners within the party. As late as 1941, the same year as the former party member Nolde was finally forbidden to work, Goebbels's organization permitted an exhibition by the Expressionist Max Pechstein. The Bauhaus, driven out of Weimar in 1924 and out of Dessau even before 1933, made its last stand under Ludwig Mies van der Rohe in Berlin, in an abandoned telephone factory in the Steglitz district, where it was able to hold out for only a matter of months. In 1935, Werner Heldt, who ten years later was to record the harrowing consequences of Nazism in a series of paintings titled *Berlin by the Sea*, made a sarcastically acerbic drawing of a Nazi mass rally, a *Demonstration of Zeroes*, those same "zeroes" who then ruled Berlin.

Yet niches of liberalism still remained, even during the darkest years of terror, and they were more frequent in Berlin than anywhere else in Germany. These zones of "calm in the eye of the storm," as the critic Heinz Ohff has called them, provided protection and aid to many a denounced and persecuted artist.

In the field of drama, too, Berlin theaters were able to put on productions of a kind that would have been impossible elsewhere in the Third Reich. Schiller's *Don Carlos* was staged at the Staatstheater as a drama of liberation so markedly opposed to the prevailing tendencies that the performance was interrupted by thunderous applause when the Marquis de Posa demands of his king, "Sire, grant freedom of thought!"

"It will remain to the lasting honor of art and artists in Berlin that the best among them have invariably taken the risk of opposition upon themselves, an opposition rooted in the healthy skepticism of this first metropolitan population in German history," writes Werner Doede, art historian and curator, in his book on Berlin.[1] His words even hold for the period between 1933 and 1945, before the refractory capital of the Third Reich disappeared in the rubble.

During the Weimar years, Berlin was the center of artistic opposition, of protest against the war profiteers and complacent bourgeoisie that George Grosz attacked, against a chauvinistic judiciary, against right-wing radicalism, against the deplorable conditions in which large numbers of the population lived. The year 1918 saw the founding of the leftist, if more idealistic than Marxist-oriented, *Novembergruppe* (November Group), followed the next year by the *Arbeitsrat für Kunst* (Working Council for the Arts) led by the architects Walter Gropius and Bruno Taut. Other groups convened around Raoul Hausmann and Otto Freundlich on the one hand, and John Heartfield and Grosz on the other, who in 1922 formed the *Association revolutionärer bildender Künstler* (Association of Revolutionary Visual Artists), or ASSO for short. Hans Richter and Viking Eggeling invented the abstract film; Heartfield, Grosz, Höch, and Hausmann the new medium of photomontage. Many artists from Eastern Europe made Berlin their center of operations—Alexander Archipenko, Ivan Puni, El Lissitzky, Wassily Kandinsky, Marc Chagall, Naum Gabo, and Kasimir Malevich from Russia; László Moholy-Nagy from Hungary; Henryk Berlewi from Poland. In 1922, under the auspices of the Russian Commissariat for Popular Education and Art, the legendary First Russian Art Exhibition opened at Galerie van Diemen. Held for the benefit of "the starving Russian population," this show featured all the progressive, revolutionary streams which were shortly to be suppressed in favor of a blatantly propagandistic Socialist Realism. Expressionism and Futurism had already prevailed in Berlin before the First World War, thanks to Herwarth Walden and his gallery *Der Sturm*. The year 1922, as Curt Glaser noted in his column, "*Kunstchronik*," also marked the "undisputed leadership" in Berlin of Expressionism, particularly of the Dresden *Brücke* variety, while Liebermann and Max Slevogt, the German Impressionists, had "dropped almost entirely from view."

On the whole, then, Berlin opened wide its doors to the international art scene, and gave a warm welcome to many of its outstanding representatives. "Is it not the internationality of Berlin that permits us to truly participate in our epoch?" asked the influential daily, *Berliner Tageblatt,* as early as 1898. An open-minded reception of the unfamiliar, an unbiased acceptance of innovation that facilitated the growth of the international modern movement, not only contributed to Berlin's reputation as an art center but made the scintillating variety and richness of its cultural life during the 1920s possible—before the pall of Nazi provincialism settled in and smothered it.

"Two walls run through Berlin," wrote the Hungarian composer György Ligeti in a document written to celebrate the tenth anniversary of the Berlin Artists Program, "but only one of them is visible. The other is a time-wall, comprising the years 1933 to 1945. Something very essential was cut off, crushed irrevocably, by this wall."[2] This cannot be denied. Berlin as it once was, the city that Thomas Wolfe, seismographically registering the approaching tremors of totalitarianism, described in *You Can't Go Home Again*—this city no longer exists. War, the division of Germany, the blockade, and the Wall, have left scars that can never entirely heal.

Nevertheless, attempts to give Berlin a new cultural lease on life began even before the year 1945 was out. Gerd Rosen opened the first postwar art gallery; the "degenerate artist" Karl Hofer became the first director of the Hochschule für bildende Künste (College of Visual Arts). Soon these humble beginnings had burgeoned, with surprising rapidity, into a new and diverse cultural landscape of galleries, museums, exhibition institutes, theaters, orchestras, cabarets, and radio stations.

In Kreuzberg (the same district where, in the late 1970s, the four *Neue Wilde* painters, Rainer Fetting, Helmut Middendorf, Salomé, and Bernd Zimmer, would open their cooperative Galerie am Moritzplatz) a new bohemia of painters and writers began to gather. Yet the attraction of this first German art scene since the war remained largely local; internationally it did not figure; Berlin as yet had no private collectors to speak of. Painting and sculpture reflected international trends, with no indigenous ones in sight; the really new art that was to be seen came in by way of import, generally thanks to courageous dealers. In spite of the presence of excellent artists like Hans Uhlmann or Bernhard Heiliger in sculpture, and Heldt, Alexander Camaro, Rolf Cavael, Hann Trier, Walter Stöhrer, and Fred Thieler in painting (the last of whom would exert a great influence on future developments with his gestural approach), a uniquely Berlin art was at that period still wishful thinking.

The problems faced by the "island" city, the disadvantages of its geographic, economic, social, and political situation, were further exacerbated in 1961, when the German Democratic Republic built the Wall bisecting the city. This terrifying structure, whose ugliness has in past years been slightly mitigated on the Western side by grafitti, ironically had its positive effects in the cultural area. The danger of West Berlin's total isolation was not only recognized, it was countered—with some success, as soon became apparent.

It all began with a joint American-German undertaking, initiated in 1963 by the Ford Foundation. Joe Slater, subsequently president of the Aspen Institute for Humanistic Studies, and Shepard Stone, now director of Aspen Berlin, suggested the establishment of an International Institute for Music Studies, the Berlin Literary Colloquium (LCB), and above all, an artists-in-residence program for authors, musicians, and visual artists, open to foreign participants from East and West. Since 1965 this program has been administered, under the

Figure 1: Writers Fritz Baumgartner, Günter Grass, John Dos Passos, Walter Höllerer, and Heinrich Böll at a bar in Berlin

name Berlin Artists Program, by the German Academic Exchange Service (DAAD). Founded in 1925 as the Academic Exchange Service, the DAAD acquired its present name in 1931. After interruption of its activities as a result of the Second World War, it resumed work in 1950. It is an organization of German universities and colleges which aims at promoting international relations in the field of higher education, principally by arranging exchanges for academics and students from all disciplines and from virtually every country in the world. Its legal status as a registered association assures it a certain degree of autonomy: it is not answerable directly to any state department, although financed by the foreign office in Bonn and the Berlin senate. From its central office in Bonn-Bad Godesberg the DAAD maintains branches in London, Paris, New York, Cairo, New Dehli, Rio de Janeiro, Nairobi, Tokyo, and San José.

The DAAD provides grants for education and research, finds teaching posts for Germans at foreign universities and colleges, and organizes visits for study groups from Germany and abroad. The Berlin Artists Program occupies a special position within these activities.

The invitations—twenty to twenty-five a year when resources allow, fewer in lean years—are made by an independent jury with international membership. In the meantime, composers, writers, painters, sculptors, object-makers, video and performance artists, and a number of filmmakers, from over fifty countries on five continents, have spent a year in Berlin on this program, most of them with the intent of realizing a particular project. A few have stayed less than a year, many have remained beyond the fellowship period, and some—like artists George Rickey and Edward Kienholz (United States), Peter Sedgley (Great Britain), László Lakner (Hungary), and Armando (the Netherlands); composer Isang Yun (South Korea); or writers Antonio Skarmeta (Chile) and Georges Tabori (Hungary)—have settled in Berlin more or less permanently.

Figure 2: Igor Stravinsky rehearsing *Abraham and Isaac*, Berlin 1974

In the field of literature, the ground was prepared largely by Walter Höllerer, author and literary historian, who still heads the LCB. Based on a Massachusetts Institute of Technology program, Höllerer founded an institute for language in the technological era, organized courses in prose and drama writing, arranged meetings between young and prominent authors, and brought foreign writers who seemed interesting to him to Berlin. Among the first were the beat poets Gregory Corso and Lawrence Ferlinghetti. This pioneering work was put on a

Figure 3: Morton Feldman, Berlin, July 1972

broader basis by the LCB, whose activities profited from Höllerer's close ties with *Gruppe 47*—its founder Hans-Werner Richter, and members Günter Grass, Peter Weiss, Heinrich Böll, Martin Walser, and others, who together brought a new literature to life in postwar Germany (figure 1). With their aid, Höllerer succeeded in attracting an international élite of writers to Berlin: Eugene Ionesco, John Dos Passos, Salvatore Quasimodo, and Ingeborg Bachmann who, like W. H. Auden and Michel Butor, had already been a guest of the Berlin Artists Program. The objection raised by the popular Berlin author Robert Scholz (*Am grünen Strand der Spree*), that the city may have an organized literary life but no organic one, was perhaps justified to a certain extent, but not for long. Over the years the organized literary life indeed took on organic traits, and the present scene, enriched by repeated visits from such authors as Ernst Jandl and Friederike Mayröcker (Austria), Lars Gustafsson (Sweden), Max Frisch (Switzerland), Emmett Williams (United States), and in recent years by such émigrés from East Germany as Reiner Kunze and Jurek Becker, has become one of the most interesting and diverse in Germany.

Musical life, too, received important impulses—or, as sculptor Rickey puts it, "a series of well-applied vitamin shots"—by way of cultural import. Among the first visitors was Igor Stravinsky (figure 2), who, however, did not remain long (like John Cage many years afterwards). Steve Reich, too, came only as a prominent participant in the Metamusic Festival of non-European music, one of the most successful series in the history of the Berlin Artists Program. On the other hand, Krzystof Penderecki stayed a year and a half, and Ligeti was hardly to be moved from Berlin at all until the offer of a professorship drew him to Hamburg. Isang Yun, who was kidnapped from Berlin by the South Korean secret service, tried, and convicted—a scandal that drew international protest—was finally released on German government intervention, returned to Berlin, took a college teaching post, and, as he says, found his second home in Germany. The Spaniard Luis de Pablo maintains that he composed twice as rapidly in Berlin as at home, and Morton Feldman (figure 3), the American composer who has returned again and again to participate in Berlin music life, said of his first sojourn: "My residence in Berlin was the most productive year of my life, and what makes me happy is not only . . . the music I composed in that time, but the fact that much of it was commissioned by various German radio and festival organizations."[3]

Figure 4: George Rickey installing exhibition at Haus am Waldsee, February 1969

Not everyone was this happy in Berlin, although by now, most of the program's guests can be said to have enjoyed their stay. There is no denying, however, that problems of all sorts have arisen—language barriers; integration difficulties; a reluctance on the part of official cultural institutions to include guests in their events; and mistrust on the part of native artists, especially the ideologically indoctrinated, who have always looked askance at literary internationalism. During this phase of shadow-boxing over the "social relevance" of art, particularly in the late 1960s and early 1970s, many artists living in "exile" in Berlin felt, like the Austrian writer Gerald Bisinger, that "open-minded conversations, literary debates, and even occasional good cheer . . . could be had only with foreigners."

On the other hand, it must be admitted that many a guest who apparently mistook the Berlin Artists Program for a kind of subsidized vacation showed little inclination to adjust to the city, seek contacts with German colleagues, or concern themselves with the difficult conditions under which Berlin artists work. Again and again it was realized that West Berlin is not the right place for every artist, and that not every guest is the right artist for Berlin. One episode that, at least in hindsight, seems less sad than amusing was the misconception under which the Spanish painter Antonio Saura suffered. Believing himself invited to East Berlin, Saura immediately turned around and left when he discovered that he had landed in the capitalist Western sector.

In light of a situation like this, the late influential writer Ingeborg Drewitz justifiably asked whether guests from abroad "could be expected to understand what life is like here without any knowledge of the natives' worries? Is Berlin to become merely another Salzburg or Venice, an art city for tourists?"[4] Her reply to the Berlin Artists Program, during its early phase, was a very little Yes and a very big No. A few years later she was to place the accents differently. The little Yes had expanded to twice its size, and the big No had shrunk to insignificance. "It is gratifying enough," Drewitz wrote in 1975, "that the Berlin Artists Program has long since lost its initial air of an emergency cultural aid program,

and is now suffused with the new urbanity of the late 1960s."[5] Among the causes for this change were surely long-needed improvements in the program structure and greater efforts to integrate its guests into Berlin artistic life.

A great many obstacles had to be overcome before this concord with Berlin artists—musicians, writers, painters, sculptors—was achieved, and an import program had developed into a true *exchange* program, in the sense of an exchange of ideas and projects, a productive cooperation. First of all, since it was the Ford Foundation that had initiated the project, a latent anti-American-ism exacerbated by the Vietnam War had to be overcome, along with the suspicion that not cultural import but cultural imperialism, abetted by mon-strous dollar-transfusions, was at the bottom of it all. The scholarship stipends, however, always remained within reasonable *Deutschmark* limits, although they may have seemed lavish to Berlin artists working under incomparably more adverse conditions. Then too, a glance through the guest list would have con-vinced anyone that "capitalist" countries were not excessively favored with invitations. Although the United States ranked high, as might be expected from the size of the country and the quality of its cultural substance, almost as many artists came from Eastern Europe, from Poland foremost, followed by Czecho-slovakia, Hungary, and Rumania. The Latin American contingent was also large.

The misconception that the Berlin Artists Program contributed to a star cult was likewise tenacious, despite the fact that the great majority of the writers, musicians, and visual artists it invited were certainly not yet prominent and internationally still quite unknown. Many did become known or even renowned in connection with their Berlin sojourns, for instance the authors Gustafsson, Tabori, Jandl, and Sergio Ramirez (Nicaragua), who in the mean-time holds a leading political position in his country; the composer Yun; or the visual artists Armando, Milan Knizak (Czechoslovakia), and Per Kirkeby (Denmark), who now even figures in the German Neo-Expressionist art scene, or Bruce McLean of Great Britain, who developed his painting style in Berlin. In other words, being famous was never a prerequisite for participation in the Berlin Artists Program, though it was never a hindrance, either.

When artists of international reputation choose to spend months or years in Berlin, they act as beacons for others. One of the first and most faithful of these beacons has been Rickey (figure 4). He planned to stay for six months, but remained for a year and a half, decided to keep his studio on Bundesplatz, and has continued to return regularly to the city, not only for professional reasons but, as he himself says, because of the quality of life here: "Berlin is a large international city with intelligence, attractiveness, and energy, where every-thing in the way of food and drink is to be had, where you can see and hear everything in the way of theater productions, concerts, and movies—and yet it is not completely dedicated to commercial expansion. Berlin is full of lively people, but it is not overcrowded. There are not many big cities left where it's fun to go for a walk. Berlin is one of them."[6]

Another American has sunk even deeper roots in Berlin than Rickey—Kienholz (figure 5), who spends half the year in Hope, Idaho, and the other half in his studio apartment on Meinecke Strasse in Berlin, near Kurfürstendamm, the last German boulevard to have retained its flair. Yet it had been no easy matter to convince Kienholz—after Documenta 5 in 1972, where he had exhibited *Five Car Stud*—to give Berlin a trial run. When he first arrived and saw the Wall, he exclaimed, "Jesus Christ, that can't be!" But the city's com-plex political, social, and economic situation soon began to fascinate him more and more. "Berlin is a magic city," Kienholz was later heard to say, and his wife Nancy added, "Berlin so bluntly and aptly points out what personal

Figure 5: Edward Kienholz preparing a sculp-ture by Duane Hanson for exhibition *Thirty Inter-national Artists in Berlin*, Bonn, December 1973

Figure 6: Emilio Vedova and André Masson
(left) in Vedova's studio, Berlin 1964

freedom really means." And Kienholz replied, "I would certainly have to agree."

Duane Hanson, the hyperrealist, had already had some experience of Germany when he came to Berlin, having lived for a time in Munich. But Munich is not Berlin, and he, too, faced certain initial obstacles. Lacking friends and relations to serve as models for his sculptures—those slices of suspended life that testify to the enigmatic quality of the mundane—Hanson had to find agreeable Berliners. And he eventually did find them, a little boy and then a workman who so closely resembled himself in Hanson's version that a photographer, finding him standing in her way at the Academy of Arts, asked him politely to move, more than once, and was quite put out when the sculpture did not comply.

The Dutch artist Armando, nominated by jury member Edy de Wilde, then the director of the Stedelijk Museum in Amsterdam, has put his finger on another aspect that is typical of Berlin. It is not, he says, "a pretty town, but it is an exciting one. Everything I've continually been thinking about is here. Suddenly I was right in the midst of my personal theme—human beings as culprits and victims."[7] This complex situation, to be met with nowhere else in Germany, also inspired the Italian Action Painter Emilio Vedova (figure 6)— who came to Berlin in the early 1960s, still under the auspices of the Ford Foundation—to make his "Absurd Berlin Diary," the *Plurimi di Berlino*, comprising raw, dramatic assemblages, which have been called a link between Action Painting and sculpture. They were the most-discussed works at Documenta 3 (1964) in Kassel.

Mario Merz (figure 7) took longer to relate to the city. His *Fibonacci Tables*, their proportions inspired by the number sequences of the medieval mathematician Leonardo of Pisa (alias Fibonacci), stood like foreign bodies in the rooms of the Academy of Arts during *Actions of the Avant-garde* and, owing to the presence of other works, could not be seen in relation to those rooms. It was little use for the poet Dick Higgins to attempt to raise the gloomy master's spirits with a cheery "I like Fibonacci." The "universal harmony" captured in visible formulae by Fibonacci/Merz did not become apparent until later, when Merz had one of his very first individual exhibitions. In the Haus am Lützowplatz, not

Figure 7: Mario Merz exhibition at Haus am Lützowplatz, Berlin, March–April 1974

far from the present DAAD gallery, he created from wood and neon-writing works that were related to the ambience in a concrete way. The artist's statement, "Fibonacci—that was my chance to understand space,"[8] was now made intelligible through works which gave it visible form. "Do the houses turn around you or do you turn around the houses?" was the question put to a mere 592 visitors during the four weeks of the exhibition. But as so often in the history of art, the number of those who showed interest stood in reverse proportion to the significance of the show for the artist himself and for the art scene in the following years.

Five years later another Italian, Michelangelo Pistoletto, established rapport with Berlin in a way that attracted a great deal of attention because it represented a pioneering experiment. Selecting fourteen works from the years 1962–78, Pistoletto went on a search for places to show them, sites where art and environment could enter a dialogue. In the museum atmosphere of the Nationalgalerie he exhibited his mirror-paintings; at the International Design Center (IDZ), a *Structure for Stand-Up Conversation*; in a café, his *Venus of Rags* (figure 8); an image assembled of electrical wiring at the premises of a moving company; *Upside-Down Furniture* in a factory; and at the observatory, *One Cubic Meter of Infinity*. These sites were scattered all over the city. On the way to them and during the confrontation between work of art and reality, the spectator had an opportunity to reflect on Pistoletto's Berlin experience and conduct a direct or indirect exchange with him. In this way, the works were transformed from museum pieces to social objects. The results of his interactions with the public reminded Pistoletto of the unstructured performances he had previously made with small groups, and strengthened his "conviction that it is possible to think your way through solid walls and find objects you had left on the other side."[9]

Less spectacular but no less intensive were the contacts that Charles Simonds, the New York artist, found in Berlin. Simonds seeks encounters with "little people" not only in memory and fantasy, not only in his creation of imaginary dwellings, but also in the reality of everyday life on the street, to discuss people's experiences with them, the way they see the world, and the possibility of improved life-structures in a more humane environment. This worked in Kreuzberg just as well as it had on the Lower East Side or in China. In "conversations" with the children of Turkish and Yugoslav working people, conducted

Figure 8: Michelangelo Pistoletto. *Venus of Rags*. 1968. Cement, mica, and cloth. Installed at Café Einstein, Berlin 1978

more through gestures and mimicry than words, Simonds demonstrated that artistic sensibility can be an excellent means to overcome speechlessness in the face of an ever more complicated, ever less comprehensible world.

Shusaku Arakawa, the New York-based Japanese artist, had more difficulty orienting himself. Unlike Constantin Xenakis from Greece, who says "everything is much easier in Berlin," Arakawa insists that "everything is much more complicated in Berlin." Yet as his stay approached its end, he too found the difficult city inspiring. "Complexes, complexities, and confusions are the generators for artists and others," he summed up, "and too, I enjoyed the famous champagne air."[10] This was written in 1975; he would probably enjoy it less now, because pollution has since transformed the champagne into an opaque cocktail.

Berlin does not change people; it takes them as they are and lets them go their own way. You can remain anonymous and work in peace, as did the French sculptor Jean Ipousteguy, who in the seclusion of his Dahlem studio on the city's periphery created his *Suite Prussienne*, a sequence of about two hundred drawings. Or you can mingle with the crowds: Kienholz, without a word of German, managed to become even more popular in Berlin than he had been at home. You can simply absorb something of the feel and atmosphere of Berlin while continuing to record your endless numerical sequences as did the Polish artist Roman Opalka (figure 9); or while you finish a single painting in the space of six months, like the Canadian Alex Colville, who, contented with *The River Spree* (figure 10), summed up his experience, "My interest in, and respect for Germany out of the 19th and 20th centuries . . . was very much increased. . . . I know of no other country or organization which has a program as generous and uninhibiting in its terms as the Berliner Künstlerprogramm."[11]

A feeling of deep loneliness and desertion can also overcome you in Berlin, however, particularly when language problems make communication difficult. This happened in 1973 to Pier Paolo Calzolari (figure 11), an Italian artist whose conceptual pieces of the period elicited very little response.

And it happened ten years earlier to the great Polish writer and dramatist Witold Gombrowicz. In his diary, exaggerating the experience to absurd dimensions, he records how terribly the fast pace of Berlin got on his nerves:

> Divine spark, la, la, but how can one pursue one's genius when there are so many mundanities to take care of—the telephone, the radio, the press, the exchanging of pleasantries, and the producing, producing day in, day out, like flies caught in a

Figure 9: Roman Opalka, Berlin 1977

Figure 10: Alex Colville. *The River Spree*. 1971. Oil on canvas. Neue Galerie–Collection Ludwig, Aachen

Figure 11: Pier Paolo Calzolari at his exhibition, Galerie Folker Skulima, Berlin, May–June 1973

spider's web. . . . And they're like victims of some incessantly spinning action. . . in bomb-scarred, devastated Berlin, which has a Wall, a smashed past, a future . . . on this island, an ex-capital city. . . . This liquidated place cries out for some novelty, on a grand scale. . . . But there's nothing but the telephone, activities, automobiles, offices and work, only this spider's web, spreading, all-encompassing . . . here, mundanity and triviality are demonic. [12]

Almost a quarter century has passed since this "bad guest" of the Ford Foundation, as Gombrowicz characterized himself, recorded these acerbic impressions. Yet even today it would still be foolish to maintain that Berlin cannot produce such reactions. The empty automatism does exist; and still to be found is a latent provincial prejudice against foreigners which is directed not only against the Turkish population in Kreuzberg but frequently against the "privileged" artists from abroad. These signs of narrow-mindedness definitely have their political and historical sources in the city's insular situation in general, and in the outpost mentality caused by the Soviet blockade of 1948 in particular. Yet the Berlin that Gombrowicz so bitterly criticized is no longer the "liquidated place" of his 1963–64 diary. A tradition of liberalism and tolerance has again begun to prevail, in cultural as in other matters, despite the fact that the cosmopolitan spirit and easy internationality of the former capital are gone beyond recall.

Again, while Berlin does not change people, it can and does frequently influence their work. Kienholz, for instance, began in quest of German history. He found the set pieces he needed at the flea market: scenes from Richard Wagner operas with buxom Valkyries and bearded Germanic gods, yellowed family photographs from bourgeois albums, Motherhood Medals for women whose large families ensured that the Fatherland would never be short of soldiers and brides, and finally, Hitler's cheap, mass-produced radio set, the *Volksempfänger*, the first effective mass-medium in history, with the aid of which Nazi ideology was hammered into the population. Out of these found objects Kienholz constructed the series *Volksempfängers*.

For the Japanese musician Maki Ishii, a continual oscillation between Asian and European cultures, between Tokyo and Berlin, prompted a daring attempt "to achieve a convergence, possibly even a synthesis . . . of Eastern and Western extremes in the art of music." For writer Gustafsson Berlin is both "a place of exile and an adoptive mother." Although he shied away from the official art

Figure 12: Carl Andre. *Untitled.* Installed at Körnerpark, Berlin 1985

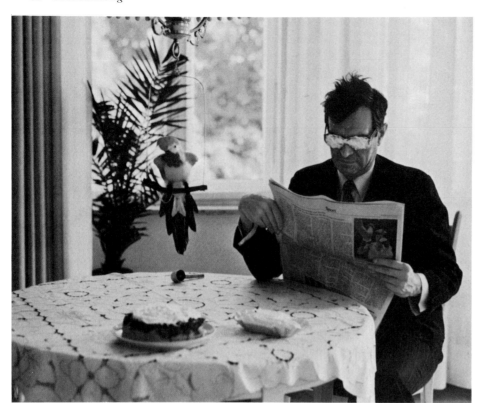

Figure 13: Marcel Broodthaers. *Berlin—or, A Dream with Cream.* 1974. Film still showing the artist

scene, preferring to sample the countless Berlin bars and talk with people about their problems, it was probably exactly this free access to the city that released in Gustafsson much "that I couldn't have written or even conceived otherwise. That is why," he confesses, "I shall love this town until I die."[13]

Rickey, too, says he would have done quite different sculptures under less challenging working conditions; and such guests as Eduardo Paolozzi, the British artist, and the poet Christopher Middleton, both agree with Gustafsson in saying that Berlin triggered new creative phases in their work. On the other hand, American artist Carl Andre's presence (figure 12) was largely unnoticed, as was the lonely visit of his German-born compatriot Jerry Zeniuk. Even the beautiful regatta, which Daniel Buren organized with boats with striped sails on the Wannsee, drew very few visitors. Berliners' reservations about radically abstract and conceptual tendencies are founded in the citizens' marked pragmatism and in their ironically detached view of reality which causes them to have difficulties with poetic metaphors or complex intellectual concepts. Thus, despite early visits by Russian Constructivists, abstract artists have always encountered greater obstacles in Berlin than realists or expressionists. Berliners resent "pure doctrine," a failing whose positive aspect becomes clear in politics, since it means that most citizens are immune to cloudy ideology, whether from the Right or Left.

One visiting artist took leave in Berlin not only of the art he so deeply loved in his skeptical, melancholy way, but of life as well: Marcel Broodthaers (figure 13), the Belgian successor to René Magritte. From his wheelchair, Broodthaers helped to arrange what was to be the last exhibition held during his lifetime, at the Nationalgalerie. He had not yet decided on its title at that point. Leafing through the catalogue, he noted the injunction printed at the top of each page: "Défense de photographier—No photographs allowed—Photographieren verboten." Then, over his own article at the end of the publication, "Das Wort Film?" It was not until the opening that the organizers of the show were told Broodthaers's title: *Invitation pour une Exposition Bourgeoise—Das Wort Film.*[14] As the opening began, the artist had not yet arrived. But then he came, climbed

out of his wheelchair, and held a wonderfully poetic talk—in French, but everyone in the audience understood him. At the conclusion of his catalogue essay, Broodthaers writes, "I must add one more thing. Berlin has been a strange city for me. There are more bridges here than in Venice. But there are also very diverse groups of people. I should have known more about them." A short time later, in the hospital, he said with his characteristic cheerful sadness, "Twice ten years," then laughed, "ten years of being a poet, ten years of being a visual artist—that's enough."[15] In January of the following year he died in Cologne.

Visiting artists' experiences have been just as contradictory as the character of the city into which they were transplanted. The problems of integrating the visitors and encouraging their active participation in cultural life are as old as the program itself, and will remain acute. But the chances for success have improved considerably. A number of excellent publications now document the presence and the work of artists-in-residence. Concert halls, broadcasting stations, museums and exhibition institutes, even the theaters on occasion, have made their facilities available to the visiting artists. Now the DAAD even has its own gallery in the center of Berlin, while the Künstlerhaus Bethanien, a converted nineteenth-century hospital located on Kreuzberg's Mariannenplatz, one of the loveliest of old Berlin squares, provides studios, workshops, and an experimental stage for drama productions to native and guest artists alike.

The realization that the future of Berlin would depend on its cultural and not on its political significance came just in time. The Berlin Artists Program has an important function to perform, as one of Berlin's "gateways to the world." Internationalism is a quality that requires much planning, constructing, and nurturing. It is an essential goal which should be cultivated, even by uncommon means. To quote critic Heinz Ohff, one of the most knowledgeable observers of the Berlin cultural scene: "In the last analysis, artificially created rainfall is just as valuable as natural rain."[16]

Notes

1. Werner Doede, *Berlin, Kunst und Künstler seit 1870* (Recklinghausen, 1961).
2. *10 Jahre Berliner Künstlerprogramm*, edited by the DAAD Berlin Artists Program (Karl Ruhrberg and Thomas Deecke) (Berlin, 1975).
3. *Ibid.*
4. *Ibid.*
5. *Ibid.*
6. *Ibid.*
7. "Berlin – Ein Pflaster für Künstler," *art* 4, April 1985.
8. Mario Merz, *"Do the houses turn around you or do you turn around the houses?"* (Berlin: Haus am Lützow-platz, 1974).
9. "Michelangelo Pistoletto," *KUNSTmagazin* 4, 1978.
10. *10 Jahre Berliner Künstlerprogramm.*
11. *Ibid.*
12. Witold Gombrowicz, *Die Tagebücher,* vol. 3 (Pfullingen, 1970).
13. *10 Jahre Berliner Künstlerprogramm.*
14. *Invitation pour une Exposition Bourgeoise* (Berlin: Nationalgalerie, 1975).
15. Conversation with the author.
16. Heinz Ohff, "Die Muse küsst den widerstrebenden Bären," *Magazin Kunst* 3, 1976.

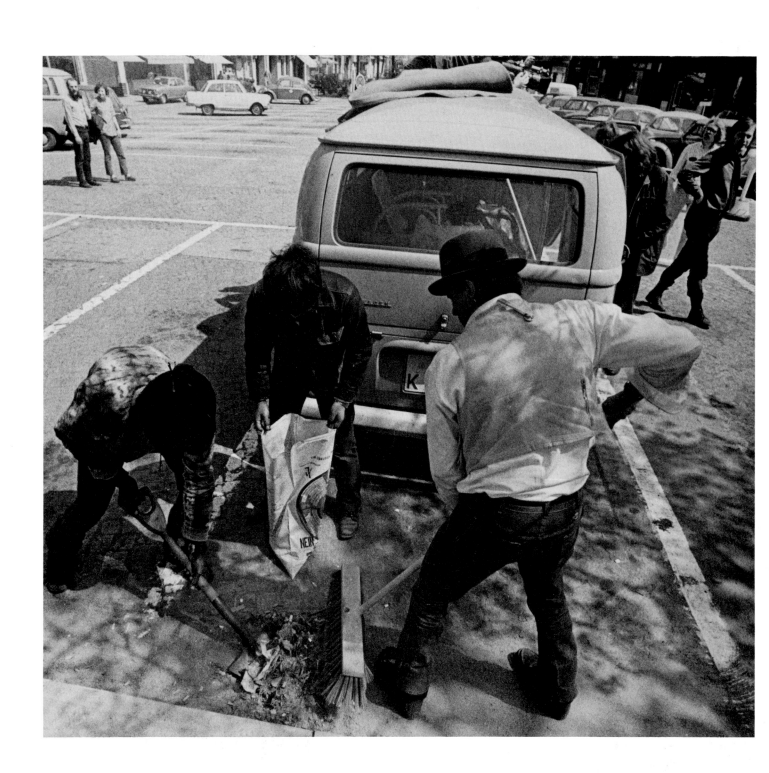

Fluxus and Fluxism in Berlin 1964-1976

René Block

Apart from the general, almost insurmountable difficulty of attempting to describe or evaluate Fluxus, the task of reporting on it and related activities (Fluxism) in which I was involved in Berlin necessitates a few preliminary remarks. These relate to the peculiarity of the locale, Berlin, and to the circumstance that, despite the influence of Fluxus on subsequent generations of artists, filmmakers, composers, and directors, it still tends to be dismissed with a weary smile. This may have something to do with the fact that Fluxus, like Futurism, Dadaism, or Surrealism, was not a style but a state of mind, not a conspiratorial group of artists but an extremely loose congeries of individuals and outsiders who, at a far remove from the art market, reflected on forms of behavior and creativity which today certainly deserve to go by the name of art. If it confused the public, irritated the spectator, that is because he, she, or they were directly involved in the art-making process. This is what Joseph Beuys meant when he declared "everyone an artist"—a creative and open-minded attitude on the part of the audience to the artistic product, which, as performance or as written conception, frequently came into being only in the eye and mind of those who participated. "What I learned from f[luxus], among other things," wrote Tomas Schmit, "was that what you can do in a sculpture doesn't need to be built as architecture; what you can say in a painting doesn't need to be done in sculpture; what you can handle in a drawing doesn't need to be said in painting; what you can clear up in a written note doesn't need to become a drawing; and what you can take care of in your head doesn't even need to be noted down! How nice that there were so many small, simple, short pieces in f."[1]

Fluxus did not spread to Berlin until 1964 (figure 1), when the pioneering Fluxus festivals of Western Europe were long over. It entered through a tiny chink in the Wall, which Beuys had just then suggested ought to be raised by three centimeters—to improve its proportions. The West Berlin cultural scene, for all its outward show of open-mindedness, lacked imagination, continually pining for the "golden twenties" as it subsidized gilt-edged culture of the classical variety and furthered a provincially academic art. Fluxus arrived just in time.

Most of the Fluxus artists lived (and still live) in New York, in the downtown district of SoHo, where George Maciunas opened his Fluxus headquarters in 1963 and Dick Higgins started his famous Something Else Press, which published important Fluxus-oriented books from 1964 to 1974. Yet leafing through the catalogue of the retrospective *1962 Wiesbaden FLUXUS 1982*, one is struck by the fact that Berlin is the city next most often mentioned in the chronology. In the main European centers of Fluxus, the festivals were seldom followed by concerts and exhibitions; in Berlin the sequence was reversed. Solo evenings by Fluxus artists sparked festivals of increasing size, culminating in the last Fluxus evening organized by Maciunas himself, the *Flux Harpsichord Concert*, in 1976.

The phenomena that since 1964 have gone by the generic name of FLUXUS emerged simultaneously at various points around the globe—in Japan

Joseph Beuys. *Sweep Up*. Berlin, May 1, 1972

(Takehisa Kosugi, Ay-O, Yoko Ono, Shieko Shiomi, Takako Saito); in the United States (John Cage, La Monte Young, Jackson Mac Low, George Brecht, Maciunas, Robert Watts, Higgins, Alison Knowles, Terry Riley); in France (Robert Filliou, Emmett Williams, Daniel Spoerri, Ben Vautier, Jean-Jacques Lebel); in the Netherlands and Denmark (Willem de Ridder, Arthur [Addi] Koepcke, Henning Christiansen, Eric Andersen); in Czechoslovakia (Milan Knizak); and in Germany, in the Cologne-Düsseldorf area (Nam June Paik, Beuys, Wolf Vostell, Schmit, Benjamin Patterson). Early gathering points, if you lived in New York, were Cage's courses at the New School for Social Research; or, if you lived in the Rhineland, the Stockhausen performances held at Mary Bauermeister's studio in Cologne.

Figure 1: Joseph Beuys. *The Chief*. Performed for eight hours at Galerie René Block, Berlin 1964

Looking back, it is astounding how rapidly an information network arose among these artists living in different cities and continents. News was spread by the few travelers among them—Cage visiting Darmstadt for the summer courses in new music, Dieter Roth traveling through the United States and Europe, Vostell commuting between Paris and Cologne, and Williams dividing his time between Paris and Darmstadt. Lists of addresses were exchanged; artists who had never met began corresponding with one another. The mails became the vehicle of a worldwide exchange of ideas; "mail art" and Conceptual art were born during this pre-Fluxus phase. This art of ideas was first published in *An Anthology*, edited for Maciunas by Mac Low and Young in New York, and in Vostell's *dé-coll/age* magazines in Cologne.

Yet even now, in 1987, twenty-five years after its first manifestations, there is still no succinct answer to the questions, "What is FLUXUS?," "What does FLUXUS want?," "Who is FLUXUS?" Generated by the group around John Cage and guided by George Maciunas, Fluxus culminated between about 1962 and 1965–66 in a series of concerts which frequently provoked scandals. The idea that Fluxus was some kind of group is a leftover from this phase, since the concerts were often performed by the same itinerant artists. Yet despite all Maciunas's organizing and publishing efforts, a group never existed—probably because he was too much concerned with an "art" production that was anonymous and collective, both entertaining (gags) and useful (design). The unsigned and undated Fluxus editions of the 1960s, printed in large runs and packed in boxes or cases, were products of this anti-attitude toward the Establishment and the art market.

The term Fluxus (*i.e.*, flowing, in flux, in motion) was chosen by Maciunas about 1960 as the title of a magazine intended to air the ideas of artists whose work went beyond traditional art forms and styles. This magazine never appeared. But the word was used for the first concert series, *Neueste Musik,* which Maciunas organized in 1962 in Wiesbaden (where he was temporarily attached to the American army as a designer).

Art historians and other intermediaries still have a hard time with Fluxus, because it simply can't be limited, categorized, or catalogued. "The most important thing about Fluxus," said Robert Watts, "is that nobody knows what it is. There should at least be something the experts don't understand. I see Fluxus wherever I go." And Brecht explains, "In Fluxus there has never been any attempt to agree on aims or methods; individuals with something unnameable in common have simply coalesced to publish and perform their work. Perhaps this common something is a feeling that the bounds of art are much wider than they have conventionally seemed, or that art and certain long-established bounds are no longer very useful."[2]

Mac Low writes:

There were relatively few of us whose works were performed at Fluxus concerts and "festivals" who agreed with Maciunas's antiart and "realistic" ideas. Many of us had first met each other in John Cage's experimental music class at The New School for Social Research on 12th St. in Greenwich Village, which he taught from about 1958 till May 1960. (During the next year or so Richard Maxfield taught the course at his home as an electronic music course; La Monte came to New York to enroll in it then as part of his graduate studies.)

Besides the officially enrolled students, Cage invited to it artists he knew personally, such as Ichiyanagi and myself, or by correspondence, such as George Brecht, who were doing work he found interesting. Others who attended it included the composer and photographer Robert Cosmos Savage, the Happening artists Al Hansen and Allan Kaprow, the poet-composer-playwright Dick Higgins, and Maxfield. The principal ideas we came to share, mainly through Cage, were derived from Zen Buddhism, the I Ching (the Chinese Book of Changes), Erik Satie, and Marcel Duchamp. . . .

Maciunas very much wanted to make a Fluxus movement and firmly to guide its destinies. For a long time he laid claim in the name of Fluxus to every work of ours that was ever played at a Fluxus concert or printed in a Fluxus publication. He issued edicts that such works be listed on printed programs as "Fluxus pieces" and that programs including a certain number of them be designated "Fluxus concerts." Though most of us ignored these decrees, still they irritated us.[3]

And in a contribution to the same catalogue, Schmit notes:

Fluxus emerged from the New York performance and conceptual activities of people like La Monte Young and George Brecht; after Maciunas had come to Wiesbaden, it initially considered itself a reservoir for literally everybody and everything that was not floundering around expressively or abstractly in the middle of the artistic mainstream at that time (as can be clearly seen from the program of the Wiesbaden festival and the first publication announcements). Very soon, however, it began to boil down to a group of particular people and quite particular activities; but after Maciunas returned to New York, it soon evaporated to a cacophony of this, that, and the other thing. . . . It's no wonder that there are so many diffuse notions of fluxus, that everybody (including the participants!) sees something different in it, and that today the funniest people cite fluxus, declare their allegiance to it, etc.[4]

What all these statements (including similar ones by Higgins and Williams) share is a reluctance to see Fluxus limited to clearly defined social or antiart-establishment aims, as Maciunas wished to do, but to keep it as open-ended as the instructions for Fluxus compositions, pieces, and events. "My events are very private, like little enlightenments I wanted to communicate to my friends, who would know what to do with them," said Brecht about the one hundred events of 1959–60 which were printed on small cards and published in his box, *Water Yam* (Edition FLUXUS, 1966). Koepcke has expressed himself similarly concerning his 123 pieces, of 1958–64, which were not published until 1972, under the title *Continue*.

Fluxus was indeed something by friends for friends. Not by chance was a 1968 exhibition in Bern and Düsseldorf, which included the work of Roth, Spoerri, André Thomkins, Williams, Filliou, and others, titled *Freunde, Friends*. The concerts, too, generally attracted only a handful of people, most of them friends or sympathizers. According to Schmit:

Getting to know, within the space of six months, Ludwig Gosewitz, Addi Koepcke, Emmett Williams, Ben Patterson, George Maciunas, Alison Knowles, Dick Higgins (and all because shortly before, almost by accident, I had met Nam June Paik), then later getting to know George Brecht—*that was the real festival!*

The others probably felt similarly at the time. And this (apart from Maciunas's untiring motor activity) was probably the source of the energy needed to get all those performances, etc., off the ground. Where would it have come from other-

wise? There was no money to be earned, no fame to be garnered; the rest of the art scene ignored us (with the notable exceptions of Jean Pierre Wilhelm and Rolf Jährling), the papers maybe printed a couple of snide commentaries on the miscellany page between the five-legged calf and the prince's wedding. . . .

Sure, but wasn't there anything you might call "devotion to the *cause?*" With Maciunas there certainly was. But we others were not exactly all militant types.[5]

Yet there were battles, of course. Later, against the powers-that-be and among the artists themselves. We in Berlin had a ringside seat for the sisyphean struggle between Vostell and Beuys, about which more later. Fluxus in Berlin, compared to other cities, had a great deal more to do with Beuys, whose events brought innovative accents to the art scene there.

The first Berlin evening, held on October 27, 1964, was devoted to Stanley Brouwn. Since at that time I was working at night as a waiter in a wine restaurant to earn money for our activities, the Berlin painter K. H. Hödicke met Brouwn at Zoo Station and entertained him that first evening. His evening was based on the conception of his *This Way Brouwn* pieces (figure 2). He would walk through a city, stopping passers-by to ask them how to get to a certain point, and requesting them to make a drawing. These drawings he would later sign and rubber-stamp. On the October evening in question, Brouwn was somewhere in Berlin, connected by walkie-talkie with the visitors in my first gallery in a basement on Frobenstrasse, asking them to tell him how to get there. His idea was to function as a medium for an imaginary drawing through the city's streets. When he finally arrived, however, after "being sent to the devil and around various churches by way of compensation," as a Berlin art critic put it, Brouwn found a gallery that had not only been abandoned by the large audience that had been there when the event began, but demolished as well. These people had expected a Happening, and, apparently feeling cheated, had taken things into their own hands.

This audience did not appear for the second evening on December 1, 1964, to which the term Fluxus was applied for the first time. Beuys planned to perform an eight-hour Fluxus song concurrently with Robert Morris in New York. Vostell described the event for the Berlin daily, *Der Tagesspiegel*, under the title "I am a Transmitter, I Emit!"

At the second evening at Galerie René Block, a situation, environment, space, demonstration, or whatever other term you want to apply to it, by Joseph Beuys took place. It was performed simultaneously to the second, like an echo (the echo, too, is a plastic principle) by Bob Morris in New York. Its title: *The Boss Fluxus Song.* The performance began at 4:00 p.m. and ended at midnight.

What was there to see?

In one room of the gallery, brightly illuminated, five by eight meters, a roll of felt lying diagonally on the floor, rolled up inside it, Beuys, professor at Düsseldorf Art Academy and since 1963 self-appointed member of the international Fluxus group with which, in 1962, George Maciunas had helped the latest music, the latest ideas, all these international efforts to their breakthrough with his Fluxus Festivals. The felt roll was 2.25 meters long and 46 cm wide; at the ends, as extensions of Beuys, it had two dead hares. The one 24 cm wide, 64 cm long; the other 70 cm long, 13 cm wide. On the left-hand wall of the room, parallel to the baseboard, was a strip of fat, made of German margarine, 167 cm in length and 7 cm thick.

Above this, 165 cm above the floor, was a tuft of hair measuring 6 by 7 cm, and to its left, two fingernails, each 1.5 cm wide (both perhaps fetishes from an undigested past?).

In the left corner of the room, another wedge of fat, 30 by 30 cm, and others to the right and left of the entrance. In the right corner, another square of fat, 5 by 5 cm. To the left of Beuys (in the roll of felt) a second roll wrapped around a thick

Figure 2: Stanley Brouwn. *This Way Brouwn.* 1964. Drawings

Figure 3: Nam June Paik. *Robot Opera*. Performed at the Brandenburg Gate, Berlin, June 17, 1965

copper rod, length 178 cm. On the right side of the room, an amplifier. So much for a detailed registration of all the facts of which the environment consisted.

What was there to hear?

Over a microphone from inside the roll, Beuys sent at irregular intervals acoustic messages which were highly amplified. We heard him breathing, sighing, clearing his throat, coughing, groaning, complaining, hissing, whistling—a catalogue of a "letterist" vocabulary of sounds. Beuys: "A primal sound that you might associate with the two dead hares."

On a second tape-recorder, a few compositions by Eric Andersen and Henning Christiansen were played at very long, irregular intervals, in apparent contrast to Beuys's sounds. . . .

People came and went. Sometimes it was quiet, even reverentially silent as in a religious, mystic act. Ritual? A lot of people waited (for what?), some finally saw Beuys crawl out of the roll at midnight. He was asked direct questions. Why did you recommend that the Wall be raised by three centimeters? Beuys: "Two types of human being impinge at the Wall who have developed different behavioral patterns in isolation from one another. We're the only country that has that!" Beuys loves all human beings.

I wonder whether Bob Morris was just crawling out of his roll in New York. What questions did they ask him?

For the majority of the audience, it was a confrontation with Beuys and his motives, and with his views on sculptural forms. For another part of the audience, it was just another excuse to get together. The social round? Did Beuys's tragic "Fluxus song" really pose an enigma to them? Sometimes it almost seemed so, then lethargy set in again. . . .

Beuys: "I'm a transmitter, I emit." A cultic rite? What was he really thinking as he lay in the roll? What was Bob Morris thinking in New York, and what was his audience there thinking? What were the dead hares thinking here and over there—can dead hares really think? What were the fat wedges thinking—can fat sculptures actually think? Can they lead us to reflect? Yes! Will the image be retained?

These are some of the questions and enigmas posed by Beuys. The ambiguity, the difficulty of decoding them, is large, but that in turn is good. In any case, the evening was a further path towards a philosophic theater.[6]

Indicatively, this first description of a Fluxus event remained the only serious, objective, and convincing review of any Fluxus concert to appear in the Berlin press (with the exception of Heinz Ohff's reviews of Vostell Happenings in the same newspaper).

Vostell's twenty-fifth Happening, his first in Berlin, took place in March 1965 in an auto-wrecking yard. Titled *Phenomena*, it confronted the audience with a prepared situation comprising absurd events. The participants included some of Vostell's Berlin artist friends, among them K.P. Brehmer, Hödicke, and Markus Lüpertz, and the Viennese "action" artist Hermann Nitsch, who happened to be in Berlin at the time. Schmit wrote a text for a Berlin magazine giving preliminary information about the event. It was to be his last positive commentary on Vostell.

The first Berlin appearances of Moorman and Paik in 1965 were sensational. At the sixth Fluxus evening, Paik planned to perform his *Robot Opera* (figure 3) in front of the Brandenburg Gate. That spring, he had built a female robot from a metal kit that could move, bow, and make itself heard over a built-in loudspeaker, all by remote control. When this dangerous-looking monster, followed by a gaggle of "opera buffs," began to approach the Red Army Monument, located on the West Berlin side near the Brandenburg Gate, the British military police in whose domain this prologue fell decided the risk was too high, and prohibited the performance. It was rapidly adjourned to Kurfürstendamm, near the Kaiser-Wilhelm Memorial Church, where the robot ploughed slowly through the crowds, singing and accompanied by Moorman on the cello. She

was seated on the back of Ludwig Gosewitz, who was down on all fours, crawling in the robot's wake. Paik controlled its movements from a distance, distributing his *Kill Pop Art* manifesto, which included such declarations as:

Opera with Aria	is banal
Opera without Aria	is boring
Karajan	is too busy
Callas	is too noisy
Zen	is too much
Paik	is too take
Drug	is too boring
Sex	is too banal.

Figure 4: Charlotte Moorman in a work by Nam June Paik, Berlin 1965

Yet, if anyone emphasized precisely the erotic aspect of music, it was Paik. He found an ideal interpreter in Moorman (figure 4), who was then organizing the music section of the annual New York Avant-garde Festival. The two artists toured the world together for a few years, initially to play Fluxus compositions, then to present the video-objects Paik designed for Moorman (*TV-Cello, TV-Bra, TV-Bed*). And both returned regularly to Berlin.

But on the evening of May 15, 1965, there was scandal in the air. The television and news cameras whirred in the overcrowded gallery as Moorman began to intone Paik's version of *Swan of Toledo* (after Saint-Saëns), then stopped halfway through, undressed, climbed into a barrel full of water, and finally clamped her cello between her wet thighs to finish the piece. But no police interrupted this Berlin performance, as they would a few months later in New York, when both Paik and Moorman were arrested during a performance of the *Opera Sextronique.*

Every artist who came to Berlin during this first year of my gallery— Brouwn, Beuys, Paik, Vostell—immediately succumbed to the aura of the divided city, which is quite tangibly different from that of the more commercialized West German cities. Its twenty-four-hour rhythm encouraged the unconventional, involved artists in night-long discussions over pea soup with salt pork at Piper's Snack Bar on Nollendorfplatz, next to Erwin Piscator's old Metropol Theater. No one was really surprised when Schmit, a few weeks after his appearance at the Frobenstrasse gallery, moved from Cologne to Berlin. Only weeks before, Gosewitz had come from Darmstadt, and H.C. Artmann and Gerhard Rühm from Vienna, followed a short time later by Oswald Wiener. These last three were members of the Vienna Group, writers whose provocative texts and activities had made them *personae non gratae* at home, and who had collaborated with the Vienna "action" artists, Otto Mühl, Nitsch, and Günter Brus. The latter, in particular, had deeply shocked the Austrian public and insulted the powers-that-be. He was able to avoid arrest only by fleeing to Berlin, where friends prevented his extradition.

So hardly a year had passed after Brouwn's first event, and suddenly Berlin had a group of artists working in intermedia, Fluxus, or Fluxus-related approaches, and living for the most part on and around Nollendorfplatz (Vostell was to follow, from Cologne, in 1972). During this period, a close and productive friendship arose among Schmit (figure 5), Gosewitz, and Rühm; and Schmit and Gosewitz realized a number of collaborative projects, publishing them under their own imprint. In their 1965 event, *One-day Publishing*, they attempted to compress the entire publishing process into twenty-four hours: "Ask authors for works, produce them, distribute them, and collect the money." Information was cabled in the middle of the night to nine authors: "November 28: One-day Publishing: Request cablegram of contribution publishable by telegram or telephone by 3:00 p.m. Production 3:00 p.m. to

Figure 5: Tomas Schmit, Berlin 1965

12:00 p.m. Gosewitz Schmit, Berlin 36, Admiralstr. 35." And to forty clients: "November 28: One-day Publishing: Works by Andersen, Brecht, Brouwn, Filliou, Gosewitz, Koepcke, Page, Rühm, Schmit, Vautier, Williams. Orders payable by cable transfer of 25 DM per work by 4:00 p.m. only. Delivery by 12:00 p.m. Please recommend us. Gosewitz Schmit, Berlin 36, Admiralstr. 35."

Among the works performed at this time were the *Büding Oratorium* (with Rühm), a "three-part conversation for three choirs," the *denkzettel*, and a *One-day Tour*, in which the artists announced their visits to six people in telegrams ranging from "Breakfast with Gosewitz and Schmit. Arrival 11 o'clock" to "Dine with Gosewitz and Schmit. Arrival 7 o'clock." Then there was the book *Von Phall zu Phall*, and the "action" *Five Minutes* (again with Rühm). Schmit recalls his contribution to this event:

Figure 6: Wolf Vostell. *Phenomena.* Happening, Berlin 1965

> I had assembled 60 different "actions," each of which
> could be performed in one second, and was to be
> repeated five times.
> And then I went through this cycle of 60-second "actions"
> five times, following a metronome. I was seated at a table
> with the various objects required arranged in
> 60 fields within easy reach.
> (For the first—and last—time in my career as an "action" artist,
> I had practiced a little beforehand, because my previous
> actions had always tended to be especially
> slow, not especially fast.)
> A sampling from the sixty actions:
> Turn over a page of a book;
> Put a flower in a vase (starting with five flowers next to it);
> Show a card reading "soon;" then one second later, a card
> reading "now;" then one second later, a card reading "just;"
> Draw a curlicue;
> Take a nail between your lips, then at a certain later
> point in time, take it out of your mouth again;
> Tear off a calendar sheet;
> Hit the table with a hammer;
> Stop the metronome and after one second release it;
> Tip over a flathead screw standing on its head;
> Throw a pingpong ball away;
> Shake a glass ball with enclosed Cologne Cathedral to
> regale it with snow;
> etc., etc. Sixty different things.[7]

These collaborative pieces by and with Schmit, Gosewitz, and Rühm had already suggested the idea of organizing a music festival, with which we hoped to clear up the confusion that had since arisen as to what exactly Fluxus meant or did not mean. After Vostell's Happenings (his second *100 Events—100 Minutes* had been given a chamber-music-style performance in November 1965, for only a few participants, random audience, and television), after Beuys's attempts to monopolize the term, and after the chaotically expressive interpretations of Paik and Moorman, the time was really ripe to present the conceptual, classical pieces in the simple, clear, and straightforward interpretations they had long been given elsewhere (figures 6 and 7). The program notes for this 1966 festival, printed poster-size, listed all of the pieces to be performed, in chronological order and in their complete, original versions.

Figure 7: Wolf Vostell: *100 Events—100 Minutes.* Happening, Berlin, November 11, 1965

The program began with Young's composition *566 for Henry Flynt* of 1960, which consisted of 566 piano clusters played at equal intervals and with equal volume (which lasted about an hour in Gosewitz's interpretation). Then came events by Brecht, including *Drip Music* and *String Quartet*; pieces by Maciunas, naturally including *In Memoriam to Adriano Olivetti* (figure 8); and Mac Low and

Robin Page's *Guitar Piece* (figure 9), in which he played a guitar for a while, then dropped it, kicked it off the stage and through the auditorium and foyer, then downstairs to the Kurfürstendamm, around the block, then back up the stairs, through foyer and auditorium, and back onto the stage. This was followed by Patterson's tea-kettle piece *Septet from "Lemons"*; Riley's *Ear Piece* (figure 10) with audience participation; and pieces by Roth, Williams, Schmit, Gosewitz, and Higgins. The festival lasted three lovely April days of 1966.

In October of that year, Higgins and Knowles arrived in Berlin. Assisted by Vostell and Brehmer, they performed a number of classical Fluxus pieces including their own, followed the day after by a "ZAJ" concert with Juan Hidalgo and Tomas Marco (figure 11). Just two weeks later, Beuys came to the last event held in the Frobenstrasse gallery, which had to be vacated. This was the ninth evening, titled *Eurasia–Siberian Symphony 1963, 32nd FLUXUS movement*. Troels Andersen recorded his impressions of this Fluxus symphony after the performance of its 34th movement in Copenhagen:

> Beuys maneuvered, along a line drawn on the floor, a dead hare whose legs and ears were extended by long, thin, black wooden stilts. These touched the floor when Beuys carried the hare on his shoulders. He walked from the wall to a blackboard, where he put the hare down. On the way back, three things happened. He scattered white powder between the hare's legs, stuck a thermometer in its mouth, and blew into a tube. Then he turned to the blackboard with its bisected cross, making the hare prick up its ears as he suspended his foot, which had an iron plate tied to it, above a similar plate on the floor. Now and then he stamped his foot down hard on this plate.
>
> That was basically the content of the event. The symbols are absolutely clear, and can all be translated. The divided cross: the division between East and West, Rome and Byzantium. The half-cross: Europe and Asia reunited, the goal towards which the hare moves. The iron plate on the floor is a metaphor—progress is difficult, the ground is frozen. The three interruptions on the return journey signify the elements snow, cold, and wind. All this symbolism becomes intelligible by reference to the key word, "Siberian."
>
> The hare's legs—the thin black stilts—indicate the significance of space. Beuys himself uses the terms "counterspace" and "countertime" to designate psychical factors that permit a relationship to, and experience of, space as an actual material given. When the hare's legs tremble, making the stilts splay—as they continually did during this suspenseful quest—and Beuys had great difficulty in getting them back into the right position, our relationship to space collapsed for a moment, something broke inside us. It was perfectly fitting that the sweat ran down Beuys's face in streams, that he looked like a man in great pain. He continually had to reinstate an equilibrium, and that while standing on only one leg.[8]

Figure 8: George Maciunas. *In Memoriam to Adriano Olivetti*. Music Festival, Berlin 1966. Left to right, Vagelis Tsakiridis, Michael Behn, Ludwig Gosewitz, Tomas Schmit, Gerhard Rühm

Figure 9: Robin Page. *Guitar Piece*. Music Festival, Berlin 1966

Figure 10: Dick Higgins performing *Ear Piece* by Terry Riley, Berlin 1966

Figure 11: "ZAJ" Concert, Berlin 1966. Left to right, Tomas Marco, Alison Knowles, Juan Hidalgo

Figure 12: Takehisa Kosugi. *Expanded Music.* Berlin 1967

Figure 13: Joseph Beuys/Henning Christiansen. *I'm Going to Let (Make) You Free.* Fluxus concert, Berlin 1969

Between this performance, which—apologies to Troels Andersen—was really indescribable in its intensity, and Beuys's next Berlin appearance in February 1969, only one other Fluxus concert took place, but one that was perhaps the most musical of all: *Expanded Music* by Kosugi (figure 12). This consisted of simple pieces performed with incredible concentration and sensibility. I still remember the sounds of a guitar suspended in space, its strings responding to the gentle touch of swaying rods; or the sound of a pair of scissors eating their way through a huge sheet of paper that concealed the stage from view; or a soft song, accompanied only by the sound of an accordion breathing in and out.

In 1968 the campus revolt and demonstrations against the Vietnam War reached their radical peak in Berlin as elsewhere, and we decided there were more important things to do than arrange Fluxus concerts. Beuys had already, in 1967, founded the German Student Party in Düsseldorf, followed by the Office of the Organization for Direct Democracy by Plebiscite, and the Free International University for Creativity and Interdisciplinary Research (FIU), for all of which we wanted to drum up support in Berlin.

February 27, 1969, the day scheduled for a Fluxus concert by Beuys and Christiansen (figure 13), turned out to be the very day on which President Richard Nixon, after much cloak-and-dagger secrecy, had finally decided to visit West Berlin after all. The security precautions would have done a totalitarian state credit. Student demonstrations were quashed before they started; the president was sealed off hermetically from the Berlin populace, who were largely pro-Nixon anyway. The atmosphere was incredibly tense, but the explosion didn't come at the Philharmonic Hall gala, it came at the Academy of Arts, whose auditorium was crowded to the breaking point. There was apparently some misunderstanding about the concert's title, *I'm Going to Let (Make) You Free,* because hecklers had occupied the stage even before the performance began. Beuys and Christiansen were immediately drowned out. Aided by certain prominent citizens, the demonstrators inundated the stage with foam and water from fire extinguishers, damaged the projection screen and stage curtains, and destroyed two pianos and various microphones. After friends had provisionally cleared the stage—Christiansen, suffering from a high fever, had continued throughout the melée to play on his green violin the *Sauerkraut Score* from a music stand draped with sauerkraut—an all-night discussion began with the few people who had stayed to listen. Beuys was accused of taking an affirmative, or regressive, stance, Fluxus was condemned as just one more instrument of repression in the hands of the ruling class, contributing nothing to the revolutionary cause.

As we later realized, these students wanted help, not concerts they couldn't understand but advice and assistance from Beuys. They wanted Happenings by artists, but with political purpose and content. The concert, wrecked as a result of a misunderstanding, was repeated a month later at the Mönchengladbach Museum. This time there were no disturbances; and this time it was titled *Or Should We Change It?*

In connection with the Berlin concert, I should mention the *Blockade 69* environment series, which opened the following day. Beuys had planned to transform a grand piano into an artwork during the concert, but he never got the chance because someone pasted an anticoncert manifesto on it and decorated it with slogans in brown paint. So naturally we decided to leave the gallery space empty that evening. Crowds of people came to the opening, but nobody dared to ask where the art was; they seemed too embarrassed or ashamed. (I myself later put the piano in its present legless state, with what remained of the green violin, and the hat Beuys wore during the concert nailed to its lid. For a long time, Beuys knew this object only from photographs. It wasn't unusual for Fluxus art, the main thing being fidelity to the author's conception.)

Beuys subsequently took a direct political stand in a Berlin event—his last, as it turned out—but this went largely unnoticed by those it should have concerned. On May 1, 1972, assisted by an African and an Asian student, he took a red broom to Karl Marx Square in West Berlin, sweeping it clean of the debris left by a May Day demonstration. He thought the square should be clean on this day of the year at least. It was a short, simple event, a direct statement of a kind rare with Beuys.

Though the phase of Fluxus concerts and events apparently ended with the 1960s, it was not because the artists had gone into retirement, but because they had shifted their emphasis from the musical/visual field toward more purely visual work. Objects, drawings, and paintings now began to emerge from their converted apartments (studios were hard to come by in Berlin), and a few collectors began to concentrate on Fluxus, or expand their collections to include it (although, again, these collectors were not based in Berlin). Art societies and small museums began to show interest, and exhibition activities increased. One high point of this period was the founding of Edition Hundertmark in Berlin. The DAAD gallery devoted a retrospective to this committed publishing enterprise (which moved to Cologne in 1975) on its tenth anniversary. Armin Hundertmark, writing in the catalogue, recalled:

> In early 1970, I decided I wanted to do more than merely collect art. My idea was to convince a number of artists I felt (and still feel) were important to contribute to an edition of small, original works. They could either reproduce the pieces for the edition themselves, or send me a model that I could reproduce. What I had in mind were objects, collages, photos, drawings, or similar things that could be distributed in small boxes.
>
> First of all, I asked the artists who were living and working in Berlin: Günter Brus, Ludwig Gosewitz, Gerhard Rühm, and Tomas Schmit. Then I wrote to Joseph Beuys, Stanley Brouwn, Robert Filliou, Ken Friedman, Juan Hidalgo, Joe Jones, Milan Knizak, Otto Mühl, Hermann Nitsch, Robin Page, Dieter Roth, Ben Vautier, and Wolf Vostell. I visited Gosewitz in Berlin, though friends had advised me not to, saying he had stopped working altogether. I called him up anyway and made an appointment. He was living in a garret in Wilmersdorf. Gosewitz showed me drawings and watercolors he had done since 1967, and selected a small drawing, *Tanker Captain*, for my first box. About two weeks later, he wrote to tell me everything was finished (I didn't have a telephone at the time). We met in a restaurant, and he gave me the 25 sheets.
>
> Gerhard Rühm wanted to contribute, too, and it was at his place that I first met Günter Brus. I had read the brochure he edited, *Under the Counter*, but didn't have his address. So at Rühm's I asked him whether he didn't want to contribute, and

went to see him a short time later. He was sharing an apartment with Margaret Raspé. His first *Schastrommel* had appeared, and he was already working on the second issue. I wanted to publish a photo of his most recent Munich action, *Acid Test*, in my edition. I had 25 prints made of the photo, and Brus signed the series.

Brus also gave me the addresses of Nitsch and Mühl. I wrote to them describing my project, and they sent me signed photographs of their events.

I also asked Tomas Schmit. He was just working on his book, *das gute dünken*, and was in need of a little money. He made a collage.

In the spring of 1970, I went to Düsseldorf, after having spoken to Beuys and Filliou on the telephone. I looked Beuys up first. He was just involved in reworking a Fluxus manifesto by George Maciunas, and he gave me a page from a catalogue. Back in Berlin, I had 25 xerox copies made of each and sent them to Beuys for him to sign and rubber-stamp.

Filliou, who at that time was living on Bagellstrasse in Düsseldorf, promised to do something for me. He subsequently sent reworked postcards. Then I went to Cologne to see Vostell. He was interested, but then he wrote a letter of refusal, saying he wouldn't contribute to an edition unless it included this or that artist.

Milan Knizak, a number of whose pieces I had already bought, sent me a model and 25 signatures, which I glued to the objects. His piece was a partially burnt man's shirt. I collected shirts and set fire to them in my garden.

Ken Friedman sent me a photocopied letter, which included the statement that the buyer who wrote to him would receive something in return.

I wrote to Ben Vautier a number of times, and when the first edition was almost finished, complete with label, his contribution finally arrived. He had written a statement about art on 25 pieces of blotting paper and signed them. So I had a supplementary label printed for the first box.

Ludwig Gosewitz and I visited Koepcke in Copenhagen. We drank dark beer and he promised me he would make and send me something, but he never did.

Stanley Brouwn wrote to say he never contributed to editions, on principle.

When all the contributions had come in, I ordered the first 25 boxes from the Merker Packaging Company in Berlin, who still work for me. A small printing shop in Mariendorf printed a label with the artists' names; I pasted it on the boxes, and filled them with the works. The first box was finished. I bought a die stamp, set the lettering, and stamped my first prospectus with it. No orders came in.[9]

But the late 1960s also brought Vostell's first bitter attacks on Beuys, his former comrade-in-arms. Vostell, not yet in Berlin, had mounted a series of polemics against Fluxus, declaring that its art-historical significance was far outshone by Happenings. When in 1968 Beuys changed the name of the German Student Party to Fluxus Zone West, Vostell decided it was time to prove who was top man in Germany:

FLUXUS
FLUXUS
FLUXUS ON THE RENAMING OF THE "GERMAN STUDENT PARTY"

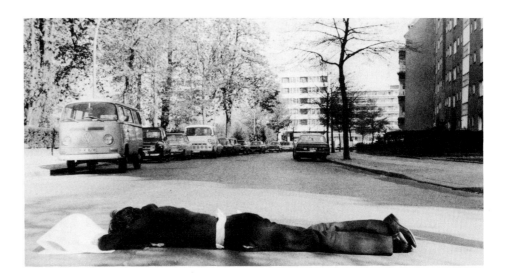

Figure 14: Ben Vautier. *Seven Ideas of Ben.* Berlin 1971

FLUXUS TO "FLUXUS ZONE WEST"
FLUXUS
FLUXUS
FLUXUS
FLUXUS
FLUXUS IS A TERM INVENTED BY GEORGE MACIUNAS
FLUXUS WAS FOUNDED BY MACIUNAS WITH THE ASSISTANCE OF PAIK
 AND VOSTELL IN WIESBADEN IN 1962
FLUXUS FESTIVALS TOOK PLACE IN 1962 IN WIESBADEN, LONDON
 COPENHAGEN AND PARIS
FLUXUS HEADQUARTERS GERMANY WAS RUN BY TOMAS SCHMIT
 1962–63 IN COLOGNE
FLUXUS FRANCE IS HEADED BY BEN VAUTIER
FLUXUS EAST IS HEADED BY MILAN KNIZAK IN PRAGUE
FLUXUS WEST IS KEN FRIEDMAN'S FLUXUS GROUP IN CALIFORNIA
FLUXUS WEST LIES WEST OF CENTRAL HEADQUARTERS NEW YORK
FLUXUS WEST IS KEN FRIEDMAN
FLUXUS EAST IS MILAN KNIZAK
FLUXUS MIDDLE IS GERMANY
FLUXUS GERMANY IS VOSTELL
FLUXUS TOWN IN GERMANY IS COLOGNE
FLUXUS AND HAPPENING CENTER IN GERMANY IS THE LABORATORY
 COLOGNE
FLUXUS DOCUMENTATION CENTER IS IN WÜRTTEMBERG
FLUXUS IS IRRECONCILABLE WITH STAR CULT OR MYSTICAL BEHAVIOR
FLUXUS IS NOT BASED ON CHRISTIAN TERMINOLOGY
FLUXUS NEVER USED THE CROSS
FLUXUS WEST IS KEN FRIEDMAN IN THE WESTERN U.S.!
FLUXUS WEST MEANS FRIEDMAN'S ACTION CENTER IN CALIFORNIA
FLUXUS WEST WILL ALWAYS BE IN THE WEST
FLUXUS WEST IS NOT IN EUROPE
VOSTELL 12/10/86, INTERFUNCTION ART THEORIES TEAM, COLOGNE
MEMBER OF THE LIDL ACADEMY, DÜSSELDORF[10]

Schmit replied from Berlin:

Vostell's manifestos shouldn't be taken so seriously as one's initial headshaking reaction might tempt one to ("the last dance is a Vostella. . . ."). But if a manifesto relates to something that is so unknown and so seldom correctly interpreted that it cannot survive misstatements uninjured, and if beyond that it mentions me personally, and if, finally, it is intended to injure, then it demands to be set right by somebody who has nothing to gain personally by manipulating the facts:

Fluxus was founded by Maciunas, with the more or less close cooperation of over 20 people. Neither Maciunas's first "Editorial Committee" list (of key contributors), which mentions 22 people, nor his second, which mentions 24, includes Vostell's name.

The European Fluxus Festivals took place in '62 in Wiesbaden, Copenhagen, and Paris, and in '63 in Düsseldorf, Amsterdam, The Hague, London, and Nice.

A Fluxus headquarters for Germany never existed. My address then in Cologne was listed as "administration," that is, an address to contact for books and information. Except for a postcard from the library of a Libyan oil company and such like things, nothing particular ever came, let alone happened.

Cologne is a town of clergymen, organized crime, and art dealing, but a Fluxus town it definitely is not.

"Fluxus is irreconcilable with star cult or mystical behavior"—You gotta be kidding me.

Well then, what *is* Fluxus, anyway? I wouldn't even try to define it—that would be impossible and presumptuous. Let the following be understood as a footnote. If you were to classify as Fluxus everything that has happened under Maciunas's leadership since '62 and calls itself Fluxus, you would have a diffuse collection of the major and mediocre, good and bad, that would resist any aesthetic classification. People like Stockhausen, Mon, Harry Kramer would have to be taken into account. . . . But if you limit the Fluxus period to the years '62, '63, and '64, and include only the 7½ European festivals, most of the Fluxus publications of the period, and the work then being done by people like Maciunas, La Monte Young, George Brecht, Emmett Williams, Ben Patterson, Paik, Koepcke, Robin Page, Ben Vautier, Jackson Mac Low, Dick Higgins, Yoko Ono, Alison

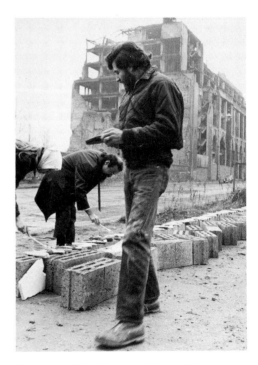

Figure 15: Allan Kaprow. *A Sweet Wall.*
Happening, Berlin 1970

Figure 16: Arthur (Addi) Koepcke. *Music While You Work*. Berlin 1970. Left to right, Koepcke, Eric Andersen, Emmett Williams, Al Hansen, Charlotte Moorman, Robert and Marianne Filliou, Carolee Schneeman

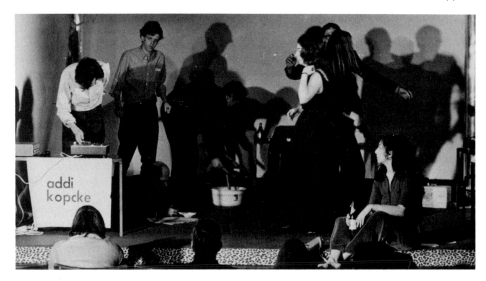

Knowles, Robert Watts, and Tomas Schmit, your pile of material would be relatively consistent, definitely unique, and indescribable. In very general terms: conceptual, concrete, nonexpressionistic, nonsymbolic, primary-level, nonformal (extremely reduced), breaking down traditional forms of presentation, sensual, nonsensical, etc.

When you consider (by comparison, say, to the George Brecht of *Water Yam*) such definitely expressionist-oriented people like Paik, Beuys or Vautier, it is concrete, sensual immediacy that assures their belonging to Fluxus in the narrower sense. When you consider expressionists like Knizak it's hard, and with Friedman very hard, to associate them with Fluxus. When you consider the aesthetically academic (and in this regard quite good) ritual symbolist Vostell, it becomes impossible to think of Fluxus.

"Fluxus town . . . Fluxus center . . . Fluxus Germany. . . ." Even Vostell used to realize that bureaucratism was Maciunas's worst fault.

Whatever the case, Fluxus is no sweet rose to hang one's own personal-political thorns on.

FLUXUS IS A COAT? THAT SIMPLY DOESN'T FIT EVERYBODY, BUT IT ISN'T NECESSARY TO TRIM THE COATTAILS TO THE WIND MADE BY ONESELF.[11]

In the 1960s, Cage and Earle Brown were invited to spend a year in Berlin sponsored by DAAD, the first Fluxus-related composers to do so. Brouwn received a grant in 1969, followed, beginning in 1972, by Corner, Filliou, Shigeko Kubota, Geoffrey Hendricks, Higgins, Jones, Kaprow, Per Kirkeby, Knizak, Kosugi, Page, Paik, Spoerri, Vautier (figure 14), Yoshimasa Wada, Watts, and Williams. This unique program suddenly transformed Berlin into the most important permanent Fluxus workshop outside New York.

Of all the innumerable activities, exhibitions, events, and concerts that have since taken place in private galleries, art societies, the Academy of Arts, the Nationalgalerie, let me describe only two by way of conclusion: the *festum fluxorum* of 1970 and the *Flux-Labyrinth with Flux Harpsichord Concert* of 1976.

In the autumn of 1970, the first important documentary show, *happening & fluxus,* initiated by Vostell and organized by Hanns Sohm and Harald Szeeman, took place at the Cologne Kunstverein. Invitations went out to every Happening and Fluxus artist, and as far as I know, only Beuys and Maciunas declined. The idea of inviting to Berlin some of the artists who had gathered in Cologne quite naturally occurred to us, and on November 14 and 15, *festum fluxorum* took place. The event was preceded, on November 11, by Kaprow's first Berlin Happening—although by that time he had discarded the overused term Happening in favor of "performance," to indicate the changeover from theatrically baroque events to his more recent, simple, and generally conceptual pieces. *A Sweet Wall* (figure 15) was the title Kaprow chose for his Berlin piece, per-

formed with the aid of a few helpers including Hödicke and Higgins, who had come from Cologne. Parallel to the original Berlin Wall, they built a short section of wall in which slices of bread, spread with jam, served as mortar. After spending hours in the rain to finish their miniature wall, they knocked it down that evening. There were lots of police in the neighborhood, but they hadn't come to observe our construction work. Nearby, in the Landwehrkanal, not far from the spot where Rosa Luxemburg was murdered, divers were searching for a cache of weapons, watched by sentries from the towers on the eastern side of the Wall.

The high point of the *festum fluxorum* events, which included Andersen, Filliou, Koepcke, Moorman, Carolee Schneemann, and Williams (who has lived with his family in Berlin since 1980), was a performance of Koepcke's *Music While You Work* (figure 16), which lasted several hours and in which Gosewitz and Schmit also took part. Each participant had chosen a certain activity, which he or she was to perform for as long as music was audible from a record player on a table, center stage. Koepcke had scratched the record and smeared it with glue except for the first few grooves, with the result that the pick-up tracked for only about sixty seconds before beginning to skid and before shutting off the record player with a terrible grating noise. The performers interrupted their activities and went over to the turntable; whoever got there first started the music up again. This was repeated until one of the performers had completed the predetermined task.

It was not until 1976 that Maciunas finally came to Berlin, to make a Fluxus labyrinth for *SoHo—Downtown Manhattan*. This exhibition on the occasion of the United States Bicentennial was devoted to the artists of SoHo, a New York district with an extremely checkered history. Until recently it had been a commercial area, favored by small manufacturers of paper and textile products, but their outmoded methods had put them out of competition and they were forced to relocate outside Manhattan. By 1965, so many lofts and buildings were vacant that the city administration began to consider razing the entire district, in spite of its historical cast-iron architecture. The large, low-rent lofts in the area were discovered by, among others, such Fluxus artists as Knowles, Higgins, Ono, Henry Flynt, and Ay-O, who settled on Canal Street and West Broadway. After living there illegally at first, many artists were able to purchase the lofts on a cooperative plan developed and propagated by Maciunas, thus saving the buildings from demolition.

Figure 17: Robert Watts at the entrance to *Flux-Labyrinth*, Berlin 1976

Figure 18: George Maciunas constructing the labyrinth, Berlin 1976

Figure 19: Larry Miller in the labyrinth, Berlin 1976

Figure 20: George Brecht in *Flux Harpsichord Concert*, Berlin 1976

Figure 21: George Maciunas and Joe Jones in *Flux Harpsichord Concert*, Berlin 1976

The exhibition, besides such approaches later typical of SoHo as Minimal, Conceptual, and video art, performance and minimal music, emphasized its importance as a center of Fluxus. Maciunas was commissioned to carry out a project he had long had in mind for a Fluxus labyrinth (figures 17, 18, and 19)—a series of comical, risky, or unsettling situations and obstacles which the audience had to overcome in order to reach the other end. Maciunas invited Watts, Paik, Ay-O, Jones, Larry Miller, Hendricks, and Wada to design various sections of the labyrinth, and delved into his own, veritably inexhaustible store of Fluxus ideas to contribute highly personal accents. The labyrinth was such an unexpected success and drew such crowds that sections of it had to be continually repaired, expanded, even completely renewed. But it survived the exhibition with flying colors.

As Watts, Wada, Miller, and Paik had also flown in from New York to help on the labyrinth, we decided to take advantage of their presence to arrange a concert with members of the old Fluxus group living in Europe. Invitations went out to Filliou and Vautier in France, to Jones, living in Asolo near Venice, and to Brecht in Cologne. This evening, the first organized by Maciunas in Germany since the Wiesbaden and Düsseldorf concerts fourteen years before, was also the last great Fluxus concert by and with Maciunas, and at this writing, the last in Berlin (figures 20 and 21).

Carefully arranged down to the long lists of materials required, as only the 1967 music festival organized by Schmit had been, the evening went off with clockwork precision—old and new pieces played in, on top of, and at the harpsichord. We heard and saw music in the composers' own, authentic interpretations. A video recording fortunately exists of this evening, where, once again, everything was in flux.

On October 20, 1977, Addi Koepcke died in Copenhagen.
On May 9, 1978, George Maciunas died in Boston.
On January 23, 1986, Joseph Beuys died in Düsseldorf.

Notes

1. Tomas Schmit, "f," in *1962 Wiesbaden FLUXUS 1982* (Wiesbaden and Berlin, 1983)
2. Emmett Williams, "Heimkehr," in *ibid*.
3. Jackson Mac Low, "How George Maciunas Met the New York Avant-garde," in *ibid*.
4. Tomas Schmit, *ibid*.
5. *Ibid*.
6. Wolf Vostell, "Ich bin ein Sender ich strahle aus," *Der Tagesspiegel* (Berlin), December 3, 1964.
7. Tomas Schmit, *Tomas Schmit* (Cologne: Kunstverein, 1978).
8. Troels Andersen, *Blockade 69* (Berlin: Galerie René Block, 1969).
9. Armin Hundertmark, *10 Jahre Edition Hundertmark* (Berlin: DAAD gallery, 1980).
10. Leaflet by Wolf Vostell, Cologne, 1968.
11. Leaflet by Tomas Schmit, Berlin, 1968.

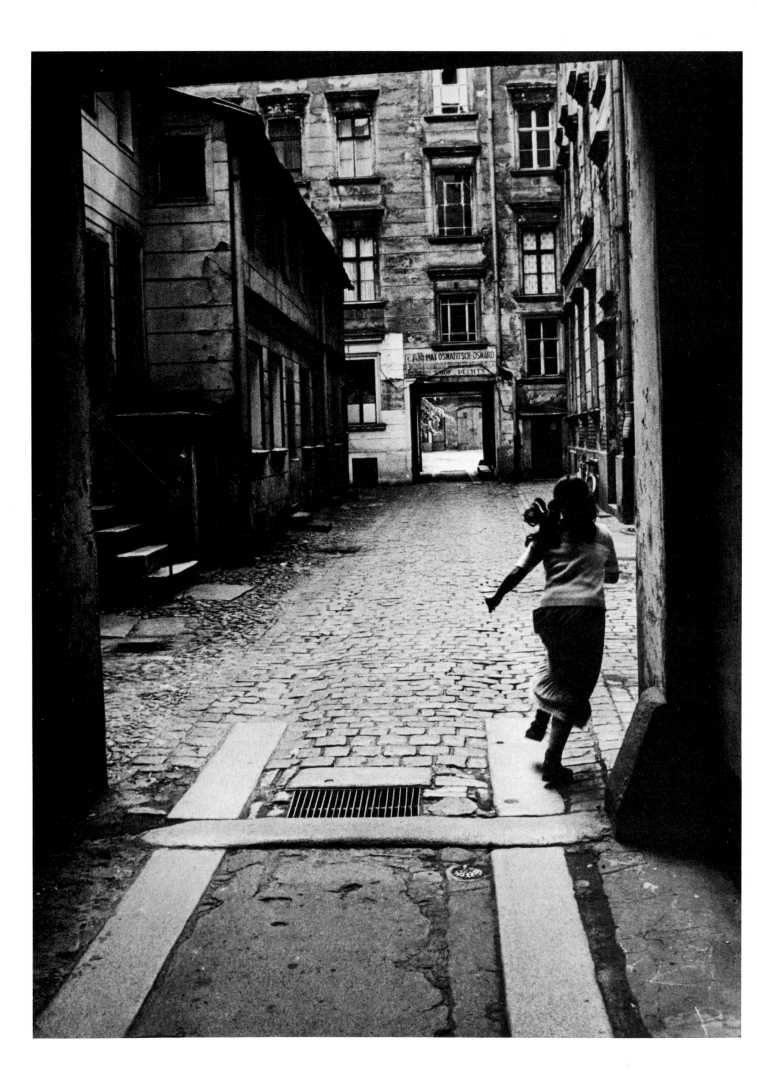

Hints of Utopia: Art in Berlin since 1977

Michael Schwarz

Figure 1: Poster for Rainer Fetting exhibition at Galerie am Moritzplatz, October–November 1977

Figure 2: Poster for opening event and exhibition by Salomé at Galerie am Moritzplatz, May 13, 1977

Courtyard, Berlin-Kreuzberg

Like all histories, the history of modern art is shot through with gaps. The closer one analyzes it, the less it seems to consist of a linear development or logical succession of styles. The modern movement has been shaped by continuity *and* new beginnings, stagnation *and* change, eclecticism *and* innovation.

Recent artistic developments in Berlin, too, can be precisely chronicled only at the risk of oversimplification. It depends on one's assessment of events whether one dates the birth of the new painting in Berlin with the founding of the Galerie am Moritzplatz in 1977 by Rainer Fetting, Helmut Middendorf, Salomé, and Bernd Zimmer (figures 1 and 2), or with the exhibition of the work of those artists at the Haus am Waldsee in 1980. Not having been an eye-witness to either event and knowing them only from what has been said and written about them, I would tend to keep the frame of reference large. When inquiring into the reasons why one generation succeeds another, earliest dates, I find, are less important than symptomatic events. There was one quite clear symptom of an impending changing of the guard among Berlin artists at the close of the 1970s. Two competing exhibitions, *Berlin: A Critical View. Ugly Realism 20s–70s* and *13° E: Eleven Artists Working in Berlin* (figures 3 and 4), were held in London in 1978. The former, at the Institute of Contemporary Arts, showed Hermann Albert, H. J. Diehl, Peter Sorge, Klaus Vogelgesang, Ulrich Baehr, Maina-Miriam Munsky and others, representing a Critical Realism that had already long enjoyed public support. The latter, at the Whitechapel Art Gallery, organized by Nicholas Serota, consisted of work by eleven Berlin artists who were either no longer or not yet to be seen in the galleries and museums—with the exception of Markus Lüpertz, whose retrospectives in Hamburg, Bern, and Eindhoven had recently documented the quality and variety of his oeuvre.

Initially, these two exhibitions seemed to be merely two sides of the same coin, for in both cases the organizers emphasized an obligation to tradition: *Ugly Realism* to the socially critical realism of the 1920s, and *13° E* to the Expressionism of Max Beckmann and Ernst Ludwig Kirchner and the Dadaism of Raoul Hausmann and Johannes Baader. Both derivations, however, were equally misleading. As Karlheinz Bohrer pointed out in a review of *Ugly Realism* for the *Frankfurter Allgemeine Zeitung:*

> Apart from the fact that their artistic roots lie more in American Pop painting than in Expressionist realism, the victims of society [the realists depict] are no longer prostitutes or soldiers, that is, social outsiders, but Everyman. . . . A repetition of motifs frequently derived from photographs, mostly of sexual and political brutality, results in a narrative painting that tends rather to confirm hysterically what it attacks than to encourage opposition to it.[1]

By comparison, the conception of the Whitechapel show was broad, covering extremely diverse tendencies in contemporary Berlin art. It included the painters Lüpertz, K. H. Hödicke, Johannes Grützke, and Bernd Koberling; the politically committed conceptual artists K. P. Brehmer and Dieter Hacker/Andreas Seltzer; the literary-oriented draftsman Günter Brus; Fluxus artists Tomas Schmit and Ludwig Gosewitz; and the Happening artist Wolf Vostell.

Figure 3: Exhibition *Berlin: A Critical View.*
Ugly Realism 20s–70s at Institute of Contem-
porary Arts, London, November 1978–
January 1979

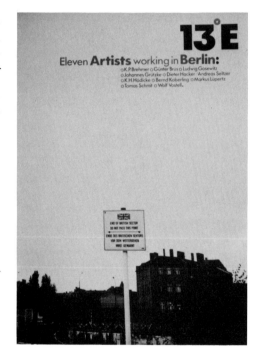

Figure 4: Cover of catalogue for exhibition
13° E: Eleven Artists Working in Berlin at
Whitechapel Art Gallery, London,
November–December, 1978

And it was the precedent of these experimentally challenging eleven, not a
Berlin realism grown hermetic, that appealed to the four young artists when
they founded the Galerie am Moritzplatz. The prime mover was Hödicke, their
teacher since 1974. In his work they found stylistic pluralism, variety of
mediums, international scope, and that ambivalence of content combined with
formal mastery they sought to emulate—without initially limiting them-
selves to any one medium. Middendorf showed paintings, drawings, and films
at his first exhibition: Berthold Schepers followed with objects, drawings, and
photographs. There were several reasons for this unorthodox diversity, not the
least of which was indecision as to what medium was best suited to expressing
transient daily experiences and states of mind.

The rapidly executed painting as a field on which to act out spontaneously
needs, aggressions, and anxieties was not yet available to Salomé (figure 5),
Fetting, or Middendorf in 1977, and had to be approached through predecessors
and models. Schepers and Anne Jud continued to reject painting as a medium of
expression (figures 6 and 7).

Another reason for the reluctance of artists to accept painting lay in an issue
raised by the two London exhibitions. They were concerned to avoid every
fixation of content, limitation of style, and dependence on any one medium,
particularly painting. Only by using the means adequate to the task at hand, and
using them well, they felt, could convincing contemporary solutions be found.
And they radicalized the issue of medium and stylistic pluralism raised by *13° E*
by demanding variety and openness within the individual oeuvre. This recalls
Peter Bürger's thesis on the aging of the modern movement,[2] formulated
in reaction to Theodor W. Adorno's *Aesthetische Theorie*. Every epoch, said
Adorno, possesses its own, advanced aesthetic material, and only by employing
it can an artist make a valid statement about that epoch. Adorno allows neither
breaks in development nor the concurrent existence of anachronistic phenomena
in art; Bürger, by contrast, postulates that a fully developed modern sensibility
would exclude no material or method. The style, form, or material used should
depend solely on the artist's concrete task and expressive aim. This thesis almost
exactly coincides with the Moritzplatz artists' belief that the search for a mean-
ingful and valid approach should begin in one's own life and personal experi-
ence. That is why, from 1977 to 1979, they concentrated on performance, on
super-8mm film—a medium in which even the most extreme self-involve-

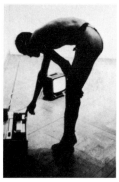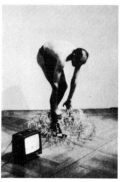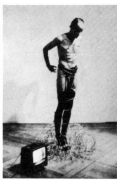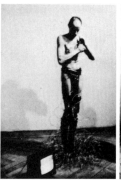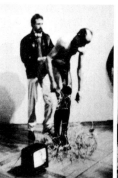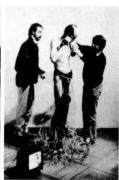

Figure 5: Salomé. *For My Sisters in Austria.*
Performed at Neue Galerie–Altes Kurhaus,
Aachen, November 30, 1978

ment can be recorded and digested—and, increasingly, on painting. The
stimulus during this phase came from Hödicke, also the teacher of Hella San-
tarossa and Reinhard Pods, when in 1976, referring back to his imagery of the
early 1960s in such paintings as *Arts and Crafts Museum* or *Backlighting*, he began
to achieve a compelling painterly translation of his reactions to the Wall, the
Wannsee, and the condemned buildings of Kreuzberg.

This district, adjoining the Wall, had attracted not only Hödicke but Midden-
dorf, Salomé, Fetting, and Zimmer. In Kreuzberg, extremes meet as in no other
part of the city. Many buildings are still scarred by shrapnel holes; entire blocks
are barely habitable; thirty percent of the Kreuzberg population is Turkish.
About 1978, when the first urban renewal plans became known, property
speculation set in, and the reaction was the beginning of a militant squatters'
movement. Kreuzberg is also a gathering place for punks, freaks, and skinheads,
who hang out in bars and let off steam at the Wall, painting and writing about it,
cursing and hymning it. Kreuzberg is their turf, the *Kietz*.

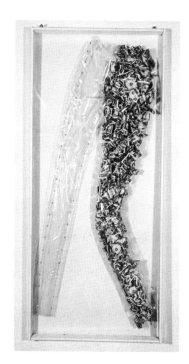

Figure 6: Anne Jud. *200-Dollar Leg.* 1979.
Plastic, paper, and metal grommets. Collection
the artist

> This term was originally applied to the small fishing villages from which Berlin
> developed. The term has survived, not for entire quarters of the town but for the
> block or two which form an urban or suburban neighborhood clearly demarcated
> from its surroundings. Members of the *Kietz* possess a vague feeling of commun-
> ity that arises less from mutual sympathy than, generally, from the fact that their
> living conditions permit them no other choice. The *Kietz* is the environment from
> which personal behavior, lifestyle, work habits, and, in the strictest sense of the
> word, a philosophy of life, an attitude to the environment, emerge and by which
> they are most immediately influenced.[3]

The artists participated in this urban sensibility by working in the neighbor-
hood, playing rock music (Middendorf), performing at the Transformer Com-
pany, Matala, and Blue Moon (Salomé), sympathizing with the squatters, or
simply by living in the *Kietz*. The form and content of their art was determined

Figure 7: Berthold Schepers. *Brush-Camera.*
1977. Super-8mm movie camera, paint brush,
wood, cord. Collection the artist

Figure 8:　Bernd Zimmer. *The Flood.* 1977. Distemper and oil on untreated canvas, in five parts. Collection the artist (detail shown)

by sheer lust for life, communicated with extreme directness. Film and video, photography and performance are intrinsically direct mediums; painting can be direct to the extent that emotions are acted out on the canvas. About 1976, Hödicke advised his former students to use housepainters' latex colors. Not only were they cheaper than oils but they permitted an immediate, spontaneous development of pictorial ideas. The Moritzplatz artists' decision to return to the traditional medium of painting was a decision in favor of a sensual, tactile medium in which results are rapidly obtained and immediately verifiable. Their subjects reflected their personal involvement: *Singer, Big City Natives, Berlin Sunset, TV, Exhibitionism/Fun, Van Gogh and Wall* were painting titles of the late 1970s. The year the Galerie am Moritzplatz was founded, Zimmer showed his five-part, monumental canvas *The Flood* (figure 8), the first large-format painting by anyone in the group. "Its effect is staggering. The spectator is drawn into enormous, mountainous waves from which showers spurt and foam shoots up in swirls of white. The roiling, blueblack masses of water are only dimly illuminated by a cool yellow filtering down from above into the cavernous troughs."[4]

Zimmer's *Flood* is an allegorical painting in several respects. The flood as a metaphor of unleashed emotion and the sea as a symbol of unlimited promise have a tradition that extends far back beyond Expressionist literature and poetry, beyond Gottfried Benn and Bertolt Brecht, Guillaume Apollinaire and André Breton. Heinrich Heine, in a poem called "Homecoming," first published in 1823–24, compared a waterfall to the power of love:

> I love her indomitably,
> Nothing can vanquish love!
> Like a wild waterfall,
> You cannot dam its flood.[5]

Zimmer's image alludes to this constellation of meaning, its untamed waters symbolizing desires and passions we tend to sublimate or suppress. It is enough to consult the catalogue of Documenta 6 (1977) to see that this theme was new in the art of the 1970s. Most art of the period was involved in an analysis of its own conditions or of political issues. A concern with existential anxieties or human passions was rare, except in the work of Francis Bacon or Willem de Kooning.

A rehabilitation of emotionally charged painting was the second fundamental achievement of the so-called *Neue Wilde* painters in Berlin and elsewhere. Their

Figure 9: Rainer Fetting. *The Bomb.* 1982. Synthetic polymer paint on canvas. Private collection

mentors Hödicke, Lüpertz, and Georg Baselitz had tended to avoid emotional expression, particularly the last two, who were teaching in Karlsruhe at the time. They were indifferent to the object; the subject matter of their paintings was painting itself. By contrast, Zimmer, Salomé, Fetting, Middendorf, Ina Barfuss, Thomas Wachweger, Barbara Heinisch, and Thomas Lange developed an approach to painting that reflected the outlook of a generation that was facing up to the threat of atomic destruction. At the 1982–83 exhibition, *Zeitgeist*, at the Martin-Gropius-Bau in Berlin, Fetting showed his canvas *The Bomb* (figure 9).

Perhaps next in importance to the Moritzplatz connection is the group called *Büro Berlin* (Berlin Bureau), with Raimund Kummer, Hermann Pitz, and Fritz Rahmann. The Berlin Bureau opened in 1978 with a show titled *Räume* (*Spaces*), described by Pitz:

> Our idea was that we were going into a room where others had been before us and had left their traces. Nobody can say where art or life begins here. Who scribbled on the wall over there? An artist? Who broke that window? An artist? The concept of the exhibition is realized not through the making of hermetically presented art but at the moment when an observer asks and answers such questions about it.[6]

The experience gained from this collective manifestation, another attempt to blur if not remove the boundaries between art and life, precipitated an influential project called *Lützowstrasse Situation* (figure 10). Fourteen artists were asked to react to a given space—an abandoned factory loft—and to the materials and traces left there by their predecessors. Each succeeding artist was free to remove these traces, integrate them in his or her own work, or simply leave them unchanged. From April to November 1979, the fifth floor at 2 Lützowstrasse witnessed fourteen consecutive "situations," each of which built on the remains of the foregoing installations. The sixth of these, for instance, was Rolf Eisenburg's *Wood Blocks in Wet Paint* (figure 11), consisting of blocks sawn from planks the artist found lying around the room and arranged on a multicolored floor. The seventh artist, Tony Cragg, finding this surface uncongenial, painted it gray to set off his floor piece *Redskin* (figure 12). In the penultimate situation, the thirteenth, Rahmann painted the walls of the room olive green, not horizontally but in a line descending obliquely from eye-level, like the view through one of the low windows. Then he collected all the relics remaining from the preceding installations and arranged them so that they appeared to slide down the inclined plane marked by the oblique, olive-green band. One room, which until then had been used for exhibition activities, was completely flooded with water by Rahmann. The sequence of installations, theoretically open-ended, was terminated when cumulative traces became so permanent that only a com-

Figure 10: Raimund Kummer. *Lützowstrasse Situation 4*. Dismantled radiators, painted with enamel. Berlin, May 27–June 10, 1979

plete renovation could expunge them. This, however, would have run counter to the intentions of Berlin Bureau.

Two conclusions may be drawn from this project and its method. The artists eschewed the pristine white cell, sought sites with a history—even if it was only that of their predecessors' work—and reacted to this history without systematically researching it. Rather, they replied spontaneously to the material they found at the site, drawing no distinction between ordinary factory equipment and traces of the art of their predecessors. The artists' goals in this project were to gain experience in dealing with spaces and with each others' approaches.

Raffael Rheinsberg is an artist in pursuit of the past. He searches piles of rubble, condemned buildings, and rooms for artifacts of a history that for many Germans seems forgotten. After his extensive projects *Anhalt Station—Ruin or Temple* and *Bricks from Condemned Berlin Buildings,* Rheinsberg realized his third large Berlin project in 1981, an archaeology of the war he called *Botschaften* (Embassies, but also Messages), based on the bombed-out former Danish embassy (figure 13). The results of his investigation were exhibited at the Berlin Museum in 1982. Photographs of the partially demolished embassy building with its staircases, reception rooms, private apartments, and such found objects as signs and notices, door fittings, first-aid kits, and key racks gave silent testimony to the past. Among the artist's most evocative finds were a file card with the name of a Polish Jew which had been stricken out and an issue of *Der Angriff* dated September 19, 1939, with the headline: "The Führer to Speak at 5:00 p.m. Today." Rheinsberg collected, sifted, and ordered these things into a compelling message. This Berlin artist reviews his country's recent history out of a deep concern, knowing that most of his contemporaries ignore or repress it. "I suppose," he admits, "this involvement with the Danish embassy, with all its echoes and the chilling sensation of its rooms, was really very hard for me to handle. The more I identified with my work, the more real the war became for me. When I saw one of those American armored cars cruising around Berlin, it gave me the shivers."[7]

This type of collecting work is, of course, only possible today in the Tiergarten district of Berlin, or, with a different emphasis, in the Bronx in New York. While most other parts of Berlin have long since been transformed by highrise developments and sweeping thoroughfares, the former diplomatic quarter in Tiergarten remains almost unchanged, witness to the devastation of war. The jagged ruins of this cityscape are haunted by ghosts of a past yet to be exorcised. A full forty years had to pass before one of the most notorious of Nazi torture chambers, in the cellar of Gestapo headquarters in the former Prince Albrecht Palace, was finally excavated and made accessible to contemporary eyes.

Figure 11: Rolf Eisenburg. *Lützowstrasse Situation 6.* Wood and wet paint. Berlin, July 1–8, 1979

Figure 12: Tony Cragg. *Lützowstrasse Situation 7: Redskin.* Found fragments of plastic objects on painted floor. Berlin, July 15–22, 1979

Figure 13: Raffael Rheinsberg. *Embassies (Archeology of a War)*. Public inspection of former Danish embassy, Berlin 1982

In the context of research like this belong several works which the artists of Berlin Bureau subsequently executed "on location." Following a concept formulated in 1978 by Pitz ("There is no such thing as artistic statements conforming to a unified postulate"), he, Rahmann, and Kummer shifted their activities to sites on the city's periphery. In 1980, on Naunynstrasse in an urban renewal area in Kreuzberg, Kummer applied red enamel paint to I-beams exposed during razing operations (figure 14). This act was low-keyed in comparison to the illegal occupation of buildings then going on in the neighborhood, but it did show those who passed the construction site every day how rapidly perfectly good apartment houses can disappear once they have been officially condemned. That same year, Rahmann launched a *New Staging of Gleisdreieck Station* at an elevated subway station which was a threatened monument of engineering design, employing the materials and methods of urban renewal. You had to be in the know or very observant to detect that no repair work was underway there. In an extremely offhand manner, Rahmann aestheticized the architecture of the station where he boarded the train every day, again by employing the concept of work. He channelled a huge puddle of water

Figure 14: Raimund Kummer. *Naunynstrasse 24–26, Berlin 36*. Found I-beams, painted with enamel. Berlin, April 1980

that had formed on the upper platform, leading it around the official construction sites; by the time the trains had stopped running, the water had flowed back to earth.

Such artists as Fritz Rahmann or Norbert Rademacher, Pitz or Bogomir Ecker, operate like guerillas, unobtrusively but with a long-range strategy, and frequently with a deceptive ambiguity of means. A good example is Pitz's *Mobile Funicular Railway* (figure 15), whose wires extend obliquely over the platform of the same elevated subway station used by Rahmann. Three aspects of this work seem particularly interesting. The first is its casual, incidental nature. The piece is installed so that no one but initiates, idlers, or children would even notice it. Working at a scale at variance with that of the billboard on the same site, Pitz employs a defensive strategy by working in miniature.

The second interesting aspect is the situation: the right of way, station, and platform of the subway. The trains emerge from a tunnel at this point, and from the elevated tracks passengers have a panoramic view of Kreuzberg across the city's roofs, a soaring feeling that lasts until the train again descends to earth. Similarly, Pitz's funicular might encourage an escape from the solid ground of fact—assuming one discovers the inconspicuous piece in the first place.

Figure 15: Hermann Pitz. *Mobile Funicular Railway*. Gleisdreieck Station, Berlin 1980

Third, on closer inspection, one detects a man with a camera in the gondola of the funicular. The piece is thus not only a metaphor for the possibility of leaving reality behind but for a mobile observation platform as well. Conceivably, it contains those very surveillance instruments so feared by the so-called "Transmitter Man," who during the early 1970s left his painted warnings on walls and fences all over Berlin: "Citizens' brains being homed in on, overheard, influenced, harrassed by transmitters. . . ." Today video cameras are perched on the rafters of every busy station in town, looking down on its squares, intersections, and pedestrian precincts.

A need to react to the daily threat of a loss of habitat and to a rising xenophobia, particularly in Berlin, determines the imagery of Olaf Metzel (figure 16). In the winter of 1980–81 he took advantage of a vacant floor of a commercial building on Böckhstrasse to realize four sculptures—sculptures that consisted of incisions in the walls of the rooms. Using an electric cutting tool, Metzel sliced drawings into the soft plaster of the brick walls, a poetic attack on the display surface that called attention to the destruction of living and work space in this part of town. It was a period of wholesale razing in Kreuzberg, when entire neighborhoods were threatened by demolition, including the former factory where Metzel worked. The artist's concern with this situation went beyond an aesthetization of violence done to material things; he also evoked the destruction of the hopes and fears of people deprived of neighborhood. One symbol of modern longings for happiness is, of course, a vacation idyll on the Mediterranean, on some southern island like Capri. With a junkstore picture of Capri on the wall and a garishly painted relief on the floor, Metzel alluded to this dream of "paradise," at the same time revealing how deceptive it is: the floor piece was cast in concrete.

Recent art in Berlin naturally extends beyond painting, sculpture, and installations to performances, audio and video installations, environments, and related mediums, for which such names as Julius, Jud, Martin Rosz, Thomas Schulz, and many others stand.

In 1985 Schulz was a guest at P.S. 1 in New York and while there he created an audio installation in an abandoned warehouse. Helped by Udo Idelberger, Schulz spanned wires with glass disks across the voluminous space to create an instrument on which he performed *Embargo Warehouse Music* (figure 17)— experimental music reacting to and accompanying the incessant traffic noise penetrating the space from outside. Both the choice of site and the hermetic

Figure 16: Olaf Metzel. *Sculpture: Böckhstrasse 7, 3rd Floor*. 1981. Mechanical incisions in wall plaster

Figure 17: Thomas Schulz. *Embargo Warehouse Music*. New York 1985

conception of the piece—no audience was present at the performance—indicate that installations of this kind represent an end point. The radical nature of Schulz's installation recalls such earlier works by Idelberger (figure 18) as a 1982 piece in which, working in a condemned factory building, he sorted the debris from a reinforced concrete ceiling into its constitutents, steel and concrete. The result was three piles of reinforcing steel with attached fragments of concrete, surrounded by a landscape of concrete lumps. A short time later the artist spent several days in a room that had been closed by the building inspection authorities clearing junk, bricks, and mortar from the floor to reveal the colored bands formed by rusty water that had dripped from the ceiling beams.

The list of pieces of this kind, in Berlin and elsewhere, could be extended indefinitely. What do they convey? Does their character reflect the resignation of young artists who, in retreat from the utopian ideas of the late 1960s, are exploring "subjective truths?" I consider these pieces positive examples of an appropriation of the environment through self-determined work. "Work is truth," declare Werner Büttner, Martin Kippenberger, and Albert Oehlen, implying that truth can be approached only through persistent effort. In this sense, the work of Pitz, Kummer, Rheinsberg, Idelberger, and Schulz seems to have utopian connotations.

While these artists can be seen as members of certain groups, others have staked out independent positions (as have, in the meantime, the Moritzplatz painters and the members of the Berlin Bureau). The same can be said of a group that took its name from its home district: 1/61, the postal code of Berlin-Kreuzberg. These extremely diverse artists, Frank Dornseif, ter Hell, Elke Lixfeld, Rainer Mang, Reinhard Pods, and Gerd Rohling, joined together in the summer of 1979 to exhibit in a renovated space in a condemned manufacturing building—a cooperative enterprise much like the Galerie am Moritzplatz, the Kulmerstrasse gallery, Moped, Garage, or Lützowstrasse Situation. The artists of 1/61 intended to achieve a certain consensus in terms of content.

Figure 18: Udo Idelberger. *1/61*. Berlin 1982

This may seem surprising in view of their obvious differences and by comparison to such typical features of artists' groups as stylistic cohesion, an idealistic program, or agreement regarding activities; at first sight they merely evince a common involvement with the classical means of painting and sculpture. Yet beyond this, an objective context that spans all their differences is discernible, a context perhaps best described as a shared consciousness specific to a time and place. Their background includes, on the one hand, the diverse alternative and emancipatory efforts now underway in Berlin's cultural scene, and on the other, the general political and cultural rollback of the past decade.[8]

This description of the cultural matrix of 1/61 is equally applicable to much other Berlin art of about 1980, for example the work of Barfuss and Wach-

weger, the Endart group, or Thomas Lange. Yet by comparison to the expressively rendered urban subjects of the Moritzplatz artists, the painters of 1/61 favor a more conceptual approach. For Pods, the canvas is still a field on which to reflect on the problems of painting: color values, pictorial space, brushwork. Vincent van Gogh, Henri Matisse, or Kirchner cannot be cited as predecessors for Pods, but Gerhard Richter can. Richter's painting activity always contains an element of self-conscious demonstration, like Brechtian acting. Not surprisingly, Pods had earlier painted politically committed pictures; and Richter, too, after a phase of Capitalist Realism, began making paintings based on photographs and others conceptualizing gestural painting.

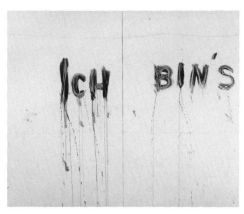

Figure 19: ter Hell. *It's Me.* 1980. Mixed mediums on canvas, in two parts. Berlinische Galerie, Berlin

Ter Hell's large-format paintings have not one but many roots, the action painting of Jackson Pollock or Fred Thieler (ter Hell's teacher), and the work of Arnulf Rainer—to name only a few. Yet thanks to his great technical virtuosity, these influences merely serve ter Hell as a background and a foil for his style of multiple messages superimposed, like the graffiti it resembles. Through subjective statements like "I want to live" or "We want to love each other but don't know how," this artist addresses the spectator directly, challenging him to read and react. Our comprehension of the message depends just as much on personal disposition as on the interweave of the verbal symbols with the formal configuration of the image. The brushed and sprayed phrases in ter Hell's paintings themselves possess structure, integrated in the overall pictorial field (figure 19). The function of these statements, then, is to arouse interest, to open up a space for personal exploration—very much in the sense in which Gotthold Lessing defined the creative moment, when he said that artists should leave room for the spectator's own vision to unfold.[9]

Still missing from this rough outline are such important artists as Eva-Maria Schön (figure 20) who, like Barfuss and Wachweger, is not from Berlin. She studied in Düsseldorf and moved to Berlin in 1980. In fact, the Berlin art community seems to have received stronger impulses from many of these more recent West German arrivals than from most of the foreign artists-in-residence under the aegis of the German Academic Exchange Service (DAAD). Exceptions prove the rule; Bruce McLean has certainly inspired many of the artists discussed here. Miriam Cahn, a guest of the DAAD two years ago and intent on staying, could prove influential. Stimulus will come from those artists who face up to the circumstances, establish a presence, and are willing to show their work.

Figure 20: Eva-Maria Schön. *A Cut Painting.* Environment at Büro Berlin, Berlin 1982

Figure 21: Helmut Middendorf. *Natives of the Big City*. 1979. Mixed mediums on canvas. Berlinische Galerie, Berlin

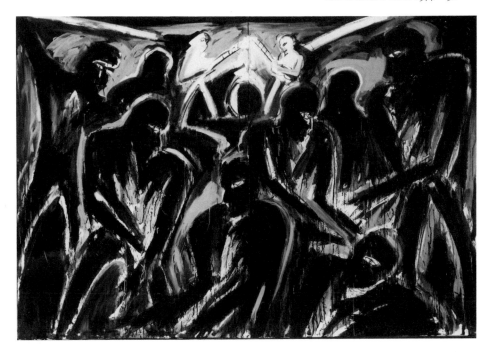

Notes

1. Karlheinz Bohrer, "Hässlicher Realismus," *Frankfurter Allgemeine Zeitung,* December 6, 1978.
2. Peter Bürger, "Das Altern der Moderne," in Ludwig von Friedemann and Jürgen Habermas (eds.), *Adorno-Konferenz* (Frankfurt am Main, 1983), pp. 177-197.
3. Eberhard Roters, "Einleitung," in *Im Westen nichts Neues* (Lucerne: Kunstmuseum, 1982).
4. Stephan Schmidt-Wulffen, "Galerie am letzten Fleck," in *Moritzplatz* (Bonn: Bonner Kunstverein, 1985), p. 17.
5. Heinrich Heine, "Die Heimkehr," *Gesammelte Werke* (Frankfurt am Main, 1954), vol. 1, p. 49.
6. Hermann Pitz, "Räume," in Raimund Kummer, Hermann Pitz, and Fritz Rahmann, *Büro Berlin: Ein Produktionsbegriff* (Berlin, 1986), p. 144.
7. Raffael Rheinsberg, "Rückblick," *Botschaften: Archäologie des Krieges* (Berlin, 1982), p. 12.
8. Wolfgang Siano, "Neue Kunst in 1/61," in *1/61* (Berlin: Böckhstrasse 7, 1980).
9. Gotthold Ephraim Lessing, *Sämtliche Schriften* (Stuttgart, 1893), vol. 9, p. 19.

The experiences of native Berliners, bolstered by the contributions and innovations of artists from Germany and abroad, have produced in recent years an art specific to Berlin. This art has been stimulated, diminished, and influenced by culture and circumstance, the city's exposed situation, and by social tensions found elsewhere only in Cologne. Berlin as cityscape, environment, matrix, has played a crucial part in the development of the art discussed here. In the meantime, some of the Moritzplatz artists have moved away or now divide their time between Berlin and other places; among those who are beginning to seek opportunities elsewhere are Wachweger, Metzel, and Gerd Rohling. Yet even in their most recent works those artists still react to the political realities of the city. Berlin is obviously a place that affects the people who work in it more deeply than any city in West Germany. And this holds not only for painters, as the conventional wisdom had it until recently.

Enough time has passed to allow the formulation of general criteria to describe the generation of Berlin artists now thirty to thirty-five years old. First, the theme of many of their pictorial inventions is an age-old one, Man. They depict human beings threatened, closed in by the Wall, observed by surveillance apparatus, deprived of their habitats. Second, the configuration of their work is often the result of a spontaneous translation of existential situations. Both painters and installation-makers avoid techniques requiring a great expenditure of time and materials (in contrast to the Critical Realists, though they share a focus on the human condition). Third, this young generation makes no bones about quoting from earlier art, but never arbitrarily, and always with an eye to integrating the citations into their own formal repertoires. Fourth, the content of their works remains ambivalent; even the lost "big-city natives" leave themselves loopholes of escape (figure 21). Their imagery contains hints of utopia.

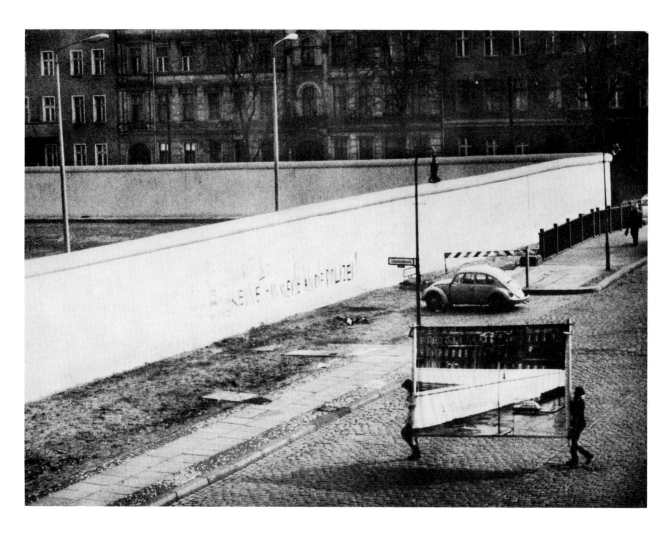

Berlin and Film

Laurence Kardish

On November 1, 1895, Berlin saw the first public exhibition of motion pictures when Max and Emil Skladanowsky ended the variety program at the Wintergarten with a presentation of their new phenomenon the Bioskop, which projected large "living" images. A minor but increasingly inventive proletarian amusement in its first decade, the cinema in its second expanded its audience to the bourgeoisie. By the end of 1917 there were over two hundred production companies in Germany, the majority in Berlin. In that year, under the political administration of General Erich F. W. von Ludendorff a major new studio, UFA (Universum Film A.G.) was formed to make screen propaganda and films that educated the public in German culture.

As an art center, Berlin saw the birth of so-called avant-garde, experimental, or abstract film when in 1921 painters Hans Richter and Viking Eggeling, and Eggeling's protegé Walter Ruttmann, respectively, worked on *Rhythmus 21, Symphonie Diagonale* (finished in 1924), and *Lichtspiel Opus 1,* possibly the first nonrepresentational film to play in a cinema. After Eggeling's death in 1925, Ruttmann carried his tendency to abstraction into *Berlin: Symphony of a Great City (Berlin: Die Sinfonie einer Grosstadt,* 1927) and later into the making of documentaries for the Third Reich. Richter, who fought the industry's glorification of war and the encroachment of censorship, quit Germany soon after Hitler's ascension to power.

Narrative features, whether informed by Expressionism, as in F. W. Murnau's *The Last Man (Der letzte Mann,* 1924), or by *Neue Sachlichkeit,* as in Phil Jutzi's *Mother Krausen's Trip to Heaven (Mutter Krausens Fahrt ins Glück,* 1929), tended to treat the individual as a victim of fate, and Berlin as a mortuary. The one work that was not fatalistic was the single Weimar feature film to suggest the communist panacea: *Whither Germany? (Kuhle Wampe—oder: Wem gehört die Welt?,* 1932),[1] directed by Slatan Dudow from a script by Bertolt Brecht and Ernst Ottwald. It anticipates contemporary German film in its recognition that change is possible, its humanism, its location shooting, and its use for the most part of people who play themselves.

The Nazis nationalized the film industry. UFA-Babelsberg remained the country's largest studio, and films continued to be made there throughout the Second World War. In 1945 Babelsberg was occupied by Soviet troops, and being just to the southwest of Berlin became part of the German Democratic Republic when it was established in 1949. Its studio became the main production center for DEFA, the state-run East German filmmaking organization.

One of Germany's first postwar films, *The Murderers Are Among Us (Die Mörder sind unter uns,* 1946), was made in Berlin's Soviet zone and melodramatically describes the insidious metamorphoses of ex-Nazis into good citizens. Set among the ruins of the devastated city, *The Murderers* was the earliest of the *Trümmerfilme* (Rubble Films) that dealt with the resumption of normalcy in a traumatized landscape.

By 1956 a system of federal subsidies, initiated in the early 1950s, stimulated production to such an extent that over 120 features were completed in Germany,

Helke Sander. *The All-round Reduced Personality—Redupers.* 1977

including Georg Tressler's *The Hooligans* (*Die Halbstarken*, 1956), a disingenuous cautionary tale about young delinquents in Berlin, which received considerable notoriety during the relatively quiet decade.

Today, there are at least a half-dozen film festivals in Germany, with the largest in Berlin, where filmmakers may show their work to colleagues and critics before it is released to the public. One of the most significant is in Oberhausen, a small industrial city in the Ruhr district, which has held a competition for short films since 1954. It was here in 1962 that a number of young German filmmakers issued a manifesto excoriating the current state of German films as ersatz Hollywood, and demanding support of their works. Three years later, partly in response to this protest and to the continued appearance of new filmmakers, Das Kuratorium junger deutscher Filme (The Board for Young German Films) was established in Wiesbaden to stimulate the cultural development of German films and further film culture's next generation. The Kuratorium provides financial support for first feature films.

The same year saw the establishment in Berlin of the Deutsche Film- und Fernsehakademie (DFFB; German Film and Television Academy), one of whose first instructors was Berlin-born Peter Lilienthal, whose Jewish family fled to Uruguay in 1939. Klaus Eder has written of Lilienthal: "The experience of exile—both his own and that of other people made a deep impression . . . , quickened his perceptions, making him acutely sensitive to all forms of oppression and power exploitation. His sympathy lies with those who begin, however mildly, to put up some resistance."[2] "Resistance" neatly encapsulates a frequent theme of Berlin cinema, and indicates a tendency of DFFB graduates to use film as a tool for social inquiry and engagement.

In 1965, the year the Kuratorium and the DFFB were established, a Berlin film appeared, *It* (*Es*) by Ulrich Schamoni, a signal for the *Neues Kino* (New Cinema) and for the beginning of the divided city's position as a major locus for independently spirited work. In the film, "It" is a fetus unexpectedly visited upon a young unmarried couple; the issue of abortion is explored, but no moral position is taken. *It* was notable for its refusal to turn a timely piece of social observation into a close-ended narrative.

What distinguishes the *Neues Kino* from earlier German cinema is defiance. Its stylistic and narrative strategies are resolutely unconventional. It valorizes those who act (even stupidly), and castigates those who allow themselves to be acted upon. When the *Neues Kino* began to appear, certain systems were in place and various organizations had been established to encourage and support the postwar generation of filmmakers in the Federal Republic and particularly in Berlin.

The term *independent filmmaker* signifies a creative and emotional commitment that amounts to a personal identification with the work. It indicates that the artist is not a hired hand to work out someone else's idea; however, the independent filmmaker may need to bring his or her idea to someone who can create the financial circumstances to realize it. Some filmmakers, like Lothar Lambert and Ulrike Ottinger, prefer to raise money and administer production themselves. Others find a producer sympathetic to personal cinema, and who, in return for distribution rights, arranges funding and provides encouragement.

Berlin is distinguished by its number of independent filmmakers and allied producers. Among the important producers are Clara Burckner, Ursula Ludwig (formerly of the Berlin Literary Colloquium), Joachim von Vietinghoff, Regina Ziegler, Renée Gundelach, and Klaus Volkenborn of Journal-Film. Chronos-Film, another Berlin company with its own private archive of German historical footage, like Journal-Film makes non-fiction films. Whereas the methodology of Chronos-Film's producers Bengt and Irmgard von zur Mühlen precludes amplification and dialectical modification of the visual material, Journal-Film

productions make explicit connections between past and present. The films are not didactic; their social ideology springs from a humanist perspective. Journal-Film has produced, among others, Jeanine Meerapfel's *Melek Leaves* (*Die Kümmeltürkin geht*, 1985), Manfred Stelzer's *Stories of Twelve and One Years* (*Geschichten aus zwölf und einem Jahr*, 1985), and Helga Reidemeister's Berlin city-portrait, *Film Location Berlin* (*DrehOrt Berlin*, 1987), filmed on both sides of the Wall.

In the late 1960s many filmmakers who had found Berlin spiritually salutary but who feared it would be difficult to conduct business in an industrially quiescent metropolis, formed the Berliner Arbeitskreis Film (BAF), a loose collective of directors and producers to function as an advocacy group and petition the senate for support. Berlin producers now apply regularly to the Filmförderung (Film Assistance Program) for support.

Berlin is not unique in Germany in offering these and other local subsidies, but it was, in 1977, one of the earliest cities to do so. Among Berlin filmmakers who have benefited are Robert von Ackeren, Thomas Brasch, Jutta Brückner, Hellmuth Costard, Uwe Frissner, Marcel Gisler, Wolf Gremm, Petra Haffter, Peter Keglevic, Ingo Kratisch, Lothar Lambert, Peter Lilienthal, Jeanine Meerapfel, Irmgard von zur Mühlen, Ulrike Ottinger, Helga Reidemeister, Frank Ripploh, Ottokar Runze, Rosa von Praunheim, Günter W. Rometsch, Helma Sanders-Brahms, Ulrich Schamoni, Uwe Schrader, Manfred Stelzer, Peter Stein, Rudolf Thome, and Lienhard Wawzryn.

In 1980 the Filmförderung initiated a "low-budget" film-assistance program specifically to help young independent filmmakers, particularly recent DFFB graduates. German television is also an active coproducer of many films. Berlin has its own station, SFB (Sender Freies Berlin), begun as Radio Free Berlin in 1953, which also produces films (for example, Lilienthal's early feature *Malatesta*). Of particular interest in Germany is Das kleines Fernsehspiel (roughly, The Little Television Playhouse), which commissions first features and works by filmmakers early in their careers, including super-8 mm films, and provided the money for Alfred Behrens's *Images of Berlin's City Railway* (*Berliner Stadtbahnbilder*, 1982), produced by Basis-Film.

The first Basis-Film was Christian Ziewer's *Dear Mother, I Am Well* (*Liebe Mutter, mir geht es gut*, 1971). *Dear Mother* (figure 1) dramatizes with pyschological precision and social acuity the stormy relationships within a group of workers who are trying to gain better working conditions. Without sanctifying the proletariat or vilifying management, the film is a breathless and convincing union tale. Its angry protagonist is played by the actor Claus Eberth, while virtually everyone else is a worker playing a worker. *Dear Mother* is billed as a documentary feature; its precise events are fictional, but the organizing process it describes is not. The script, written by Ziewer and Klaus Wiese, is a distillation of oral histories by workers, many of whom appear in the film.

When the film opened it was hailed as a work without precedent in the Federal Republic, and soon came to be known as the first Berlin workers' film. The completion of *Dear Mother* was only the halfway point in achieving a "useful" film. To this end screenings were arranged in various community centers and places where workers meet, and in factories and in schools where issues raised by the film might be discussed. *Dear Mother* was intended to be educational and instructional; it demonstrated the possibility and methodology of change. To assist in organizing these didactic encounters, Ziewer and Wiese hired a theater actress, Clara Burckner, who had helped arrange the stay of New York's Living Theater in Berlin. The making of *Dear Mother* provided the spiritual and practical impetus for the formation of Basis-Film by Ziewer, Wiese, and Burckner. In existence for fifteen years, Basis-Film has become well known in Berlin and active in Bonn, encouraging support for independent German filmmakers.

Figure 1: Christian Ziewer. *Dear Mother, I Am Well.* 1971

One critic who noted the absence of women in workers' films was Ziewer's DFFB classmate, Helke Sander, who helped form Aktionsrat zur Befreiung der Frauen (Action Committee for the Liberation of Women), a model for the women's movement in Germany. In 1973 Die Freunde der deutschen Kinemathek (The Friends of the German Cinematheque) presented the First International Women's Film Seminar in Berlin, which Sander organized with Claudia von Alemann. Out of this eventually came *Frauen und Film,* perhaps the most efficacious quarterly in the social development of cinema. The magazine, edited by Sander, included reports, essays, interviews, and reviews by and about women in film. During the nine years in which it was published in Berlin that city became a major center not only for feminist film criticism but for women making films.

In 1977, Sander, with the help of Burckner from Basis-Film, wrote, directed, and starred in her first feature, *The All-round Reduced Personality—Redupers* (*Die allseitig reduzierte Persönlichkeit—Redupers*). The loquacious title is lifted from some familiar blather broadcast over East Berlin radio about "the all-round realizable socialist personality," and cheekily signifies Sander's deadpan masquerade as Edda the "Reduced." *Redupers* is about a woman and a city, each functioning as a metaphor for the divided other. Its approach is cool and ironic, so much so that even its brilliant black-and-white photography appears so crisp as to be deceptively depthless. Edda, on the verge of a nervous collapse, is a single mother who barely has time for her daughter's needs, her own sexual life, and sleep. She works as a freelance photographer earning little money. From one disconnected event to another, she realizes that her metropolitan peregrinations have neither order nor meaning, particularly because she cannot allow herself to interpret what she witnesses, only to shoot it. She belongs to a women's action group that is preparing an exhibition, to be shown on billboards throughout the city, of large-scale photographs on the specifics of Berlin life. Although the women wish to employ the images to illustrate and enlighten, the sponsors want to use the project to promote tourism. "The women have to be inventive in order to get their idea across. They must not avoid conflicts," writes Sander. *Not* avoiding conflicts for the approximately seventy-two hours covered by *Redupers* is what occupies Edda publicly, while privately she realizes

that the control of her time is lost. "One should be free to chose what doesn't concern one."

The film begins to answer, with objectivity and humor, the question of "why women so seldom manage to achieve anything." It is not antimale, in the same way that the Berlin workers' films are not antimanagement. The films are about individuals and their relationships within specific constituencies.

Redupers' opening shot is a startling one in which the receding presence of the Wall transforms itself into the fence line of a residential street. The film is an elegant but not uncritical encomium to a city somewhat reduced but not diminished. This curious characteristic is also treated, with melancholy, in another work produced by Basis-Film: Alfred Behrens's audio-visual essay, *Images of Berlin's City Railway* (figure 2). Berlin opened the world's first electrified railway line in 1881. Several interconnecting urban lines emerged, and two networks developed, the U-Bahn (underground) and the S-Bahn (mostly elevated). In 1937 the S-Bahn carried 512 million passengers, and in 1976 a quarter as many. The S-Bahn comprises several lines that run across the city from sector to sector. Until recently it was administered from the East, one reason why West Berliners boycotted it after the Wall was built.

In 1980 only thirty-eight of West Berlin's seventy-seven S-Bahn stations were in operation, and Berlin's topography was swathed by corridors of "post-industrial wasteland." On his arrival in Berlin in 1962 Behrens was impressed by the sight and sound of passengerless trains rolling over great streaks of the city stopping at deserted platforms of empty, well-located stations, many of which were of architectural note. His fascination with the transportation system continued. In 1981, after a strike by West Berlin S-Bahn workers against their boss, the government in the East, the administration of the lines in the western sector was incorporated into West Berlin's own efficient transportation network. *Images of Berlin's City Railway* developed as a poetic argument concerning the future of the system; it is a series of hushed impressions over several seasons. Some of the film was shot clandestinely in East Berlin, but the whole work is suffused with a disorienting sense of the eerie and the furtive, feelings not necessarily negative, that qualify the viscosity of life in that strange city.

However significant are the few individual works produced by Basis-Film, its greatest importance to Berlin and *Neues Kino* lies in its distribution activity. It handles, among others, the following films and filmmakers, whose work in one way or another deals with the edgy contemporaneousness of Berlin: Ulrike Ottinger's *Portrait of a Woman Drinker* (*Bildnis einer Trinkerin*, 1979), Helga

Figure 2: Alfred Behrens. *Images of Berlin's City Railway.* 1982

Reidemeister's *Who Says It's Fate!*, Elfi Mikesch's *Macumba*, Rosa von Praun-heim's *City of Lost Souls* (*Stadt der verlorenen Seelen*), Jeanine Meerapfel's *Melek Leaves*, Manfred Stelzer's *Tales of Twelve and One Years*, and Helma Sanders-Brahms's *Laputa*.

Portrait of a Woman Drinker (figure 3) is the fourth feature Ottinger shot and the fourth in which Tabea Blumenschein, who designed the film's extensive wardrobe, stars. Ottinger's cinema is neo-Caligaric: grotesque, flamboyant, and goofily foreboding. Her films are romantic cynosures, striking in both structure and interior design, but curiously enough, not artificial. They proceed determinedly on some barely sensible oneiric trajectory, the episodic narratives resolute rather than arbitrary. Ottinger's dictum seems to be, In excess lies honesty, with satisfaction comes death. This is certainly the case with the bibu-lous lady of *Portrait of a Woman Drinker,* who arrives in a shocking red dress at Berlin's Tegel (Reality) Airport to commence her mortal itinerary. Wherever She travels so does a Chorus in houndstooth whose members, Social Question, Exact Statistics, and Common Sense, are all of different disapproving minds. Each sequence finds She in another startling couture outfit in yet another Berlin drink spot, as She fulfills her destiny of terminal inebriation. In She's narcissistic determination to kill herself pleasurably, Ottinger analogizes fashion and alcohol and presents Berlin as an active presence, providing the protagonist with congenial spaces for her program and protecting her with anonymity.

Ottinger's cinema is aligned with theater and exaggeration, while the films of Reidemeister focus on quotidian scenes and pedestrian behavior, as in *Who Says It's Fate!* (figure 4). Both films are about a woman who has chosen to act without regard for social convention in order to realize her true self. Ottinger's woman is a pose, a loaded metaphor, so to speak: it does not matter that she may not be a sober feminist signifier, but in doing what she wants, living and expiring in solitary hedonism, she may be read positively. Using methods that appear casual, almost banal, Reidemeister has crafted an exceedingly sharp documentary about a woman who persists in making her own life.

After twenty years of marriage and four children, Irene Rakowitz of *Who Says It's Fate!*, taught "to serve and be humble," divorced her husband and began an independent life with her children in which she could be free, as *Redupers'* Edda

would say, "to be able to choose what doesn't concern one." Irene, an original tenant of the Märkische Viertel, a working-class "satellite" town built near the Berlin Wall between 1964 and 1972, where the filmmaker was a social worker, really did break the chain of economic and cultural deprivation by fighting for better housing conditions. Reidemeister does not detail Irene's biography; but through conversations, information about her history emerges. The black-and-white 16mm film is structured around encounters, arguments, and dialogues between Irene and the offscreen filmmaker, Irene and her family (except her daughter Carmen, who will speak against her but not to her), Irene and her male friend, and between the filmmaker and the children. Much is verbally imparted but the film's emotional power derives in part from the facial expressions and body language of Irene and her family. They are at times asynchronous.

Irene, a woman of coruscating heart and will, can take the criticism of her children, but can also give it—and she does. This feisty woman speaks honestly, not to make herself superior or to ridicule her children but to make herself understood and to teach them how to complain: "Otherwise they wouldn't be able to open their mouths at all. They'd be cringing just the way I used to." The filmmaker subscribes to Irene's ethics. The ability not to cringe is a first step toward social change and this attitude divides Berlin's Weimar films from the *Neues Kino* works of the past two decades.

Mikesch's *Macumba* also takes place in an interior space as uncongenial as Irene's apartment, but which is in some dark way enticing. The characters in this melancholy charade may or may not be fictions of Isabelle (played by Magdalena Montezuma), a mystery writer who seems to be their ontological proprietress. Isabelle and her bizarre tribe (including among others Mikesch, and filmmakers Heinz Emigholz and Frank Ripploh) inhabit a prewar apartment block that has been neglected and otherwise abandoned. Marked for imminent demolition, the place is in a ruinous state, but its cracking paint, dimly illuminated staircases, and the soft noise of its rusty decay provide a spectral beauty not unlike that of the deserted S-Bahn. Max Taurus, an uninspired private eye, on the track of the guilty party to a "universally visible and general" crime arrives at Isabelle's lair. Once inside the sleuth loses his way, becomes passive, and is absorbed. Perhaps Isabelle's curious labyrinth is Berlin itself defeating

Figure 4: Helga Reidemeister. *Who Says It's Fate!* 1979

anyone as common as Max; but an interpretive reading adds unnecessary weight to a haunting experience.

Like the Austrian Mikesch, Meerapfel is native neither to Berlin nor to Germany. Mikesch's native tongue, however, is German, whereas that of Meerapfel (born in Buenos Aires to émigré Jews) is Spanish. Meerapfel's films are explicit about a central fact of Berlin life—being alien, a foreigner, physically at some ease, perhaps even welcome, but in some essential way estranged. *Melek Leaves*, Meerapfel's third feature and second documentary, is not the literal translation of the German *Die Kümmeltürkin geht* (roughly, The Dirty Turk Goes). *Melek Leaves* begins as if it is an indictment of German callousness toward its alien workers, but Meerapfel has nothing so simple in mind. The ordinary story line belies her real intent. Owing to rising unemployment, Melek Tez, a Turkish national who has spent fourteen years in Berlin doing menial work, is offered money to depart Berlin for Istanbul. Meerapfel records Melek's decision to accept this offer and her last weeks in Berlin. While Melek might seem only an anonymous "other" within Berlin's Turkish ghetto, Meerapfel discovers a combative woman with a singular mix of positive and negative qualities. Meerapfel subverts the notion of typicality, and neatly restores the individual to the dehumanizing epithet. Melek leaves, a Berliner at heart, resisting Germany's attempts to define her.

Melek Leaves is also cunning in its construction; it appears random, but is artfully artless. This description is also appropriate for the work of Rosa von Praunheim. Born Holger Mischwitzky, von Praunheim has made more than a dozen features since 1968 in Berlin. His roomy apartment functions as a mini-Babelsberg. Various rooms serve as soundstages and warehouses; kitchen and bathroom are repainted and redesigned as a film project requires. Costumes, props, and sets awaiting modification and reuse fill closets and bedroom. A parodistic theatricality, an earnest sloppiness, and an episodic presentation of narrative are part of the filmmaker's energetic strategies. His films serve as invitations to spar with current ideas, not necessarily endorsed by the filmmaker, about community, sexual orientation, and personal identity. The films engage, confuse, shift, and suggest.

Many of the works are manifestoes; the distinction between fiction and non-fiction is not salient since anything staged serves to reveal a truth. Von Praunheim came to international attention with his capsulated didactic drama *It Is Not the Homosexual Who Is Perverse but the Situation in which He Lives* (*Nicht der Homosexuelle ist pervers, sondern die Situation in der er lebt*, 1971). The film's declamatory title obliges the viewer to read the work as non-fiction, and the film itself jumpily chronicles the journey of an inexperienced young homosexual in Berlin, from sentimental monogamy through a consuming promiscuity, and into membership in a gay commune. It is worth noting that in exhorting one group the filmmaker does not take an adversarial position toward the other.

Von Praunheim's *City of Lost Souls* (figure 5) is a good-natured musical that turns Berlin loose on "Stage Door" typology. According to von Praunheim, Berlin, not New York, is now the Mecca for "the new, the extreme, the flipped-out," and to prove his point the filmmaker gathered together a number of show-business substars working, or trying to, in Berlin. He encouraged the performers to do a series of improvisations, videotaped them, and out of this perky accumulation concocted a conceit for a disjointed folly about strange strangers in a strange land. There is much posturing and naughty behavior but underneath the film's lyrical insistence that Berlin is "a city without shame," there is a sense of sadness, an unarticulated recognition of being lost at sea and a slight hope that the shifting city will provide some kind of anchor.

The cast of *The City of Lost Souls* constitutes the film's characters. Cast-as-

Figure 5: Rosa von Praunheim. *City of Lost Souls.* 1983

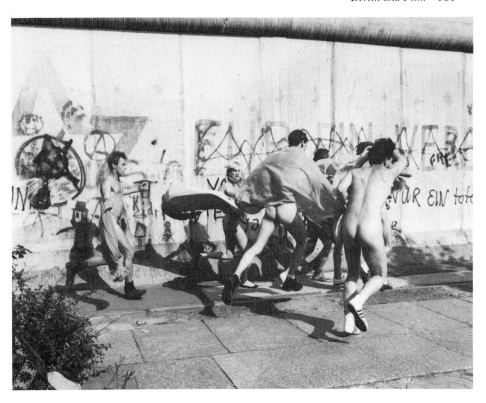

character also describes the approach of Stelzer's fiction-shaped documentary *Tales of Twelve and One Years*. In late 1971, while the Berlin senate wrangled over what to do with the empty Bethanien hospital, seventy-seven young people spontaneously occupied the Kreuzberg building in the first of over six hundred "squattings" in the Federal Republic during the next five years. The commune became a model for self-organized youth centers. Stelzer, who had been among its earliest occupants, returned thirteen years later to interview some of the original squatters. Reluctant to meet his old friends as a reporter, Stelzer devised a strategy for the film: he invites someone who was a major influence on the squatters and once a student in Berlin himself to join his investigation. Karl Marx arrives by train with his daughter Jenny, sees the commune, but because of a prior commitment leaves her to report back to him later. Jenny discovers that, with one exception, these once-eager activists are no longer interested in ideology. The pedestrian materiality of everyday life and common coping have replaced commitment to change. One of the most poignant moments in recent cinema observes two former communards, now taxi drivers and family men, standing proudly on a new roof for which one of them will have to work the rest of his life to afford. Surveying a fresh housing tract under a cloudy sky, they ruefully acknowledge their self-centeredness as a coming-of-age. *Tales of Twelve and One Years* proceeds for the most part like a superior detective story where each "suspect" makes a revelation about passage.

Sanders-Brahms takes the idea of Berlin as an "island" to be an emotional truth not just a geographic metaphor. This assumption is the resonant heart of her film *Laputa* (figure 6). After several months two lovers—he from Paris, she from Warsaw—meet again in Berlin "for little more than an hour," the length of the film, time enough to reintroduce themselves, argue, hurt one another, consummate their passion, laugh together, remonstrate, and part. Neither can tolerate the absence of the other but their biographies stop them cold from moving into each other's lives. Berlin permits the two of them to become a couple but only between airplanes. *Laputa* is an exquisite concentration of a relationship whose perimeters are so constricted that its desperate adults must necessarily injure one another.

Although much of *Laputa* is shot in interior spaces, one feels little distinction between inside and outside. Berlin is a transit station through which to pass. Fluidly photographed in saturated colors and shadowy tones, *Laputa* identifies Berlin as the Floating Island described in *Gulliver's Travels* as not so much an unwelcoming and implausible place as extraterrestrial. Laputa's inhabitants, like *Laputa*'s passengers, experience "continued disquietudes, never enjoying a moment's peace of mind; and their disturbances proceed from causes which little affect the rest of mortals."[3]

Laputa has several themes that recur in Sanders-Brahms's work. These include the problematic position of women and the ceaseless fluctuation between actuality and make-believe. This last concern is particularly germane in Berlin, where the exigencies of international diplomacy combine with the Realpolitik of the Wall to create situations of pretending that are so extreme they threaten to be mistaken for reality itself.

Lothar Lambert is a maverick who has created a one-man school of Berlin filmmaking: the "no-budget" film, also known as the "Kleenex" movie, inexpensive enough to be dispensable but too tough to be disposable. Lambert has acquired Berlin's self-mocking, palliative humor and its tendency to action. Although he has made fifteen features, he resists describing filmmaking as employment. For Lambert, it is a continuous avocation always one willful step away from being a profession. He conceives, writes, shoots, edits, often stars in, designs the posters for, and markets, the films. For the most part, he also produces them on the receipts, if any, of his last film and the money earned from his regular job as a freelance film and television critic.

His cinema is inhabited by searchers, primarily but not exclusively homosexual, ingenuous and perplexed, who attempt with varying degrees of success to come to terms with their sexual and emotional longings. Lambert's protagonists are basically good people who, in their confusion, do not quite lose their dignity; he never condescends to his characters or treats them as aberrant. Lambert often begins with a bare scenario, hardly elaborated; a small cast is assembled and shooting begins casually. During the film's shooting a more detailed story emerges, but the narrative really takes shape on the editing table where Lambert locates the real adventure in filmmaking. The first film Lambert edited himself

was *1 Berlin-Harlem* (figure 7), a fiction around an American soldier whom he had earlier befriended and whom he asked to play the lead. With mock dispassion *1 Berlin-Harlem* describes the dispiriting months between a black G.I.'s discharge and his reluctant return to the United States. Trying not to be diminished by the social, sexual, and racial prejudices circumscribing him, he explodes in a rage that turns murderous. The narrative is refractory, but it does allow the G.I. a tour of marginal Berlin.

Lambert's cinema has been celebrated as a no-budget endeavor, but there are many filmmakers in Berlin for whom even a no-budget film is an extravagance: those who make super-8mm films. These are not aesthetic poor cousins to 16mm and 35mm films. The super-8mm films may be as vibrant, as fluid, and as visually sophisticated as any work in the more costly gauges, whose range of stylistic and thematic approaches they may vigorously mimic or cheekily deconstruct. In the early 1980s Berlin became a center for super-8mm filmmaking, exhibition, and distribution. Some super-8mm works have come out of school exercises, others are made by visual artists working primarily in other mediums, such as the painters Rainer Fetting and Helmut Middendorf. Some filmmakers, like Michael Brinntrup, blissfully ignore conventional technical limitations and expand the presentation possibilities for super-8mm. Brinntrup's single-screen *The Rhine, A German Tale* (*Der Rhein, ein deutsches Märchen*, 1983) is an ambiguous reworking of a home movie of a family trip which the filmmaker layers so that an uncomfortable equation is made between sentiment of nostalgia and the spirit of war.

OYKO is one informal super-8mm filmmaking collective with an ever-changing membership, typical of many groups in Berlin. It began in a building where resident squatters showed and discussed their films. Other groups, including the *Notorische Reflexe* (NR) and *Die Tödliche Doris* (The Deadly Doris), comprise visual and performing artists. Christoph Döring and Knut Hoffmeister, NR members, have each completed a number of super-8mm films including the former's fervid recollections of late-night taxi driving, *3302*, and the latter's *Berlin/Alamo* (1983), a riotous record of Berlin's demonstrative response to an American military parade. The Deadly Doris's *The Life of Sid Vicious* (*Das Leben des Sid Vicious*), perhaps Berlin's most notorious super-8mm

Figure 7: Lothar Lambert. *1 Berlin-Harlem*. 1974

Figure 8: Ernie Gehr. *Signal—Germany on the Air.* 1985

film, is a short biography of the punk star performed by toddlers. Another group, the ambitious *Teufelsberg Studio*, since 1980 has completed several cheaply sequined melodramas at once genre and gender subversive. Its chilling short, *Pictures from Our Hometown* (*Bilder aus unserer Heimatstadt*), however, is more dyspeptic than comic. Super-8mm films are shown all over town in theaters, galleries, bars, clubs, concert halls, garages, and occupied buildings. Berlin has its own super-8mm film festival, Interfilm, whose fourth edition in 1986 attracted 250 films from all over the world. Interfilm takes place at the Kino Eiszeit with some presentations at the Arsenal, two cinemas that make Berlin particularly rich in film culture.

 Both the Arsenal and the Kino Eiszeit testify to the validity of the Berlin idea that, in order to get something going, you improvise a project into existence. The Arsenal was founded by The Friends of the German Cinematheque in the early 1960s to acquaint Berlin with films not shown there for thirty years and also with contemporary developments.[4] Taking the name from the title of Alexander Dovzhenko's Soviet masterwork, *Arsenal* (1929), the Friends, under Ulrich and Erika Gregor, opened their own daily cinema, in January of 1970, in a residential section of central Berlin. The Arsenal presents several exhibitions, screening three to four films (or videos) daily, and provides explanatory notes for each. The Kino Eiszeit, whose name means Ice Age, refers to Alexander Kluge's observation from prehistoric drawings that man has an atavistic urge to make images connoting motion and was begun by several of OKYO's members. Located in a partially renovated Kreuzberg loft, Kino Eiszeit shows films and videos, holds concerts of modern music, and like the Friends, also distributes films which would otherwise not be available in Germany. The Eiszeit is one of about twenty-five "off-kinos" in Berlin: an "off-kino" is off by virtue of its program not location—a mix of repertory and new independent work—and may also be known as a *Programmkino*. In the complex and fluctuant network between filmmaking and film showing there exists in Berlin a nourishing and immediate symbiosis, and a feeling of the connectedness of Berlin to world cinema.

 Dislocation is an experience familiar to Berlin life and a theme frequent in Berlin art. The dislocation derives in part from the city's spectacular resurrection and its disassociation with a past that in spite of cursory reminders becomes

Figure 9: Yvonne Rainer. *Working Title: Journeys from Berlin 1971*. 1980

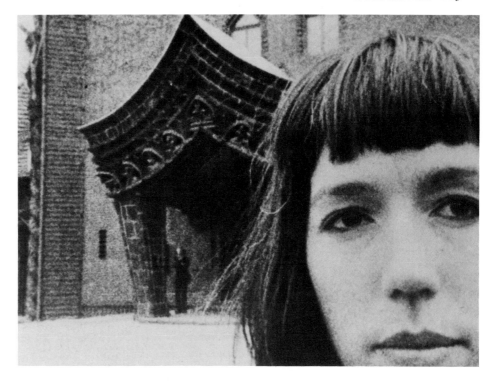

Notes

1. *Kuhle Wampe* was the name of a tent camp for the unemployed outside Berlin.
2. Klaus Eder, *Peter Lilienthal* (Munich: Goethe-Institut, 1984), p. 2. Trans. Margaret Deriaz.
3. Jonathan Swift, *Gulliver's Travels* (London: Penguin Books, 1984), Part 3 ("A Voyage to Laputa, Balbinarbi, Glubbdubdrib, Luggnagg, and Japan"), p. 207.
4. The Friends of the German Cinematheque and the German Cinematheque itself (Die Stiftung Deutsche Kinemathek) are two separate entities. The Cinematheque, founded in 1963 with the film and memorabilia collections of Gerhard Lamprecht, is an archive that maintains a publishing division, a cinema, and a direct connection to the DFFB.

increasingly, not less, unthinkable. It also derives in part, of course, from its concrete geographic isolation. The DAAD program is one of several official maneuvers to keep Berlin culturally contiguous to the rest of the West. DAAD's first two film fellows were Americans living in Europe: Robert Beavers, who made *Diminished Fame* (1970), and Steve Dwoskin. Out of Dwoskin's residency emerged *Little Bird* (*Kleiner Vogel*) and *Just Waiting*, which sees Berlin as a space suffused with consumerism, bad history, and anxiety. Ernie Gehr, a more recent American fellow, does not have as negative a view of Berlin, but also deals with the conjunction of past and present. Gehr's film *Signal—Germany on the Air* (figure 8) works neatly with the notion of the city as an international port and cleverly with the idea of guilt. Visually the film is comprised of shots of exterior streets and fields full of stationary verticals and fluid horizontals. The soundtrack, which commences with a foreign shout, is a mixture of natural sounds, including rain and traffic, and "insignificant" snippets taken from Berlin's multilingual airwaves.

DAAD filmmakers form an eclectic international group bound only by their Berlin residency. The program does not require that works necessarily be made there. For example, Yvonne Rainer's 1980 film *Working Title: Journeys from Berlin 1971* (figure 9) was for the most part not shot in that city. *Journeys* is a complex and lengthy work that appears to be unfinished, but is replete with ideas and confessions in seemingly discrete sequences. It rambles purposefully and openly, and is thematically consistent with most independent Berlin films: the intellectual focus is on choice, identity, and the slippery crisis area between private morality and public action.

In Berlin, filmmakers (of whom only a small number has been discussed here), producers, support groups, festivals and events, institutions, organizations, and schools work independently, but nevertheless manage to form a kind of mercurial and inchoate network. The effect of this on the recent history of cinema in Berlin not only favors the art of film itself but grounds it deeply and uniquely in Berlin's peculiar social and emotional soul to blossom into a cinema ripe with alienation, disputatiousness, and humanity.

Biographies of the Filmmakers

ALFRED BEHRENS

1944　Born Altona
1962　Began living in Berlin
1968　First radio plays

Principal Films

1976　*Der Tod meines Vaters (The Death of my Father)* (made with Michael Kuball)
1980　*Sie verlassen den amerikanischen Sektor (You are Leaving the American Sector)*
1982　*Berliner Stadtbahnbilder (Images of Berlin's City Railway)*
1985　*Walkman Blues*

STEPHEN DWOSKIN

1939　　Born New York
1974–75　DAAD fellowship in Berlin
　　　　Lives in London

Principal Films

1961　*Asleep*
1963　*Chinese Checkers*
1964　*Alone*
1968　*Me, Myself and I*
1967　*Soliloquy*
1968　*Take Me*
1970　*Trixi*
1971　*Times For*
1971　*Dirty*
1972　*Oyn Amo*
1973　*Tod und Teufel (Death and Devil)*
1974　*Behindert (Hindered)*
1975　*Just Waiting*
1975　*Girl*
1976　*Central Bazaar*
1976　*Kleiner Vogel*
1977　*The Silent Cry*
1981　*Das innere Bloss (Outside In)*
1983　*Shadows from Light*
1986　*Ballet Black*

ERNIE GEHR

1943　Born United States
1982　DAAD fellowship in Berlin

Principal Films

1968　*Morning*
1968　*Wait*
1969　*Transparency*
1970　*History*
1970　*Serene Velocity*
1971　*Still*
1974　*Shift*
1976　*Table*
1979　*Eureka (Geography)*
1981　*Mirage*
1985　*Signal—Germany on the Air*

LOTHAR LAMBERT

1944　Born Rudolfstadt, Thuringia
　　　Spent childhood in Berlin
　　　Studied at Free University, Berlin
　　　Works as film and television critic
　　　Lives in Berlin

Principal Films

1971　*Kurzschluss* (made with Wolfram Zobus)
1972　*Ex und Hopp* (made with Wolfram Zobus)
1973　*Sein Kampf/Ein Schuss Sehnsucht (His Struggle/A Touch of Longing)* (made with Wolfram Zobus)
1974　*1 Berlin-Harlem* (made with Wolfram Zobus)

1979　*Tiergarten*
1980　*Die Alptraumfrau (Nightmare Woman)*
1981　*Fucking City*
1982　*Fräulein Berlin*
1983　*Paso Doble—Ein Paar tanzt aus reihe (Paso Doble—Dancing Out of Line)*
1984　*Drama in Blond*
1986　*Die Liebeswüste (The Desert of Love)*

JEANINE MEERAPFEL

1943　　Born Buenos Aires, Argentina
1964–68　Studied at Film Institute, Ulm
　　　　Lives in Berlin

Principal Films

1967　*Regionalzeitung (Regional Newspaper)*
1981　*Malou*
1981　*Im Land meiner Eltern (In the Land of My Parents)*
1985　*Die Kümmeltürkin geht (Melek Leaves)*
1987　*Die Verliebten (Days to Remember)*

ELFI MIKESCH (also known as OH MUVIE)

1940　Born Austria
1966　Moved to Berlin
1969　Made photo-novel *Oh Muvie* (with Rosa von Praunheim)
1978　Worked on *Frauen und Film* magazine
　　　Lives in Berlin

Principal Films

1971　*Charisma*
1975　*Family Sketch*
1978　*Ich denke oft an Hawaii—ein Film für jedes Wohnzimmer (I Often Think of Hawaii)*
1979　*Exekution—A Study of Mary*
1980　*Was soll'n wir denn machen ohne den Tod (What Would We Do Without Death)*
1982　*Macumba*
1983　*Canale Grande* (made with Friederike Pezold)
1985　*Verführung: die grausame Frau (Seduction: The Cruel Woman)* (made with Monika Treut)

ULRIKE OTTINGER

1942　Born Konstanz
1973　Moved to Berlin

Principal Films

1973　*Vostell Berlinfieber (Berlin Fever—Wolf Vostell)*
1974　*Laokoon und Söhne (Laocoön and Sons)* (made with Tabea Blumenschein)
1975　*Die Betörung der blauen Matrosen (The Enchantment of the Blue Sailors)* (made with Tabea Blumenschein)
1977　*Madame X—eine absolute Herrscherin (Madame X—An Absolute Ruler)*
1979　*Bildnis einer Trinkerin (Portrait of a Woman Drinker/Ticket of No Return)*
1981　*Freak Orlando*
1983　*Dorian Gray im Spiegel der Boulevardpresse (Dorian Gray as Reflected in the Yellow Press)*
1985　*China—Die Künste, Der Alltag (China—The Arts, The Everyday)*
1986　*Superbia (Pride)*

ROSA VON PRAUNHEIM

1942　　Born Holger Mischwitsky, Riga, Latvia
1944　　Moved to Berlin
1954–61　Lived in Praunheim district of Frankfurt
1962–67　Studied at Hochschule für bildende Künste, Berlin
1969　　Made photo-novel *Oh Muvie* (with Elfi Mekesch)
　　　　Lives in Berlin

Principal Films

1967　*Von Rosa von Praunheim*
1968　*Grotesk-burlesk-pittoresk* (with Werner Schroeter)
1968　*Rosa Arbeiter auf goldener Strasse*
1969　*Schwestern der Revolution (Sisters of the Revolution)*
1970　*Die Bettwurst (The Bed Sausage)*
1971　*Nicht der Homosexuelle ist pervers, sondern die Situation, in der er lebt (It Is Not the Homosexual Who Is Perverse but the Situation in which He Lives)*
1972　*Leidenschaften (Passions)*
1976　*Underground and Emigrants*
1977　*Ich bin ein Antistar: Das skandalöse Leben der Evelyn Künneke (I Am an Antistar: The Scandalous Life of Evelyn Künneke)*
1979　*Tally Brown, New York*
1979　*Army of Lovers or, Revolt of the Perverts*
1981　*Unsere Leichen leben noch (Our Bodies Are Still Alive)*
1982　*Rote Liebe (Red Love)*
1983　*Stadt der verlorenen Seelen—Berlin Blues (City of Lost Souls—Berlin Blues)*
1984　*Horror Vacui—die Angst vor der Leere (Horror Vacui—The Fear of Emptiness)*
1986　*Ein Virus kennt keine Moral (A Virus Respects no Morals)*
1987　*Dolly, Lotte and Maria*
1987　*Anita—Dances of Vice*

YVONNE RAINER

1934　　Born San Francisco
1976–78　DAAD fellowship in Berlin
　　　　Lives in New York

Principal Films

1967　*Volleyball*
1968　*Trio Film*
1972　*Lives of Performers*
1974　*Film about a Woman Who. . .*
1976　*Kristina Talking Pictures*
1980　*Working Title: Journeys from Berlin 1971*
1985　*The Man Who Envied Women*

HELGA REIDEMEISTER

1940　　Born Halle/Saale
1961–65　Studied at Hochschule für bildende Künste, Berlin
1973–77　Studied at DFFB, Berlin
　　　　Lives in Berlin

Principal Films

1977　*Der gekaufte Traum (The Bought Dream)*
1979　*Von wegen "Schicksal" (Who Says It's Fate!)*
1983　*Mit starrem Blick aufs Geld (With One Eye on the Money)*
1987　*DrehOrt Berlin (Film Location Berlin)*

HELKE SANDER

1937	Born Berlin
1965	Studied at DFFB, Berlin
1973	Organized (with Claudia von Alemann) First International Women in Film Seminar
1974–83	Founded and edited *Frauen und Film* magazine
	Lives in Berlin

Principal Films

1966	*Subjektitüde (Subjectivity)*
1967	*Silvo*
1969	*Kinder sind keine Rinder (Children Are Not Cattle)*
1971	*Eine Prämie für Irene (A Bonus for Irene)*
1972	*Macht die Pille frei? (Does the Pill Liberate?)*
1977	*Die allseitig reduzierte Persönlichkeit— Redupers (The All-round Reduced Personality—Redupers)*
1981	*Der subjektive Faktor (The Subjective Factor)*
1984	*Der Beginn aller Schrecken ist Liebe (The Trouble with Love)*
1986	*Futtern! (Gluttony)*

HELMA SANDERS-BRAHMS

1940	Born Helma Sanders, Emden, East Friesland
	Lives in Berlin

Principal Films

1969	*Angelika Urban, Verkäuferin, verlobt (Angelika Urban, Salesgirl, Engaged)*
1970	*Gewalt (Violence)*
1973	*Die letzten Tage von Gomorrha (The Last Days of Gomorrha)*
1974	*Unter dem Pflaster ist der Strand (Under the Pavement is Sand)*
1975	*Shirins Hochzeit (Shirin's Wedding)*
1977	*Heinrich*
1979	*Deutschland, bleiche Mutter (Germany, Pale Mother)*
1981	*Die Berührte (No Mercy, No Future)*
1984	*Flügel und Fesseln (The Future of Emily)*
1986	*Laputa*

MANFRED STELZER

1944	Born Goeggingen, Bavaria
1972–76	Studied at DFFB, Berlin
	Lives in Berlin

Principal Films

1972	*Allein machen sie dich ein* (made with Suzanne Beyler, Rainer März)
1975	*Wir haben nie gespürt, was Freiheit ist* (made with Johannes Flütsch)
1979	*Monarch* (made with Johannes Flütsch)
1981	*Die Perle der Karibik (The Pearl of the Caribbean)*
1983	*Schwarzfahrer*
1984	*Thron und Taxis*
1985	*Geschichten aus zwölf und einem Jahr (Tales of Twelve and One Years)*
1987	*Die Chinesen kommen (The Chinese are Coming)*

CHRISTIAN ZIEWER

1941	Born Danzig
	Lived in Berlin as a child
1966–68	Studied at DFFB, Berlin
	Lives in Berlin

Principal Films

1967	*Karl Moll, Jahrgang 30*
1969	*Liebe Mutter, mir geht es gut (Dear Mother, I am Well)*
1974	*Schneeglöckchen blühn im September (Snowdrops Bloom im September)*
1976	*Der aufrechte Gang (Walking Tall)*
1978	*Aus der Ferne sehe ich dieses Land (From Afar I see My Land)*
1985	*Der Tod des weissen Pferdes (The Death of the White Steed)*

Super-8mm Filmmakers:

MICHAEL BRINNTRUP

Born 1959, Münster
Film: *Der Rhein, ein deutsches Märchen*, 1983

CHRISTOPH DOERING

Born 1953, Aschaffenburg
Film: *3302*, 1979

GABO

Film: *Einkriegezeck*, 1984

KNUT HOFFMEISTER

Born 1956
Film: *Berlin/Alamo*, 1980

DIE TÖDLICHE DORIS

(Wolfgang Müller, Nikolaus Utermöhlen, Dagmar Dimitroff)
Film: *Das Leben des Sid Vicious*, 1982

TEUFELSBERG–PRODUKTION

(Ades Zabel, Ogar Grafe, Barbara Hamer)
Film: *Bilder aus unserer Heimatstadt*, 1983

Selected Bibliography

Beatt, Cynthia, and Voser, Silvia (eds.). *Berlin im Film 1965–1985* (Berlin: Freunde der deutschen Kinemathek, 1985).

Berg-Ganschow, Uta (ed.). *Berlin. Aussen und Innen. 53 Filme aus 90 Jahren. Materialien zu einer Retrospektive* (Berlin: Stiftung Deutsche Kinemathek, 1984).

Ortkemper, Hubert (ed.). *Film in Berlin. 5 Jahre Berliner Filmförderung* (Berlin: Colloquium Verlag Otto H. Hess, 1983).

Rosenbaum, Jonathan. *Film: The Front Line —1983* (Denver: Arden Press Inc., 1983).

Sanborn, Keith J. *Super-8/Berlin. The Architecture of Division* (Buffalo: Hallwalls, 1983).

Silberman, Marc. "Camera Obscura: A Journal of Feminism and Film Theory/6," in *Women Filmmakers in West Germany: A Catalog* (Berkeley: Camera Obscura Collective, 1980), pp. 123–152.

Silberman, Marc. "Camera Obscura: A Journal of Feminism and Film Theory/11," in *Women Filmmakers in West Germany: A Catalog (Part 2)* (Berkeley: Camera Obscura Collective, 1983), pp. 133–145.

Plates

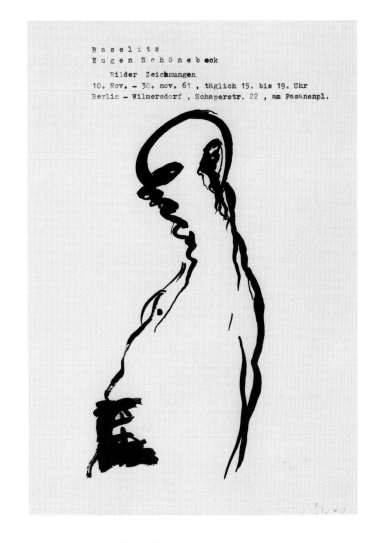

1 Georg Baselitz. *Invitation*. 1961

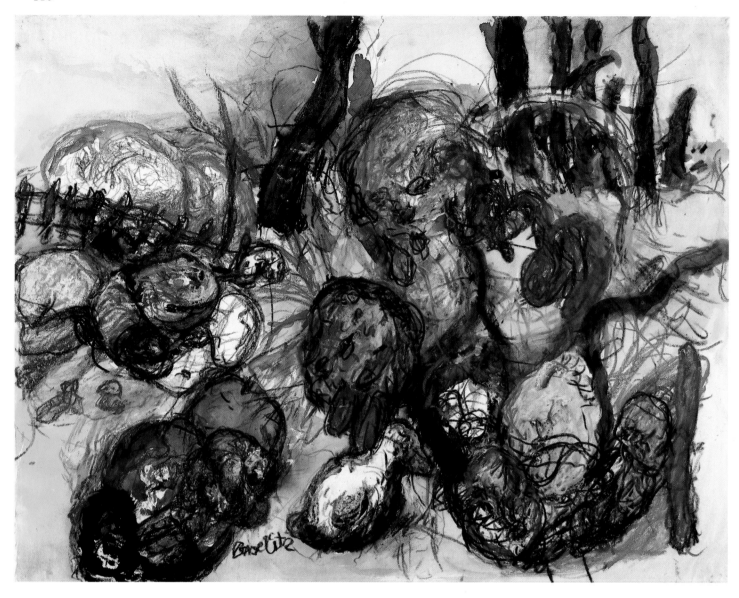

2 Georg Baselitz. *Saxon Landscape*. 1962–63

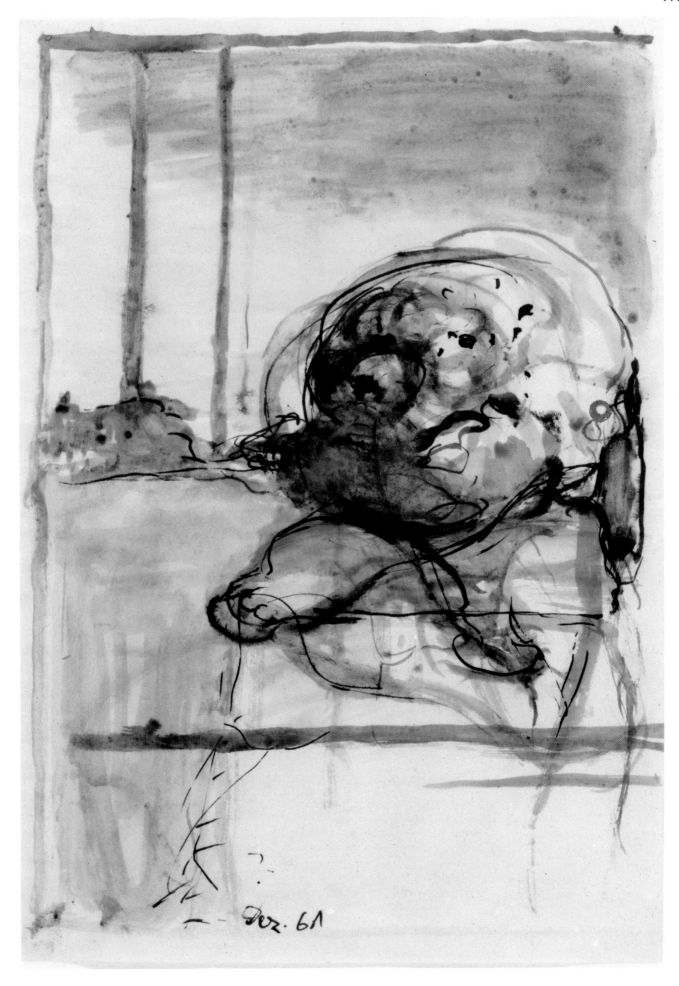

3 Georg Baselitz. *Amorphous Landscape.* 1961

112

[4–13] Georg Baselitz. *P.D. Feet.* 1963

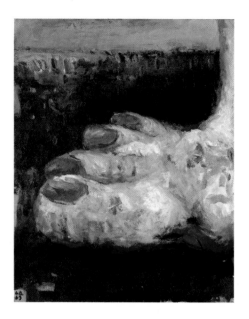

4 *First P.D. Foot: The Foot*

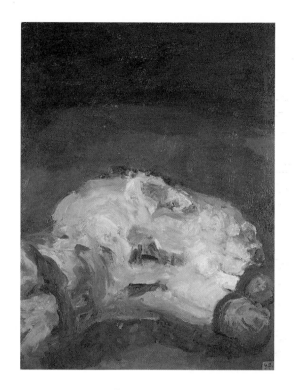

5 *Second P.D. Foot: Birthplace*

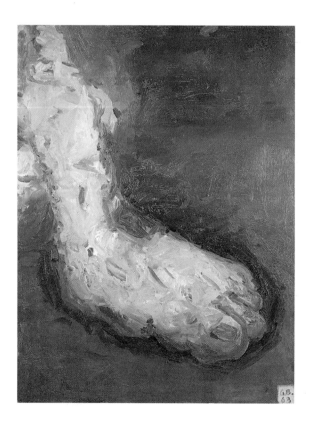

6 *Third P.D. Foot*

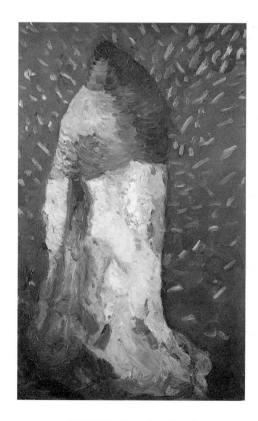

7 *Fifth P.D. Foot: Russian Foot*

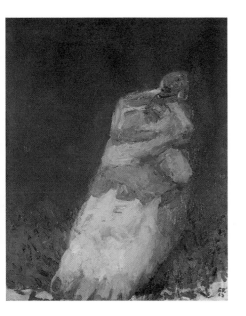

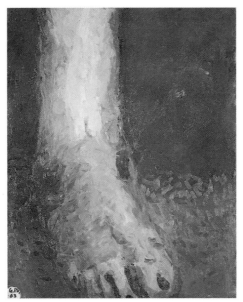

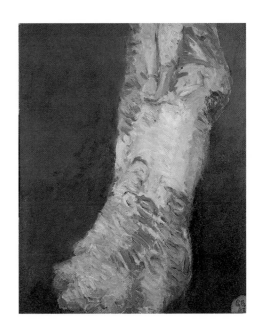

8 *Sixth P.D. Foot*

9 *P.D. Foot: Celt*

10 *Eighth P.D. Foot: The Hand*

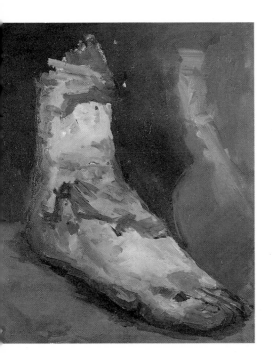

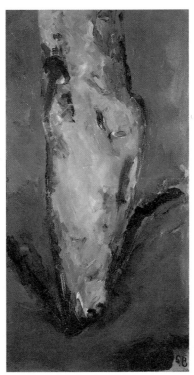

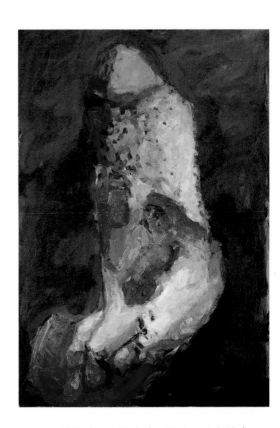

11 *P.D. Foot*

12 *P.D. Foot*

13 *P.D. Foot: Birthplace Existential Cleft*

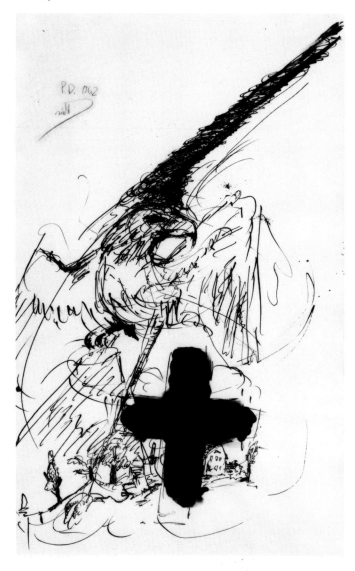

14 Georg Baselitz. *Pandemonium Drawing*. 1962

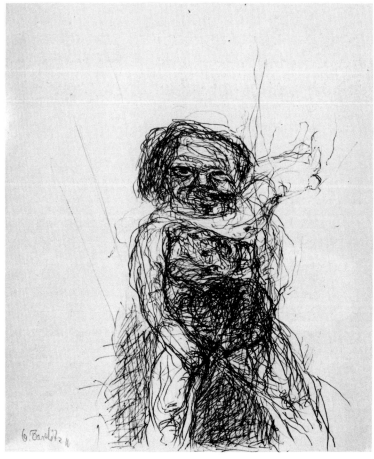

15 Georg Baselitz. *Antonin Artaud*. 1962

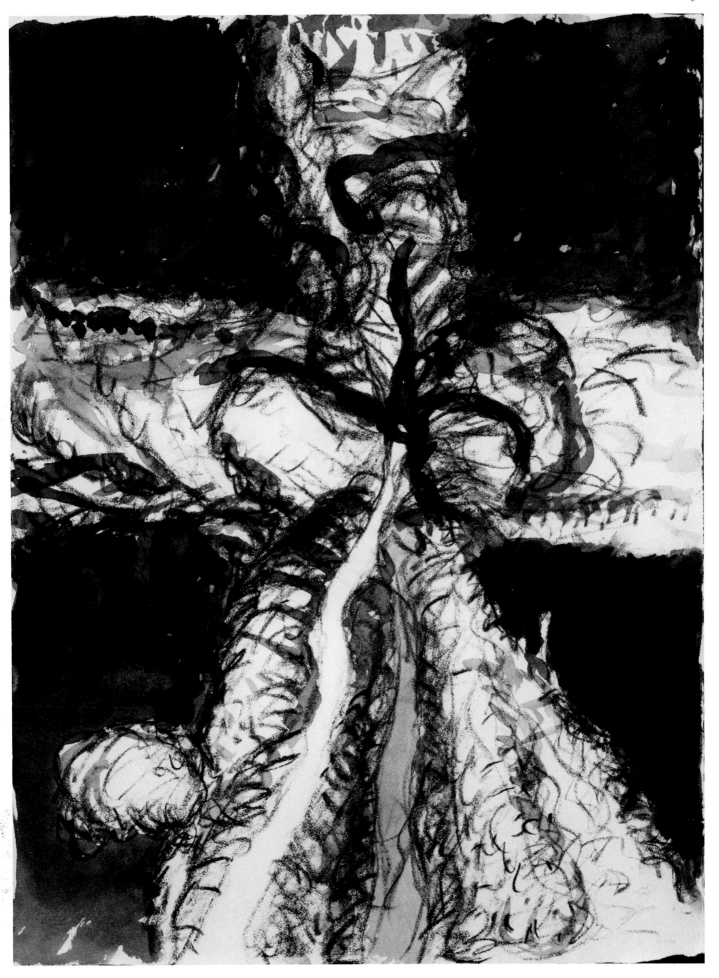

16 Georg Baselitz. *Cross.* 1964

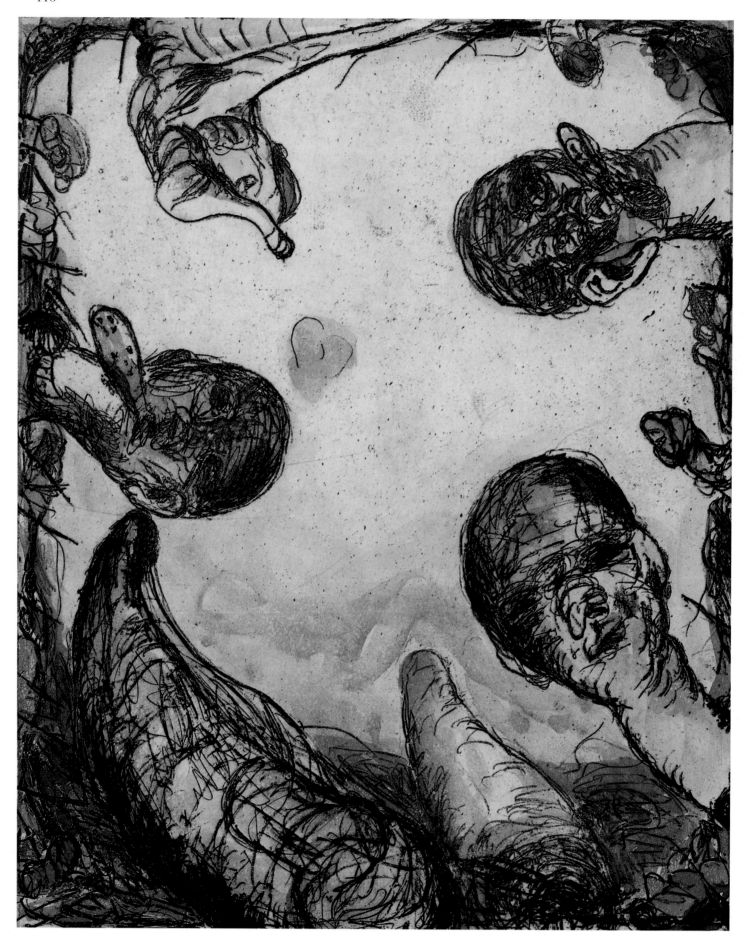

17 Georg Baselitz. *Oberon*. 1963–64

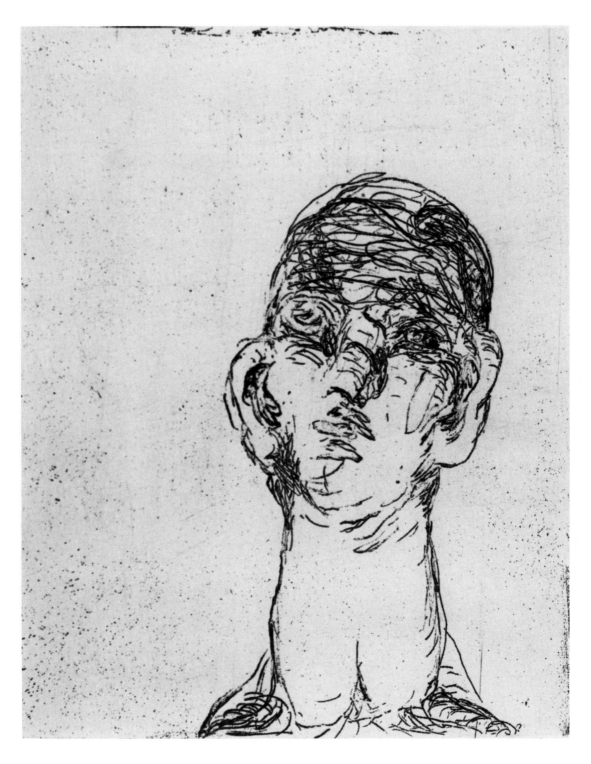

18 Georg Baselitz. *Idol.* 1964

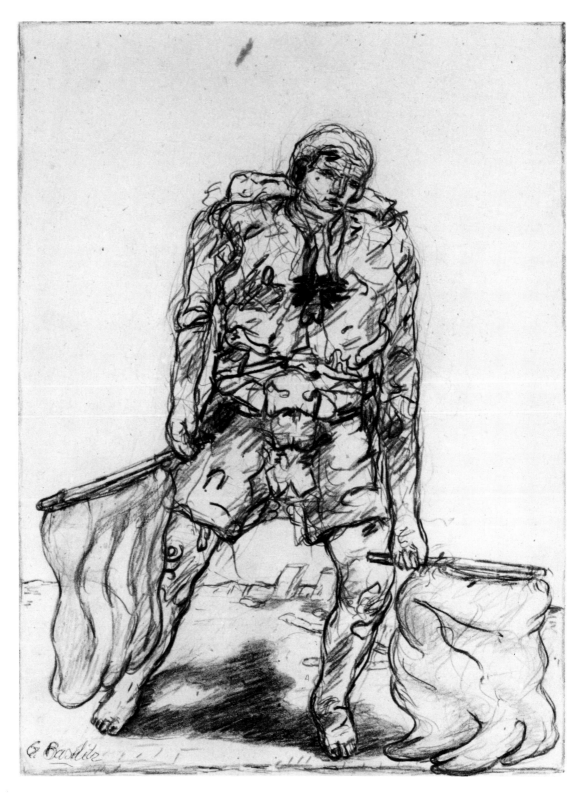

19 Georg Baselitz. *Untitled (Hero).* 1965

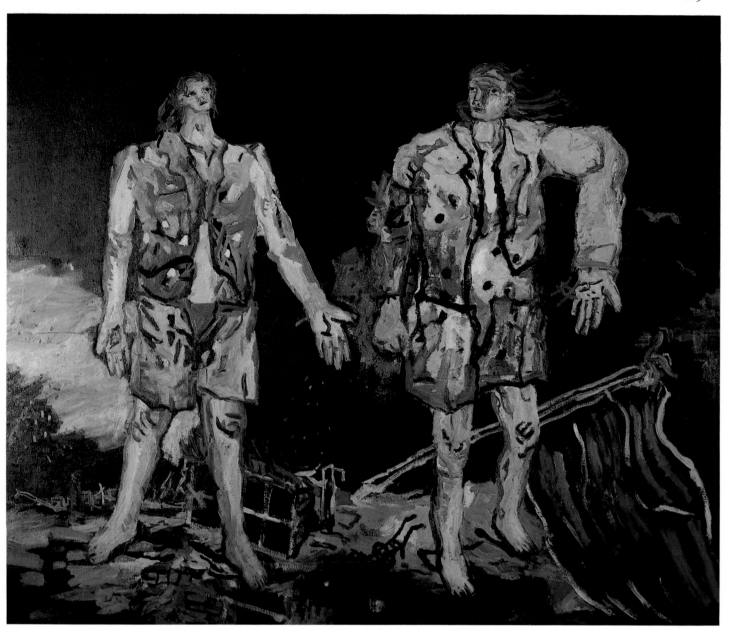

20 Georg Baselitz. *The Great Friends*. 1965

21 Georg Baselitz. *Untitled (Tree).* 1965

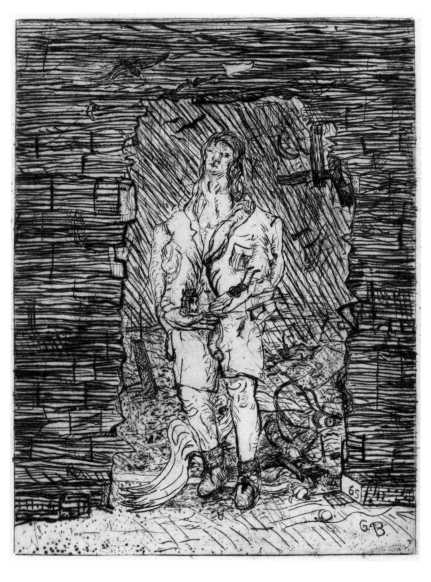

22 Georg Baselitz. *Untitled.* 1965

23 Georg Baselitz. *Shepherd.* 1966

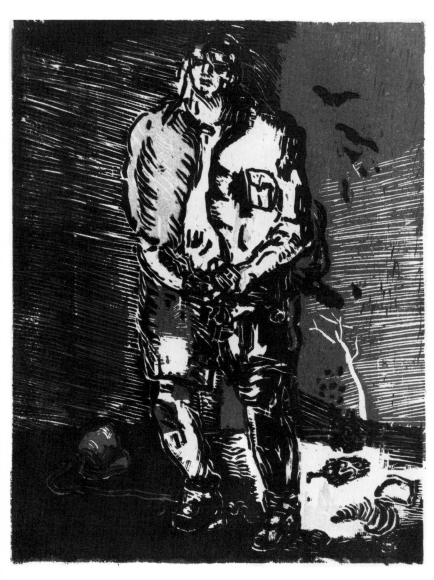

24 Georg Baselitz. *L. R.* 1966

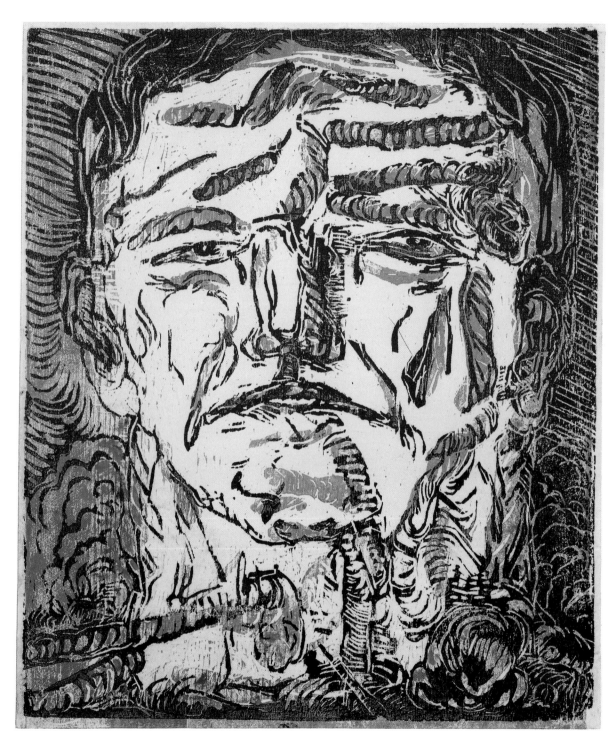

25 Georg Baselitz. *Large Head.* 1966

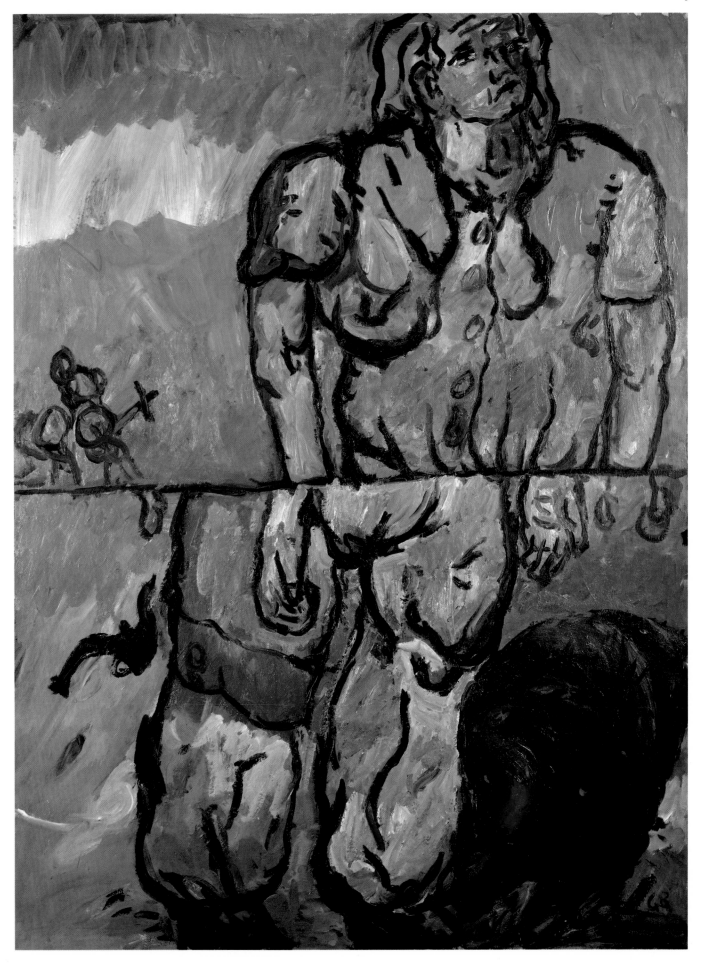

26 Georg Baselitz. *MMM in G and A*. 1961–66

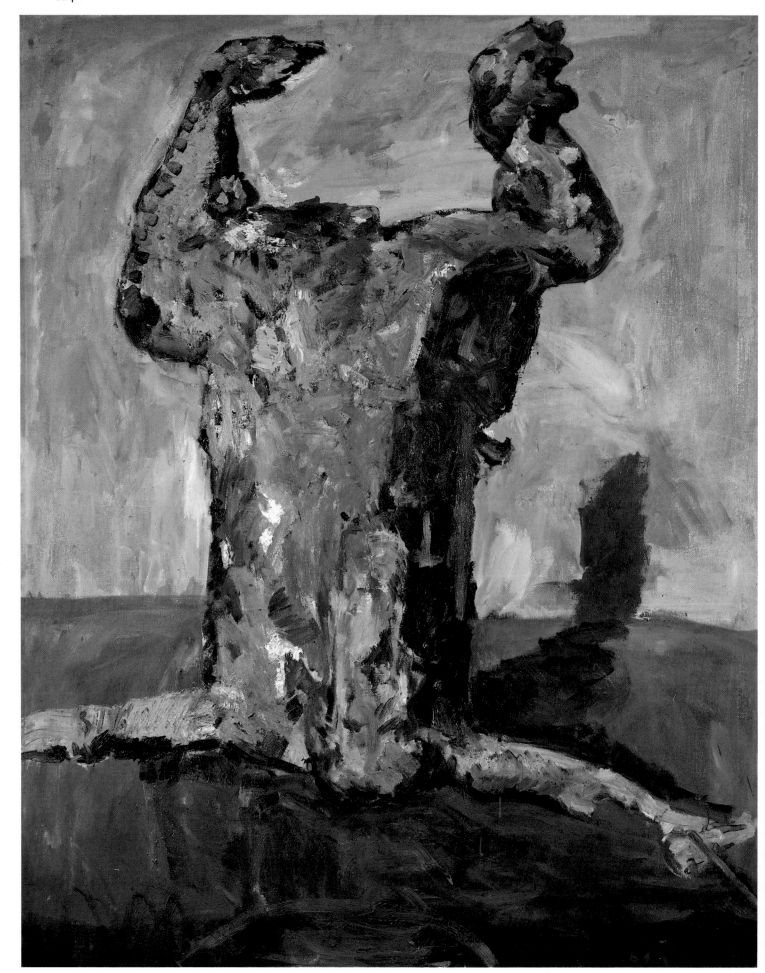

27 Eugen Schönebeck. *Bait.* 1963

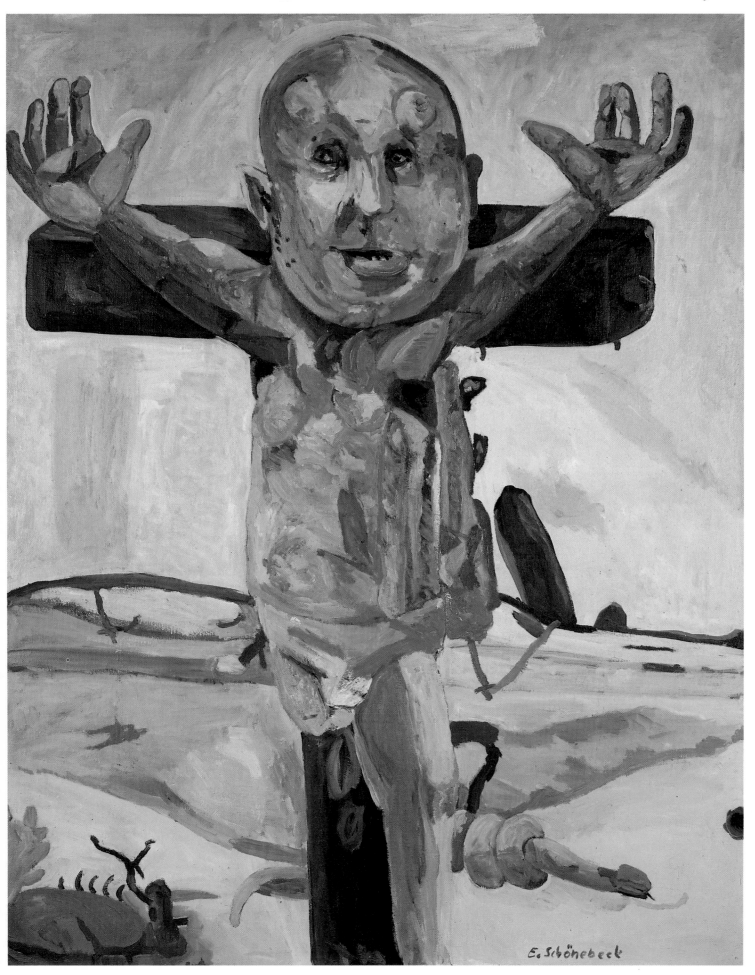

28 Eugen Schönebeck. *The Crucified.* 1964

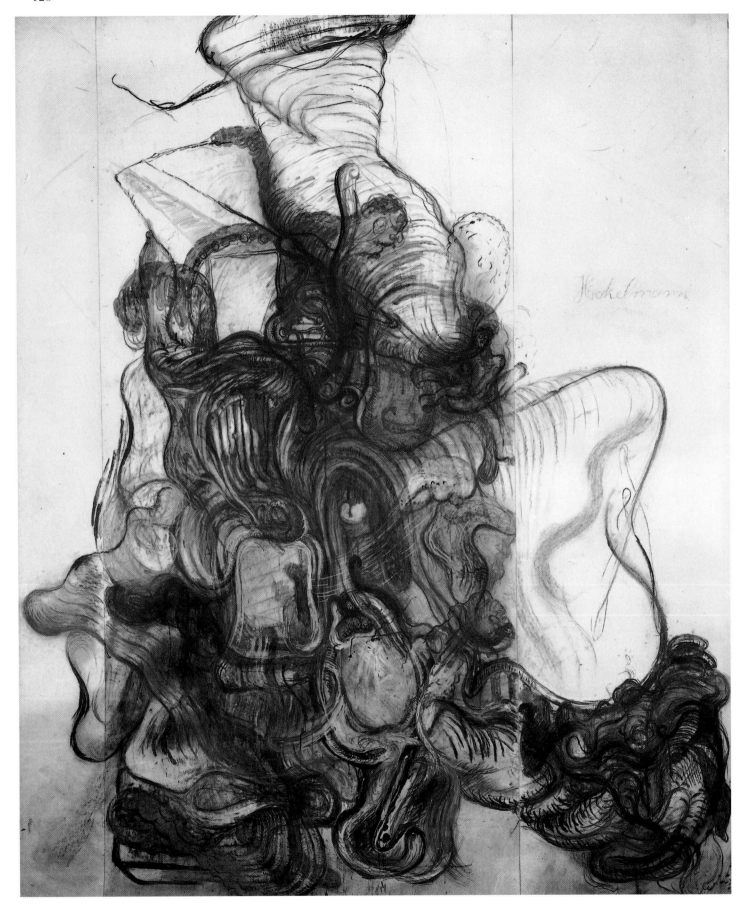

29 Antonius Höckelmann. *Shepherd's Life.* 1966

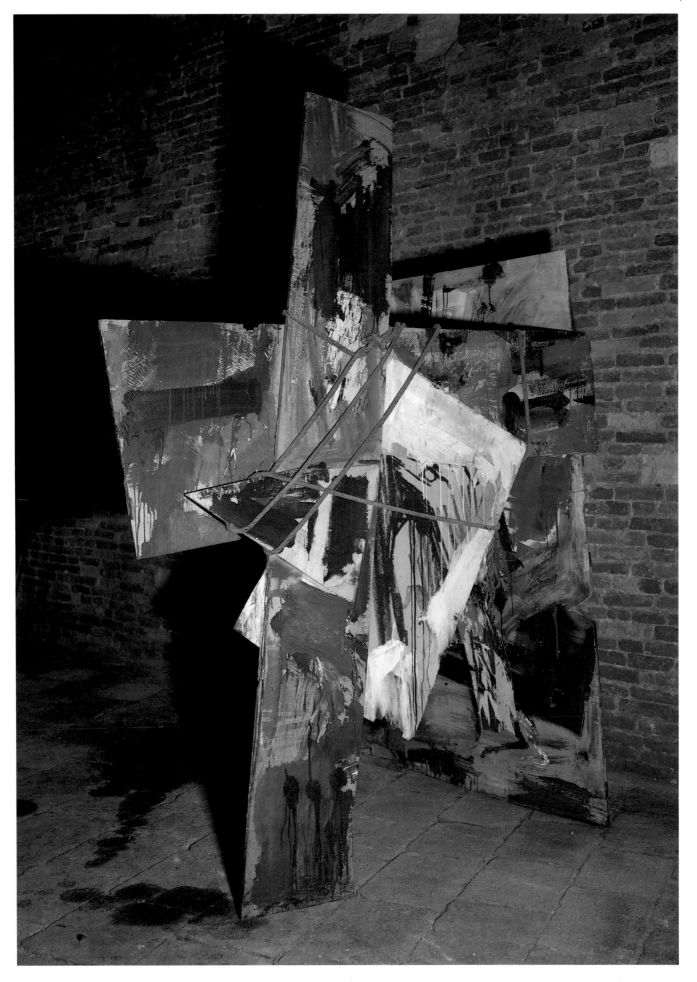

30 Emilio Vedova. *Absurd Berlin Diary '64: Plurimo N–6.* 1964

31 Fred Thieler. *Epitaph for Franz Kline.* 1962

32 Fred Thieler. *Evergreen.* 1963

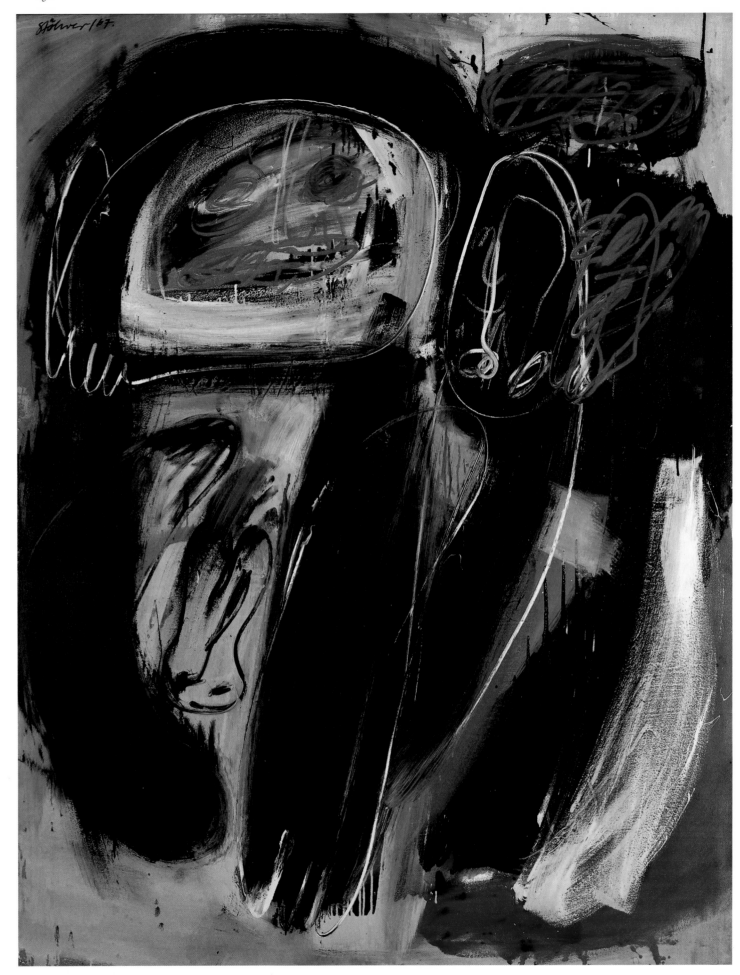

33 Walter Stöhrer. *Figure.* 1967

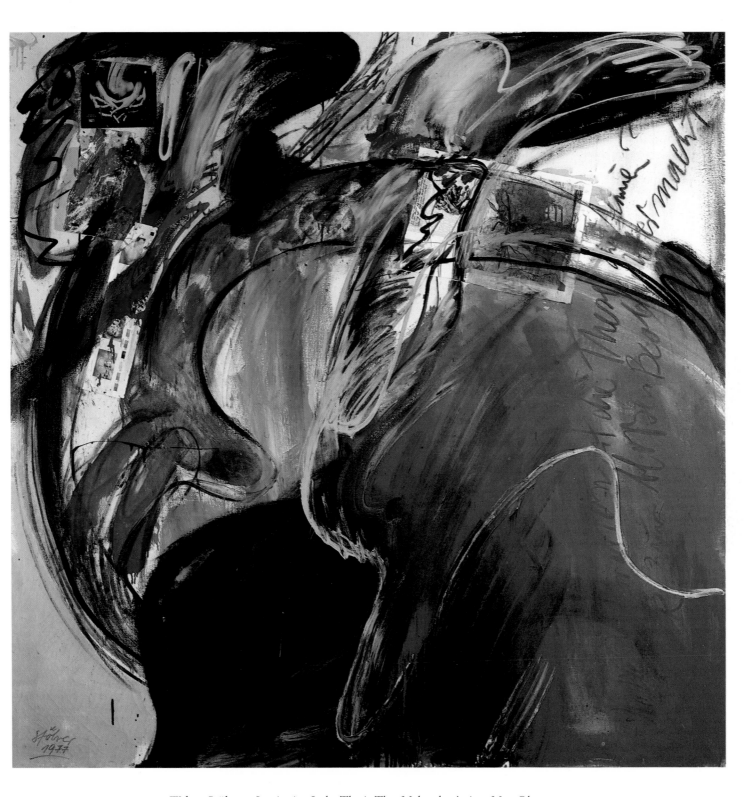

34 Walter Stöhrer. *Inspiration Is the Thesis That Makes the Artist a Mere Observer.* 1977

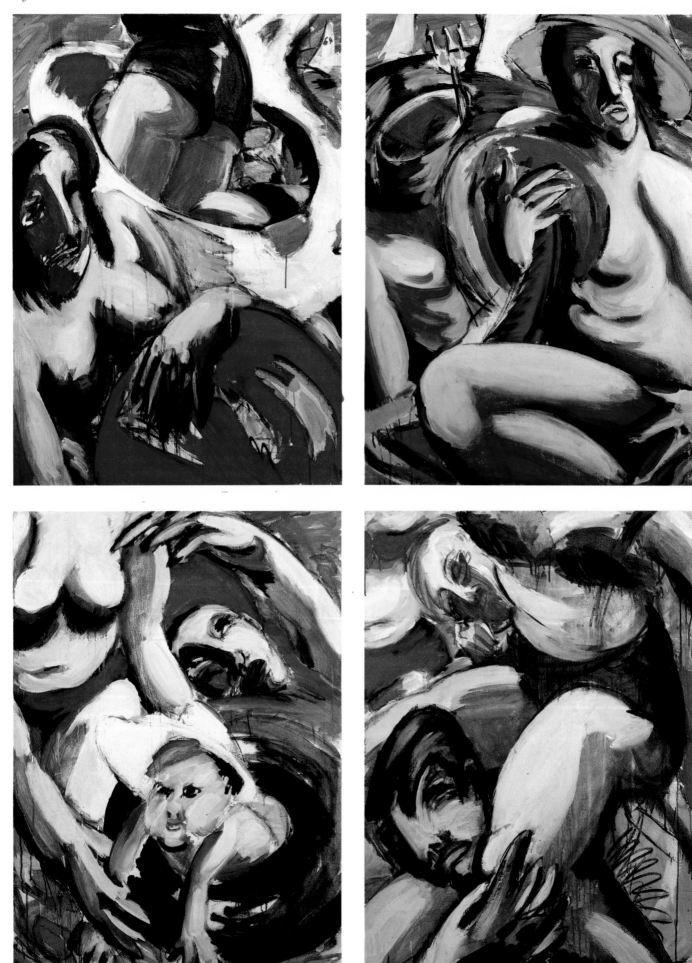

35 K. H. Hödicke. *At Grosses Fenster.* 1964

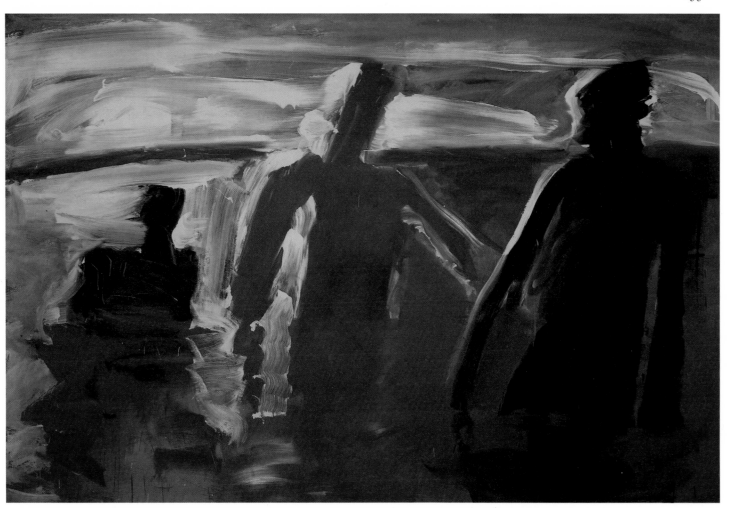

36 K. H. Hödicke. *Against the Light.* 1976

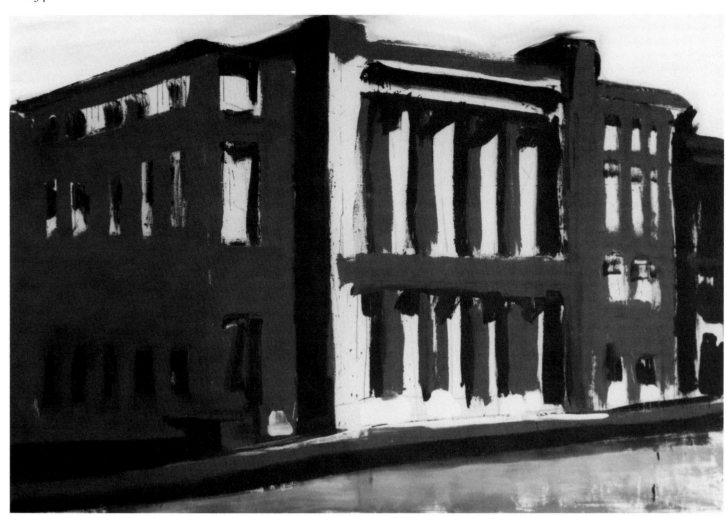

37 K. H. Hödicke. *War Ministry*. 1977

38 K. H. Hödicke. *Nocturne.* 1983

39 Markus Lüpertz. *Dithyramb (Triptych)*. 1964

40 Markus Lüpertz. *Interior III*. 1974

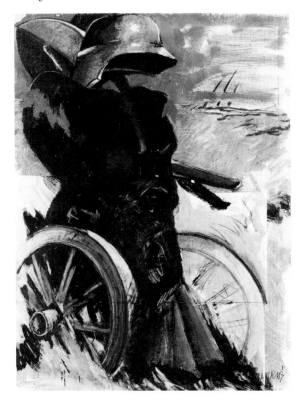

41 Markus Lüpertz. *Black–Red–Gold: Dithyrambic.* 1974

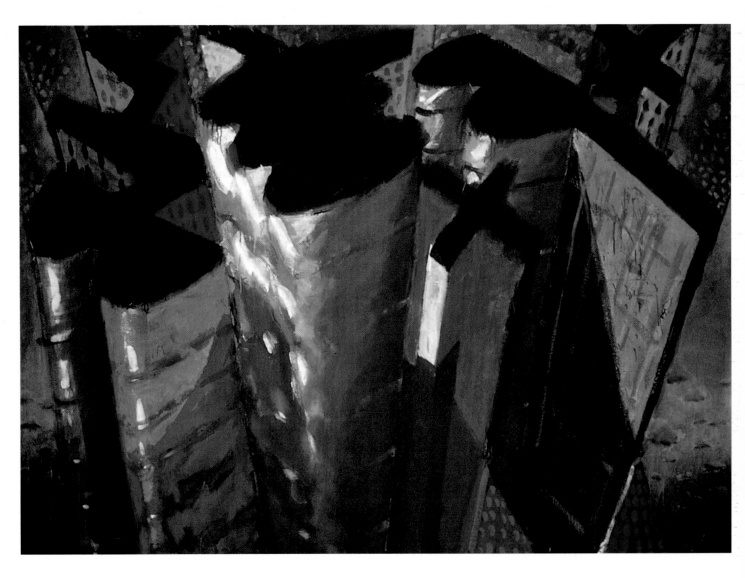

42 Markus Lüpertz. *Lüpolis: Dithyrambic.* 1975

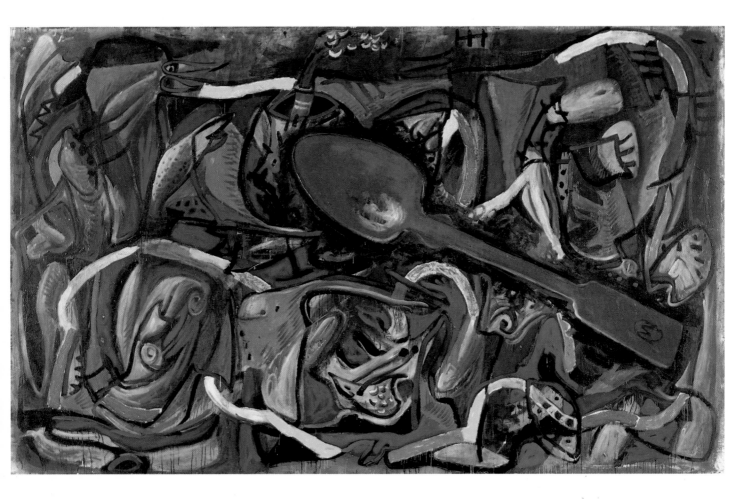

43 Markus Lüpertz. *The Big Spoon.* 1982

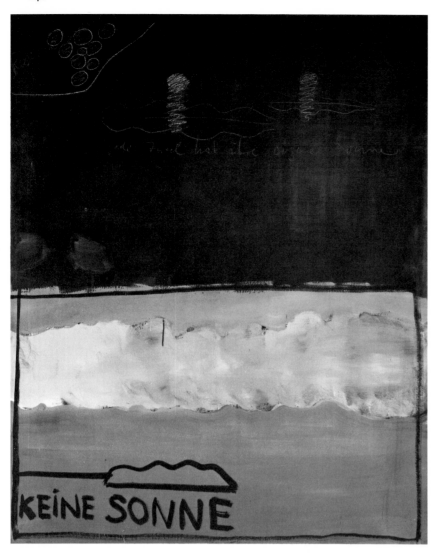

44 Bernd Koberling. *No Sun*. 1969

45 Bernd Koberling. *Fishing*. 1963

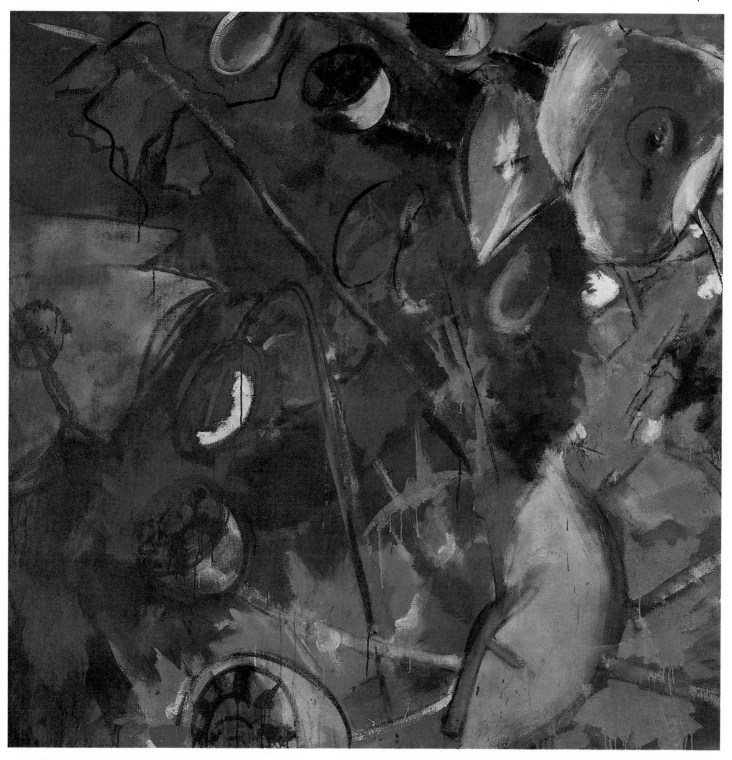

46 Bernd Koberling. *Bud Bloom Pod 1.* 1976

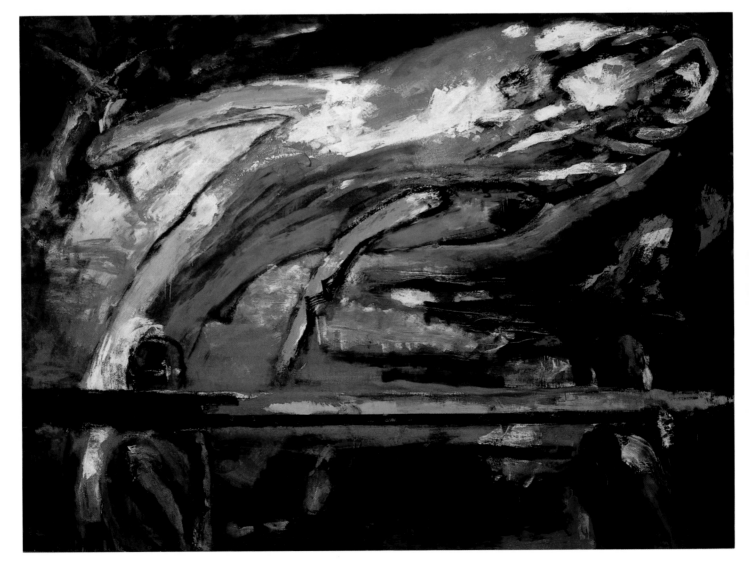

47 Bernd Koberling. *Touching the Horizon.* 1986

48 David Hockney. *Berlin: A Souvenir*. 1962–63

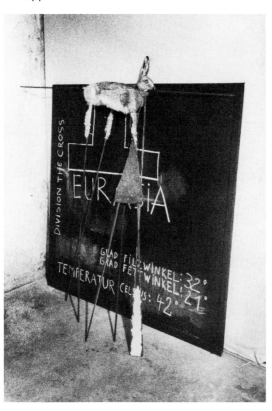

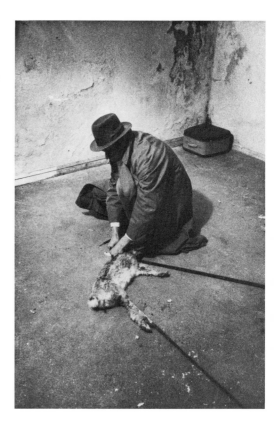

49 Joseph Beuys.
*Eurasia: 32nd Movement
of the Siberian Symphony.*
Performed at Galerie René Block,
Berlin, October 28, 1966

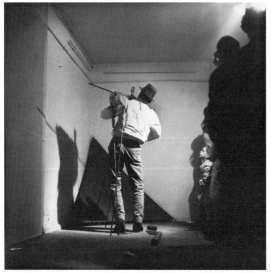

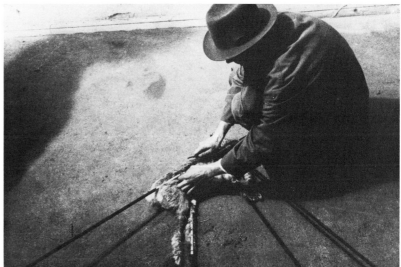

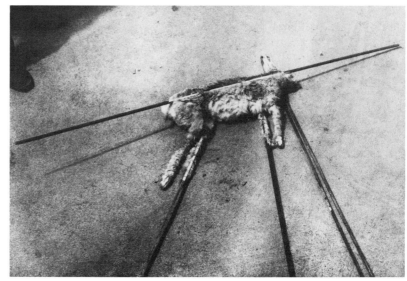

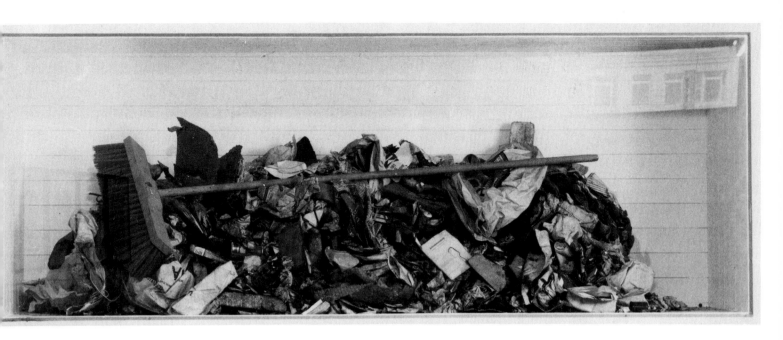

50 Joseph Beuys. *Sweep Up*. 1972

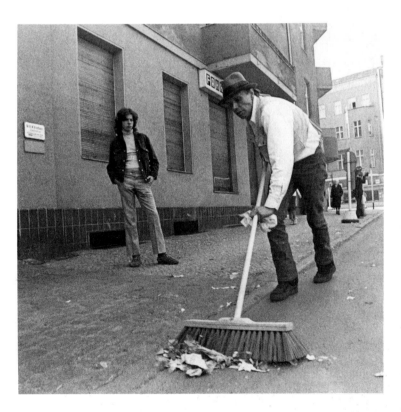

Joseph Beuys. *Sweep Up*. Berlin, May 1, 1972

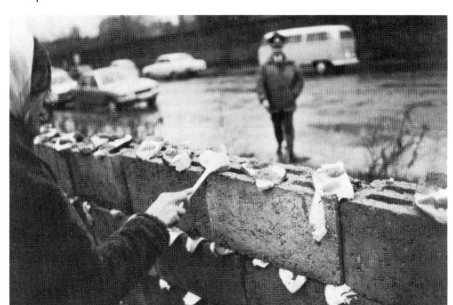

51 Allan Kaprow. *A Sweet Wall.*
Berlin, November 9, 1970

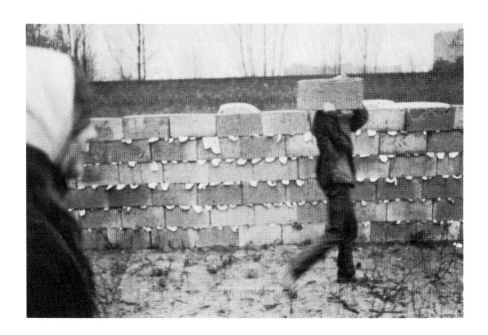

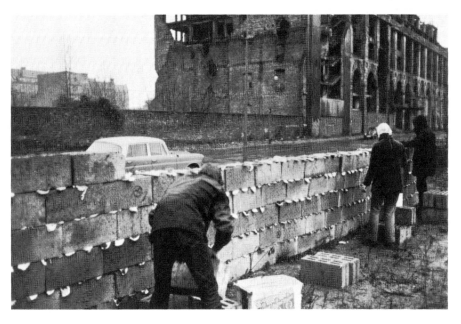

52 Ludwig Gosewitz. *Sundial*. 1968

53 Ludwig Gosewitz. *Big Inversion with Shipwrecked Person*. 1968

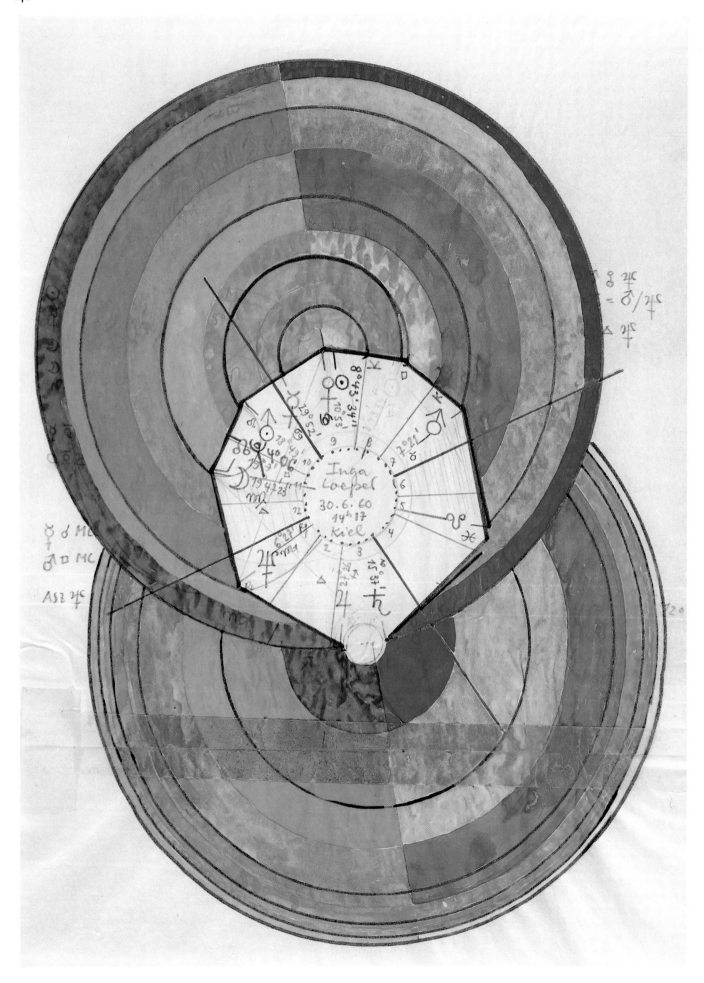

54 Ludwig Gosewitz. *Natal Figure: 30.6.1960 (Inga Loeper).* 1980

55 Ludwig Gosewitz. *Planetary Clock.* 1968. Detail

56 Arthur Koepcke. *Continue.* 1972

57 Arthur Koepcke. *Piece 65.* 1966

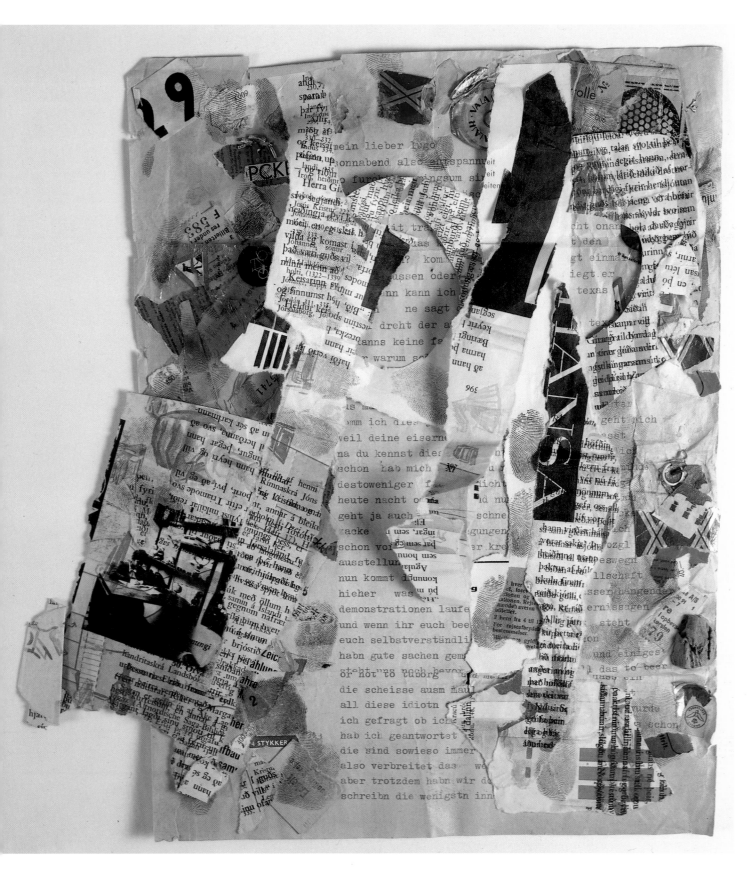

58 Arthur Koepcke. *Letter to Ludwig Gosewitz.* 1962

59 Tomas Schmit. *The Heisenberg Uncertainty Principle.* 1971

60 Tomas Schmit. *Heisenberg's Peach Sofa, with Sybil.* 1971

61 Tomas Schmit. *The Atlas Nipples.* 1976

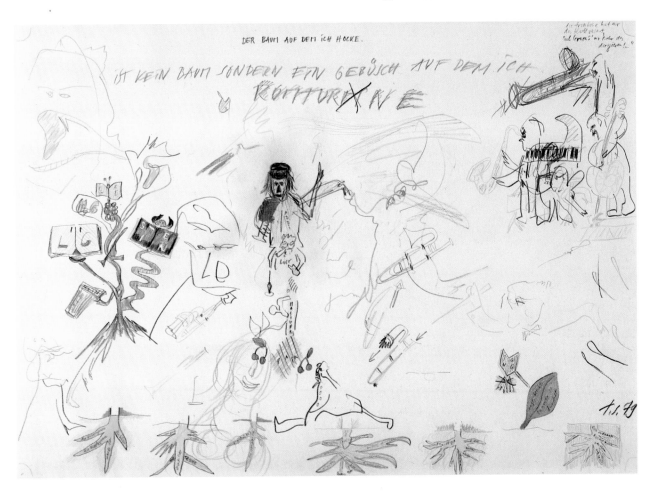

62 Tomas Schmit. *The Tree on Which I Sit.* 1979

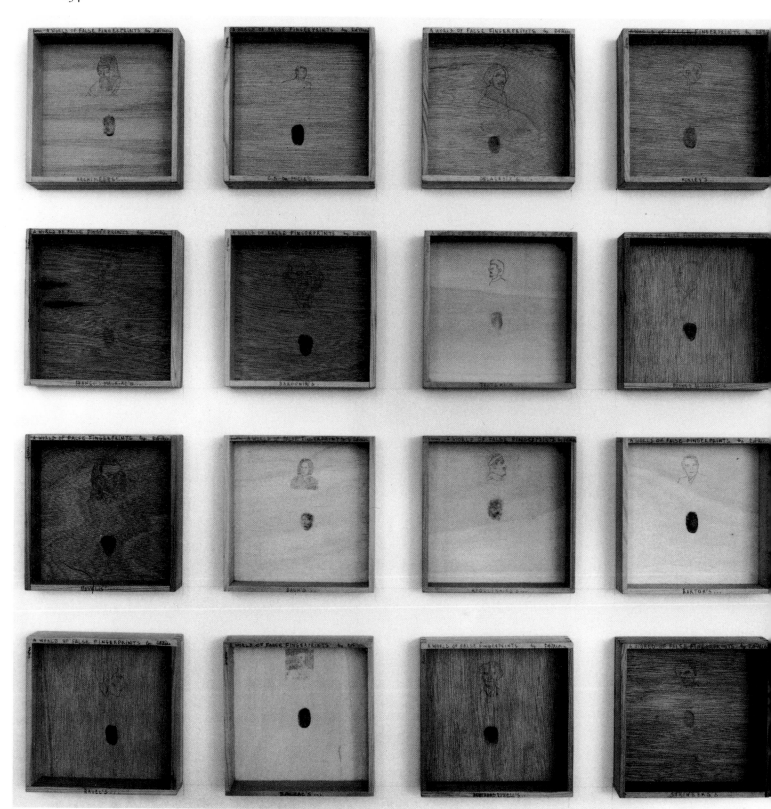

63 Robert Filliou. *A World of False Fingerprints.* 1975

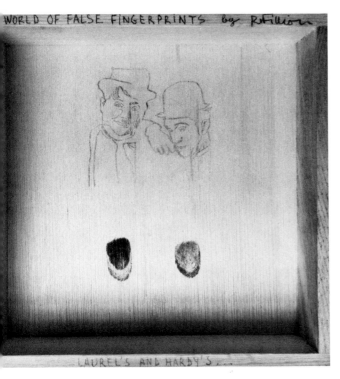

Laurel and Hardy's

Delacroix's

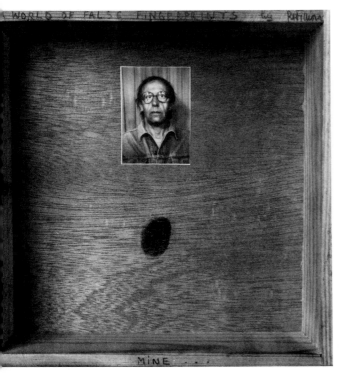

Mine

Garbo's

64 Emmett Williams.
Peacock Island. 1981

65 Emmett Williams.
Kaiser-Wilhelm Memorial Church. 1981

66 Emmett Williams.
Brandenburg Gate and the Hindenburg. 1981

67 Emmett Williams. *Potsdam Square II.* 1981

68 Emmett Williams. *Portraits of a Fluxus Artist as Hors- d'Oeuvre d'Art.* 1983

69 K. P. Brehmer. *Selection Packet No. 20.* 1967

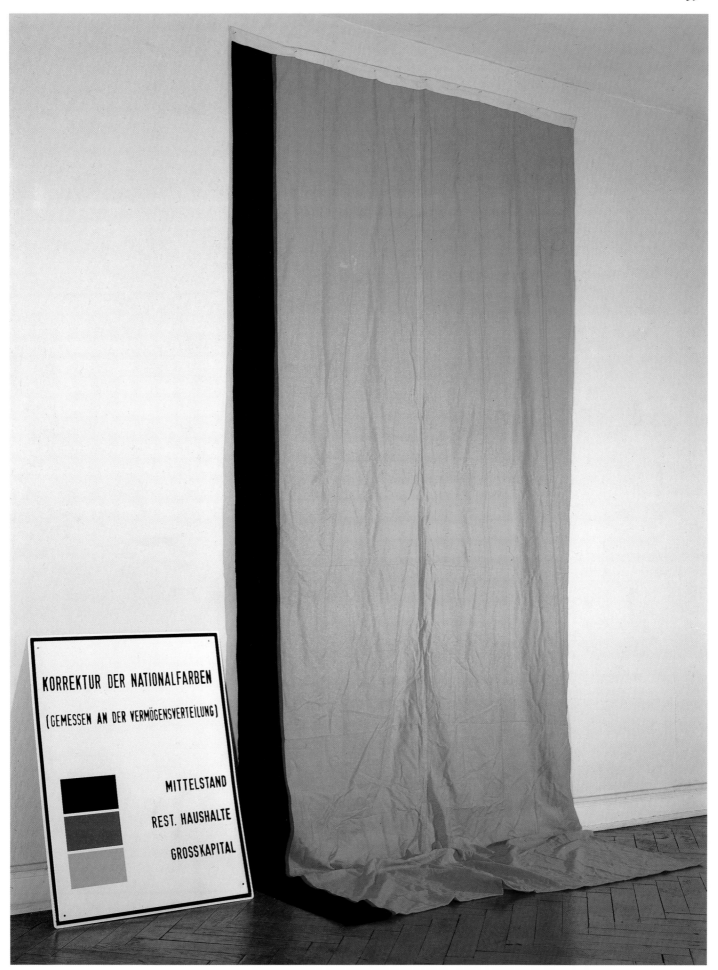

KORREKTUR DER NATIONALFARBEN

(GEMESSEN AN DER VERMÖGENSVERTEILUNG)

MITTELSTAND

REST. HAUSHALTE

GROSSKAPITAL

70 K. P. Brehmer. *Correction of the National Colors According to the Distribution of Wealth.* 1970

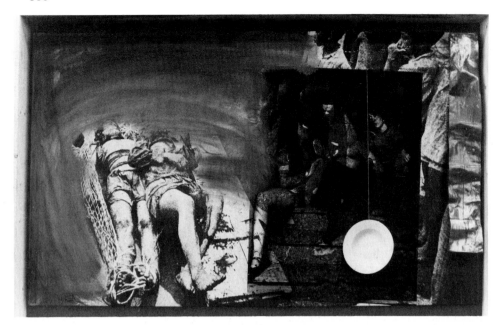

71 Wolf Vostell. *Berlin-Fever III.* 1973

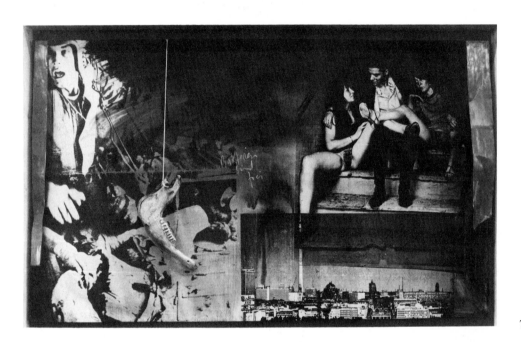

72 Wolf Vostell. *Berlin-Fever IV.* 1973

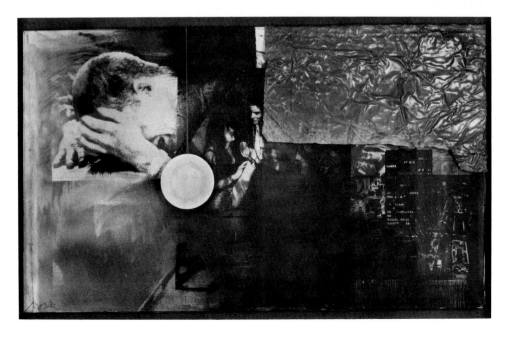

73 Wolf Vostell. *Berlin-Fever V.* 1973

74 Wolf Vostell.
Mania Cycle: Film. 1973

75 Wolf Vostell.
Mania Cycle: Emigration. 1973

76 Wolf Vostell.
Mania Cycle: Police Terror. 1973

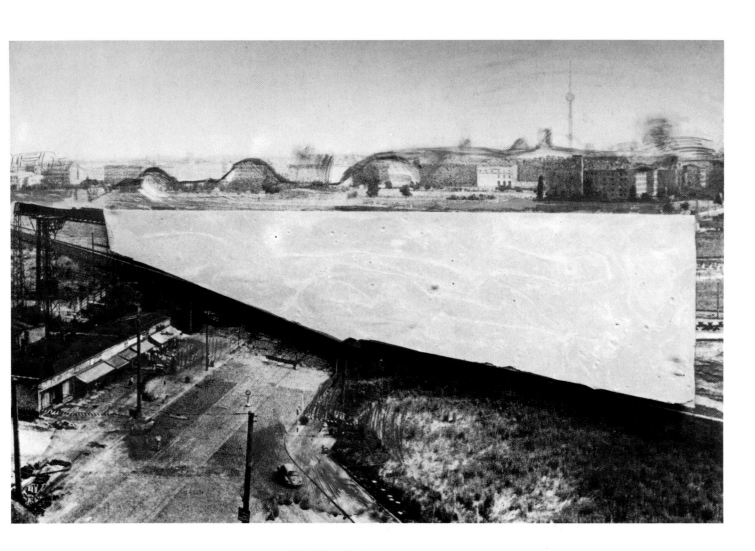

77 Wolf Vostell. *Potsdam Square.* 1975

78 Edward Kienholz/Nancy Reddin Kienholz. *The Kitchen Table (No. 1).* 1975–77. Transition bronze

79 Edward Kienholz/Nancy Reddin Kienholz. *The Kitchen Table (No. 1).* 1975–77. Bronze

80　Edward Kienholz/Nancy Reddin Kienholz. *Mother with Child with Child (Washboard Series)*. 1976–82

81 Günter Brus. *Europa*. 1979

82 Günter Brus. *C. F. Hill*. 1979

83 Günter Brus. *Füssli.* 1979

84 Martin Rosz. *Arachne*. 1975–76

Arachne (Detail)

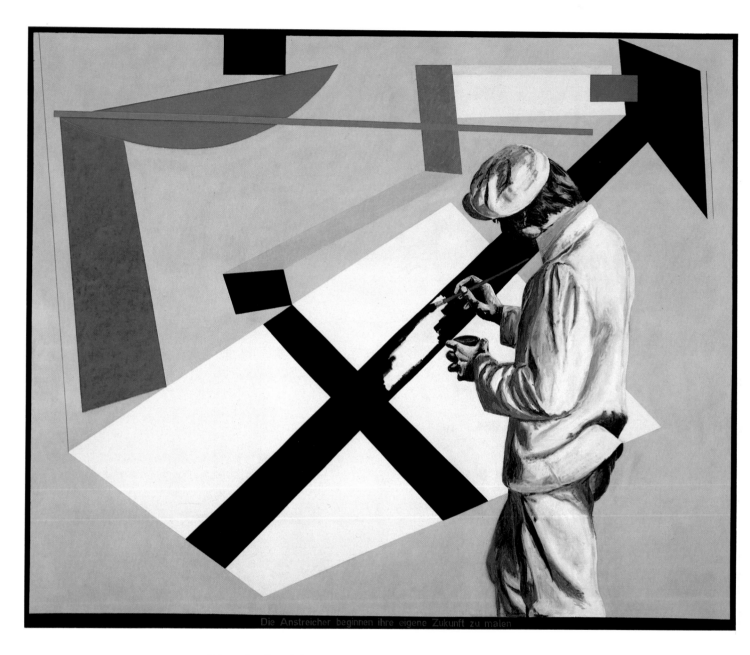

85 Dieter Hacker. *The House Painters Begin to Paint Their own Future.* 1976

86 Dieter Hacker. *Dream II.* 1984

87 Dieter Hacker. *The Day.* 1985

88 Salomé. *Self-Portrait.* 1976

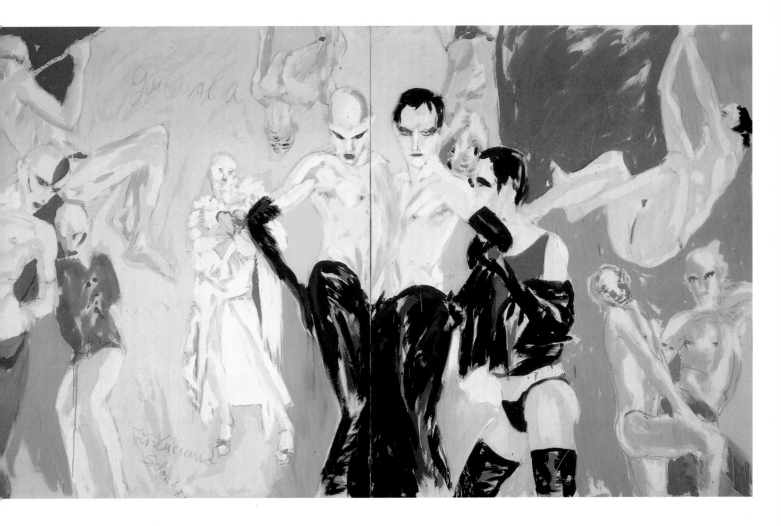

89 Salomé. *For Luciano.* 1979

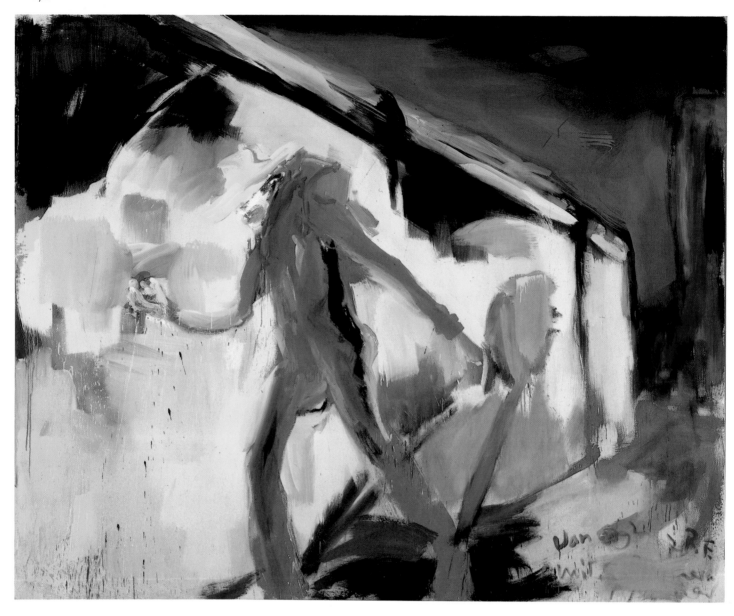

90 Rainer Fetting. *Van Gogh and Wall v.* 1978

91 Rainer Fetting. *Moritzplatz 1*. 1980

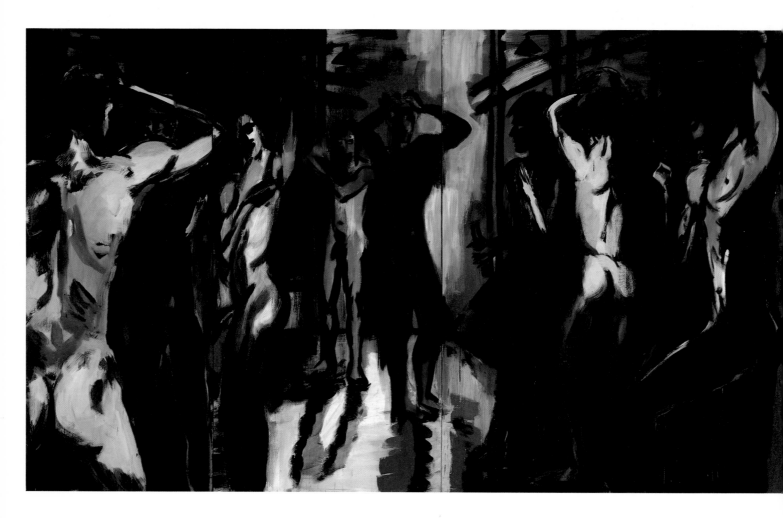

92 Rainer Fetting. *Large Shower (Panorama)*. 1981

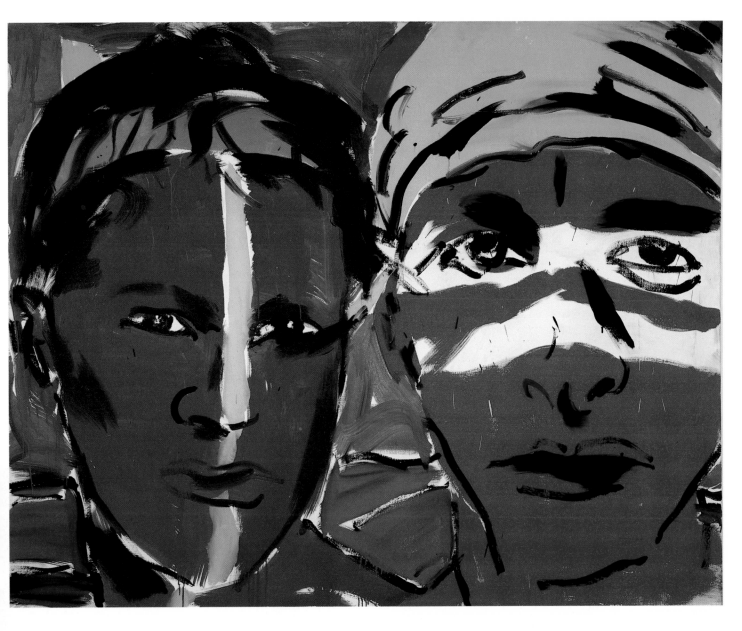

93 Luciano Castelli. *Indians 1.* 1982

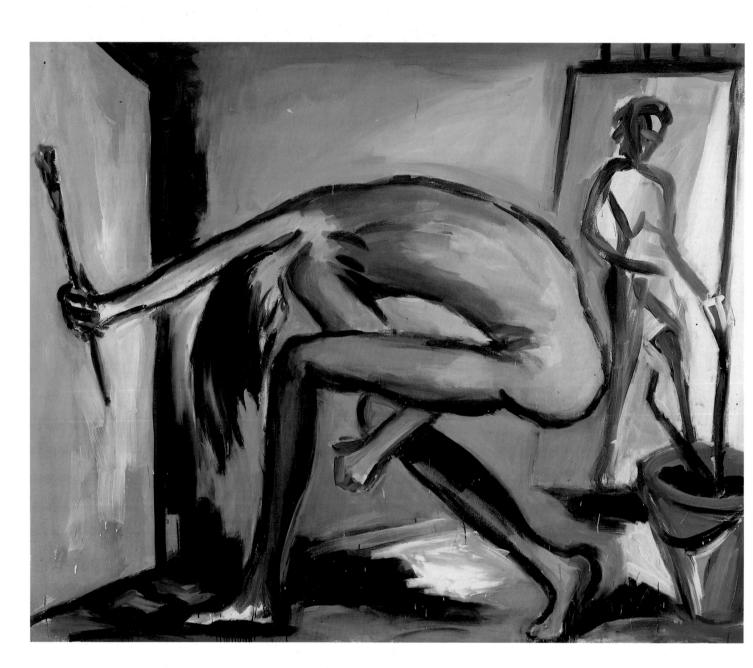

94 Helmut Middendorf. *Painter*. 1982

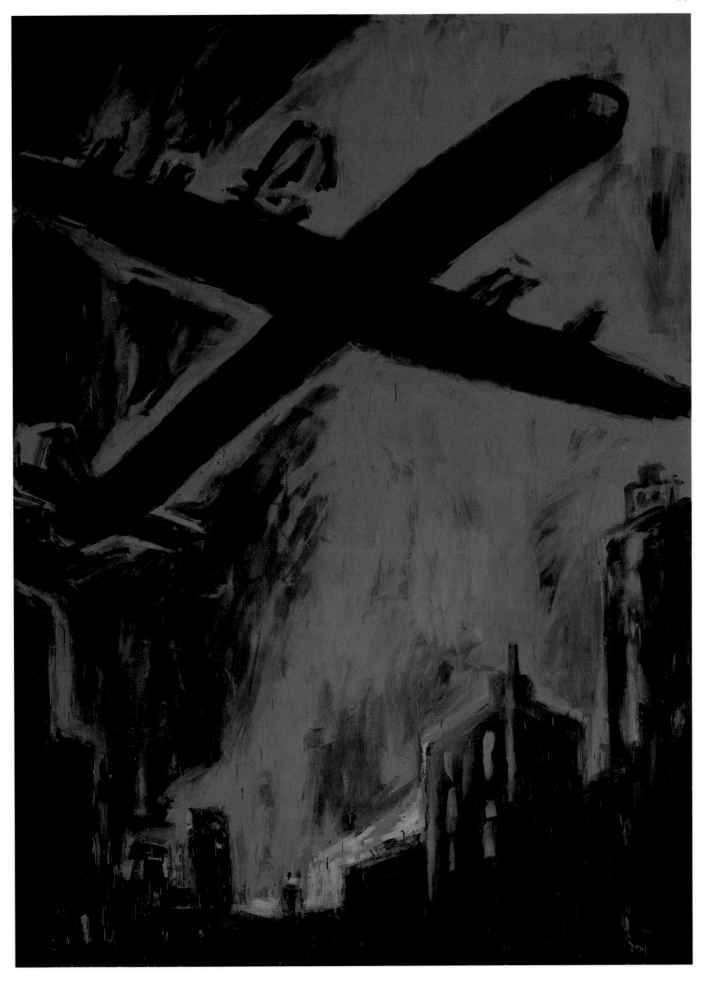

95 Helmut Middendorf. *Airplane Dream*. 1982

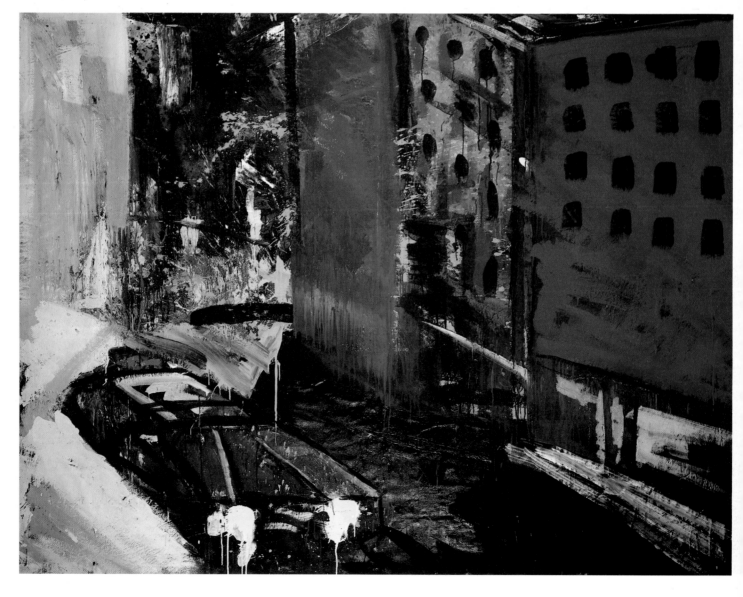

96 Bernd Zimmer. *Berlin.* 1978

97 Bernd Zimmer. *Big Waterfall II*. 1980

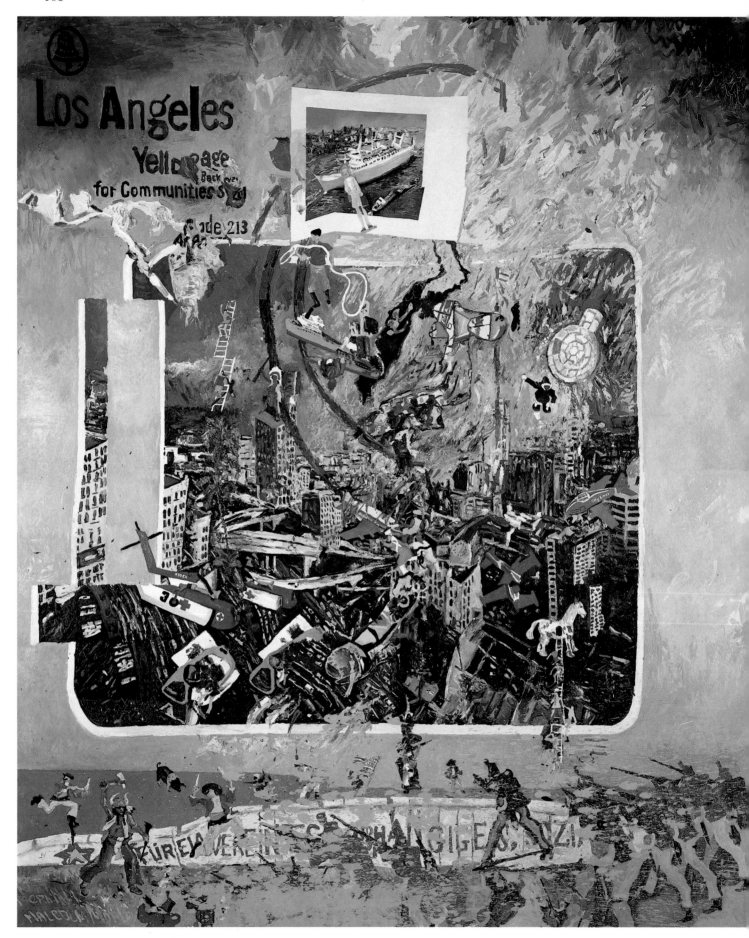

98 Malcolm Morley. *The Day of the Locust.* 1977

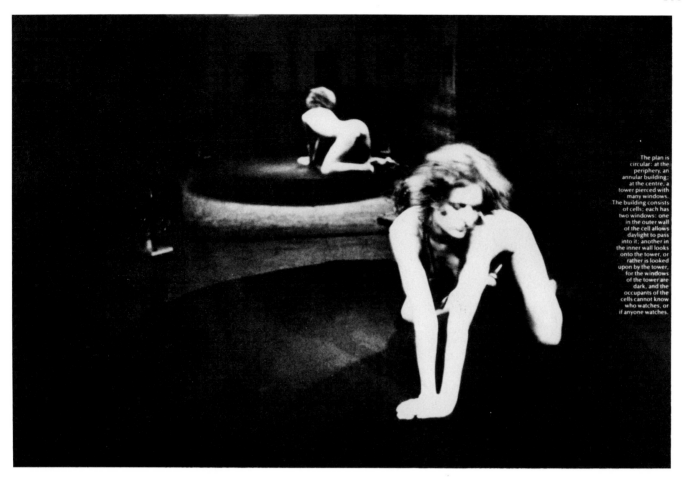

The plan is circular: at the periphery, an annular building; at the centre, a tower pierced with many windows. The building consists of cells; each has two windows: one in the outer wall of the cell allows daylight to pass into it; another in the inner wall looks onto the tower, or rather is looked upon by the tower, for the windows of the tower are dark, and the occupants of the cells cannot know who watches, or if anyone watches.

99 Victor Burgin. *Zoo IV*. 1978. Diptych

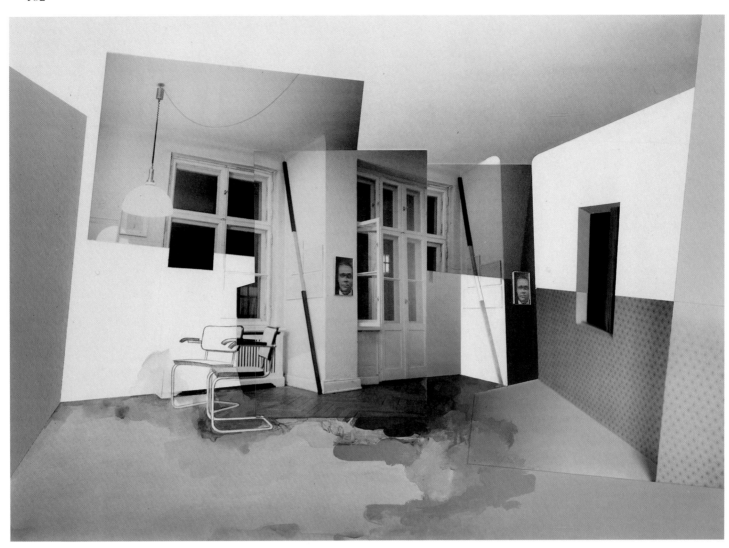

100 Richard Hamilton. *Apartment Block*. 1979

101 Richard Hamilton. *Berlin Interior*. 1979

102 Daniel Spoerri. *Fragment of Interior of Paris-Bar, Berlin*. c. 1979

Paris-Bar, Berlin, 1986

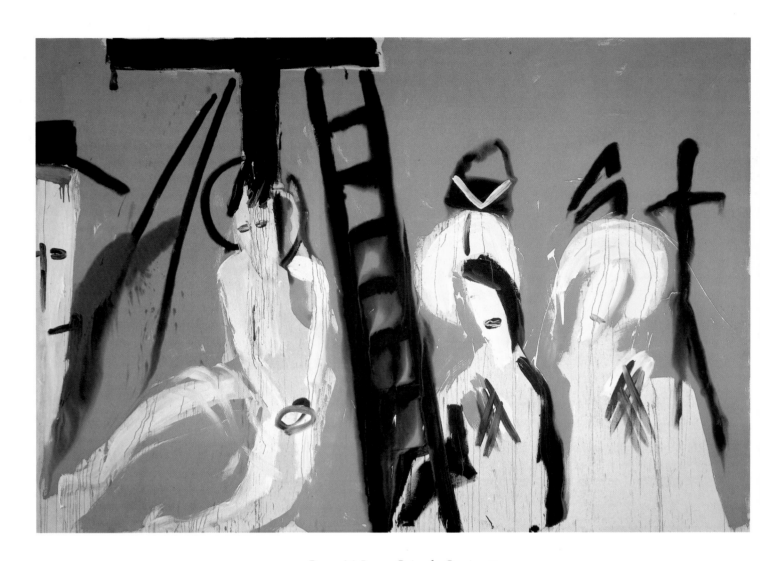

103 Bruce McLean. *Going for Gucci*. 1984

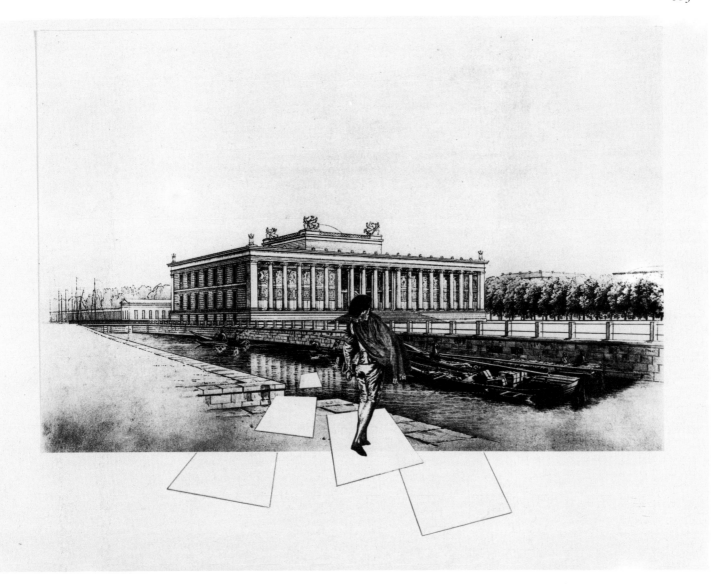

104 Giulio Paolini. *Study with a Figure from "Embarquement pour Cythère" by A. Watteau.* 1981–82

105 Giulio Paolini. *Study for the Presentation of the Work as a Doric Frieze.* 1981–82

I had a dream when I was living and working in West Berlin — near the Berlin Wall I dreamed a dog forced its way into a garden of birds because the fence was broken. It picked up one of the birds in its mouth. Later, when I was awake, the memory of this dream fragment led me to thoughts about freedom and aggression, fear of "the enemy" and the need for personal space. 2782117

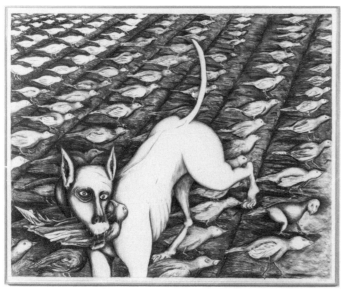

106 Jonathan Borofsky. *Berlin Dream at 2,833,792.* 1983

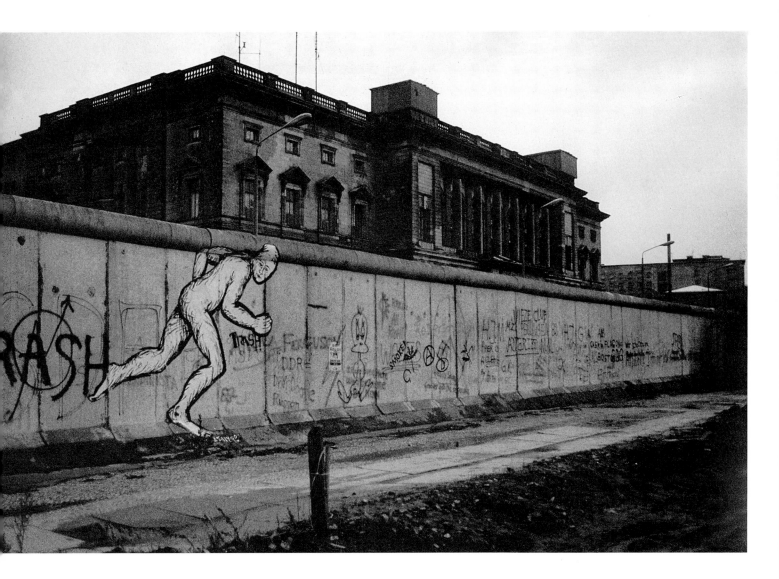

107 Jonathan Borofsky. *Running Man*. 1982. Drawing on the Berlin Wall

108 Terry Fox. *Berlin Wall Scored for Sound.* 1982

109 Terry Fox. *The Berlin Wall Scored for Sound.* 1982

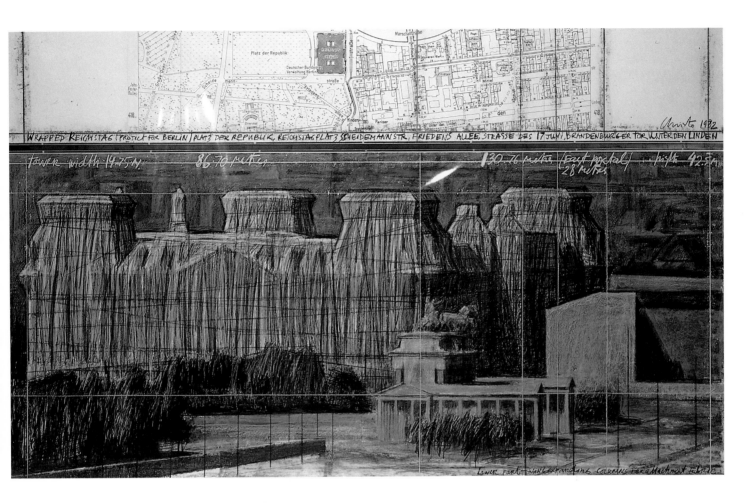

110 Christo. *Wrapped Reichstag: Project for Berlin.* 1982

[111–116] Paul-Armand Gette.
A Walk in Berlin
from Grosser Stern to Askanischer Platz:
Exotic as Banality. 1980

111 *Robinia Pseudo-Acacia L.* (North America),
Grosser Stern, Tiergarten

112 *Ailanthus altissima Swingle* (China),
Hildebrandtstrasse, Tiergarten

113 *Aesculus Hippocastanum L.* (Balkans),
Stauffenbergstrasse, Tiergarten

114 *Robinia Pseudo-Acacia L.* (North America),
Potsdammer Strasse, Tiergarten

115 *Robinia Pseudo-Acadia L.* (North America),
Askanischer Platz, Kreuzberg

116 *Acer Negundo L.* (North America),
Askanischer Platz, Kreuzberg

117 Leland Rice. *Chaplin Wall*. 1985–86

118 Leland Rice. *Détente*. 1985–86

119 William Eggleston. *Untitled from Democratic Forest (Steam Heater).* c. 1986

120 William Eggleston. *Untitled from Democratic Forest (Reclining Woman Frieze).* c. 1986

121 Armando. *Flag*. 1980–81

122 Armando. *Flag II*. 1982 123 Armando. *Flag*. 1982

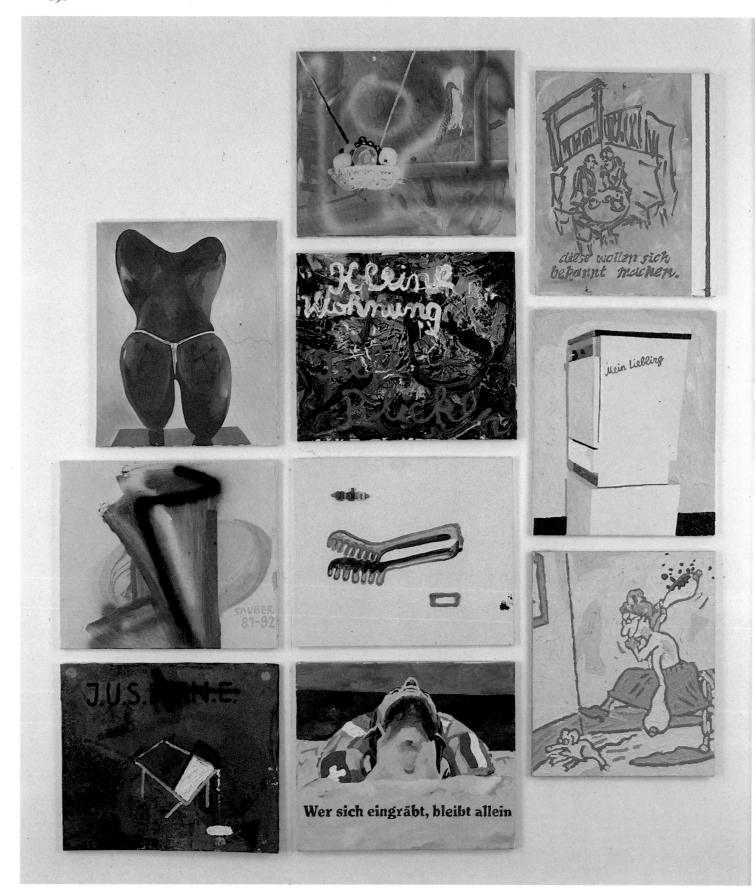

124 Martin Kippenberger. *The Hindered Flannel Rags.* 1981–82

125 Ina Barfuss/Thomas Wachweger.
Destruction Is Your Life Devotion. 1982

126 Ina Barfuss/Thomas Wachweger.
Red Cross. 1980

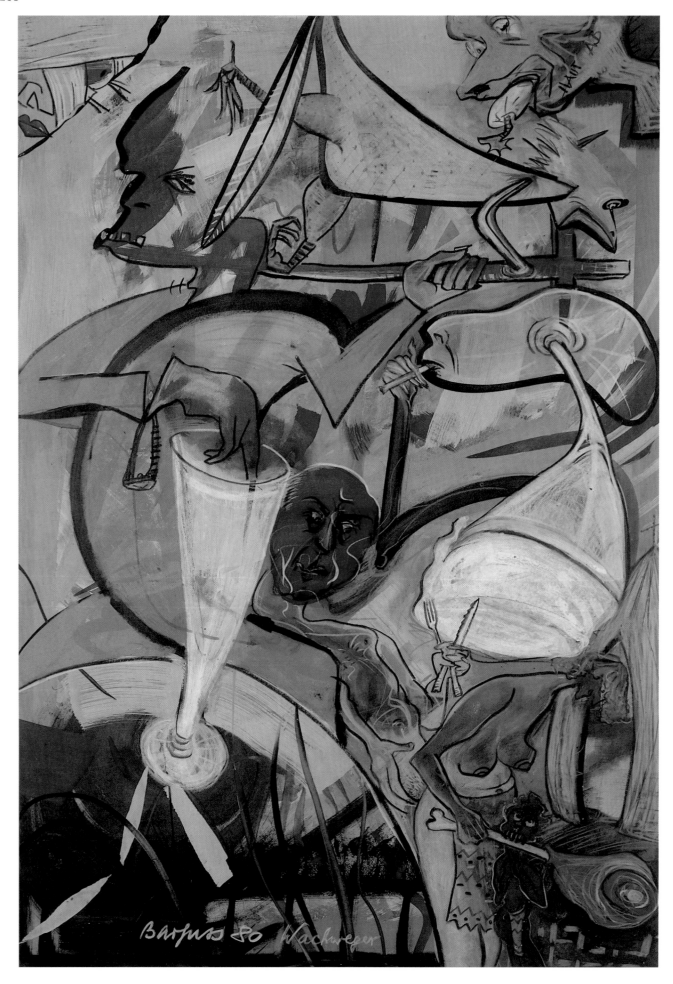

127 Ina Barfuss/Thomas Wachweger. *Foreign Aid*. 1980

128 Ina Barfuss. *Abandoned Hope*. 1984

129 Thomas Wachweger.
All Sisters Will Be Brothers. 1984

130 Peter Chevalier.
Roebuck with Iris II. 1986

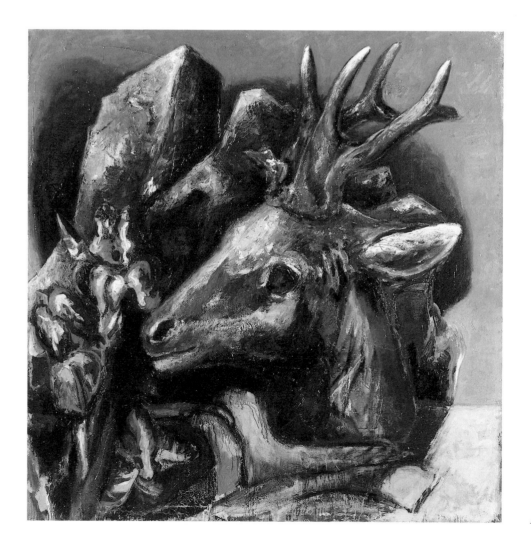

131 Peter Chevalier.
Roebuck with Iris I. 1986

132 Hermann Pitz. *Gilda–Signs*. 1979–82

Gilda–Signs (Detail)

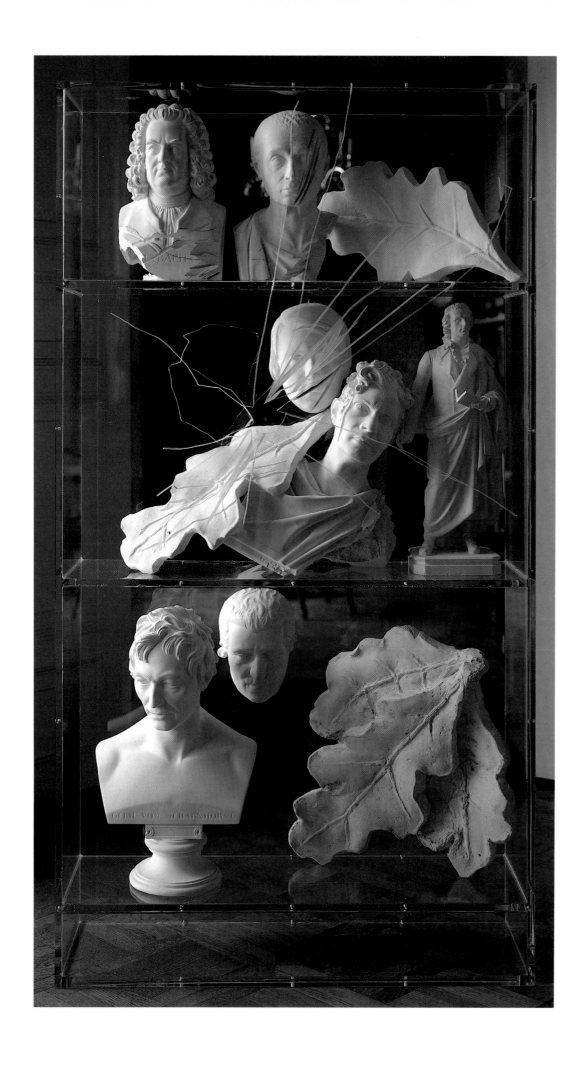

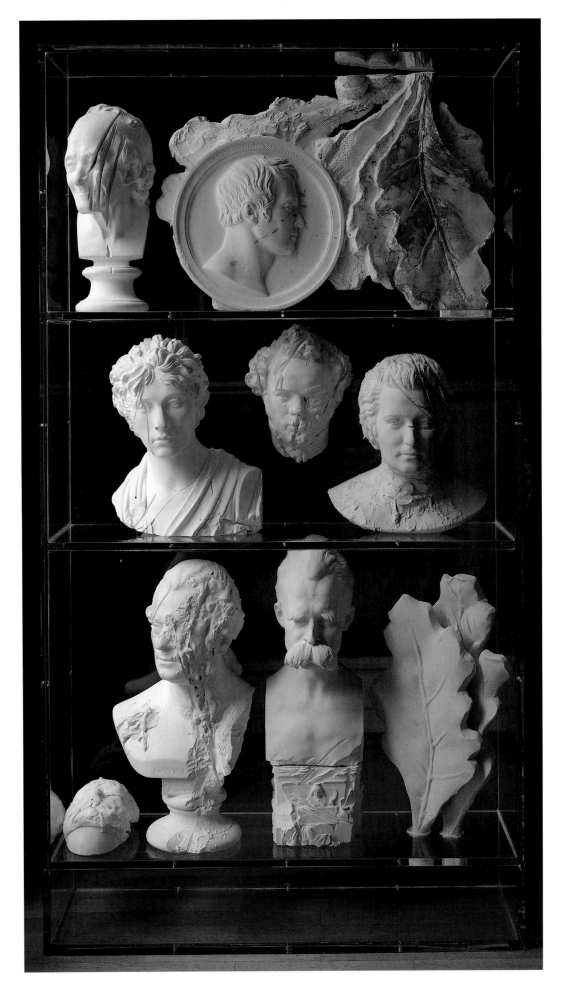

133 Olaf Metzel. *Oak Leaf Studies*. 1986. Two vitrines

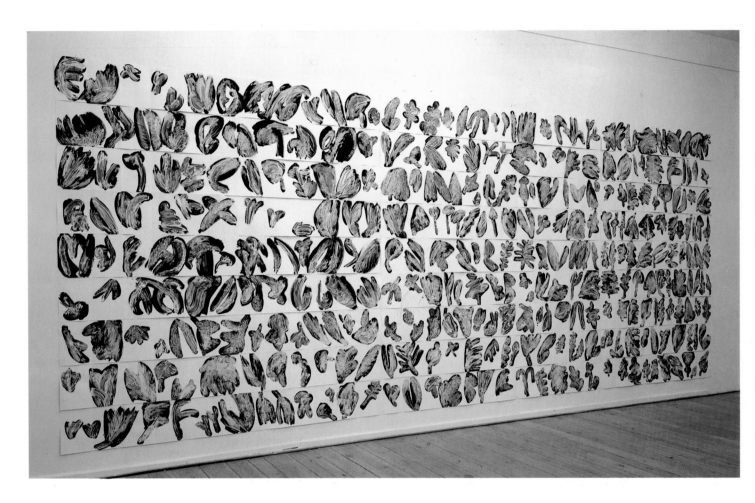

134 Eva-Maria Schön. *Attempts to Get Close to a Leaf.* 1986

135 ter Hell. *Autonomy*. 1986

Editions

136 Günter Brus. *The Gardens in the Exosphere*. 1977

138 Günter Brus. *Phantom Palaces.* 1979

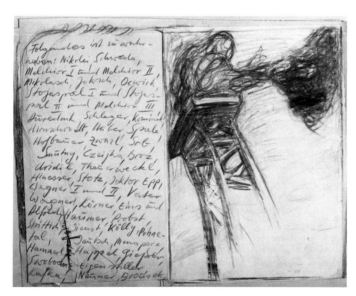

137 Günter Brus. *The Balcony of Europe.* 1972

139 Günter Brus.
Waltz of the Joys of the Night. 1975

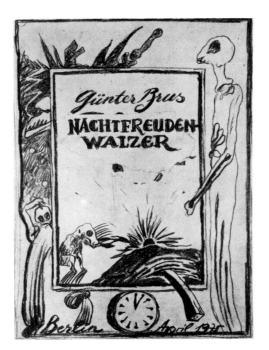

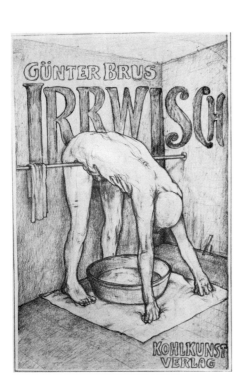

140 Günter Brus. *Imp.* 1971

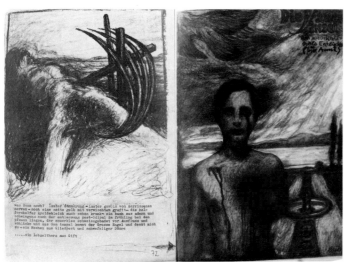

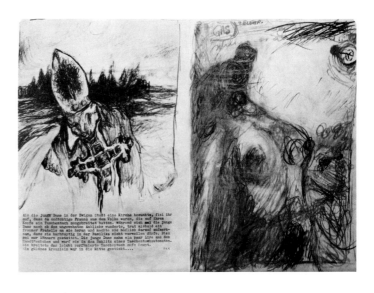



141 Martin Rosz. *Half Images 1982–84.* 1984

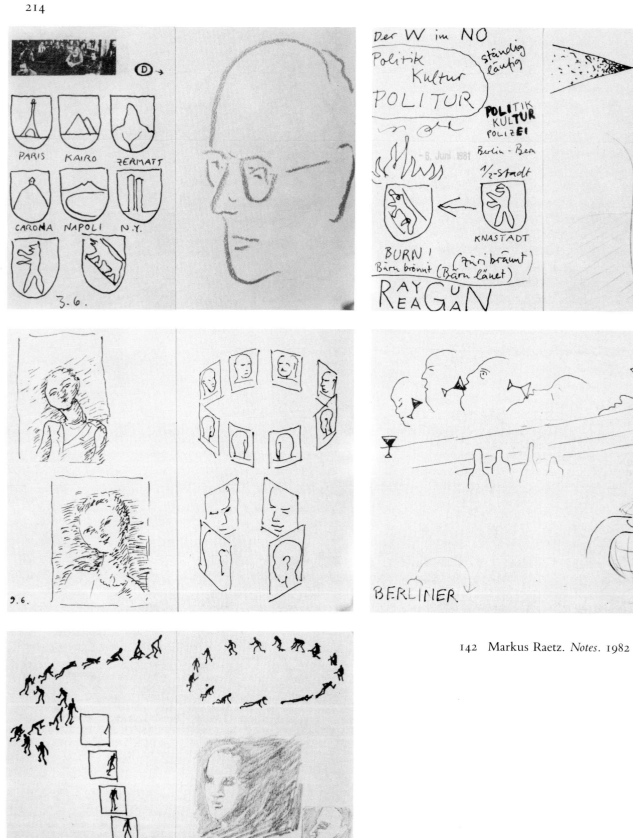

142 Markus Raetz. *Notes.* 1982

143 Ben Vautier. *My Berlin Inventory*. 1979

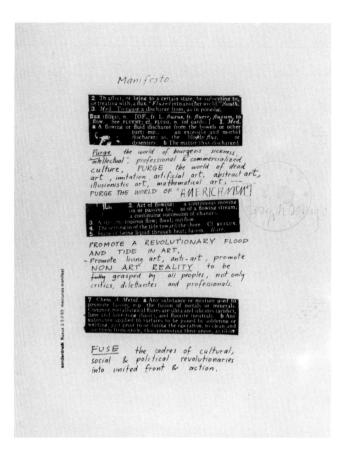

144 Edition Hundertmark. *Box 1.* 1970

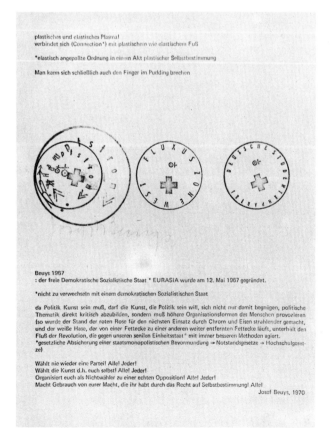

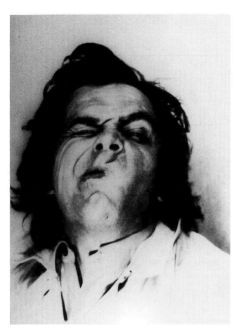

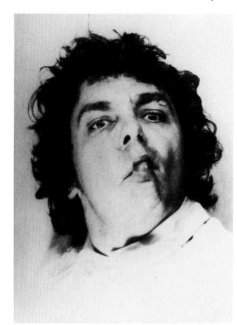

145 Arnulf Rainer. *Nerve Spasm.* 1971

146 Milan Knizak. *Fluxus East.* 1971

147 Tomas Schmit. *Potatoes Boiled in Their Jackets*. 1984

148 Edition Hundertmark. *Ten Year Box*. 1980

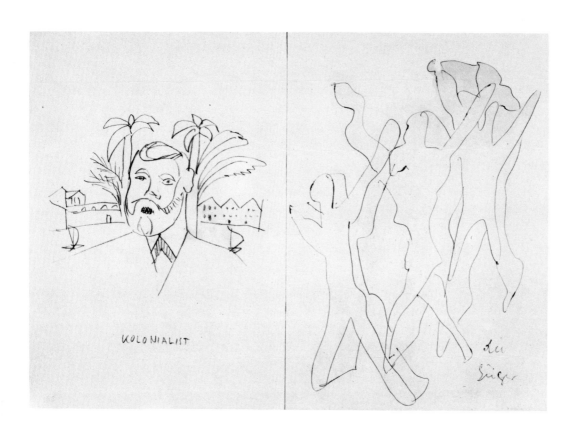

149 K. H. Hödicke. *Calendar Pages.* 1980

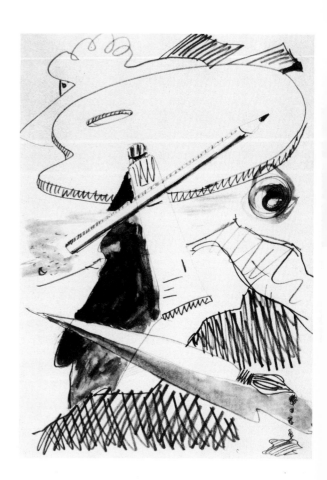

150 Bernd Zimmer.
*Lombok, Zwieselstein, Berlin Drawings, Paintings,
Graphics, etc.* 1981

PRESTEL ART BOOKS

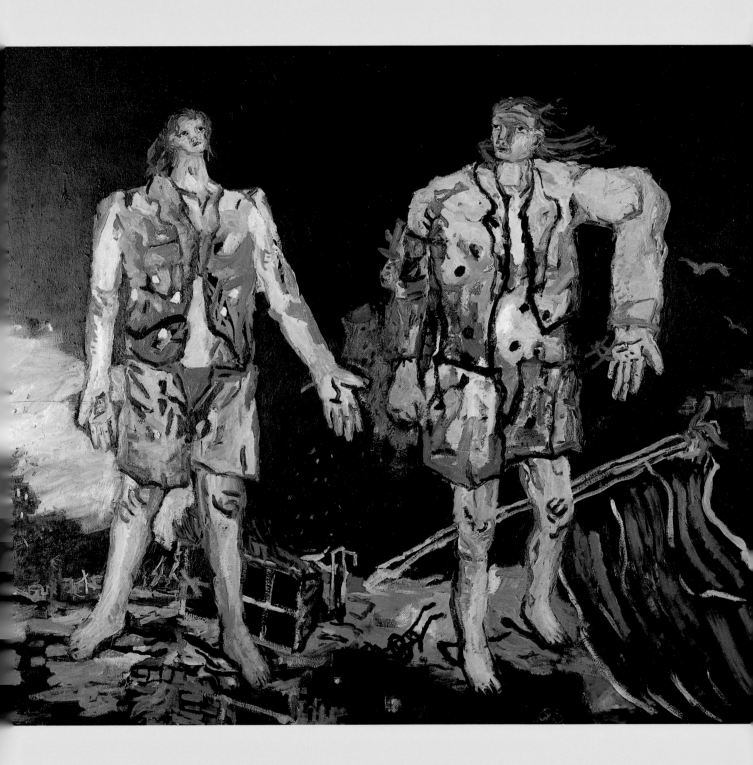

Distributed by te Neues Publishing Company, New York

Museum Ludwig, Cologne

Paintings, Sculptures, Environments from Expressionism to the Present Day
By Siegfried Gohr.
Since the opening of its monumental new building in 1986, the Museum Ludwig in Cologne, West Germany, has displayed a collection of 20th-century art which ranks as one of the finest in Europe, particularly in the field of American art of the 60s. This volume presents the most important works from the museum.
272 pages, 217 color plates, 8 b/w illus.
ISBN -0792-4. 8 ⅛ × 11 ¾ in. Cloth $ 45.00

Two-Volume Set:
Museum Ludwig, Cologne
with *Bestandskatalog*
Catalogue raisonné of the complete collection)
Catalogue raisonné: Edited by S. Gohr, compiled by E. Weiss and G. Kolberg. Text in German. The *Bestandskatalog* (catalogue raisonné) is an important reference work which gives detailed information on the 1236 works in the collection and biographical notes for each of the 540 artists represented. It is available in a case with the volume of selected masterpieces described above.
296 pages with 501 b/w illustrations.
Available in 2-volume set only:
ISBN -0791-6. 2 volumes in case: $ 70.00

Naum Gabo

Sixty Years of Constructivism
Edited by S. A. Nash und J. Merkert. Catalogue of the retrospective exhibition in Dallas, Toronto, New York, Berlin, Düsseldorf, and London, 1985-1987. Including catalogue raisonné of the constructions and sculptures.
This catalogue comprises the most comprehensive survey ever presented of the art of Naum Gabo, recognized as a pioneer of modern sculpture and a leader in the Constructivist movement.
272 pages, 278 illustrations, 18 in full color.
ISBN -0742-8. 8 ¾ × 11 in. Cloth $ 45.00

David Smith

Sculpture and Drawings
Edited by Jörn Merkert. Catalogue of the retrospective exhibition held at the Whitechapel Art Gallery, London, 1986-1987. David Smith was one of the great sculptors of the 20th century. He was the essential link between Julio Gonzalez and Anthony Caro, the bridge between strong, gestural brushwork in the wake of Picasso and the anonymity of constructed objects.
192 pages, 193 illustrations, 17 in full color.
ISBN -0793-2. 8 ⅛ × 11 in. Cloth $ 37.50

Gothic and Renaissance Art in Nuremberg 1300-1550

Edited by G. Bott, P. de Montebello, R. Kahsnitz und W. D. Wixom. Catalogue of the exhibition in New York and Nuremberg, 1986.
In the Middle Ages and the Renaissance, Nuremberg enjoyed great renown and prosperity as an imperial city. The treasures of that time are presented in our book.
"This catalogue, produced by the great Munich house of Prestel-Verlag, is monumental even by the standards of today."
The New York Times
500 pages, 562 illus., 148 in full color.
ISBN -0765-7. 9 × 11 ¾ in. Cloth $ 65.00

Paul Klee

The Düsseldorf Collection
By W. Schmalenbach. Catalogue of the collection at the Kunstsammlung Nordrhein-Westfalen.
This volume provides a full documentation of the collection's 92 works by Paul Klee, created between 1906 and 1939. The text is a vividly written work-by-work commentary.
128 pages, 92 illustrations, 58 in full color, and 5 photographs of the artist.
ISBN -0794-0. 7 ½ × 10 ¼ in. Cloth $ 27.50

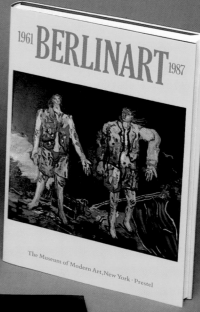

British Art in the 20th Century

The Modern Movement

Edited by Susan Compton. Catalogue of the exhibition in London and Stuttgart, 1987. "A lively, radical, well-researched, not seldom dismissive and passionate anthology... a monumental catalogue."

The New York Times
457 pages, 472 illus., 277 in full color.
70 illustrated artists' biographies.
ISBN -0798-3. 9 × 11 ¾ in. Cloth $ 70.00

Georg Baselitz

Druckgraphik – Prints – Estampes
1963-1983

Edited by Siegfried Gohr. Catalogue in English, French, and German of the exhibition in Munich, Geneva, Trier, Paris, and London, 1984-1985.

Georg Baselitz has achieved international acclaim for his expressive paintings of upside-down figures. This book presents the graphic work of one of the most famous contemporary German artists.

172 pages, 148 illustrations, 20 in full color.
ISBN -0632-4. 8 ¼ × 11 in.
Paperback $ 30.00

German Art in the 20th Century

Painting and Sculpture 1905-1985

Edited by C. M. Joachimides, N. Rosenthal, and W. Schmied. Catalogue of the exhibition in London and Stuttgart, 1985-1986. "Never has so much German 20th-century art been gathered together. We have an exciting piece of revisionist art history, all the more thrilling as it has put to the fore some of the most marvellous and disquieting and disturbing art of the century.
We have here a catalogue of German art of unequalled breadth, depth and scope..."

Sunday Times/London
518 pages, 623 illus., 293 in full color.
52 illustrated artists' biographies.
ISBN -0743-6. 9 × 11 ¾ in. Cloth $ 70.00

Carnegie International 1985

Edited by John R. Lane and John Caldwell. 15 essays by various authors. Catalogue of the exhibition held in Pittsburgh, 1985-1986. This catalogue, with numerous essays and carefully selected works by 42 artists of international renown, is one of the most important recent publications on contemporary art.

260 pages, 158 illustrations, 33 in full color.
ISBN -0750-9. 9 ¼ × 12 in.
Paperback $ 35.00

BERLINART 1961-1987

Edited and with an introduction by K. McShine. With contributions by R. Block, L. Kardish, K. Ruhrberg, W. Schmied, M. Schwarz, J. Willett. Berlin is one of the most important and exciting centers of the international art scene. Baselitz, Beuys, Christo, Hamilton, Hockney, Lüpertz and Middendorf, to name only a few, lived and worked in the city. Painting and sculpture as well as film and performance art around the world received new impulses from Berlin. This book focuses on the art of the city in the last quarter century on the occasion of an exhibition at The Museum of Modern Art, New York.

276 pp., approx. 350 illus., 80 color plates.
ISBN -0815-7. 9 × 11 ¾ in. Cloth $ 40.00
After January 1, 1988: $ 45.00

Wang Yani
Pictures by a Young Chinese Girl
With contributions by R. Goepper,
H. Goetze, and Wang Shiquiang.
This book presents the pictures of a child
prodigy, who continues the age-old tradi-
tion of Chinese painting in works displaying
both astonishing technical accomplishment
and a rich artistic imagination. Her works
can be seen in a U.S. museum for the first
time in 1987.
116 pages, 61 color plates, 11 b/w illus.
ISBN -0816-5. 8 ½ x 12 in.
Hardcover $ 30.00

The Egyptian Museum Cairo
Official Catalogue
By Dr. M. Saleh and H. Sourouzian.
Photographs by J. Liepe.
This is the first official catalogue of the mu-
seum to be published in ninety years and
will remain the standard work on the collec-
tion for decades to come.
268 pages, 313 illus., 290 in full color.
ISBN -0797-5. 8 ½ × 9 ¼ in.
Hardcover $ 37.50

Museums in Cologne
A Guide to 26 Collections
Edited by Hugo Borger.
An invaluable guide for the lover of art and
visitor to Cologne, this book introduces
each museum with illustrated commentaries
on its most important exhibits, the history
of the collection, and, of course, opening
hours and address. With an appendix
containing the addresses of the most impor-
tant art and antique dealers.
280 pages, 387 illustrations, mostly in color.
ISBN -0787-8. 5 × 9 in. Paperback $ 19.95

This is a selection of books from
Prestel Publishers, Munich.

Prestel's ISBN prefix: 3-7913-
*All prices are subject to change without
notice. Prices listed as of June 1, 1987.*

Cover: George Baselitz, *The Great Friends,
1965.* Detail.

Please write for our complete
catalogue and send all orders to:
te Neues Publishing Company
15 East 76th Street
New York, NY 10021
(212) 288-0265
Telefax (212) 570-2373

te Neues Publishing Company
15 East 76th Street
New York, NY 10021

151 Rainer Verlag. Books. 1981–86

List of Plate Illustrations

Works of art are listed in the order in which they appear in the Plates. Titles appear in English and German or, in two cases, Italian. Dimensions are given in feet and inches and centimeters, height preceding width; a third dimension, depth, is given for some sculptures. Works listed under "Editions" are cited by artist or publisher.

1 Georg Baselitz. *Invitation (Einladung).* 1961. India ink and type on paper. 11³/₄ x 8¹/₄″ (29.9 x 21 cm). Private collection.

2 Georg Baselitz. *Saxon Landscape (Sächsische Landschaft).* 1962–63. Pen, charcoal, and tempera on paper. 18⁷/₈ x 24³/₈″ (48 x 62 cm). Staatliche Graphische Sammlung, Munich. Wittelsbacher Ausgleichsfonds, Collection Prinz Franz von Bayern.

3 Georg Baselitz. *Amorphous Landscape (Amorphe Landschaft).* 1961 India ink and water-color on paper. 11¹/₂ x 8¹/₂″ (29.3 x 21.7 cm). Wittelsbacher Ausgleichsfonds, Collection Prinz Franz von Bayern, Munich.

[4–13] Georg Baselitz. *P. D. Feet (P. D. Füsse).* 1963. Crex Collection, Hallen für neue Kunst, Schaffhausen.

4 *First P. D. Foot: The Foot (Erster P. D. Fuss: Der Fuss).* Oil on canvas. 39¹/₂ x 32″ (100.5 x 81.5 cm).

5 *Second P. D. Foot: Birthplace (Zweiter P. D. Fuss: Alte Heimat).* Oil on canvas. 47¹/₄ x 35³/₈″ (120.2 x 90 cm).

6 *Third P. D. Foot (Dritter P. D. Fuss).* Oil on canvas. 51³/₈ x 39¹/₂″ (130.5 x 100.5 cm).

7 *Fifth P. D. Foot: Russian Foot (Fünfter P. D. Fuss: Russischer Fuss).* Oil on canvas. 51¹/₂ x 32¹/₈″ (131 x 81.7 cm).

8 *Sixth P. D. Foot (Sechster P. D. Fuss).* Oil on canvas. 39¹/₂ x 32″ (100.5 x 81.5 cm).

9 *P. D. Foot: Celt (P. D. Fuss: Kelte).* Oil on canvas. 39¹/₂ x 32″ (100.5 x 81.5 cm).

10 *Eighth P. D. Foot: The Hand (Achter P. D. Fuss: Die Hand).* Oil on canvas. 39¹/₂ x 32″ (100.5 x 81.5 cm).

11 *P. D. Foot (P. D. Fuss).* Oil on canvas. 45¹/₄ x 39¹/₂″ (114.8 x 100 cm).

12 *P. D. Foot (P. D. Fuss).* Oil on canvas. 49¹/₄ x 25¹/₂″ (125.2 x 65 cm).

13 *P. D. Foot: Birthplace: Existential Cleft (P. D. Fuss: Alte Heimat: Scheide der Existenz).* Oil on canvas. 51¹/₄ x 35³/₈″ (130.3 x 90 cm).

14 Georg Baselitz. *Antonin Artaud.* 1962. Ball-point pen on paper. 10¹/₈ x 8¹/₄″ (25.6 x 21.1 cm). Kunstmuseum Basel, Kupferstichkabinett. Karl A. Burckhardt-Koechlin-Fonds.

15 Georg Baselitz. *Pandemonium Drawing (Pandämonium Zeichnung).* 1962. India ink on transparent paper. 22⁵/₈ x 13″ (57.5 x 33 cm). Ludwig Collection, Aachen.

16 Georg Baselitz. *Cross (Kreuz).* 1964. India ink and chalk on paper. 20¹/₂ x 15¹/₂″ (52.2 x 39.3 cm). Kunstmuseum Basel, Kupferstichkabinett.

17 Georg Baselitz. *Oberon.* 1963–64. Hand-colored etching. 12 x 9³/₄″ (30.5 x 24.8 cm). Private collection.

18 Georg Baselitz. *Idol.* 1964. Etching and drypoint. 12 x 9³/₄″ (30.5 x 24.8 cm). Städtisches Museum, Leverkusen, Graphische Sammlung.

19 Georg Baselitz. *Untitled (Hero) [Ohne Titel (Held)].* 1965. Pencil and charcoal on tan paper. 19³/₄ x 14³/₄″ (50 x 37.5 cm). Galerie Beyeler, Basel.

20 Georg Baselitz. *The Great Friends (Die grossen Freunde).* 1965. Oil on canvas. 8′ 2³/₈″ x 9′ 10¹/₈″ (250 x 300 cm). Museum Moderner Kunst, Vienna, on loan from Ludwig Collection, Aachen.

21 Georg Baselitz. *Untitled (Tree) [Ohne Titel (Baum)].* 1965. Pencil, ink, and gouache on paper. 20¹/₂ x 16¹/₂″ (52.3 x 42.1 cm). Galerie Michael Werner, Cologne.

22 Georg Baselitz. *Untitled (Ohne Titel).* 1965. Drypoint and etching. 12¹/₄ x 9⁵/₈″ (31 x 24.5 cm). Städtisches Museum, Leverkusen, Graphische Sammlung.

23 Georg Baselitz. *Shepherd (Hirte).* 1966, incorrectly dated 1965. Drypoint.

12¹/₂ x 9¹/₄″ (32 x 23.7 cm). Courtesy David Nolan, New York.

24 Georg Baselitz. *L. R.* 1966. Woodcut. 17 x 13³/₈″ (43 x 34 cm). Private collection, courtesy David Nolan, New York.

25 Georg Baselitz. *Large Head (Grosser Kopf).* 1966. Color woodcut. 19 x 16″ (48 x 41 cm). Städtisches Museum, Leverkusen, Graphische Sammlung.

26 Georg Baselitz. *MMM in G and A.* 1961/62/66. Oil on canvas. 76³/₄ x 57¹/₈″ (195 x 145 cm). Saatchi Collection, London.

27 Eugen Schönebeck. *Bait (Der Köder).* 1963. Oil on canvas. 63³/₄ x 51¹/₄″ (162 x 130 cm). Collection Dr. Hanspeter Rabe, Berlin.

28 Eugen Schönebeck. *The Crucified (Der Gekreuzigte).* 1964. Oil on canvas. 63³/₄ x 51¹/₂″ (162 x 130 cm). Collection Dr. Hanspeter Rabe, Berlin.

29 Antonius Höckelmann. *Shepherd's Life (Hirtenleben).* 1966. Charcoal, india ink, and chalk on paper. 10′ 10″ x 8′ 10¹/₄″ (330 x 270 cm). Private collection.

30 Emilio Vedova. *Absurd Berlin Diary '64: Plurimo N-6 (Absurdes Berliner Tagebuch '64: Plurimo N-6).* 1964. Mixed mediums and iron hinges. 8′ 10″ x 6′ 6¹/₂″ x 70³/₄″ (272 x 200 x 180 cm). Collection the artist.

31 Fred Thieler. *Epitaph for Franz Kline (Epitaph für Franz Kline).* 1962. Mixed mediums on canvas. 10′ 9³/₄″ x 65″ (325 x 165 cm). Collection Stober, Berlin.

32 Fred Thieler. *Evergreen.* 1963. Mixed mediums on canvas. 8′ 8¹/₄″ x 6′ 2³/₄″ (265 x 190 cm). Galerie Georg Nothelfer, Berlin.

33 Walter Stöhrer. *Figure (Figur).* 1967. Oil and mixed mediums on canvas. 71 x 55″ (180 x 140 cm). Galerie Georg Nothelfer, Berlin.

34 Walter Stöhrer. *Inspiration Is the Thesis That Makes the Artist a Mere Observer (Inspiration ist die These die den Künstler zum blossen Beobachter*

macht). 1977. Mixed mediums on canvas.
6′ 6″ x 6′ 6″ (198 x 198 cm). Collection
Claus H. Wencke, Bremen.

35 K.H. Hödicke. *At Grosses Fenster (Am
Grossen Fenster)*. 1964. Synthetic polymer paint
on canvas. Four parts, each: 51¹/₄ x 37¹/₂″
(135 x 90 cm). Collection the artist.

36 K.H. Hödicke. *Against the Light (Im Gegen-
licht)*. 1976. Synthetic resin on untreated cotton.
6′ 6³/₄″ x 9′ 10″ (200 x 300 cm).
Collection Peter Pohl.

37 K.H. Hödicke. *War Ministry (Kriegs-
ministerium)*. 1977. Synthetic resin on canvas.
6′ 5/8″ x 8′ 10¹/₄″ (184.5 x 270 cm).
Berlinische Galerie, Berlin.

38 K. H. Hödicke. *Nocturne (Nocturno)*. 1983.
Synthetic resin on canvas. 6′ 6³/₄″ x 9′ 6¹/₄″
(200 x 290.2 cm). Gallery Gmyrek,
Düsseldorf.

39 Markus Lüpertz. *Dithyramb (Triptych)
[Dithyrambe (Triptych)]*. 1964. Distemper on
canvas. Three panels: left, 6′ 6³/₄″ x 39¹/₂″;
center, 6′ 9¹/₂″ x 39¹/₂″; right, 6′ 6³/₄″ x 39¹/₄″
(200 x 100 cm; 207 x 100 cm; 200 x 100 cm).
Collection Peter Pohl.

40 Markus Lüpertz. *Interior III (Interieur III)*.
1974. Distemper on canvas. 6′ 4³/₄″ x 8′ 5¹/₄″
(195 x 257 cm). Private collection, Courtesy
Galerie Michael Werner, Cologne, and Mary
Boone – Michael Werner Gallery, New York.

41 Markus Lüpertz. *Black–Red–Gold:
Dithyrambic (Schwarz–Rot–Gold: Dithyram-
bisch)*. 1974. Gouache on paper on canvas.
8′ 11″ x 6′ 10¹/₂″ (272 x 210 cm).
Kunsthalle Hamburg.

42 Markus Lüpertz. *Lüpolis: Dithyrambic
(Lüpolis: Dithyrambisch)*. 1975. Mixed mediums
on canvas. 6′ x 8′ 2¹/₂″ (183 x 250 cm).
Private collection, courtesy Galerie Michael
Werner, Cologne, and Mary Boone – Michael
Werner Gallery, New York.

43 Markus Lüpertz. *The Big Spoon
(Der grosse Löffel)*. 1982. Oil on canvas.
6′ 7³/₈″ x 10′ 10¹/₂″ (201.6 x 331.5 cm).
The Museum of Modern Art, New York.
Given anonymously.

44 Bernd Koberling. *No Sun (Keine Sonne)*.
1969. Synthetic resin on canvas.
63 x 51¹/₈″ (160 x 130 cm).
Collection Reinhard Onnasch, Berlin.

45 Bernd Koberling. *Fishing (Am Fischwasser)*.
1963. Egg tempera and silver paint on canvas.
39¹/₄″ x 6′ 10³/₄″ (100 x 210 cm).
Collection the artist.

46 Bernd Koberling. *Bud Bloom Pod I
(Knospen-Blüten Kapseln I)*. 1976. Synthetic
resin and distemper on jute. 70⁵/₈″ x 70⁵/₈″
(180 x 180 cm). Private collection.

47 Bernd Koberling. *Touching the Horizon*.
1986. Oil on canvas. 7′ 4″ x 10′ 2″ (223 x
310 cm). Private collection.

48 David Hockney. *Berlin: A Souvenir*.
1962–63. Oil on canvas. 7 x 7′ (214 x
214 cm). Saatchi Collection, London.

49 Joseph Beuys. *Eurasia, 32nd Movement of the
Siberian Symphony*. Documentary photographs
of performance at Galerie René Block, Berlin
1966. Collection Lothar Schirmer, Munich.

50 Joseph Beuys. *Sweep Up (Ausfegen)*. 1972.
Sand, stones, paper, litter, broom, etc.
c. 6′ 6³/₄″ x 6′ 6³/₄″ x 25¹/₂″
(c. 200 x 200 x 65 cm).
Private collection, Berlin.

[50] Joseph Beuys. *Sweep Up (Ausfegen)*.
Documentary photographs of event in Berlin,
May 1, 1972.

51 Allan Kaprow. *A Sweet Wall*. Documen-
tary photographs of event in Berlin, November
9, 1970. Édition Block, Berlin.

52 Ludwig Gosewitz. *Sundial (Sonnenuhr)*.
1968. Pencil and ink on paper, mounted brass,
lead pin, and wood box. 12³/₄ x 10¹/₂ x 1¹/₂″
(32.5 x 26.5 x 3.5 cm). Edition Hundertmark,
Cologne, and Collection Armin Hundertmark,
Cologne.

53 Ludwig Gosewitz. *Big Inversion with Ship-
wrecked Person (Grosse Inversion mit Schiff-
brüchigem)*. 1968. Pencil and watercolor on
paper, and collage. 28³/₄″ x 6′ 2″ (73 x
188 cm). Private collection, Berlin.

54 Ludwig Gosewitz. *Natal Figure 30.6.1960
(Inga Loeper). [Geburtsfigur 30.6.1960 (Inga
Loeper)]*. 1980. Pencil and watercolor on
paper. 11³/₄″ x 8⁵/₈″ (30 x 22 cm).
Private collection, Berlin.

55 Ludwig Gosewitz. *Planetary Clock
(Planetenuhr)*. 1968. Watercolor and pencil
on various papers, mounted on wood.
16¹/₂ x 11¹/₂ x 2″ (42 x 29 x 5 cm).
Collection M. and C. Koschate, Frankfurt.

56 Arthur Koepcke. *Continue*. 1972. Box with
various objects and "concept" papers for 124
pieces. Édition Block, Berlin.

57 Arthur Koepcke. *Piece 65*. 1966.
Newsprint, felt-tip pen, and cardboard.
34³/₄ x 24¹/₄″ (88 x 62 cm).
Private collection, Berlin.

58 Arthur Koepcke. *Letter to Ludwig Gosewitz
(Brief an Ludwig Gosewitz)*. 1962. Collage.
15³/₄ x 9¹/₂″ (40 x 24 cm).
Private collection, Berlin.

59 Tomas Schmit. *The Heisenberg Uncertainty
Principle (Die Heisenbergsche Unschärferelation)*.
1971. Wood, wire, and felt-tip pen.

3/4 x 8 x 14¹/₄″ (2 x 20 x 36.5 cm).
Private collection, Berlin.

60 Tomas Schmit. *Heisenberg's Peach Sofa,
with Sybil (Heisenbergs Pfirsichsofa, mit Sibille)*.
1971. Pencil on paper. 8 x 14¹/₂″ (20 x 37 cm).
Private collection, Berlin.

61 Tomas Schmit. *The Atlas Nipples (Die
Atlasnippel)*. 1976. Pencil on paper. 17 x 24″
(43 x 61 cm). Private collection, Berlin.

62 Tomas Schmit. *The Tree on Which I Sit
(Der Baum auf dem ich hocke)*. 1979. Pencil
on paper. 17 x 24″ (43 x 61 cm).
Private collection, Berlin.

63 Robert Filliou. *A World of False Fingerprints*.
1975. Pencil and stamping ink on wood, offset
print, wood boxes and certificate. Sixteen
boxes: each box, 6¹/₄ x 6¹/₄ x 2″ (16 x 16 x
5 cm). Certificate: 16³/₄ x 16³/₄″ (42.5 x
42.5 cm). Édition Block, Berlin.

64 Emmett Williams. *Peacock Island (Pfauen-
insel)*. 1981. Xerography, synthetic polymer
paint on canvas. 29¹/₂ x 21¹/₂″ (75 x 55 cm).
Collection the artist.

65 Emmett Williams. *Kaiser-Wilhelm Memorial
Church (Kaiser-Wilhelm-Gedächtniskirche)*. 1981.
Xerography, synthetic polymer paint on
canvas. 29¹/₂ x 21³/₄″ (75 x 55 cm). Collection
the artist.

66 Emmett Williams. *Brandenburg Gate and the
Hindenburg (Brandenburger Tor und Hindenburg)*.
1981. Xerography, synthetic polymer paint on
canvas. 21¹/₂ x 29¹/₂″ (55 x 75 cm).
Collection the artist.

67 Emmett Williams. *Potsdam Square II (Pots-
damer Platz II)*. 1981. Xerography, synthetic
polymer paint on canvas. 21¹/₂ x 29¹/₂″
(55 x 75 cm). Collection the artist.

68 Emmett Williams. *Portraits of a Fluxus
Artist as Hors-d'Oeuvre d'Art*. 1983. Collage.
23³/₈ x 23¹/₄″ (59.5 x 59 cm). Collection Anna
and Otto Block, Berlin.

69 K. P. Brehmer. *Selection Packet No. 20
(Auswahlbeutel Nr. 20)*. 1967. 51¹/₄ x 70³/₄″
(130 x 180 cm). Collection the artist.

70 K. P. Brehmer. *Correction of the National
Colors According to the Distribution of Wealth
(Korrektur der Nationalfarben gemessen an der Ver-
mögensverteilung)*. 1970. Fabric and enamel
board. 13′ 1¹/₂″ x 51¹/₄″ (400 x 130 cm).
Collection the artist.

71 Wolf Vostell. *Berlin-Fever III (Berlin-
Fieber III)*. 1973. Screen print, lead foil, acrylic,
and porcelain plate on emulsified canvas.
55 ¹/₄″ x 6′ 10³/₄″ (140 x 210 cm).
Collection Gino di Maggio.

72 Wolf Vostell. *Berlin-Fever IV* (*Berlin-Fieber IV*). 1973. Screen print, lead foil, acrylic, and ox jawbone on emulsified canvas. 55¼″ x 6′ 10¾″ (140 x 210 cm). Collection Gino di Maggio.

73 Wolf Vostell. *Berlin-Fever V* (*Berlin-Fieber V*). 1973. Screen print, lead foil, and porcelain plate on emulsified canvas. 55¼″ x 6′ 10¾″ (140 x 210 cm). Galerie Inge Baecker, Cologne.

74 Wolf Vostell. *Mania Cycle: Film* (*Zyklus Mania: Film*). 1973. Pencil on smudged magazine photograph and knife in wood box covered with plexiglass. 15¾ x 11¾ x 4¾″ (40 x 30 x 12 cm). Staatliche Museen Preussischer Kulturbesitz, Nationalgalerie, Berlin.

75 Wolf Vostell. *Mania Cycle: Emigration* (*Zyklus Mania: Emigration*). 1973. Pencil on smudged magazine photograph and plastic box in wood box covered with plexiglass. 15¾ x 11¾ x 4¾″ (40 x 30 x 12 cm). Collection Jörn Merkert, Düsseldorf.

76 Wolf Vostell. *Mania Cycle: Police Terror* (*Zyklus Mania: Polizeiterror*). 1973. Pencil on smudged magazine photograph, fragment of skull, and plastic ball in wood box covered with plexiglass. 15¾ x 11¾ x 4¾″ (40 x 30 x 12 cm). Staatliche Museen Preussischer Kulturbesitz, Nationalgalerie, Berlin.

77 Wolf Vostell. *Potsdam Square* (*Potsdamer Platz*). 1975. Concrete, watercolor, and pencil on photograph. 27½ x 40½″ (70 x 103 cm). Berlinische Galerie, Berlin.

78 Edward Kienholz/Nancy Reddin Kienholz. *The Kitchen Table* (*No. 1*). 1975–77. Mixed mediums and bronze. 42⅛ x 66⅞ x 21¼″ (107 x 170 x 54 cm). Collection the artists, courtesy L.A. Louver Gallery, Venice, CA.

79 Edward Kienholz/Nancy Reddin Kienholz. *The Kitchen Table* (*No. 1*). 1975–77. Bronze and wire antennas. 42⅛ x 66⅞ x 21¼″ (107 x 170 x 54 cm), not including antennas. Collection the artists.

80 Edward Kienholz/Nancy Reddin Kienholz. *Mother with Child with Child* (*Washboard Series*). 1976–82. Mixed mediums. Three parts, each: 31½ x 17¼ x 4¾″ (77.5 x 43.8 x 12 cm). Private collection, Berlin.

81 Günter Brus. *Europa*. 1979. Colored pencil on paper. 48½ x 32½″ (122 x 83 cm). Collection Jean-Paul Jungo, Morges, Switzerland.

82 Günter Brus. *C. F. Hill*. 1979. Colored pencil on paper. 48½ x 33″ (125.5 x 84 cm). Private collection, Switzerland.

83 Günter Brus. *Füssli*. 1979. Colored pencil on paper. 48½ x 33″ (125.5 x 84 cm). Private collection, Switzerland.

84 Martin Rosz. *Arachne*. 1975–77. Synthetic polymer paint on paper. Seven panels: overall c. 11 x 22′ (c. 240 x 670 cm). Private collection.

85 Dieter Hacker. *The House Painters Begin to Paint Their own Future* (*Die Anstreicher beginnen ihre eigene Zukunft zu malen*). 1976. Oil on canvas. 6′ 5″ x 7′ 10½″ (196 x 240 cm). Städtische Galerie im Lenbachhaus, Munich.

86 Dieter Hacker. *Dream II* (*Traum II*). 1984. Oil on canvas. 6′ 6¾″ x 6′ 6¾″ (200 x 200 cm). Collection Dr. Hans-Jochem Lüer, Cologne.

87 Dieter Hacker. *The Day* (*Der Tag*). 1985. Oil on canvas. 7′ x 9′ 6″ (213 x 290 cm). Private collection.

88 Salomé. *Self-Portrait* (*Selbstporträt*). 1976. Synthetic resin on canvas. 6′ 6¾″ x 9′ 10⅛″ (200 x 300 cm). Collection Stober, Berlin.

89 Salomé. *For Luciano*. 1979. Synthetic polymer paint on canvas. 6′ 6¾″ x 9′ 10¼″ (240 x 400 cm). Collection Luciano Castelli.

90 Rainer Fetting. *Van Gogh and Wall V* (*Van Gogh und Mauer V*). 1978. Oil on canvas. 6′ 8″ x 8′ 4″ (201 x 251 cm). Collection Marx.

91 Rainer Fetting. *Moritzplatz I*. 1980. Dispersion on untreated cotton. 69 x 7′ 2½″ (175 x 220 cm). Collection Marx.

92 Rainer Fetting. *Large Shower* (*Panorama*) [*Grosse Dusche* (*Panorama*)]. 1981. Dispersion on nettle cloth. 9′ 5⅜″ x 16′ 5⅝″ (288 x 489.5 cm). Collection Marx.

93 Luciano Castelli. *Indians I* (*Indianer I*). 1982. Dispersion on canvas. 63″ x 6′ 6¾″ (160 x 200 cm). Collection Chase Manhattan Bank.

94 Helmut Middendorf. *Painter*. 1982. Synthetic polymer paint on canvas. 6′ 2¾″ x 7′ 6½″ (190 x 230 cm). Private collection.

95 Helmut Middendorf. *Airplane Dream* (*Flugzeugtraum*). 1982. Synthetic polymer paint and oil on canvas. 13′ 1½″ x 9′ 10″ (400 x 300 cm). Collection Federal Republic of Germany.

96 Bernd Zimmer. *Berlin*. 1978. Oil, tar, and dispersion on canvas. 6′ 2¾″ x 8′ 6¾″ (190 x 260 cm). Collection Salomé.

97 Bernd Zimmer. *Big Waterfall II* (*Grosser Wasserfall II*). 1980. Dispersion on canvas. 8′ 2½″ x 6′ 6¾″ (250 x 200 cm). Galerie Thomas, Munich.

98 Malcolm Morley. *The Day of the Locust*. 1977. Oil on canvas. 8′ x 60″ (244 x 152.5 cm). Collection Carol Johnssen, courtesy Galerie Jöllenbeck, Cologne.

99 Victor Burgin. *Zoo IV*. 1978. Gelatin-silver prints. Two panels, each: 31½ x 40⅝″ (80 x 103.3 cm). Courtesy John Weber Gallery, New York.

100 Richard Hamilton. *Apartment Block*. 1979. Collage, acrylic, pencil, and washes. 22¼ x 30″ (50 x 70 cm). Collection Massimo Valsecchi, courtesy Waddington Graphics, London.

101 Richard Hamilton. *Berlin Interior*. 1979. Photogravure, engraving, etching, roulette, aquatint, and burnishing. Edition of 100. 22¼ x 29⅞″ (56.5 x 76 cm). Courtesy Waddington Graphics, London.

102 Daniel Spoerri. *Fragment of Interior of Paris-Bar, Berlin*. c. 1979. Wood board, glass, metal, paper, china, etc. 14½″ x 6′ 6¾″ x 19⅝″ (37 x 200 x 50 cm). Private collection.

103 Bruce McLean. *Going for Gucci*. 1984. Synthetic polymer paint on canvas. 8′ 2½″ x 12′ 1½″ (250 x 370 cm). Collection Bishopric of Westfalia.

104 Giulio Paolini. *Study with a Figure from "Embarquement pour Cythère" by A. Watteau* (*Studio con una Figura da "Embarquement pour Cythère" di A. Watteau*). 1981–82. Collage. 16½ x 23⅜″ (42 x 59.5 cm). Collection the artist.

105 Giulio Paolini. *Study for the Presentation of the Work as a Doric Frieze* (*Studio per la presentazione dell'opera come fregio di ordine dorico*). 1981–82. Collage. 13¾ x 19⅝″ (35 x 50 cm). Collection the artist.

106 Jonathan Borofsky. *Berlin Dream at 2,833,792*. 1983. Charcoal on paper and acrylic on wall. 60¼″ x 6′ 3″ (153 x 190.5 cm). The Museum of Contemporary Art, Los Angeles. The Barry Lowen Collection.

107 Jonathan Borofsky. *Running Man*. 1982. Photograph of work painted on Berlin Wall as part of *Zeitgeist* exhibition.

108 Terry Fox. *Berlin Wall Scored for Sound*. 1982. Pencil on paper. 24 x 32¼″ (61 x 82 cm). Galerie Löhrl, Mönchengladbach.

109 Terry Fox. *The Berlin Wall Scored for Sound*. 1982. Pencil and felt-tip pen on paper. 17¾ x 19½″ (45.2 x 49.7 cm). Private collection, Berlin.

110 Christo. *Wrapped Reichstag: Project for Berlin*. 1982. Pencil, charcoal, crayon, pastel, and map. Drawing in two parts: 15″ x 8′ and 42″ x 8′ (38 x 244 cm and 106.6 x 244 cm). Collection Jan E. Clee.

[111–116] Paul-Armand Gette. *A Walk in Berlin from Grosser Stern to Askanischer Platz: Exotic as Banality*. 1980. Gelatin-silver prints with hand-applied Letraset. Six prints: each 9⅜ x 11¾″ (24 x 30 cm). Collection the artist.

111 *Robinia Pseudo-Acacia L.* (North America), Grosser Stern, Berlin Tiergarten.

112 *Ailanthus altissima Swingle* (China), Hildebrandtstrasse, Berlin Tiergarten.

113 *Aesculus Hippocastanum L.* (Balkans), Stauffenbergstrasse, Berlin Tiergarten.

114 *Robinia Pseudo-Acacia L.* (North America), Potsdamer Strasse, Berlin Tiergarten.

115 *Robinia Pseudo-Acacia L.* (North America), Askanischer Platz, Berlin Kreuzberg.

116 *Acer Negundo L.* (North America), Askanischer Platz, Berlin Kreuzberg.

117 Leland Rice. *Chaplin Wall* (*Chaplin Mauer*). 1985–86. Silver-dye bleach print (Cibachrome). 28³/₄ x 34¹/₂″ (73.1 x 87.7 cm). Courtesy the artist and Rosamund Felsen Gallery, Los Angeles.

118 Leland Rice. *Détente*. 1985–86. Silver-dye bleach print (Cibachrome). 28¹/₂ x 34″ (72.5 x 86.4 cm). Courtesy the artist and Rosamund Felsen Gallery, Los Angeles.

119 William Eggleston. *Untitled from Democratic Forest (Steam Heater)*. c. 1986. Chromogenic color print (Ektacolor). 20 x 24″ (50.9 x 61 cm). Middendorf Gallery, Washington, D.C.

120 William Eggleston. *Untitled from Democratic Forest (Reclining Woman Frieze)*. c. 1986. Chromogenic color print (Ektacolor). 20 x 24″ (50.9 x 61 cm). Middendorf Gallery, Washington, D.C.

121 Armando. *Flag* (*Fahne*). 1980–81. Oil on canvas. 7′ 10¹/₂″ x 69″ (240 x 175 cm). Rijksmuseum Kröller-Müller, Otterlo.

122 Armando. *Flag II* (*Fahne II*). 1982. Oil on canvas. 7′ 10¹/₂″ x 61″ (240 x 155 cm). Collection Loveday and Bruce Raben, courtesy Turske and Whitney Gallery.

123 Armando. *Flag* (*Fahne*). 1982. Oil on canvas. 7′ 10¹/₂″ x 61″ (240 x 155 cm). Collection Peter and Ursula Raüe, Berlin.

124 Martin Kippenberger. *The Hindered Flannel Rags (Die verhinderten Flannelläppchen)*. 1981–82. Oil on canvas. Ten panels: six panels 19³/₄ x 23¹/₂″ (50 x 60 cm), four panels 23¹/₂ x 19³/₄″ (60 x 50 cm). Hessisches Landesmuseum, Darmstadt.

125 Ina Barfuss/Thomas Wachweger. *Destuction Is Your Life Devotion*. 1982. Mixed mediums on paper. 39³/₈ x 27¹/₂″ (100 x 70 cm). Baviera Collection.

126 Ina Barfuss/Thomas Wachweger. *Red Cross (Rotes Kreuz)*. 1980. Mixed mediums on paper. 39³/₈ x 27¹/₂″ (100 x 70 cm). Baviera Collection.

127 Ina Barfuss/Thomas Wachweger. *Foreign Aid. (Entwicklungshilfe)*. 1980. Chalk and gouache on paper. 39³/₈ x 27¹/₂″ (100 x 70 cm). Private collection.

128 Ina Barfuss. *Abandoned Hope (Gescheiterte Hoffnung)*. 1984. Gouache. 51 x 39¹/₄″ (130 x 100 cm). Deutsche Bank, Hamburg.

129 Thomas Wachweger. *All Sisters Will Be Brothers (Alle Schwestern werden Brüder)*. 1984. Mixed mediums on canvas. 6′ 4³/₄″ x 69″ (195 x 175 cm). Collection Bazon Brock, Wuppertal.

130 Peter Chevalier. *Roebuck with Iris II (Rehbock mit Iris II)*. 1986. Oil on canvas. 59 x 59″ (150 x 150 cm). Collection Anne MacDonald Walker.

131 Peter Chevalier. *Roebuck with Iris I (Rehbock mit Iris I)*. 1986. Oil on canvas. 59 x 59″ (150 x 150 cm). Raab Galerie, Berlin.

132 Hermann Pitz. *Gilda–Signs (Gilda–Schilder)*. 1979–82. Paper, cardboard, iron, plastic flowers. Installation variable: c. 6′ 6″ x 10′ (c. 200 x 300 cm). Galerie Bernhard Wittenbrink, Munich.

133 Olaf Metzel. *Oak Leaf Studies (Eichenlaubstudien)*. 1986. Plexiglass and plaster. Two vitrines: each 6′ 6³/₄″ x 43¹/₄″ x 13³/₄″ (200 x 110 x 35 cm). Collection the artist.

134 Eva-Maria Schön. *Attempts to Get Close to a Leaf (Versuche, sich einem Blatt zu nähern)*. 1986. Distemper on paper. Dimensions variable: c. 11′ 6″ x 13′ 2″ (c. 350 x 400 cm). Collection the artist.

135 ter Hell. *Autonomy (Autonomie)*. 1986. Mixed mediums on canvas. 9′ ¹/₄″ x 9′ 10″ (275 x 300 cm). Galerie Fahnemann, Berlin.

136 Günter Brus. *The Gardens in the Exosphere (Die Gärten in der Exosphäre)*. 1977. 12¹/₈ x 16¹/₂″ (30.8 x 41.9 cm). The Museum of Modern Art, New York.

137 Günter Brus. *The Balcony of Europe (Der Balkon Europas)*. 1972. Pencil on paper in cardboard box. 12 x 16″ (31 x 41 cm). Edition Hundertmark, Cologne, and Collection Armin Hundertmark, Cologne.

138 Günter Brus. *Phantom Palaces (Phantom-Paläste)*. 1979. Edition Hundertmark. Handwritten manuscript with multicolored drawings. 11³/₄ x 16¹/₂″ (30 x 42 cm). Edition Hundertmark, Cologne, and Collection Armin Hundertmark, Cologne.

139 Günter Brus. *Waltz of the Joys of the Night (Nachtfreudenwalzer)*. 1975. Dürschlag, Berlin. 12³/₄ x 9³/₄″ (32.4 x 24.8 cm). The Museum of Modern Art, New York.

140 Günter Brus. *Imp (Irrwisch)*. 1971. Kohlkunstverlag, Frankfurt. 11¹/₂ x 8¹/₄″ (29.5 x 20.5 cm). Buchhandlung Walther König, Cologne.

141 Martin Rosz. *Half Images 1982–84 (Halbe Bilder 1982–84)*. 1984. Rainer Verlag. 12 x 8³/₄ x 1¹/₂″ (30.3 x 22.2 x 3.7 cm). The Museum of Modern Art, New York.

142 Markus Raetz. *Notes (Notizen)*. 1982. 6 x 4″ (15.3 x 10.2 cm). The Museum of Modern Art, New York.

143 Ben Vautier. *My Berlin Inventory*. 1979. Berliner Künstlerprogramm des Deutschen Akademischen Austauschdienstes. Edition of 1000. 8¹/₂ x 6¹/₂ x 1″ (21.7 x 16.6 x 2.5 cm). The Museum of Modern Art, New York.

144 Edition Hundertmark. *Box 1 (1 Karton)*. 1970. (Includes original works by: Beuys, Brus, Filliou, Friedman, Gosewitz, Knizak, Rühm, Mühl, Nitsch, Schmit, Vautier.) Edition of 30. Cardboard box, mixed mediums. Box: 10 x 12³/₄″ (25.3 x 32.2 cm). Edition Hundertmark, Cologne, and Collection Armin Hundertmark, Cologne.

145 Arnulf Rainer. *Nerve Spasm (Nervenkrampf)*. 1971. Twelve photographs and handwritten title page in cardboard box. Box: 13 x 13¹/₄ x ⁵/₈″ (33 x 34 x 1.5 cm). Edition Hundertmark, Cologne, and Collection Armin Hundertmark, Cologne.

146 Milan Knizak. *Fluxus East (Fluxus Ost)*. 1971. Edition Hundertmark, edition of 20. Four objects in a box, mixed mediums. Box: 13¹/₄ x 17¹/₂ x 4¹/₂″ (33.5 x 44.5 x 12 cm). Edition Hundertmark, Cologne, and Collection Armin Hundertmark, Cologne.

147 Tomas Schmit. *Potatoes Boiled in Their Jackets. (pellkarto/fffel/n)*. 1984. Drawings in box. Each drawing: 8¹/₄ x 11³/₄″ (21 x 29.8 cm). Private collection, Berlin.

148 Edition Hundertmark. *Ten Year Box (10 Jahres Karton)*. (Includes works by: Andersen, Beuys, Blume, Böhmler, Brus, Filliou, Gerz, Limura, Kirves, Knizak, Knowles, Lurie, Nitsch, Rainer, Rühm, Saito, Schäuttelen, Schmit, Steiger, Schwegler, Valoch, Vautier, Wewerka.) Edition of 40. Cardboard box, mixed mediums. Box: 14 x 15³/₄ x 2¹/₄″ (36 x 40 x 6 cm). Edition Hundertmark, Cologne, and Collection Armin Hundertmark, Cologne.

149 K.H. Hödicke. *Calendar Pages (Kalenderblätter)*. 1980. Rainer Verlag, Berlin, with Berliner Künstlerprogramm des Deutschen Akademischen Austauschdienstes. Edition of 1000. 9¹/₂ x 6⁷/₈″ (24.3 x 17.5 cm). The Museum of Modern Art, New York.

150 Bernd Zimmer. *Lombok, Zwieselstein, Berlin Drawings, Paintings, Graphics, etc. (Lombok,*

Zwieselstein, Berlin Zeichnungen, Bilder, Graphik & c.). 1981. Rainer Verlag, Berlin. Edition of 1000, of which 30 include original drawing. 9¹/₂ x 6³/₄″ (24.1 x 17.3 cm). The Museum of Modern Art, New York.

151 Rainer Verlag, Berlin. Books.

Twenty Years: Rainer Verlag, An Anthology (Zwanzig Jahre: Rainer Verlag, Eine Anthologie). 1986. 5³/₈ x 4″ (15.1 x 10.2 cm). The Museum of Modern Art, New York.

H. C. Artmann. *The Boasting of the Primeval Forest in the Jungle (Das prahlen des urwaldes im dschungel).* 1983. 6 x 4″ (15 x 10.2 cm). The Museum of Modern Art, New York.

Rainer Haarmann, Max Newmann, Martin Rosz. *nachdenklichlachdenknich.* 1981. Edition of 750, of which 25 include 3 original postcards. 6¹/₈ x 4³/₈″ (15.6 x 11.1 cm). The Museum of Modern Art, New York.

K. H. Hödicke. *Somersault Pictures and Poems (Purzelbaum Bilder und Gedichte).* 1984. Edition of 1000, of which 40 include an original drawing. 6 x 4″ (15 x 10.2 cm). The Museum of Modern Art, New York.

Martin Rosz. *Still Lifes 1982–84 (Stilleben 1982–84).* 1984. Edition of 500, of which 20 include an original drawing. 6 x 4″ (15 x 10.2 cm). The Museum of Modern Art, New York.

Martin Rosz. *Drawings 1981–84 (Zeichnungen 1981–84).* 1985. Edition of 500, of which 20 include an original drawing. 6 x 4″ (15 x 10.2 cm). The Museum of Modern Art, New York.

Ben Vautier. *Fluxus and Friends Going out for a Drive.* 1983. Edition of 1000. 6 x 4″ (15 x 10.2 cm). The Museum of Modern Art, New York.

Markus Raetz. *Notes (Notizen).* 1982. 6 x 4″ (15.3 x 10.2 cm). The Museum of Modern Art, New York.

[Not illustrated]
George Brecht. *Fluxkit Null (Fluxnullkit).* 1978. Edition Hundertmark, edition of 180. Leaflet in four parts, 2 drawings, 19 text sheets in box. Box: 12¹/₂ x 9″ (32 x 23 cm). Edition Hundertmark, Cologne, and Collection Armin Hundertmark, Cologne.

Chronology

Compiled by Thomas Schulte

Within each year, entries for cultural events in Berlin precede those elsewhere; these are followed by notable political events relating to Berlin.

1961

FEBRUARY 2–MARCH 19: Akademie der Künste exhibits *Expressionism: Literature and Art 1910–1925*.

SEPTEMBER: Austrian sculptor Karl Prantel organizes international sculptors' working session in front of the Reichstag building; the sculptures are left in place as a permanent exhibition. The event will be repeated in 1963.

SEPTEMBER 24: German Opera building, designed by Fritz Bornemann, opens; it replaces the former German Opera House, destroyed during the war.

NOVEMBER 10–30: Georg Baselitz and Eugen Schönebeck exhibit their works in abandoned house at Schaperstrasse 22, and publish a manifesto, later to be called first *Pandemonium*.

DECEMBER 17: Kaiser-Wilhelm-Memorial Church, heavily damaged during the war, reopens; renovated by Egon Eiermann.

Der Sturm, retrospective shown at Schloss Charlottenburg.

Konrad Bayer and Gerhard Rühm, the first of numerous Viennese writers and artists, move to Berlin.

AUGUST 13: German Democratic Republic (GDR) closes the borders between East and West Berlin and begins construction of the Berlin Wall.

AUGUST 19–21: Vice President Lyndon B. Johnson visits West Berlin.

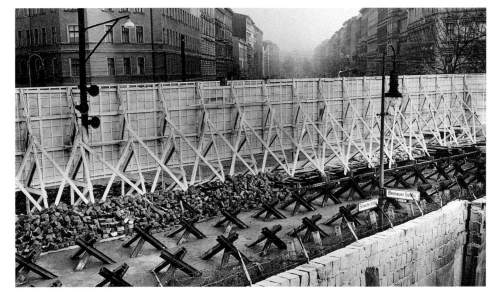

Berlin Wall at Bernauerstrasse, 1961

1962

SPRING: Baselitz and Schönebeck write second *Pandemonium,* which begins: "Negation is a gesture of genius, not a wellspring of responsibility."

JUNE 5–AUGUST 30: Haus am Waldsee opens with survey show *Gegenwart bis 1962* (*Contemporary Art to 1962*), organized by Manfred de la Motte. Important international painters, representing Action Painting, *tachisme*, and *l'art informel*, are introduced to the Berlin public, among them Piero Dorazio, Jean Dubuffet, Jean Fautrier, Sam Francis, Rupprecht Geiger, K. O. Götz, Hans Hartung, Gerhard Hoehme, Georges Mathieu, Matta, Henri Michaux, Robert Motherwell, Robert Rauschenberg, Jean-Paul Riopelle, Mark Rothko, Antonio Saura, Bernard Schultze, Emil Schumacher, K. R. H. Sonderborg, Fred Thieler, Mark Tobey, and Cy Twombly.

OCTOBER 7–DECEMBER 30: Akademie der Künste shows *George Grosz*.

JUNE 29: West German parliament guarantees economic aid and privileges for companies and individuals that settle in Berlin, representing a first step toward independence for the isolated city.

1963

OCTOBER 1: Galerie Werner and Katz, Kurfürstendamm 234, opens with works by Baselitz that cause a scandal. Two paintings, *The Great Piss-Up* and *The Naked Man*, are confiscated by the authorities; artist and gallery owners are accused of obscenity. They are acquitted years later.

OCTOBER 15: New Philharmonic Hall, designed by Hans Scharoun, opens.

The Ford Foundation establishes Artists-in-Residence Program.

Markus Lüpertz moves to Berlin, paints Donald Duck Series, and develops the "Dithyramb."

JUNE 26: President John F. Kennedy visits West Berlin.

1964

MARCH 4–MARCH 24: Akademie der Künste shows *André Masson*.

Sculptures in front of Reichstag, 1961

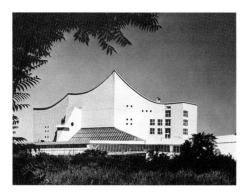

Hans Scharoun. New Philharmonic Hall, 1963

JUNE 7–JULY 5: Retrospective of work by German Expressionist Karl Schmidt-Rottluff at Akademie der Künste.

JUNE 16: The cooperative gallery Grossgörschen 35 is established, and shows, in its first year, exhibitions of works by artists who represent different artistic directions but reject abstract painting: H. J. Diehl, K. H. Hödicke, Bernd Koberling, Lüpertz, Wolfgang Petrick, and others.

Galerie Michael Werner opens. The first exhibition, *First Orthodox Salon*, presents only Baselitz's large painting *Oberon*.

SEPTEMBER 15: Galerie René Block opens with a group exhibition, *Neodada/Pop/Décollage/Capitalist Realism*, with works by K. P. Brehmer, Hödicke, Konrad Lueg, Sigmar Polke, Gehard Richter, Wolf Vostell, and others.

OCTOBER: Amerikahaus shows drawings by Arshile Gorky.

OCTOBER 27: First of a series of Fluxus evenings organized by René Block, with Stanley Brouwn's *This Way Brouwn*.

NOVEMBER 20, 1964–JANUARY 3, 1965: Akademie der Künste exhibits *Neue Realisten & Pop Art*, organized by W. A. L. Beeren of the Gemeente Museum, The Hague, and shown in Germany only in Berlin. The show includes Arman, Joseph Cornell, Christo, Marcel Duchamp, David Hockney, Robert Indiana, Jasper Johns, Yves Klein, Roy Lichtenstein, Man Ray, Claes Oldenburg, Rauschenberg, Larry Rivers, James Rosenquist, George Segal, Daniel Spoerri, Jean Tinguely, Andy Warhol, Tom Wesselman, and others.

DECEMBER 12: Block organizes first Berlin Happening, *The Chief*, by Joseph Beuys.

Guests of Artists-in-Residence program include Wojciech Fangor, André Masson, Remo Remotti, Antonio Saura, Igor Stravinsky, and Emilio Vedova.

1965

JANUARY–NOVEMBER: Galerie René Block presents series of performances, including: Bazon Brock's *My God, What's Happening?*, Vostell's *Phenomena*, Tomas Schmit's *Action*, Nam June Paik's *Robot Opera*, Charlotte Moorman/Paik's *Fluxus Concert*, Vostell's *Berlin—100 Events—100 Minutes—100 Places*.

Galerie René Block exhibits *Hommage à Berlin*; includes works by Beuys, Brehmer, Brouwn, Hödicke, Lueg, Polke, Richter, and others.

SEPTEMBER 9–OCTOBER 24: The gallery Grossgörschen 35 celebrates its first anniversary with an exhibition of works by Hödicke, Lüpertz, Koberling, and others who showed at the gallery during its first year.

Hochschule für bildende Künste shows *American Sculpture—U.S.A. 20th Century*, organized by Eberhard Roters. Included are works by Louise Bourgeois, Alexander Calder, Cornell, Herbert Ferber, Raoul Hague, Frederick Kiesler, Gaston Lachaise, Ibram Lassaw, Seymour Lipton, Elie Nadelman, Reuben Nakian, Louise Nevelson, Barnett Newman, Isamu Noguchi, Oldenburg, George Rickey, José de Rivera, Segal, Jason Seley, David Smith, Mark di Suvero, Wilfred Zogbaum, William Zorach, among others.

SEPTEMBER 25–OCTOBER 24: Galerie Benjamin Katz shows works of Schönebeck.

Artists-in-Residence Program is transferred to DAAD (German Academic Exchange Service) and renamed Berliner Künstlerprogramm (Berlin Artists Program). Peter Nestler is its first director.

Fluxus artists Ludwig Gosewitz and Tomas Schmit move to Berlin.

JULY 1: Ten thousand Berlin students protest federal and local education policies. The rally marks the beginning of participation by Germany's young generation in the international youth movement of the sixties.

1966

JANUARY: Rainer Verlag established in Berlin-Kreuzberg by Rainer Pretzell to publish illustrated books and books for bibliophiles, mostly by artists and writers working in Berlin. The first is *Dracula, Dracula* by Austrian author H. C. Artmann.

JANUARY 29–FEBRUARY 12: Rudolph Springer and Michael Werner organize Baselitz exhibition at Galerie Springer, presenting the painting *The Great Friends*, and publish a poster with the Baselitz manifesto *Why the Painting "The Great Friends" Is a Good Painting*. After the show closes, Baselitz leaves Berlin to settle in West Germany.

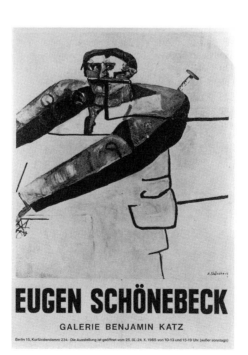

EUGEN SCHÖNEBECK
GALERIE BENJAMIN KATZ

Poster for Eugen Schönebeck exhibition, 1965

SPRING: Lüpertz has two shows, at Grossgörschen 35 and Galerie Potsdamer, titled *Kunst die im Wege steht (Art That Is in the Way)*, and publishes *Dithyrambic Manifesto*: "The grace of the century will be made visible by the Dithyramb founded by myself."

MAY 5–JULY 10: Akademie der Künste shows *Young Generation: Painters and Sculptors in Germany*, organized by Will Grohmann, which includes works by Baselitz, Brehmer, Johannes Gecceli, Hödicke, and Walter Stöhrer.

SUMMER: Grossgörschen group dissolves. Hödicke, Lüpertz, and Koberling walk out as a result of "violent differences of opinion" with the Critical Realist faction, which will retain influence on Grossgörschen 35 and make it the center of Berlin's realistic movement of the seventies, with painters Ulrich Baehr, Diehl, Petrick, Peter Sorge, and others.

OCTOBER 4–NOVEMBER 17: Galerie René Block presents *The Non-Baroque in Art*, including Beuys, Brehmer, Hödicke, Jörg Immendorf, Lueg, Polke, Richter, and Vostell.

OCTOBER 31: Block organizes a series of concerts of new and experimental music, and presents Beuys's Fluxus event *Eurasia: Siberian Symphony 1963, 32nd Movement*.

NOVEMBER 27, 1966–JANUARY 8, 1967: Akademie der Künste presents retrospective *Max Beckmann*.

DECEMBER 9: Galerie René Block moves from Kreuzberg to Schaperstrasse, Berlin-Charlottenburg, and opens with an exhibition of works by Richter.

Student protests against the Vietnam War, the federal education system, and obsolete social structures take place, led by student leader Rudi Dutschke.

DECEMBER 1: Chancellor Ludwig Erhard resigns. Kurt Georg Kiesinger succeeds him and Berlin's Mayor Willy Brandt becomes minister of foreign affairs. Brandt is succeeded by deputy mayor Heinrich Albertz.

1967

JANUARY 9–FEBRUARY 19: Haus am Waldsee shows *New Realism*, with works by Baehr, Diehl, Lueg, Petrick, Polke, Richter, and others.

SEPTEMBER 15: Brücke Museum opens in Berlin-Dahlem. Devoted to collecting and researching German Expressionism, it had been made possible by Schmidt-Rottluff and Erich Heckel, former members of *Die Brücke*.

OCTOBER–NOVEMBER: Akademie der Künste shows *Avantgarde in East Europe: 1910–1930*, with works by Malevich, El Lissitzky, and others; organized by Eberhard Roters.

OCTOBER 22–NOVEMBER 18: Galerie René Block shows *Hommage à Lidice*, which includes Beuys, Brehmer, Lueg, Gotthard Graubner, Hödicke, Immendorf, Koberling, Blinky Palermo, Polke, Richter, Günther Uecker, Vostell, and others. A gift of the exhibition is made to the city of Lidice, Czechoslovakia.

Schönebeck retires from the art business.

Guests of the DAAD program include Kenneth Armitage.

Ludwig Mies van der Rohe. Neue Nationalgalerie, 1968

Exhibition *Berlin-Berlin*, organized by Deutsche Gesellschaft für bildende Kunst Berlin, shown at the Zapeion in Athens. Includes work by Baselitz, Hödicke, and Lüpertz.

JUNE 2: Benno Ohnesorg, Free University student, is killed in political demonstration against a visit of the Shah of Iran to Berlin. The incident causes a series of violent encounters between police and students.

SEPTEMBER 26: Mayor Albertz resigns, and is succeeded by Klaus Schütz.

1968

JUNE–JULY: Galerie René Block presents *Minimal Art USA*, the first such exhibition in Berlin, including works by Carl Andre, Donald Judd, Gary Kuehn, Sol LeWitt, Robert Morris, and others. Later in the year, Block exhibits a retrospective of the graphic works of Richard Hamilton: *I'm Dreaming of a White Christmas*.

SEPTEMBER 5: Opening of the Neue Nationalgalerie, designed by Ludwig Mies van der Rohe, with exhibition *Piet Mondrian*.

Galerie Poll is established; it will concentrate on the art of the Critical Realists and will be involved in the organization of many government-supported exhibitions shown outside Berlin.

Guests of the DAAD program include Dorazio, Peter Handke, and Rickey.

APRIL 11: Socialist student leader Rudi Dutschke is shot and severely wounded by a West German Rightist. Violent demonstrations follow.

1969

JANUARY 1–FEBRUARY 21: Richter's *City Pictures* shown at Galerie René Block.

FEBRUARY 28–NOVEMBER 11: Block organizes *Blockade 69*, a series of nine environmental exhibitions in his gallery, which includes environments by Beuys (*Konzertflügeljom*), Palermo (*Meditation Room*), and Hödicke (*René's Dream, Shack for Ten Laying Héns*), among others.

MARCH 23–APRIL 27: Akademie der Künste shows *Minimal Art*, organized by Gemeente Museum, The Hague. It includes Ronald Bladen, Dan Flavin, Judd, LeWitt, Morris, Richard Smith, and Michael Steiner.

JUNE 1–29: Over 300 recent graphic works by Pablo Picasso shown at Akademie der Künste.

JULY 1: Deutsche Gesellschaft für bildende Kunst, Berlin, replaced by two art associations, Neuer Berliner Kunstverein (NBK) and Neue Gesellschaft für bildende Kunst (NGBK), both of which intend to concentrate on the problems of art and society, organize exhibitions and other cultural events, and operate "in the wide field between governmental art support and private art dealing."

Benjamin Katz and Galerie Bassenge collaborate on first exhibition of Marcel Broodthaers in Germany.

Viennese artist Günter Brus settles in Berlin after being harassed by Austrian police on charges connected with his work. In Berlin he abandons performance and concentrates on graphic work. It is ten years before he is able to return to Austria.

FEBRUARY 27: President Richard M. Nixon visits West Berlin.

OCTOBER 21: Brandt becomes first Social Democratic chancellor.

1970

FEBRUARY 20: Galerie René Block presents *Gilbert and George—The Human Sculptures* with the performance *Underneath the Arches* at Forum Theater, Berlin.

APRIL–NOVEMBER: *Akustische Räume*, series of acoustic environments by Maurizio Kagel, Paik, Markus Raetz, Vostell, and others, installed at Galerie René Block.

JUNE 13–AUGUST 2: Akademie der Künste shows *The Sidney and Harriet Janis Collection*, organized by The Museum of Modern Art, New York.

NOVEMBER 11: Block organizes Allan Kaprow's *A Sweet Wall*.

NOVEMBER 14–15: Block arranges Festum Fluxorum at Forum Theater, with Eric Andersen, Robert Filliou, Al Hansen, Moorman, and Emmet Williams, among others.

NOVEMBER 29, 1970–JANUARY 3, 1971: Akademie der Künste exhibits *Max Ernst*, from the de Menil collection.

Edition Hundertmark established by Armin Hundertmark. Publishes works by Fluxus artists Beuys, Gosewitz, and Schmit, and Austrian artists connected to Berlin, Brus, Hermann Nitsch, Arnulf Rainer, and Rühm. The first publication is a portfolio of works by eleven artists.

Goethe-Institut, Berlin, and DAAD program organize an exhibition of works by DAAD artists, among them Armitage, Dorazio, Jan Kotik, and Vedova.

Guests of the DAAD program include Kotik, Mark Brusse, and Ernst Jandl.

MARCH 26: Quadripartite talks on the status of Berlin begin.

MAY 14: Andreas Baader, who will become one of the leaders of the terrorist Red Army Faction (RAF/Baader-Meinhof group) escapes from confinement in West Berlin.

1971

MARCH 5–APRIL 3: Galerie René Block shows *Designs, Scores, Projects, Drawings*, including works by Beuys, George Brecht, Hanne Darboven, Jan Dibbets, Filliou, Gosewitz, Hödicke, Arthur Koepcke, Imi Knoebel, LeWitt, Piero Manzoni, Palermo, Panamarenko, Polke, Richter, Dieter Roth, Rainer Ruthenbeck, Schmit, Ben Vautier, and Vostell.

MARCH 12–JULY: Akademie der Künste shows *Kurt Schwitters: Works 1908–1947*.

APRIL 3–MAY 1: Block exhibits Readymades by Marcel Duchamp.

MAY 20–JULY 14: *Hannah Höch: Collages 1916–1971*, shown at Akademie der Künste.

SEPTEMBER 15–NOVEMBER 7: Nationalgalerie shows *Metamorphoses of the Object: Art and Anti-art, 1910–1970*, a collaborative touring exhibition dedicated to object art since Duchamp, Futurism, Dada, and Surrealism. In collaboration with NBK, the Nationalgalerie also exhibits *Naum Gabo* and *Mark Rothko*.

NGBK organizes *Functions of Art in Our Society* at Berlin's Technical University.

Dieter Hacker establishes 7. Produzentengalerie to show and discuss his own work, which seeks creativity in the trivial and looks for triviality in

7. Produzentengalerie on Grainauerstrasse, 1971

Wolf Vostell. *Berlin Sleeping-Car*, 1972

"so-called art." The first exhibition is *Jeder könnte sein eigener Künstler sein (Everybody Could Be His own Artist)*.

Vostell moves from Cologne to Berlin.

Guests of the DAAD program include Christian Ludwig Attersee, Alex Colville, Peter Sedgley, Bridget Riley, and Rickey.

SEPTEMBER 3: Quadripartite agreement on Berlin is signed. The U.S.S.R. guarantees unhindered access to West Berlin. A *de facto* recognition of the German Democratic Republic by the Federal Republic of Germany is assumed.

1972

MAY 1: Block organizes Beuys's *Ausfegen (Sweep Up)* on Karl-Marx-Platz.

JULY–SEPTEMBER: NBK organizes Vostell's Happenings *Berliner Stuhl (Berlin Chair)* and *Berliner Schlafwagen (Berlin Sleeping-Car)*, part of his project *Desastres della Guerra*. Vostell produces a video movie about the events, with tapes by Beuys, Brehmer, Peter Campus, Hödicke, Rebecca Horn, and others.

Austrian poet Oswald Wiener opens the restaurant *Exil*, which will become an important meeting place for the artistic community in Berlin.

Restaurant *Exil*, with ceiling painted by Günter Brus, 1972

Guests of the DAAD program include Shusaku Arakawa, Brouwn, Rafael Canogar, Austrian writer Friedrich Achleitner, and John Cage.

Periodical *Berliner Kunstblatt* established by Berlin art dealers to provide information on artistic events in Berlin.

20 Berliner Realisten, organized by the administrations of Berlin-Schöneberg and the city of Salzburg, is shown in Salzburg, Austria.

Prinzip Realismus, organized by Galerie Poll, DAAD, and Goethe-Institut, Munich, and sponsored by the Berlin senate and Berlin-Lotto, features works by artists of the *Aspekte* group: Bettina von Arnim, Baehr, Diehl, Maina-Miriam Munsky, Petrick, Sorge, and others. The show, divided into two sections, tours 21 European cities, including Berlin.

MAY–NOVEMBER: *Berlin Scene 1972*, three exhibitions held in Stuttgart, London, and Hamburg, initiated by Kunstverein Stuttgart, sponsored by the Berlin senate, and organized by René Block and DAAD, shows, in different combinations, works of Berlin artists Brehmer, Gosewitz, Hödicke, Koberling, Schmit, Vostell, and foreign artists working in Berlin, Arakawa, Attersee, Brus, Sedgley, and others.

DECEMBER 21: Treaty between the Federal Republic of Germany and the German Democratic Republic is signed; the two parties agree to respect each other as independent states and to exchange official ambassadors. West Berliners are allowed to visit East Berlin and the GDR more frequently.

1973

JANUARY 14–FEBRUARY 18: Edward Kienholz's *Five Car Stud* is presented at Akademie der Künste along with *Prinzip Realismus*.

SEPTEMBER 9–OCTOBER 3: *Actions of the Avant-garde* (ADA) organized by NBK, DAAD, and Berlin Festival at Akademie der Künste: "actions" and environments by Filliou, Taka Iimura, Wolf Kahlen, Kaprow, Mario Merz, and Vostell's *Berlin Fieber*.

OCTOBER 13: International colloquium for experimental arts held at Akademie der Künste.

Karl Ruhrberg, former head of the Kunsthalle Düsseldorf, becomes the new director of DAAD program. Guests include Pier Paolo Calzolari, Merz, Joel Fisher, Stuart Brisley, Makoto Fujiwara, and Kienholz.

DECEMBER 7, 1973–JANUARY 22, 1974: Galerie Abis shows *Eugen Schönebeck: Paintings, Sketches, Drawings, 1962–1973*, the artist's first exhibition since 1965 and the last until 1986.

SEPTEMBER 18: East and West Germany are admitted to United Nations. The four powers continue to represent Berlin.

1974

MAY 8–JUNE 15: NBK shows *Multiples: An Attempt to Present the Development of the Object Edition*.

JULY–AUGUST: Nationalgalerie, in collaboration with DAAD, shows retrospective *Richard Hamilton*.

Daniel Buren at *Actions of the Avant-garde 2*, 1974

SEPTEMBER 26–OCTOBER 11: *Actions of the Avant-garde 2*, organized by NBK and DAAD, presents works by Amelith, Daniel Buren, Canogar, Jochen Gerz, Kämmerling, Kienholz, Jannis Kounellis, and Vostell in various places in Berlin.

SEPTEMBER 27: *The Berlin Concert* performed by Austrian artists Attersee, Brus, Nitsch, Roth, Rühm, Steiger, Weiner, and Rainer.

FALL: Künstlerhaus Bethanien, a former hospital built in the nineteenth century in Berlin-Kreuzberg, opens. It provides studios and workshops to artists who work or want to work in Berlin. Bethanien enables artists to present work to the public and also becomes a center for performance activities.

Guests of DAAD program are James Lee Byars, Filliou, Broodthaers, Lazlo Lakner, Eduardo Paolozzi, Franz Gertsch, Duane Hanson, Hamilton, Buren, Steve Reich, and others.

Byars presents *It's Gotta Be Beautiful* at Galerie René Block and *The Golden Tower* at Galerie Springer.

MAY 6: Chancellor Brandt resigns because of an espionage affair.

James Lee Byars. *The Golden Tower* at Galerie Springer, 1974

Künstlerhaus Bethanien, 1974

MAY 16: Helmut Schmidt is elected chancellor. Dietrich Genscher succeeds Walter Scheel as foreign minister; Scheel becomes president.

NOVEMBER 10: The president of Berlin's supreme court is killed by members of the RAF.

1975

JANUARY 19–FEBRUARY 23: Akademie der Künste shows works by Hanson, Gertsch, and Filliou.

JANUARY–JUNE: Nationalgalerie shows work of Broodthaers and Paolozzi, and a retrospective of the work of Vostell.

JUNE 1: Dieter Honisch becomes director of Nationalgalerie, succeeding Werner Haftmann.

SEPTEMBER–OCTOBER: Haus am Waldsee shows *Art in the Third Reich—Documents of the Subjugation.*

OCTOBER 1: Hochschule für bildende Kunst (College of Visual Arts) is integrated into the Hochschule der Künste (College of Arts), which includes fine, performing, and applied arts.

NOVEMBER: Schmidt-Rottluff, one of the first postwar professors at College of Visual Arts, establishes a scholarship fund for young artists.

Berlinische Galerie established under the directorship of Eberhard Roters to provide a permanent site for the city of Berlin's collection of nineteenth- and twentieth-century art made in Berlin.

DECEMBER: NBK (with DAAD) shows *8 from Berlin*, including works by Gosewitz, Hödicke, Kienholz, Koberling, and Schönebeck. The exhibition, organized by Berlin art dealer Folker Skulima for the Scottish Arts Council, is also presented in Edinburgh.

DECEMBER–JANUARY 1976: Haus am Waldsee shows *Körpersprache (Body Language).*

Guests of DAAD program include Kenneth Selson, Weiner, Kaprow, Christian Boltanski, Don Potts, and Eduardo Arroyo.

FEBRUARY 27: Members of the anarchist group "2. Juni" kidnap West Berlin mayorial candidate Peter Lorenz. He is released after imprisoned terrorists are freed and flown to South Yemen.

1976

FEBRUARY: Christo visits Berlin to discuss his project *Wrapped Reichstag* with leading officials.

SEPTEMBER 3: *Flux Harpsichord Concert* is organized at Akademie der Künste by Block. Participants are Brecht, Filliou, Joe Jones, George Maciunas, Larry Miller, Paik, Vautier, and others.

SEPTEMBER–OCTOBER: Nationalgalerie shows *New York in Europe: American Art in European Collections*, covering American art since 1945, from Abstract Expressionism to Conceptual art.

SEPTEMBER–OCTOBER: Akademie der Künste presents *Soho—Downtown Manhattan*, organized by Block; includes performance, music, and literature.

SEPTEMBER–OCTOBER: Haus am Waldsee shows *Andy Warhol: The Complete Drawings.*

Guests of DAAD program include On Kawara, Dan Graham, Roman Opalka, and Stephan von Huehne.

1977

MARCH 8–APRIL 10: NBK and Frauen in der Kunst organize *Künstlerinnen International, 1877–1977 (Female Artists International: 1877–1977)* at Schloss Charlottenburg, presenting works by more than eighty artists.

MAY 12–JUNE 10: *14 American Women Artists* shown at Amerikahaus.

MAY 13: Galerie am Moritzplatz opens with a performance by Salomé. The cooperative gallery is made possible by Salomé, Rainer Fetting, Helmut Middendorf, Bertholdt Schepers, Rolf von Bergmann, Anne Jud, and other artists, many of whom attended or were connected to Hödicke's class at the College of Arts.

MAY 5–29: Nationalgalerie presents Kienholz's series *Volksempfängers*, a group of sculptures based on objects found in Berlin flea markets.

AUGUST 14: Fifteenth European art exhibition sponsored by the Federal Republic and Berlin takes place in Berlin. *Tendencies of the Twenties*, in four parts, covers the full range of art and culture in Europe during the third decade of the twentieth century and its influences on the present. Part 1, *Vom Konstruktivismus zur konkreten Kunst*, is shown at Nationalgalerie; Parts 2 and 3, *Von der futuristischen zur funktionellen Stadt—Plannen und Bauen in Europa 1913-1933* and *Dada in Europa*, at Akademie der Künste; and Part 4, *Neue Wirklichkeit—Surrealismus und Neue Sachlichkeit*, at Schloss Charlottenburg.

AUGUST 21: Staatliche Kunsthalle Berlin opens on Budapesterstrasse to show exhibitions organized by NBK, NGBK, Berlinische Galerie, and others.

It will also be the center of Berlin's annual international film festival. The first exhibition, thematically connected to *Tendencies of the Twenties*, is called *Who Owns the World? Art and Society in the Weimar Republic.*

Guests of the DAAD program include Douglas Davis, Malcolm Morley, Anne and Patrick Poirier, Charles Simonds, Joe Tilson, and others.

MARCH 10–APRIL 19: *Berlin Now*, a collaboration of DAAD, Goethe House, New York, and the Berlin senate, is presented in New York. It consists of three separate exhibitions: *Realistic Tendencies* at the New School Art Center (Diehl, Petrick, Sorge, and Vogelgesang), *Abstraction, Conception, Performance* at Gallery Denise René and The Kitchen (Geccelli, Horn, Kawara, Rosz, and Sedgley), and *Hannah Höch: Collages and Photomontages* at Goethe House.

MARCH 25: Mayor Schütz resigns and is later succeeded by Dietrich Stobbe.

Siegfried Buback, Federal Attorney General, and Jürgen Ponto, director of a major bank, are killed by members of the Baader-Meinhof group, who also kidnap and kill Hans-Martin Schleyer, President of the Employers Association and of the Federal Association of German Industry.

OCTOBER 13: A Lufthansa airplane is hijacked by individuals connected to the group; the hostages are freed five days later. On the same day, the anarchist leaders Andreas Baader and Gudrun Ensslin are found dead in their prison cells.

1978

FEBRUARY–APRIL: Haus am Waldsee shows retrospective of work by Koberling.

MAY 27: Galerie am Moritzplatz celebrates its first anniversary with the exhibition *Ein Jahr Moritzplatz,* including von Bergmann, Fetting, Jud, Middendorf, Salomé, Schepers, and Bernd Zimmer.

JULY 1: Wieland Schmied succeeds Karl Ruhrberg as director of DAAD program.

AUGUST 13: The club S.O. 36 opens in Berlin-Kreuzberg. It will become an important meeting place for young artists and punks. Near Moritzplatz, S.O. 36 presents live concerts and is used for exhibitions and performances. The installation of Zimmer's huge painting *Stadtbild 3/28* in October marks the beginning of various similar events by artists Middendorf, Fetting, Jud, Elvira Bach, and others.

SEPTEMBER 24–NOVEMBER 12: *Räume*, the first in a series of site-specific exhibitions, is organized by Gilbert Huelsegger, Raimund Kummer, Hermann Pitz, and others in an abandoned loft on Lützowstrasse in Berlin-Tiergarten. Other participants are Mario Bertocini, Wolfgang Koethe, Jan Kotik, Wolf Pause, Michelangelo Pistoletto, and Rudolph Valenta. The group will later evolve into *Büro Berlin.*

DECEMBER 12: Berlin decides to organize an international building exhibition.

DECEMBER 15: The new Staatsbibliothek Preussischer Kulturbesitz (State Library), designed by Scharoun, is inaugurated.

Nationalgalerie shows exhibitions of work by Edvard Munch and A. R. Penck.

Berlinische Galerie moves into own exhibition spaces at Jebenstrasse.

Guests of DAAD program include Victor Burgin, Pistoletto, Maria Lassnig, Terry Riley, and Vautier.

APRIL: Rosz arrives in New York under aegis of Berlin senate to work at P.S. 1.

JULY 12–NOVEMBER 6: Exhibition *Paris-Berlin*, organized by Werner Spies and Pontus Hulten, shown at Centre Georges Pompidou in Paris. It covers German and French art between 1900 and 1933, and includes a special section on Berlin.

NOVEMBER 11–DECEMBER 22: *13° E: Eleven Artists Working in Berlin* shown at Whitechapel Art Gallery, London, includes recent work of Brehmer, Brus, Gosewitz, Grützke, Hacker, Hödicke, Koberling, Lüpertz, Schmit, and Vostell.

NOVEMBER 15, 1978–JANUARY 2, 1979: Institute of Contemporary Arts, London, presents *Berlin: A Critical View. Ugly Realism 20s–70s*, which tries to illustrate a continuous tradition of Critical Realism in Berlin in the twentieth century by showing works of Otto Dix, Max Beckmann, Grosz, John Heartfield, and other artists of the prewar period together with works of Petrick, Sorge, Diehl, Grützke, and other realists of the seventies.

At the Hayward Gallery, London, the show *London-Berlin: The Seventies meet the Twenties* concentrates on German realism of the twenties, mainly works connected to *Neue Sachlichkeit*.

1979

MARCH 15–NOVEMBER 18: *Lützowstrasse Situation* is presented in a loft space, and consists of installations by Jochen Bentrup, Ferry Biler, Tony Cragg, Rolf Eisenburg, Dan Freudenthal, Kuno Gonschior, Koethe, Kotik, Kummer, Helga Möhrke, Boris Nieslov, Pitz, Fritz Rahmann, and Valenta.

JULY: The cooperative gallery 1/61, named after one of the Berlin-Kreuzberg postal codes, opens on Boeckhstrasse. Its artists are ter Hell, Rainer Mang, Reinhard Pods, Gerd Rohling, and Frank Dornseif.

SEPTEMBER 15: Galerie René Block closes after exactly fifteen years. The last exhibition shows works by Beuys, most done in Berlin. For this show Beuys knocks the plaster off the gallery walls and packs it into twenty wooden crates.

Wall plaster from Galerie René Block packed in crates by Joseph Beuys, 1979

Bauhaus-Archiv, after plans by Walter Gropius. 1979

NOVEMBER 29, 1979–JANUARY 20, 1980: Nationalgalerie shows retrospective *Ernst Ludwig Kirchner: 1880–1938*.

DECEMBER 5: A new building for the Bauhaus-Archiv, based on plans by Walter Gropius, is opened. It includes spaces for displaying the archives and for temporary exhibitions.

DAAD opens its own gallery on Kurfürstenstrasse to show works by the program's artists.

Guests of the DAAD program include Armando, Didier Bay, Peter Campus, Joe Jones, Howard Kanovitz, Jiri Kolar, Shigeko Kubota, Gary Kuehn, and Stephen Willats.

Squatters begin to occupy empty apartments and houses in Berlin-Kreuzberg, marking the beginning of a wave of protest against an official housing policy that favors speculators and disregards traditional neighborhoods.

1980

JANUARY 20–MARCH 2: Akademie der Künste and DAAD organize the exhibition *Für Augen und Ohren*, which covers the history of music and art from the musical box to the acoustic environment, and is accompanied by a program of musical performances.

FEBRUARY 29–APRIL 10: Haus am Waldsee shows *Violent Painting*, organized by Ernst Busche and presenting the Moritzplatz painters Fetting, Middendorf, Salomé, and Zimmer. It is the first official show of these artists as a group.

MARCH 3: Kummer, Pitz, and Rahmann, who were among the organizers of *Lützowstrasse Situation*, open *Büro Berlin*, whose intention is to extend the idea of *Lützowstrasse Situation* and make places all over the city available to Berlin artists for projects. Among the first of these is *Neuinszenierung des U-Bahnhofs Gleisdreieck* (*New Staging of Gleisdreieck Station*) on April 3.

MARCH–APRIL: Nationalgalerie shows one hundred drawings by Beuys, as well as his sculpture *Tram Stop*.

APRIL 3–MAY 1: *The Curved Horizon: Art in Berlin 1945-1965*, organized by Johannes Gachnang and shown at Akademie der Künste, includes Berlin artists Werner Heldt, Hans Uhlmann, Fred Thieler, Baselitz, Schönebeck, and Lüpertz; foreigner Rainer; and artists associated with Block: Beuys, Polke, and Richter.

JULY 5–SEPTEMBER 28: The 150th anniversary of Staatliche Museen Preussischer Kulturbesitz is celebrated at Nationalgalerie with the exhibition *Menschen in der Kunst des Abendlandes* (*Images of Man in the Art of the Western World*), a loan exhibition that includes works never shown in Germany.

JULY 1: S.O. 36 closes. Martin Kippenberger, who had been involved in its conception and organization, is assaulted by punks who mistake him for a senate official.

Guests of the DAAD program include Spoerri, Kounellis, Williams, Nan Hoover, Paul-Armand Gette, and Bernhard Luginbühl.

NOVEMBER 16, 1980–JANUARY 11, 1981: *Realism and Expressionism in Berlin Art* shown at Frederick S. Wight Art Gallery, University of California, Los Angeles. Organized by Eberhard Roters, Ursula Prinz, and Jack W. Carter, and sponsored by the Berlin senate.

Photograph for *Violent Painting* exhibition poster, 1980. Left to right, Salomé, Middendorf, Fetting, Zimmer

1981

JANUARY 16–MARCH 1: Haus am Waldsee shows retrospective of work by Hödicke.

MARCH 13: Bicentennial of the birth of Karl-Friedrich Schinkel, architect, designer, and painter, who greatly influenced the appearance of the city of Berlin, is celebrated with two major exhibitions: *Karl-Friedrich Schinkel: Architektur, Malerei, Kunstgewerbe* at Schloss Charlottenberg and *Karl-Friedrich Schinkel: Werke und Wirkung* at Martin-Gropius-Bau (formerly the Museum of Applied Arts, designed by Martin Gropius and Heino Schmieden, and first opened in 1881; this exhibition is the first to be held there following the building's postwar reconstruction).

MAY 1981: Galerie am Moritzplatz closes. Its last exhibition presents Thomas Hornemann and Zimmer.

MAY 5–20: *Performance—Another Dimension* presented at Künstlerhaus Bethanien, repeated in March 1982.

JUNE 14–JULY 1: Akademie der Künste shows *Bildwechsel: Neue Malerei aus Deutschland* (*The Changing Image: New Painting from West Germany*). Organized by Ernst Busche, the exhibition attempts an overview of emerging young German

artists at the turn of the decade, and includes works by Peter Bömmels, Werner Büttner, Peter Chevalier, Walter Dahn, Jiri Dokoupil, Fetting, Horst Gläsker, ter Hell, Middendorf, Albert Oehlen, Eva-Maria Schön, Andreas Schulze, Isolde Wawrin, Zimmer, and others.

AUGUST 15–NOVEMBER 15: *Prussia: Attempting a Resumé* is shown at Martin-Gropius-Bau.

AUGUST 21: Berliner Schaubühne, an influential German theater, moves into a new building at Lehninerplatz and Kurfürstendamm, a copy of Erich Mendelsohn's Universum Movie Theater of 1927–28, which had been destroyed during the war.

Guests of the DAAD program include Mac Adams, Terry Fox, Michael Morris, Vincent Trasov, Raetz, Giulio Paolini, Dick Higgins, and Richard Kostelanetz.

JANUARY 15–MARCH 18: *A New Spirit in Painting* shown at the Royal Academy of Arts, London. Organized by Christos M. Joachimides, Norman Rosenthal, and Nicholas Serota, it includes Baselitz, Fetting, Hacker, Hockney, Hödicke, Lüpertz, Bruce McLean, and Malcolm Morley.

JANUARY 17–MARCH 8: *Art Allemagne Aujourd'-hui: Différents aspects de l'art actuel en République fédérale d'allemagne* shown at Musée d'Art Moderne de la Ville de Paris. Organized by René Block and Suzanne Pagé, it includes Baselitz, Beuys, Brehmer, Gosewitz, Hacker, Hödicke, Koepcke, Lüpertz, Schmit, Eva-Maria Schön, and Vostell.

JULY: *Situation Berlin* shown in Nice.

OCTOBER 11–NOVEMBER 15: *Im Westen nichts Neues: Wir malen Weiter: Luciano Castelli, Rainer Fetting, Helmut Middendorf, Salomé, Bernd Zimmer & Super-8 aus Westberlin* shown at Kunstmuseum, Lucerne; organized by Martin Kunz.

JANUARY 15: Berlin senate and Mayor Stobbe resign. Hans Jochen Vogel, Federal Minister of Justice, succeeds Stobbe.

JUNE: New administration attempts to clear 165 houses in Berlin-Kreuzberg of squatters with help from the police, causing a series of violent rallies continuing into 1982.

1982

MARCH–APRIL: *Beuys, Rauschenberg, Twombly, Warhol: Works from the Marx Collection* shown at Nationalgalerie.

MAY 25–JUNE 13: *11 Berliner Bildhauer: Junge Kunst aus Berlin, II* (*11 Berlin Sculptors: Young Art from Berlin, II*) shown at Berlinische Galerie; organized by the Goethe-Institut, Munich.

OCTOBER 7–DECEMBER 12: Nationalgalerie shows *Kunst wird Material* (*Art Becomes Material*). The exhibition includes Andre, Cragg, Nikolaus Lang, Kaprow, Kounellis, Klaus Rinke, Ulrich Rückriem, Uecker, and Vostell.

OCTOBER 16, 1982–JANUARY 16, 1983: The exhibition *Zeitgeist* is organized in cooperation with NBK at Martin-Gropius-Bau. It presents works largely produced for this event by forty-five artists, among them Baselitz, Beuys, Borofsky, Bömmels, Werner Büttner, Byars, Calzolari, Sandro Chia, Francesco Clemente, Enzo Cucchi,

Fetting, Gilbert & George, Hacker, Höckelmann, Immendorf, Kiefer, Per Kirkeby, Koberling, Kounellis, Lüpertz, McLean, Merz, Middendorf, Morley, Mimmo Paladino, Penck, Polke, Susan Rothenberg, Julian Schnabel, Frank Stella, Twombly, and Warhol.

OCTOBER: Akademie der Künste shows German Expressionist works from the collection of Lothar G. Buchheim.

Guests of DAAD program include Kirkeby, André Thomkins, McLean, Bernadette Bour, and Joan Jonas.

APRIL 17–JUNE 13: *Känsla och Hårdhet: Konstnär i Berlin* (*Feeling and Violence*) shown at Kulturhuset, Stockholm. Organized by Kerstin Danielsson, Margareta Hallerdt, Beate Sydhoff, Peter Hielscher, and Ursula Prinz, it includes Chevalier, Fetting, ter Hell, Metzel, Middendorf, Rosz, Salomé, and Zimmer. Shown in October at Kunstverein, Munich, as *Gefühl & Härte: Neue Kunst aus Berlin*, organized by Wolfgang Jean Stock.

SEPTEMBER 29–NOVEMBER 12: *Berlin: La rage de peindre* (*Berlin: The Rage of Painting*) shown at Musée Cantonal des Beaux-Arts, Lausanne. Organized by Erika Billeter, it includes Fetting, Hödicke, Koberling, Lüpertz, Middendorf, and Salomé from the collections of Peter Pohl and Hans Hermann Stober.

JUNE 11: President Ronald Reagan visits Berlin.

OCTOBER 1: Helmut Kohl succeeds Schmidt as chancellor.

1983

JANUARY 21–APRIL: DAAD shows *A Little History of Fluxus in Three Parts* with actions, performances, lectures, concerts, and exhibitions by Kirkeby, McLean, and others.

APRIL: Baselitz succeeds Thieler as professor of painting at College of Arts.

AUGUST 27–28: *Im Theater* (*At the Theater*), organized by Kummer, Pitz, and *Büro Berlin*, takes place at Hebbel Theater. More than eighty participants are involved in various activities that interpret and use the theater as a specific environment.

SEPTEMBER–OCTOBER: *Schauplatz* is organized in the multistory parking lot of the Berlin Opera

Exhibition *Zeitgeist*, 1982–83

House. Fifteen artists are represented, among them Susanne Mahlmeister and Katja Hajek.

OCTOBER–NOVEMBER: Nationalgalerie shows *Picasso: The Sculptural Oeuvre*, organized by Werner Spies.

DECEMBER: DAAD shows *Der Hang zum Gesamtkunstwerk* (*The Tendency Toward the Synthesis of the Arts*), organized by Harald Szeemann, and previously shown in Düsseldorf and Zurich. It takes place at Schloss Charlottenburg and includes works by Beuys, Duchamp, Phillip Otto Runge, Oskar Schlemmer, Kurt Schwitters, Richard Wagner, and others. In connection with this exhibition, DAAD gallery organizes a show that includes works of Cage, Filliou, Paik, Karl-Friedrich Schinkel, Hans Jürgen Syberberg, and Robert Wilson.

Guests of the DAAD program include Philip Corner, Geoffrey Hendricks, Ted Joans, and Robert Creeley.

JANUARY 31–MARCH 15: *Salomé, Luciano Castelli, Rainer Fetting: Peintures, 1979–1982* shown at CAPC, Musée d'Art Contemporain, Bordeaux.

MARCH 15–MAY 14: *New Painting from Germany: Georg Baselitz, Rainer Fetting, Karl Horst Hödicke, Jörg Immendorf, Bernd Koberling, Markus Lüpertz, Helmut Middendorf, A. R. Penck, Sigmar Polke, Salomé, Bernd Zimmer* shown at Tel Aviv Museum. Organized by Nehama Guralnik.

JUNE–AUGUST: *Expressions: New Art from Germany* shown at St. Louis Art Museum and elsewhere, organized by Jack Cowart; includes Baselitz and Lüpertz.

OCTOBER: Eleven Düsseldorf galleries present artists from Berlin in a project called *Transit*. Included are Chevalier, Hödicke, Koberling, Thomas Lange, Middendorf, Petrick, Rickey, and Stöhrer.

1984

MARCH 11–APRIL 20: Akademie der Künste presents the first major retrospective of work by Willem de Kooning in Germany.

MAY 18–JULY 29: Nationalgalerie shows Beckmann retrospective from Munich, which will travel to St. Louis and Los Angeles as part of the celebration of the centennial of Beckmann's birth.

MAY–AUGUST: *Kunstlandschaft Bundesrepublik*, a series of regional exhibitions of German art by younger artists, shown in forty-six cities. The two exhibitions in Berlin, of art from the Ruhr region and Westphalia, are at Künstlerhaus Bethanien and Kunstquartier in the former AEG factory. Berlin art is shown in Baden-Württemberg.

AUGUST 31–OCTOBER 7: Staatliche Kunsthalle shows *Durchblick—Kunst der DDR* with works of forty-one contemporary artists from East Germany from the collection of Peter Ludwig.

SEPTEMBER–DECEMBER: DAAD organizes *Rosenfest*, a public workshop project for artists, composers, writers, musicians, actors, dancers, and directors. It consists of a theater production; an exhibition at the DAAD gallery that includes Buren, Christiansen, Kounellis, Kirkeby, Paolini, Weiner, and others; and a presentation of films by Weiner, Carlo Cartucci, and Kirkeby. *Rosenfest*

Houses by Hans Hollein (right) and Rob Krier (left) at International Building Exposition, 1984

Overture, with scenery after Heinrich von Kleist, is performed at Galerie am Körnerpark.

Guests of the DAAD program include Colette, Andre, Stephen McKenna, Josef Mikl, and Andrej Tarkowskij.

APRIL 5–MAY 6: *Ursprung und Vision: Neue Deutsche Malerei*, organized by Christos M. Joachimides, shown at Centre Cultural de la Caixa de Pensions, Barcelona. Later shown at Fundacio Caixa de Pensions, Barcelona, and Palacio Velázquez, Madrid. Includes Baselitz, Chevalier, Fetting, Hacker, Hödicke, Koberling, Lüpertz, and Middendorf.

JUNE 1–JULY 29: *Neue Malerei—Berlin* shown at Kestner-Gesellschaft, Hannover. Organized by Carl Haenlein, it includes Barfuss, Chevalier, Fetting, ter Hell, Middendorf, Salomé, Thomas Wachweger, Zimmer, and others.

JUNE 15–AUGUST 15: *Positionen Berlin (w. = weiblich)* shown at Frauen Museum, Bonn. Organized by Gisela Eckardt and Rita Sartorius.

SEPTEMBER: *Échanges: Artistes français à Berlin, 1964–1984*, shown at Goethe-Institut, Paris. Organized by René Block, it includes Gette and Vautier.

SEPTEMBER 21–NOVEMBER 4: *La Métropole retrouvée: Nouvelle peinture à Berlin*, organized by Christos M. Joachimides, shown at Palais des Beaux-Arts, Brussels. Includes Barfuss, Chevalier, Fetting, Hacker, Hödicke, Koberling, Middendorf, Salomé, Wachweger, and Zimmer.

JUNE 3–JULY 28: *Women of Influence: Six American Women Artists*, shown at Amerikahaus; includes work by Colette, Jenny Holzer, Ellen Lampert, Laurie Simmons, and others.

SEPTEMBER 9–OCTOBER 28: *Berlin um 1900* shown at Akademie der Künste in cooperation with Berlinische Galerie.

OCTOBER 12–NOVEMBER 25: *Upheavals: Manifestos, Manifestations: Conceptions in the Arts at the Beginning of the Sixties: Berlin, Düsseldorf, Munich* shown at Städtische Kunsthalle, Düsseldorf, organized by Klaus Schrenk; includes Baselitz, Beuys, Höckelmann, Koberling, Lüpertz, and Schönebeck.

One of the first projects of the *International Building Exposition (IBA)* is completed, a complex of eight houses at Rauchstrasse designed by different architects or teams: Aldo Rossi, Henry Nielebock, Giorgio Grassi, Klaus Theo Brenner & Benedict Tonon, Rob Krier (two buildings), Francy Valen-

tiny & Hubert Hermann, and Hans Hollein. The entire project will be completed in 1987.

FEBRUARY 9: Eberhard Diepgen succeeds Richard von Weizsäcker as mayor of Berlin.

MAY 23: von Weizsäcker is elected president of the Federal Republic.

1985

APRIL–MAY: *Antoine Watteau* shown at Schloss Charlottenburg.

MAY 10: New building for Museum of Decorative Arts, designed by Rolf Gutbrod, is inaugurated.

MAY 12–JULY 15: *Treasures from the Forbidden City in Peking* shown at Martin-Gropius-Bau.

AUGUST 31–OCTOBER 6: Staatliche Kunsthalle presents *Elementarzeichen*, organized by Lucie Schauer for NBK. The exhibition concentrates on the elementary sign as a phenomenon of visual communication in art of the twentieth century and includes works by Willi Baumeister, Beuys, Brassaï, Adolph Gottlieb, Keith Haring, Paul Klee, Astrid Klein, Yves Klein, Joan Miró, Penck, Raetz, Schön, Antoní Tàpies, and others.

SEPTEMBER 27–JANUARY 12: *1945–1985. Art in the Federal Republic of Germany* shown at Nationalgalerie, using the entire exhibition space of the museum. The show presents more than 200 artists, among them some sixty from Berlin or connected to the Berlin scene: Barfuss, Baselitz, Castelli, Fetting, Geccelli, Raimund Girke, Gosewitz, Grützke, Werner Heldt, ter Hell, Hödicke, Hofer, Koberling, Lüpertz, Metzel, Middendorf, Petrick, Raffael Rheinsberg, Gerd Rohling, Salomé, Schönebeck, Stöhrer, Rolf Szymanski, Thieler, Hann Trier, Hans Uhlmann, Vostell, and Wachweger.

Guests of the DAAD program include Earle Brown, Miriam Cahn, Cha-Oh Ouhi, Dennis Oppenheim, Jean Dupuy, Ilan Averbuch, and Matthew Collings.

OCTOBER 11–DECEMBER 22: *German Art in the 20th Century* presented at Royal Academy of Arts, London.

1986

FEBRUARY 2–MARCH 17: Retrospective *Fred Thieler: Works 1940–1986* shown at Akademie der Künste.

FEBRUARY 7–MARCH 13: Nationalgalerie shows *Francis Bacon*, a retrospective organized by the Tate Gallery, London.

MARCH 8–APRIL 27: *1960–1985: Aspekte Italienischer Kunst* shown at Haus am Waldsee in two parts; includes works by some forty artists, among them (part 1) Calzolari, Mario Ceroli, Giorgio Griffa, Merz, Paolini, Pistoletto; and (part 2) Nicola de Maria, Carlo Maria Mariani, and Mimmo Paladino.

APRIL 25–JUNE 1: *Gerhard Richter: 1962–1985*, retrospective at Nationalgalerie, organized with Kunsthalle Düsseldorf, Kunsthalle Bern, and others.

JUNE 6–JULY 4: Sculptures by Lüpertz shown at Schloss Charlottenburg. The show is organized by NBK.

SEPTEMBER 7–OCTOBER 19: Naum Gabo retrospective shown at Akademie der Künste.

NOVEMBER 14, 1986–JANUARY 15, 1987: *Ludwig Mies van der Rohe Centennial Exhibition*, organized by Arthur Drexler of The Museum of Modern Art, New York, at Nationalgalerie.

NOVEMBER 17, 1986–JANUARY 1, 1987: *Androgyn*, organized by Ursula Prinz and NBK, examines androgyny as a theme in art from ancient times to the present; shown at Akademie der Künste.

NOVEMBER 22: Berlinische Galerie moves into Martin-Gropius-Bau and shows the first comprehensive exhibition of its collection of Berlin art.

NOVEMBER 25, 1986–JANUARY 10, 1987: The first Schönebeck exhibition since 1973, *Drawings 1959–1964*, shown at Galerie Menzel.

JULY 4–SEPTEMBER 7: *Berlin Aujourd'hui* shown at Musée de Toulon, organized by Jean-Rober Soubiran and Joachim Becker. Includes Barfuss, Castelli, Chevalier, Fetting, ter Hell, Metzel, Middendorf, Salomé, and Wachweger.

1987

JANUARY 13–MARCH 1: Akademie der Künste shows *Richard Oelze: 1900–1980*.

JANUARY 16–MARCH 8: *Toulouse Lautrec: The Graphic Work* shown at Nationalgalerie.

FEBRUARY–APRIL: *Der Unverbrauchte Blicke (The Unspoiled View)*, an exhibition of contemporary art from Berlin collections, is shown at Martin-Gropius-Bau. Included are works by Baselitz, Chia, Cucchi, Dahn, Fetting, Hödicke, Kienholz, Koberling, Richard Long, Morris Louis, Polke, Richter, Schönebeck, Serra, Stella, Stöhrer, and others.

MARCH 21–MAY 28: *750 Years of Architecture and Urban Development in Berlin*, an exhibition organized by IBA, is shown at Nationalgalerie.

MARCH 22–APRIL 26: Akademie der Künste shows *Hans Arp: 1886-1966*.

APRIL 25: Official beginning of the celebration of the 750th anniversary of Berlin. Among the events which will take place throughout the year are numerous art-related activities.

APRIL 25: *Sculpture-boulevard*, an installation of eight sculptures by ten artists working in Berlin, opens on Kurfürstendamm and Tauentzienstrasse. All sculptures were commissioned by NBK. Among the artists are Kienholz, Metzel, Rickey, Szymanski, and Vostell.

APRIL 25–JULY 12: Kunsthalle Berlin presents a show of recent Berlin art titled *Momentaufnahme (Picturing the Moment)*.

Biographies of the Artists

Compiled by Marjorie Frankel Nathanson

ARMANDO

1929 Born Amsterdam
Studies art history at the Gemeente Universiteit, Amsterdam

1958 Cofounder of Dutch *informele* group

1960 Cofounder of Group Zero

1979–80 DAAD Fellowship to Berlin

Lives in Berlin

Selected Individual Exhibitions

1954 Galerie Le Canard, Amsterdam

1960 Galerie 't Venster, Rotterdam

1969 De Utrechtse Kring, Utrecht
Galerie Krikhaar, Amsterdam

1970 Internationale Galerij Orez, The Hague

1974 Stedelijk Museum, Amsterdam

1975 Art & Project, Amsterdam

1976 Centraal Museum, Utrecht

1977 Art & Project, Amsterdam
Stedelijk Museum, Amsterdam

1978 Galerie Nouvelles Images, The Hague

1979 Akademie der Künste, Berlin

1980 EP Galerie Jürgen Schweinebraden,
East Berlin

1981 Galerie Springer, Berlin
Stedelijk Museum, Amsterdam

1983 Galerie Springer, Berlin
Nationalgalerie, Berlin

1984 Nationalgalerie, Berlin
Westfälischer Kunstverein, Münster
Venice Biennale
Studio Carlo Grossetti, Milan

1985 Collection d'Art, Amsterdam
Museum Boymans–van Beuningen,
Rotterdam
Kunstverein Hamburg

1986 Zellermayer Galerie, West Berlin
Turske & Turske, Zurich

Selected Group Exhibitions

1959 *Niederländische Kunst seit 1945*, Westfälischer
Kunstverein, Münster
Holländische Informelle Gruppe,
Galerie Günar, Düsseldorf

1960 *Dutch Informal Group*, New Vision Centre
Gallery, London

1962 *Anti peinture*, Hessenhuis, Antwerp
Nul, Stedelijk Museum, Amsterdam

1964 *Zero-O-Nul*, Haags Gemeentemuseum,
The Hague
Zero, New Vision Centre Gallery, London
Group Zero, Institute of Contemporary Art,
Philadelphia

1965 *Zero Avantgarde 1965*, Atelier di Fontana, Milan
Nul negentien honderd vijf en zestig, Stedelijk
Museum, Amsterdam

1973 *Lof der tekenkunst*, Stedelijk van Abbemuseum,
Eindhoven

1981 *Schwarz*, Kunsthalle Düsseldorf

1982 *'60–'80, Attitudes/Concepts/Images*, Stedelijk
Museum, Amsterdam
Documenta 7, Kassel
Moderns Nederlandse Schilderkunst, Stedelijk
Museum, Amsterdam

1984 *An International Survey of Recent Painting and
Sculpture*, The Museum of Modern Art,
New York
Biennale of Sidney
Kunstlandschaft Bundesrepublik, Städtisches
Museum, Ludwigsburg
De Nederlandse Identiteit, Stedelijk Museum,
Amsterdam

1985 *Das Selbstporträt im Zeitalter der Photographie*,
Württembergischer Kunstverein, Stuttgart
Neuerwerbungen '75–'85, Nationalgalerie,
Berlin

1986 *Das andere Land*, Grosse Orangerie, Schloss
Charlottenburg, Berlin

INA BARFUSS

1949 Born Lüneburg

1968–74 Studies at the Hochschule für bildende
Künste, Hamburg

1978 Moves to Berlin

Lives in Berlin

Selected Individual Exhibitions

1974 Galerie Silvio R. Baviera, Zurich

1980 Galleria d'Arte, Silvio R. Baviera, Cavigliano

1982 *Der moderne Mensch*, Neue Gesellschaft für
bildende Kunst, Berlin

1983 Galerie Monika Sprüth, Cologne

1984 Galerie Springer, Berlin

1985 Galerie Springer, Berlin

1986 Haus am Waldsee, Berlin

1987 Monica Sprüth, Cologne

Selected Group Exhibitions

1980 Galerie Paul Maenz, Cologne

1981 Galerie Petersen, Berlin

1984 *Wer überlebt, winkt*, Neue Gesellschaft für
bildende Kunst, Berlin
Galerie Skulima, Berlin
Tiefe Blicke, Hessisches Landesmuseum,
Darmstadt
von hier aus, NOWEA Exhibition Center,
Pavillion 13, Düsseldorf

1985 *1945–1985, Kunst in der Bundesrepublik Deutsch-
land*, Nationalgalerie, Berlin

GEORG BASELITZ

1938 Born Georg Kern in Deutschbaselitz (now German Democratic Republic)

1956 Moves to Berlin; assumes name of his birthplace

1956–57 Studies at the Hochschule für bildende und angewandte Kunst, East Berlin

1957–64 Studies at Hochschule für bildende Künste, West Berlin, with Hann Trier

1961 First *Pandemonium* manifesto (with Eugen Schönebeck)

1962 Second *Pandemonium* manifesto (with Schönebeck)

1965 Stipend to Villa Romana, Florence

1966 Leaves Berlin, moves to Osthofen, near Worms

1977 Appointment to Akademie der bildenden Künste, Karlsruhe

1978 Appointed Professor, Akademie der bildenden Künste, Karlsruhe

1983 Appointed Professor, Hochschule der Künste, Berlin

1986 Kunstpreis der NORD/LB, Hannover
Kaiserring-Preis der Stadt Goslar

Lives in Berlin and Derneburg

Selected Individual Exhibitions

1961 First *Pandemonium*, Schaperstrasse 22, Berlin (with Schönebeck)

1963 Galerie Werner & Katz, Berlin

1964 Galerie Michael Werner, Berlin

1965 Galerie Michael Werner, Berlin
Galerie Friedrich und Dahlem, Munich

1966 Galerie Springer, Berlin

1970 Kunstmuseum Basel
Wide White Space Gallery, Antwerp

1971 Galerie Rothe, Heidelberg

1972 Kunstverein Hamburg
Staatliche Graphische Sammlung, Munich

1973 Galerie Neuendorf, Hamburg

1974 Galerie Michael Werner, Cologne
Städtisches Museum, Schloss Morsbroich, Leverkusen

1975 Galerie Michael Werner, Cologne

1976 Kunsthalle, Bern
Haus der Kunst, Munich

1977 Galerie Heiner Friedrich, Cologne

1979 Stedelijk van Abbemuseum, Eindhoven

1980 Whitechapel Art Gallery, London
Galerie Springer, Berlin

1981 Kunsthalle Düsseldorf
Stedelijk Museum, Amsterdam
Galerie Michael Werner, Cologne
Xavier Fourcade Gallery, New York
Brooke Alexander Gallery, New York

1982 Anthony d'Offay, London
Galerie Fred Jahn, Munich

1983 Los Angeles County Museum of Art, Los Angeles
Georg Baselitz, Monumental Prints, The Museum of Modern Art, New York

1984 Kunstmuseum Basel
Stedelijk van Abbemuseum, Eindhoven

1985 DAAD gallery, Berlin
Haus am Waldsee, Berlin

1986 Kunstmuseum Winterthur
Galerie Beyeler, Basel
Mary Boone–Michael Werner Gallery, New York

1987 Thaddäus Ropac Galerie, Salzburg, Austria

Selected Group Exhibitions

1964 *Deutscher Künstlerbund*, Hochschule für bildende Künste, Berlin

1966 *Junge Generation—Maler und Bildhauer in Deutschland*, Akademie der Künste, Berlin

1968 *14 x 14*, Kunsthalle Baden-Baden

1972 Documenta 5, Kassel

1973 *Bilder-Objekte-Filme-Konzepte*, Städtische Galerie im Lenbachhaus, Munich

1975 São Paulo Biennale

1977 Documenta 6, Kassel

1980 Venice Biennale
Der gekrümmte Horizont: Kunst in Berlin, 1945–1967, Akademie der Künste, Berlin

1981 *Art Allemagne Aujourd'hui*, Musée d'Art Moderne de la Ville de Paris
A New Spirit in Painting, Royal Academy of Arts, London

1982 Documenta 7, Kassel
'60–'80, Attitudes-Concepts-Images, Stedelijk Museum, Amsterdam
Zeitgeist, Martin-Gropius-Bau, Berlin

1983 *Expressions, New Art from Germany*, Saint Louis Art Museum

1984 *An International Survey of Recent Painting and Sculpture*, The Museum of Modern Art, New York
Origen y Vision: Nueva Pintura Alemana, Centre Cultural de la Caixa de Pensions, Barcelona
Die wiedergefundene Metropole—Neue Malerei in Berlin, Palais des Beaux-Arts, Brussels
von hier aus, NOWEA Exhibition Center, Pavillion 13, Düsseldorf

1985 *The European Iceberg: Creativity in Germany and Italy Today*, Art Gallery Ontario, Toronto
German Art in the 20th Century: Painting and Sculpture 1905–1985, Royal Academy of Arts, London

Carnegie International, Museum of Art, Carnegie Institute, Pittsburgh
Deutsche Kunst seit 1960 aus der Sammlung Prinz Franz von Bayern, Bayerische Staatsgemäldesammlungen, Staatsgalerie moderner Kunst, Munich
Kunst in der Bundesrepublik Deutschland 1945–1985, Nationalgalerie, Berlin
Zoographie, Galerie Gmyrek, Düsseldorf
Das Selbstporträt im Zeitalter der Photographie, Württembergischer Kunstverein Stuttgart

1986 *Deutsche Kunst im 20. Jahrhundert*, Staatsgalerie, Stuttgart
Androgyn, Neuer Berliner Kunstverein, Berlin

JOSEPH BEUYS

1921 Born Krefeld
Childhood in Rindern and Cleves

1941–46 Soldier and prisoner of war

1946 Returns to Cleves

1947–52 Studies sculpture at the Kunstakademie, Düsseldorf

1961 Appointed Professor of Sculpture, Kunstakademie, Düsseldorf
Cofounder of European Fluxus movement

1967 Cofounder of German Students Party as Meta-Party, later expanded as Fluxus Zone West

1972 Manifesto for a "Free International University" (with Heinrich Böll)
Dismissal from the Kunstakademie, Düsseldorf

1975 Honorary doctorate from Nova Scotia College of Art and Design, Halifax

1976 Lichtwark Prize, Hamburg

1978 Dismissal from the Kunstakademie ruled illegal by Kassel Federal Industrial Tribunal
Thorn Prikker Medal, Krefeld

1985 Lehmbruck Prize, Duisburg

1986 Dies Düsseldorf

Selected Individual Exhibitions

1961 *Zeichnungen/Aquarelle/Ölbilder/Plastische Bilder aus der Sammlung der Grinten*, Städtisches Museum Haus Koekkoek, Cleves

1967 Städtisches Museum, Mönchengladbach

1968 Stedelijk van Abbemuseum, Eindhoven

1969 *Zeichnungen, kleine Objekte*, Kunstmuseum Basel

1970 *Zeichnungen*, Galerie René Block, Berlin

1972 *Selbstporträts—Weekend*, Galerie René Block, Berlin

1973 Ronald Feldman Fine Arts, New York

1974 *The Secret Block for a Secret Person in Ireland*, Museum of Modern Art, Oxford

1976 Venice Biennale

1977 *Richtkräfte*, Nationalgalerie, Berlin

1979 Solomon R. Guggenheim Museum,
 New York
 Ronald Feldman Fine Arts, New York

1979–80 Museum Boymans–van Beuningen,
 Rotterdam

1983 *Joseph Beuys: Drawings and Watercolors 1941–83*,
 Victoria and Albert Museum, London

1984 Kunstmuseum Winterthur

1986 Ronald Feldman Fine Arts, New York
 Kunstverein für die Rheinlande und Westfalen,
 Düsseldorf
 Hallen für Neue Kunst, Schaffhausen

Selected Group Exhibitions

1964 Documenta 3, Kassel
 Galerie René Block, Berlin

1968 Documenta 4, Kassel

1970 *Jetzt, Künste in Deutschland Heute*, Kunsthalle
 Köln, Cologne

1971 *Happening & Fluxus*, Kölnischer Kunstverein,
 Cologne

1972 Documenta 5, Kassel

1974 *Art into Society, Society into Art*, Institute of
 Contemporary Arts, London

1977 Documenta 6, Kassel

1980 Venice Biennale

1982 *'60–'80, Attitudes, Concepts, Images*, Stedelijk
 Museum, Amsterdam
 Documenta 7, Kassel
 Zeitgeist, Martin-Gropius-Bau, Berlin

1984 *von hier aus*, NOWEA Exhibition Center,
 Pavillion 13, Düsseldorf

1985 *Deutsche Kunst seit 1960 aus der Sammlung Prinz
 Franz von Bayern*, Bayerische Staatsgemälde-
 sammlungen, Staatsgalerie moderner Kunst,
 Munich
 7000 Eichen, Kunsthalle Tübingen
 *German Art in the 20th Century: Painting and
 Sculpture 1905–1985*, Royal Academy of Arts,
 London
 *1945–1985, Kunst in der Bundesrepublik Deutsch-
 land*, Nationalgalerie, Berlin
 Zoographie, Galerie Gmyrek, Düsseldorf
 Das Selbstporträt im Zeitalter der Photographie,
 Württembergischer Kunstverein, Stuttgart

1986 *Individuals: A Selected History of Contemporary
 Art 1945–1986*, The Museum of Contemporary
 Art, Los Angeles

Selected Performances

1964 *The Chief*, Galerie René Block, Berlin

1966 *Eurasia*, Galerie René Block, Berlin

1972 *Sweep Up (Ausfegen)*, Galerie René Block,
 Berlin

1974 *I Like America and America Likes Me*, René Block
 Gallery, New York

JONATHAN BOROFSKY

1942 Born Boston

1964 B.F.A., Carnegie-Mellon University,
 Pittsburgh
 Ecole de Fountainebleau

1966 M.F.A., Yale School of Art and Architecture,
 New Haven

1969–77 Teaches at the School of Visual Arts,
 New York

1977–80 Teaches at the California Institute of the
 Arts

1982 Travels to Berlin

 Lives in Venice, California

Selected Individual Exhibitions

1975 Paula Cooper Gallery, New York

1976 Wadsworth Atheneum, Hartford

1978 Projects Gallery, The Museum of Modern Art,
 New York

1979 Paula Cooper Gallery, New York

1981 Kunsthalle Basel

1982 Museum Boymans–van Beuningen,
 Rotterdam

1983 Kunstmuseum Basel

1984 Moderna Museet, Stockholm
 Philadelphia Museum of Art
 Whitney Museum of American Art, New York

1986 *Jonathan Borofsky: New Works*, Arthur M.
 Sackler Museum, Harvard University Art
 Museum, Cambridge
 Currents 31, Saint Louis Art Museum

Selected Group Exhibitions

1969 *No. 7*, Paula Cooper Gallery, New York

1973 Artists Space, New York

1975 *Auteography*, Whitney Museum of American
 Art (downtown branch), New York

1976 Venice Biennale
 SoHo—Downtown Manhattan, Akademie der
 Künste, Berlin

1979 Biennial, Whitney Museum of American Art,
 New York

1982 Documenta 7, Kassel
 New Work on Paper 2: Five Artists, The Museum
 of Modern Art, New York
 Zeitgeist, Martin-Gropius-Bau, Berlin

1983 *Directions 1983*, Hirshhorn Museum and
 Sculpture Garden, Washington, D.C.
 New Art, Tate Gallery, London

1984 *An International Survey of Recent Painting and
 Sculpture*, The Museum of Modern Art,
 New York

1985 Carnegie International, Museum of Art,
 Carnegie Institute, Pittsburgh
 São Paulo Biennale

1986 *Painting and Sculpture Today: 1986*, Indianapolis
 Museum of Art
 The Generic Figure, Corcoran Gallery of Art,
 Washington, D.C.

GEORGE BRECHT

1925 Born Halfway, Oregon

1946–50 Studies at the Philadelphia College of
 Pharmacy and Science

Early 1950s Begins to paint

1958–59 Attends John Cage's class at the New
 School for Social Research, New York

1983 Will Grohmann Kunstpreise, Akademie der
 Künste, Berlin

 Lives in Cologne

Selected Individual Exhibitions

1959 *Toward Events*, Reuben Gallery, New York

1965 *The Book of the Tumbler on Fire*, Fischbach
 Gallery, New York

1969 Städtisches Museum, Mönchengladbach

1970 *Land Mass Translocation*, Eugenie Butler
 Gallery, Los Angeles

1972 *Boxes*, Galerie Michael Werner, Cologne

1973 *Chair Events*, Galerie Michael Werner, Cologne

1978 *Jenseits von Dingen (Eine Heteroperspektive)*,
 Kunsthalle Bern

Selected Group Exhibitions

1960 *Below Zero*, Reuben Gallery, New York
 New Forms—New Media, I and II, Martha
 Jackson Gallery, New York

1961 *Art in Motion*, Moderna Museet, Stockholm
 Environments, Situations, Spaces, Martha Jackson
 Gallery, New York
 The Art of Assemblage, The Museum of Modern
 Art, New York
 Mixed Media and Pop Art, Albright-Knox Art
 Gallery, Buffalo

1964 *Boxes*, Dwan Gallery, Los Angeles

1965 *11 from the Reuben Gallery*, Solomon R. Guggen-
 heim Museum, New York

1966 *Intermedia*, Something Else Gallery, New York
 Games, Fischbach Gallery

1967 *Poems To Be Seen, Poems To Be Read*, Museum of Contemporary Art, Chicago

1969 Städtisches Museum, Mönchengladbach (with Robert Filliou)

1984 *von hier aus*, NOWEA Exhibition Center, Pavillion 13, Düsseldorf

K. P. BREHMER

1938 Born Berlin

1959–61 Studies at the Werkkunstschule, Krefeld

1961–63 Studies at the Kunstakademie, Düsseldorf

1971 Professor, Hochschule für bildende Künste, Hamburg

Lives in Berlin, Hamburg and Vietze/Elbe

Selected Individual Exhibitions

1964 Galerie René Block, Berlin

1967 Galerie René Block, Berlin
Galerie Zwirner, Cologne

1971 Kunstverein Hamburg

1974 René Block Gallery, New York

1985 *Wie mich die Schlange sieht/ Wie ich die Schlange sehe*, DAAD gallery, Berlin

1986 *Wie mich die Schlange sieht/ Wie ich die Schlange sehe*, Stadtgalerie Saarbrücken

Selected Group Exhibitions

1966 *Junge Generation*, Akademie der Künste, Berlin

1971 *Metamorphose des Dinges*, Nationalgalerie, Berlin

1972 Documenta 5, Kassel

1974 *Art into Society, Society into Art*, Institute of Contemporary Arts, London

1977 *Working Party*, Whitechapel Art Gallery, London

1978 *13° E: Eleven Artists Working in Berlin*, Whitechapel Art Gallery, London

1980 *Cartes de la terre*, Centre Georges Pompidou, Paris

1984 *Der Hang zum Gesamtkunstwerk*, Akademie der Künste, Berlin

1985 *Vom Klang der Bilder*, Staatsgalerie, Stuttgart

GÜNTER BRUS

1938 Born Ardning, Austria

1957–60 Studies at the Akademie für angewandte Kunst, Vienna

1964 First Happening, paints his own body

1965 Walks through Vienna painted white; fined

1968 Happening, *Kunst + Revolution*, University of Vienna; two months' investigative detention, then six months' imprisonment for insulting Austrian symbols and committing indecent and immoral acts

1969 Flees to Berlin

1976 Prison sentence commuted to a fine; visits Austria

1979 Moves from Berlin to Graz

Lives in Graz

Selected Individual Exhibitions

1965 Galerie Junge Generation, Vienna

1971 Galerie Michael Werner, Cologne

1974 Galerie Springer, Berlin

1976 Kunsthalle Bern

1978 Galerie Heike Curtze, Vienna

1979 DAAD gallery, Berlin
Whitechapel Art Gallery, London

1981 Galerie Heike Curtze, Vienna

1984 Stedelijk van Abbemuseum, Eindhoven

1985 Galerie A, Amsterdam

1986 Galerie Heike Curtze, Vienna
Museum des 20. Jahrhunderts, Vienna

Selected Group Exhibitions

1961 *Aktionsmalerei*, Galerie Junge Generation, Vienna

1971 *Happening & Fluxus*, Kölnischer Kunstverein, Cologne

1972 Documenta 5, Kassel
The Berlin Scene, Gallery House, London

1978 *13° E: Eleven Artists Working in Berlin*, Whitechapel Art Gallery, London

1980 Venice Biennale

1982 Documenta 7, Kassel

1983 *New Art*, Tate Gallery, London

1984 *Brus, Nitsch, Rainer*, Galerie Maeght-Lelong, Zurich

1986 Renaissance Society, Chicago

Selected Performances

1966 *Aktion mit einem Baby*, Adalbert-Stifter-Strasse, Vienna

1969 *Intelligenztest*, Villa Raspé, Berlin
Körperanalyse I, Villa Raspé, Berlin

VICTOR BURGIN

1941 Born Sheffield, England

1962–65 Royal College of Art, London; A.R.C.A.

1965–67 Yale University, New Haven; M.F.A.

1967–73 Teaches at Trent Polytechnic

1973– Teaches at Polytechnic of Central London

1976–77 US/UK Bicentennial Arts Exchange Fellowship

1978–79 DAAD Fellowship to Berlin

1986 Artist-in-residence, Massachusetts Institute of Technology, Cambridge

Lives in London

Selected Individual Exhibitions

1971 Galerie Daniel Templon, Paris

1974 Galerie Daniel Templon, Paris

1976 Institute of Contemporary Arts, London

1977 John Weber Gallery, New York
Stedelijk van Abbemuseum, Eindhoven

1978 Museum of Modern Art, Oxford

1979 DAAD gallery, Berlin

1984 John Weber Gallery, New York

1986 Institute of Contemporary Arts, London
John Weber Gallery, New York
Knight Gallery, Charlotte, North Carolina
Liliane and Michel Durand-Dessert, Paris

Selected Group Exhibitions

1965 *Four Young Artists*, Institute of Contemporary Arts, London

1970 *Information*, The Museum of Modern Art, New York

1971 *Guggenheim International Exhibition*, Solomon R. Guggenheim Museum, New York
Biennale São Paulo

1972 Venice Biennale
Documenta 5, Kassel

1974 *Project '74: Kunst bleibt Kunst*, Wallraf-Richartz-Museum, Cologne

1987 *British Art in the 20th Century: The Modern Movement*, Royal Academy of Arts, London

LUCIANO CASTELLI

1951 Born Lucerne

1968–69 Studies at the School for Applied Arts, Lucerne

1969–72 Apprentices as a calligrapher

1973 In Austria

1974 In Hollywood

1977–78 In Rome

1978 Moves to Berlin

1982 Travels to the Canary Islands with Rainer Fetting

1985–86 In the Philippines

Lives in Berlin

Selected Individual Exhibitions

1971 Galerie Toni Gerber, Bern

1975 Galerie Stähli, Zurich

1978 Galerie Handschin, Basel

1979 Galerie Stähli, Zurich

1981 Centre d'Art Contemporain, Geneva

1982 Annina Nosei Gallery, New York
Musée Cantonal des Beaux-Arts, Lausanne

1984 Galerie Farideh Cadot, Paris

1985 Kunstmuseum Luzern, Lucerne
Galerie Eric Franck, Geneva

1986 Galerie Raab, Berlin
Galerie Gisele Linder, Basel

1987 Richard Gray Gallery, Chicago

Selected Group Exhibitions

1971 Paris Biennale

1972 Documenta 5, Kassel

1974 Paris Biennale

1980 Venice Biennale

1982 *12 Künstler aus Deutschland*, Kunsthalle, Basel

1984 *An International Survey of Recent Painting and Sculpture*, The Museum of Modern Art, New York

1985 *Das Selbstporträt im Zeitalter der Photographie*, Württembergischer Kunstverein, Stuttgart

1986 *Androgyn*, Neuer Berliner Kunstverein, Berlin

1987 *Berlin*, Charles Cowles Gallery, New York

PETER CHEVALIER

1953 Born Karlsruhe

1976–80 Studies painting at the Hochschule für bildende Künste, Braunschweig

1985 Bernhard Sprengel Prize, Hannover

Lives in Berlin

Selected Individual Exhibitions

1981 Galerie Poll, Berlin

1982 Galerie Gmyrek, Düsseldorf

1983 Galerie Raab, Berlin

1985 Luhring, Augustine & Hodes Gallery, New York

1986 Galerie Raab, Berlin
Kunstverein Braunschweig

Selected Group Exhibitions

1980 *Ten Young Painters from Berlin*, Goethe Institut, London

1981 *Bildwechsel—Neue Malerei aus Deutschland*, Akademie der Künste, Berlin

1982 Paris Biennale

1983 Annina Nosei Gallery, New York

1984 *Origen y Vision: Nueva Pictura Alemana*, Centre Cultural de la Caixa de Pensions, Barcelona
Die wiedergefundene Metropole, Palais des Beaux-Arts, Brussels

1985 *Metaphor and/or Symbol—A Perspective on Contemporary Art*, National Museum of Modern Art, Tokyo
Galerie Raab, Berlin
Zoographie, Galerie Gmyrek, Düsseldorf

1986 *Berlin Aujourd'hui*, Musée de Toulon

1987 *Berlin*, Charles Cowles Gallery, New York
Berlin, Amerikahaus, Berlin

CHRISTO

1935 Born Christo Javacheff, Gabrovo, Bulgaria

1952–56 Studies at the Fine Arts Academy, Sofia

1956 Arrives in Prague

1958 Arrives in Paris

1964 Moves to New York

Selected Projects

1958 *Packages* and *Wrapped Objects*, Paris

1961 Project for *Packaging of a Public Building*
Stacked Oil Barrels and *Dockside Packages*, Cologne Harbor

1962 *Iron Curtain-Wall of Oil Barrels*, Rue Visconti, Paris

1963 *Showcases*

1964 *Store Fronts*

1966 *Air Package* and *Wrapped Tree*, Stedelijk van Abbemuseum, Eindhoven
42,390 Cubic Feet Package, Walker Art Center, Minneapolis, School of Art

1968 *Packed Kunsthalle Berne (Packaging of a Public Building)*
5,600 Cubic Meters Package, Documenta 4, Kassel
Corridor Store Front
1,240 Oil Barrels Mastaba and *Two Tons of Stacked Hay*, Philadelphia Institute of Contemporary Art

1969 *Packed Museum of Contemporary Art*, Chicago
Wrapped Coast, Little Bay, One Million Square Feet, Sydney, Australia

1970 *Wrapped Monuments*, Milan: Monument to Vittorio Emanuele, Piazza Duomo; Monument to Leonardo da Vinci, Piazza Scala

1972 *Wrapped Reichstag, Project for Berlin*, in progress
Valley Curtain, Grand Hogback, Rifle, Colorado, 1970–72

1974 *The Wall, Wrapped Roman Wall, Via V. Veneto and Villa Borghese, Rome*
Ocean Front, Newport, Rhode Island

1976 *Running Fence, Sonoma and Marin Counties, California 1972–76*

1977–78 *Wrapped Walk Ways, Loose Park, Kansas City, Missouri, 1977–78*

1979 *The Mastaba of Abu Dhabi, Project for the United Arab Emirates*, in progress

1980 *The Gates, Project for Central Park, New York*, in progress

1980–83 *Surrounded Islands, Biscayne Bay, Greater Miami, Florida, 1980–83*

1985 *The Umbrellas, Project for Japan and Western U.S.A.*, in progress
The Pont Neuf Wrapped, Paris, 1975–85

WILLIAM EGGLESTON

1939 Born Memphis

Attends Vanderbilt University, Nashville; Delta State College, Cleveland, Mississippi; University of Mississippi, Oxford

1957 Begins photographing

1966 Begins working almost exclusively in color

1974 Lecturer, Harvard College, Cambridge Guggenheim Fellowship Award

1975 Grant, National Endowment for the Arts

1979–80 Research Fellowship, Massachusetts Institute of Technology, Cambridge

1980 Grant, National Endowment for the Arts

Lives in Memphis

Selected Individual Exhibitions

1974 Jefferson Place Gallery, Washington, D.C.

1975 Carpenter Center for the Arts, Harvard College, Cambridge

1976 The Museum of Modern Art, New York

1977 Corcoran Gallery of Art, Memphis Castelli Graphics, New York

1979 Volkshochschule, Berlin

1980 Charles Cowles Gallery, New York

1983 Werkstatt für Photographie, Berlin

1984 Art Institute of Chicago Middendorf Gallery, Washington, D.C.

1985 Allen Street Gallery, Dallas

Selected Group Exhibitions

1972 *Photography Workshop Invitational*, Corcoran Gallery of Art, Washington, D.C.

1975 *14 American Photographers*, Baltimore Museum of Art
Color Photography: Inventors and Innovators 1850–1975, Yale University Art Gallery, New Haven

1977 *10 Photographes Contemporains: tendances actuelles aux Etats-Unis*, Galerie Zabriskie, Paris

1978 *Mirrors and Windows*, The Museum of Modern Art, New York
Amerikanische Landschaftsphotographie, Die Neue Sammlung, Munich

1979 *American Photography in the 1970's*, Art Institute of Chicago

1980 *Aspects of the 70's*, DeCordova Museum, Lincoln, Massachusetts
Nuages, Bibliothèque Nationale, Paris

1981 *Color in Contemporary Photography*, University Museum, Southern Illinois University, Carbondale

RAINER FETTING

1949 Born Wilhelmshaven

1968–72 Trains as carpenter; works in theater, considers becoming stage designer

1972–78 Studies at the Hochschule der Künste, Berlin

1977 Cofounder of Galerie am Moritzplatz (with Helmut Middendorf, Salomé, and Bernd Zimmer)

1978–79 DAAD Fellowship to New York

1982 Travels to the Canary Islands with Luciano Castelli

Lives in Berlin and New York

Selected Individual Exhibitions

1977 *Images of the City*, Galerie am Moritzplatz, Berlin

1978 *Figure and Portrait*, Galerie am Moritzplatz, Berlin

1979 Interni Galerie, Berlin

1981 Anthony d'Offay, London

1982 Mary Boone, New York
Galerie Silvia Menzel, Berlin

1983 Yvon Lambert, Paris

1984 Galerie Raab, Berlin
Marlborough Gallery, New York

1986 Kunsthalle Basel
Marlborough Gallery, New York
Folkwang Museum, Essen
Galerie Raab, Berlin

Selected Group Exhibitions

1977 *Die Zwanziger Jahre Heute*, Hochschule der Künste, Berlin

1978 *1 Jahr Moritzplatz*, Galerie am Moritzplatz, Berlin

1979 *Heftige Malerei*, Haus am Waldsee, Berlin

1981 *A New Spirit in Painting*, Royal Academy of Arts, London
Bildwechsel—Neue Malerei aus Deutschland, Akademie der Künste, Berlin

1982 *12 Künstler aus Deutschland*, Kunsthalle Basel
Zeitgeist, Martin-Gropius-Bau, Berlin

1983 *New Art*, Tate Gallery, London

1984 *An International Survey of Recent Painting and Sculpture*, The Museum of Modern Art, New York
von hier aus, NOWEA Exhibition Center, Pavillion 13, Düsseldorf
Origen y Vision: Nueva Pintura Alemana, Centre Cultural de la Caixa de Pensions, Barcelona

1985 *1945–1985, Kunst in der Bundesrepublik Deutschland*, Nationalgalerie, Berlin

Das Selbstporträt im Zeitalter der Photographie, Württembergischer Kunstverein, Stuttgart

1986 *Wild Visionary Spectral: New German Art*, Art Gallery of South Australia, Adelaide

1987 *Berlin*, Charles Cowles Gallery, New York
Berlin, Amerikahaus, Berlin

ROBERT FILLIOU

1926 Born Sauve, France

1946–51 Studies at the University of California

1951–73 In Asia, Spain, Denmark, France, and Germany

1974 DAAD Fellowship to Berlin

Lives in France

Selected Individual Exhibitions

1961 Galerie Køpcke, Copenhagen

1962 Galerie Légitime, Paris

1966 Galerie Ranson, Paris

1968 Galerie Mayer, Stuttgart

1969 Galerie Schmela, Düsseldorf

1970 Galerie Handschin, Basel
Neue Galerie, Aachen
Galerie Michael Werner, Cologne

1971 Galerie René Block, Berlin
Wide White Space Gallery, Antwerp
Stedelijk Museum, Amsterdam

1972 Galerie La Bertesca, Milan

1973 Galerie Buchholz, Munich

1974 Akademie der Künste, Berlin

1975 Palais des Beaux-Arts, Brussels

1976 *Telepathic Music*, John Gibson Gallery, New York

1978 Centre Georges Pompidou, Paris

1981 *Robert Filliou + seeing on all sides + voyant partout*, Galerie Bama, Paris

1984 Musée d'Art Moderne de la Ville de Paris

Selected Group Exhibitions

1962 *Misfits Fair*, Gallery One, London

1964 Galerie Zwirner, Cologne (with Daniel Spoerri)

1969 Städtisches Museum, Mönchengladbach (with George Brecht)

1970 Edinburgh International Festival

1972 Folkwang Museum, Essen
Documenta 5, Kassel

1984 *von hier aus*, NOWEA Exhibition Center, Pavillion 13, Düsseldorf

TERRY FOX

1943 Born Seattle

1962 Attends the Accademia di Belle Arti, Rome, for one month

1981 DAAD Fellowship to Berlin

Lives in Florence

Selected Individual Exhibitions

1970 Reese Palley Gallery, San Francisco
Museum of Contemporary Art, San Francisco

1972 Galerie Ileana Sonnabend, Paris

1973 University Art Museum, University of California, Berkeley

1974 Everson Museum of Art, Syracuse

1976 The Kitchen, New York

1979 Galerie Danny Keller, Munich

1982 *Metaphorical Instruments*, DAAD gallery, Berlin
Folkwang Museum, Essen

1983 Frankfurter Kunstverein, Frankfurt

1984 Ronald Feldman Fine Arts, New York

Selected Group Exhibitions

1971 Projects Gallery, The Museum of Modern Art, New York
Prospect 71, Kunsthalle Düsseldorf

1972 Documenta 5, Kassel
Projection, Louisiana Museum, Humlebaek

1973 *All Night Sculptures*, Museum of Conceptual Art, San Francisco

1975 Biennial, Whitney Museum of American Art, New York

1976 *Videotapes Produced in Europe*, The Kitchen, New York

1977 Documenta 6, Kassel

1981 *Video Meetings*, Galerie Stampa, Basel
Arsenal 2 Video/Arsenal 2, Berlin

1982 *Revolutions Per Minute—The Art Record*, Ronald Feldman Fine Arts, New York

1983 *Site Strategies*, Oakland Museum

PAUL-ARMAND GETTE

1927 Born Lyon

1980 DAAD Fellowship to Berlin

Lives in Paris

Selected Individual Exhibitions

1960 Galerie La Roue, Paris

1965 Galerie Delta, Rotterdam

1966 Galerie Iolas, Geneva

1972 *Cristallographie*, Musée d'Art Moderne de la Ville de Paris

1973 Institute of Contemporary Arts, London

1973 Städtische Galerie im Lenbachhaus, Munich

1980 DAAD gallery, Berlin

1981 Frankfurter Kunstverein, Frankfurt

1983 *Perturbation*, Musée d'Art Moderne de la Ville de Paris

1984 *Osservazione*, Studio d'ARS, Milan

1986 *Toilettes 3 eme étage*, Musée National d'Art Moderne, Paris

1987 Galerie Claire Burrus, Paris

Selected Group Exhibitions

1959 *Exposition Internationale du Surréalisme*, Galerie Daniel Cordier, Paris

1965 *Between Poetry and Painting*, Institute of Contemporary Arts, London

1972 School of Art, Museum of Modern Art, Oxford

1977 Documenta 6, Kassel

1980 Venice Biennale

1981 São Paulo Biennale

1982 *Paris 1960–1980*, Museum des 20. Jahrhunderts, Vienna

LUDWIG GOSEWITZ

1936 Born Naumburg/Saale

1950 Studies music history, literature, history, philosophy, and linguistics at Frankfurt am Main and Marburg on the Lahn

1964 Studies astrology

1965 Moves to Berlin

1967–68 Works in publishing

1972–78 Studies at the school of glass manufacture in Zwiesel

1973–78 Works in studio for glass manufacture in Berlin

1973–74 In Africa

1974 Will Grohmann Kunstpreis, Akademie der Künste, Berlin

1977 In U.S.

Lives in Berlin

Selected Individual Exhibitions

1971 Galerie Michael Werner, Cologne
Museum of Modern Art, Copenhagen

1972 Galerie René Block, Berlin

1973 Galerie Michael Werner, Cologne

1976 Galerie A, Amsterdam
Zeichnungen, Galerie Nächst St. Stephan, Vienna

1980 Galerie Michael Werner, Cologne
DAAD gallery, Berlin

1983 Galerie Petersen, Berlin
Galerie Fred Jahn, Munich

1985 *Konkretionen 1960–1971/objets en verre nouveaux 1984/85*, Galerie der Edition Hundertmark, Cologne

Selected Group Exhibitions

1963 *Schrift und Bild*, Stedelijk Museum, Amsterdam

1964 *Neue Tendenzen*, Galerie Aktuell, Bern

1965 *Visuelle Poesie*, Situationen 60 Galerie, Berlin

1967 *Fetische*, Galerie René Block, Berlin

1971 *Konkrete Poesie*, Stedelijk Museum, Amsterdam

1972 *Berlin Scene*, Gallery House, London

1975 *8 from Berlin*, Fruit Market Gallery, Scottish Arts Council, Edinburgh

1976 *The First Picture Show*, Galerie Skulima, Berlin

1977 *Berlin Now*, Goethe House, New York
Zauber und Zuber, Galerie Petersen, Berlin

1978 *Drawings*, Galerie am Moritzplatz, Berlin
13° E: Eleven Artists Working in Berlin, Whitechapel Art Gallery, London

1984 *von hier aus*, NOWEA Exhibition Center, Pavillion 13, Düsseldorf

1985 *Wirken und Wirkung (für Helga Retzer)*, DAAD gallery, Berlin
1945–1985, Kunst in der Bundesrepublik Deutschland, Nationalgalerie, Berlin

1986 *Europa-Amerika*, Museum Ludwig, Cologne

DIETER HACKER

1942 Born Augsburg

1960–65 Studies at the Akademie der bildenden Künste, Munich

1970 Moves to Berlin

1971 Opens 7. Produzentengalerie, Berlin

1974 Guest Professor at Hochschule der Künste, Hamburg
Editor of *Volksfoto*

Lives in Berlin

Selected Individual Exhibitions

1965 *EFFEKT*, Deutsches Institut für Film und Fernsehen, Munich

1967 Modern Art Agency, Lucio Amelio, Naples

1968 Galerie Schutze, Bad Godesberg

1970 Modern Art Agency, Lucio Amelio, Naples

1978 Galerie René Block, Berlin

1981 DAAD gallery, Berlin
Städtische Galerie im Lenbachhaus, Munich

1982 Museum am Ostwall, Dortmund

1984 Marlborough Gallery, New York
Zellermayer Gallery, Berlin

1985 Kunstverein Hamburg
Marlborough Fine Art Ltd., London

1986 Marlborough Gallery, New York

Selected Group Exhibitions

1968 *Public Eye*, Hamburger Kunsthaus, Hamburg

1974 *Art into Society, Society into Art*, Institute of Contemporary Arts, London

1977 Paris Biennale

1978 *13° E: Eleven Artists Working in Berlin*, Whitechapel Art Gallery, London

1979 *Eremit? Forscher? Sozialarbeiter?*, Kunstverein, Hamburg

1981 *A New Spirit in Painting*, Royal Academy of Arts, London

1982 *Zeitgeist*, Martin-Gropius-Bau, Berlin

1984 *Origen y Vision: Nueva Pintura Alemana*, Centre Cultural de la Caixa de Pensions, Barcelona

RICHARD HAMILTON

1922 Born in London

1938–40 Studies painting at the Royal Academy of Arts, London

1941–45 Works as jig-and-tool draftsman

1946 Begins 18 months of military service

1948–51 Studies painting at the Slade School of Art, London

1952 Member of Independent Group

1953–66 Lecturer King's College, University of Durham (later University of Newcastle-upon-Tyne)

1957–61 Teaches interior design, Royal College of Art, London

1960 William and Noma Copley Foundation Award for painting

1963 Visits U.S.

1969 First prize (with Mary Martin), John Moores, Liverpool
Exhibition 7

1970 Talens Prize International

1974 DAAD Fellowship to Berlin

Lives in Henley-on-Thames, England

Selected Individual Exhibitions

1966 *The Solomon R. Guggenheim Museum*, Robert Fraser Gallery, London

1970 Tate Gallery, London
Complete Graphics, Galerie Onnasch, Berlin

1971 Galerie René Block, Berlin
Richard Hamilton: Graphic Work, Castelli Graphics, New York

1972 *Prints, Multiples and Drawings*, Whitworth Art Gallery, Manchester

1974 Nationalgalerie, Berlin

1976 *Collaborations of Ch. Rotham*, Galeria Cadaqués, Cadaqués, Spain

1980 *Interiors 1964–79*, Charles Cowles Gallery, New York
Anthony d'Offay, London

1983 *Image and Process*, Tate Gallery, London

Selected Group Exhibitions

1957 Designs and organizes *An Exhibit*, Hatton Gallery, Newcastle-upon-Tyne

1969 *Information: Tilson, Jones, Phillips, Paolozzi, Kitaj, Hamilton*, Kunsthalle Basel

1973 *Grafische Techniken*, Neuer Berliner Kunstverein, Berlin

1985 *Das Selbstporträt im Zeitalter der Photographie*, Württembergischer Kunstverein, Stuttgart

1987 *British Art in the 20th Century: The Modern Movement*, Royal Academy of Arts, London

TER HELL

1954 Born Norden

1976–81 Studies art at the Hochschule der Künste, Berlin

1979 Founding of the group and the gallery 1/61, Berlin

1982 DAAD Fellowship to P.S. 1, New York

1983 Kunstpreis Glockengasse, Cologne
1st Prize, Philip Morris GmB's "Dimension IV—Neue Malerei aus Deutschland"

Lives in Berlin

Selected Individual Exhibitions

1978 Galerie Georg Nothelfer, Berlin

1979 Galerie 1/61, Berlin

1981 Galerie Georg Nothelfer, Berlin

1982 *Kompliment an alle, Trilogie*, P.S. 1, New York

1983 Galerie Fahnemann, Berlin
Neuer Berliner Kunstverein, Berlin
Galerie Dany Keller, Munich

1984 Gallery Wallner, Malmö
Bezüge 7/MEK, Galerie Löhrl, Mönchengladbach

1985 Galerie Fahnemann, Berlin

1986 Galerie Hartz und Klier, Oldenburg

1987 Galerie Fahnemann, Berlin

Selected Group Exhibitions

1978 Kunstmarkt Düsseldorf

1979 *Alkohol, Nikotin, fff*, Galerie am Moritzplatz, Berlin
12 Räume—12 Künstler, DAAD gallery, Berlin

1981 *Bildwechsel—Neue Malerei aus Deutschland*, Akademie der Künste, Berlin

1982 *Dada Montage Konzept*, Berlinische Galerie,
 Berlin
 P. S. 1 Studio, New York

1983 *Xenophilia*, The Clocktower, New York
 Generics, Neuer Berliner Kunstverein, Berlin
 Dimension IV—Neue Malerei aus Deutschland,
 Nationalgalerie, Berlin

1984 *Neue Malerei Berlin*, Kestner-Gesellschaft,
 Hannover

1985 *Neuerwerbungen 1975–1985*, Nationalgalerie,
 Berlin

1986 *Berlin Aujourd'hui*, Musée de Toulon

ANTONIUS HÖCKELMANN

1937 Born Oelde, Westphalia

1951–57 Apprentices as woodcarver

1957–61 Studies at the Hochschule für bildende
 Künste, Berlin

1960–61 In Naples, four months

1961 Begins to work part-time at the post office,
 Berlin

1970 Moves to Cologne

Selected Individual Exhibitions

1966 Galerie Michael Werner, Berlin

1969 Galerie Michael Werner, Cologne
 Galerie Benjamin Katz, Berlin

1971 Galerie Michael Werner, Berlin

1975 Städtisches Museum, Schloss Morsbroich,
 Leverkusen
 Kunsthalle Bern

1979 Galerie Fred Jahn, Munich

1980 Galerie Zellermayer, Berlin

1981 Galerie Heike Curtze, Düsseldorf

1982 Galerie Zimmer, Düsseldorf

1983 Galerie Zellermayer, Berlin
 Galerie Fred Jahn, Munich

1984 Kunstverein Bremerhaven

1985 Kunstverein für die Rheinlande und Westfalen,
 Düsseldorf

Selected Group Exhibitions

1964 *Berliner Bildhauer und Maler*, Galerie S. Ben
 Wargin

1966 Galerie Stummer & Hubschmid, Zurich

1969 Second Internationale Frühjahrsmesse, Berlin

1972 *14 x 14*, Kunsthalle Baden-Baden
 Zeichnung II, Städtisches Museum, Schloss
 Morsbroich, Leverkusen

1974 Galerie Michael Werner, Cologne

1977 Documenta 6, Kassel

1980 *Der gekrümmte Horizont: Kunst in Berlin,
 1947–1967*, Akademie der Künste, Berlin

1982 *Zeitgeist*, Martin-Gropius-Bau, Berlin

1984 *von hier aus*, NOWEA Exhibition Center,
 Pavillion 13, Düsseldorf

1985 *Aktuelle Skulptur*, Galerie Zellermayer, Berlin
 *Deutsche Kunst seit 1960 aus der Sammlung Prinz
 Franz von Bayern*, Bayerische Staatsgemäl-
 desammlungen, Staatsgalerie moderner Kunst,
 Munich
 Zoographie, Galerie Gmyrek, Düsseldorf

DAVID HOCKNEY

1937 Born Bradford, England

1953–57 Bradford College of Art

1959–62 Royal College of Art, London

1963–64 Teaches at the University of Iowa,
 Iowa City

1965 Teaches at the University of Colorado, Denver

1966–67 Teaches at the University of California,
 Los Angeles

1967 Teaches at the University of California,
 Berkeley

1983 Honorary Degree, University of Bradford,
 England

1985 Honorary Degree, San Francisco Art Institute
 Honorary Doctorate in Fine Art, Otis Parsons
 Institute, Los Angeles

 Lives in Los Angeles

Selected Individual Exhibitions

1963 Kasmin Gallery, London

1966 Stedelijk Museum, Amsterdam
 Kasmin Gallery, London

1968 The Museum of Modern Art, New York
 Galerie Mikro, Berlin

1969 Andre Emmerich Gallery, New York

1970 Whitechapel Art Gallery, London
 Galerie Springer, Berlin

1972 Andre Emmerich Gallery, New York
 Kasmin Gallery, London

1974 Musée des Arts Décoratifs, Palais du Louvre,
 Paris

1976 Louisiana Museum, Humlebaek
 Sonnabend Gallery, New York

1979 The Museum of Modern Art, New York
 M. H. de Young Memorial Museum,
 San Francisco

1981 Knoedler Gallery, London

1982 Centre Georges Pompidou, Paris

1983 Kunsthalle Basel
 Andre Emmerich Gallery, New York
 Walker Art Center, Minneapolis

1984 Museum of Contemporary Art, Chicago
 Fort Worth Art Museum

1985 San Francisco Museum of Modern Art

1986 Tate Gallery, London
 Galerie Gmyrek, Düsseldorf
 International Center of Photography,
 New York

Selected Group Exhibitions

1960 *London Group*, RBA Galleries, London

1961 *New Painting 1958–1961*, Arts Council of Great
 Britain (tour)
 Paris Biennale

1962 *Four Young Artists*, Institute of Contemporary
 Arts, London

1963 *British Painting in the Sixties*, Whitechapel Art
 Gallery, London

1964 *British Painters of Today*, Kunsthalle Düsseldorf
 Nieuwe Realisten, Gemeente Museum,
 The Hague

1965 *London: The New Scene*, Walker Art Center,
 Minneapolis

1967 Carnegie International, Museum of Art,
 Carnegie Institute, Pittsburgh
 British Art Today, Hamburg
 Documenta 4, Kassel

1968 Venice Biennale
 Young Generation: Great Britain, Akademie der
 Künste, Berlin

1971 *Snap*, National Portrait Gallery, London
 British Sculpture and Painting, 1960–1970,
 National Gallery of Art, Washington, D.C.

1973 *Henry Moore to Gilbert and George: Modern British
 Art from the Tate Gallery*, Palais des Beaux-Arts,
 Brussels

1977 *British Painting 1952–77*, Royal Academy of
 Arts, London

1981 *A New Spirit in Painting*, Royal Academy of
 Arts, London
 Westkunst, Museen der Stadt Köln, Cologne

1982 *'60–'80 Attitudes, Concepts, Images*, Stedelijk
 Museum, Amsterdam
 Carnegie International, Museum of Art,
 Carnegie Institute, Pitsburgh

1984 *Drawings, 1974–1984*, Hirshhorn Museum and
 Sculpture Garden, Washington, D.C.

1985 *Representation Abroad*, Hirshhorn Museum and
 Sculpture Garden, Washington, D.C.
 Das Selbstporträt im Zeitalter der Photographie,
 Württembergischer Kunstverein, Stuttgart

1986 *Public and Private: American Prints Today*, 24th
 National Print Exhibition, The Brooklyn
 Museum, New York

1987 *British Art in the 20th Century: The Modern
 Movement*, Royal Academy of Arts, London

K. H. HÖDICKE

1938 Born Nuremberg

1959 Studies at the Hochschule für bildende Künste, Berlin

1964 Joins the cooperative gallery Grossgörschen 35, Berlin

1966 Travels to New York

1968 Villa Massimo Prize, Rome

1974 Professor, Hochschule der Künste, Berlin

1980 Becomes member of the Akademie der Künste, Berlin

Lives in Berlin

Selected Individual Exhibitions

1964 Galerie Grossgörschen 35, Berlin

1965 *Arcades, Distortions*, Galerie René Block, Berlin
Galerie Niepel, Düsseldorf

1967 *Arcade with Windows*, Galerie René Block, Berlin

1969 Galerie René Block, Berlin

1974 Galerie Wintersberger, Cologne

1977 Badischer Kunstverein, Karlsruhe

1978 René Block Gallery, New York

1980 Galerie Springer, Berlin
DAAD gallery, Berlin

1981 Haus am Waldsee, Berlin
Annina Nosei Gallery, New York

1982 L.A. Louver Gallery, Los Angeles
Galerie Skulima, Berlin

1983 Galerie Munro, Hamburg
Annina Nosei Gallery, Berlin
Galerie Gmyrek, Düsseldorf

1984 Galerie Skulima, Berlin
Kunstverein Hamburg

1985 Studio d'Arte Cannaviello, Milan

1986 Kunstsammlung Nordrhein-Westfalen, Düsseldorf
Galerie Skulima, Berlin

Selected Group Exhibitions

1964 *Neodada/Pop/Décollage/Capitalist Realism*, Galerie René Block, Berlin

1965 *Retrospektive 1964–65*, Grossgörschen 35, Berlin

1966 *Junge Generation*, Akademie der Künste, Berlin

1967 *Neuer Realismus*, Haus am Waldsee, Berlin

1969 *Blockade 69*, Galerie René Block, Berlin

1971 *Metamorphose des Dinges*, Nationalgalerie, Berlin

1974 First Biennale, Berlin

1975 *8 from Berlin*, Fruit Market Gallery, Scottish Arts Council, Edinburgh

1976 *Soho—Downtown Manhattan*, Akademie der Künste, Berlin

1977 Documenta 6, Kassel

1978 *13° E: Eleven Artists Working in Berlin*, Whitechapel Art Gallery, London

1980 *Der gekrümmte Horizont: Kunst in Berlin, 1945–1967*, Akademie der Künste, Berlin

1981 *A New Spirit in Painting*, Royal Academy of Arts, London

1982 *Zeitgeist*, Martin-Gropius-Bau, Berlin

1984 *Origen y Visión: Nueva Pintura Alemana*, Centre Cultural de la Caixa de Pensions, Barcelona
An International Survey of Recent Painting and Sculpture, The Museum of Modern Art, New York

1985 *German Art in the 20th Century: Painting and Sculpture 1905–1985*, Royal Academy of Arts, London
Zoographie, Galerie Gmyrek, Düsseldorf

1987 *Berlin*, Amerikahaus, Berlin

ALLAN KAPROW

1927 Born Atlantic City

1943–45 Attends the High School of Music and Art, New York

1945–49 New York University; B.A.

1947–48 Studies at the Hans Hofmann School of Fine Arts, New York

1949–50 Studies philosophy at New York University

1950–52 Columbia University, New York; M.A., art history

1953–61 Faculty, Rutgers University, New Brunswick

1956–58 Studies music composition with John Cage, New School for Social Research, New York

1961–69 Faculty, State University of New York at Stony Brook

1967 Guggenheim Fellowship Award

1969–74 Faculty, California Institute of the Arts, Valencia

1974 Faculty, University of California, San Diego—La Jolla

1975 DAAD Fellowship to Berlin

1979 Grant, National Endowment for the Arts
Guggenheim Fellowship Award

Lives in San Diego

Selected Individual Exhibitions

1953 Hansa Gallery, New York

1954 Hansa Gallery, New York

1955 Urban Gallery, New York

1956 Bernard-Ganymede Gallery, New York

1959 Hansa Gallery, New York

1969 John Gibson Gallery, New York

1971 Galerie Baecker, Bochum

1976 Los Angeles Institute of Contemporary Art
Kunsthalle Bremen
Galerie René Block, Berlin

1977 Galerie Zellermayer, Berlin

1979 Ullrich Museum, Wichita State University, Wichita

1986 Museum am Ostwall, Dortmund

Selected Group Exhibitions

1952 Jabberwocky Gallery, New York

1954 Hansa Gallery, New York

1957 *The New York School—Second Generation*, Jewish Museum, New York
Collage in America, Zabriskie Gallery, New York

1958 *Collages and Constructions*, White Art Museum, Cornell University, Ithaca
Carnegie International, Museum of Arts, Carnegie Institute, Pittsburgh

1960 *New Forms—New Media 1*, Martha Jackson Gallery, New York

1965 *Eleven from the Reuben Gallery*, Solomon R. Guggenheim Museum, New York

1973 *Aktionen der Avantgarde*, Neuer Berliner Kunstverein, Akademie der Künste, Berlin

1974 *What's the Time?*, René Block Gallery, New York

1975 *Video Art*, Institute of Contemporary Art, Philadelphia

1976 *Medium Film—Filme von Künstlern*, Berlin Künstlerprogramm des DAAD, Akademie der Künste, Berlin

1977 Biennial, Whitney Museum of American Art, New York
Paris—New York, Centre Georges Pompidou, Paris

1981 *Westkunst*, Museen der Stadt Köln, Cologne

Selected Happenings and Activities

1970 *A Sweet Wall*, Galerie René Block, Berlin

EDWARD KIENHOLZ and NANCY REDDIN KIENHOLZ

1927 Edward, born Fairfield, Washington

1944 Nancy, born Los Angeles

1945 Edward Attends Eastern Washington State College

1953–73 Lives in Los Angeles
Nancy works as court reporter

1973 Move to Hope, Idaho

1973–74 DAAD Fellowship to Berlin

Live in Hope, Idaho, and Berlin

Selected Individual Exhibitions

1955 Coronet Louvre, Los Angeles

1959 Ferus Gallery, Los Angeles

1961 Pasadena Art Museum

1963 Dwan Gallery, Los Angeles
Alexander Iolas Gallery, New York

1965 Dwan Gallery, New York

1970 Moderna Museet, Stockholm
Galerie Onnasch, Cologne
Galerie Michael Werner, Cologne

1972 Gemini G.E.L., Los Angeles
Wide White Space Gallery, Antwerp

1973 Galerie Michael Werner, Cologne
Akademie der Künste, Berlin

1977 *Volksempfängers*, Nationalgalerie, Berlin
The Art Show, Centre Georges Pompidou, Paris

1978 Akademie der Künste, Berlin

1979 Louisiana Museum, Humlebaek
Galerie Maeght, Paris

1981 L.A. Louver Gallery, Los Angeles

1984 *Human Scale*, San Francisco Museum of Modern Art

1985 Museum of Contemporary Art, Chicago

1986 L.A. Louver Gallery, Los Angeles

Selected Group Exhibitions

1961 *The Art of Assemblage*, The Museum of Modern Art, New York

1962 *Fifty California Artists*, Whitney Museum of American Art, New York

1966 *68th American Exhibition of Painting and Sculpture*, The Art Institute of Chicago

1968 Documenta 4, Kassel
Dada, Surrealism and Their Heritage, The Museum of Modern Art, New York

1969 *Kompas 4: West Coast USA*, Stedelijk van Abbemuseum, Eindhoven

1975 *8 from Berlin*, Fruit Market Gallery, Scottish Arts Council, Edinburgh

1977 Venice Biennale

1978 *Aspekte der 60er Jahre: Aus der Sammlung Reinhard Onnasch*, Nationalgalerie, Berlin

1981 Biennial, Whitney Museum of American Art, New York

1984 *Content: A Contemporary Focus 1974–84*, Hirshhorn Museum and Sculpture Garden, Washington, D.C.

1985 *Transformations in Sculpture: Four Decades of American and European Art*, The Solomon R. Guggenheim Museum, New York

1986 *TV Generations*, LACE Gallery, Los Angeles

MARTIN KIPPENBERGER

1953 Born Dortmund

1978 Establishes "Kippenbergers Büro," Berlin

1979 Establishes the discotheque S.O. 36, Berlin

1981 Leaves Berlin

Lives in Cologne

Selected Individual Exhibitions

1981 *Kippenberger in Nudelauflauf sehr gerne*, Galerie Petersen, Berlin

1983 *Song of Joy*, Neue Galerie, Sammlung Ludwig, Aachen
Kennzeichen eines Unschuldigen, Galerie Zwirner, Cologne

1986 *Miete Strom Gas*, Hessisches Landesmuseum, Darmstadt
Gib mir das Sommerloch, Galerie Klein, Bonn

Selected Group Exhibitions

1978 *Aschamatta, Bier für junge Leute*, Kippenbergers Büro, Berlin

1979 *Buenas dias*, S.O. 36, Berlin
Kommen, kucken, kaufen, Künstlerhaus Hamburg

1981 *Vom Jugendstil zum Freistil*, Galerie Petersen, Berlin

1983 Galerie Max Hetzler, Stuttgart
Realismusstudio 24, Neue Gesellschaft für bildende Kunst, Berlin

1984 *Wahrheit ist Arbeit*, Folkwang Museum, Essen
Museum Villa Stuck, Munich
von hier aus, NOWEA Exhibition Center, Pavillion 13, Düsseldorf

1986 *Macht und Ohnmacht der Beziehungen*, Museum am Ostwall, Dortmund

MILAN KNIZAK

1940 Born Pilsen, Czechoslovakia

1957–58 Attends Teachers Training College, Prague

1963–64 Studies at the Academy of Art, Prague

1963–65 Travels to Poland

1964 Cofounder of group Aktual, Prague

1966 In Prague, meets with Fluxus artists Dick Higgins, Alison Knowles, Ben Vautier, Jeff Berner, and Sege Oldenbourg

1968–70 In U.S.

1970–71 In Marienbad

1977–78 Studies mathematics at the University of Prague

1979–80 DAAD Fellowship to Berlin

Selected Individual Exhibitions

1957 Marienbad, Czechoslovakia

1964 Galerie Viola, Prague

1968 *Fluxus West*, Ken Friedman, San Diego

1970 Galerie Art Intermedia, Cologne

1972 Museum am Ostwall, Dortmund

1976 Galerie A, Amsterdam

1980 Galerie ARS VIVA!, Berlin

Selected Group Exhibitions

1963 Malostanská Beseda, Prague

1967 *Aktual Art International*, Museum of Modern Art, San Francisco

1970 *Happening & Fluxus*, Kölnischer Kunstverein, Cologne
New Multiple Art, Whitechapel Art Gallery, London

1972 *Multiples — The First Decade*, Philadelphia Museum of Art
Fluxshoe, University of Exeter, England

1974 Paris Biennale

1976 *Flux-Show*, Galerie A, Amsterdam

1977 Documenta 6, Kassel

1980 *Für Augen und Ohren*, Akademie der Künste, Berlin

BERND KOBERLING

1938 Born Berlin

1955–58 Trains as chef; works as chef until 1968

1958–60 Studies at the Hochschule der Künste, Berlin

1961–63 In England

1969–70 Villa Massimo Prize, Rome

1970–74 In Cologne

1976–81 Visiting lecturer, Hamburg, Düsseldorf, and Berlin

1981 Professor, Hochschule für bildende Künste, Hamburg

Lives in Berlin and Hamburg

Selected Individual Exhibitions

1965 Galerie Grossgörschen 35, Berlin

1966 Galerie René Block, Berlin

1969 Galerie Michael Werner, Cologne

1974 Galerie Abis, Berlin

1978 Haus am Waldsee, Berlin

1980 Galerie Art in Progress, Düsseldorf

1983 Galerie Gmyrek, Düsseldorf

1984 Galerie Onnasch, Berlin

1985 São Paulo Biennale

1986 L.A. Louver Gallery, Los Angeles
Galerie Gmyrek, Düsseldorf
Kunstverein Braunschweig

Selected Group Exhibitions

1965 *Retrospektive 1964–65*, Galerie Grossgörschen 35, Berlin

1967 *Geburtstag Grossgörschen 35*, Galerie René Block, Berlin

1971 *20 Deutsche*, Galerie Onnasch, Berlin

1974 First Biennale, Berlin

1975 *8 from Berlin*, Fruit Market Gallery, Scottish Arts Council, Edinburgh

1978 *13° E: Eleven Artists Working in Berlin*, Whitechapel Art Gallery, London

1981 *A New Spirit in Painting*, Royal Academy of Arts, London
Berlin expressiv, Berlinische Galerie, Berlin

1982 *Landscapes*, Robert Miller, New York
Zeitgeist, Martin-Gropius-Bau, Berlin

1984 *American/European Painting, Drawing & Sculpture*, L.A. Louver Gallery, Los Angeles
An International Survey of Recent Painting and Sculpture, The Museum of Modern Art, New York
Origen y Vision: Nueva Pintura Alemana, Centre Cultural de la Caixa de Pensions, Barcelona

1985 São Paulo Biennale
German Art in the 20th Century: Painting and Sculpture 1905–1985, Royal Academy of Arts, London
Zoographie, Galerie Gmyrek, Düsseldorf

ARTHUR KOEPCKE

1928 Born Hamburg

1953 Moves to Copenhagen

1958 Opens gallery

1963 Closes gallery

1973–74 Professor at the Royal Academy of Fine Art, Copenhagen

1977 Dies Copenhagen

Selected Individual Exhibitions

1963 Galerie Koepcke, Copenhagen

1964 Galerie Allen, Copenhagen

1965 Kompagnistraede 20

1970 Louisiana Museum, Humlebaek

1971 Galerie René Block, Berlin

1973 Galerie René Block, Berlin
Galerie Arnesen, Copenhagen

1974 Galerie René Block, New York
Galerie 38, Copenhagen

1976 Galerie 38, Copenhagen

Selected Group Exhibitions

1962 *Fluxus Internationale Festspiele Neuester Musik*, Wiesbaden
Festival of Misfits, Gallery One, London
Festum Fluxorum Fluxus, Copenhagen

1963 Fluxus Festival, Copenhagen

1964 *Action, Agit-Pop, Dé-coll/age Happenings, Events, l'Autrisme, Art Total, Re-Fluxus*, Technische Hochschule, Aachen

1964 *Flux-Festival Fluxus*, Kunstcentrum T'venster, Rotterdam

1966 *Advanced Art, Acke, Novy Realismus, Happenings*, event, Prague

MARKUS LÜPERTZ

1941 Born Liberec, Bohemia (now Czechoslovakia)

1956–61 Studies at the Werkkunstschule, Krefeld

1962–63 Spends one year at Maria Laach Monastery; works in coal fields and for the department of roads. Additional studies at Krefeld and at the Kunstakademie, Düsseldorf

1963 Moves to Berlin

1964 Cofounder of Galerie Grossgörschen 35

1970 Stipend to Villa Romana, Florence

1974 Teaches at the Akademie der bildenden Künste, Karlsruhe

1984 Travels to New York

1986 Professor, Staatliche Kunstakademie, Düsseldorf

Lives in Berlin and Düsseldorf

Selected Individual Exhibitions

1964 *Dithyrambische Malerei*, Galerie Grossgörschen 35, Berlin

1966 *Kunst, die im Wege steht*, Galerie Gross-görschen 35, Berlin
Galerie Potsdamer, Berlin

1968 Galerie Springer, Berlin
Galerie Michael Werner, Cologne

1973 Staatliche Kunsthalle, Baden-Baden

1974 Galerie Michael Werner, Cologne

1976 Galerie Zwirner, Cologne

1977 Kunsthalle Hamburg

1979 Whitechapel Art Gallery, London

1980 Galerie Michael Werner, Cologne

1981 Galerie Michael Werner, Cologne
Galerie Springer, Berlin

1982 Galerie Fred Jahn, Munich
Galerie Onnasch, Berlin
Stedelijk van Abbemuseum, Eindhoven

1983 Waddington Galleries, London
Kestner-Gesellschaft, Hannover
DAAD gallery, Berlin

1984 Galerie Maeght-Lelong, Zurich
Mary Boone/Michael Werner Gallery, New York
Origen y Vision: Nueva Pintura Alemana, Centre de la Caixa de Pensions, Barcelona

1985 Galerie Michael Werner, Cologne

1986 Galerie Maeght-Lelong, Zurich
Galerie Springer, Berlin
Museum Boymans–van Beuningen, Rotterdam
Gillespie Laage Salomon, Paris
Städtische Galerie im Lenbachhaus, Munich

Selected Group Exhibitions

1965 *Retrospektive 1964–65*, Galerie Grossgörschen 35, Berlin

1969 *14 x 14*, Kunsthalle, Baden-Baden

1971 *20 Deutsche*, Galerie Onnasch, Berlin

1973 Paris Biennale

1974 First Biennale, Berlin

1977 Documenta 6, Kassel

1978 *13° E: Eleven Artists Working in Berlin*, Whitechapel Art Gallery, London

1980 *Der gekrümmte Horizont: Kunst in Berlin 1945–1967*, Akademie der Künste, Berlin

1981 *A New Spirit in Painting*, Royal Academy of Arts, London

1982 *Avanguardia—Transavanguardia*, Rome
Documenta 7, Kassel
Zeitgeist, Martin-Gropius-Bau, Berlin

1984 *Ursprung und Vision—Neue Deutsche Malerei*, Palacio Velázquez, Madrid
An International Survey of Recent Painting and Sculpture, The Museum of Modern Art, New York
Content: A Contemporary Focus (1974–84), Hirshhorn Museum and Sculpture Garden, Washington, D.C.
von hier aus, NOWEA Exhibition Center, Pavillion 13, Düsseldorf

1985 *The European Iceberg (Creativity in Germany and Italy Today)*, Art Gallery of Ontario, Toronto
1945–1985, Kunst in der Bundesrepublik Deutschland, Nationalgalerie, Berlin
German Art in the 20th Century: Painting and Sculpture 1905–1985, Royal Academy of Arts, London
Carnegie International, Museum of Art, Carnegie Institute, Pittsburgh
Deutsche Kunst seit 1960 aus der Sammlung Prinz Franz von Bayern, Bayerische Staatsgemälde-

sammlungen, Staatsgalerie moderner Kunst, Munich
Zoographie, Galerie Gmyrek, Düsseldorf
Das Selbstporträt im Zeitalter der Photographie, Württembergischer Kunstverein, Stuttgart

1986 *Deutsche Kunst im 20. Jahrhundert*, Staatsgalerie Stuttgart
The Global Dialogue, Louisiana Museum, Humlebaek

1987 *Berlin*, Charles Cowles Gallery, New York

BRUCE McLEAN

1942 Born Glasgow

1961–63 Studies at the Glasgow School of Art

1963–66 Studies at St. Martin's School, London

1981 DAAD Fellowship to Berlin

1985 John Moores Painting Prize

Lives in London

Selected Individual Exibitions

1969 Galerie Konrad Fischer, Düsseldorf

1971 Galerie Yvon Lambert, Paris

1972 Tate Gallery, London

1975 *Early Works*, Museum of Modern Art, Oxford

1978 *The Object of the Exercise*, The Kitchen, New York

1981 Kunsthalle Basel
Whitechapel Art Gallery, London
Anthony d'Offay, London

1982 Mary Boone, New York
Stedelijk van Abbemuseum, Eindhoven

1983 Galerie Dany Keller, Munich
DAAD gallery, Berlin
Bruce McLean: Berlin/London, Whitechapel Art Gallery, London

1984 Galerie Fahnemann, Berlin
Galerie Dany Keller, Munich
Art Place, New York

1985 *New Paintings*, Anthony d'Offay, London
Simple Manners or Physical Violence, Galerie Gmyrek, Düsseldorf

1987 Anthony d'Offay, London

Selected Group Exhibitions

1965 *Five Young Artists*, Institute of Contemporary Art, London

1969 *Op Losse Schroeven*, Stedelijk Museum, Amsterdam

1970 *Information*, The Museum of Modern Art, New York
São Paulo Biennale

1977 *In Terms Of: An Institutional Farce Sculpture*, Serpentine Gallery, London
Documenta 6, Kassel

1979 *Lives*, Hayward Gallery, London

1980 Venice Biennale

1981 *A New Spirit in Painting*, Royal Academy of Arts, London
New Work, Anthony d'Offay, London
British Sculpture in the Twentieth Century, Whitechapel Art Gallery, London

1982 Documenta 7, Kassel
Zeitgeist, Martin-Gropius-Bau, Berlin
Biennale of Sydney

1983 *New Art at the Tate Gallery*, London

1984 *The Critical Eye/I*, Paul Mellon Centre for British Art, Yale University, New Haven
An International Survey of Recent Painting and Sculpture, The Museum of Modern Art, New York

1985 *Bilder für Frankfurt*, Bestandsausstellung des Museums für moderne Kunst, Frankfurt
John Moores Liverpool Exhibition 14, Walker Art Center, Minneapolis
Zoographie, Galerie Gmyrek, Düsseldorf

1987 *British Art in the 20th Century: The Modern Movement*, Royal Academy of Arts, London

OLAF METZEL

1952 Born Berlin

1971–77 Studies at the Freie Universität and the Hochschule der Künste, Berlin

1977–78 DAAD Fellowship to Italy

1986 DAAD Fellowship to P.S. 1, New York
Guest Professor, Hochschule für bildende Künste, Hamburg

1987 Villa Massimo, Rome
Kunstpreis Glockengasse, Cologne

Lives in Berlin

Selected Individual Exhibitions

1982 Kunstraum, Munich

1984 DAAD gallery, Berlin

1985 Künstlerhaus Bethanien, Berlin
Galerie Fahnemann, Berlin

Selected Group Exhibitions

1981 *Bildhauertechniken*, Kunsthalle Berlin
Situation Berlin, Musée d'Art Contemporain, Nice

1982 *Gefühl und Härte: Künstler in Berlin*, Kulturhuset, Stockholm

1983 *Künstler-Räume*, Hamburger Kunstverein, Hamburg

1984 Biennale of Sydney
Kunstlandschaft Bundesrepublik, Württembergischer Kunstverein, Stuttgart
von hier aus, NOWEA Exhibition Center, Pavillion 13, Düsseldorf

1985 *1945–1985, Kunst in der Bundesrepublik Deutschland*, Nationalgalerie, Berlin

1986 *Berlin Aujourd'hui*, Musée de Toulon
Jenisch-Park Skulptur, Jenisch-Park, Hamburg

HELMUT MIDDENDORF

1953 Born Dinklage

1971–79 Studies at the Hochschule der Künste, Berlin; involved with experimental film

1977 Cofounder of Galerie am Moritzplatz (with Rainer Fetting, Salomé, and Bernd Zimmer)

1980 DAAD Fellowship to New York

Lives in Berlin

Selected Individual Exhibitions

1977 Galerie am Moritzplatz, Berlin

1978 *Gitarren*, Galerie Nothelfer, Berlin

1979 Galerie am Moritzplatz, Berlin

1981 Galerie Gmyrek, Düsseldorf
Mary Boone, New York (with Rainer Fetting)

1982 Galerie Yvon Lambert, Paris

1983 Bonlow Gallery, New York
Kunstverein Düsseldorf

1984 Annina Nosei Gallery, New York

1985 Galerie Skulima, Berlin
Galerie Thomas, Munich

1986 Annina Nosei Gallery, New York

1987 Galerie Buchmann, Basel

Selected Group Exhibitions

1971–79 Freie Berliner Kunstausstellung

1975 *Dreissig Jahre Frieden*, Haus am Lützowplatz, Berlin

1978 *1 Jahr Galerie am Moritzplatz*, Berlin

1979 *12 Räume—12 Künstler*, DAAD gallery, Berlin

1980 *Heftige Malerei*, Haus am Waldsee, Berlin

1981 *Situation Berlin*, Musée d'Art Contemporain, Nice

1982 *Currents II: New Figuration from Europe*, Milwaukee Art Center
Zeitgeist, Martin-Gropius-Bau, Berlin

1984 *Neue Malerei—Berlin*, Kestner-Gesellschaft, Hannover
Origen y Vision: Nueva Pintura Alemana, Centre Cultural de la Caixa de Pensions, Barcelona
An International Survey of Recent Painting and Sculpture, The Museum of Modern Art, New York

1985 *1945-1985, Kunst in der Bundesrepublik Deutschland*, Nationalgalerie, Berlin
Arbeiten auf Papier, Galerie Menzel, Berlin
Malerei, Galerie Onnasch, Berlin
São Paulo Biennale
Zoographie, Galerie Gmyrek, Düsseldorf

1986 *Berlin Aujourd'hui*, Musée de Toulon

MALCOLM MORLEY

1931 Born London

1957 Graduates Royal College of Art, London
A.R.C.A. Associate of the Royal College of Art, London

1958 Moves to New York

1965–66 Instructor, Ohio State University, Columbus

1967-69 School of Visual Arts, New York

1972 State University of New York, Stony Brook

1977 DAAD Fellowship to Berlin; becomes ill, stays in Berlin several months only

1977–79 Lives in Florida

1984 1st Annual Turner Prize, Tate Gallery, London

Lives in New York

Selected Individual Exhibitions

1957 Kornblee Gallery, New York

1964 Kornblee Gallery, New York

1967 Kornblee Gallery, New York

1973 Stefanotti Gallery, New York

1976 The Clocktower, Institute for Art and Urban Resources, New York

1977 Galerie Jurka, Amsterdam

1979 Nancy Hoffman Gallery, New York

1980 *Matrix*, Wadsworth Atheneum, Hartford

1981 *New Paintings and Watercolors*, Xavier Fourcade Gallery, New York
Malcolm Morley: Paintings, Akron Art Museum

1983 *Malcolm Morley*, Whitechapel Art Gallery, London

1984 *Malcolm Morley: New Paintings, Watercolors and Prints*, Xavier Fourcade Gallery, New York

1985 *Malcolm Morley*, Fabian Carlsson Gallery, London
Carnegie International, Museum of Art, Carnegie Institute, Pittsburgh

1986 Xavier Fourcade Gallery, New York
Pace Editions, New York

Selected Group Exhibitions

1966 *The Photographic Image*, The Solomon R. Guggenheim Museum, New York

1967 São Paulo Biennale

1969 *Aspects of a New Realism*, Milwaukee Art Center

1970 *22 Realists*, Whitney Museum of American Art, New York
American Art Since 1960, The Art Museum, Princeton University

1971 *Kunst der 20. Jahrhunderts*, Städtische Kunsthalle, Düsseldorf
Radical Realism, Museum of Contemporary Art, Chicago

1972 *Colossal Scale*, Sidney Janis Gallery, New York
Documenta 5, Kassel

1973 Galleri Fabian Carlsson, Göteborg
Hyperrealisme, Galerie Isy Brachot, Brussels

1976 *Soho—Downtown Manhattan*, Akademie der Künste, Berlin

1977 *British Painting 1952–1977*, Royal Academy of Arts, London
Documenta 6, Kassel

1980 *One Major New Work Each*, Xavier Fourcade Gallery, New York

1981 *A New Spirit in Painting*, Royal Academy of Arts, London

1982 *Zeitgeist*, Martin-Gropius-Bau, Berlin

1983 *New Art*, Tate Gallery, London

1984 *An International Survey of Recent Painting and Sculpture*, The Museum of Modern Art, New York

1985 Carnegie International, Museum of Art, Carnegie Institute, Pittsburgh

1986 *A Propos de Dessin*, Galerie Adrien Maeght, Paris

1987 *British Art in the 20th Century: The Modern Movement*, Royal Academy of Arts, London

GIULIO PAOLINI

1940 Born Genoa

1981 DAAD Fellowship to Berlin

Lives in Turin

Selected Individual Exhibitions

1964 Galleria La Salita, Rome

1965 Galleria Notizie, Turin

1968 Galleria Notizie, Turin

1971 Galerie Paul Maenz, Cologne

1972 Sonnabend Gallery, New York

1973 Royal College of Art, London

1974 Modern Art Agency, Lucio Amelio, Naples
The Museum of Modern Art, New York

1975 Galerie Art in Progress, Munich

1976 Galerie Yvon Lambert, Paris

1977 Sperone Westwater Fischer, New York
Städtisches Museum, Mönchengladbach

1978 *Del bello intelligibile*, Musée d'Art Moderne de la Ville de Paris

1980 Stedelijk Museum, Amsterdam

1982 *Del bello intelligibile*, Neuer Berliner Kunstverein, Berlin

1983 Galerie Paul Maenz, Cologne

1986 Staatsgalerie, Stuttgart
Galerie Paul Maenz, Cologne

1987 Mario Pieroni, Rome

Selected Group Exhibitions

1961 XII Premio Lissone

1964 IX Premio Castello Svevo, Turin

1965 Galleria Notizie, Turin

1966 Galleria Schwarz, Milan

1969 Paris Biennale

1970 Venice Biennale
Information, The Museum of Modern Art, New York

1971 *Arte Povera*, Kunstverein München, Munich
Paris Biennale

1972 *De Europa*, John Weber Gallery, New York
Documenta 5, Kassel

1973 *Eight Italians*, Art & Project, Amsterdam
Paris Biennale
São Paulo Biennale

1974 *4 aus Italien*, Kunsthalle Bern

1976 Venice Biennale

1977 Documenta 6, Kassel
São Paulo Biennale
Europe in the Seventies: Aspects of Recent Art, Art Institute of Chicago

1979 *Words*, Museum Bochum
Institute of Contemporary Art, London

1981 *Identité Italienne*, Centre Georges Pompidou, Paris

1982 *'60–'80, Attitudes, Concepts, Images*, Stedelijk Museum, Amsterdam
Documenta 7, Kassel

1984 *An International Survey of Recent Painting and Sculpture*, The Museum of Modern Art, New York

1985 *Das Selbstporträt im Zeitalter der Photographie*, Württembergischer Kunstverein, Stuttgart

1986 *Androgyn*, Neuer Berliner Kunstverein, Berlin
Galerie Christian Stein, Milan

HERMANN PITZ

1956 Born Oldenburg

1978–80 Studies at the Hochschule der Künste, Berlin

1978 Founding member of the gallery Lützowstrasse Situation (later renamed Büro Berlin), Berlin

1987 Fellowship granted by Berlin Senate to P.S. 1, New York

Lives in Berlin

Selected Individual Exhibitions

1982 Kabinett für Aktuelle Kunst, Bremerhaven

1984 Galerie Wittenbrink, Regensburg

1985 Galerie Fahnemann, Berlin
Galerie Wittenbrink, Munich

1986 Städtische Galerie im Lenbachhaus, Munich
Galerie Albert Baronian, Brussels

1987 Stichting De Appel, Amsterdam

Selected Group Exhibitions

1978 *Räume*, Berlin

1979 Lützowstrasse Situation, Berlin

1980 *Gleisdreieck*, Büro Berlin (with Raimund Kummer and Fritz Rahmann)
Kunstverein Hamburg

1981 *Art Allemagne Aujourd'hui*, Musée d'Art Moderne de la Ville de Paris
Gegensbilder, Kunstverein Karlsruhe

1982 Büro Berlin

1983 Büro Berlin

1984 Galerie Wittenbrink, Regensburg

1985 Galerie Fahnemann, Berlin

1986 *Jenisch-Park Skulptur*, Jenisch-Park, Hamburg
Museum Wiesbaden

MARKUS RAETZ

1941 Born Buren an der Aare, Switzerland

1956–61 Educated as teacher

1961–63 Works as a teacher

1965 Travels to Poland

1969–73 Lives in Amsterdam

1971 Travels to Morocco and Spain

1973–76 Lives in Carona, Ticino, Switzerland

1981–82 DAAD Fellowship to Berlin

Lives in Bern

Selected Individual Exhibitions

1966 Galerie Toni Gerber, Bern

1969 Galerie Bischofberger, Zurich

1970 Galerie René Block, Berlin

1972 Kunstmuseum Basel

1974 Galerie Toni Gerber, Bern

1975 Kunstmuseum Luzern, Lucerne
Kunsthaus Zurich
Neue Galerie am Landesmuseum Joanneum, Graz

1977 Kunstmuseum Bern
Kunsthalle Bern

1979 Galerie Stähli, Zurich

1980 Stedelijk Museum, Amsterdam

1982 DAAD gallery, Berlin

1982 Kunsthalle Basel

1983 Musée d'Art Moderne de la Ville de Paris

1986 Kölnischer Kunstverein, Cologne

Selected Group Exhibitions

1965 Paris Biennale

1968 Documenta 4, Kassel

1969 *20 Jonge Zwitsers*, Stedelijk Museum, Amsterdam

1970 *Information*, The Museum of Modern Art, New York

1972 Documenta 5, Kassel

1977 São Paulo Biennale

1982 Documenta 7, Kassel

1984 *An International Survey of Recent Painting and Sculpture*, The Museum of Modern Art, New York
Skulptur im 20. Jahrhundert, Basel

ARNULF RAINER

1929 Born Baden, Austria

1947–49 High School, Villach, Carinthia

1963 Begins working in studios in Berlin, Munich, and Cologne

1980 Works in studios in Upper Austria and Bavaria

1981 Appointed Professor, Akademie der Schönen Künste, Vienna
Max Beckmann Award of the City of Frankfurt
Becomes member of the Akademie der Künste, Berlin

Lives in Vienna, Upper Austria, and Bavaria

Selected Individual Exhibitions

1951 Galerie Kleinmayr, Klagenfurt

1952 Galerie Springer, Berlin

1956 Galerie Nächst St. Stephan, Vienna

1962 Galerie Schmela, Düsseldorf

1964 Galerie Springer, Berlin

1968 Museum des 20. Jahrhunderts, Vienna

1971 São Paulo Biennale

1972 Busch Reisinger Museum, Harvard University, Cambridge

1975 Hessisches Landesmuseum, Darmstadt

1976 Galerie Michael Werner, Cologne

1977 Städtische Galerie im Lenbachhaus, Munich

1978 Venice Biennale

1979 Galerie Ulysses, Vienna

1980 Stedelijk van Abbemuseum, Eindhoven
Whitechapel Art Gallery, London
Nationalgalerie, Berlin

1982 Louisiana Museum, Humlebaek

1983 Kunstmuseum Hannover

1984 Centre Georges Pompidou, Paris

1985 Museum of Modern Art, Oxford

1986 Musée des Beaux-Arts, Lausanne
Grey Art Gallery, New York University

Selected Group Exhibitions

1951 *Hundsgruppenausstellung*, Institut für Wissenschaft und Kunst, Vienna

1957 *Wiener Secession*, Kunstverein Düsseldorf

1959 Documenta 2, Kassel

1960 *Hollegha, Mikl, Prachensky, Rainer*, Galerie Springer, Berlin

1961 *Abstraktive Malerei und Plastik in Österreich seit 1945*, Galerie Secession, Vienna

1964 *Labyrinthe*, Akademie der Künste, Berlin

1968 *Die Entwicklung der Wiener Schule*, Künstlerhaus, Vienna

1972 Venice Biennale
Documenta 5, Kassel

1977 Documenta 6, Kassel
The Spirit of Vienna, René Block Gallery, New York

1980 *Der gekrümmte Horizont: Kunst in Berlin 1945–1967*, Akademie der Künste, Berlin
Venice Biennale

1982 Documenta 7, Kassel

1985 *Deutsche Kunst seit 1960 aus der Sammlung Prinz Franz von Bayern*, Bayerische Staatsgemäldesammlungen, Staatsgalerie moderner Kunst, Munich
Das Selbstporträt im Zeitalter der Photographie, Württembergischer Kunstverein, Stuttgart

LELAND RICE

1940 Born Los Angeles

1964 B.S., Arizona State University, Tempe

1969 M.A., California State University, San Francisco

1969–72 Assistant Professor, California College of Arts and Crafts, Oakland

1973–79 Lecturer in Art, Pomona College, Claremont, California

1978 Photography Grant, National Endowment for the Arts

1979–80 Guggenheim Fellowship Award

1981 Lecturer, University of Southern California, Los Angeles

1982 Artist-in-residence, University of California, Los Angeles

Lives in Berkeley

Selected Individual Exhibitions

1972 Center of the Eye Gallery, Aspen

1973 Witkin Gallery, New York

1974 School of the Art Institute of Chicago

1977 Diane Brown Gallery, Washington, D.C.
Hirshhorn Museum and Sculpture Garden, Washington, D.C.

1979 Rosamund Felson Gallery, Los Angeles Diane Brown Gallery, Washington, D.C.

1981 Rosamund Felson Gallery, Los Angeles

1985 Rosamund Felson Gallery, Los Angeles

Selected Group Exhibitions

1968 *Young Photographers 68*, Purdue University Art Museum

1969 *Vision and Expression*, George Eastman House, Rochester, New York

1971 *Young California Photographers*, Musée Reattu, Arles

1972 *Survey of Southern California Photography*, Los Angeles County Museum of Art, Los Angeles

1973 *The Document*, Tyler School of Art, Philadelphia

1974 *Photography in America*, Whitney Museum of American Art, New York

1976 *Exposing: Photographic Definitions*, Los Angeles Institute of Contemporary Art
Rooms, The Museum of Modern Art, New York

1977 *The Light in the Interior*, Museum of Fine Arts, Boston

1978 *Mirrors and Windows: American Photography Since 1960*, The Museum of Modern Art, New York
Art at Work, Whitney Museum of American Art (downtown branch), New York

1980 *Aspects of the 70s, Photography: Recent Directions*, De Cordova Museum, Lincoln, Massachusetts

1981 Biennial, Whitney Museum of American Art, New York

1982 *Color as Form: A History of Color Photography*, Corcoran Gallery of Art, Washington, D.C.

1984 *Photography in California: 1945–1980*, San Francisco Museum of Modern Art

MARTIN ROSZ

1939 Born Königsberg

1958 Attends Hochschule für bildende Künste, Berlin

1961 Travels to Jerusalem

1975 Travels to Colmar, site of Grünewald's *Isenheim Altarpiece*

1978 DAAD Fellowship to P.S. 1, New York

1979 Visits MacDowell Colony, New Hampshire
Berliner Kunstpreis, Berlin

1980 Kunstpreis der Böttcherstrasse, Bremen

1983 Villa Romana Prize, Florence

Lives in Berlin

Selected Individual Exhibitions

1980 Kunstverein Hannover
Künstlerhaus Bethanien, Berlin
Kunstmesse Düsseldorf and Galerie von Loeper, Hamburg

1984 Kunstverein Heilbronn

1986 Galerie Metta Linde, Lübeck

Selected Group Exhibitions

1973 *Fetisch Jugend — Tabu Tod*, Haus am Waldsee, Berlin

1982 *Kansla och Hardhet*, Kulturhuset, Stockholm

1985 *1945–1985, Kunst in der Bundesrepublik Deutschland*, Nationalgalerie, Berlin

1986 *Von Beuys bis Stella, Internationale Graphik des letzten Jahrzehnts*, Kupferstichkabinett, Staatliche Museen, Berlin
Kunst in Berlin von 1870 bis Heute, Berlinische Galerie, Berlin
Androgyn, Neuer Berliner Kunstverein, Berlin

SALOMÉ

1954 Born Wolfgang Cilarz in Karlsruhe

1973 Moves to Berlin

1974–80 Studies at the Hochschule der Künste, Berlin; M. A.

1977 Cofounder of Galerie am Moritzplatz (with Rainer Fetting, Helmut Middendorf, and Bernd Zimmer)

1981 DAAD Fellowship to P.S. 1, New York
Lives in Berlin

Selected Individual Exhibitions

1977 *Malerei, Fotos, Objekte, Performance*, Galerie am Moritzplatz, Berlin
Galerie Petersen, Berlin

1978 *Frühling, Sommer Herbst Winter*, Galerie am Moritzplatz, Berlin

1979 *Salomé—Selbstdarstellung*, Neue Gesellschaft für bildende Kunst, Berlin

1981 Galerie am Moritzplatz, Berlin
Galerie Lietzow, Berlin
Annina Nosei Gallery, New York

1982 Galerie Zwirner, Cologne

1983 Galerie Farideh Cadot, Paris

1984 *Götterdämmerung*, Galerie Raab, Berlin
Malerei und Zeichnung 74–84, Galerie Thomas, Munich

1985 *Wasserschau*, Davies-Long Gallery, Los Angeles
Galerie Raab, Berlin

Selected Group Exhibitions

1975 Galerie am Moritzplatz, Berlin
Neue Galerie, Sammlung Ludwig, Aachen

1978 Galerie am Moritzplatz, Berlin

1980 *Heftige Malerei*, Haus am Waldsee, Berlin
Annina Nosei Gallery, New York

1981 *Situation Berlin*, Musée d'Art Contemporain, Nice

1982 Documenta 7, Kassel
Biennale of Sydney
Gefühl und Härte, Kulturhuset, Stockholm
Zeitgeist, Martin-Gropius-Bau, Berlin

1984 *An International Survey of Recent Painting and Sculpture*, The Museum of Modern Art, New York
Neue Malerei Berlin, Kestner-Gesellschaft, Hannover
Artistic Collaboration in the 20th Century, Hirshhorn Museum and Sculpture Garden, Washington, D.C.
von hier aus, NOWEA Exhibition Center, Pavillion 13, Düsseldorf

1985 *The European Iceberg: Creativity in Germany and Italy Today*, Art Gallery of Ontario, Toronto
São Paulo Biennale
1945–1985, Kunst in der Bundesrepublik Deutschland, Nationalgalerie, Berlin
Das Selbstporträt im Zeitalter der Photographie, Württembergischer Kunstverein, Stuttgart

1986 *Berlin, Aujourd'hui*, Musée de Toulon
Androgyn, Neuer Berliner Kunstverein, Berlin

1987 *Berlin*, Charles Cowles Gallery, New York

TOMAS SCHMIT

1943 Born Thier
Lives in Berlin

Selected Individual Exhibitions

1969 Jysk Kunstgalerie, Copenhagen

1971 Galerie René Block, Berlin

1972 Galerie Michael Werner, Cologne

1974 Galerie Cornels, Baden-Baden

1976 Galerie Springer, Berlin
Galerie A, Amsterdam

1977 Galerie Michael Werner, Cologne

1978 Kölnischer Kunstverein, Cologne

1981 7. Produzentengalerie, Hamburg

1982 Galerie Petersen, Berlin

Selected Group Exhibitions

1964 *Visuelle Poesie*, Situationen 60 Galerie, Berlin

1970 *Happening & Fluxus*, Kölnischer Kunstverein, Cologne

1971 *Zeichnungen*, Galerie René Block, Berlin

1972 *Szene Berlin*, Stuttgart

1973 *Deutsche Zeichnungen der Gegenwart*, Bielefeld

1974 *What's the Time?*, René Block Gallery, New York

1977 Documenta 6, Kassel
Bookworks, The Museum of Modern Art, New York

1978 *13° E: Eleven Artists Working in Berlin*, Whitechapel Art Gallery, London

1984 *von hier aus*, NOWEA Exhibition Center, Pavillion 13, Düsseldorf

EVA–MARIA SCHÖN

1948 Born Dresden

1966–69 Teaches photography, Düsseldorf

1970–74 Attends the Werkkunststudium, Düsseldorf

1974–78 Studies at the Kunstakademie, Düsseldorf

1980 Moves to Berlin

1982 Stipend to Villa Romana, Florence

1983–85 Karl Schmidt-Rottluff Stipend
Lives in Berlin

Selected Individual Exhibitions

1978 Museum, Pforzheim

1979 Galerie Max Hetzler, Stuttgart

1981 Galerie Dany Keller, Munich
Galerie Anselm Dreher, Berlin

1982 Kunst- und Museumsverein Wuppertal

1983 Kunstmarkt, Cologne

1985 Goethe Institute, Paris

1986 ON-Galerie, Poznan, Poland
Künstlerhaus Bethanien, Berlin

Selected Group Exhibitions

1976 *Rinke-Klasse,* Museum Wiesbaden

1979 *Schlaglichter,* Landesmuseum, Bonn
Europa 79, Stuttgart

1981 *Art Allemagne Aujourd'hui,* Musée d'Art
Moderne de la Ville de Paris
Situation Berlin, Musée d'Art Contemporain,
Nice

1983 *Künstler-Räume,* Kunstverein Hamburg

1984 *Die Stipendiaten der Karl Schmidt-Rottluff Förde-
rungsstiftung,* Brücke-Museum, Berlin

1986 *Kunst mit Eigen-Sinn,* Museum des 20. Jahr-
hunderts, Vienna
Elementarzeichen, Neuer Berliner Kunstverein,
Berlin

EUGEN SCHÖNEBECK

1936 Born Dresden
Attends the School of Wall Painting, East Berlin

1955 Moves to West Berlin

1955–61 Studies at the Hochschule für bildende
Künste, Berlin

1957 Meets Georg Baselitz

1961 First *Pandemonium* manifesto (with Baselitz)

1962 Second *Pandemonium* manifesto (with Baselitz)

1966 Stops painting
Lives in Berlin

Selected Individual Exhibitions

1961 *First Pandämonium,* Schaperstrasse 22, Berlin
(with Baselitz)

1965 Galerie Benjamin Katz, Berlin

1973 Galerie Abis, Berlin

1986 *Eugen Schönebeck: Zeichnungen, 1960–1963,*
Silvia Menzel, Berlin

Selected Group Exhibitions

1965 *Grosse Berliner Kunstausstellung,* Hallen am
Funkturm, Berlin

1966 *Das Porträt,* Haus der Kunst, Munich

1967 *Junge Berliner Maler und Bildhauer,* Zapeion,
Athens

1969 *Sammlung Ströher 1968,* Nationalgalerie, Berlin,
and Kunsthalle Düsseldorf

1972 *Zeichnungen II,* Städtisches Museum, Schloss
Morsbroich, Leverkusen

1973 *14 x 14,* Staatliche Kunsthalle, Baden-Baden

1974 First Biennale, Berlin

1975 *8 from Berlin,* Fruit Market Gallery, Scottish
Arts Council, Edinburgh

1980 *Der gekrümmte Horizont: Kunst in Berlin
1945–1967,* Akademie der Künste, Berlin

1981 *Schilderkunst in Duitsland: Peinture en Allemagne
1981,* Palais des Beaux-Arts, Brussels

1982 *German Drawings of the 60s,* Yale University Art
Gallery, New Haven

1985 *Deutsche Kunst seit 1960 aus der Sammlung Prinz
Franz von Bayern,* Bayerische Staatsgemälde-
sammlungen, Staatsgalerie moderner Kunst,
Munich
*German Art in the 20th Century: Painting and
Sculpture 1905–1985,* Royal Academy of Arts,
London
*1945–1985, Kunst in der Bundesrepublik Deutsch-
land,* Nationalgalerie, Berlin

DANIEL SPOERRI

1930 Born Galati, Romania

1980 DAAD Fellowship to Berlin
Lives in Munich and Switzerland

Selected Individual Exhibitions

1961 Galleria Schwarz, Milan
Galerie Koepcke, Copenhagen

1962 Galerie Lawrence, Paris

1963 Galerie Zwirner, Cologne

1964 Allan Stone, New York

1971 Kunsthalle Hamburg
Stedelijk Museum, Amsterdam

1972 Centre Georges Pompidou, Paris

1986 Galleria Niccoli, Parma.

Selected Group Exhibitions

1961 *The Art of Assemblage,* The Museum of Modern
Art, New York

1962 *The New Realists,* Sidney Janis Gallery, New
York

1963 Paris Biennale

1964 *Pop, Pop, Pop, etc,* Museum des 20. Jahr-
hunderts, Vienna
Neue Realisten & Pop Art, Akademie der Künste,
Berlin
Galerie Zwirner, Cologne (with Robert Filliou)

1970 *3: New Multiple Art,* Whitechapel Art Gallery,
London
Happening & Fluxus, Kölnischer Kunstverein,
Cologne

1975 Venice Biennale

1985 *1945–85, Kunst in der Bundesrepublik Deutsch-
land,* Nationalgalerie, Berlin

Selected Happenings

1962 Festum Fluxorum, FLUXUS, Paris

1963 Festum Fluxorum, FLUXUS, Musik u. Anti-
musik, Das Instrumentale Theater, Kunst-
akademie, Düsseldorf

1972 *Feilschmarkt mit Kindern,* Akademie der Künste,
Berlin

WALTER STÖHRER

1937 Born Stuttgart
Studies at the Hochschule der bildenden Künste,
Karlsruhe

1959 Moves to Berlin

1971 Will Grohmann-Preis, Akademie der Künste,
Berlin

1976 Berliner Kunstpreis, Akademie der Künste,
Berlin

1977 Stipend to Villa Romana, Florence

1981 Visiting Professor at Hochschule der Künste,
Berlin

1986 Professor at the Hochschule der Künste,
Berlin
Lives in Berlin

Selected Individual Exhibitions

1961 Kellergalerie im Schloss, Darmstadt

1962 Galerie Schüler, Berlin

1965 Galerie Nächst St. Stephan, Vienna

1968 Galerie Schüler, Berlin

1971 Galerie Schüler, Berlin

1976 Galerie Georg Nothelfer, Berlin

1977 Neue Galerie, Bochum

1979 DAAD gallery, Berlin

1981 Galerie Lutz, Stuttgart

1982 Städtische Galerie, Nordhorn
Galerie Wentzel, Cologne

1983 Kunsthalle Bremen
Kunstverein Braunschweig
Galerie Georg Nothelfer, Berlin

1984 Kunstmuseum Düsseldorf
Galerie Adrien Maeght, Paris

1985 Lefebre Gallery, New York

1986 Galerie Christa Schübbe, Düsseldorf-Mettmann

Selected Group Exhibitions

1958 Paris Biennale

1960 121. Frühjahrsausstellung, Kunstverein Hannover

1963 *Skripturale Malerei*, Haus am Waldsee, Berlin

1966 *Junge Generation*, Akademie der Künste, Berlin
Junge Berliner Künstler, Kunsthalle Basel

1967 128. Frühjahrsausstellung, Kunstverein Hannover

1972 *Informelles—Formelles*, Kunstverein Wolfsburg

1977 *21 deutsche Künstler*, Louisiana Museum, Humlebaek

1981 *Berlin expressiv*, Berlinische Galerie, Berlin

1982 *Zwischen himmlischer und irdischer Liebe*, Galerie Brusberg, Berlin

1983 *Kunst in der Bundesrepublik Heute*, Trondheim/Oslo

1985 *1945–1985, Kunst in der Bundesrepublik Deutschland*, Nationalgalerie, Berlin

1986 Walter Bischoff, Chicago

1987 *Berlin*, Amerikahaus, Berlin

FRED THIELER

1916 Born Königsberg

1936-41 Studies medicine and does military service

1946-50 Studies painting at the Akademie der bildenden Künste, Munich

1950-51 In Holland

1951-53 In Paris; studies with Stanley William Hayter

1953-59 In Munich

1953 Becomes member of Neue Gruppe, Munich

1954 Becomes member of Deutscher Künstlerbund, Berlin

1959 Professor, Hochschule für bildende Künste, Berlin

1972–73 Guest Professor, College of Art and Design, Minneapolis

1978 Becomes member of the Akademie der Künste, Berlin
Becomes member of the Neue Darmstädter Sezession, Darmstadt

1980–83 Vice President, Akademie der Künste, Berlin

1981 Professor Emeritus, Hochschule der Künste, Berlin

1985 Lovis Corinth Prize

Lives in Berlin

Selected Individual Exhibitions

1948 Galerie Heinrich Jördens, Bremen

1950 Kaiser Wilhelm Museum, Krefeld

1951 Galerie "Le Canard," Amsterdam

1954 Galerie für moderne Kunst, Oslo

1955 Galerie Schüler, Berlin

1957 Galerie Schmela, Düsseldorf

1962 Haus am Waldsee, Berlin

1963 Museum Wiesbaden

1965 Galerie Potsdamer, Berlin

1968 Städtisches Kunstmuseum, Bonn

1970 Galerie Schüler, Berlin

1976 Galerie Georg Nothelfer, Berlin

1978 Neue Galerie, Bochum

1983 Galerie Georg Nothelfer, Berlin

1986 Akademie der Künste, Berlin

Selected Group Exhibitions

1953 Group *ZEN 49*, Munich

1955 Cercle Volnay, Paris
Glanz und Gestalt, Museum Wiesbaden

1957 *Eine neue Richtung in der Malerei*, Städtische Kunsthalle, Mannheim

1958 Venice Biennale

1959 Documenta 2, Kassel
São Paulo Biennale

1962 *Gegenwart bis '62*, Haus am Waldsee, Berlin
Sixteen German Artists, Corcoran Gallery, Washington, D.C.

1964 Documenta 3, Kassel

1967 *Collage '67*, Städtische Galerie im Lenbachhaus, Munich

1973 *Thema: Informel*, Städtisches Museum, Schloss Morsbroich, Leverkusen

1980 *Der gekrümmte Horizont: Kunst in Berlin, 1945–1967*, Akademie der Künste, Berlin

1983 *Grauzonen/Farbwelten*, Neue Gesellschaft für bildende Kunst, Akademie der Künste, Berlin

1985 *1945–1985, Kunst in der Bundesrepublik Deutschland*, Nationalgalerie, Berlin

1987 *Berlin*, Amerikahaus, Berlin

BEN VAUTIER

1935 Born Naples

Lives in Turkey, Egypt, and Greece

1949 Arrives in Nice

1951 Stops studies

1978–79 DAAD Fellowship to Berlin

Lives in Nice

Selected Individual Exhibitions

1960 *Rien et Tout,* Laboratoire 32, Nice

1964 Gallery Amstel 47, Amsterdam

1970 *Tout et Rien,* Galerie Daniel Templon, Paris

1971 *Gestes et objets,* Galerie René Block, Berlin

1972 *Actions,* Galerie Daniel Templon, Paris
Galerie Krebs, Berne

1973 *Art-Ben,* Stedelijk Museum, Amsterdam
Galerie Zwirner, Cologne

1975 Galerie Bischofberger, Zurich
John Gibson Gallery, New York

1979 DAAD gallery, Berlin
Galerie A.K., Frankfurt
Galerie Leger, Malmö

1980 Galerie Daniel Templon, Paris

1983 Galerie Beaubourg, Paris

1984 Galerie R.Z.A., Düsseldorf

1985 Galerie Baudoin Lebon, Paris

Selected Group Exhibitions

1958 *Scorbut,* Laboratoire 32, Nice

1962 *Misfits Fair,* Gallery One, London

1969 Festival Non Art, Nice

1971 Galerie Daniel Templon, Paris
Documenta 5, Kassel

1975 Galerie Bischofberger, Zurich

1976 *Soho—Downtown Manhattan*, Akademie der Künste, Berlin

1978 DAAD gallery, Berlin

1979 Biennale of Sydney
Exposition Fluxus, Bologne
DAAD gallery, Berlin

1982 *'60–'80, Attitudes, Concepts, Images*, Stedelijk Museum, Amsterdam
Castelli Graphics, New York
John Gibson Gallery, New York

1983 São Paulo Biennale
Le Grand Palais, Paris

1984 Goethe Institut, Paris

1985 Process und Konstruction, Munich
Das Selbstporträt im Zeitalter der Photographie, Württembergischer Kunstverein, Stuttgart
1945-1985, Kunst in der Bundesrepublik Deutschland, Nationalgalerie, Berlin

EMILIO VEDOVA

1919 Born Venice

1937–40 Studies in Rome and Florence

1956 Solomon R. Guggenheim Foundation Prize for Italy

1960 First International Painting Prize, Venice Biennale

1964 DAAD Fellowship to Berlin

1973 Visits U.S.

Lives in Venice

Selected Individual Exhibitions

1942 Gallery La Spiga e Corrente, Milan

1948 Venice Biennale

1950 Venice Biennale

1951 Catherine Viviano Gallery, New York
São Paulo Biennale

1953–54 São Paulo Biennale

1955 Documenta 1, Kassel

1956 Galerie Günther Franke, Munich

1957 Galerie Springer, Berlin

1959 Documenta 2, Kassel
Stedelijk Museum, Amsterdam

1960 Venice Biennale

1961 The Ateneo, Madrid
Palazzo della Gran Guardia, Verona

1962 Kunstverein Freiburg

1963 Marlborough Gallery, Rome

1964 Documenta 3, Kassel
Staatliche Kunsthalle, Baden-Baden

1965 Institute of Contemporary Art, Chicago

1970 Galerie Rothe, Heidelberg

1975–76 Museo Civico Castello Visconteo, Pavio

1979 Perth Art Gallery of Western Australia

1981 Städtisches Museum, Schloss Morsbroich, Leverkusen

1982 Stedelijk van Abbemuseum, Eindhoven
Kunstverein Braunschweig

1983 Galerie Fred Jahn, Munich

1984 Museo Correr, Venice

1986 Staatsgalerie moderner Kunst, Munich
Galerie Ulysses, Vienna

Selected Group Exhibitions

1956 Venice Biennale
Documenta 1, Kassel

1959 *Vitalità nell'arte*, Palazzo Grassi, Venice
De vitaliteit in de Kunst, Stedelijk Museum, Amsterdam
São Paulo Biennale

1960 Venice Biennale

1964 Documenta 3, Kassel

1966–67 Expo '67, Montreal

1971 *Graphik der Welt*, Nuremberg

1973 *Für die Struktur einer anderen Zeit*, Städtisches Museum, Schloss Morsbroich, Leverkusen
Haus am Waldsee, Berlin

1978 Venice Biennale

1980 *Dieci pittori—arte atratta in Italia 1909/1959*, Galleria Nazionale d'Arte Moderna, Rome

1981 *Westkunst*, Museen der Stadt Köln, Cologne

1982 Venice Biennale
Documenta 7, Kassel

1983 *L'Informale in Italia—viluppi del l'informale*, Galleria Arte Moderna, Bologna

1984 *Orwell und die Gegenwart*, Museum moderner Kunst, Palais Liechtenstein, Vienna

1985 *The European Iceberg: Creativity in Germany and Italy Today*, Art Gallery of Ontario, Toronto

1986 *Capriccio—Musique et Art du XXᵉ Siecle*, Palais des Beaux-Arts, Brussels
Europa/America, Museum Ludwig, Cologne

WOLF VOSTELL

1932 Born Leverkusen

1954 Studies at the Werkkunstschule, Wuppertal

1955–56 Studies at the Ecole des Beaux-Arts Nationale Supérieure, Paris

1957 Studies at the Kunstakademie, Düsseldorf

Lives in Berlin and Malpartida, Spain

Selected Individual Exhibitions

1958 Salones Educacíon y Descanso, Cáceres, Spain

1962 Galerie Monet, Amsterdam

1963 Smolin Gallery, New York

1965 Galerie René Block, Berlin

1966 Kölnischer Kunstverein, Cologne

1967 Galerie René Block, Berlin
Museum of Contemporary Art, Chicago

1969 Galerie van de Loo, Munich

1972 Galerie Art in Progress, Zurich

1974 Kunsthalle Bremen
Musée d'Art Moderne de la Ville de Paris

1975 Carsta Zellermayer, Berlin
Neuer Berliner Kunstverein, in cooperation with the Nationalgalerie, Berlin

1976 Kunsthalle, Nuremberg

1979 Fundacíon Miró, Madrid

1980 Kunstverein Braunschweig
Los Angeles Institute of Contemporary Art

1981 DAAD gallery, Berlin

1985 Musée d'Art Moderne de Strasbourg

1986 Galerie Wewerka, Hannover

Selected Group Exhibitions

1961 Salon des Comparaisons, Musée d'Art Moderne de la Ville de Paris

1962 *Schrift und Bild I*, Kunsthalle Baden-Baden

1963 *Schrift und Bild II*, Stedelijk Museum, Amsterdam

1964 *Deutscher Künstlerbund*, Haus am Waldsee, Berlin
Neodada/Pop/Décollage/Capitalist Realism, Galerie René Block, Berlin

1965 *Hommage à Berlin*, Galerie René Block, Berlin

1966 *Junge Generation*, Akademie der Künste, Berlin

1967 *Pictures To Be Read—Poetry To Be Seen*, Museum of Contemporary Art, Chicago

1968 Venice Biennale
13 Deutsche Maler, Städtisches Museum, Schloss Morsbroich, Leverkusen
Houston Contemporary Arts Museum

1969 *Kunst der sechziger Jahre*, Sammlung Ludwig, Wallraf-Richartz-Museum, Cologne
Superlimited Books—Boxes and Things, Jewish Museum, New York

1970 *Happenings & Fluxus*, Kölnischer Kunstverein, Cologne
3: New Multiple Art, Whitechapel Art Gallery, London

Kunst und Politik, Frankfurter Kunstverein, Frankfurt

1971 *Multiples: The First Decade*, Philadelphia Museum of Art
Nationalgalerie, Berlin

1972 *Projektion*, Louisiana Museum, Humlebaek
Neuer Berliner Kunstverein, Berlin
Szene Berlin 72, Kunstverein Hamburg

1974 *Kunst in Deutschland 1968–1973*, Städtische Galerie im Lenbachhaus, Munich

1975 Moderna Museet, Stockholm
Berlinische Galerie, Berlin

1976 KHAV, Kaprow Happening Activity Vostell, Hochschule der Künste, Berlin

1978 *13° E: Eleven Artists Working in Berlin*, Whitechapel Art Gallery, London

1985 *1945–1985, Kunst in der Bundesrepublik Deutschland*, Nationalgalerie, Berlin

1984 *von hier aus*, NOWEA Exhibition Center, Pavillon 13, Düsseldorf
Neue Malerei Berlin, Kestner-Gesellschaft, Hannover
Galerie Skulima, Berlin

1985 *1945–1985, Kunst in der Bundesrepublik Deutschland*, Nationalgalerie, Berlin

EMMETT WILLIAMS

1925 Born Greenville, South Carolina

1943–46 Serves in U.S. Army

1949 B.A., Kenyon College, Ohio

1949–66 Lives and works in France, Germany, and Switzerland
Member of "Darmstädter Kreis" for Concrete Poetry; "dynamisches Theater," etc., with Daniel Spoerri and Claus Bremer; "Domaine Poetique" with Robert Filliou and others; and since 1962, the international Fluxus movement

1966–70 Editor-in-chief, Something Else Press, New York

1970–72 Professor, School of Critical Studies, California Institute of Arts

1972–74 Guest Professor, Nova Scotia College of Art and Design, Halifax

1975–77 Visiting artist, Mount Holyoke College, Massachusetts

1977–78 Guest lecturer, Research Fellow, Carpenter Center for the Visual Arts, Harvard University, Cambridge

1980 DAAD Fellowship to Berlin

1981–85 Guest lecturer, Hochschule für bildende Künste, Hamburg, and Hochschule der Künste, Berlin

Lives in Berlin

Selected Individual Exhibitions

1963 Galerie Koepcke, Copenhagen

1969 University of Kentucky, Lexington

1973 Galerie Inge Baecker, Bochum

1977 Nantenshi Gallery, Tokyo
Mount Holyoke College, Massachusetts

THOMAS WACHWEGER

1943 Born Breslau

1963–70 Studies at the Hochschule für bildende Künste, Hamburg

1978 Moves to Berlin

Lives in Berlin

Selected Individual Exhibitions

1974 Galerie Silvio R. Baviera, Zurich

1983 *Zuoberst — Zuunterst*, Neue Gesellschaft für bildende Kunst, Berlin

1984 Galerie Springer, Berlin

1985 Galerie Monika Sprüth, Cologne
Galerie Springer, Berlin

1986 Haus am Waldsee, Berlin

Selected Group Exhibitions

1980 Galerie Paul Maenz, Cologne

1981 Galerie Petersen, Berlin

1979 Staatsgalerie, Stuttgart

1980 Carpenter Center for the Visual Arts, Harvard University, Cambridge

1981 Gemeente Museum, The Hague

1982 Nationalgalerie, Berlin

1983 Centre Georges Pompidou, Paris

1985 Galerie Petersen, Berlin

1986 Galerie Wewerka, Hannover
Kunstverein/Kunsthalle, Friedrichshafen

Selected Group Exhibitions

1959 *Motion in Vision, Vision in Motion*, Hessenhuis, Antwerp

1962 *Festival of Misfits*, Gallery One, London

1966 *Object Poems*, Something Else Gallery, New York

1968 *Guillaume Apollinaire*, Institut of Contemporary Arts, London

1970 *Happenings & Fluxus*, Kölnischer Kunstverein, Cologne
The Word as Image, Jewish Museum, New York
Konkrete Poésie, Stedelijk Museum, Amsterdam

1972 *Poésie Visuelle*, Galerie Bama, Paris

1975 *Printsequences*, The Museum of Modern Art, New York

1978 *Lettres, Signes, Ecritures*, Konsthall, Malmö

1979 *The Open and Closed Book*, Victoria and Albert Museum, London

1980 *Printed Art: A Review of Two Decades*, The Museum of Modern Art, New York

1982 *1962 Wiesbaden FLUXUS 1982*, Museum Wiesbaden
Kunstquartier—Ausländische Künstler in Berlin, former AEG factory, Ackerstrasse, Berlin

1983 *Fluxus etc.*, Neuberger Museum, Purchase, New York
20 Jahre Fluxus, Neue Galerie der Staatlichen Kunstsammlungen, Kassel
Eine kleine Geschichte von Fluxus, DAAD gallery, Berlin

1984 *Copy Art*, Pegasus Gallery, Berlin

1985 *Biennale des Friedens*, Kunstverein und Kunsthaus, Hamburg
1945–85, Kunst in der Bundesrepublik Deutschland, Nationalgalerie, Berlin

1986 *Musik und Sprache*, Technische Universität, Ackerstrasse, Berlin
Das Andere Land—Ausländische Künstler in der Bundesrepublik, Grosse Orangerie, Schloss Charlottenburg, Berlin
Neues im Berlin Museum, Berlin Museum
20 Jahre Rainer Verlag, DAAD gallery, Berlin

Selected Performances

1962 *Fluxus Internationale Festspiele Neuester Musik*, Städtisches Museum, Wiesbaden
Festival of Misfits, Institute of Contemporary Arts, London

1963 *Festum Fluxorum*, Staatliche Kunstakademie, Düsseldorf
Poésie et cetera américaine, Musée d'Art Moderne de la Ville de Paris

1964 Flux-Festival, Galerie t'Venster, Rotterdam

1970 Fluxus Festival, Galerie René Block/Forum Theater, Berlin

1976 *Delayed Flux New Year's Event*, The Clocktower, New York

1981 *Performance I, The Boy and the Bird*, Künstlerhaus Bethanien, Berlin

1982 *Performance II: Genesis*, Künstlerhaus Bethanien, Berlin
1962 Wiesbaden FLUXUS 1982, Museum Wiesbaden

1983 *Musik um 1962*, Hochschule der Künste, Berlin

1984 *Sprachen der Künste Spirale*, Akademie der Künste, Berlin

1986 *Sprachen und Laute: Werke von Kurt Schwitters und Emmett Williams*, Kunstsammlung Nordrhein-Westfalen, Düsseldorf
An Alphabet Symphony, Kölnischer Kunstverein, Cologne

BERND ZIMMER

1948 Born Planegg

1968 Apprentices in business and publishing

1973–79 Studies philosophy and religion at Freie Universität, Berlin

1977 Cofounder of Galerie am Moritzplatz, Berlin (with Rainer Fetting, Helmut Middendorf, and Salomé)

1979–80 Karl Schmidt-Rottluff Stipend

1982–83 Stipend to Villa Massimo, Rome

Lives in Berlin

Selected Individual Exhibitions

1977 *Flut*, Galerie am Moritzplatz, Berlin

1978 *Stadtbilder—Hochbahn*, Galerie am Moritzplatz, Berlin

1979 Galerie Interni, Berlin

1980 *Bilder—Landschaften*, Galerie Gmyrek, Düsseldorf

1981 Barbara Gladstone Gallery, New York
Galerie Yvon Lambert, Paris
Galerie Georg Nothelfer, Berlin

1982 Galerie Buchmann, St. Gallen

1983 *Abgründe: Ihr Berge, tanzt!*, Galerie Gmyrek, Düsseldorf

1986 Kunstverein Braunschweig

Selected Group Exhibitions

1978 *Handzeichnungen*, Galerie am Moritzplatz, Berlin
Freie Berliner Kunstausstellung, Berlin

1979 *Alkohol, Nikotin, fff*, Galerie am Moritzplatz, Berlin

1980 *Heftige Malerei*, Haus am Waldsee, Berlin
Junge Kunst aus Berlin, Berlinische Galerie, Berlin

1981 *Bildwechsel*, Akademie der Künste, Berlin
Situation Berlin, Musée d'Art Contemporain, Nice

1982 *Currents II: New Figuration from Europe*, Milwaukee Art Center
Gefühl und Härte: Künstler in Berlin, Kulturhuset, Stockholm

1983 *Cologne—Nice—Berlin*, Bonlow Gallery, New York

1984 *An International Survey of Recent Painting and Sculpture*, The Museum of Modern Art, New York

1985 *Zoographie*, Galerie Gmyrek, Düsseldorf

Bibliography

Compiled by Daniel A. Starr

The bibliographic documentation that follows is arranged in four sections: Individual Artists, Group Exhibition Catalogues, Berlin, and General. Section I lists publications by the artists, monographs, and exhibition catalogues. The selection concentrates on the artist's activities in Berlin. Section II lists major exhibition catalogues, especially for exhibitions held in Berlin or that included Berlin artists. Section III lists bibliographies, monographs, and periodicals that pertain primarily to Berlin. Section IV lists monographs and periodicals about German and international art that include Berlin artists.

The documentation of group exhibition catalogues gives the title of the catalogue, the first place of exhibition, subsequent places of exhibition, the dates of the exhibition, the organizer or organizers of the exhibition, and the artists from *BERLINART 1961–1987* who are included in the catalogue. The title of the exhibition, the publisher, and the author of the catalogue are given only when they differ from the title of the catalogue, first place of exhibition, and organizer or organizers. Catalogues of recurring group exhibitions, such as Documenta; Rosc; the Paris, São Paulo, Sydney, and Venice biennials; have been excluded, as have the major recurring exhibitions of German art, such as the annual Freie Berliner Kunstausstellung, the annual exhibition of the Deutscher Künstlerbund, the annual Deutscher Kunstpreis der Jugend, and the 14 mal 14 and Prospect exhibitions.

I. INDIVIDUAL ARTISTS

ARMANDO

By the artist

Krijgsgewoel. Amsterdam: De Bezige Bij, 1986.
Machthebbers: Verslagen uit Berlijn en Toscane. Amsterdam, 1983.
10 Studien zur Dekadenz. Sassenheim: Stichting Sikkensprijs, 1981. Text by Wim Beeren; resulting from the award of the 1979 Sikkensprijs.

Exhibition catalogues

Armando. Berlin: Galerie Springer, 1981. In German and Italian.
Armando. Berlin: Galerie Springer, 1985. Includes Armando's "Die Parabel vom Meer und der Knopfdose," translated from the Dutch.
Blotkamp, Carel. *Armando.* Amsterdam: Stedelijk Museum, 1974.
—, and Heusinger von Waldegg, Joachim. *Armando.* Paris: Institut Néerlandais, 1984. In French and German.
De Groot, Elbrig, and van Adrichem, Jan, eds. *Armando: 100 Tekeningen, 1952–1984/100 Zeichnungen, 1952–1984/100 Drawings, 1952–1984.* Rotterdam: Museum Boymans-Van Beuningen, 1985.
Ferron, Louis, ed. *Armando: Schilder/Schrijver.* Weesp: De Haan, 1985.

Fuchs, R. H. *Armando.* Berlin: DAAD, 1979. Catalogue of the exhibition at the Akademie der Künste, Berlin.
—. *Armando.* Eindhoven: Stedelijk Van Abbemuseum; Amsterdam: Stedelijk Museum, 1981. In Dutch, English, and German.
Schweinebraden, Jürgen. *Armando: Fahnen.* Berlin: Nationalgalerie, Staatliche Museen Preussischer Kulturbesitz, 1984.

INA BARFUSS / THOMAS WACHWEGER

By the artists

Über sieben Brücken musst du gehen: Mussten wir Auch. Stuttgart: Max-Ulrich Hetzler GmbH, 1982. With Markus Oehlen, Werner Büttner, Georg Herold, Albert Oehlen, and Martin Kippenberger.

Exhibition catalogues

Faust, Wolfgang Max, ed. *Ina Barfuss, Thomas Wachweger: Die Kunst der Triebe: Arbeiten von 1980 bis 1985.* Dortmund: Museum am Ostwall, 1985.
Kempas, Thomas. *Ina Barfuss, Thomas Wachweger: Gemälde, Zeichnungen, Gemeinschaftsarbeiten, 1978–1986: Ausstellung in 2 Folgen.* Berlin: Haus am Waldsee, 1986.
Straka, Barbara, ed. *Ina Barfuss: Der moderne Mensch: Bilder und Zeichnungen, 1979–1982.* Berlin: Neue Gesellschaft für Bildende Kunst, 1982.
Thomas Wachweger. Berlin: Galerie Springer, 1985.

GEORG BASELITZ

By the artist

Die Gesänge des Maldoror. Munich: Rogner & Bernhard, 1976. Text by the Comte de Lautréamont (Isadore Ducasse); translated by Ré Soupault; illustrated by Baselitz.
Sächsische Motive. Berlin: Rainer Verlag and DAAD, 1985.

Monographs

Jahn, Fred. *Baselitz, Peintre-Graveur.* Vol. 1: *Werkverzeichnis der Druckgraphik, 1963–1974.* Bern: Verlag Gachnang & Springer, 1983.

Exhibition catalogues

Calvocoressi, Richard. *Baselitz.* London: Waddington Galleries, 1982.
Danzker, Jo-Anne Birnie. *Georg Baselitz.* Vancouver: Vancouver Art Gallery, 1984. Includes translations of first and second *Pandemonium*.
Gachnang, Johannes. ed. *Baselitz: Malerei, Handzeichnungen, Druckgraphik.* Bern: Kunsthalle, 1976.
Georg Baselitz: Zeichnungen, 1960–1974. Cologne: Galerie Michael Werner, 1974.
Gohr, Siegfried, ed. *Georg Baselitz: Gemälde, Handzeichnungen und Druckgraphik.* Cologne: Museen der Stadt Köln, 1976.
van Grevenstein, Alexander. *Georg Baselitz, Das Strassenbild.* Amsterdam: Stedelijk Museum, 1981. In Dutch and English.
Harten, Jürgen. *Georg Baselitz, Gerhard Richter.* Düsseldorf: Kunsthalle, 1981.
Isselbacher, Audrey. *Georg Baselitz: Monumental Prints.* New York: The Museum of Modern Art, 1983.
Jablonka, Rafael. *Ruins: Strategies of Destruction in the Fracture Paintings of Georg Baselitz, 1966–69.* London: Anthony d'Offay, 1982.

Koepplin, Dieter, and Fuchs, Rudi. *Georg Baselitz: Zeichnungen 1958–1983.* Basel: Kunstmuseum, 1984.
Schilling, Jürgen. *Georg Baselitz.* Braunschweig: Kunstverein, 1981.
Schulz-Hoffmann, Carla, and Jahn, Fred, eds. *Georg Baselitz.* Munich: Galerieverein München and Staatsgalerie Moderner Kunst, 1976.
Serota, Nicholas, and Francis, Mark. *Baselitz: Paintings, 1960–83.* London: Whitechapel Art Gallery, 1983. Includes translations of Baselitz's writings. Dutch/English version published as *Georg Baselitz: Schilderijen/Paintings, 1960–83* (Amsterdam: Stedelijk Museum, 1984).
Schilling, Jürgen. *Georg Baselitz.* Braunschweig: Kunstverein, 1981. Includes text of first and second *Pandemonium*.

JOSEPH BEUYS

By the artist

Aus Berlin: Neues vom Kojoten. New York: Ronald Feldman Gallery, in cooperation with René Block, Berlin 1979.
Jeder Mensch ein Künstler: Gespräche auf dem Documenta 5, 1972. Frankfurt: Ullstein, 1975.
Words Which Can Hear. London: Anthony d'Offay, 1981.
Zeichnungen, 1947–59. Cologne: Schirmer Verlag, 1972. Includes a conversation between Beuys and Hagen Lieberknecht.

Monographs

Adriani, Götz; Konnertz, Winfried; and Thomas, Karin. *Joseph Beuys: Life and Works.* Woodbury, N.Y.: Barron's, 1979. Originally published in German as *Joseph Beuys* (Cologne: M. DuMont Schauberg, 1973).
Bastian, Heiner. *Abschied von Joseph Beuys: Noch steht nichts geschrieben.* Cologne: Verlag der Buchhandlung Walther König, 1986.
—. *Joseph Beuys: Blitzschlag mit Lichtschein auf Hirsh/Lightning with Stag in its Glare, 1958–1985.* Bern: Benteli Verlag, 1986.
Joseph Beuys. Heidelberg: Edition Staeck, 1983. A catalogue of all of Beuys's multiples published by the Edition Staeck.
Joseph Beuys: Zu seinem Tode: Nachrufe, Aufsätze, Reden. Bonn: Inter Nationes, 1986.
Murken, Axel Hinrich. *Joseph Beuys und die Medizin.* Münster: Coppenrath, 1979. In English and German.
Schellmann, Jörg, and Klüser, Bernd. *Joseph Beuys: Multiples: Catalogue Raisonné, Multiples and Prints, 1965–80.* 5th ed. Munich: Schellmann and Klüser, 1980. In English and German.
Tisdall, Caroline. *Joseph Beuys, Coyote.* 2nd ed. Munich: Schirmer-Mosel, 1980.
Vischer, Theodora. *Beuys und die Romantik: Individuelle Ikonographie, individuelle Mythologie?* Cologne: Walter König, 1983.

Exhibition catalogues

Bastian, Heiner. *Joseph Beuys: Zeichnungen/Dessins.* Berlin: Heiner Bastian; Bern: Benteli Verlag, 1984. Published in conjunction with a series of exhibitions.
—, and Simmen, Jeannot. *Joseph Beuys: Zeichnungen/Tekeningen/Drawings.* Berlin: Nationalgalerie, Staatliche Museen Preussischer Kulturbesitz; Rotterdam: Museum Boymans-Van Beuningen, 1979; also published in a trade ed. (Munich: Prestel-Verlag, 1979).

van der Grinten, Franz Joseph, and others. *Joseph Beuys: Wasserfarben, Aquarelle und aquarellierte Zeichnungen, 1936–1976.* Düsseldorf: Kunstverein für die Rheinlande und Westfalen, 1986.

van der Grinten, Hans. *Joseph Beuys: Braunkreuz.* 2nd ed. Münster: Westfälisches Landesmuseum für Kunst und Kulturgeschichte. 1985. First ed. published by the Nijmeegs Museum.

Joachimides, Christos M. *Joseph Beuys: Richtkräfte.* Berlin: Nationalgalerie, 1977.

Oellers, Adam C., and van der Grinten, Franz Joseph. *Kreuz + Zeichen: Religiöse Grundlagen im Werk von Joseph Beuys.* Aachen: Suermondt-Ludwig-Museum, 1985.

Tisdall, Caroline. *Joseph Beuys: The Secret Block for a Secret Person in Ireland.* Oxford: Museum of Modern Art, 1974.

—. *Joseph Beuys.* New York: Solomon R. Guggenheim Museum, 1979; also published in a trade ed. (London: Thames and Hudson, 1979).

JONATHAN BOROFSKY

Exhibition catalogues

Geelhaar, Christian, and Koepplin, Dieter. *Jonathan Borofsky: Zeichnungen, 1960–1983.* Basel: Kunstmuseum, 1983.

Granath, Olle; Simon, Joan; Koepplin, Dieter; and Armstrong, Richard. *Jonathan Borofsky.* Stockholm: Moderna Museet, 1984

Rosenthal, Mark, and Marshall, Richard. *Jonathan Borofsky.* Philadelphia: Philadelphia Museum of Art in Association with the Whitney Museum of American Art, New York, 1984.

Simon, Joan. *Jonathan Borofsky: Dreams, 1973–81.* London: Institute of Contemporary Arts; Basel: Kunsthalle, 1981.

GEORGE BRECHT

By the artist

Autobiographie: Eine Auswahl von siebenundzwanzig Träumen. Cologne: Galerie der Spiegel, 1973. Translated by Tomas Schmit.

Chance-Imagery. New York: Something Else Press, 1966.

Games at the Cedilla, or, The Cedilla Takes Off. New York: Something Else Press, 1967. With Robert Filliou.

Letters and Jazz for Richard Hamilton, Lester Young, Charlie "Yardbird" Parker. Cologne: Edition Hundertmark, 1983. With Stefan Wewerka.

Die Reise nach Amsterdam. Düsseldorf: Verlaggalerie Leaman, 1977. With Alex Kayser, Milan Mölzer, and André Thomkins.

Vicious Circles and Infinity: An Anthology of Paradoxes. New York: Penguin, 1979. With Patrick Hughes.

Monographs

Martin, Henry. *An Introduction to George Brecht's "Book of the Tumbler on Fire."* Milan: Multhipla, 1978. Includes interviews with Brecht and an anthology of his writings.

Exhibition catalogues

Texte zu einer Hetrospektive von George Brecht. Bern: Kunsthalle, 1978. Interviews with Brecht by Henry Martin et al.

K. P. BREHMER

By the artist

Ideale Landschaft (Farbmusterbuch No. 2). Berlin: Galerie René Block, 1968. With Jürgen Becker.

Exhibition catalogues

Block, René, ed. *KP Brehmer: Wie mich die Schlange sieht, Wie ich die Schlange sehe.* Berlin: DAAD, 1985.

Brehmer, K. P., and Schulte, Friedrich. *KP Brehmer: Wie mich die Schlange sieht, Wie ich die Schlange sehe.* Saarbrücken: Stadtgalerie, 1986.

K. P. Brehmer: Produktion, 1962–1971. Hamburg: Kunstverein, 1971.

GÜNTER BRUS

By the artist

Art des Giftes: Dauer der Vergiftung: Sitz der Schmerzen. Berlin: Edition Hundertmark, 1973.

Der Balkon Europas. Berlin: Edition Hundertmark, 1972.

Der blaue Wald. Berlin: Edition Hundertmark, 1975.

Die Drossel. Nos. 13–17. Berlin, 1975–76. Edited by Brus.

Die Gärten in der Exosphäre. N.p., 1979.

Jeden jeden Mittwoch. Berlin: Edition Hundertmark, 1977. With Dominik Steigler.

Des Knaben Wunderhorn. Berlin: DAAD, 1979.

Körperanalyse I. Berlin: Edition Hundertmark, 1969.

Die lachende Verwesung. Berlin: Edition Hundertmark, 1976.

Nachfreuden-Walzer: Berlin, April, 1975. N.p., n.d.

Die neue Dekadenz. Berlin: Edition Hundertmark, 1972.

Die Schastrommel. Nos. 1–12. Bolzano, 1970–74. Edited by Brus.

Selbstverstümmelung. Vienna, 1976.

16 Variationen über ein plakatives Thema. Berlin, 1975.

Zerreissprobe. Berlin: Edition Hundertmark, 1974.

Exhibition catalogues

Amanshauser, Hildegund, and Ronte, Dieter, eds. *Günter Brus: Der Überblick.* Vienna: Museum Moderner Kunst, 1986. With contributions by Brus, Arnulf Meifert, Dieter Ronte, Gerhard Roth, and Peter Weibel.

Brus, Günter; Gachnang, Johannes; and Meifert, Arnulf, eds. *Günter Brus: Zeichnungen und Schriften.* Bern: Kunsthalle, 1976.

Meifert, Arnulf. Edited by Mark Francis. *Günter Brus, Bild-Dichtungen.* London: Whitechapel Art Gallery, 1980.

VICTOR BURGIN

By the artist

Between. London: Basil Blackwell Limited in Association with the Institute of Contemporary Arts, London, 1986.

The End of Art Theory: Criticism and Postmodernity. Atlantic Highlands, N.J.: Humanities Press International, 1986.

Family. New York: Lapp Princess Press, 1977.

Formations of Fantasy. London and New York: Methuen, 1986. Edited with James Donald and Cora Kaplan.

Interview: UK 76 — US 77 — Zoo 78. Berlin: DAAD, 1979.

"Modernism in the *Work* of Art." New York: John Weber Gallery, 1977.

Victor Burgin. Eindhoven: Stedelijk van Abbemuseum, 1977.

Work and Commentary. London: Latimer New Dimensions, 1973.

Exhibition catalogues

Burgin, Victor. *Victor Burgin.* Eindhoven: Stedelijk van Abbemuseum, 1977. Includes text, "Modernism in the *Work* of Art," and works from 1973–76.

LUCIANO CASTELLI

By the artist

A Look Behind the Screen. Berlin: Raab Galerie, 1986.

Piratin Fu. Geneva: Galerie Eric Franck, 1985. Includes text by Erika Billeter.

Monographs

Billeter, Erika. *Luciano Castelli: Ein Maler träumt sich / A Painter Who Dreams Himself.* Bern: Benteli Verlag, 1986.

Exhibition catalogues

Billeter, Erika, ed. *Luciano Castelli: Tableaux peints à Berlin, 1980–82. Regard sur le présent, 2.* Lausanne: Musée Cantonal des Beaux-Arts, 1982.

PETER CHEVALIER

Exhibition catalogues

Bojescul, Wilhelm. *Peter Chevalier: Bilder und Zeichnungen.* Braunschweig: Kunstverein, 1986.

Chevalier: Ideal Landschaft Stadt am Meer / Ideal Landscape City by the Sea. Berlin: Raab Galerie, 1986.

Peter Chevalier. Freiburg: Kunstverein, 1985.

Peter Chevalier. Berlin: Raab Galerie, 1983. Includes texts by Jeannot Simmen, Otto Weininger, and Roland Hagenberg.

Wildermuth, Armin. *Peter Chevalier.* St. Gallen: Buchmann, Galerie & Edition, 1983.

CHRISTO

By the artist

5600 Cubicmeter Package: 4. Documenta Kassel 1968. Baierbrunn: Verlag Wort und Bild, 1968.

Monographs

Alloway, Lawrence. *Christo.* New York: Harry N. Abrams, 1969.

Bourdon, David. *Christo.* New York: Harry N. Abrams, 1970.

—. Tomkins, Calvin; Gorgoni, Gianfranco. *Christo: Running Fence: Sonoma and Marin Counties, California, 1972–76.* New York: Harry N. Abrams, 1978.

—. Hahan, Otto, and Restany, Pierre. *Christo.* Milan: Edizioni Apollinaire, 1965.

Christo; Valley Curtain. New York: Harry N. Abrams, 1973.

Cullen, Michael, and Volz, Wolfgang, comps. *Christo: Der Reichstag.* Frankfurt: Suhrkamp, 1984.

Goheen, Ellen, and Volz, Wolfgang. *Christo: Wrapped Walk Ways: Loose Park, Kansas City, Missouri, 1977–78.* New York: Harry N. Abrams, 1978.

Hovdenakk, Per. *Christo: Complete Editions, 1964–82.* Munich: Schellmann & Klüser; New York: New York University Press, 1982.

Laporte, Dominique. *Christo.* Paris: Art Press / Flammarion, 1985. English translation: New York: Pantheon, 1986.

Shunk-Kender. *Christo: Wrapped Coast, One Million Sq. Ft., Little Bay-1969, New South Wales, Australia.* Minneapolis: Contemporary Art Lithographers, 1969.

Spies, Werner. *Christo: Surrounded Islands, Biscayne Bay, Greater Miami, Florida, 1980–83.* Cologne: DuMont, 1984. English translation: New York: Harry N. Abrams, 1985. Chronology and photographs by Wolfgang Volz.

—. Volz, Wolfgang. *The Running Fence Project: Christo.* Rev. ed. New York: Harry N. Abrams, 1980.

Yard, Sally, and Hunter, Sam. *Christo: Ocean Front.* Princeton: Princeton University Press, 1975.

Exhibition catalogues

van der Marck, Jan. *Christo: Collection on Loan from the Rothschild Bank AG, Zurich.* La Jolla: La Jolla Museum of Contemporary Art, 1981.

Rubin, William. *Christo Wraps the Museum.* New York: The Museum of Modern Art, 1968.

Schmied, Wieland. *Christo: Project for Wrapped Reichstag, Berlin: Collages, Drawings, Scale Model and Photographs.* London: Annely Juda Fine Arts, 1977.

Weiss, Evelyn; Kolberg, Gerhard; and Vogelsang, Bernd. *Christo: Projekte in der Stadt, 1961–81.* Cologne: Museum Ludwig, 1981.

Yanagi, Masahiko, and Irgang, Harriet, eds. *Christo: Wrapped Reichstag Project for Berlin.* Tokyo: Satani Gallery, 1986. Includes an interview with Christo in English.

WILLIAM EGGLESTON

By the artist

"The Berlin Series." *Aperture* 96 (Fall 1984), pp. 60–75. Text excerpted from *The Wall Jumper* by Peter Schneider.

Elvis at Graceland. Memphis, Tenn.: Cypress Press, 1983. Text by Ken Brixey and Twyla Dixon.

Exhibition catalogues

Szarkowski, John. *William Eggleston's Guide.* New York: The Museum of Modern Art, 1976.

RAINER FETTING

Exhibition catalogues

Busche, Ernst. *Rainer Fetting.* Berlin: Galerie am Moritzplatz, 1978.
Faust, Wolfgang Max. *Rainer Fetting.* Berlin: Raab Galerie, 1983. In English, German, and Italian.
Felix, Zdenek, ed. *Rainer Fetting.* Essen: Museum Folkwang; Basel: Kunsthalle, 1986.
Rainer Fetting: Bilder, 1973–1984. Berlin: Raab Galerie, 1985. Includes a conversation between Fetting and Klaus Ottmann in English and German.
Rosenthal, Norman. *Rainer Fetting: New York Landscapes, Portraits and Sculpture.* New York: Marlborough Gallery, 1986.
Sarnoff, Richard. *Rainer Fetting: Holzbilder (Wood Paintings).* New York: Marlborough Gallery, 1984.
Seymour, Anne. *Rainer Fetting.* London: Anthony d'Offay; New York: Mary Boone, 1982.

ROBERT FILLIOU

By the artist

Ample Food for Stupid Thought. New York: Something Else Press, 1965.
An Anecdoted Topography of Chance (Re-Anecdoted Version). New York: Something Else Press, 1966. With Daniel Spoerri; translated and further anecdoted by Emmett Williams.
A Filliou Sampler. New York: Something Else Press, 1967.
Games at the Cedilla, or, The Cedilla Takes Off. New York: Something Else Press, 1967. With George Brecht.
Hand Show. Villingen: SABA-Studio, 1967. Photographs by Scott Hyde.
Lehren und Lernen als Auffuehrungskuenste/ Teaching and Learning as Performing Arts. Cologne and New York: Gebr. Koenig, 1970. With contributions by John Cage, Allan Kaprow, Benjamin Patterson, Dieter Roth, and Joseph Beuys.
Mister Blue from Day to Day: MTWThFSaS/Herr Blau von Tag zu Tag. Hamburg: Edition Lebeer Hossmann, 1983.
The Seat of Ideas. Calgary: Syntax, 1981. Includes a "logical analysis" by Edwige Regenwetter; translation of *Le siège des idées* (Brussels: Lebeer Hossmann, 1977).

Exhibition catalogues

Becker, Wolfgang, and Brock, Astrid, eds. *Robert Filliou: Der 1.000.010. Geburtstag der Kunst, 17. Januar 1973.* Aachen: Neue Galerie der Stadt, 1973.
Erlhoff, Michael. *Das immerwährende Ereignis zeigt/ The Eternal Network Presents/La Fête permanente présente: Robert Filliou.* Hannover: Sprengel-Museum, 1984.

TERRY FOX

By the artist

Hobo Signs. Munich: Kunstraum München, 1985. Edited by Christine Tacke.

Exhibition catalogues

Felix, Zdenek, ed. *Terry Fox: Metaphorical Instruments.* Essen: Museum Folkwang; Berlin: DAAD, 1982.
Richardson, Brenda. *Terry Fox.* Berkeley: University Art Museum, 1973.
Tacke, Christine, and Fox, Terry. *Terry Fox: Catch Phrases.* Munich: Kunstraum München, 1985.

PAUL-ARMAND GETTE

By the artist

Alnus Glutinosa (L.) Gaertner. Geneva: Ecart, 1977.
Amphisbène. Paris: Eter, 1966. With Élie Charles Flamand.
Ether. N.p., 1966.

Exotik als Banalität: De l'exotisme en tant que banalité. Berlin: Edition Copie and DAAD, 1980. Text by Günter Metken.
Morphomythologie. Paris: Éditions Lettrisme et Hypergraphie, 1966.
P.-A. Gette. Paris: Miroir, 1968.

Exhibition catalogues

Marcadé, Bernard. *Paul-Armand Gette: Perturbation.* Paris: ARC, Musée d'Art Moderne de la Ville de Paris, 1983.
Metken, Günter. *Paul-Armand Gette: Arbeiten, 1959–1979.* Munich: Städtische Galerie im Lenbachhaus, 1979.

LUDWIG GOSEWITZ

By the artist

Meff Musik: Fotodokumente, Texte, Zeichnungen. Munich: Omnibus Press, 1978. With Eiche, Pathena, Prometheus, Scheich, Wolf, and Zita.

Exhibition catalogues

Gosewitz, Ludwig, and Retzer, Helga, eds. *Ludwig Gosewitz: Gesammelte Werke, 1960–1980, und neues Glas.* Berlin: DAAD, 1980.

DIETER HACKER

By the artist

Aufklärung und Agitation in der Kunst Chinas: Aufklärung und Agitation in der Kunst der Bundesrepublik. Berlin, 1976.
Bilder gegen die Zeit. Dortmund: Museum am Ostwall, 1982.
Kritik des Konstruktivismus. Berlin, 1972.
Millionen Touristen fotografieren den schiefen Turm von Pisa: Wie viele halten ihren Fotoapparat schief? Berlin, 1972.
Die Schönheit muss auch manchmal wahr sein: Beiträge zu Kunst und Politik. Berlin: 7. Produzentengalerie, 1982. Edited by Bernhard Sandfort; includes contributions by Beuys, Brehmer, and Hacker.
Stupid Pictures. London: Goethe-Institut, 1979.
Volkskunst. Berlin, 1972.
Welchen Sinn hat Malen? Berlin, 1974.

Exhibition catalogues

Hacker, Dieter; Retzer, Helga; and Stooss, Toni, eds. *Die politische Arbeit des Künstlers beginnt bei seiner Arbeit: 7. Produzentengalerie, Dieter Hacker: Zwischenbericht, 1971–1981.* Berlin: DAAD, 1981.
Die Kunst muss dem Bürger im Nacken sitzen, wie der Löwe dem Gaul: Dieter Hacker, 7. Produzentengalerie, 1971–1981. Munich: Städtische Galerie im Lenbachhaus, 1981. Includes texts by Hacker.
Pelgrims, L., ed. *Dieter Hacker: Kunst und Gesellschaft.* Antwerp: Ministerie van Nationale Opvoeding en Nederlandse Cultuur for the exhibition at the Internationaal Cultureel Centrum, Antwerp, 1981.
Rosenthal, Norman. *Dieter Hacker: Oil Paintings, Works on Paper, Sculpture in Bronze.* New York: Marlborough Gallery, 1986.
—. *Dieter Hacker: Paintings and Works on Paper: First London Exhibition.* London: Marlborough Fine Art (London) Ltd., 1985.
Schmied, Wieland. *Dieter Hacker.* Berlin: Zellermayer Galerie, 1984.
Vester, Karl-Egon. *Dieter Hacker.* Hamburg: Kunstverein in Hamburg, 1985.

RICHARD HAMILTON

By the artist

Collaborations of Ch. Rotham. Stuttgart: Edition Hansjörg Mayer, 1977. With Dieter Roth.
Collected Works, 1953–1982. London and New York: Thames and Hudson, n.d.
Richard Hamilton: Prints, 1939–1983: A Complete Catalogue of Graphic Works. Stuttgart and London: Edition Hansjörg Mayer, 1984.

Exhibition catalogues

Field, Richard S. *Richard Hamilton: Image and Process: Studies, Stage, and Final Proofs from the Graphic Works,*

1952–1982. Stuttgart: Edition Hansjörg Mayer in Association with the Tate Gallery, London, 1983. Catalogue of an exhibition that circulated through 1987; includes an introduction by Hamilton.
—. *The Prints of Richard Hamilton.* Middletown, Conn.: Davison Art Center, Wesleyan University, 1973.
Franz, Erich, ed. *Richard Hamilton: Interfaces.* Bielefeld: Kunsthalle, 1979.
Griesbach, Lucius, and Schmied, Wieland, eds. *Richard Hamilton.* Berlin: Nationalgalerie, Staatliche Museen Preussischer Kulturbesitz in association with DAAD, 1974.
Knox, George. *Richard Hamilton Graphics.* Vancouver: Vancouver Art Gallery, 1978.
Morphet, Richard. *Richard Hamilton.* London: Tate Gallery, 1970.
Russell, John. *Richard Hamilton.* New York: Solomon R. Guggenheim Museum, 1973. Includes commentaries by Hamilton.

TER HELL

By the artist

Raum 41, Bonn. Berlin: Galerie Fahnemann; Bonn: Raum 41, 1985. Text by Wolfgang Siano.

Exhibition catalogues

Siano, Wolfgang. *Ter Hell.* Munich: Dany Keller Galerie; Berlin: Galerie Fahnemann, 1983. In English and German.

ANTONIUS HÖCKELMANN

Exhibition catalogues

Antonius Höckelmann: Kranbaum IV, Puigel und andere Plastiken aus Alufolie, 1983–84. Berlin: Zellermayer Galerie, 1984.
Gohr, Siegfried. *Antonius Höckelmann: Skulpturen, Handzeichnungen.* Cologne: Josef-Haubrich-Kunsthalle, 1980. Includes "Antonius Höckelmanns Berliner Jahre, 1964–1970" by Wolfgang Kahlcke.
Hering, Karl-Heinz, ed. *Antonius Höckelmann: Werke, 1980 bis 1984: Bilder, Skulpturen, Zeichnungen.* Düsseldorf: Kunstverein für die Rheinlande und Westfalen, 1985. Includes an essay by Martin Hentschel.
Schmidt, Marianne; Werner, Michael; and Gachnang, Johannes, eds. *Antonius Höckelmann: Zeichnungen und Plastiken,* Bern: Kunsthalle, 1975.
Smitmans, Adolf, ed. *Antonius Höckelmann: Gesichter und Masken.* Liesborn: Museum Abtei, 1984.
Vester, Karl-Egon. *Antonius Höckelmann,* Hamburg: Kunstverein in Hamburg, 1986.

DAVID HOCKNEY

By the artist

The Blue Guitar. London and New York: Petersburg Press, 1977. Includes Wallace Stevens's "The Man with the Blue Guitar."
Cameraworks. New York: Knopf, 1984. Includes essay, "True to Life," by Lawrence Weschler.
China Diary. New York: Harry N. Abrams, 1982. With Stephen Spender.
David Hockney by David Hockney. New York: Harry N. Abrams, 1977. Edited by Nikos Stangos; introductory essay by Henry Geldzahler.
18 Portraits by David Hockney. Los Angeles: Gemini G.E.L., 1977.
On Photography. New York: André Emmerich Gallery, 1983.
Paper Pools. New York: Harry N. Abrams, 1980. Edited by Nikos Stangos.
Photographs by David Hockney. Washington, D.C.: International Exhibitions Foundation, 1986. Catalogue of a circulating exhibition; introduction by Mark Haworth-Booth.
72 Drawings by David Hockney. New York: Viking Press, 1971.
Six Fairy Tales from the Brothers Grimm with Original Etchings by David Hockney. London: Petersburg Press, 1970.

Monographs

Livingstone, Marco. *David Hockney*. New York: Holt, Rinehart, and Winston, 1981.

Exhibition catalogues

Brighton, Andrew. *David Hockney: Prints, 1954–77*. Nottingham: Midland Group and the Scottish Arts Council in Association with Petersburg Press, 1979.

Friedman, Martin. *Hockney Paints the Stage*. Minneapolis: Walker Art Center; New York: Abbeville Press, 1983. With contributions by John Cox, John Dexter, David Hockney, and Stephen Spender.

Glazebrook, Mark. *David Hockney: Paintings, Prints and Drawings, 1960–1970*. London: Whitechapel Art Gallery, 1970. Includes an interview with Hockney.

Pillsbury, Edmund. *David Hockney: Travels with Pen, Pencil and Ink: Selected Prints and Drawings, 1962–1977*. London and New York: Petersburg Press, 1978.

Schmied, Wieland, ed. *David Hockney*. Hannover: Kestner-Gesellschaft, 1970.

Weiermair, Peter, ed. *David Hockney*. Frankfurt am Main: Frankfurter Kunstverein, 1983.

Wilder, Nicholas. *David Hockney: Paintings of the Early 1960's*. New York: André Emmerich Gallery, 1985.

K. H. HÖDICKE

By the artist

Annatomie-Autonomie-Annomalie. Berlin: Rainer Verlag, 1976

Kalenderblätter: Aufzeichnungen, 1969–79. Berlin: DAAD, 1980.

Purzelbaum: Bilder und Gedichte. Berlin: Rainer Verlag, 1984.

Exhibition catalogues

Billeter, Erika; Hansen, Al; Hödicke, K. H.; Merkert, Jörn; Testori, Giovanni; and Wietz, Helmut. *K. H. Hödicke: Gemälde, Skulpturen, Objekte, Filme*. Düsseldorf: Kunstsammlung Nordrhein-Westfalen, 1986.

Block, René, and Schwarz, Michael, eds. *K. H. Hödicke*. Karlsruhe: Badischer Kunstverein, 1977.

Hödicke, K. H., and Schneede, Uwe M. *Berlin & Mehr: K. H. Hödicke*. Hamburg: Kunstverein in Hamburg, 1984.

Kempas, Thomas. *K. H. Hödicke: Bilder, 1962–1980*. Berlin: Haus am Waldsee, 1981.

ALLAN KAPROW

By the artist

Air Condition. N.p., 1975.

Allan Kaprow. Dortmund: Museum am Ostwall, 1986. Exhibition catalogue edited by Kaprow.

Allan Kaprow. Pasadena: Pasadena Art Museum, 1967. Exhibition catalogue.

Assemblage, Environments & Happenings. New York: Harry N. Abrams, 1966. With a selection of scenarios by Wolf Vostell et al.

Blindsight. Wichita: Department of Art Education, College of Fine Arts, Wichita State University, 1979.

Days Off: A Calendar of Happenings. New York: Junior Council of The Museum of Modern Art, 1970.

Echo-logy. New York: D'Arc Press, 1975.

Likely Stories. Milan: Galleria Luciano Anselmino, 1975.

Satisfaction. New York: M. L. D'Arc Gallery, 1976.

Some Recent Happenings. New York: Something Else Press, 1966.

Sweet Wall Testimonials. Berlin: Edition René Block and DAAD, 1976.

2 Measures. Turin: Galleria Martano, 1974.

Untitled Essay and Other Works. New York: Something Else Press, 1967.

Monographs

Kaiser, W. M. H. *Happenings-Activities by Allan Kaprow, U.S.A.* Amsterdam and New York, 1977.

Schnackenburg, Bernhard. *Allan Kaprow: Activity-Dokumente, 1968–1976*. Bremen: Kunsthalle, 1976.

EDWARD KIENHOLZ

By the artist

The Art Show: 1963–1977, Edward Kienholz. Berlin: DAAD; Paris: Centre National d'Art et de Culture Georges Pompidou, 1977.

Kienholz, Ten Tableaux, Paris. Paris: C.I.A.C., n.d. Includes a conversation between Kienholz and Pontus Hulten.

Exhibition catalogues

Bastian, Heiner. *Edward Kienholz: 10 Objekte von 1960 bis 1964*. Cologne: Galerie Onnasch, 1971.

Deecke, Thomas, ed. *The Art Show: 1963–1977: Edward Kienholz*. Berlin: DAAD, 1977. Photographic documentation by Nancy Reddin Kienholz of the completion of "The Art Show" at the Galerie Folker Skulima, Berlin, on March 3, 1977.

Harten, Jürgen, ed. *Edward Kienholz*. Düsseldorf: Städtische Kunsthalle, 1970.

Hopps, Walter. *Works from the 1960's by Edward Kienholz*. Washington, D.C.: Washington Gallery of Modern Art, 1967.

Hultén, K. G. P., and Waldén, Katja, eds. *Edward Kienholz: 11+11 Tableaux*. Stockholm: Moderna Museet, 1970.

Merkert, Jörn. *Edward Kienholz: Volksempfängers*. Berlin: Nationalgalerie, Staatliche Museen Preussischer Kulturbesitz, 1977. In English and German.

Nievers, Knut; Lindenberg, Ilona; and Kienholz, Nancy Reddin. *ROXYS and Other Works aus der Sammlung Reinhard Onnasch*. Bremen: Gesellschaft für Aktuelle Kunst, 1982.

Ohff, Heinz. *The Berlin Women: Edward Kienholz, Nancy Reddin Kienholz*. Berlin: Dibbert Galerie, 1982.

MARTIN KIPPENBERGER

By the artist

Abschied vom Jugendbonus! Vom Einfachsten nach Hause. Munich: Galerie Dany Keller, 1983.

Durch die Pubertät zum Erfolg. Berlin: Neue Gesellschaft für Bildende Kunst, 1981.

Endlich. 1–3. Bonn: Galerie Erhard Klein, 1986.

Gedichte. Berlin: Rainer Verlag, 1984. With Albert Oehlen.

Gedichte II. Berlin: Rainer Verlag, 1986. With Albert Oehlen.

Die I2..P.-Bilder. Cologne: Galerie Max Hetzler, 1984. Edited by Wilfried W. Dickhoff.

1984: Wie es wirklich war am Beispiel Knokke. Frankfurt: Galerie Bärbel Grässlin, 1985. With an afterword, "Der Tanz des Kippenbergers," by Sophia Ungers.

No Problem/No Problème. Stuttgart: Edition Patricia Schwarz, Galerie Kubinski, 1986. With Albert Oehlen.

Sand in der Vaseline: Brasilien 1986. Düsseldorf: CCD Galerie; Hamburg: PPS Galerie, 1986. With Albert Oehlen; edited by Bernd Füchtenschneider.

Sehr Gut/Very Gut. Berlin: Verlag S.O. 36, 1979.

Über sieben Brücken musst du gehen: Mussten wir Auch. Stuttgart: Max-Ulrich Hetzler GmbH, 1982. With Markus Oehlen, Ina Barfuss, Werner Büttner, Georg Herold, Albert Oehlen, and Thomas Wachweger.

14.000.000, für ein Hallöchen. N.p., n.d. With Albert Oehlen.

Vom Eindruck zum Ausdruck: 1/4 Jahrhundert Kippenberger. Berlin: Verlag Pikasso's Erben, 1979.

Was immer auch sei, Berlin bleibt Frei. Berlin-Kreuzberg: Alternativ Verlag, 1981. With Gerhard Lampersberg. "Einmalige Welturaufführung im Café Einstein, Berlin, 24./25. März 1981."

Wer diesen Katalog nicht gut findet muss sofort zum Arzt. Stuttgart: Max-Ulrich Hetzler GmbH, 1983. With Werner Büttner, Albert Oehlen, and Markus Oehlen.

241 Bildtitel zum Ausleihen für Künstler. Cologne: Walther König, 1986.

Exhibition catalogues

Gretenkort, Detlev, and Schmidt, Johann-Karl, eds. *Martin Kippenberger: Miete, Strom, Gas*. Darmstadt: Hessisches Landesmuseum, 1986. In English and German.

MILAN KNIZAK

By the artist

Aktual Schmuck: Czechoslovakia. Cullompton: Beau Geste Press, 1974. Material about the group gathered by Knizak.

Zeremonien. Remsheid, Germany: Vice-Versand, 1971.

Exhibition catalogues

Groh, Renate, and Groh, Klaus, eds. *Milan Knizak: Aktionen, Konzepte, Projekte, Dokumentationen*. Oldenburg: Kunstverein, 1980.

Knizak, Milan. *Lauter ganze Hälften*. Hamburg: Hamburger Kunsthalle, 1986. Includes an essay by Thomas Strauss.

—. *Unvollständige Dokumentation, 1961–1979/Some Documentary, 1961–1979*. Berlin: Edition Ars Viva, 1980.

BERND KOBERLING

Exhibition catalogues

Bojescul, Wilhelm; Gottlieb, Lennart; Koberling, Bernd; and Pauseback, Michael, eds. *Bernd Koberling: Malerei, 1963–1985/Malerier, 1963–1985*. Aarhus: Kunstmuseum; Braunschweig: Kunstverein, 1986.

Kempas, Thomas, ed. *Bernd Koberling: Malerei, 1962–1977*. Berlin: Haus am Waldsee, 1978.

Lindenberg, Ilona, ed. *Bernd Koberling: Inseln: Bilder aus den Jahren 1969/70 und 1980/82*. Berlin: Reinhard Onnasch Ausstellungen, 1982. Includes an essay by Wieland Schmied.

Simmen, Jeannot. *Bernd Koberling: Moderne Peripherie*. Düsseldorf: Galerie Gmyrek, 1983.

Wildermuth, Armin. *Bernd Koberling: Bilder, 1980–1983*. Hamburg: Galerie Ascan Crone, 1983.

ARTHUR KOEPCKE

Monographs

Addi Koepcke: In Memoriam Envelope. Geneva: Galerie Marika Malacorda, 1979.

MARKUS LÜPERTZ

By the artist

Die Erschaffung der Welt: Zwölf Träume. Berlin: Galerie im Körnerpark, Kunstamt Neukölln, 1983.

Tagebuch: New York, 1984. Bern: Gachnang & Springer, 1984.

Exhibition catalogues

Blistène, Bernard. *Markus Lüpertz: Sculptures*. Repères, cahiers d'art contemporain, no. 28. Paris: Galerie Maeght-Lelong, 1986.

Boone, Mary, and Werner, Michael. *Markus Lüpertz*. New York: Mary Boone, Michael Werner Gallery, 1986. Includes an essay by Siegfried Gohr.

Fuchs, R. H. *Markus Lüpertz*. Eindhoven: Stedelijk Van Abbemuseum, 1977. Text in Dutch and English.

—. *Markus Lüpertz: Zehn Bilder*. Hamburg: Galerie Ascan Crone, 1984.

—; Gachnang, Johannes; and Gohr, Siegfried. *Markus Lüpertz: Hölderlin*. Eindhoven: Stedelijk Van Abbemuseum, 1982.

Gallwitz, Klaus, ed. *Markus Lüpertz: Bilder, Gouachen und Zeichnungen, 1967–1973*. Baden-Baden: Staatliche Kunsthalle, 1973.

Godfrey, Tony. *Markus Lüpertz*. London: Waddington Galleries, 1981.

Gohr, Siegfried. *Markus Lüpertz: Gemälde und Handzeichnungen, 1964–1979*. Cologne: Josef-Haubrich-Kunsthalle, 1979.

Haenlein, Carl, ed. *Markus Lüpertz: Bilder, 1970–1983*. Hannover: Kestner-Gesellschaft, 1983.

Holsten, Siegmar. *Markus Lüpertz*. Hamburg: Hamburger Kunsthalle, 1977.

Kneubühler, Theo. *Markus Lüpertz: Dithyrambische und Stil-Malerei*. Bern: Kunsthalle, 1977.

Markus Lüpertz: Grüne Bilder. Berlin: Reinhard Onnasch Ausstellungen, 1982.

Schampers, Karel, and de Groot, Elbrig, eds. *Markus Lüpertz: Schilderijen/Bilder, 1973–1986*. Rotterdam: Museum Boymans–Van Beuningen, 1987.

Schmied, Wieland. *Markus Lüpertz: Die Bürger von Florenz: Sechs Plastiken*. Cologne: Michael Werner in Köln, 1983.
—. *Markus Lüpertz: Zeichnungen, 1978–1983*. Berlin: DAAD, 1983.
Serota, Nicholas, ed. *Markus Lüpertz: "Stil" Paintings, 1977–79*. London: Whitechapel Art Gallery, 1979. Text by Siegfried Gohr.
Zweite, Armin, ed. *Markus Lüpertz: Belebte Formen und kalte Malerei: Gemälde und Skulpturen*. Munich: Prestel-Verlag, 1986. Catalogue of the exhibition held at the Städtische Galerie im Lenbachhaus, Munich.

BRUCE McLEAN

By the artist

Dream Work. London: Knife Edge Press, 1985. With Mel Gooding.
Retrospective: King for a Day and 999 Other Pieces/Works/Things, Etc., 1969. London: Situation Publications, 1972.

Exhibition catalogues

Amaya, Mario. *Bruce McLean*. New York: Art Palace, 1984.
Brown, David, and Kent, Sarah. *Bruce McLean*. Glasgow: Third Eye Centre, 1980.
Bruce McLean Retrospective. London: Situation Publications, 1972. Catalogue of the exhibition at the Tate Gallery, London.
Dimitrijevic, Nena. *Bruce McLean*. London: Whitechapel Art Gallery, 1981.
Francis, Mark, ed. *Bruce McLean: Berlin/London*. London: Whitechapel Art Gallery, 1983. Consists of photographs by Dirk Buwalda of McLean making stone carvings, and a poem by John James.
Gooding, Mel. *Bruce McLean*. Berlin: Galerie Fahnemann, 1984. In English and German.
Krempel, Ulrich, and Rosenthal, Norman. *Bruce McLean: Simple Manners or Physical Violence: Neue Bilder*. Düsseldorf: Galerie Gmyrek, 1985. In English and German.

OLAF METZEL

Exhibition catalogues

Block, René, ed. *Olaf Metzel*. Berlin: DAAD Galerie, 1984.
Horn, Luise, ed. *Olaf Metzel: Skulptur*. Munich: Kunstraum München, 1982.

HELMUT MIDDENDORF

Exhibition catalogues

Gmyrek, Wolfgang. *Helmut Middendorf*. Düsseldorf: Galerie Gmyrek, 1984. Catalogue of the exhibition held at the Kunstverein Braunschweig; includes essays by Heinrich Klotz and Wilhelm Bojescul.
Helmut Middendorf. Berlin: Galerie Folker Skulima, 1985. Includes a conversation among Jiri Svestka, Volker Diehl, and Middendorf.
Helmut Middendorf. St. Gallen: Galerie & Edition Buchmann, 1982. Catalogue of the exhibition held at the Groninger Museum, Groningen, and the Kunsthalle, Düsseldorf, in 1983; includes essays by Armin Wildermuth and Wolfgang Max Faust in English and German.
Schmidt, Katharina, ed. *Helmut Middendorf: Die Umarmung der Nacht: Wandmalerei*. Baden-Baden: Staatliche Kunsthalle, 1983.
Wildermuth, Armin. *Helmut Middendorf, Bernd Zimmer*. St. Gallen: Galerie & Edition Buchmann, 1982.

MALCOLM MORLEY

By the artist

Fallacies of Enoch. Toronto: Novak Graphics, 1984. With poems by John Yau.

Exhibition catalogues

Morley, Malcolm, and Yau, John. *Malcolm Morley*. London: Fabian Carlsson Gallery/Editions, 1984.
Serota, Nicholas, ed. *Malcolm Morley: Paintings, 1965–82*. London: Whitechapel Art Gallery, 1983.

GIULIO PAOLINI

By the artist

Ennesima: Appunti per la descrizione di sei disegni datati 1975/Notes pour la description de six dessins datés 1975/Notes for a Description of Six Drawings Dated 1976. Paris: Yvon Lambert, 1975.
Giulio Paolini. 2 vols. Villeurbanne: Nouveau Musée, 1984. In Italian.
Idem. Einaudi letteratura, 39. Turin: Giulio Einaudi, 1975. With an introduction by Italo Calvino.

Monographs

Celant, Germano. *Giulio Paolini*. New York: Sonnabend Press, 1972.
Fagiolo, Maurizio, and Quintavalle, Arturo Carlo. *Giulio Paolini*. Parma: Università di Parma, 1976.

Exhibition catalogues

Franz, Erich, ed. *Giulio Paolini: Del bello intelligibile*. Bielefeld: Kunsthalle, 1982.
Inboden, Gudrun, ed. *Giulio Paolini*. 4 vols. Stuttgart: Staatsgalerie, 1986.
Kunz, Martin. *Giulio Paolini: Hortus Clausus*. Lucerne: Kunstmuseum, 1981. Text in English, German, and Italian.
Maubant, Jean Louis, and Soutif, Daniel. *Paolini: Melanconia ermetica*. Repères, cahiers d'art contemporain, no. 21. Paris: Galerie Maeght-Lelong, 1985.
Paolini Giulio; Elliott, David; van Grevenstein, Alexander; and Mignot, Dorine. *Giulio Paolini*. Amsterdam: Stedelijk Museum; Oxford: Museum of Modern Art, 1980.

HERMANN PITZ

By the artist

Büro Berlin: Ein Produktionsbegriff. Berlin: Künstlerhaus Bethanien, 1986. With Raimund Kummer and Fritz Rahmann.

Exhibition catalogues

Pitz, Hermann, and Siano, Wolfgang. *Hermann Pitz*. Berlin: Galerie Fahnemann, 1985.

MARKUS RAETZ

By the artist

Markus Raetz: Die Buecher. 3 vols. Zurich: Galerie und Edition Stähli, 1975.
Mimi. Zurich: Galerie & Edition Stähli, 1981.
Notizen, 1981–82. Berlin: Rainer Verlag, 1982; also published in a variant ed. by DAAD on the occasion of an exhibition in the DAAD gallery, Berlin.

Exhibition catalogues

Ammann, Jean-Christophe; Maubant, Jean-Louis; Pagé, Suzanne; and Weiermair, Peter. *Markus Raetz: Arbeiten/Travaux/Works, 1971–1981*. Basel: Kunsthalle, 1982.
Koepplin, Dieter. *Markus Raetz*. Basel: Kunstmuseum, 1972.
Skreiner, Wilfried. *Markus Raetz: Zeichnungen, Aquarelle, "Die Bücher."* Graz: Neue Galerie am Landesmuseum Joanneum, 1975.

ARNULF RAINER

By the artist

Arnulf Rainer. Eindhoven: Stedelijk Van Abbemuseum; London: Whitechapel Art Gallery, 1980. Exhibition catalogue.

Exhibition catalogues

Christusköpfe + Kruzifikationen. Graz: Verlag Droschl, 1980.
Face Farces. Vienna and Cologne: Galerie Ariadne, 1971. Text in English and German.
Leonardo Überzeichnungen. Vienna: Löcker & Wögenstein, 1977.
Misch- und Trennkunst. N.p., n.d. With Dieter Roth.
Reste: Zugemalte Übermalungen, 1954–1978/Remnants: Painted-Over Overpaintings, 1954–1978. Stuttgart and London: Edition Hansjörg Mayer for Eaton House, 1978.

Tägliches Kleinzeug. Berlin: Edition Hansjörg Mayer, 1976.

Monographs

Breicha, Otto. *Arnulf Rainer: Überdeckungen: Mit einem Werkkatalog sämtlicher Radierungen, Lithographien und Siebdrucke, 1950–1971*. Österreichische Graphiker der Gegenwart, vol. 7. Vienna: Edition Tusch, 1972.

Exhibition catalogues

Aurenhammer, Hans, and Rainer, Arnulf. *Arnulf Rainer: Totenmasken, 1978*. Munich: Edition der Galerie Heiner Friedrich, 1978.
Baum, Peter. *Arnulf Rainer: Face-Farces, Fotoübermalungen und Fotoüberzeichnungen, 1969–1976*. Linz: Neue Galerie, Wolfgang-Gurlitt-Museum, 1976. Includes texts by Rainer.
von Berswordt-Wallrabe, H.-L. Alexander. *Arnulf Rainer: Fingermalereien (1975–1984), Christus-Frauen-Tote (1982–1984)*. Bochum: M Bochum, Galerie für Film, Foto, Neue Konkrete Kunst und Video, 1984.
Cladders, Johannes, ed. *Arnulf Rainer: Gesichter mit Goya*. Mönchengladbach: Städtisches Museum Abteiberg, 1984.
Hofmann, Werner. *Arnulf Rainer*. Vienna: Museum des 20. Jahrhunderts, 1968. Includes texts by Rainer.
—. *Arnulf Rainer: Linguaggio del Corpo/Körpersprache/Body Language*. N.p., 1978. Catalogue of the exhibition at the Austrian Pavilion, Venice Biennale, 1978; includes texts by Rainer.
—; Rainer, Arnulf; and Fuchs, Rudi. *Arnulf Rainer: Face Farces, 1969–1975*. Vienna: Zentralsparkasse und Kommerzialbank, 1983.
Honisch, Dieter. *Arnulf Rainer*. Berlin: Nationalgalerie, Staatliche Museen Preussischer Kulturbesitz, 1980.
Kern, Hermann. *Arnulf Rainer: Gestische Handmalereien*. Munich: Kunstraum München, 1974. Includes texts by Rainer.
—. *Arnulf Rainer: Photoüberzeichnungen Franz Xaver Messerschmidt*. Munich: Kunstraum München, 1977.
Schweisguth, Claude. *A. Rainer: Mort et sacrifice*. Paris: Centre Georges Pompidou, 1984.
Stumm, M. *Arnulf Rainer: Werke, 1956–1976*. Vienna: Schapira und Beck Galerie, 1976.
Zweite, Armin; Hartmann, Wolfgang; and Dahlem, Franz. *Arnulf Rainer: "Der grosse Bogen."* Bern: Kunsthalle, 1977.

LELAND RICE

By the artist

Frances Benjamin Johnston: Women of Class and Station. Long Beach, Calif.: Art Museum and Galleries, California State University, 1979. With Constance W. Glenn.
Herbert Bayer: Photographic Works. Los Angeles: ARCO Center for Visual Arts, 1977. Includes an essay by Beaumont Newhall.
Photographs of Moholy-Nagy from the Collection of William Larson. Claremont, Calif.: Galleries of the Claremont Colleges, 1975. Edited with David W. Steadman.

Exhibition catalogues

The Photography of Leland Rice. Washington, D.C.: Smithsonian Institution Press, 1977. Catalogue of an exhibition held at the Hirshhorn Museum and Sculpture Garden, Washington, D.C.

MARTIN ROSZ

By the artist

Halbe Bilder, 1982–84. Berlin: Rainer Verlag, 1984.
Stilleben, 1982–84. Berlin: Rainer Verlag, 1984.
Nachdenklichlachdenknich. Berlin: Rainer Verlag, 1981. With Rainer Haarmann and Max Neumann.
Zeichnungen, 1981–84. Berlin: Rainer Verlag, 1985.

Exhibition catalogues

Deecke, Thomas, and Rosz, Martin. *Martin Rosz: Tableaux-Zyklen-Räume-Schriften, 1960–1979*. Münster: Westfälischer Kunstverein, 1979.

SALOMÉ

Exhibition catalogues

Bastian, Heiner. *Salomé: Wasserschau*. Los Angeles: Davies/Long Gallery, 1985. Essay in English and German.

Markwitz, Reinhard v.d. *Salomé: Malerei*. Berlin: Galerie Lietzow, 1981.

Salomé bei Thomas: Bilder und Zeichnungen, 1974–1984. Munich: Galerie Thomas, 1984. Includes an interview with Salomé by Elke Sonntag in English and German.

Salomé: Frauen in Deutschland. Berlin: Raab Galerie, 1986. Essay by Ingrid Raab in English and German.

TOMAS SCHMIT

By the artist

The Four Suits. New York: Something Else Press, 1965. With Benjamin Patterson, Philip Corner, and Alison Knowles; foreword by Dick Higgins.

Was ist das Zeichen für "Kein Zeichen"? Cologne: Michael Werner in Köln, 1986.

Exhibition catalogues

Schmit, Tomas. *Tomas Schmit*. Cologne: Kölnischer Kunstverein, 1978. With an introduction by Wulf Herzogenrath.

EVA-MARIA SCHÖN

By the artist

Nicht Weiss, Nicht Schwarz, Hell auf Dunkel. Berlin: Künstlerhaus Bethanien, 1986.

Exhibition catalogues

Eva-Maria Schön: Malerei. Wuppertal: Kunst- und Museumsverein, 1982.

Kohrs, Klaus Heinrich, ed. *Eva-Maria Schön*. Berlin: Karl Schmidt-Rottluff Förderungsstiftung, 1985. Catalogue of the exhibition at the Ausstellungshallen Mathildenhöhe, Darmstadt.

EUGEN SCHÖNEBECK

Exhibition catalogues

Eugen Schönebeck: Zeichnungen, 1960–1963. Berlin: Galerie Silvia Menzel, 1986.

Joachimides, Christos M., and Gallwitz, Klaus. *Eugen Schönebeck: Bilder, Skizzen, Zeichnungen, 1962–1973*. Berlin: Galerie Abis, 1973.

DANIEL SPOERRI

By the artist

An Anecdoted Topography of Chance (Re-Anecdoted Version). New York: Something Else Press, 1966. With Robert Filliou; translated and further anecdoted by Emmett Williams.

Hommage à Isaac Feinstein. Amsterdam: Stedelijk Museum, 1971.

Material: Zeitschrift für konkrete und ideogrammatische Dichtung. Nos. 1–5. Darmstadt, 1957–59. Edited and published by Spoerri.

Die Morduntersuchung. Geneva: ECART, 1973.

Le musée sentimental de Prusse: Aus grosser Zeit! Eine Ausstellung der Berliner Festspiele GmbH im Berlin-Museum. Berlin: Fröhlich & Kaufmann, 1981. With Marie-Louise Plessen.

The Mythological Travels of a Modern Sir John Mandeville, Being an Account of the Magic, Meatballs, and Other Monkey Business Peculiar to the Sojourn of Daniel Spoerri upon the Isle of Symi, Together With Divers Speculations Thereon. New York: Something Else Press, 1970. Translated and introduced by Emmett Williams.

Mythology & Meatballs: A Greek Island Diary Cookbook. Berkeley: Aris Books, 1982. Translated by Emmett Williams; a rev. ed. of *The Mythological Travels of a Modern Sir John Mandeville*

Le Petit colosse de Simi. Nos. 1–. Simi, Greece, 1966–. Edited and published by Spoerri.

Topographie anécdotée ✳ du hasard. Paris: Editions Galerie Lawrence, n.d.

Wenn Alle Künste Untergehn, Die edle Kochkunst bleibt bestehen. Amsterdam: Stedelijk Museum, 1971.

Exhibition catalogues

Bardon, Annie, and Köser, Martina. *Daniel Spoerri*. Reutlingen: Schul-, Kultur- und Sportamt, 1985.

Daniel Spoerri. Zurich: Zürcher Kunstgesellschaft und Helmhaus, 1972.

Gautier, Blaise, ed. *Daniel Spoerri*. CNAC Archives, new series, 2. Paris: Centre National d'Art Contemporain, 1972.

WALTER STÖHRER

Exhibition catalogues

Hoffmann, Christine, and Stooss, Toni, eds. *W. Stöhrer: "Hommage à Konrad Bayer," Arbeiten von 1960–1978: "Schwarze Toscana," Arbeiten aus Italien, 1978*. Berlin: DAAD, 1979.

Meyer zu Eissen, Annette, and Blume, Dieter, eds. *Walter Stöhrer: Arbeiten, 1962–1983*. Bremen: Kunsthalle, 1983; also issued by the Kunstmuseum, Düsseldorf, 1984.

Vowinckel, Andreas, ed. *Walter Stöhrer*. Stuttgart: Württembergischer Kunstverein, 1980.

FRED THIELER

Monographs

Nothelfer, Georg, ed. *Fred Thieler zum 70. Geburtstag, Berlin, 17. März 1986*. Berlin: Galerie Georg Nothelfer, 1986.

Exhibition catalogues

de la Motte, Manfred, ed. *Fred Thieler*. 2 vols. Bonn: Galerie Hennemann, 1976–80.

—. *Fred Thieler*. Berlin: Galerie Georg Nothelfer, 1983.

—, and Ohff, Heinz. *Fred Thieler: Arbeiten der letzten fünf Jahre: Ölbilder, Gouachen, Zeichnungen, Druck-Graphik*. Berlin: Haus am Waldsee, 1962.

Volkmann, Barbara, and Raddatz, Rose-France. *Fred Thieler: Arbeiten, 1940–1986*. Berlin: Akademie der Künste, 1986.

Zemter, Wolfgang, ed. *Fred Thieler*. Bonn: Edition der Galerie Hennemann, 1979. Catalogue of the exhibition, "Retrospektive Fred Thieler," held at the Märkisches Museum, Witten.

BEN VAUTIER

By the artist

Berlin Inventory/Berliner Inventar. Berlin: DAAD, 1979.

Fluxus and Friends Go Out for a Drive. Berlin: Rainer Verlag, 1983.

A Letter From Berlin. Berlin: DAAD, 1979. A reduced, facsimile reprint of Vautier's "Letter from Berlin," seven of which were issued in 1978 and 1979.

Me Ben I Sign. Cranleigh: Beau Geste Press, 1975. Translation by David Mayor of the first chapter of "Ecrit pour la gloire à force de tourner en rond et d'être jaloux."

Poésies. Colombes: Jassaud, 1974.

Textes théoretiques: Tracts, 1960–1974. Milan: Politi, 1975.

Tout Ben. Paris: Chêne, 1974.

Exhibition catalogues

Petersen, Ad, and Bloem, Marja. *Art-Ben*. Amsterdam: Stedelijk Museum, 1973.

Vautier, Ben. *Ben Libre*. Saint-Étienne: Musée d'Art et d'Industrie, 1981.

EMILIO VEDOVA

By the artist

Scontri di situazioni; Libertà dell'espressione. Milan: Pesce d'Oro, 1963. Reprint of two articles.

Monographs

Vedova Compresenze. Milan: Electa, 1981. In English and Italian.

Exhibition catalogues

Cacciari, Massimo. *Vedova*. Florence: Centro Tornabuoni, 1985.

Celant, Germano, ed. *Vedova, 1935–1984*. Milan: Electa, 1984.

Schilling, Jürgen. *Emilio Vedova*. Braunschweig: Kunstverein, 1981.

Schulz-Hoffmann, Carla. *Emilio Vedova*. Munich: Hirmer-Verlag, 1986. Catalogue of the exhibition held by the Bayerische Staatsgemäldesammlungen at the Staatsgalerie Moderner Kunst, Munich.

WOLF VOSTELL

By the artist

Aktionen: Happenings und Demonstrationen seit 1965: Eine Dokumentation. Reinbek bei Hamburg: Rowohlt, 1970.

Berlin and Phenomena. New York: Something Else Press, 1966. Two scenarios.

Décollage: Bulletin aktueller Ideen. Nos. 1–7. Cologne, 1962–69. Edited by Vostell.

Dé-coll/age Happenings. New York: Something Else Press, 1966.

Dé-coll/agen, 1954–69: Dé-coll/agen, Plakate, Verwischungen, Objekte, Happening Partituren, Happening Fall Outs, elektronische Verwischungen, elektronische Objekte. Berlin: Edition 17 and Galerie René Block, 1969. Bio-bibliographical documentation by Hans Sohm.

Elektronischer Dé-coll/age Happening Raum, 1959–1968. Frankfurt am Main: Typos Verlag, 1969.

Fantastic Architecture. New York: Something Else Press, 1969. Translation of *Pop Architektur, Concept Art* (Düsseldorf: Droste, 1969). With Dick Higgins.

Happening Calvario. Chisel Book, 3. Genoa: Edizioni Masnata La Bertesca, 1973.

Happenings: Fluxus, Pop Art, Nouveau Réalisme: Eine Dokumentation. Reinbek bei Hamburg: Rowohlt, 1965. Edited with Jürgen Becker.

Miss Vietnam and Texts of Other Happenings. Translated by Carl Weissner. Nova Broadcast, 2. San Francisco: Nova Broadcast Press, 1968.

Wolf Vostell. Edition, 17. Berlin: Galerie René Block, 1969

Monographs

Wick, Rainer. *Vostell, Soziologisch*. Bonn, 1969.

Exhibition catalogues

Mekert, Jörn. *Vostell: Retrospektive, 1958–1974*. Berlin: Neuer Berliner Kunstverein in cooperation with the Nationalgalerie, Staatliche Museen Preussischer Kulturbesitz, 1975.

Rhode, Werner. *Vostell: Mania*. Munich: Galerie van de Loo, 1973.

Schiller, Peter H., ed. *Wolf Vostell: Die Nackten und die Toten*. Berlin: Edition Arts Viva! and Edition Wewerka, 1983.

Schilling, Jürgen. *Wolf Vostell: Dé-coll/agen, Verwischungen, Schichtenbilder, Bleibilder, Objektbilder, 1955–1979*. Braunschweig: Kunstverein, 1980.

Schultz, Michael, ed. *Wolf Vostell*. Berlin: Edition Wewerka, 1985. Includes an interview with Vostell by Michael Wewerka.

Smith, Robert L. *Wolf Vostell: LAICA-Los Angeles, Ars Viva!-Berlin, 1980*. Los Angeles: Los Angeles Institute of Contemporary Art, 1980. Published for the exhibition, "Vostell in the U.S.A."

Stooss, Toni, and Vostell, Wolf. *Vostell und Berlin: Leben und Werk, 1964–1981*. Berlin: DAAD, 1982.

Vostell, Wolf, and Körber, Marie-Luise. *Wolf Vostell: Zeichnungen, 1952–1976*. Dortmund: Museum am Ostwall, 1977. Published in a reduced format without the notes and commentaries under the title *Wolf Vostell* (Hannover: Kestner-Gesellschaft, 1971).

EMMETT WILLIAMS

By the artist

An Anecdoted Topography of Chance (Re-Anecdoted Version). New York: Something Else Press, 1966. By Daniel Spoerri with Robert Filliou; translated and further anecdoted by Williams.

An Anthology of Concrete Poetry. New York: Something Else Press; Stuttgart: Edition Hansjörg Mayer, 1967.

The Book of Thorn & Eth. Stuttgart and London: Edition Hansjörg Mayer, 1968; reprinted, Berlin: Rainer Verlag, 1983.

The Boy and the Bird. Stuttgart: Edition Hansjörg Mayer; London: Eaton House Publishers, 1979. First published in 1969, in an ed. illustrated by Tom Wasmuth.

Chicken Feet, Duck Limbs, and Dada Handshakes. Vancouver: Western Front, 1984.

Faustzeichnungen. Berlin: Rainer Verlag, 1983.

Holdup. New York: Works Editions, 1980. With Keith Godard.

The Last French-Fried Potato and Other Poems. A Great Bear Pamphlet. New York: Something Else Press, 1967.

Schemes & Variations. Stuttgart and London: Edition Hansjörg Mayer, 1981. Catalogue of the exhibition organized by the DAAD and Nationalgalerie, Berlin; in English and German.

Selected Shorter Poems, 1950–1970. Stuttgart and London: Edition Hansjörg Mayer, 1978.

Sweethearts. Stuttgart and London: Edition Hansjörg Mayer, 1967; New York: Something Else Press, 1968.

A Valentine for Noël: 4 Variations on a Scheme. Stuttgart: Edition Hansjörg Mayer; Barton, Vt.: Something Else Press, 1973.

The Voyage. Stuttgart and London: Edition Hansjörg Mayer, 1975.

BERND ZIMMER

By the artist

Lombok, Zwieselstein, Berlin: Zeichnungen, Bilder, Graphik & c. Berlin: Rainer Verlag, 1981.

28 Tage in Freiburg. Freiburg: Kunstverein, 1981. 57 original offset-lithographs published on the occasion of the exhibition, "Bilder für Freiburg."

Exhibition catalogues

Bernd Zimmer: Abgründe. Ihr Berge, tanzt! Düsseldorf: Galerie Gmyrek, 1983. Text in English and German by Jürgen Schilling and Michael Krüger.

Bojescul, Wilhelm, and Zimmer, Bernd. *Bernd Zimmer: Bilder-Landschaften, 1983–1985.* Braunschweig: Kunstverein, 1986.

Kohrs, Klaus Heinrich, ed. *Bernd Zimmer: Bilder.* Berlin: Karl Schmidt-Rottluff Förderungsstiftung, 1981. Catalogue of the exhibition held at the Ausstellungshallen Mathildenhöhe, Darmstadt.

Wildermuth, Armin. *Helmut Middendorf, Bern Zimmer.* St. Gallen: Galerie & Edition Buchmann, 1982.

II. Group Exhibitions and Catalogues

1961

Hedendaagse Schilder- en Beeldhouwkunst in Duitsland. St.-Pietersabdij, Ghent, November 10–December 3, and Nationaal Hoger Instituut voor Schone Kunsten, Antwerp, December 8, 1961–January 5, 1962; organized by the Deutscher Künstlerbund, Berlin. Includes Thieler.

1962

Signum 62. Akademie der Künste, Berlin.

Bildhauer-Zeichnungen: von Mitgliedern der Akademie der Künste. Akademie der Künste, Berlin, May 6–June 17; organized by Herta Elisabeth Killy.

Gegenwart bis 1962. Haus am Waldsee, Berlin, June 5–August 30; organized by Manfred de la Motte. Reopening exhibition of the Haus am Waldsee. Includes Thieler.

Sixteen German Artists. Corcoran Gallery of Art, Washington, D.C., November 27–December 30, and tour through December 31, 1963; organized under the sponsorship of the Embassy of the Federal Republic of Germany. Includes Thieler.

1963

Schrift und Bild/Schrift en beeld/Art and Writing/L'art et l'écriture. Stedelijk Museum, Amsterdam, May 3–June 10, and Staatliche Kunsthalle, Baden-Baden, June 14–August 4; organized by Dietrich Mahlow. Includes Gosewitz, Stöhrer, Vedova, and Vostell.

Kunst Diktatur: Gestern und Heute. Galerie S, Berlin, June 16–July 10; organized by Ben Wargin. Includes Thieler.

Rückblick und Gegenwart: Friedrich Ahlers-Hestermann, Ernst Fritsch, Max Kaus, Heinrich Graf Luckner, Gerhard Marcks, Richard Scheibe. Akademie der Künste, Berlin, November 24–December 29; organized by Peter Pfankuch.

1964

Nykysaksalaista maalaustaidetta: Suomi 1964/Tyskt måleri i dag: Finland 1964. Organized by the Landesmuseum für Kunst und Kulturgeschichte, Münster. Includes Thieler.

The Spirit of New Berlin in Painting and Sculpture. 1964–65; organized by the City of Berlin and circulated by the American Federation of Arts. Catalogue text by Eberhard Roters. Includes Stöhrer and Thieler.

Möglichkeiten. Haus am Waldsee, Berlin, March 21–May 3. Catalogue included in the general catalogue to the 13. Ausstellung, Deutscher Künstlerbund, Berlin. Includes Thieler and Vostell.

Actions, Agit-Prop, De-Collage, Happening, Events, Antiart, L'autrisme, Art Total, Refluxus: Festival der neuen Kunst. Aachen, July 20; organized by Valdis Abolins and Tomas Schmit. Catalogue edited by Schmit and Wolf Vostell. Includes Beuys, Filliou, Gosewitz, Koepcke, Schmit, Vautier, Vostell, and Williams.

Stadien und Impulse. Haus am Waldsee, Berlin, September 11–October 25; organized by Thomas Kempas. Includes Vedova.

Neodada, Pop, Decollage, Kapit. Realismus. Galerie René Block, Berlin, September 15–November 5. Includes Brehmer, Hödicke, and Vostell.

Britische Malerei der Gegenwart. Haus am Waldsee, Berlin, October 30–December 5; organized by Karl-Heinz Hering. Düsseldorf: Kunstverein für die Rheinlande und Westfalen, 1964. Includes Hamilton and Hockney.

Neue Realisten & Pop Art. Akademie der Künste, Berlin, November 20, 1964–January 3, 1965; organized by Peter Pfankuch. Catalogue by Elisabeth Killy. Includes Hamilton, Hockney, and Spoerri.

1965

Kinetik und Objekte. Staatsgalerie, Stuttgart, February 21–March 21, and Badischer Kunstverein, Karlsruhe, April 11–May 16; organized by Johannes Cladders. Includes Beuys.

Grossgörschen 35 Retrospektive: 1964/65, Ein Jahr. Grossgörschen 35, Berlin-Schöneberg, September 9–October 24; organized by Lorenz Frank. Catalogue documents the individual exhibitions of the gallery's first year. Includes Hödicke, Koberling, and Lüpertz.

1966

Junge Berliner Künstler. Kunsthalle, Basel, May 7–June 12; organized by Eberhard Roters and Arnold Rüdlinger. Includes Thieler.

Junge Realisten. Haus am Lützow-Platz, Berlin, June 3–30, and tour through December 24. Exhibition of group founded in 1956.

Junge Generation: Maler und Bildhauer in Deutschland. Akademie der Künste, Berlin, June 5–July 10; organized by Will Grohmann. Catalogue by Herta Elisabeth Killy, Dirk Scheper, and Barbara Kuprian. Includes Baselitz, Brehmer, Hödicke, Stöhrer, and Vostell.

Labyrinthe: Phantastische Kunst vom 16. Jahrhundert bis zur Gegenwart. Deutsche Gesellschaft für Bildende Kunst (Kunstverein Berlin) and the Akademie der Künste, Berlin, October–November, and tour; organized by Eberhard Roters. Includes Baselitz and Rainer.

1967

Berlin-Berlin: Junge Berliner Maler und Bildhauer. Zapeion, Athens; organized by the Deutsche Gesellschaft für Bildende Kunst (Kunstverein Berlin). Includes Baselitz, Hödicke, and Lüpertz.

Jacques Damase présente: Jeunes peintres de Berlin. Galerie Motte, Geneva and Paris. Catalogue texts by Eberhard Roters and Jacques Damase. Includes Baselitz, Lüpertz, and Stöhrer.

Neuer Realismus. Haus am Waldsee, Berlin, January 6–February 19, and Kunstverein, Braunschweig, March 5–April 9; organized by Heinz Ohff. Includes Hödicke.

Wege 1967: Deutsche Kunst der jungen Generation. Museum am Ostwall, Dortmund, January 22–March 5; organized by Eugen Thiemann. Includes Beuys.

Fetisch-Formen. Städtisches Museum, Schloss Morsbroich, Leverkusen, April 7–May 15, and Berliner Kunstverein, Haus am Waldsee, Berlin, May 23–July 2; organized by Rolf Wedewer, Eberhard Roters, and Thomas Kempas. Includes Beuys.

Figurationen. Württembergischer Kunstverein, Stuttgart, July 29–September 10; organized by Dieter Honisch. Includes Baselitz.

1968

Ornamentale Tendenzen in der zeitgenössischen Malerei. Haus am Waldsee, Berlin, March 1–April 15, and tour; organized by Thomas Kempas, Eberhard Roters, and Rolf Wedewer. Includes Koberling.

Junge Generation Grossbritannien. Akademie der Künste, Berlin, April 28–June 9; organized by Elizabeth Killy. Includes Hockney.

Sammlung 1968 Karl Ströher. Neue Pinakothek, Munich, June 14–August 9; organized by the Galerie-Verein, Munich. Also shown in an expanded version in 1969 in Berlin. Includes Beuys.

Visuell Konstruktiv: Berliner Künstler der Gegenwart, 1. Kunstbibliothek, Berlin, June 30–August 7; organized by Heinz Ohff. Berlin: Deutsche Gesellschaft für Bildende Kunst (Kunstverein Berlin), 1968.

Sammlung 1968 Karl Ströher. Kunstverein, Hamburg, August 24–October 6. Includes Beuys.

Retrospektive Grossgörschen 35. Galerie des XX. Jahrhunderts, Berlin, October 31–November 24, and Kunstverein, Wolfsburg, March 1969.

Berlin XXe siècle: De l'expressionisme à l'art contemporain. Musée Cantonal des Beaux-Arts, Lausanne, November 27, 1968–January 5, 1969; organized by Lyss Becker and Eberhard Roters.

4 junge Künstler, 4 Räume. Modern Art Museum, Munich, December. Catalogue text by Yvonne Hagen. Includes Koberling.

13 Deutsche Maler. Städtisches Museum, Schloss Morsbroich, Leverkusen, December 6, 1968–January 16, 1969; organized by Rolf Wedewer. Includes Koberling and Vostell.

Akademie 1968: Die Mitglieder der Abteilung Bildende Kunst und ihre Gäste zeigen Arbeiten aus den Jahren 1958–1968. Akademie der Künste, Berlin, December 8, 1968–January 12, 1969; organized by Elisabeth Killy.

1969

Blockade '69; Räume von Beuys, Palermo, Hödicke, Panamarenko, Lohaus, Giese, Knoebel, Ruthenbeck, Polke. Galerie René Block, Berlin, February 28–November 22; a series of six exhibitions.

Sammlung 1968 Karl Ströher. Nationalgalerie, Berlin, March 1–April 14, and tour; organized by the Deutsche Gesellschaft für Bildende Kunst (Kunstverein Berlin) and the Nationalgalerie. Includes Baselitz, Beuys, Lüpertz, and Schönebeck.

Op Losse Schroeven: Situaties en Cryptostructuren. Stedelijk Museum, Amsterdam, March 15–April 27; organized by Wim Beeren. Includes Beuys.

Live in Your Head: When Attitudes Become Form: Works – Concepts – Processes – Situations – Information/ Wenn Attitüden Form werden: Werke – Konzepte – Vorgänge – Situationen – Informationen. Kunsthalle, Bern, March 22–April 27; organized by Harald Szeemann. Including Beuys, Kienholz, McLean, and Raetz.

Deutsche Avantgarde 1. Kestner-Gesellschaft, Hannover, March 27–April 27; organized by Wieland Schmied.

Concrete Poetry. Fine Arts Gallery, University of British Columbia, Vancouver, March 28–April 19; organized by Alvin Balkind. Includes Kaprow and Williams.

Industrie und Technik in der deutschen Malerei. Wilhelm-Lehmbruck-Museum, Duisburg, May 7–July 7; organized by Siegfried Salzmann. Includes Brehmer and Vostell.

Festival non art-anti art: La verité est art: Comment changer l'art et l'homme/Festival of Non Art, Anti Art, Truth Art: How to Change Art and Mankind. "Everywhere in the World," June 1–15. Includes Beuys, Brecht, Filliou, Gosewitz, Koepcke, Spoerri, Vautier, and Vostell.

1970

Konzepte einer neuen Kunst. Städtisches Museum, Göttingen, January–April. Catalogue of four concurrent exhibitions; organized by Michael Badura and Reinhard Rock. Includes Beuys, Hödicke, Lüpertz, and Spoerri.

Happening & Fluxus. Kölnischer Kunstverein, Cologne, February 6, 1970–January 6, 1971; organized by Harald Szeemann. Catalogue edited by H. Sohm. Includes Beuys, Kaprow, Knizak, Spoerri, Vautier, Vostell, and Williams.

Jetzt: Künste in Deutschland Heute. Kunsthalle, Cologne, February 14–May 18; organized by Helmut R. Leppien. Includes Beuys, Brehmer, and Vostell.

Zinke Berlin: Günter Anlauf, Günter Bruno Fuchs, Robert Wolfgang Schnell. Haus am Waldsee, Berlin, March 6–15.

Kunst und Politik. Badischer Kunstverein, Karlsruhe, May 31–August 16; organized by Georg Bussmann. Includes Beuys, Brehmer, Kienholz, and Vostell.

Zeichnungen: Baselitz, Beuys, Buthe, Darboven, Erber, Palermo, Polke, Richter, Roth. Städtisches Museum, Schloss Morsbroich, Leverkusen, June 12–July 19, and tour; organized by Rolf Wedewer and Fred Jahn, Munich: Jahn & Kluser, 1970.

Information. The Museum of Modern Art, New York, July 2–September 20; organized by Kynaston McShine. Includes Beuys, Brehmer, Burgin, McLean, Paolini, and Raetz.

Strategy: Get Arts. Edinburgh International Festival, August 23–September 12; organized by Richard Demarco. Includes Beuys.

Galerie Potsdamer, Berlin. Galerie des XX. Jahrhunderts, Berlin, November 6–December 13. Catalogue includes a list of the exhibitions held at the Galerie Potsdamer, 1965-68. Includes Koberling, Lüpertz, and Thieler.

3 Toward Infinity: New Multiple Art. Whitechapel Art Gallery, London, November 19, 1970–January 3, 1971; organized by Biddy Peppin. London: Arts Council of Great Britain, 1970. Includes Beuys, Brehmer, Christo, Hamilton, Hödicke, Kaprow, Knizak, Koepcke, Vautier, Vostell, and Williams.

1971

Kunst und Politik. Kunsthalle, Basel, January 24–February 21; organized by Georg Bussmann. 2nd ed. Includes Beuys, Brehmer, Kienholz, Vedova, and Vostell.

Entwürfe, Partituren, Projekte: Zeichnungen. Galerie René Block, Berlin, March 5–31; organized by René Block. Includes Beuys, Brehmer, Gosewitz, Hödicke, Koepcke, Lüpertz, Schmit, Vautier, and Vostell.

Multiples: The First Decade. Philadelphia Museum of Art, March 5–April 4; organized by John L. Tancock. Includes Christo, Gosewitz, Hamilton, Hödicke, Knizak, and Vostell.

Die Puppe: Aspekte zum Bild der Frau. Haus am Waldsee, Berlin, March 5–April 11. Includes Brehmer and Hamilton.

Aktiva '71: Kunst der Jungen in Westdeutschland. Haus der Kunst, Munich, March 20–May 9; organized by Thomas Grochowiak. Includes Brehmer, Koberling, Lüpertz, and Stöhrer.

Metamorphose des Dinges: Kunst und Antikunst, 1910–1970. Palais des Beaux-Arts, Brussels, April 22–June 6, and tour through June 1972, including the Nationalgalerie, Staatliche Museen Preussischer Kulturbesitz, Berlin, September 15–November 7, 1971; organized by Werner Haftmann. Brussels: La Connaissance, 1971; also published as *De Metamorfose van het Object: Kunst en Antikunst* (Brussels: La Connaissance, 1971). Includes Beuys, Brehmer, Christo, Hamilton, Hödicke, Kienholz, Spoerri, and Vostell.

20 Deutsche. Onnasch-Galerie, Berlin and Cologne, August; organized by Reinhard Onnasch. Catalogue text by Klaus Honnef. Includes Beuys, Koberling, and Lüpertz.

Zeitgenössische deutsche Kunst. National Museum of Modern Art, Tokyo, October 20–December 5, and the National Museum of Modern Art, Kyoto, December 16, 1971–January 30, 1972; organized by Yukio Kobayashi and Michiaki Kawakita. Includes Beuys.

1972

Plastik und Musik. Akademie der Künste, Berlin.

Fluxshoe. A traveling exhibition in the United Kingdom; organized by David Mayor. Cullompton: Beau Geste Press, 1972. Includes Beuys, Fox, Gette, Gosewitz, Koepcke, Vautier, and Vostell.

Projektion: Film, Video, Fotos og Dias af 75 Kunstnere. Louisiana Museum for Moderne Kunst, Humlebaek, Denmark, January 22–February 14. Includes Beuys, Brehmer, Burgin, Fox, Hamilton, Hödicke, McLean, Vautier, and Vostell.

Fetisch Jugend, Tabu Tod. Städtisches Museum, Schloss Morsbroich, Leverkusen, May 26–July 16; Haus am Waldsee, Berlin, September 8–October 22; and tour through February 25, 1973. Catalogue edited by Rolf Wedewer.

Szene Berlin Mai '72. Württembergischer Kunstverein, Stuttgart, May 26–June 18; organized by René Block. Includes Brehmer, Brus, Gosewitz, Hödicke, Koepcke, Schmit, and Vostell.

Zeichnungen der deutschen Avantgarde. Galerie im Taxispalais, Innsbruck, June 6–July 2, and tour; organized by Peter Weiermair. Includes Baselitz and Höckelmann.

Szene Rhein-Ruhr '72. Museum Folkwang, Essen, July 9–September 3; organized by Dieter Honisch. Includes Beuys.

The Berlin Scene, 1972. Gallery House, London, October 20–November 19; organized by René Block. Includes Brehmer, Brus, Gosewitz, Hödicke, Koberling, Lüpertz, and Schmit.

Realität, Realismus, Realität. Von der Heydt-Museum, Wuppertal, October 28–December 17; Haus am Waldsee, Berlin, January 12–February 25, 1973; and tour through December 15, 1973; organized by the Ausstellungsverbund. Catalogue edited by Johann Heinrich Müller, Tilman Osterwold, and Rolf Wedewer. Includes Beuys.

Zeichnungen 2. Städtisches Museum, Schloss Morsbroich, Leverkusen, November 10, 1972–January 7, 1973; organized by Rolf Wedewer. Includes Baselitz, Gosewitz, Höckelmann, Lüpertz, and Schönebeck.

Plastik 71: Anfassen, Erfahren, Begreifen. Haus am Waldsee, Berlin, November 12–December 17; organized by Thomas Kempas. Exhibition of 20 Berlin sculptors.

Berlin-Szene 1972. Kunstverein, Hamburg, December 8, 1972–January 14, 1973. Includes Brehmer, Brus, Gosewitz, Hödicke, Koberling, Lüpertz, Schmit, and Vostell.

1973

Prinzip Realismus: Malerei, Plastik, Graphik: Albert, Arnim, Baehr, Diehl, Gorella, Munsky, Petrick, Schmettau, Sorge, Vogelsang, Waller. Akademie der Künste, Berlin, January 14–February 18, and tour; circulated by the DAAD, Berlin. Catalogue edited by Peter Hielscher and Lothar C. Poll; Berlin: DAAD, 1971.

Thema: Informel; Teil I: Zur Struktur einer "anderen" Zeit. Städtisches Museum, Schloss Morsbroich, Leverkusen, February–March, and Haus am Waldsee, Berlin, March–April; organized by Rolf Wedewer, Thomas Kempas, and Lothar Romain.

Catalogue edited by Katharina Schmidt. Includes Thieler and Vedova.

Grafische Techniken. Neuer Berliner Kunstverein in the Kunstbibliothek, Berlin, February 24–March 24; organized by René Block. Berlin: Neuer Berliner Kunstverein, 1973. Includes Beuys, Brehmer, Hamilton, Hockney, Hödicke, Kaprow, Koepcke, Schmit, Thieler, Vautier, and Vostell.

Kunst im politischen Kampf: Aufforderung, Anspruch, Wirklichkeit. Kunstverein, Hannover, March 31–May 13; organized by Christos M. Joachimides and Helmut R. Leppien. Includes Beuys, Brehmer, Hacker, and Vostell.

Bilder, Objekte, Filme, Konzepte. Städtische Galerie im Lenbachhaus, Munich, April 3–May 13; organized by Michael Petzet. Includes Baselitz and Beuys.

ADA: Aktionen der Avantgarde: Berlin 1973. Neuer Berliner Kunstverein in the Akademie der Künste, Berlin, September 9–October 3. Catalogue edited by Jörn Merkert and Ursula Prinz. Includes Filliou, Kaprow, and Vostell.

Kunst in Deutschland, 1898–1973. Hamburger Kunsthalle, Hamburg, November 10, 1973–January 6, 1974, and Städtische Galerie im Lenbachhaus, Munich, February 1–March 11, 1974; organized by Werner Hofmann. Includes Beuys and Vostell.

30 Internationale Künstler in Berlin: Gäste des Deutschen Akademischen Austauschdienstes, Berliner Künstlerprogramm. Beethoven-Halle, Bonn, December 14–27. Catalogue edited by Karl Ruhrberg and Thomas Deecke; Berlin: DAAD, 1973. Includes Hamilton and Kienholz.

1974

Identität: Versuche bildhafter Selbstdefinition: Arbeiten von Christian Boltanski, Anna Oppermann, Bernhard Praesant, Martin Rosz und Roger Welch, sowie von 42 Schülern der Klassen 5 a, b und c des Gymnasiums i. E. Köln-Höhenhaus. Haus am Waldsee, Berlin, March 29–May 12, and Frankfurter Kunstverein, Frankfurt am Main, June 21–August 11; organized by Thomas Kempas.

Multiples: Ein Versuch die Entwicklung des Auflagenobjektes darzustellen/Multiples: An Attempt to Present the Development of the Object Edition. Neuer Berliner Kunstverein in der Kunstbibliothek, Berlin, May 8–June 15; organized by René Block. Includes Beuys, Brecht, Brehmer, Christo, Filliou, Gosewitz, Hamilton, Hödicke, Kaprow, Kienholz, Koepcke, Vautier, and Vostell.

Erste Biennale Berlin. Rooms of the Heinz Mosch Company, Berlin, May 10–June 11. Includes Hödicke, Koberling, Lüpertz, and Schönebeck.

Projekt '74: Kunst bleibt Kunst: Aspekte internationaler Kunst am Anfang der 70er Jahre. Kunsthalle, Cologne, July 6–September 8; organized by the Wallraf-Richartz-Museum, Cologne; the Kunsthalle, Cologne; the Kunst- und Museumsbibliothek, Cologne; and the Kunstverein, Cologne. Catalogue and documentation in English and German; edited by Albert Schug and Dieter Ronte. Includes Beuys, Burgin, Fox, Kaprow, McLean, Morley, Paolini, and Vostell.

Medium Fotografie: Fotoarbeiten bildender Künstler von 1910 bis 1973. Kunstverein, Hamburg, July 27–September 4; Haus am Waldsee, Berlin, September 20–November 3, and tour. Catalogue edited by Rolf Wedewer and Fred Jahn; Leverkusen: Städtisches Museum, Schloss Morsbroich, 1974.

Schule der Neuen Prächtigkeit: Manfred Bluth, Johannes Grützke, Matthias Koeppel, Karlheinz Ziegler. Neuer Berliner Kunstverein in der Kunstbibliothek, Berlin, September 7–October 3, and tour; organized by Dietrich Gronau.

Landschaft: Gegenpol oder Fluchtraum? Städtisches Museum, Schloss Morsbroich, Leverkusen, September 27–November 10, and Haus am Waldsee, Berlin, November 29, 1974–January 12, 1975; organized by Rolf Wedewer and Walter Ehrmann. Includes Baselitz, Beuys, Brehmer, Christo, Hockney, and Koberling.

Art/Vidéo confrontation 74. ARC 2, Musée d'Art Moderne de la Ville de Paris, November 8–December 8. Includes Brehmer, Beuys, Gette, Hamilton, Kaprow, and Vostell.

1975

Video Art. Institute of Contemporary Art, University of Pennsylvania, Philadelphia, January 17–February 28, and tour through November 2; organized by Suzanne Delehanty. Includes Fox, Hödicke, Kaprow, Paolini, and Vostell.

Realismus und Realität: Ausstellung zum 11. Darmstädter Gespräch. Kunsthalle, Darmstadt, May 24–July 6; organized by Bernd Krimmel for the City of Darmstadt and the Kunstverein, Darmstadt. Includes Hockney, Kienholz, and McLean.

8 from Berlin. Fruit Market Gallery, Edinburgh, August 16–September 14; organized by Folker Skulima. Edinburgh: Scottish Arts Council, 1975. Includes Gosewitz, Hödicke, Kienholz, Koberling, and Schönebeck.

Geteilte Interpretation: Maler sehen Die Mauer. Haus am Checkpoint Charlie, Berlin, September; organized by Rainer Hildebrandt. Berlin: Arbeitsgemeinschaft 13. August, 1975. Includes Vostell.

Körpersprache. Haus am Waldsee, Berlin, December 12, 1975–January 25, 1976, and Frankfurter Kunstverein, Frankfurt am Main, February 13–March 28, 1976; organized by Georg Bussmann and Thomas Kempas. Frankfurt-am-Main: Kunstverein, 1975. Includes Rainer.

1976

Made in Berlin: K. P. Brehmer, K. H. Hödicke, Rebecca Horn. René Block Gallery, New York, April–June.

Schuhwerke: Aspekte zum Menschenbild. Kunsthalle am Marientor, Norishalle, and U-Bahnhof am Hauptbahnhof, Nuremberg, May 28–September 29; organized by Barbara Bredow and Curt Heigl. Includes Brehmer, Castelli, and Vostell.

New York–Downtown Manhattan: Soho: Ausstellungen, Theater, Musik, Performance, Video, Film. Akademie der Künste, Berlin, September 5–October 17; organized by René Block. Includes Beuys, Borofsky, Brehmer, Christo, Fox, Hödicke, Kaprow, Morley, Paolini, Schmit, Vautier, Vostell, and Williams.

Prospect-Retrospect: Europa, 1946–1976. Städtische Kunsthalle, Düsseldorf, October 20–31; organized by Konrad Fischer and Hans Strelow. Cologne: Verlag der Buchhandlung Walther König, 1976. Exhibition documents the history of the Prospect as well as other exhibitions.

Bild, Raum, Klang: 11 internationale Künstler, Gäste des Berliner Künstlerprogramms, Deutscher Akademischer Austauschdienst. Wissenschaftszentrum, Bonn-Bad Godesberg, November 12–December 15. Catalogue edited by Thomas Deecke; Berlin: DAAD, 1976. Also issued by the Institut für Auslandsbeziehungen, Stuttgart, for the traveling exhibition. Includes Kienholz.

Boîtes. ARC 2. Musée d'Art Moderne de la Ville de Paris, December 16, 1976–January 30, 1977, and Maison de la Culture, Rennes, February 3–March 2, 1977; organized by Suzanne Pagé and Françoise Chatel. Includes Beuys, Brehmer, Christo, Gette, Hamilton, Hödicke, Kienholz, Vautier, and Vostell.

1977

Künstlerinnen International, 1877-1977. Schloss Charlottenburg, Berlin; organized by the Arbeitsgruppe Frauen in der Kunst. Berlin: Neue Gesellschaft für bildende Kunst, 1977.

Pejling af Tysk Kunst: 21 Kunstnere fra Tyskland. Louisiana Museum for Moderne Kunst, Humlebaek, Denmark, February; organized by Klaus Gallwitz. Catalogue published in *Louisiana Revy*, vol. 17, no. 2 (February 1977). Includes Beuys, Höckelmann, Schmit, and Stöhrer.

Berlin Now: Contemporary Art, 1977. Catalogue of a three-part exhibition held in New York, March–April 1977: (1) *Hannah Höch: Collage and Photomontages*, Goethe House; (2) *Realistic Tendencies*, New School Art Center: (3) *Abstraction, Conception, Performance*, Denise René Galerie; organized by Dieter Honisch, Thomas Kempas, Eberhard Roters, Lucie Schauer, and Paul Mocsanyi. Berlin: Artists-in-Berlin Program of the German Academic Exchange Service and the Department of Arts and Sciences for Goethe House, New York, 1977. (3) includes Gosewitz and Rosz.

Malerei und Photographie im Dialog von 1840 bis Heute. Kunsthaus, Zurich, May 13–July 24; organized by Erika Billeter. Bern: Benteli Verlag, 1977. Includes Beuys, Brecht, Christo, Hamilton, Hockney, Kaprow, Paolini, Rainer, Vautier, and Vostell.

Zum Beispiel Villa Romana, Florenz: Zur Kunstförderung in Deutschland, I. Staatliche Kunsthalle, Baden-Baden, June 18–August 17, and Palazzo Strozzi, Florence, November–December; organized by Hans Albert Peters. Includes Baselitz and Lüpertz.

11 Deutsche Maler: Ausstellung zur Kieler Woche. Kunsthalle zu Kiel and Schleswig-Holsteinischer Kunstverein, Kiel, June 19–August 6; organized by Jens Christian Jensen. Includes Hödicke.

Berliner Galerien: Parallelausstellungen zur 15. Europäischen Kunstausstellung 1977. Berlin, August–October. Catalogue of 28 exhibitions; Berlin: Interessengemeinschaft Berliner Kunsthändler, 1977.

12 depuis '45. Musées Royaux des Beaux-Arts de Belgique, Brussels, October 1–November 27; organized by Werner Schmalenbach for Europalia '77 Bundesrepublik Deutschland. Catalogue edited by Dieter Brandt; Brussels: Europalia, 1977.

Aspekt Grossstadt. Künstlerhaus Bethanien, Berlin, October 7–November 13, and tour through March 12, 1978. Catalogue edited by Daghild Bartels; Berlin: Künstlerhaus Bethanien and Gruppe Aspekt, 1977.

Europe in the Seventies: Aspects of Recent Art. Art Institute of Chicago, October 8–November 27, and tour through January 31, 1979; organized by A. James Speyer and Anne Rorimer. Includes Burgin and Paolini.

Tendenzen der Kunst in der Bundesrepublik Deutschland nach 1945. Szépművészeti Múzeum, Budapest, November 19–December 31; organized by Zdenek Felix. Includes Beuys.

1978

Museum des Geldes: Über die seltsame Natur des Geldes in Kunst, Wissenschaft und Leben. Städtische Kunsthalle and Kunstverein für die Rheinlande und Westfalen, Düsseldorf; organized by Jürgen Harten and Horst Kurnitzky. 2 vols. Includes Beuys and Kienholz.

Aspekte der 6oer Jahre: Aus der Sammlung Reinhard Onnasch. Nationalgalerie, Staatliche Museen Preussischer Kulturbesitz, Berlin, February 2–April 23; organized by Dieter Honisch. Catalogue of the exhibition and of the collection: exhibition includes Christo, Hockney, Kienholz, and Lüpertz; collection also includes Beuys and Koberling.

10 Jahre Graphothek Berlin: Ausstellung der ersten 7 Graphothekspender: Droste, Grzimek, Kühl, Kunde, Otterson, Petrick, Seidel-Fichert: Plastik, Malerei, Graphik. Rathaus-Galerie, Berlin-Wittenau, March 5–April 21; organized by Georg Pinagel.

Kunst des 20. Jahrhunderts aus Berliner Privatbesitz. Akademie der Künste, Berlin, April 9–May 15; organized by Hanspeter Heidrich. Berlin: Interessengemeinschaft Berliner Kunsthändler, 1976. Includes Baselitz, Beuys, Brecht, Brehmer, Brus, Christo, Filliou, Gosewitz, Höckelmann, Hödicke, Kienholz, Koberling, Koepcke, Lüpertz, Rainer, Rosz, Schmit, Schönebeck, Stöhrer, Thieler, and Vostell.

Works from the Crex Collection, Zürich / Werke aus der Sammlung Crex, Zürich. InK, Zurich, May, and tour; organized by Urs Raussmüller. Includes Baselitz and Lüpertz.

Abbilder, Leitbilder: Berliner Skulpturen von Schadow bis Heute. Neuer Berliner Kunstverein in der Orangerie, Schloss Charlottenburg, Berlin, May 20–July 23; organized by Helmut Börsch-Supan.

Rolf v. Bergmann, Rainer Fetting, Ep. Hebeisen, Anne Jud, Thomas Müller, Helmut Middendorf, Salomé, Berthold Schepers, Bernd Zimmer. Galerie am Moritzplatz, Berlin, May 28–June 26. Catalogue of the exhibition *1 Jahr Galerie am Moritzplatz*; introduction by Ernst Busche.

Das Bild des Künstlers: Selbstdarstellungen. Hamburger Kunsthalle, Hamburg, June 16–August 27; organized by Siegmar Holsten. Hamburg: Hans Christians Verlag, 1978. Includes Beuys, Brehmer, and Hamilton.

Prozesse: Physikalische, biologische, chemische. Haus an der Redoute, Bonn–Bad Godesberg, September

21–October 22; organized by Margarethe Jochimsen. Bonn: Bonner Kunstverein and Städtisches Kunstmuseum, 1978. Includes Brecht and Hödicke.

Künstler des Hauses. Künstlerhaus Bethanien, Berlin, October 3–29.

Selbstgespräche: Arbeiten von Kunststudenten: Michael Bauch ... et al.: Gruppenarbeit von Dirk Behrens ... et al. Württembergischer Kunstverein, Stuttgart, October 19– November 26, and Haus am Waldsee, Berlin, January 28–March 18, 1979; organized by Tilman Osterwold. Includes Zimmer.

13°E: Eleven Artists Working in Berlin. Whitechapel Art Gallery, London, November 10–December 22; organized by Christos M. Joachimides. Includes Brehmer, Brus, Gosewitz, Hacker, Hödicke, Koberling, Lüpertz, Schmit, and Vostell.

Berlin, a Critical View: Ugly Realism, 20s–70s. Institute of Contemporary Arts, London, November 15, 1978–January 2, 1979; organized by Sarah Kent and Eckhart Gillen; sponsored by Berliner Festspiele.

Westberliner Künstler stellen aus: Malerei und Graphik seit 68. Kunsthalle, Rostock, November 29, 1978–January 1, 1979; organized by Norbert Stratmann for the Verband bildender Künstler der DDR and the Kunsthalle, Rostock. Exhibition also shown at the gallery of the United Association of the Visual Artists of the USSR, Moscow, January 30–February 26, 1979, and at the Elefanten Press Galerie, Berlin, March 16–May 6, 1979, under the title *Westberliner Realisten*. Berlin: Elefanten Press Verlag, 1979. Includes Brehmer.

Nationalgalerie Berlin – 10 Jahre im neuen Haus. Wissenschaftszentrum, Bonn–Bad Godesberg, December 12, 1978–January 21, 1979. Catalogue edited by Lucius Grisebach; Berlin: Nationalgalerie, Staatliche Museen Preussischer Kulturbesitz, 1978. Includes Beuys and Kienholz.

Rückschau Villa Massimo Rom, 1957–1974. Staatliche Kunsthalle, Baden-Baden, December 20, 1978–January 28, 1979, and tour including the Staatliche Kunsthalle, Berlin, April 15–May 1, 1979; organized by Hans Albert Peters. Includes Hödicke and Koberling.

1979

Staatliche Akademie der Bildenden Künste Karlsruhe, zum 125jährigen Bestehen. Staatliche Akademie der Bildenden Künste, Karlsruhe. Includes Baselitz and Lüpertz.

Wahrnehmungen, Aufzeichnungen, Mitteilungen: Die Erweiterung des Wirklichkeitsbegriffs in der Kunst der 6oer und 7oer Jahre. Museum Haus Lange, Krefeld, January 21–March 18; organized by Gerhard Storck. Includes Beuys.

Umrisse: Bilder, Objekte, Videos, Filme von Künstlerinnen. Kunsthalle and Schleswig-Holsteinischer Kunstverein, Kiel, May 6–June 4; organized by Gesa Rautenberg.

Zeichen setzen durch Zeichnen. Kunstverein in Hamburg, May 26–July 1; organized by Günther Gercken and Uwe M. Schneede. Includes Baselitz, Beuys, Höckelmann, and Schmit.

Eremit? Forscher? Sozialarbeiter?: Das veränderte Selbstverständnis von Künstlern. Kunstverein and Kunsthaus, Hamburg, July 14–August 26; organized by Uwe M. Schneede. Includes Hacker and Wachweger.

Kunst in Berlin von 1960 bis Heute. Berlinische Galerie, Berlin, July 17–December 23. Second in a series of three exhibitions of works from the gallery's collections; organized by Ursula Prinz and Eberhard Roters. Includes Gosewitz, Höckelmann, Hödicke, Schmit, Schönebeck, Stöhrer, Thieler, and Vostell.

Malerei auf Papier: Georg Baselitz, Jörg Immendorf, Anselm Kiefer, Markus Lüpertz, A. R. Penck, Arnulf Rainer. Badischer Kunstverein, Karlsruhe, July 24–September 16; organized by Michael Schwarz.

Die Entfremdung der Stadt. Neuer Berliner Kunstverein in der Nationalgalerie, Berlin. July 27–August 23; organized by Brigitta Schrieber. Includes Hödicke and Lüpertz.

Schlaglichter: Eine Bestandsaufnahme aktueller Kunst im Rheinland. Rheinisches Landesmuseum, Bonn, September 20–November 4. Catalogue edited by Renate Heidt, Klaus Honnef, Barbara Kückels, and Norbert Radtke; Cologne: Rheinland-Verlag, 1979. Includes Höckelmann and Schön.

Günter Bruno Fuchs: Zinke, Berlin, 1959–1962: Anlauf, Fuchs, Schnell. Künstlerhaus Bethanien, Berlin, October–November, and Goethe-Institut, Amsterdam, 1980; organized by Peter Hielscher.

Videowochen Essen '79/Videoweeks Essen '79. Museum Folkwang, Essen, October 28–December 16; organized by Zdenek Felix. Includes Beuys, Fox, and Kaprow.

Weich und Plastisch: Soft-Art. Kunsthaus, Zurich, November 16, 1979–February 4, 1980; organized by Erika Billeter. Includes Beuys, Christo, Kaprow, and Kienholz.

Le Stanze. Castello Colonna, Genazzano, Italy, November 30, 1979–February 29, 1980; organized by Achille Bonito Oliva. Florence: Centro Di, 1979. Includes Paolini.

1980

Les Nouveaux Fauves/Die neuen Wilden: Sammlung Ludwig. Neue Galerie–Sammlung Ludwig, Aachen, January 19–March 21; organized by Wolfgang Becker. 2 vols. Includes Baselitz and Lüpertz.

Für Augen und Ohren: Von der Spieluhr zum akustischen Environment: Objekte, Installationen, Performances. Akademie der Künste, Berlin, January 20–March 2; organized by Nele Hertling and René Block. Includes Beuys, Brehmer, Hamilton, and Kaprow.

Heftige Malerei: Rainer Fetting, Helmut Middendorf, Salomé, Bernd Zimmer. Haus am Waldsee, Berlin, February 29–April 20; organized by Thomas Kempas.

Zehn Jahre Edition Hundertmark: 1970–1980, Berlin-Köln. DAAD Galerie, Berlin, March 12–April 13. Catalogue edited by Armin Hundertmark and Dietmar Kirves; Berlin: DAAD, 1980. Includes Beuys, Brehmer, Brus, Gosewitz, Koepcke, Schmit, Vautier, Vostell, and Williams.

Forms of Realism Today: Federal Republic of Germany/Formes du Realisme Aujourd'hui: République Fédérale d'Allemagne. Art Gallery of Hamilton, Ontario, March 14–April 13; organized by Thomas Grochowiak. Includes Baselitz and Vostell.

Der gekrümmte Horizont: Kunst in Berlin, 1945–1967. Akademie der Künste, Berlin, April 3–May 1; organized by Johannes Gachnang. Berlin: Interessengemeinschaft Berliner Kunsthändler, 1980. Includes Baselitz, Beuys, Brehmer, Gosewitz, Höckelmann, Hödicke, Lüpertz, Schmit, Schönebeck, Thieler, and Vedova.

Wendepunkt: Kunst in Europa um 1960. Museum Haus Lange, Krefeld, May 11–June 6; organized by Gerhard Storck. Includes Beuys and Rainer.

Nice à Berlin/Nizza in Berlin. DAAD Galerie, Berlin, May 16–June 8; organized by Claude Fournet, Jacques Lepage, Marc Sanchez, and Ben Vautier. Catalogue edited by Toni Stooss; Berlin: DAAD, 1980. Includes Filliou and Vautier.

Treffpunkt Parnass Wuppertal, 1949–1965. Von der Heydt-Museum, Wuppertal, May 31–July 13; organized by Will Baltzer and Alfons W. Biermann for the Kunst- und Museumsverein Wuppertal. Schriften des Rheinischen Museumamtes, Nr. 11. Cologne: Rheinland-Verlag, 1980. Includes Beuys and Vostell.

Zeichen des Glaubens, Geist der Avantgarde: Religiöse Tendenzen in der Kunst des 20. Jahrhunderts. Grosse Orangerie, Schloss Charlottenburg, Berlin, May 31–July 13; organized by Wieland Schmied. Stuttgart: Electa/Klett-Cotta, 1980. Includes Baselitz, Beuys, Koberling, Lüpertz, Schönebeck, and Vostell.

Kunst in Europa na '68. Museum van Hedendaagse Kunst and Centrum voor Kunst en Cultuur, Ghent, June 21–August 31. Includes Beuys, Burgin, and Paolini.

Junge Kunst aus Berlin. Berlinische Galerie, Berlin, August 19–September 7; Rathaus, Munich, September 15–28; and international tour; organized by the Goethe-Institut, Munich, and the Senator für Kulturelle Angelegenheiten, Berlin. Catalogue in English and German; edited by Thomas Kempas; Munich: Goethe-Institut, 1980. Includes Fetting, ter Hell, Middendorf, Stöhrer, and Zimmer.

Realism and Expressionism in Berlin Art. Frederick S. Wight Art Gallery, University of California, Los Angeles, November 16, 1980–January 11, 1981; organized by Eberhard Roters, Ursula Prinz, and Jack

W. Carter; sponsored by the Senator für Kulturelle Angelegenheiten, Berlin. Catalogue essay by Eberhard Roters; catalogue prepared by Ursula Prinz. Includes Thieler.

Après le classicisme. Musée d'Art et d'Industrie, St. Étienne, November 21, 1980–January 10, 1981; organized by Jacques Beauffet, Bernard Ceysson, Anne Dary-Bossut, and Didier Semin. Includes Baselitz, Castelli, Fetting, Lüpertz, McLean, Middendorf, Salomé, and Zimmer.

1981

Fleischeslust: Die Wiederkehr des Sinnlichen: Die Erotik in der neuen Kunst. Galerie Paul Maenz, Cologne, 1981. Includes Fetting.

Junge Kunst aus Westdeutschland '81. Palais Schaumburg, Stuttgart, 1981. Stuttgart: Galerie Max-Ulrich Hetzler, 1981. Includes Schön.

Phoenix. Alte Oper, Frankfurt am Main, 1981; organized by Manfred de la Motte and Walter E. Baumann. Includes Christo, ter Hell, Spoerri, Stöhrer, Thieler, and Zimmer.

A New Spirit in Painting. Royal Academy of Arts, London, January 15–March 18; organized by Christos M. Joachimides, Norman Rosenthal, and Nicholas Serota. Includes Baselitz, Fetting, Hacker, Hockney, Hödicke, Lüpertz, McLean, and Morley.

Art Allemagne Aujourd'hui: Différents Aspects de l'Art Actuel en République Fédérale d'Allemagne. ARC/Musée d'Art Moderne de la Ville de Paris, January 17–March 8; organized by Réne Block and Suzanne Pagé. Includes Baselitz, Beuys, Brehmer, Gosewitz, Hacker, Hödicke, Koepcke, Lüpertz, Schmit, and Vostell.

Berlin realistisch, 1890–1980. Berlinische Galerie, Berlin, February 13–May 3; organized by Ursula Prinz and Eberhard Roters. Längsschnitte, 1. Includes Vostell.

Hunden tillstöter under veckans lopp/Der Hund stösst im Laufe der Woche zu mir: Jörg Immendorff, Per Kirkeby, Markus Lüpertz, A. R. Penck. Moderna Museet, Stockholm, February 14–March 29; organized by Olle Granath.

Rundschau Deutschland. Fabrik, Lothringerstrasse 13, Munich, March 13–April 11; organized by Stefan Szczesny and Troels Wörsel. Munich: Kulturreferat der Landeshauptstadt, 1981. Includes Barfuss, Fetting, Kippenberger, Salomé, Wachweger, and Zimmer.

Malmoe. Malmö Konsthall, March 20–May 3. Catalogue edited by Ingvar Claeson and Eje Högestätt. Includes Burgin, Gette, and Williams.

Bildhauertechniken: Dimensionen des Plastischen. Neuer Berliner Kunstverein in der Staatliche Kunsthalle, Berlin, March 21–April 20; organized by Lucie Schauer. Includes Beuys, Brehmer, Christo, Hödicke, Kienholz, Metzel, and Vostell.

Performance—Eine andere Dimension/Performance — Another Dimension. Künstlerhaus Bethanien, Berlin, May 5–20, 1981, and March 19–30, 1982. Catalogue, edited by Kirsten Martins and Peter P. J. Sohn, documents two performance festivals; Berlin: Fröhlich & Kaufmann, 1983. Includes Fox, McLean, and Williams.

Schilderkunst in Duitsland, 1981/Peinture en Allemagne, 1981. Vereniging voor Tentoonstellingen van het Paleis voor Schone Kunsten te Brussel/Société des Expositions du Palais des Beaux-Arts de Bruxelles, May 27–July 12; organized by Johannes Gachnang. Includes Baselitz, Höckelmann, Hödicke, Lüpertz, and Schönebeck.

Westkunst: Zeitgenössische Kunst seit 1939. Museen der Stadt, Cologne, May 30–August 16; organized by Kaspar Koenig. Catalogue by Laszlo Glozer; Cologne: DuMont, 1981. Includes Baselitz, Beuys, Christo, Hamilton, Hockney, Kienholz, Morley, Paolini, Vedova, and Vostell.

Heute (Westkunst). Rheinhallen, Museen der Stadt, Cologne, May 30–August 16, 1981. Includes Borofsky, Castelli, and Salomé.

6 junge Maler, 1981. Catalogue of six exhibitions at the Galerie Poll, Berlin, June 1–November 28, 1981. Includes Chevalier (November 16–28, 1981).

Bildwechsel: Neue Malerei aus Deutschland. Akademie der Künste, Berlin, June 14–July 1, 1981; organized

by Ernst Busche for the Interessengemeinschaft Berliner Kunsthändler. Catalogue by Hanspeter Heidrich; Berlin: Fröhlich & Kaufmann, 1981. Includes Chevalier, Fetting, ter Hell, Middendorf, Schön, and Zimmer.

Situation Berlin. Galerie d'Art Contemporain des Musées de Nice, July, and tour; organized by Toni Stooss and Marc Sanchez. Berlin: DAAD, 1981. Includes Castelli, Chevalier, Fetting, ter Hell, Metzel, Middendorf, Salomé, Schön, and Zimmer.

Berlin, eine Stadt für Künstler. Kunsthalle, Wilhelmshaven, summer. Includes Castelli, Chevalier, Fetting, ter Hell, Metzel, Middendorf, Salomé, Schön, and Zimmer.

Gegen-Bilder: Die Kunst der jungen deutschen Generation. Badischer Kunstverein, Karlsruhe, July 3–September 20; organized by Michael Schwarz. Includes Pitz.

Berlin konstruktiv. Berlinische Galerie, Berlin, July 9–August 30; organized by Ursula Prinz and Eberhard Roters. Längsschnitte, 2.

Fluxus Etc.: The Gilbert and Lila Silverman Collection. Cranbrook Academy of Art Museum, Bloomfield Hills, Michigan, September 20–November 1; organized by Jon Hendricks. *Addenda I* edited by Jon Hendricks (New York: Ink &, 1983); *Addenda II* edited by Jon Hendricks (Pasadena: Baxter Art Gallery, California Institute of Technology, 1983), for the exhibition held in Pasadena, September 28–October 30, 1983.

5 Berliner Künstler in New York/5 Berlin Artists in New York: Eberhard Blum, Josef Erben, Wolfram Erber, Jasper Halfmann, Wolf Kahlen. DAAD Galerie, Amerikahaus and Atelier Erber, Berlin, September 26–November 8; organized by Jörg Ludwig and Toni Stooss. Catalogue consists of a pamphlet about each artist in English and German; Berlin: DAAD and the Amerikahaus, 1981.

Baroques 81: Les débordements d'une avant-garde internationale. ARC, Musée d'Art Moderne de la Ville de Paris, October 1–November 15; organized by Suzanne Pagé. Includes Borofsky, Castelli, and Salomé.

Neue Tendenzen der Zeichnung. Kunstverein, Munich, October 7–November 15, 1981; Berlinische Galerie, Berlin, February 5–March 14, 1982; and tour. Catalogue edited by Eduard Beaucamp, Hans Albert Peters, Eberhard Roters, and Wolfgang Jean Stock; Munich: Prestel-Verlag, 1981. Finalists in the competition "Dimension '81," sponsored by Philip Morris GmbH. Includes ter Hell and Zimmer.

Im Westen nichts Neues: Wir malen Weiter: Luciano Castelli, Rainer Fetting, Helmut Middendorf, Salomé, Bernd Zimmer & Super-8 aus Westberlin. Kunstmuseum, Lucerne, October 11–November 15, and tour; organized by Martin Kunz.

Schwarz. Städtische Kunsthalle, Düsseldorf, October 16–November 29; organized by Hannah Weitemeier. Includes by Armando, Beuys, Hödicke, and Kaprow.

Traum. Aktionsgemeinschaft österreichischer Galerien, Austria, December 3, 1981–January 20, 1982; an exhibition in ten galleries. Includes Brus (in the Galerie Heike Curtze, Vienna) and Fox (in the Modern Art Galerie, Vienna).

Vom Jugendstil zum Freistil. Galerie Petersen, Berlin, December 6, 1981–January 20, 1982. Catalogue published in *Happy-Happy* (December 1981). Includes Barfuss and Wachweger.

Berlin expressiv. Berlinische Galerie, Berlin, December 10, 1981–January 24, 1982; organized by Ursula Prinz and Eberhard Roters. Längsschnitte 3. Includes Chevalier, Fetting, ter Hell, Hödicke, Koberling, Middendorf, Salomé, Schönebeck, Stöhrer, and Thieler.

Fluxus—Aspekte eines Phänomens. Kunst- und Museumsverein, Wuppertal, in the Von der Heydt-Museum, Wuppertal, December 15, 1981–January 31, 1982; organized by Ursula Peters and Georg F. Schwarzbauer. Includes Beuys, Koepcke, Schmit, Vautier, Vostell, and Williams.

1982

Künstler verwenden Fotografie—Heute. Institut für Auslandsbeziehungen, Stuttgart; organized by Wulf Herzogenrath. Includes Beuys, Brus, and Hacker.

La Nuova Pittura Tedesca. Studio Marconi, Milan.

Catalogue text by Johannes Gachnang and Siegfried Gohr. Includes Baselitz and Lüpertz.

Crossroads Parnass: International Avant-Garde at Galerie Parnass, Wuppertal, 1949–1965. Goethe-Institut, Paris, January 18–February 26, and tour through September 11; organized by Günter Coenen and Günter Bär. London: Goethe- Institut, 1982. Includes Beuys and Vostell.

German Drawings of the 60's. Yale University Art Gallery, New Haven, January 27–March 28; Art Gallery of Ontario, Toronto, April 17–May 30; organized by Dorothea Dietrich-Boorsch. Includes Baselitz, Beuys, Höckelmann, Lüpertz, and Schönebeck.

10 Junge Künstler aus Deutschland. Museum Folkwang, Essen, February 2–March 21; organized by Zdenek Felix. Includes Fetting, Middendorf, and Salomé.

Joseph Beuys, Robert Rauschenberg, Cy Twombly, Andy Warhol: Sammlung Marx. Nationalgalerie, Staatliche Museen Preussischer Kulturbesitz, Berlin, March 2–April 12, and Städtisches Museum Abteiberg, Mönchengladbach, May 6–September 30. Catalogue by Heiner Bastian; Munich: Prestel-Verlag, 1982.

Momentbild: Künstlerphotographie. Kestner-Gesellschaft, Hannover, March 5–April 18; organized by Carl Haenlein. Includes Castelli, Hamilton, Hockney, and Raetz.

12 Künstler aus Deutschland. Kunsthalle, Basel, March 14–April 25, and Museum Boymans–Van Beuningen, Rotterdam, May 8–June 21; organized by Jean-Christophe Ammann. Catalogue edited by Jean-Christophe Ammann and Margrit Suter; Basel: Basler Kunstverein, 1982. Includes Castelli, Fetting, and Salomé.

Avanguardia, Transavanguardia. Mura Aureliane, Rome, April–July; organized by Achille Bonito Oliva. Milan: Electa, 1982. Includes Baselitz, Beuys, Christo, Lüpertz, Paolini, and Vedova.

'60 '80: Attitudes/Concepts/Images. Stedelijk Museum, Amsterdam, April 9–July 11; organized by Ad Petersen, Karel Schampers, and Marja Bloem. Amsterdam: Van Gennep, 1982. Includes Armando, Baselitz, Beuys, Christo, Hamilton, Hockney, Kienholz, Paolini, and Vautier.

Känsla och Hårdhet: Konstnär i Berlin. Kulturhuset, Stockholm, April 17–June 13; organized by Kerstin Danielsson, Margareta Hallerdt, Beate Sydhoff, Peter Hielscher, and Ursula Prinz. Includes Chevalier, Fetting, ter Hell, Metzel, Middendorf, Rosz, Salomé, and Zimmer.

Spiegelbilder. Kunstverein, Hannover, May 9–June 30, and tour; organized by Thomas Kempas, Siegfried Salzmann, and Katrin Sello. Includes Beuys, Fetting, Hödicke, Middendorf, and Paolini.

Kunstquartier: Ausländische Künstler in Berlin. Former AEG factory, Ackerstrasse, Berlin, May 14–June 17; organized by Michael Nungesser. Berlin: Interessengemeinschaft Berliner Kunsthändler, 1982. Includes Armando and Williams.

11 Berliner Bildhauer: Junge Kunst aus Berlin, II. Berlinische Galerie, May 25–June 13; organized by the Goethe-Institut, Munich.

Vergangenheit, Gegenwart, Zukunft: Zeitgenössische Kunst und Architektur. Württembergischer Kunstverein, Stuttgart, May 26, June 9, June 23–August 22; organized by Tilman Osterwold, Andreas Vowinckel, and Frank Werner. Includes Hödicke.

Die neue Künstlergruppe, Die wilde Malerei. Im Klapperhof 33, Cologne, June 5–30. Cologne: Claus Peter Wittig, 1982. Includes Brus.

The Pressure to Paint. Marlborough Gallery, New York, June 4–July 9; organized by Diego Cortez. Includes Baselitz, Fetting, and Lüpertz.

Thinking of Europe. Living Art Museum, Reykjavik, June 5–20; organized by Demetrio Paparoni. Includes Koberling, Middendorf, and Zimmer.

Videokunst in Deutschland, 1963–1982: Videobänder, Videoinstallationen, Video-Objekte, Videoperformances, Fotografien. Kölnischer Kunstverein, Cologne, June 6–July 18, and tour through March 1983; organized by the Kölnischer Kunstverein; the Badischer Kunstverein, Karlsruhe; the Kunsthalle, Nuremberg; the Städtische Galerie im Lenbachhaus, Munich; and the Nationalgalerie, Berlin. Catalogue

edited by Wulf Herzogenrath; Stuttgart: Verlag Gerd Hatje, 1982. Includes Beuys and Vostell.

Mythe, Drame, Tragédie. Musée d'Art et d'Industrie, St. Etienne, summer; organized by Jacques Beauffet and Bernard Ceysson. Includes Baselitz and Lüpertz.

Dada-Montage-Konzept. Berlinische Galerie, Berlin, June 22–August 7; organized by Ursula Prinz and Eberhard Roters. Längsschnitte, 4. Includes Brehmer, Gosewitz, Hacker, ter Hell, Hödicke, Rosz, Schmit, Schön, and Vostell.

Fra Galerie Køpcke til i Dag: En Linie i Dansk Nutidskunst og dens Udenlandske Relationer. Nikolaj, Kommunes Udstillningsbygning, Copenhagen, May 10–June 6, and Aarhus Kunstmuseum, Århus, June 26–August 15; organized by Kristian Jakobsen. Includes Beuys, Kienholz, Koepcke, Spoerri, Vautier, and Vostell.

Werke aus der Sammlung Crex. Kunsthalle, Basel, July 18–September 12; organized by Jean-Christophe Ammann. Includes Baselitz.

In Virtù del Possesso delle Mani: Bernd Koberling, Helmut Middendorf, Bernd Zimmer. Museo Civico d'Arte Contemporanea di Gibellina, July 23–September 6; organized by Demetrio Paparoni.

Bilder sind nicht verboten: Kunstwerke seit der Mitte des 19. Jahrhunderts mit ausgewählten Kultgeräten aus dem Zeitalter der Aufklärung. Städtische Kunsthalle and Kunstverein für die Rheinlande und Westfalen, Düsseldorf, August 28–October 24; organized by Jürgen Harten. Includes Beuys, Kienholz, Rainer, and Spoerri.

10 Jahre Berliner Malerpoeten. Galerie im Rathaus Tempelhof, Berlin, September 13–October 24; organized by Aldona Gustas. Berlin: Kunstamt Berlin-Tempelhof, 1982.

1962 Wiesbaden FLUXUS 1982: Eine kleine Geschichte von Fluxus in drei Teilen. Museum Wiesbaden, Nassauischer Kunstverein, and Harlekin Art, Wiesbaden, September 14–November 14, and tour including the DAAD Galerie, Berlin, January 21–April 24, 1983; organized by René Block. Three concerts under the title "The Spirit of Fluxus" were given in conjunction with the exhibition in the Amerikahaus, Berlin, February 16–18, 1983. Catalogue edited by Réne Block and Anne Marie Freybourg; includes an illustrated history of Fluxus, 1962–82; Wiesbaden: Harlekin Art, and Berlin: DAAD, 1983. Includes Beuys, Gosewitz, Koepcke, Schmit, Vautier, Vostell, and Williams.

Deutsche Zeichnungen der Gegenwart/Contemporary German Drawings. Museum Ludwig, Cologne, September 24–November 14, and tour; organized by Christoph Brockhaus. Cologne: Lufthansa, 1982. Also issued in a Spanish/Portuguese ed. as *El Dibujo Contemporáneo Alemân/Desenhos Contemporâneos Alemaes.* Includes Baselitz, Beuys, and Höckelmann.

Berlin: La rage de peindre. Musée Cantonal des Beaux-Arts, Lausanne, September 29–November 12; organized by Erika Billeter. German translation published as *Berlin: Das malerische Klima einer Stadt* (Bern: Benteli, 1982). Includes Fetting, Hödicke, Koberling, Lüpertz, Middendorf, and Salomé, from the collection of Peter Pohl and Hans Hermann Stober.

Kunst wird Material. Nationalgalerie, Staatliche Museen Preussischer Kulturbesitz, Berlin, October 7–December 5; organized by Dieter Honisch, Michael Pauseback, and Britta Schmitz. Includes Beuys, Kaprow, and Vostell.

Gefühl & Härte: Neue Kunst aus Berlin. Kunstverein, Munich, October 8–November 14; organized by Ursula Prinz and Wolfgang Jean Stock. Catalogue by Ursula Prinz; Berlin: Frölich & Kaufmann, 1982. Includes Chevalier, Fetting, ter Hell, Middendorf, Salomé, and Zimmer.

Drei Berliner Maler: Ter Hell, Reinhard Pods, Gerd Rohling. Galleria Peccolo, Livorno, October 9; organized in collaboration with the Goethe-Institut, Genoa. Catalogue includes a chronology of artistic events in Berlin, 1960–82.

Zeitgeist: Internationale Kunstausstellung Berlin 1982. Martin-Gropius-Bau, Berlin, October 15, 1982–January 16, 1983, organized by Christos M. Joachimides and Norman Rosenthal. Berlin: Frölich & Kaufmann, 1982. English translation published as *Zeitgeist: International Art Exhibition Berlin 1982* (New

York: Braziller, 1983). Includes Baselitz, Beuys, Borofsky, Fetting, Hacker, Höckelmann, Hödicke, Koberling, Lüpertz, McLean, Middendorf, Morley, and Salomé.

Stadt und Utopie: Modelle idealer Gemeinschaften. Neuer Berliner Kunstverein in the Staatliche Kunsthalle, Berlin, October 22–November 28; organized by Lucie Schauer. Berlin: Frölich & Kaufmann, 1982.

La Giovane Transavanguardia Tedesca. Ex Silos Molino Forno, Piazzale Calcigni, San Marino, October 31–December 12; organized by Achille Bonito Oliva for ASART (Associazione degli Artisti) and the Galleria Nazionale d'Arte Moderna, San Marino. Includes Barfuss, Fetting, Middendorf, Salomé, Wachweger, and Zimmer.

Junge Kunst in Deutschland—Privat Gefördert. Kölnischer Kunstverein, Cologne, November 13, 1982–January 9, 1983; Nationalgalerie, Berlin, January 20–February 20, 1983; and tour through May 29, 1983; organized by Dieter Honisch. Berlin: "Kunstbuch Berlin" im Rembrandt Verlag, 1982.

La Giovane Pittura in Germania/Die Junge Malerei in Deutschland. Galleria d'Arte Moderna, Bologna, November 20, 1982–January 10, 1983; organized by Zdenek Felix. Casalecchio di Reno: Grafis, 1982. Includes Fetting, Kippenberger, Middendorf, and Salomé.

1983

25 Mladih Nemskih Slikarjev. Moderna Galerija, Ljubljana, 1983. Includes Salomé.

Kunst, Landschaft, Architektur: Architekturbezogene Kunst in der Bundesrepublik Deutschland. International tour; organized by Dieter Honisch. Catalogue by Robert Häusser and Dieter Honisch; Stuttgart: Institut für Auslandsbeziehungen, 1983. Includes Thieler.

Mensch und Landschaft in der zeitgenössischen Malerei und Graphik aus der Bundesrepublik Deutschland. Moscow, Leningrad. Düsseldorf: Kunstverein für die Rheinlande und Westfalen, 1983. Includes Baselitz, Hödicke, Lüpertz, and Middendorf.

Hans Peter Adamski, Siegfried Anzinger, Elvira Bach, Martin Disler, Georg Jiri Dokoupil, Claude Sandoz, Andreas Schulze, Stefan Szczesny, Volker Tannert, Bernd Zimmer. Galerie Pfefferle, Munich, January 1983; organized by Karl Pfefferle. Munich: Edition Pfefferle, 1983.

Für Rupprecht Geiger: Günter Fruhtrunk, Raimund Girke, Gotthard Graubner, Erwin Heerich, Ernst Hermanns, Konrad Klapheck, Norbert Kricke, Alf Lechner, Heinz Mack, Gerhard Richter, Reiner Ruthenbeck, Emil Schumacher, Günther Uecker. Galerie der Künstler, Munich, January 18–February 13; organized by Wolfger Pöhlmann and Walter Storms. Munich: Kulturreferat der Landeshauptstadt, 1983.

New Figuration: Contemporary Art from Germany. Frederick S. Wight Art Gallery, University of California, Los Angeles, January 18–February 13; organized by Donald B. Kuspit. Includes Baselitz, Hödicke, Lüpertz, Middendorf, and Salomé.

Salomé, Luciano Castelli, Rainer Fetting: Peintures, 1979–1982. CAPC, Musée d'Art Contemporain, Bordeaux, January 31–March 15.

Der Hang zum Gesamtkunstwerk: Europäische Utopien seit 1800. Kunsthaus, Zurich, February 11–April 30, and tour; organized by Harald Szeemann. Aarau and Frankfurt am Main: Verlag Sauerländer, 1983. A supplement was published for the showing at the Orangerie of Schloss Charlottenburg and the DAAD Galerie, Berlin, December 22, 1983–February 19, 1984; organized by René Block and Anne Marie Freybourg (Berlin: DAAD, 1983). Includes Beuys (and Filliou in Paris).

Als Beispiel Edition Hundertmark. Karl Ernst Osthaus Museum, Hagen, February 26–April 3; organized by Johann Heinrich Müller. Includes Beuys, Brus, Gosewitz, Höckelmann, Schmit, and Vautier.

New Painting from Germany: Georg Baselitz, Rainer Fetting, Karl Horst Hödicke, Jörg Immendorf, Bernd Koberling, Markus Lüpertz, Helmut Middendorf, A. R. Penck, Sigmar Polke, Salomé, Bernd Zimmer. Tel Aviv Museum, March 15–May 14; organized by Nehama Guralnik.

Grosstadtdschungel: Neuer Realismus aus Berlin: Zeichnungen von Peter Sorge, Klaus Vogelgesang: Photo-

graphien von Elfi Fröhlich, Wolfgang Krolow, Karl-Ludwig Lange, Thomas Leuner, Hans W. Mende, Miron Zownir. Kunstverein, Munich, March 18–May 1; organized by Wolfgang Jean Stock.

L'Italie & L'Allemagne: Nouvelles sensibilités, nouveaux marchés: Gravures de Chia, Paladino, Cucchi, Clemente, Baselitz, Penck, Lüpertz, Immendorff. Cabinet des Estampes, Musée d'Art et d'Histoire, Geneva, March 25–May 22; organized by Rainer Michael Mason.

Quergalerie: Lilli Engel, Ricarda Fischer, Fritz Gilow, Raffael Rheinsberg, Axel Schaefer, Matthias Wagner, Susanne Wehland, Sverre Wyller. Neuer Berliner Kunstverein, Berlin, April 9–May 14.

Todesbilder in der zeitgenössischen Kunst: Mit einem Rückblick auf Hodler und Munch. Kunstverein, Hamburg, April 23–June 5, and Städtische Galerie im Lenbachhaus, Munich, August 9–September 11; organized by Günther Gercken and Uwe M. Schneede. Includes Beuys and Brus.

Brandung: Reise an den Strand eines erfundenen Meeres: Reinhard v.d. Marwitz, Peter Herbrich, Thomas Lange. Galerie im Kutscherhaus, Berlin, May 1–15. Berlin: Albino, 1983.

Egal, Hauptsache gut—Qu'importe, si c'est bien! Une exposition à l'occasion à 20e anniversaire de l'Office franco-allemand pour la Jeunesse/Eine Ausstellung zum 20jährigen Bestehen des Deutsch-Französischen Jugendwerks. Exhibition held in seven museums in Bonn, May 8–June 19, and at the Parc Chanot, Marseilles, July 2–August 7. Bad Honnef: Office Franco-Allemande pour la Jeunesse/Deutsch-Französisches Jugendwerk, 1983. Includes Kummer and Pitz.

Informel: Symposion Informel; Die Malerei der Informellen Heute. Moderne Galerie des Saarland Museums, Saarbrücken, May 8–June 19; organized by Georg-W. Költzsch. Catalogue of the symposium held October 8–12, 1982, and of the exhibition. Includes Thieler.

De Statua: An Exhibition on Sculpture. Stedelijk Van Abbemuseum, Eindhoven, May 9–June 19; organized by R. H. Fuchs. Includes Baselitz, Beuys, and Lüpertz.

Bücher, Bilder, Objekte aus der Sammlung Reiner Speck: To the Happy Few. Museum Haus Lange and Museum Haus Esters, Krefeld, May 15–July 10; organized by Marianne Stockebrand and Volker Döhne. Krefeld: Krefelder Kunstmuseen, 1983. Includes Beuys and Brus.

Expressions: New Art from Germany. Saint Louis Art Museum, June–August, and tour; organized by Jack Cowart. Munich: Prestel-Verlag in Association with the Saint Louis Art Museum, 1983. Includes Baselitz and Lüpertz.

Künstler-Räume im Kunstverein und Anderswo. Kunstverein, Hamburg, June 19–July 31; organized by Uwe M. Schneede. Includes Metzel, Rosz, and Schön.

Bilder der Angst und der Bedrohung: Neuerwerbungen aus den achtziger Jahren. Graphische Sammlung, Kunsthaus, Zurich, August 12–October 23; organized by Ursula Perruchi-Petri. Includes Borofsky.

Schauplatz: Kunst-Raum-Projekt-Berlin. Neuer Berliner Kunstverein, Berlin, September 4–October 2; organized by Wolfgang Waclaw.

Umfeld Bethanien. Künstlerhaus Bethanien, Berlin, a series of six exhibitions, September 8, 1983–May 20, 1984; organized by Walter Aue. Berlin: Publica, 1985.

Neue Malerei in Deutschland. Nationalgalerie, Berlin, September 10–October 30, and tour. Catalogue of the "Dimension IV" competition and exhibition sponsored by Philip Morris GmbH; edited by Jürgen Harten, Dieter Honisch, and Hermann Kern; Munich: Prestel-Verlag, 1983. Includes ter Hell (first-prize winner).

Modern Nude Paintings, 1880–1980. National Museum of Art, Osaka, October 7–December 4. Includes Baselitz, Castelli, Hamilton, and Salomé.

Transit: Berliner Künstler in Düsseldorfer Galerien. Artists present in 11 galleries in Düsseldorf, October 15; organized by Heinz Ohff. Includes Stöhrer (Galerie Art in Progress Valeska Hepper, October 13–November 22) and Chevalier, Hödicke, Koberling, Middendorf, and Zimmer ("Kontext-Kontest," Galerie Gmyrek, October 14–November 19).

Gifts from 31 Artists from the Federal Republic of Germany: Gifts of the Artists with the Cooperation of the Institute for Foreign Relations, Stuttgart. National Gallery of Modern Art, New Delhi, October 25–November 13; organized by Laxmi P. Sihare. Includes Baselitz.

Berliner Maler zu Gast im ZDF. ZDF-Kasino, Mainz-Lerchenberg. November 11–December 11; organized by Bernd Tönnessen. Includes Barfuss, Chevalier, ter Hell, Koberling, Stöhrer, Wachweger, and Zimmer.

Sculpture from Germany. San Francisco Museum of Modern Art, December 9, 1983–February 5, 1984, and tour; organized by Michael R. Klein, Independent Curators Incorporated, New York. Includes Beuys.

Electra: L'électricité et l'électronique dans l'art au XXe siècle/Electricity and Electronics in the Art of the XXth Century. Musée d'Art Moderne de la Ville de Paris, December 10, 1983–February 5, 1984; organized by Frank Popper. Includes Beuys and Vostell.

1984

Kunst aus Berlin, 1984. Gesellschaft für aktuelle Kunst, Bremen; organized by the Galerie Georg Nothelfer, Berlin. Includes Stöhrer, Thieler, and Zimmer.

Cross Section/Querschnitt: Galerie Poll, Berlin. Goethe-Institut, London, January, and tour; organized by Eva and Lothar C. Poll. Includes Hödicke.

Rationalisierung 1984. Staatliche Kunsthalle and Neue Gesellschaft für bildende Kunst, Berlin, January 1–February 8. Catalogue edited by Ricarda Buch.

Materialien, Elemente, Ideen. Berlinische Galerie, Berlin, January 17–April 2; organized by Tino Bierling et al.

Sammlung Metzger: Zeitgenössische Malerei aus der Bundesrepublik Deutschland/Metzger Gyujtemény: Kortárs Festészet a Németországi Szovetségi Koztársaságból. Kunsthalle Budapest/Mucsarnok Budapest, January 24–February 26; organized by Zdenek Felix. Essen: Museum Folkwang, 1984. Includes Barfuss, Fetting, Kippenberger, Middendorf, and Zimmer.

Berlin '84 Malerei: Klazina Boer, Thuur Camps, Jürgen Frisch, John Noel Smith, Jan Erik Willgohs. Galerie Garage, Berlin, January 29–March 4.

7 Positionen: Arbeitsstipendiaten 1982: Matthias Hollefreund, Hermann Kiessling, Raimund Kummer, Hans W. Mende, Helga Möhrke, Marianne Pohl, Hanefi Yeter. Haus am Waldsee, Berlin, February 4–March 11; organized by Thomas Kempas.

Wahrheit ist Arbeit. Museum Folkwang, Essen, February 4–March 11; organized by Zdenek Felix. Includes Kippenberger.

Symbol Tier. Galerie Krinzinger and Forum für aktuelle Kunst, Innsbruck, February 14–March 17; organized by Ursula Krinzinger. Includes Beuys, Fox, Rainer, and Spoerri.

Zwischen Plastik und Malerei. Kunstverein, Hannover, February 4–March 18, and Haus am Waldsee, Berlin, March 30–May 13; organized by Thomas Kempas and Katrin Sello. Includes Brus.

Art & Andrology, 1: On the Occasion of the 3rd International Symposion of Operative Andrology. Galerie Wewerka, Berlin, March; organized by Michael Wewerka and Alpay Kelâmi. Catalogue edited by Michael Schultz; texts by Alpay Kelâmi and Dieter Biewald; Berlin: Galerie Wewerka Edition, 1984. Includes Vostell.

Deutsche Landschaft Heute. Neuer Berliner Kunstverein in Schloss Charlottenburg, Berlin, March 10–April 22, and Schloss Herrenhausen, Hannover, April 28–June 3. Hamburg: ART, Das Kunstmagazin, 1984. Includes Hödicke.

Écritures dans la peinture. Villa Arson, Nice, April–June. 2 vols. Nice: Centre National des Arts Plastiques, Villa Arson, 1984. Includes Vautier and Vostell.

Ursprung und Vision: Neue Deutsche Malerei. Centre Cultural de la Caixa de Pensions, Barcelona, April 5–May 6, with title *Origen i Visió: Nova Pintura Alemanya* (Barcelona: Fundacio Caixa de Pensions, 1984); Palacio Velázquez, Madrid, May 2–June 29, with title: *Origen y Visión: Nueva Pintura Alemana* (Madrid: Ministerio de Cultura, Direccion General de Bellas Artes y Archivos, 1984); organized by Christos M. Joachimides. Berlin: Frölich & Kaufmann,

1984. Includes Baselitz, Chevalier, Fetting, Hacker, Hödicke, Koberling, Lüpertz, and Middendorf.

Die Stipendiaten der Karl Schmidt-Rottluff Förderungsstiftung: Arbeiten auf Papier, Skulpturen. Brücke-Museum, Berlin, April 7–May 13; organized by Leopold Reidemeister and Klaus Heinrich Kohrs. Berlin: Karl Schmidt-Rottluff Förderungsstiftung, 1984. Includes Schön and Zimmer.

Paravents. Schloss Lörsfield, May 5–June 18; organized by Jule Werner. Includes Höckelmann and Lüpertz.

Nackt in der Kunst des 20. Jahrhunderts: Gemälde, Skulpturen, druckgraphische Werke, Videofilme und Performances. Sprengel-Museum, Hannover, May 6–July 1; organized by Udo Liebelt. Includes Castelli, Fetting, and Salomé.

An International Survey of Recent Painting and Sculpture. The Museum of Modern Art, New York, May 17–August 19; organized by Kynaston McShine. Includes Armando, Baselitz, Borofsky, Castelli, Fetting, Hödicke, Koberling, Lüpertz, McLean, Middendorf, Morley, Paolini, Raetz, Salomé, and Zimmer.

Kunst und Medien. Staatliche Kunsthalle, Berlin, May 22–June 17; organized by the Staatliche Kunsthalle, Berlin, and the Bundesverband Bildender Künstler, Bonn. Berlin: Publica, 1984.

Nudes/Nus/Nackte. Galerie Beyeler, Basel, June–August. Includes Baselitz, Beuys, Fetting, and Salomé.

Neue Malerei—Berlin. Kestner-Gesellschaft, Hannover, June 1–July 29; organized by Carl Haenlein. Includes Barfuss, Chevalier, Fetting, ter Hell, Middendorf, Salomé, Wachweger, and Zimmer.

Kunstlandschaft Bundesrepublik: Junge Kunst in deutschen Kunstvereinen. Exhibition, *Region Berlin*, held in 11 cities in Germany, June 3–August 26; organized by Annie Bardon, Thomas Kubisch, Hannes Maier-Hohenstein, Josef Mayer, and Tilman Osterwold. Catalogue edited by Sibylle Maus; 11 vols. Stuttgart: Klett-Cotta, 1984. Includes Hacker, ter Hell, Metzel, Rosz, Salomé, Schön, Stöhrer, Thieler, and Zimmer.

Artistic Collaboration in the Twentieth Century. Hirshhorn Museum and Sculpture Garden, Washington, D.C., June 9–August 19, and tour through January 15, 1985; organized by Cynthia Jaffee McCabe. Washington, D.C.: Smithsonian Institution Press, 1984. Includes Beuys, Castelli, Hamilton, and Salomé.

Positionen Berlin (w. = weiblich). Frauen Museum, Bonn, June 15–August 15; organized by Gisela Eckhardt and Rita Sartorius.

Sammlung Stahl: Realisten in Berlin. Berlinische Galerie, Berlin, June 27–September 16.

1984: Sechs Installationen. Neuer Berliner Kunstverein, Berlin, June 30–August 18.

Bella Figura: Eine Skulpturen-Ausstellung. Wilhelm-Lehmbruck-Museum, Duisburg, July 1–September 2, organized by Karl-Egon Vester. Includes Baselitz, Höckelmann, and Lüpertz.

Échanges: Artistes français à Berlin, 1964–1984. Goethe-Institut, Paris, September; organized by René Block. Catalogue in French and German edited by Odile Vassas; Berlin: DAAD, 1984. Includes Gette and Vautier.

Sorgfalt '84: Positionen deutscher Kunst seit 1945: Ein imaginäres Museum für Rottweil. Halle am Stadion, Rottweil, September 8–October 7, organized by Manfred de la Motte. Rottweil: Haup amt, Stadtverwaltung Rottweil, 1984. Includes Stöhrer and Thieler.

German Painting of Today: New Expressionists. Hara Museum of Contemporary Art, Tokyo, September 8–October 14, and Otani Memorial Art Museum, Nishinomiya City, November 18–December 16. Catalogue of an exhibition of works from the collection of Dr. Peter Ludwig; Tokyo: Fondation Arc-en-Ciel, 1984. Includes Baselitz, Fetting, and Lüpertz.

La Métropole retrouvée: Nouvelle peinture Berlin. Société des Expositions du Palais des Beaux-Arts, Brussels, September 21–November 4, and Service Culturel de Bayer AG, Leverkusen, November 18–December 16; organized by Christos M. Joachimides. Brussels: Palais des Beaux-Arts, and Berlin: Weidenfeld Kunstbuch, 1984; also published in German as *Die*

wiedergefundene Metropole: Neue Malerei in Berlin (Berlin: Frölich & Kaufmann, 1984). Includes Barfuss, Chevalier, Fetting, Hacker, Hödicke, Koberling, Middendorf, Salomé, Wachweger, and Zimmer.

Von hier aus: Zwei Monate neuer deutscher Kunst in Düsseldorf. Messegelände, Düsseldorf, September 29–December 2; organized by Kasper König for the Gesellschaft für Aktuelle Kunst, Düsseldorf. Cologne: DuMont, 1984. Includes Barfuss, Baselitz, Beuys, Brecht, Fetting, Filliou, Gosewitz, Höckelmann, Kippenberger, Lüpertz, Metzel, Salomé, Schmit, and Wachweger.

Content: A Contemporary Focus, 1974–1984. Hirshhorn Museum and Sculpture Garden, Washington, D.C., October 4, 1984–January 6, 1985; organized by Howard N. Fox, Miranda McClintic, and Phyllis Rosenzweig. Washington, D.C.: Smithsonian Institution Press, 1984. Includes Borofsky, Burgin, Kienholz, Lüpertz, and Morley.

Upheavals: Manifestos, Manifestations: Conceptions in the Arts at the Beginning of the Sixties: Berlin, Düsseldorf, Munich/Aufbrüche: Manifeste, Manifestationen: Positionen in der bildenden Kunst zu Beginn der 60er Jahre in Berlin, Düsseldorf und München. Städtische Kunsthalle, Düsseldorf, October 12–November 25; organized by Klaus Schrenk. Cologne: DuMont, 1984. Includes Baselitz, Beuys, Höckelmann, Hödicke, Koberling, Lüpertz, and Schönebeck.

La Raffinerie du Plan K: Die 3. + 4. Dimension: Installation, Skulptur, Performance. Brussels, November 13–30; organized by Frank Barth. Catalogue in French and German; Brussels: Goethe-Institut and Berlin: Künstlerhaus Bethanien, 1984. Includes Pitz.

Metaphor and/or Symbol: A Perspective on Contemporary Art. National Museum of Modern Art, Tokyo, November 23, 1984–January 28, and National Museum of Art, Osaka, February 1–March 10, 1985; organized by Kenji Adachi, Michiaki Kawakita, and Tado Ogura. Includes Chevalier and Middendorf.

Museumsprobe: Eine Auswahl aus der Sammlung der Berlinischen Galerie. Berlinische Galerie, Berlin, December 6, 1984–April 28, 1985; organized by Ursula Prinz and Eberhard Roters.

Rosenfest Berlin 1984: Worte, Bilder, Musik, Theater. DAAD Galerie and Hebbel-Theater, Berlin, December 14, 1984–January 20, 1985. Catalogue edited by René Block, Anne Marie-Freybourg, and Kurt Thöricht; Berlin: DAAD, 1984. Includes Paolini.

1985

Once artistas de Berlin. Centro Cultural de la Villa, Madrid, 1985; organized by Eva and Lothar C. Poll.

Drawings: 12 Artists from Berlin (A Travelling Exhibition, 1985/86.) Organized by Tina Aujesky and Clemens Fahnemann. Catalogue essay by Wolfgang Max Faust; Berlin: Senator for Cultural Affairs, 1985. Includes Barfuss, Chevalier, Fetting, ter Hell, Metzel, Middendorf, Salomé, and Wachweger.

L'autoportrait à l'âge de la photographie: peintres et photographes en dialogue avec leur propre image/Das Selbstporträt im Zeitalter der Photographie: Maler und Photographen im Dialog mit sich Selbst. Musée Cantonal des Beaux-Arts, Lausanne, January 18–March 24, and Württembergischer Kunstverein, Stuttgart, April 11–June 9; organized by Erika Billeter. Also published by the Württembergischer Kunstverein, Stuttgart, with the titles reversed. Includes Baselitz, Beuys, Castelli, Fetting, Hamilton, Hockney, Hödicke, Lüpertz, Paolini, Salomé, and Vautier.

The European Iceberg: Creativity in Germany and Italy Today. Art Gallery of Ontario, Toronto, February 8–April 7; organized by Germano Celant. Includes Baselitz, Beuys, Lüpertz, Paolini, and Salomé.

Bilder für Frankfurt. Deutsches Architekturmuseum, Frankfurt am Main, February 8–April 14; exhibition of the collection of the Museum für Moderne Kunst, Frankfurt, organized by Susanne Willisch and Rolf Lauter. Catalogue of the collection edited by Peter Iden and Rolf Lauter; Munich: Prestel-Verlag, 1985. Includes Baselitz, McLean, Middendorf, and Stöhrer.

Krankheit und Kranksein in der Gegenwartskunst. Rathaus und Brüder Grimm-Stube, Marburg, March 22–April 28, and tour through December 15; organized by Armin Geus. Includes Beuys.

Raum, Zeit, Stille. Kölnischer Kunstverein, Cologne, March 23–June 2; organized by Wulf Herzogenrath. Includes Beuys.

First Exhibition-Dialogue on Contemporary Art in Europe/Primeira Exposiçã-Diálogo Sobre a Arte Contemporãon na Europa. Centro de Arte Moderna, Fundação Calouste Gulbenkian, Lisbon, March 28–June 16; organized by René Berger. Includes Baselitz, Beuys, Kienholz, Morley, Paolini, Vedova, and Vostell.

Magirus 117: Kunst in der Halle. Installations in Ulm, March 30–May 19; organized by Dorothée Bauerle. Ulm: Ulmer Museum, 1985. Includes Metzel.

Alles und Noch Viel Mehr: Das poetische ABC. Kunsthalle and Kunstmuseum, Bern, April 12–June 2; organized by G. J. Lischka. Bern: Benteli, 1985. Includes Pitz, Raetz, and Schön.

States of War: New European and American Paintings. Seattle Art Museum, April 18–June 23; organized by Bruce Guenther. Includes Baselitz and Fetting.

Intorno al Flauto Magico. Palazzo della Permanente, Milan, April 24–July 21; organized by Giuliana Rovero. Milan: Mazzotta, 1985. Includes Fetting, Hockney, and Paolini.

100 Jahre Kunst in Deutschland, 1885-1985. 28. Internationale Tage, Ingelheim am Rhein, April 28–June 30; organized by François Lachenal and Patricia Rochard. Catalogue also published in English as *100 Years of Art in Germany, 1885–1985.* Includes Baselitz, Beuys, Lüpertz, and Salomé.

7000 Eichen. Kunsthalle, Tübingen, March 2–April 14, and Kunsthalle, Bielefeld, June 2–August 11; organized by Heiner Bastian. Catalogue in English and German; Bern: Benteli, 1985. Includes Beuys, Koberling, McLean, Middendorf, and Salomé.

Rheingold: 40 Künstler aus Köln und Düsseldorf/40 artisti da Colonia e Düsseldorf. Palazzo della Società Promotrice delle Belle Arti, Turin, May 25–June 30; organized by Wulf Herzogenrath and Stephan von Wiese. Cologne: Wienand Verlag, 1985. Includes Beuys.

Representation Abroad. Hirshhorn Museum and Sculpture Garden, Washington, D.C., June 5–September; organized by Joe Shannon. Washington, D.C.: Smithsonian Institution Press, 1985. Includes Castelli and Hockney.

Berliner Aufzeichnungen/Berlin Notes: Ricarda Fischer, Michael Morris, Joachim Peeck, Vincent Trasov, Yana Yo. Walter Phillips Gallery, Banff, Alberta, June 6–30, and tour. Includes a section on artists' books published by Rainer Verlag (Gosewitz, Hödicke, Raetz, Rosz, and Williams).

Deutsche Kunst seit 1960 aus der Sammlung Prinz Franz von Bayern. Staatsgalerie moderner Kunst, Munich, June 20–September 15. Catalogue by Carla Schulz-Hoffmann and Peter-Klaus Schuster, with additions from the collections of the Galerie-Verein, Munich, and the Staatsgalerie moderner Kunst; Munich: Prestel-Verlag, 1985. Includes Baselitz, Beuys, Höckelmann, Lüpertz, and Schönebeck.

Wolfgang Amadeus Mozart—Neue Bilder: Eine internationale Ausstellung. Galerie Thaddaeus Ropac, Salzburg, summer; organized by Thaddaeus Ropac. Catalogue text by Thomas Zaunschirm; Salzburg: Edition Galerie Thaddaeus Ropac, 1985. Includes Castelli, Chevalier, Fetting, Kippenberger, Rainer, Salomé, and Vedova.

Kunst des 20. Jahrhunderts aus privaten Sammlungen im Lande Bremen. Kunsthalle, Bremen, June 30–September 15; organized by Siegfried Salzmann. Includes Armando, Baselitz, Beuys, Brus, Paolini, Rainer, Salomé, and Stöhrer, and Thieler.

Anniottanta. Gallerie Salamon Agustini Algranti, Milan, July 4–September 30; organized by Renato Barilli, Flavio Caroli, Augusto Fanti, Ennio Grassi, and Giuseppe Rossi. Catalogue edited by Carlo Gentili; Milan: Mazzotta, 1985. Includes Castelli, Fetting, Kippenberger, Middendorf, and Salomé.

Vom Klang der Bilder: Die Musik in der Kunst des 20. Jahrhunderts. Staatsgalerie, Stuttgart, July 6–September 22; organized by Karin von Maur. Munich: Prestel-Verlag, 1985. Includes Beuys, Brehmer, Brus, Fox, Gosewitz, Vostell, and Williams.

Quergalerie im Eisstadion. Eisstadion Wedding, Berlin, July 23–August 11. Includes Schön.

Moritzplatz. Bonner Kunstverein, Bonn, August 24–September 21, and tour; organized by Stephan Schmidt-Wulffen. Includes Castelli, Fetting, Middendorf, Salomé, and Zimmer.

Elementarzeichen: Urformen visueller Information. Staatliche Kunsthalle, Berlin, August 31–October 6; organized by Inken Nowald and Lucie Schauer for the Neuer Berliner Kunstverein. Berlin: Frölich & Kaufmann, 1985. Includes Beuys, Raetz, and Schön.

30 Jahre Karl-Hofer-Gesellschaft, 5 Jahre nach der Wiedergründung. Kunstquartier Ackerstrasse, Berlin, September 6–29, and DSL Bank, Bonn, October 16–November 17; organized by Hermann Wiesler. Includes Fetting, Middendorf, and Schönebeck.

Apokalypse: Ein Prinzip Hoffnung?: Ernst Block zum 100. Geburtstag. Wilhelm-Hack-Museum, Ludwigshafen am Rhein, September 8–November 17; organized by Bernhard Holeczek and Richard W. Gassen. Heidelberg: Edition Braus, 1985. Includes Beuys, Borofsky, Fetting, and Lüpertz.

Dreissig Jahre durch die Kunst: Museum Haus Lange, 1955–85. Museum Haus Lange and Museum Haus Esters, Krefeld, September 15–December 1, 1985; organized by Gerhard Storck. 2 vols. Krefeld: Krefelder Kunstmuseen, 1985. Includes Beuys and Christo.

Zoographie: Tiere in der zeitgenössischen Kunst. Galerie Gmyrek, Düsseldorf, September 27–November 2. Includes Beuys, Brus, Hödicke, McLean, and Middendorf.

1945–1985: Kunst in der Bundesrepublik Deutschland. Nationalgalerie, Staatliche Museen Preussischer Kulturbesitz, Berlin, September 27, 1985–January 21, 1986; organized by Dieter Honisch. Catalogue edited by Lucius Grisebach, Jürgen Schweinebraden, and Freiherr von Wichmann-Eichhorn. Includes Barfuss, Baselitz, Beuys, Castelli, Fetting, Gosewitz, ter Hell, Höckelmann, Hödicke, Kippenberger, Koberling, Koepcke, Lüpertz, Metzel, Middendorf, Rosz, Salomé, Schönebeck, Stöhrer, Thieler, Vautier, Vostell, Wachweger, and Williams.

10X: Arbeitsstipendiaten des Landes Berlin 1984. Galerie im Körnerpark, Berlin, September 29–October 27; organized by Elke Messer. Berlin: Senator für Kulturelle Angelegenheiten and Kunstamt Neuköln, 1985.

Maler interpretieren Die Mauer. Museum Haus am Checkpoint Charlie, Berlin, October; organized by Rainer Hildebrandt. Catalogue of the continuing exhibition of works from the museum's collection; Berlin: Verlag Haus am Checkpoint Charlie, 1985. Includes Vostell.

German Art in the 20th Century: Painting and Sculpture, 1905–1985. Royal Academy of Arts, London, October 11–December 22, and Staatsgalerie, Stuttgart, February 8–April 27, 1986; organized by Christos M. Joachimides, Norman Rosenthal, and Wieland Schmied. Munich: Prestel-Verlag, 1985. Includes Baselitz, Beuys, Hödicke, Koberling, Lüpertz, and Schönebeck.

Räume heutiger Zeichnung: Werke aus dem Basler Kupferstichkabinett. Staatliche Kunsthalle, Baden-Baden, October 12–December 1, and Tel Aviv Museum, January 2–March 8, 1986; organized by Siegmar Holsten. Catalogue texts by Dieter Koepplin, Marie Therese Hurni, and Paul Tanner. Includes Baselitz, Beuys, and Borofsky.

Von der Fläche in den Raum: Micaela Holzheimer, Elke Lixfeld, Barbara Nemitz, Sarah Schumann: Bildwände, Raumobjekte, Installationen. Neuer Berliner Kunstverein in der Orangerie, Schloss Charlottenburg, Berlin, October 19–November 17; organized by Lucie Schauer.

Sip. Berlin. Kunstquartier Ackerstrasse, Berlin, October 20–November 3; organized by the Künstlergruppe Sip. Berlin. Includes Schön.

22 Berliner Realisten. Dominikanerkirche, Osnabrück, November; organized by Leonie Baumann, Evelyn Kuwertz, Hans Schreiber, and Elisabeth Wagner. Berlin: Bildungswerk des Berufsverbandes Bildender Künstler Berlin, 1985.

Bericht 1985: 3 Jahre Ankäufe des Senats. Staatliche Kunsthalle, Berlin, November–December 29; organized by Elke Coldewey, Gabriele Horn, and Dieter Ruckhaberle. Includes Armando, Barfuss, Chevalier, Fetting, Gosewitz, Hacker, ter Hell,

Hödicke, Koberling, McLean, Metzel, Rosz, Salomé, Schmit, Vostell, Wachweger, and Williams.

Wirken und Wirkung: Ein Salut von 80 Künstlern. DAAD Galerie, Berlin, November 19, 1985– January 5, 1986; organized by René Block and Ingrid Bleier. Berlin: DAAD, 1985. Includes Gosewitz, Hacker, Kaprow, and Williams.

Vom Zeichnen: Aspekte der Zeichnung, 1960–1985. Frankfurter Kunstverein, Frankfurt am Main, November 19, 1985–January 1, 1986, and tour through April 27, 1986; organized by Monika Faber, Ingrid Mössinger, and Peter Weiermair. Includes Baselitz, Beuys, Borofsky, Brus, Christo, Gosewitz, Hamilton, Hockney, Höckelmann, Hödicke, Lüpertz, Paolini, Raetz, Schmit, and Vedova.

Das Eiserne Fenster/Het Ijzeren Venster/The Iron Window: Georg Baselitz, Kurt Schwitters, Jan Dibbets, Piet Mondrian, Jannis Kounellis, Kasimir Malevitch. Stedelijk Van Abbemuseum, Eindhoven, December 1985–January 1986; organized by Rudi Fuchs.

Zugehend auf eine Biennale des Friedens: Skulpturen, Bilder, Mailart, Video, akustische Objekte, Installationen: Hamburger Woche für Bildende Kunst 1985. Kunsthaus and Kunstverein, Hamburg, December 1985– January 12, 1986; organized by René Block. Catalogue edited by René Block and Inge Lindemann. Includes Beuys, Brehmer, Christo, Fox, Gette, Kaprow, Koberling, McLean, Metzel, Schön, Vautier, Vostell, and Williams.

The Neo-Figure: An International Survey: 13 Points of View. Yares Gallery, Scottsdale, Arizona, December 5, 1985–January 8, 1986. Includes Fetting and McLean.

Ouverture: Arte Contemporanea. Castello di Rivoli, Turin, December 18, 1985–February 1986; organized by Rudi Fuchs. Includes Armando, Baselitz, Beuys, Brus, Lüpertz, Paolini, Rainer, and Vedova.

1986

Station Berlin: Werke ausländischer Künstler aus der Sammlung der Berlinischen Galerie. Berlinische Galerie, Berlin, January–March 1986; organized by Tino Bierling.

Mater dulcissima. Chiesa dei Cavalieri di Malta, Syracuse, Italy, January 18–February 19; organized by Demetrio Paparoni. Syracuse, Italy: Edizioni Tema Celeste, 1986. Includes Paolini and Vedova.

Wild, Visionary, Spectral: New German Art. Art Gallery of South Australia, Adelaide, February 28–April 20, and tour through August 24; organized by Ron Radford. Catalogue by Ron Radford, Karl Ruhrberg, and Wolfgang Max Faust. Includes Baselitz, Beuys, Fetting, and Hödicke.

Die Maler und das Theater im 20. Jahrhundert. Schirn Kunsthalle, Frankfurt am Main, March 1–May 19; organized by Denis Bablet and Erika Billeter. Includes Brus, Lüpertz, and Vostell.

Images of Shakespeare: Kunst aus Berlin. Kunstforum in der Grundkreditbank, Berlin, April; organized by Renate Brosch for the Deutsche Shakespeare Gesellschaft West on the occasion of the Third International Shakespeare Congress. Includes Barfuss, Chevalier, Fetting, ter Hell, Hödicke, Lüpertz, Middendorf, Salomé, Stöhrer, and Wachweger.

Falls the Shadow: Recent British and European Art: 1986 Hayward Annual. Hayward Gallery, London, April 9–June 15; organized by Barry Barker, Jon Thompson, and Susan Ferleger Brades. London: Arts Council of Great Britain, 1986. Includes Baselitz, Hamilton, Lüpertz, and Paolini.

Das andere Land: Ausländische Künstler in der Bundesrepublik. Grosse Orangerie, Schloss Charlottenburg, Berlin, April 29–May 25, and tour; organized by Liselotte Funcke. Catalogue edited by Peter Spielmann; Berlin: Edition Deplana, 1986. Includes Williams.

Das Bild der Frau in der Plastik des 20. Jahrhunderts. Wilhelm-Lehmbruck-Museum, Duisburg, May 4–June 15; organized by Christoph Brockhaus and Thorsten Rodiek. Includes Beuys, Höckelmann, and Kienholz.

Macht und Ohnmacht der Beziehungen: Werke der Sammlung Museum Baviera, 1955–1986. Museum am Ostwall, Dortmund, May 4–June 15; organized by Silvio R. Baviera. Includes Barfuss, Brecht, Brus,

Hamilton, Hödicke, Kippenberger, Raetz, Rainer, and Wachweger.

De Sculptura. Wiener Festwochen im Messepalast, Vienna, May 16–July 20; organized by Harald Szeemann. Includes Beuys.

Jenisch-Park: Skulptur. Jenisch-Park, Hamburg-Othmarschen, June 1–November 30. Hamburg: Kunstbehörde, 1986. Includes Metzel and Pitz.

Limelight. Udstillingsbygningen ved Charlottenborg, Copenhagen, June 8–July 20; organized by John Hunov. Includes Brecht and Höckelmann.

Malstrom: Bilder und Figuren, 1982–1986: Ralf Kerbach, Helge Leiberg, Hans Scheib, Cornelia Schleime, Reinhard Stangl. Haus am Waldsee, Berlin, June 13–June 27, and Mannheimer Kunstverein, Mannheim, January 11–February 8, 1987.

The Barry Lowen Collection. Museum of Contemporary Art, Los Angeles, June 16–August 10; organized by Ann Goldstein. Catalogue essay by Christopher Knight. Includes Borofsky and Morley.

Chambres d'amis. Museum van Hedendaagse Kunst, Ghent, June 21–September 21; organized by Jan Hoet. Includes Middendorf and Paolini.

Group Show. Annina Nosei Gallery, New York, July. Includes Middendorf.

Berlin aujourd'hui. Musée de Toulon, July 4– September 7; organized by Jean-Rober Soubiran and Joachim Becker. Includes Barfuss, Castelli, Chevalier, Fetting, ter Hell, Metzel, Middendorf, Salomé, and Wachweger.

Zeitspiegel II, 1945–1986. Galerie Pels-Leusden, Berlin, July 7–October 15. Catalogue edited by Verena Tafel. Includes Baselitz, Fetting, ter Hell, Höckelmann, Hödicke, Koberling, Lüpertz, Salomé, Stöhrer, Thieler, and Vostell.

Beuys zu Ehren: Zeichnungen, Skulpturen, Objekte, Vitrinen und das Environment, "Zeige deine Wunde," von Joseph Beuys: Gemälde, Skulpturen, Zeichnungen, Aquarelle, Environments und Video-Installationen von 70 Künstlern. Städtische Galerie im Lenbachhaus, Munich, July 16–November 2; organized by Armin Zweite and Helmut Friedel. Includes Baselitz, Beuys, Brus, Hamilton, Kienholz, Lüpertz, McLean, Paolini, Rainer, and Vedova.

Raumbilder in Bronze: Per Kirkeby, Markus Lüpertz, A. R. Penck. Kunsthalle, Bielefeld, July 20– September 28; organized by Detlev Gretenkort and Ulrich Weisner.

Villa Massimo: Bewerbungen um das Rom-Stipendium 1986. DAAD Galerie, Berlin, August; organized by Anne Marie Freybourg. Berlin: DAAD, 1986. Includes Metzel.

Momente——Zum Thema Urbanität. Kunstverein, Braunschweig, August 3–September 7; organized by Wilhelm Bojescul. Includes Chevalier, Metzel, Middendorf, Pitz, and Zimmer.

Kunst und Sport: Malerei, Graphik und Plastik des 20. Jahrhunderts in Baden-Württemberg. Galerie der Stadt, Stuttgart, August 9–September 14; organized by Brigitte Reinhardt. Includes Salomé.

Das Automobil in der Kunst, 1886-1986: Malerei, Graphik, Skulptur, Happening, Plakat, Karikatur, Photographie, Trivialkunst, Design, Architektur. Haus der Kunst, Munich, August 9–October 5; organized by Reimar Zellar. Munich: Prestel-Verlag, 1986. Includes Beuys, Christo, Kaprow, Kienholz, Kippenberger, and Vostell.

Kunst als Kultur/Art as Culture: Recent Art from Germany. Ezra and Cecile Zilkha Gallery, Center for the Arts, Wesleyan University, Middletown, Connecticut, August 27–October 19; organized by John T. Paoletti. Includes Baselitz.

Die 60er Jahre: Kölns Weg zur Kunstmetropole: Vom Happening zum Kunstmarkt. Kölnischer Kunstverein, Cologne, August 31–November 16; organized by Wulf Herzogenrath. Includes Baselitz, Beuys, Brehmer, Christo, Hamilton, Höckelmann, Hockney, Kaprow, Kienholz, Koberling, Lüpertz, Raetz, Schmit, Vautier, Vostell, and Williams.

Europa/Amerika: Die Geschichte einer künstlerischen Faszination seit 1940. Museum Ludwig, Cologne, September 6–November 30; organized by Siegfried Gohr and Rafael Jablonka. Includes Armando, Baselitz, Beuys, Borofsky, Gosewitz, Höckelmann, Lüpertz, and Vedova.

Der Traum vom Raum: Gemalte Architektur aus 7 Jahrhunderten. Albrecht Dürer Gesellschaft in der Kunsthalle and Norishalle, Nuremberg, September 13–November 23; organized by Kurt Löcher. Marburg: Dr. Wolfram Hitzeroth Verlag, 1986. Includes Lüpertz.

The Window in Twentieth-Century Art. Neuberger Museum, State University of New York, Purchase, September 21, 1986–January 18, 1987, and Contemporary Arts Museum, Houston, April 24–June 29, 1987; organized by Suzanne Delehanty. Includes Christo, Hockney, and Kienholz.

Von Beuys bis Stella: Internationale Graphik des letzten Jahrzehnts im Berliner Kupferstichkabinett. Kupferstichkabinett, Staatliche Museen Preussischer Kulturbesitz, Berlin, September 26–November 11; organized by Alexander Dückers. Includes Armando, Baselitz, Beuys, Castelli, Fetting, Hacker, Hamilton, ter Hell, Höckelmann, Hödicke, Lüpertz, McLean, Middendorf, Rosz, Salomé, and Vostell.

Philadelphia Collects Art since 1940. Philadelphia Museum of Art, September 28–November 30; organized by Mark Rosenthal and Ann Percy. Includes Baselitz, Borofsky, and Christo.

Blaue Dünen irisieren: Ars Viva '86/87: Ausstellung der Förderpreisträger des Kulturkreises im Bundesverband der Deutschen Industrie e.V. Kunsthalle, Bremen, October 4–November 9, and Museum Wiesbaden, December 9, 1986–January 11, 1987; organized by Annette Meyer zu Eissen. Includes Pitz.

Boston Collects Contemporary Painting & Sculpture. Museum of Fine Arts, Boston, October 22, 1986– February 1, 1987; organized by Theodore E. Stebbins, Jr. and Judith Hoos Fox. Includes Baselitz.

Androgyn: Sehnsucht nach Vollkommenheit. Neuer Berliner Kunstverein, Berlin, November 17, 1986–January 4, 1987, and Kunstverein, Hannover, February 7–April 12, 1987; organized by Ursula Prinz. Berlin: Dietrich Reimer Verlag, 1986. Includes Baselitz, Castelli, Paolini, Rosz, and Salomé.

Perspectives 5: New German Art. Portland Art Museum and Oregon Art Institute, Portland, November 18, 1986–January 4, 1987; organized by John S. Weber. Includes Barfuss, Chevalier, and Wachweger.

"Fröhliche Wissenschaft:" Das Archiv Sohm. Staatsgalerie, Stuttgart, November 22, 1986–January 11, 1987; organized by Thomas Kellein. Includes Beuys, Brecht, Brus, Castelli, Christo, Filliou, Gette, Gosewitz, Hamilton, Hockney, Kaprow, Knizak, Koepcke, Rainer, Schmit, Spoerri, Vautier, Vostell, and Williams.

Individuals: A Selected History of Contemporary Art, 1945–1986. Museum of Contemporary Art, Los Angeles, December 10, 1986–January 10, 1987; organized by Julia Brown Turrell. Catalogue edited by Howard Singerman; New York: Abbeville Press, 1986. Includes Beuys and Kienholz.

1987

Mythos Berlin Konzepte: Katalog zur Werkstattausstellung, "Mythos Berlin" 1987. Former Anhalter Station, Berlin, June 13–September 12; organized by Ulrich Baehr, Freya Mülhaupt, and Eberhard Knödler-Bunte. Berlin: Mythos Berlin Ausstellung GmbH, 1986. Includes Vostell.

III. BERLIN

BIBLIOGRAPHIES

Krewson, Margrit B. *Berlin, 750 Years: A Selective Bibliography.* Washington, D.C.: Library of Congress, 1986.

Scholz, Ursula, and Stromeyer, Rainold, eds. *Berlin-Bibliographie (1961 bis 1966) im der Senatsbibliothek Berlin.* Veröffentlichungen der Historischen Kommission zu Berlin, vol. 43, Bibliographien, 4. Berlin and New York: Walter de Gruyter, 1973. Extensive bibliography on Berlin includes articles, dissertations, and exhibition catalogues, but excludes works on individuals.

—. *Berlin-Bibliographie (1967 bis 1977) in der Senatsbibliothek Berlin.* Veröffentlichungen der Historischen Kommission zu Berlin, vol. 58, Bibliographien, 5. Berlin and New York: Walter de Gruyter, 1984.

BOOKS

Akademie der Künste, 1960–1970. Berlin: Gebr. Mann Verlag, 1970.

Akademie der Künste, 1970–1979. 4 vols. Berlin: Akademie der Künste, 1979.

Biewald, Dieter. *Berliner Künstler im Gespräch mit Mir.* Berlin: Nicolai, 1973.

Conradt, Gerd, ed. *Berlin Confrontation: Ford Foundation: Künstler in Berlin/Artists in Berlin/Artistes à Berlin.* Berlin: Presse- und Informationsamt, 1965. Includes Vedova.

Deutscher Akademischer Austauschdienst. *10 Jahre Berliner Künstlerprogramm.* Berlin: DAAD, 1975.

Diehl, Volker, and Hagenberg, Rolands, eds. *Maler in Berlin.* Berlin: Happy-Happy, 1982. Text by Hagenberg; consists of interviews with, statements by, and portraits of artists, dealers, and critics.

Gillen, Eckart; Moortgat, Elisabeth; Riecke, Gerhard; and Geisert, Helmut; eds. *Sammlung Berlinische Galerie: Kunst in Berlin von 1870 bis heute.* Berlin: Berlinische Galerie, 1986.

Gorella, Arwed D.; Poll, Lothar C.; and Sorge, Peter; eds. *Prinzip Realismus: Dokumentation der Ausstellungsreihe 1972–1974.* Berlin: DAAD, in cooperation with the Galerie Poll, 1975. Includes a chronology from 1970–1974 by Lothar C. Poll and reprints of reviews of exhibitions.

Gustas, Aldona, ed. *Berliner Malerpoeten.* Herford and Berlin: Nicolaische Verlagsbuchhandlung, 1974. Introduction by Karl Krolow.

—. *Berliner Malerpoeten: Pittori poeti berlinesi.* Quaderni di poesia. Genoa: Edizioni S. Marco dei Giustiniani, 1977. Introduction by Egon Graf Westerholt.

Hildebrandt, Rainer. *Die Mauer Spricht/The Wall Speaks.* 4th ed. Berlin: Verlag Haus am Checkpoint Charlie, 1985. Catalogue of paintings on the Berlin Wall. 1st ed. published 1982.

Höcker, Karla. *Gespräche mit Berliner Künstlern.* Berlin: Stapp, 1964.

Irmscher, Christel; Lang, Siegfried K.; and Schulz, Wolfgang; eds. *748 Jahre Berlin: Kunst und Kultur 1985.* Göttingen: Fotografie-Verlag, 1985. Surveys contemporary art, artists, and art institutions in West Berlin.

Klotz, Heinrich. *Die Neuen Wilden in Berlin.* Stuttgart: Klett-Cotta, 1984.

Kummer, Raimund; Pitz, Hermann; and Rahmann, Fritz. *Büro Berlin: Ein Produktionsbegriff.* Berlin: Künstlerhaus Bethanien, 1986. With essays by Uwe M. Schneede and Wolfgang Siano. Includes ter Hell, Metzel, Middendorf, Pitz, Schön, and Vautier.

Kunst in Berlin, 1945 bis Heute: Literatur, Theater, Film, Foto, Musik, Malerei, Skulptur, Architektur, Akademie der Künste. Stuttgart: Belser Verlag, 1969. Includes Baselitz, Beuys, Brehmer, Lüpertz, Thieler, Vedova, and Vostell.

Pretzell, Rainer, ed. *Zwanzig Jahre Rainer Verlag: Eine Anthologie.* Berlin: Rainer Verlag, 1986. Includes Baselitz, Brehmer, Gosewitz, ter Hell, Hödicke, Kippenberger, Koberling, Middendorf, Raetz, Rosz, Vautier, Williams, and Zimmer.

—. *Zwei Jahrzehnte Rainer Verlag: Ein Almanach.* Berlin: Rainer Verlag, 1986. Includes Baselitz, Brehmer, Gosewitz, ter Hell, Hödicke, Kippenberger, Middendorf, Raetz, Rosz, Vautier, Williams, and Zimmer.

Schauer, Lucie, and Bremer, Rosemarie. *10 Jahre NBK: Bilanz und Rechenschaft aus Berlin.* Berlin: Neuer Berliner Kunstverein, 1979.

Storch, Wolfgang, ed. *Geländewagen, 1: Berlin.* Berlin: Verlag Ästhetik und Kommunikation, 1979. Includes Hödicke, Koberling, Middendorf, Salomé, and Zimmer.

PERIODICALS

Berlin in Geschichte und Gegenwart: Jahrbuch des Landesarchivs Berlin. Berlin: Landesarchiv Berlin, 1982–.

Berliner Kunstblatt. Berlin: Interessengemeinschaft Berliner Kunsthändler, 1972–84. Continued by *Kunstblatt.*

Berlins kulturelles Jahr. Berlin: Presse- und Informationsamt des Landes Berlin, 1977–.

Berliner Künstler der Gegenwart. Berlin: Neuer Berliner Kunstverein, 1971–.

Kunstblatt: Informationsmagazin über die Kunst in Berlin. Berlin: Interessengemeinschaft Berliner Kunsthändler, 1985–. Continues *Berliner Kunstblatt.*

"Kunstszene Berlin '85." Special issue of *Das Kunstwerk,* vol. 38, nos. 4/5 (September 1985).

NYB: New York Berlin. New York: Sound Art Foundation, 1985–.

"748 Jahre Berlin: Kunst und Kultur 1985: Erster Teil." Special issue of *Fotografie: Zeitschrift für Kultur Jetzt,* no. 39 (September/October 1985).

IV. GENERAL

BOOKS

Block, René. *Grafik des kapitalistischen Realismus: KP Brehmer, Hödicke, Lueg, Polke, Richter, Vostell: Werkverzeichnise bis 1971.* Berlin: Edition René Block, 1971.

Bonito Oliva, Achille. *Dialoghi d'artista: Incontri con l'arte contemporanea, 1970–1984.* Milan: Electa, 1984. Includes Beuys, Fox, and Paolini.

Caroli, Flavio. *Magico primario: L'arte degli anni ottanta.* Milan: Gruppo Editoriale Fabbri, 1982. Includes Baselitz, Borofsky, and Castelli.

Claus, Jürgen. *Expansion der Kunst: Beiträge zur Theorie und Praxis öffentlicher Kunst.* Frankfurt am Main and Berlin: Verlag Ullstein, 1982. Includes Vostell.

—. *Treffpunkt Kunst: Gegenwart und Zukunft des Schöpferischen in Natur, Medien, Politik.* Bonn: Keil Verlag, 1982. Includes Beuys, Kienholz, and Vostell.

Damus, Martin. *Funktionen der bildenden Kunst im Spätkapitalismus: Untersucht anhand der avantgardistischen Kunst der sechziger Jahre.* Frankfurt am Main: Fischer Taschenbuch Verlag, 1973. Includes Beuys, Christo, Kaprow, and Vostell.

Dienst, Rolf-Gunter. *Deutsche Kunst: Eine neue Generation.* Cologne: DuMont Schauberg, 1970.

—. *Noch Kunst: Neuestes aus deutschen Ateliers.* Düsseldorf: Droste Verlag, 1970. Includes Beuys.

—. *Pop-Art: Eine kritische Information.* Wiesbaden: Limes Verlag, 1965. Includes Hamilton, Hockney, and Vostell.

Dückers, Alexander. *Erste Konzentration: Georg Baselitz, Antonius Höckelmann, Jörg Immendorff, Per Kirkeby, Markus Lüpertz, A. R. Penck.* Munich: Maximilian Verlag, Sabine Knust, 1982. Catalogue of an edition of prints by the artists.

Eichler, Richard W. *Viel Gunst für schlechte Kunst: Kunstförderung nach 1945.* Munich: J. F. Lehmanns Verlag, 1968. Includes Baselitz, Beuys, Hödicke, Stöhrer, Thieler, and Vostell.

Electronic Art: Elektronische und elektrische Objekte und Environments: Neon Objekte: Kalender 69. Düsseldorf: Verlag Kalender, 1969. Includes Raetz and Vostell.

Evers, Ulrika. *Deutsche Künstlerinnen des 20. Jahrhunderts: Malerei, Bildhauerei, Tapisserie.* Hamburg: Ludwig Schultheis Verlag, 1983.

Faust, Wolfgang Max. *Das Bilderbuch.* Grünwald: Edition Pfefferle, 1981. A collection of offset lithographs by 25 German, Austrian, and Swiss artists, with biographies, bibliographies, and an essay by Faust.

—, and de Vries, Gerd. *Hunger nach Bildern: Deutsche Malerei der Gegenwart.* Cologne: DuMont, 1982.

Fischer, Alfred M., and van der Borch, Agnes. *100 Arbeiten auf Papier aus der Graphischen Sammlung des Museums Ludwig mit Bestandsverzeichnis der Zeichnungen.* Cologne: Museum Ludwig, 1986. Includes Baselitz, Beuys, Christo, Hamilton, Höckelmann, Hockney, Lüpertz, and Vostell.

—, ed. *Städtisches Kunstmuseum Bonn: Sammlung deutscher Kunst seit 1945.* 2 vols. Bonn: Städtisches Kunstmuseum, 1983.

Franzke, Andreas. *Skulpturen und Objekte von Malern des 20. Jahrhunderts.* Cologne: DuMont, 1982. Includes Baselitz, Hamilton, and Lüpertz.

Freeman, Phyllis; Himmel, Eric; Pavese, Edith; and Yarowsky, Anne, eds. *New Art.* New York: Harry N. Abrams, 1984.

Godfrey, Tony. *The New Image: Painting in the 1980s.* Oxford: Phaidon, 1986.

Gohr, Siegfried, ed. *Museum Ludwig Köln: Gemälde, Skulpturen, Environments vom Expressionismus bis zur Gegenwart.* 2 vols. Vol. 1 published in English as *Museum Ludwig Cologne: Paintings, Sculptures, Environments. From Expressionism to the Present Day.* Munich: Prestel-Verlag, 1986.

Graevinitz, Antje van; Hoekstra, J. A.; and Kuipers, J. *Kunst Nu in het Groninger Museum: Aanwinsten, 1978–1982/Kunst unserer Zeit im Groninger Museum: Neuerwerbungen, 1978–1982.* Groningen: Martini Pers, 1982. Includes Armando, Baselitz, Paolini, and Zimmer.

Groh, Klaus, ed. *If I had a mind . . . (Ich stelle mich vor . . .): Concept-Art, Project-Art.* Cologne: Dumont Schauberg, 1971. Includes Christo.

Grohmann, Will, ed. *New Art around the World.* New York: Abrams, 1966. Translation of *Kunst unserer Zeit* (Cologne: DuMont Schauberg, 1966).

Gruber, Bettina, and Vedder, Maria. *Kunst und Video: Internationale Entwicklung und Künstler.* Cologne: DuMont, 1983. Includes Fox and Vostell.

Haase, Amine. *Gespräche mit Künstlern.* Cologne: Wienand Verlag, 1981. Includes Baselitz and Beuys.

Hermand, Jost. *Pop International: Eine kritische Analyse.* Frankfurt am Main: Athenäum-Verlag, 1971. Includes Beuys, Hamilton, Hockney, Kaprow, Vautier, Vostell, and Williams.

Herzogenrath, Wulf, ed. *Selbstdarstellung: Künstler über Sich.* Düsseldorf: Droste, 1973. Includes Beuys.

Jensen, Jens Christian, ed. *Druckgraphische Mappenwerke nach 1945 im Besitz der Kunsthalle zu Kiel, Graphische Sammlung: Bestandskatalog.* Kiel: Kunsthalle zu Kiel, 1986. Includes entries for Baselitz, Beuys, Höckelmann, Koberling, Lüpertz, Middendorf, and Vostell.

Kiffl, Erika. *Künstler in ihrem Atelier: Eine Fotodokumentation.* Munich: Mahnert-Lueg, 1979. Includes texts by artists and their critics, and a foreword by Jörg Krichbaum.

Klotz, Heinrich, and Krase, Waltraud. *New Museum Buildings in the Federal Republic of Germany/Neue Museumsbauten in der Bundesrepublik Deutschland.* Includes a text by Markus Lüpertz. New York: Rizzoli, 1985.

Költzsch, Georg-W., ed. *Deutsches Informel: Symposion Informel.* 2nd, corrected and expanded ed. Berlin: Edition Galerie Georg Nothelfer, 1986.

Kultermann, Udo. *Art and Life.* New York: Praeger Publishers, 1971. Originally published as *Leben und Kunst: Zur Funktion der Intermedia* (1970). Includes Beuys, Brus, Christo, and Kaprow.

—. *The New Painting.* Rev. ed. Boulder, Colorado: Westview Press, 1977. Translation of *Neue Formen des Bildes* (1976), 2nd ed.; 1st German ed., 1969. Includes Armando, Brehmer, Christo, Hacker, Hamilton, Hockney, Hödicke, Koberling, Morley, Paolini, Raetz, Thieler, Vedova, and Williams.

Murken-Altrogge, Christa, and Murken, Axel Hinrich. *Vom Expressionismus bis zur Soul and Body Art: "Prozesse der Freiheit:" Moderne Malerei für Einsteiger.* Cologne: DuMont, 1985.

Raum, Hermann. *Die bildende Kunst der BRD und Westberlins.* Leipzig: VEB E.A. Seemann, 1977. West German art from an East German perspective; includes Beuys.

Roh, Franz. *German Art in the 20th Century.* Greenwich, Connecticut: New York Graphic Society, 1968. Translation of *Geschichte der deutschen Kunst von 1900 bis zur Gegenwart* (Munich: Bruckmann, 1958) with additional material by Juliane Roh covering the period 1955–68. Also published in an abridged version with the title *German Painting in the 20th Century.*

Roh, Juliane. *Deutsche Kunst der 60er Jahre: Malerei, Collage, Op-Art, Graphik.* Munich: Bruckmann, 1971.

Rotzler, Willy. *Objekt-Kunst von Duchamp bis Kienholz*. Cologne: DuMont Schauberg, 1972. Includes Beuys, Christo, Kienholz, and Vostell.

Ruhrberg, Karl. *Kunst im 20. Jahrhundert: Das Museum Ludwig—Köln: Auswahlkatalog*. Cologne: Museum Ludwig, 1986. Includes Baselitz, Beuys, Borofsky, Christo, Fetting, Hamilton, Hockney, Hödicke, Kaprow, Kienholz, Koberling, Lüpertz, Middendorf, Morley, Salomé, Schönebeck, Stöhrer, Thieler, Vostell, and Zimmer.

Sager, Peter. *Neue Formen des Realismus: Kunst zwischen Illusion und Wirklichkeit*. Cologne: DuMont Schauberg, 1973. Includes Hamilton, Morley, and Raetz.

Sauer, Christel. *Die Sammlung Fer / The Fer Collection*. Edited by Paul Maens. Cologne: Gerd de Vries, 1983. Includes an English translation.

Schmied, Wieland. *Malerei nach 1945 in Deutschland, Österreich und der Schweiz*. Frankfurt am Main: Propyläen, 1974. With contributions by Peter F. Althaus, Eberhard Roters, and Anneliese Schröder.

Thomas, Karin. *Bis Heute: Stilgeschichte der bildenden Kunst im 20. Jahrhundert*. 7th ed. Cologne: DuMont, 1986. First ed. published in 1971.

—. *Zweimal deutsche Kunst nach 1945: 40 Jahre Nähe und Ferne*. Cologne: DuMont, 1985.

—, ed. *Tiefe Blicke: Kunst der achtziger Jahre aus der Bundesrepublik Deutschland, der DDR, Österreich und der Schweiz*. Cologne: DuMont, 1985. Catalogue of the collection in the Hessisches Landesmuseum, Darmstadt; introduction by Johann-Karl Schmidt and essays by Sascha Anderson et al.

Vogt, Paul. *Geschichte der deutschen Malerei im 20. Jahrhundert*. Cologne: DuMont Schauberg, 1972.

Wedewer, Rolf, and Konrad, Fischer. *Konzeption—Conception: Dokumentation einer heutigen Kunstrichtung / Documentation of Today's Art Tendency*. Cologne: Westdeutscher Verlag, 1969. Includes Burgin, McLean, and Raetz.

Wildermuth, Armin. *Wiederkehr der Bilder*. Basel: Galerie Buchman, 1983. Includes summaries in English.

Winkler, Gerd. *Kunstwetterlage*. Stuttgart: Belser, 1973.

PERIODICALS

Arbeitskreis "Kunst in Deutschland." *Deutsche Kunst der Gegenwart in öffentlichen Sammlungen: Jahrbuch der Neuerwerbungen*. Berlin: Albert Hentrich, 1983–.

Faust, Wolfgang Max, ed. "Deutsche Kunst, hier, heute." *Kunstforum International* 47 (December 1981/ January 1982). Issue devoted to German art, including "Van Gogh an der Mauer: Die neue Malerei in Berlin, Tradition und Gegenwart," by Ernst Busche, pp. 108–16.

—, ed. "Zwischenbilanz I: Gemeinschaftsbilder." *Kunstforum International* 67 (November 1983). Issue on group work in German art, including articles on Barfuss/Wachweger, Castelli, Fetting, and Salomé.

Honnef, Klaus, ed. "Zwischenbilanz II: Neue deutsche Malerei." *Kunstforum International* 68 (December 1983). Issue on German painting, including articles on Barfuss, Fetting, and Middendorf.

Kulturchronik: News and Views from the Federal Republic of Germany. Bonn: Inter Nationes, 1982–.

Kunstjahrbuch. Hannover: Fackelträger-Verlag, 1970–80.

First Pandemonium Manifesto

November 1961

The poets lay in the kitchen sink,
body in morass.
The whole nation's spittle
floated on their soup.
They grew between mucus membranes
into the root areas of humanity.
Their wings did not carry them heavenward—
they dipped their quills in blood,
not a drop wasted writing—
but the wind bore their songs,
and those have shaken faith.

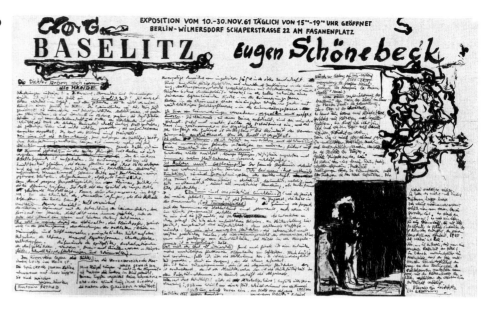

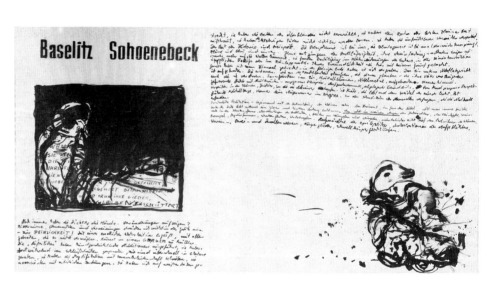

The poets are still throwing up their hands. Point to changes? Bitterness, impotence, and negation are not expressed in gesture. TILL IT HURTS! With a final, finite truth pouring out. No truck with those who can't wrap art up in a SMELL. I have no kind word to say to the amiable. They have proceeded by art-historical accretion, they have ruled neat lines under things, they have practised mystification with all the passion of a collector. The survivors' beds are not unmade—remnants of the last housework stuffed under the bed—the gelatinous threads have not become visible, the unfruitful troubles derided. The rest of history is instances.

We have blasphemy on our side! They have escaped their sickbeds. Their simplifying methods have swept them on to the crests of the waves. The ice beneath the foggy maze is broken. They are all frozen stiff—those who believe in fertility, those who believe in it—those who deny their pens and those who revere them. Fiery furrows in the ice, flowerlike crystals, crisscross icicles, starry sky torn open. Frozen nudes with encrusted skin—spilt trail of blood. The amiable are washed up, deposited as sediment. Faces that the moon pulls, in perspective, in the rivers, faces into which waste water drips. The toad that licks up the singers' spittle. Glowing crystal mountain. Homer, the water of thine eye, in the mountain lake. Caught in the curlicues of the manuals which invented the method.

Pacifying meditation, starting with the contemplation of the little toe. On the horizon, in the depths of the fog, you can always see faces. Under the blanket a being stirs, and behind the curtain someone laughs. IN MY EYES CAN BE SEEN the altar of Nature, the sacrifice of flesh, bits of food in the drain, evaporation from the bedclothes, bleeding from stumps and aerial roots, oriental light on the pearly teeth of lovely women, gristle, negative shapes, spots of shadow, drops of wax, parades of epileptics, orchestrations of the flatulent, warty, mushy, and jellyfishy beings, bodily members, braided erectile tissue, mouldy dough, gristly growths in a desert landscape.

Withered, timorous conifers and flailing deciduous trees in the memory. Anthropomorphic potbellied putty rocks (without Arcimboldi). M. Vrubel in the cold sacristy of a Byzantine stone church—in the memory form. Redon in the fleece of a one-eyed sheep, in the garden where the soft-leaved plants have faces—in the memory form. I am warped, bloated, and sodden with memories. The destinies that make no one look up: I have them all on record. By night, troubles soon come to mind, like starlings in late summer—a negative film. The influence of the stars is undeniable, the purity of the night sky is awesome, only the source is poisoned. The many killings, which I daily experience in my own person,

and the disgrace of having to defend my excessive births, lead to a malady of age and experience. Ramparts are built, byways pursued, sweets on offer, and more and more slides, sleepier and sleepier.

They have harassed me. The alien rhythm betrays them into the craziest dances. I deplore their rhythmic function. They are special editions of passion. Their art is a breathing exercise—ecstatic, contemplative, misty, inward, mathematical. Art as a meditative action, as the manifestation of an in-group.

In me there are pre-pubertal enclaves (the smell when I was born); in me there is the greening of youth, love in decoration, the tower-building idea. The greening of youth and the coming autumn leaves are valid, even if I fall into paranoid decline in winter. In me the brewers of poison, the annihilators, the degenerates, have attained a place of honor.

The seat of all unfruitful religion. Piles of squatting background monks, spread out in tiers, rigidly staring. In me there is a dead-end slide, the longing for Grecian columns, the addiction to excess, the Mannerists' addiction to excess, a tangle of tendrils and artifices, coldness and devotion—it is always enforced love. Because revulsion often overcame me without warning, I took—and still take—delight in sullying my

own moments of innocent openness. Flat-chested and lacerated, I assail the hollow spaces. It has turned into impressiveness. Another procedure that shame demands. Shame is not Situationism, it is the slide into the abyss, it is frightening, it is mob delusion, it is a relapse into the pubertal ooze. Euphoria deepens abysses.

Case 13

Often saw original mind in E.,
but character mixed.
December joy: I am thy death.

Second Pandemonium Manifesto

Spring 1962

Negation is a gesture of genius,
not a wellspring of responsibility.

With solemn obsessiveness, autocratic elegance, with warm hands, pointed fingers, rhythmic love, radical gestures—we want to excavate ourselves, abandon ourselves irrevocably—as we have no questions, as we look at each other, as we are wordless, as we, noblest profanity—our lips kiss the canvas in constant embrace—as we pull sweat-rags through our veins and mendicantly, non-violently, corrosively, painfully, carry our color ordeal over into life, as we naturally sully our cave tomb with exuberance—what our sacrifice is, we are. In happy desperation, with inflamed senses, undiligent love, gilded flesh: vulgar Nature, violence, reality, fruitless—parents forgotten—in answer to the vanished question, in our looks at you, lust and blood, our bodies prove that we love. Audacious twinness (deux, deux, deux) springs from love. Doubly pregnant cave. We have moved into a locked cave of Pandemoniac origin. Dark images (splendor in front, squalor behind)—mighty infatuation with senseless death. No outstanding debts. No. Twenty-four hypocritical years purged to the last dregs, to the creatorial uniform death in the front-line city. Left to my own devices, with no fear of the sudden break. I look into myself. Now I am here! Hygienic solace maintains the advantage gained by my isolation. First my restless eyes—mold gathered between ecstatic reactions of erectile tissue, then caress the gristle in the randy evening hours. Fantastic reality! Nameless life passes by. Fantastic reality—the picture of my great parturition. On a foray into the crematorium, I found I had set out into my own bloody nose, navel oozing, on a painful migration into my eyes. Then I shut myself into a blazing light and departed. The last note I heard hung sweetly in the air. The smell chews ivy. In tulip gardens, gates of retirement set up to the saturnine schizophrenic G. As we do not lose our way amid hybrid dough fantasies. Our friends are still deceased. Glad mourning is the breath of our cave. The rampart of broken fingernails (plucked in euphoria), a witness of resistance, preserves us from non-satanic tortures. Blunt fingers with no nails, tombs of the one minute in the place of collective sadness. Finger joints fill A.A.'s mouth. We are still the only friends of our happy intercourse. The enticing, seductive WE. Fastidious contemporaries, democratic visitors—wealth of this city. It stinks. We live through endless ecstasy. My secret. Paranoia, on to paranoia, in the outspread fingers, the knuckles that leave the gentle rhythm of paranoia on the wall. We love cigarettes with mourning-bands. We are capable of distinguishing, we are not blind, but we are deaf. We foment rebellion among epileptics. The sexual knots of pain enclosed in larval disguise. Physical weakness in the moment of climax. No intolerable signs of degeneracy. Honest depravity with a blasphemous stamp. The greatest Mannerist de-monstrance. Essential feigned isolation. This penetrable crust which contains Artaud (bursting sign). Colorful linens of esoteric light outdazzle the entry of pale youth. Social desolation lashed with dirty tricks—the age's style. Secretions of the flesh, sexual fantasy,

embrace with kisses, direct love (two, two)—I see them!—timeless threads preserved among women. That is the Creatorium. A Pandemoniac redoubt which makes further hope impossible. Demoniac vulgarity is constantly visible beauty. This is the essential malice. Demoniac vulgarity is constantly visible beauty. The men's god-substitute, praised in chorus of unanimous reserve. Herein have I chosen. The smell conceals a plainness. Nothing reflects, nothing evaporates. I always find myself thrown back, whereby historical instances no longer serve. I always find dwindling lust. The choice is indecisive, unemotive, lasting splendor, nevertheless pathogenic. The torments of the jellyfish, who ever feels them? Secret malady . . . uniform death—soothing, fetishistic agonies of conscience. The year of sweet apprehension once lived through, here surviving is now the most painful ordeal of all. I am in Pandemonium undergoing hygienic solace. My handsome, overdue body is in this (A.A.'s) especially colorful shadow. Passionate feelings of the crowd, corroborating clichés, visiting religious soul-brothels, with rhythm and click of backgammon, smiling inanely at the one thing that is painful. What is victorious about this?—Do you want to see me cry? Pandemoniac shots in the back along the roadbed—umbilical rails. Recognized a family that coughs among the hinds' udders in Saxony without need of inner help. More of these little nest explosions—such a lot of skin scrubbed away already. Glass eyes cool them off. Never note down an observation. A. Gallen! Standing barefoot on suppurating stumps of felled trees, shouting into madness. I have only now been offered the annual rings. Far and wide I shake drops of water from my feet. Poor A. Gallen. Death has long been abandoned as a school disease. I. Ducasse is fateful, without willingness to love. An epidemic of pederasts shitting blood—doubly fruitful in a religious sense, if none of you helps out the wings of words. In this I myself stand resurrected. All downright poetry. Cleared away. Here I lie in tulips—G.'s epitaph. I'm the vanguard of my journey. No picture without silk stockings as a guiding thread, no picture without this useless crowd of ecstatic faces in boxes. Extract from five-year professional

training. As they can't say anything to me. I warned you. In spite of that, these passionate bonds—you all do know. No more materialstations. Of which there still remains—uniquely—one real possibility which has come my way. To let the unnamable bleed, the crystallization of a miscarriage, to let exuded ice-ups ice up, is to transcend all automation—autism is a flower stalk.

Only one life—living withdrawn, in attacks against life. Mourn the loss—no mourning for the lost. Flying clods steered into Pandemonium. Feverish apertures feverishly filled. No impossible leadership without a hidden malady. Constant renewal of the toxins. Euphoria deepens the abysses. All withdraw. The fancy enjoyments have won. For all the rebellion, for all the loving embrace (insanity) I see you all drift away. Times of never-halting devastation. Upswing through Pandemoniac roofing to the ultimate vision. Cold snaps enforce moments of salvation, such as: calling a word to mind, all those poets in boxes, oil painting, care of adhesives, fear of looking at excrement, horizontal formats, remains of housework under the bed, trips to Paris, repression of exhibitionism, building blocks . . . Pandemoniac upswing through the creatorial roofing to the ultimate vision, the Pandemoniac redoubt, which leaves no more room for hope. Ripped away all skin, the last simile, and cut oneself through to the quick. Ineluctable, unshakeable, upright stasis, where no end-products (precise pictures) are present. Past it goes, past it goes, through Circassia. Paranoid March, Ride of the Paranoids, Paranoids' Leap, paranoiacide, December joy . . . and so I swim from your sight in sperm—away from the surprised eyes of my mother.

Irreconcilable with cognac and sober—fastidious democratic contemporaries. Asiandom of the Season. Now the membrane borrowed from the sacrosanct surface, vibrating canvas (lending sexual maturity a helping hand), lovingly violated. Ripped away, the last skin, the last simile. On, far on, on into the white quick. Look good in boxes, all the heads, the poets, confusion of profusion. Lightning without God into bare woods, body of mine born into clearest water. Fearsome darkness in the ice crystal of one and only truth. Up, floated twisting celestial updraught to the final mission.

I am of invisible extent. Systematic mortification of the regions without sensation (grading off) in a single lapse of time. The infinity that blows from my mouth. I am on the moon as others are on the balcony. Life will go on.

All writing is crap.

NOTE: The translations of the manifestoes are excerpts from the complete texts. The contribution of Schönebeck to the first manifesto is not given. The illustration for the second manifesto represents only one sheet; the second sheet, with drawings and text by Schönebeck, was not available for this publication.

Lenders to the Exhibition

Baviera Collection
Bishopric of Westphalia
Anna Block, Berlin
Otto Block, Berlin
K. P. Brehmer
Bazon Brock
Luciano Castelli
The Chase Manhattan Bank, N. A.
Jan E. Clee
Deutsche Bank, Hamburg
The Federal Republic of Germany
Paul-Armand Gette
Dieter Hacker
Armin Hundertmark
Carol Johnssen
Jean-Paul Jungo, Morges, Switzerland
K. H. Hödicke
Edward and Nancy Reddin Kienholz
Bernd Koberling
M. and C. Koschate, Frankfurt
Ludwig Collection, Aachen
Gino di Maggio
Marx Collection
Dr. Hans-Jochem Lüer
Jörn Merkert, Düsseldorf
Olaf Metzel
Reinard Onnasch, Berlin
Giulio Paolini, Turin
Peter J. Petersen, Berlin
Peter Pohl
Dr. Hanspeter Rabe
Loveday and Bruce Raben
Peter and Ursula Raüe, Berlin
Leland Rice
Salomé
Lothar Schirmer, Munich
Eva-Maria Schön
Stober Collection, Berlin
Massimo Valsecchi
Emilio Vedova
Anne MacDonald Walker
Claus H. Wencke, Bremen
Emmett Williams
Wittelsbacher Ausgleichsfonds, Munich

Kunstmuseum Basel, Basel
Berlinische Galerie, Berlin
Staatliche Museen Preussischer Kulturbesitz,
 Nationalgalerie, Berlin
Hessisches Landesmuseum, Darmstadt
Cabinet des Estampes, Geneva
Hamburger Kunsthalle, Hamburg
Städtisches Museum, Leverkusen
Saatchi Collection, London

The Museum of Contemporary Art, Los Angeles
Staatliche Graphische Sammlung, Munich
Städtische Galerie im Lenbachhaus, Munich
Rijksmuseum Kröller-Müller, Otterlo,
 the Netherlands
Crex Collection, Hallen für Neue Kunst,
 Schaffhausen, Switzerland
Museum Moderner Kunst, Vienna

Galerie Inge Baecker, Cologne
Galerie Beyeler, Basel
Edition Block, Berlin
Mary Boone–Michael Werner Gallery,
 New York
Galerie Fahnemann, Berlin
Rosamund Felsen Gallery, Los Angeles
Galerie Gmyrek, Düsseldorf
Edition Hundertmark
Galerie Jöllenbeck, Cologne
Buchhandlung Walther König, Cologne
L. A. Louver Gallery, Venice, California
Galerie Lohrl, Mönchengladbach
Middendorf Gallery, Washington, D. C.
David Nolan, New York
Galerie Nothelfer, Berlin
Raab Galerie, Berlin
Galerie Thomas, Munich
Turske and Whitney Gallery, Los Angeles
Waddington Graphics, London
John Weber Gallery, New York
Galerie Michael Werner, Cologne
Galerie Wittenbrink, Munich